# BATTLE LINES

## *Essays on Western Culture, Jewish Influence, and Anti-Semitism*

BRENTON SANDERSON
*Kevin MacDonald*

The Occidental Press

# CONTENTS

# FOREWORD BY DR. KEVIN MACDONALD

Brenton Sanderson began writing for *The Occidental Observer* and *The Occidental Quarterly* in 2011. I have been an enthusiastic supporter of his work from the beginning – his first essays were on the "War on White Australia" which, I am happy to learn, will be coming out in a separate, much anticipated, volume.

As an editor, one quickly learns to appreciate essays that are well-researched and well-written, and Sanderson's work has always been up to the highest standard. Each of these essays is a gem. The general theme of *Battle Lines* is the difficult question of Jewish influence – difficult at least partly because the literature is littered with apologetic writings, so that getting a firm grasp on such a topic requires great persistence and honesty. As he writes in the Introduction, "The Jewish Question is foundational to the demographic transformation of the West, the revolution in its sexual and ethical mores, and to the trajectory of Western politics, art and culture." We can't avoid talking about it if we want to be honest about what is happening. But doing so is a thankless task, a reason for being scorned and ostracized, fired from one's job, barred from influential positions in the media and academic world. Sanderson quotes Richard Wagner writing in the nineteenth century, "It is distressing to me always to come back to the theme of the Jews. But one cannot escape it if one looks to the future."

And 150 years after Wagner's statement, it is still absolutely true. We simply can't avoid discussing the Jews. Honest discussions of Jewish

VIII – FOREWORD BY DR. KEVIN MACDONALD

influence are absolutely necessary if White people are going to have a future.

Much of Sanderson's work has been on Jewish influence on culture, particularly in the arts and the media. These are major contributions. Beginning in the early twentieth century Jews have had enormous influence on the visual arts as artists, critics, dealers, and collectors. In 1973 Sophy Burnham published *The Art Crowd*, estimating that 80 per cent of the 2,500 core "art market personnel" – dealers, curators, gallery owners, collectors, critics, consultants and patrons of the arts – were Jewish.[1]

So it's not surprising that Jewish attitudes would be reflected in what counts as fine art and whose work gets promoted. As Sanderson notes in his essay on Tristan Tzara and the Dada movement, there was a "Jewish intellectual substructure of many of these twentieth century art movements... manifest in their unfailing hostility toward the political, cultural and religious traditions of Europe and European-derived societies."

Given this reality, it is not difficult to envision Jewish critics championing Jewish artists or non-Jews like Jackson Pollock whose work can be seen as advancing this hostility toward the culture of the West. Nor is it difficult to imagine Jewish art dealers promoting such artists (e.g., Sidney Janis promoting Mark Rothko [Chapter 9] whose fame had nothing to do with any recognizable talent but was inextricably linked to his being a member of a Jewish sub-culture). The same goes for Jewish art museum curators (e.g., Katherine Kuh promoting Rothko), Jewish collectors (e.g., Charles Saatchi promoting Damien Hirst), and Jewish critics (Clement Greenberg promoting Jackson Pollock).

Gustav Mahler and Leonard Bernstein were doubtless very talented musicians and composers. However, their elevation to the status of cultural icons cannot be explained by talent alone. Once again Sanderson documents a coterie of Jews promoting these figures, including Bernstein promoting Mahler. Bernstein in particular has always fascinated me because of his flamboyant personality and style. Sanderson notes that his fame rivaled that of Elvis Presley or Marilyn Monroe. Even I,

who was not particularly drawn to classical music at the time, was quite aware of him and recall being struck by his impassioned performances as a conductor. The issue of Jewish personality is relatively unexplored, but it seems that Jews often have extreme personalities – personalities that make people stand out in whatever their field of endeavor, with Bernstein being a prime example. In my first book on Jews, *A People That Shall Dwell Alone*, I summarized data indicating that, on average, Jews rated highly on all the personality systems.

And while Jews have been able to promote certain individuals to the status of cultural icon, they have also attempted to tear down others, Richard Wagner being the most prominent example. In the case of Wagner, his towering musical genius presents a major obstacle in this endeavor, but there can be little doubt that there has been a campaign against Wagner waged by Jewish music critics and producers. Sanderson provides an amazing quote from Bernstein, "'I hate Wagner, but I hate him on my knees' – a grudging acknowledgement of the scale of German composer's achievement." Despite his prodigious talent, Wagner is now routinely labeled a "deeply pathological personality" – a common description by Jews eagerly seeking out any flaw in a person they dislike for deeper reasons. The result has been that performances of Wagnerian works like *The Ring* "in the modern era have invariably sought to satirize the drama to subvert the message Wagner attempts to convey." If they can't ban him outright because the music is too powerful, they can nip at the edges with satire and false messaging.

Another aspect of Jewish influence on culture has been the sexual revolution. In writing *The Culture of Critique* I always thought of the chapter on Freud as pivotal for understanding what had happened since the 1960s. Freud's war on sexual and family mores has had vastly more devastating effects on people at the lower end of the IQ distribution than the solidly middle class or upper class. Those at the lower end of the IQ distribution benefit more from the social supports embedded in religion and traditional culture, but these have essentially been destroyed since the 1960s. Since then, all the markers of family function have declined precipitously, including increases in divorce, lower rates of

marriage, births out of wedlock, and single parenting – all of which are linked to negative effects on children and all more common in people of lower socioeconomic status. In recent decades this has been exacerbated by drug abuse, especially opioid abuse, which is again more common among people on the lower rungs of society.

Here Sanderson emphasizes how the ongoing sexual revolution, originated by a vastly disproportionate number of Jewish intellectuals, has filtered into the entertainment industry, focusing on the work of Jenji Kohan (*Orange is the New Black*) and Jill Soloway (*Transparent)*. When I was growing up in the 1950s, religious and patriotic groups exercised significant power over the content of movies and television. Marriage and having children were generally depicted as rewarding life choices, and all the psychological research indicates that traditional married families are indeed more likely to result in well-adjusted children.

However, such families are a vanishing breed in the Western media landscape, replaced by shows presenting divorced families, single parenting, and homosexual and transgender relationships as normal and fulfilling. Both Kohan and Soloway are strongly identified Jews (Kohan wanted to become a rabbi and Soloway said that Jews in Hollywood are "recreating culture to defend ourselves post-Holocaust"). Their careers have taken place completely within a Jewish milieu – a good indication of the fundamentally Jewish nature of the entertainment industry. A non-Jew wishing to have a career in the industry could not possibly produce, write, or direct anything that offends Jewish sensibilities.

Another important theme in *Battle Lines* is Jewish apologia for the crimes of communism, a topic that must remain suppressed "regardless of how many historians (Jewish and non-Jewish) confirm the decisive role Jews played in providing the ideological basis for, and the establishment, governance and administration of, the former communist dictatorships of Central and Eastern Europe." Daniel Goldhagen is typical of those Jews who want to totally suppress this history, asserting that any linking of Jews with communism is a "calumny." However, Sanderson provides extensive reviews of two books by Jewish authors with a different slant – that yes, Jews were decisive, but whatever they

did was justified by anti-Semitism. For example, the much-exaggerated pogroms of the late nineteenth century are used to justify the murder of millions and the oppressive police states, and Jews are absolved from any role in triggering the anti-Jewish attitudes widely felt by the peoples of Eastern and Central Europe. This is outright falsification of history. And as Sanderson notes,

> Free discussion of the Jewish role in communist crimes under-mines Jewish pretensions to moral authority grounded in their self-designated status as history's preeminent victims. In con-temporary academia there are, in addition, strong personal and professional disincentives for highlighting the Jewish role in com-munist crimes, and it is, therefore, not surprising that non-Jewish historians and intellectuals are equally reluctant to recognize the Jewish backgrounds of many revolutionaries and to explore how their Jewish identity influenced their beliefs and actions. The Jewish-controlled media organs in the U.S. have conditioned most Americans to suffer a sort of mental allergic reaction to topics sensitive to Jews.

This is an excellent general description of all topics related to Jewish influence. Jews are ethnically motivated to see themselves in a positive light, while non-Jews rightly fear their careers in academia, the media, or politics will be jeopardized if they honestly and openly discuss the impact of Jews on Western societies. The result is a plethora of glaring omissions, and disingenuous analyses often accompanied by a maudlin philo-Semitism.

The reasons White academics or journalists produce this drivel are easy to understand. Such endeavors are massively incentivized, whether by obtaining tenure in the university system or getting a position in the elite media or politics. The message from our latter-day commissars is clear: "Sell out and we'll make you a star." Brenton Sanderson has not sold out. These essays offer excellent scholarship, clear writing, and most of all, honesty – a rare trait indeed in the contemporary West.

# INTRODUCTION

My path to writing for *The Occidental Observer* and *The Occidental Quarterly* began in 2010 when I came across a video of Dr. Kevin MacDonald being interviewed by Mark Green. The topic was the Jewish intellectual movements featured in MacDonald's masterpiece *The Culture of Critique*. Fascinated by the discussion, I ordered his famous trilogy on Judaism. These books, together with MacDonald's *Cultural Insurrections*, convinced me that Judaism was indeed a group evolutionary strategy, and that the Jewish intellectual movements discussed in *Culture of Critique* can accurately be conceptualized as post-Enlightenment manifestations of Judaism as a group evolutionary strategy. Everything I have written on the topic of Jews and Jewish influence is built on these conceptual foundations.

As an academic specializing in politics, economics and history, I was already familiar with the various intellectual movements discussed in *Culture of Critique*. I had, for example, explored the leading texts of the Frankfurt School, including *Dialectic of Enlightenment* and *The Authoritarian Personality*. While it had occurred to me that the authors of these works were Jewish, it was only upon reading *Culture of Critique* that I appreciated the full sociological significance of this fact. I found the chapter outlining Jewish influence on immigration policy in the United States both profoundly interesting and infuriating. MacDonald included a small section on Jewish influence on immigration and multicultural policies in Australia, which, as an Australian, I thought merited more expansive treatment. I felt suitably qualified to undertake this

task, and thus was born my essay series *The War on White Australia* – to be published in a forthcoming volume.

My generation of Australians was the last to grow up in an overwhelmingly White and culturally-cohesive nation. From a young age I had a strong racial identity – something of a mystery given that my parents were not particularly racially conscious. The topic of Jewish influence was, however, mentioned while I was growing up, and I recall my father pointing out the endless Jewish names in film credits, and explaining to me how the Jewish domination of Hollywood determined the type of films that were made and their moral messaging (e.g., Germans cast as arch villains and Jews as intelligent, unjustly-victimized, moral paragons). My father's rather critical outlook regarding Jews was, however, counter-balanced by the cloying philo-Semitism of my evangelical Christian mother.

While reading Dr. MacDonald's famous trilogy, I discovered his personal website, and then *The Occidental Observer* and *The Occidental Quarterly*. I was immediately impressed by the quality of the writing and willingness to discuss the profoundly important (though taboo) topic of Jewish influence on Western societies. It has been a pleasure to offer my thoughts on this and other topics alongside Professor MacDonald, Dr. Andrew Joyce and a host of other outstanding intellects.

In 2010, *The Occidental Quarterly* ran an essay competition on the theme of "Libertarianism and White Nationalism." My entry, "Free to Lose: Jews, White and Libertarianism" – subsequently published in *The Occidental Quarterly* – was very well received (see Chapter 1). Reviewing the essay for this volume, I find its core argument – that libertarian ideas and policies harm the interests of White people in racially-diverse, multicultural states – has only been confirmed by the political and economic developments of the last decade.

A notion from *Culture of Critique* that deeply resonated with me was MacDonald's observation that Darwinian ethnic competition is carried out through the construction of culture. He makes the point that no evolutionist should be surprised that "intellectual activities of all types may at bottom involve ethnic warfare, any more than one

should be surprised at the fact that political and religious ideologies typically reflect the interests of those holding them."[2] As outlined in Chapter 19, the Dada movement reflected the ethnic interests of its Jewish founder, Tristan Tzara, whose revolt against European social constraints stemmed from his Jewish identity, and his belief that the Jews of Romania (and particularly in his native Moldavia) were the innocent victims of pervasive anti-Semitism.

In response to this, and the horrors of World War One, the Dadaists (led by Tzara) tried to accomplish a great negative work of destruction. Presaging the poststructuralists and deconstructionists of the sixties and seventies, they believed the only hope for European civilization was to destroy those systems based on reason and logic and replace them with "exacerbated individualism, universal doubt and aggressive iconoclasm," which would overthrow the traditional Western "canons of reason, taste and hierarchy, of order and discipline in society, of rationally controlled inspiration in imaginative expression."[3]

Jews have, for many decades, maintained an incredibly powerful presence as cultural critics in Western societies. I had always been struck by the tendency of Jewish intellectuals to use their position as gatekeepers of Western culture to advance their ethnic interests through how they conceptualize the artistic and intellectual achievements of Jews and Europeans. The tendency has been to overstate and ethnically-particularize Jewish achievement (i.e., to actively construct Jewish geniuses), thereby making it a locus for ethnic pride. European achievement is, on the other hand, downplayed, or where undeniable, universalized and thus neutralized as a potential basis for White pride and group cohesion.

Prominent examples of this tendency are the Jewish cults that have grown up around the composer Gustav Mahler (see Chapter 2), the Abstract Expressionist painter Mark Rothko (see Chapter 9), and the conductor and composer Leonard Bernstein (see Chapter 17). The flipside of this intense ethnic nepotism are Jewish efforts to downplay or denigrate the achievements (and personal reputations) of leading non-Jewish cultural figures. A prominent example of this phenomenon

is the Jewish response to the German composer Richard Wagner (see Chapters 6 and 20).

A leading critic of Jewish influence on the culture and society of his time, Wagner has been the subject of numerous books and documentaries condemning his anti-Semitism and his putative status as the spiritual and intellectual godfather to Adolf Hitler. In the Jewish-dominated cultural milieu of the contemporary West, this idea has taken on such a life that Wagner's name is seldom mentioned today without the obligatory disclaimer that, while admittedly a musical genius, his reputation is forever sullied by his standing as a morally-loathsome anti-Semite. Ignoring whether his views regarding Jewish influence on German art, culture and politics had any validity, Jewish music writers and intellectuals have furiously attacked the composer for just having expressed them. Unable to convincingly refute his arguments, they have ascribed psychiatric disorders to the composer, portraying him as a racist, psychopathic, proto-Nazi monster. The Jewish response to Wagner is a highly instructive case study in ethnic warfare through the construction of culture.

Wagner was far from alone among leading cultural figures in nineteenth-century Europe in criticizing Jewish influence on European civilization. The great French novelist Honoré de Balzac offered mordant observations on the Jewish penchant for usury, ethnic networking, swindling and avarice (see Chapter 13). About thirty Jewish characters inhabit the pages of Balzac's novels. He modelled his Jewish financier, Nucingen, who appears in more of his novels than any other character, on Baron James Meyer de Rothschild, whom he knew personally. Balzac was acutely conscious (and critical) of the immense and steadily growing significance of money in European society, and of the ethnic group inseparably linked to it.

Certain non-Jewish figures have been lionized (to the point of absurdity) in films and television shows made by Jews to further their ethnic interests. Among these is the noted English World War Two cryptanalyst Alan Turing (see Chapter 11). The Jewish makers of the 2014 film *The Imitation Game* were drawn to Turing's story "as a tale

of a brilliant outsider forced to work with others to win the war against German evil." In this film portrayal, Turing becomes a Jewish proxy: a homosexual outsider victimized by the British establishment while using his intellectual brilliance to fight the worst enemies of the Jews. The recent Jewish sanctification of Turing as noble gay victim and Nazi nemesis is the photographic negative of pre- and post-World War Two Jewish efforts to smear Hitler and his National Socialist comrades as sexual perverts.

The Freudian notion that human aggression was linked to sexual repression has had profoundly negative consequences for Western societies. Anti-Semitism, regarded as a form of aggression, was understood to result from the denial of sexuality, and the role of the Jewish mission of psychoanalysis was to end anti-Semitism by freeing the *goyim* of their sexual repressions. Accordingly, the promotion of sexual liberation has been a central preoccupation of Jewish activists, intellectuals, and producers of culture.

The result has been the deliberate hypersexualization of Western culture – the practical ethno-political application of psychoanalytic theory to a traditional Western culture regarded as inherently authoritarian, fascistic and anti-Semitic due to its "repressive" sexual morality. An adjunct of the Jewish-led sexualization of popular culture is the idealization and championing of sexual and gender non-conformists. Jews have been integral to mainstreaming homosexuality and transgenderism – fully evident in the work of Jewish Hollywood directors and producers like Jenji Kohan (see Chapter 5) and Jill Soloway (see Chapter 15). Kohan is renowned for her series *Orange is the New Black* – an incredibly degenerate show that inverts traditional Western morality and glamorizes homosexuality. Soloway is famous for her series *Transparent* – a transgender-themed show that, in addition to promoting "gender fluidity," glorifies the non-White, non-heterosexual "other."

In his essay "Evolution and Ethics," the nineteenth-century English biologist and writer Thomas Huxley argued that human ethics are a by-product of natural selection and the struggle for existence between groups. Implicit in Huxley's theory (discussed in Chapter 3), is that an

effective form of group warfare involves subverting the shaming code of rival groups to fracture their cohesion and reduce their solidarity, and render them less effective competitors in the struggle for survival. The hypersexualization of Western culture and undermining of traditional gender roles has radically reduced the ability of Whites to compete with Jews.

As well as sexual revolutionaries, Jews have featured prominently as political revolutionaries and radicals – most notably as leaders of Bolshevik Revolution in 1917, and the post-World War Two Soviet satellite states in Eastern Europe. In this capacity, and especially as leaders and functionaries of the secret police, they were responsible for the mass murder of millions of Eastern Europeans. This has not, however, prevented Jewish historians and intellectuals from romanticizing Jewish involvement in communism and from morally absolving their ethnic kinsmen for involvement in some of the worst crimes of the twentieth century. (See my review of *Revolutionary Yiddishland: A History of Jewish Radicalism* in Chapter 4).

Jewish Marxist academic Phillip Mendes peddles an analogous brand of Jewish apologetics in his 2014 book *Jews and the Left: The Rise and Fall of a Political Alliance* (see Chapter 16). Rather than decrying his radical Jewish forerunners as handmaidens and functionaries of oppression and genocide, Mendes, while admitting the vast scale of Jewish involvement in the radical left, insists this was a justified response to European anti-Semitism. Offering feeble apologies for Jewish practices that engendered hostility among native Europeans, he resorts to that evergreen of Jewish apologetic historiography: the purported irrationality and malevolence of the European mind and character.

Equally eager to attribute psychopathology to Europeans is the noted Jewish historian, Daniel Goldhagen. Having built an academic career on morally indicting Europeans for their inveterate anti-Semitism and supposedly enthusiastic participation in "the Holocaust," Goldhagen denies any Jewish role in communism and its crimes, insisting anyone making such a link is a moral pariah. In Chapter 10, I review Goldhagen's 2013 screed *The Devil That Never Dies: The Rise and Threat*

*of Global Antisemitism* – a mendacious and weakly-argued account of the historical and sociological phenomenon of anti-Semitism. Other examples of Jewish apologia critically analyzed in this volume include the book *Jewcentricity: Why the Jews Are Praised, Blamed, and Used to Explain Everything* by Adam Garfinkle (Chapter 7), and speeches on anti-Semitism by the neoconservative pundit and Israel hawk, Caroline Glick (Chapter 8) and the former Chief British Rabbi Jonathan Sacks (Chapter 18).

In an academic environment where Jews and their acolytes aggressively police the boundaries of acceptable discourse, and where promoting Jewish ethnic interests is massively incentivized, it is hardly surprising that non-Jewish historians also regularly indulge in Jewish apologetics. A good example is the German historian Götz Aly, who, in his 2014 book *Why the Germans? Why the Jews? Envy, Race Hatred, and the Prehistory of the Holocaust*, ascribes inter-war German anti-Semitism to their pathological envy of "intellectually-superior" and upwardly socially mobile Jews. I critically analyze Aly's book in Chapter 12.

Whether the Jews comprise a religion, a nation, or an ethnic group (or a combination of these) has always been central to the Jewish Question. Since the advent of Boasian anthropology in the 1920s, and especially since the end of World War Two, Jews have been integral to excluding all forms of racialist thinking from public discourse in the West. They have successfully convinced hundreds of millions of people that such thinking is intrinsically wrong, evil, and undiscussable, with one notable exception: it is absolutely acceptable (indeed it is strongly encouraged) to criticize White people and ascribe to them responsibility for all the world's problems. This is very different to what many Jewish intellectuals espoused in the late nineteenth and early twentieth centuries. In Chapter 14, I examine pre-Boasian Jewish attitudes to race, where racial differences in intelligence and other traits were taken for granted, where the historical development and trajectory of nations (including the Jewish nation) was held to be contingent on such differences, and where the preservation of Jewish racial purity was an explicitly-stated objective.

The conflict of interest between Jews and White people in Western societies is so fundamental it is impossible for those genuinely seeking to promote White interests to ignore it. The Jewish Question is foundational to the demographic transformation of the West, the revolution in its sexual and ethical mores, and to the trajectory of Western politics, art and culture. Moreover, Jewish intellectual activism has shaped the very self-conception of White people in profoundly maladaptive ways. While many people, after decades of this conditioning, suffer a sort of mental allergic reaction whenever the topic of Jews is raised, it is of such overriding importance it simply cannot be set aside. As Richard Wagner observed towards the end of his life: "It is distressing to me always to come back to the theme of the Jews. But one cannot escape it if one looks to the future."[4]

# Free to Lose: Jews, Whites and Libertarianism

In the first two decades of the twenty first century the political philosophy of libertarianism attracted a wave of support in the United States, particularly among the mainly White Tea Party movement, and the supporters of Ron and Rand Paul. One catalyst was the perceived failings of the Obama administration's response to the Global Financial Crisis and subsequent recession: a response characterized by an expansion of government ownership, spending, and regulation of the U.S. economy, with a corresponding decline in individual liberty. To espouse free-market libertarianism in this context seemed a rational corrective to Obama's economic agenda, given the libertarian commitment to the maximization of individual liberty and minimization of the state – at a time when a bloated dysfunctional state seemed to lie at the heart of the problems facing White people.

While there is a spectrum of libertarianism that straddles the left-right binary of contemporary politics, in today's world, libertarianism is primarily associated with the commitment to market liberalism that was the hallmark of the Austrian and Chicago Schools of economics. The 1974 Nobel Prize for Economics was awarded to the libertarian theorist Friedrich von Hayek. For the preceding thirty years the economic theories of the British economist John Maynard Keynes held

1

sway throughout the West. Keynesianism, involving state intervention in the economy through deficit spending to stimulate output and employment, is based on the idea that governments can and should act to eliminate the worst vicissitudes of the business cycle. Through manipulation of the federal budget and monetary policy a government can, theoretically, engineer economic outcomes.

Keynesianism emerged as a midpoint between free-market neo-liberalism and socialist state-planning. The stagflation problem resulting from the OPEC oil crisis of the early 1970s threw the post-war Keynesian consensus into turmoil, and set the scene for the re-emergence of political support for free-market libertarianism and, ultimately, for the election of Margaret Thatcher in Britain and Ronald Reagan in the U.S. and, subsequently, their legions of political imitators throughout the world. At the forefront of this renaissance of libertarian thought, alongside Hayek, was a group of Jewish intellectuals whose ideas and advocacy were key to this achievement, and to libertarianism's subsequent and enduring appeal. The most prominent and influential being Ludwig von Mises, Milton Friedman, and Ayn Rand.

It is one of the seeming paradoxes of political history in the past century that Jews have been prominent as theorists and activists for ostensibly opposing ideological forces: socialist collectivism on the one hand, and free-market libertarianism (and neoconservatism) on the other. However, this paradox fades when viewed through the lens of Kevin MacDonald's theory of Judaism as a group evolutionary strategy. According to this theory, Judaism emerged historically as a strategy to promote the economic welfare and reproductive success of Jews as a genetically distinct population. In *Culture of Critique*, MacDonald examines a range of twentieth-century intellectual movements that had decisive Jewish involvement, and concludes that they share a common tacit agenda in promoting the group evolutionary interests of Jews at the expense of non-Jews.[5] Accordingly, they can be accurately regarded as Jewish intellectual movements that are post-Enlightenment manifestations of Judaism as a group evolutionary strategy. A major focus in *Culture of Critique* is on the role of Jews in the formulation and

advocacy of Marxist and Cultural Marxist ideologies, such as the Critical Theory of the Frankfurt School.

My purpose here is not to determine whether libertarianism is, like the Frankfurt School, a Jewish intellectual movement. Here I will examine, firstly, why free-market libertarian ideas have held a strong attraction to a prominent subset of Jewish intellectuals; and secondly, the practical effect of libertarian economic and social policies on European-derived populations.

## Jews and Libertarianism

In a speech to the Mont Pelerin Society in 1972 entitled *Capitalism and the Jews,* Milton Friedman explored the seeming paradox that, despite the Jews having thrived under capitalism, they had played a central role in the formulation and advocacy of leftist political ideologies. He observed that, despite the Jews as a people having done very well under capitalist societies,

> for the past century, the Jews have been a stronghold of anti-capitalist sentiment. From Karl Marx through Leon Trotsky to Herbert Marcuse, a sizable fraction of the revolutionary anti-capitalist literature has been authored by Jews. Communist parties in all countries, including the party that achieved revolution in Russia but also present-day Communist parties in Western countries, and especially in the U.S., have been run and manned to a disproportionate extent by Jews – though I hasten to add that only a tiny fraction of Jews have ever been members of the Communist party. Jews have been equally active in the less-revolutionary socialist movements in all countries, as intellectuals generating socialist literature, as active participants in leadership, and as members.[6]

Friedman finds this somewhat difficult to reconcile with the fact that "Jews owe an enormous debt to capitalism." It is obvious that, as an

intelligent and capable people, Jews are always likely to thrive in the competitive context of the unfettered market. Accordingly, for Friedman, the real enemy to Jewish interests (and the interests of other able minority groups) are the barriers to entry and anti-competitive practices that, in various historical instances, have restricted their full participation in the economic affairs of a nation. For Friedman, it is axiomatic that

> the feature of capitalism that has benefited the Jews has, of course, been competition. Wherever there is a monopoly, whether it be private or governmental, there is room for the application of arbitrary criteria in the selection of the beneficiaries of the monopoly – whether these criteria be color of skin, religion, national origin or what not. Where there is free competition, only performance counts. The market is color blind. No one who goes to the market to buy bread knows or cares whether the wheat was grown by a Jew, Catholic, Protestant, Muslim, or atheist; by whites or blacks. Any miller who wishes to express his personal prejudices by buying only from preferred groups is at a competitive disadvantage, since he is keeping himself from buying from the cheapest source. He can express his prejudice, but he will have to do so at his own expense, accepting a lower monetary income than he could otherwise earn.[7]

Friedman was influenced by the ideas of Ludwig von Mises, who expressed a similar view in 1944. Identifying why free-market capitalism is good for Jews and other ethnic minorities, he writes:

> In an unhampered market society there is no legal discrimination against anybody. Everyone has the right to obtain the place within the social system in which he can successfully work and make a living. The consumer is free to discriminate, provided that he is ready to pay the cost. A Czech or a Pole may prefer to buy at higher cost in a shop owned by a Slav instead of buying

cheaper and better in a shop owned by a German. An anti-Semite may forego being cured of an ugly disease by the employment of the "Jewish" drug Salvarsan and have recourse to a less efficacious remedy. In this arbitrary power consists what economists call consumer's sovereignty.[8]

Another celebrated Jewish libertarian, who nevertheless rejected the label, was Ayn Rand (born Alisa Zinovyevna Rosenbaum). While Rand and her theory of Objectivism have never been much respected in academia, she exerted enormous popular influence through her writings. In her book *The Virtue of Selfishness* (1964) she also made the link between the extent of free markets and the relative absence of discrimination against minorities in a society. She writes that:

> no political system can establish universal rationality by law (or by force). But capitalism is the only system that functions in a way which rewards rationality and penalizes all forms of irrationality, including racism. A fully free, capitalist system has not yet existed anywhere. But what is enormously significant is the correlation of racism and political controls in the semi-free economies of the 19th century. Racial and/or religious persecutions of minorities stood in inverse ratio to the degree of a country's freedom. Racism was strongest in the more controlled economies, such as Russia and Germany – and weakest in England, the then freest country of Europe.[9]

The foregoing statements, each framed in the language of ethical universalism, clearly disclose the chief attraction of free-market libertarianism to Jews like Friedman, von Mises and Rand. Free markets, they affirm, advance the interests of Jews through imposing an impersonal economic discipline on non-Jews through which their ethnocentricity and anti-Semitic prejudice can be circumvented. That this proposition contains a great deal of truth is confirmed by the historical record: Jews

have indeed prospered under the conditions of free-market capitalism among often hostile majority European-derived populations.

It may have occurred to the reader, however, that while Friedman, von Mises and Rand opposed the existence of monopolies that provided "room for the application of arbitrary criteria in the selection of the beneficiaries of the monopoly," in reality Jews, even in the freest of markets, are notorious for developing and using ethnic monopolies in precisely this fashion. Indeed this is a major theme of MacDonald's *A People That Shall Dwell Alone* where he observes that from "the standpoint of the group, it was always more important to maximize the resource flow from the non-Jewish community to the Jewish community, rather than to allow individual Jews to maximize their interests at the expense of the Jewish community."[10]

The massive extent of Jewish nepotism in their business dealings is so exhaustively documented (very frequently by Jews themselves) as to be beyond dispute. Such is the rarity of instances where Jews use other Jews in a purely instrumental manner, they are cause for shock and trauma within the Jewish community (witness the Bernie Madoff affair). Given this, while, as Friedman, von Mises and Rand assert, the free market may hinder ethnocentric discrimination among Whites (a group which, owing to its evolutionary history, is strongly predisposed to individualism), the hyper-ethnocentrism of the Jews (and the Chinese) predispose them to transcend this "rational" discipline imposed by the free market. MacDonald notes the propensity of these groups to engage in "tribal economics" involving high levels of within-group economic cooperation and patronage, which confers on them "an extraordinarily powerful competitive advantage against individual strategies."[11]

Accordingly, the free-market libertarian agenda, when promoted in the context of a society that is multi-racial, and where some racial groups exceed Whites in their ethnocentricity, may not promote the group evolutionary interests of Whites in enhancing their access to resources and reproductive success. The truth of this proposition is confirmed by the tendency of European governments through history to impose laws barring Jews from many industries and professions. That such laws were

so widespread, and deemed so necessary, is indicative of an awareness, borne of experience, of the tendency of Jews to adopt a racial collectivist strategy in competition to the individualistic strategies of the majority Europeans – and that this would invariably result in Jewish market dominance, and concomitant outbreaks of anti-Semitism. That such restrictions were rendered less effective by their inconsistent application across the political patchwork of European jurisdictions through history was regarded by Friedman as a saving grace for Jewish populations:

> Throughout the nearly two thousand years of the Diaspora, Jews were repeatedly discriminated against, restricted in the activities they could undertake, on occasion expelled en masse, as in 1492 from Spain, and often the object of the extreme hostility of the peoples among whom they lived. They were able nonetheless to exist because of the absence of a totalitarian state, so that there were always some market elements, some activities open to them to enter. In particular, the fragmented political structure and the numerous separate sovereignties meant that international trade and finance in particular escaped close control, which is why Jews were so prominent in this area.
>
> It is no accident that Nazi Germany and Soviet Russia, the two most totalitarian societies in the past two thousand years (modern China perhaps excepted), also offer the most extreme examples of official and effective anti-Semitism. ... If we come to more recent times, Jews have flourished most in those countries in which competitive capitalism had the greatest scope: Holland in the sixteenth and seventeenth centuries, and Britain and the U.S. in the nineteenth and twentieth centuries, Germany in the late nineteenth and early twentieth century – a case that is particularly pertinent when that period is compared with the Hitler period.[12]

Agreeing with the thesis that free markets have been good for Jews, Jerry Muller, in his *Capitalism and the Jews* (2010), observes that when Jews have been allowed to compete with non-Jews on equal terms, they have always done disproportionately well.[13] Nevertheless, this economic success has been a source of both pride and embarrassment to Jews. It has prompted some anti-Semites to (erroneously) condemn capitalism as inherently Jewish. For the left, meanwhile, the reality of differential group achievement under conditions of legal (and assumed biological) equality is an embarrassment and a disgrace. They have hidden their discomfiture under the intellectual fig leaf of "systemic racism."

### Whites and Libertarianism

It should be evident from the foregoing that the only time that Whites will be acting in their evolutionary self-interest in embracing free-market libertarianism is when they live in a racially homogeneous society where their group interests are not imperiled by the utility-maximizing behavior of individuals; or in a multi-racial society where competing racial groups do not exceed Whites in their ethnocentrism, or exceed Whites in their ethnocentrism, but lack the intellect to capitalize on this by employing altruistic group strategies in competition with individualistic Whites.

The upshot of this is that the free-market libertarian agenda is likely to disadvantage Whites in societies with significant Ashkenazi Jewish and East-Asian populations. Such societies certainly include the contemporary United States and most other Western nations. In contrast, experience has shown that other racial groups, with their relatively lower mean IQs, despite their comparatively higher levels of ethnocentrism, are unlikely to out-compete Whites in the context of a free-market economy.[14] These groups, however, represent an evolutionary threat to Whites of an entirely different order: with their comparatively high birth rates, crime rates, and levels of welfare-dependency involving the large-scale transfer of resources away from White communities.

If White ethnocentrism could be enhanced sufficiently to prompt Whites to adopt cohesive group strategies on a large scale (i.e., strategies that involve some controls on individual behavior – a form of altruism), then the economic playing field could be levelled to allow more effective competition with Jews. However, given that Ashkenazi Jews have higher mean IQs than Whites (particularly with regard to verbal IQ, which is a strong predictor of commercial aptitude), they are probably still likely to out-compete Whites in such a hypothetical conflict of racial group altruistic strategies.[15] Nevertheless, the large-scale adoption of altruistic group strategies, even if offering only a partial improvement in the relative economic welfare of Whites compared to other racial groups, would be beneficial.

A major barrier to Whites adopting such strategies are the ideologies that dominate the climate of opinion (especially in the education system) in Western nations today, some of which are explored by MacDonald in *Culture of Critique*, and which are calculated to thwart the emergence of manifestations of White ethnocentrism. A century ago the social sciences were effectively divorced from the biological sciences. While a reconciliation of sorts began in the 1970s, the humanities and social sciences remain intellectual closed-shops, estranged from the contradictory findings of the biological sciences.

It has undoubtedly been one of the chief attractions of leftist collectivism for Jews that free-market libertarianism – through the theoretical removal of the possibility of state coercion of individuals – effectively protects non-Jews in the expression of their anti-Semitism in their personal behavior. Friedman concedes the point, noting that

competitive capitalism has permitted Jews to flourish economically and culturally because it has prevented anti-Semites from imposing their values on others, and from discriminating against Jews at other people's expense. But the other side of that coin is that it protects anti-Semites from having other people's values imposed on them. It protects them in the expression of their anti-Semitism in their personal behavior so long as they do it at their

own expense. Competitive capitalism has therefore not eliminated social anti-Semitism. The free competition of ideas that is the natural companion of competitive capitalism might in time lead to a change in tastes and values that would eliminate social anti-Semitism but there is no assurance that it will. As the New Testament put it, "In my Father's house are many mansions."[16]

Implied in the above is that anti-Semitism is essentially irrational, and that Jews, while able to avoid economic manifestations of anti-Semitism through the operation of the free market, will have to wait for non-Jews to become more enlightened for social anti-Semitism to disappear. Likewise, for von Mises: "the truth is that while the Jews are the objects of anti-Semitism, their conduct and qualities did not play a decisive role in inciting and spreading its modern version."[17] Therefore, consistent with Jewish intellectual movements like Freudian psychoanalysis and the Frankfurt School, anti-Semitism is characterized by these leading Jewish theorists of libertarianism as being symptomatic of the delusion or psychopathology of non-Jews, rather than a mostly rational and predictable response to a threat to the group evolutionary interests of non-Jews.

It would seem that libertarian ideas are particularly hazardous to the collective interests of White people because we are naturally attracted to them. As MacDonald notes, our evolutionary history makes us prone to individualism in the first place.[18] You then get a negative feedback loop where libertarian ideology intensifies this innate individualism to encourage ever greater individualism among Whites, and an ever greater aversion to manifestations of White ethnocentrism. Where the spirit of free-market libertarian individualism reigns, Whites willingly maximize their individual self-interest at the expense of the group evolutionary interests of the White community – with disastrous long-term consequences.

## *Multiculturalism, Immigration, and Libertarianism*

The ideological and political stances of White libertarian individualists neatly dovetail with many of the doctrines of the anti-White left – multiculturalism being the prime example. The pro-market individualism of Western nations has, as a by-product, led to the embrace of a profoundly shallow concept of culture. Many Westerners now see cultural differences as if they were merely differences in consumer tastes and preferences. In a consumerist society, diversity is celebrated – as diversity is the basis for consumer choice. The consumer is king, and he demands that his own personal and individual preferences be satisfied.

Multiculturalism is, therefore, the natural anthropology of a consumer-friendly economy. Because our own lives are filled with personalized choices, each made according to our unique tastes, we have come to approach culture in the same spirit. For many Whites, a culture is like an individual choice of a consumer product. Accordingly, the naive White multiculturalist treats differences in human cultures as if they were analogous to a preference for Coca-Cola over Pepsi – that is, mainly a difference in consumer tastes – consumer sovereignty at work. This view, however, is radically different from the view implicit in less tolerant traditions like Judaism and Islam that regard cultures as weapons in the struggle for survival and supremacy of those who carry on those traditions. It is not surprising that, in an intellectual climate of almost limitless White libertarian tolerance for cultural diversity, non-White immigrant communities feel free to openly express disdain for European-derived peoples, disparaging their culture and their central place in world history.

A large majority of Jews have historically been strongly in favor of a libertarian immigration policy for the White-majority countries in which they reside. That this attitude is generally not extended to the state of Israel is, naturally enough, a source of consternation and ridicule among White Nationalists. This hypocrisy extended to the likes of Friedman and Rand. Friedman's position with regard to immigration to the U.S. was that, providing that immigrants (from whatever racial or cultural source) are entering the nation to take up employment, as

opposed to state welfare, there is no rational reason to oppose that immigration. With reference to the large-scale immigration into the U.S. in the late nineteenth century, he opined that:

> You will find that hardly a soul who will say that it was a bad thing. Almost everybody will say it was a good thing. "But what about today? Do you think we should have free immigration?" "Oh, no," they'll say, "We couldn't possibly have free immigration today. Why, that would flood us with immigrants from India, and God knows where. We'd be driven down to a bare subsistence level." What's the difference? How can people be so inconsistent? Why is it that free immigration was a good thing before 1914 and free immigration is a bad thing today?

> Well, there is a sense in which that answer is right. There's a sense in which free immigration, in the same sense as we had it before 1914 is not possible today. Why not? Because it is one thing to have free immigration to jobs. It is another thing to have free immigration to welfare. And you cannot have both. If you have a welfare state, if you have a state in which every resident is promised a certain minimal level of income, or a minimum level of subsistence, regardless of whether he works or not, produces it or not. Then it really is an impossible thing.[19]

So if there is a job waiting for an individual – regardless of their race – it would be irrational to exclude that person. However, the apparent attraction of non-discriminatory immigration for Friedman did not extend to the state of Israel. While Friedman frequently railed against the socialist tendencies of various Israeli governments, he was a strong supporter of the Jewish ethnostate, and there is no record of him ever noticing Israel's racially-restrictive immigration policy – much less decrying it. This surely demonstrates that in such matters the moral criterion of whether it was "good for the Jews" surpassed his professed

universal libertarian commitment to the alleged benefits of a free and open immigration policy.

Ayn Rand demonstrated an even greater capacity for hypocrisy with her attitude toward respective manifestations of White and Jewish ethnocentrism. She declared that "there is no such thing as a collective or racial achievement" and espoused the moral superiority of her type of individualism which "regards man – every man – as an independent, sovereign entity who possesses an inalienable right to his own life, a right derived from his nature as a rational being."[20] For Rand, however, "every man" did not include the Arabs in their conflict with Israel. Instead, she regarded the fight between the Jews and the Arabs as fight between civilized men and savages. In 1979, she declared that: "If you mean whose side should you be on – Israel or the Arabs? I would certainly say Israel, because it's the advanced, technological, civilized country amidst a group of almost totally primitive savages who have not changed for years, and who are racist and who resent Israel because it's bringing industry and intelligence and modern technology into their stagnation."[21]

To what extent does the libertarian immigration agenda, advocated with such patent inconsistency by the like of Friedman and Rand, serve the interests of Whites in terms of immigration policy? White National- ists generally do not have a problem with immigration *per se*, but rather with large-scale non-White immigration that shifts the demographic balance of power away from European-derived populations. Because of their strict individualism, libertarians dismiss the importance of race in human affairs. Most prominent libertarian theorists endorse a policy of non-discrimination with regard to immigration – although this princi- pal is rarely extended by Jewish libertarians to the state of Israel.

The anthropological reality is, as Australian academic Frank Salter observes, the precise opposite of the individualist fantasy propagated by libertarianism: that, until recent decades, almost all human societies have sought, like Israel, to prevent permanent mass migration in their own group evolutionary interests. Western societies since about 1965 have been the rare exceptions. Salter observes that:

Hunter-gatherers and primitive agriculturalists, farmers and herders have all laid claim to a territory and fiercely defended it. Marriage partners have been found almost exclusively within the ethnic group, encompassing the local dialect. The psychological motivations for this are well established in such predispositions as social identity mechanisms, collectivism, assortment by similarity, innate cognition of human kinds, and rational choice. Evolutionary origins of territoriality and ethnocentrism are indicated by their being human universals as well as being found in apes. And from the evolutionary perspective, which acknowledges the limited carrying capacity of all territories and of the world itself, it is maladaptive to allow one's lineage – family, clan or ethnic group – to be replaced by others.

The vital interest all societies have in controlling a territory also falsified the assertion that national security consists solely of defending individual citizens from attack, for example by vetting immigrants for terrorist connections, as is already the practice with tourists. Unlike tourists, immigrants affect the receiving country's numbers, identity and cohesion. Societies thus have a corporate interest in retaining national sovereignty, which entails control of a territory. This helps to explain the historical pattern of corporate liberty being put before citizens' rights. Inviting the world to a country as prosperous as Australia would result in the displacement of the Australian people inside their historical homeland. This is an outcome even more maladaptive than enslavement because it would be permanent.[22]

The question then arises as to why European-derived people in Western nations would, through accepting large-scale non-White immigration, act in a way that is entirely contrary to their group evolutionary interests. Part of the problem is that Northern Europeans are, as a product of their evolutionary development, inherently more individualistic and

less ethnocentric than other racial groups.[23] This makes them predisposed to the type of individualism that has been at the core of Western market capitalism for centuries – an individualism that originally was a source of strength and only became problematic in the context of the establishment of large non-White communities within formerly homogenous White nations.

While individual Whites may benefit from non-White immigration (such as a business proprietor or a leftist political candidate), in terms of their evolutionary interests as a distinct genetic community, non-White immigration is a huge negative. MacDonald notes that more ethnocentric and less individualistic groups (most prominently Jews) have exploited this tendency of Europeans to lobby for changes to immigration policies to serve their own group interests.[24] The libertarianism of Friedman, von Mises and Rand, whether intentionally or not, has aided and abetted Cultural Marxists in furthering Jewish ethnic interests with regard to its influence on immigration policies of Western nations.

The libertarian individualist agenda favoring the free global movement of people, in conjunction with the openly anti-White and anti-Western agendas of the Cultural Marxists, has facilitated the demographic transformation of Western nations in the past few decades. Because of their denial of the significance of race, libertarians are never going to be allies in the fight to save White populations from demographic and political eclipse. Growth in the popularity of libertarian ideas among Whites is as likely to undermine White racial solidarity as effectively as any of the more openly anti-White nostrums of the left. Racial collectivism is *the* only effective means to promote our group interests now and into the future.

# Why Mahler? Norman Lebrecht and the Construction of Jewish Genius

2011 marked the centenary of the death of Gustav Mahler. This followed hard on the heels of the one hundred and fiftieth anniversary of the composer's birth in 2010. In addition to an upsurge in performances of Mahler's works by orchestras around the world, 2010 saw the release of a second book about Mahler by the journalist and music critic Norman Lebrecht entitled: *Why Mahler? How One Man and Ten Symphonies Changed the World.* This book is the latest in a long line of encomiums by Jewish music critics and intellectuals that have transformed Mahler's image from that of a relatively minor figure in the history of classical music at mid-twentieth century, into the cultural icon of today. Lebrecht wants his work to "address the riddle of why Mahler had risen, from near oblivion, to displace Beethoven as the most popular and influential symphonist of our age."[25]

Like his previous book about Mahler (*Mahler Remembered*) the focus is on alerting us to Mahler's towering genius, and how this genius was inextricably bound up with his identity as a Jew. Overlaying this,

as ever, is the lachrymose vision of Mahler the saintly Jewish victim of gentile injustice. Lebrecht's book is yet another reminder of how Jewish intellectuals have used their privileged status as self-appointed gatekeepers of Western culture to advance their group interests through the way they conceptualize the respective achievements of Jews and Europeans.

Through stressing, as Lebrecht does, the Jewish origins of figures like Mahler, Jewish intellectuals have made them personifications of a specifically Jewish genius ("Einstein" did not become a synonym for "genius" by accident). This betokens an acknowledgement of the immense importance of ethnic role models in the promotion of ethnic pride and group cohesion, and how ethnocentric Jews, like Lebrecht, have hyped the former to promote the latter. This form of Jewish intellectual activity is clearly directed at influencing social categorization processes in a way that benefits Jews.

### Constructing Mahler as Jewish Genius

The clear tendency among Jewish intellectuals has been for Jewish achievement to be overstated and particularized and made a locus for ethnic pride. Meanwhile, European achievement is downplayed, or where undeniable, universalized and thereby neutralized as a potential basis for White pride and group cohesion. Accordingly, the racial origins of Shakespeare is de-emphasized (scarcely an Englishman or European) and he is instead held up as an exemplar of a "universal human genius" whose astonishing abilities are supposedly latent in all branches of human family (see, for example, Harold Bloom's *Shakespeare: The Invention of the Human*). The alternative approach has been to claim that Shakespeare's works were actually written by a Jewish woman named Amelia Bassano Lanier. Contrastingly, Mahler's achievement is held to be specifically and inseparably Jewish, and a reflection of Jewish intellectual brilliance.

This raging hypocrisy is bad enough. The duplicity is, however, is made the worse by the vast cognitive dissonance involved in

simultaneously denying the reality of a collective White racial achievement, while stridently affirming the reality of a collective intergenerational guilt that must be urgently instilled in all White people. Intellectual consistency is ostensibly less important here than spreading the meme that: *Whites can only be criticized as a group, never praised – while non-Whites (especially Jews) can only be praised as a group, never criticized.*

The cult of Mahler since the sixties is an object lesson in the role of Jewish ethnic networking and ethnocentrism in the construction of what now passes for Western culture. Lebrecht openly acknowledges that the core of Mahler's support, even during his own lifetime, had a foundation in Jewish ethnic networks. He points out that: "Not just in Berlin... but in Hamburg, Munich, Leipzig and Vienna, the Jewish middle classes formed the core of Mahler's audience. ... Mahler would have known, much as Saul Bellow and Philip Roth did in Chicago and New York, that there were people who queued up for his next work. They might not understand it or even like it, but they demanded the installment as of right, as their stake in his story. It was this public that gave Mahler the confidence, in the face of racist opposition, to carry on composing."[26] Mahler's core group of friends, associates and supporters were no exception. Mahler's wife to be, Alma Schindler, noted in her diary that Mahler's friends were "all conspicuously Jewish."[27] From then to now, the propagation of the cult of Mahler has been predominantly a Jewish affair.

Perhaps the most prominent and influential proponent of the "Mahler as Jewish genius" trope was Leonard Bernstein who attributed to the composer superhuman powers of prophecy. In 1967 he claimed that it is "only after we have experienced all this through the smoking ovens of Auschwitz, the frantically bombed jungles of Vietnam, through Hungary, Suez, the Bay of Pigs, the farce-trial of Sinyavsky and Daniel, the refueling of the Nazi machine, the murder in Dallas, the arrogance of South Africa, the Hiss-Chambers travesty, the Trotskyite purges, Black Power, Red Guards, the Arab encirclement of Israel, the plague of McCarthyism, the Tweedledum armaments race – only after

all this can we finally listen to Mahler's music and understand that it foretold all."[28]

Lebrecht, taking up where Bernstein left off, is likewise convinced that Mahler is more than just a great artist. "Music, in Mahler's view, did not exist for pleasure. It had the potential for a 'world-shaking effect' in politics and public ethics."[29] Moreover, the man and his music are said to be "central to our understanding of the course of civilisation and the nature of human relationships."[30] His symphonies are supposedly prophesies of war, modern technology, and environmental degradation. For Lebrecht, in his Third and Seventh symphonies Mahler hinted at a future ecological disaster; in the Sixth he warned of an imminent world war. "His First Symphony tackled child mortality," while "his Second denied church dogma on the afterlife." The Fourth symphony is said by Lebrecht to have "proclaimed racial equality."[31]

This kind of overblown rhetoric is even too much for Philip Kennicott, the music critic for *The New Republic,* who notes that: "Mahler is not the only artist who attracts this sort of nonsense, but his partisans seem particularly inclined to it, in part because the composer lived during a period of great intellectual foment. ... The truth of Mahler's complicated life is more interesting, and more stirring, than Lebrecht's attempts to cast him as an artistic superhero and a Jewish victim."[32]

### Constructing Mahler as Jewish Victim

The cult of Mahler as noble Jewish victim was first given impetus by Arnold Schoenberg (himself an ethnocentric Jew and Zionist) who "canonized Mahler as 'this martyr, this saint' and in a Prague lecture in March 1912 announced: 'Rarely has anyone been so badly treated by the world; nobody, perhaps, worse.'"[33] Frankfurt School music theorist Theodor Adorno took up the theme in 1960, affirming that: "Mahler's tonal chords, plain and unadorned, are the explosive expressions of the pain felt by the individual subject imprisoned in an alienated society. ... They are also allegories of the lower depths of the insulted and the socially injured. ... Ever since the last of the *Lieder eines fahrenden Gesellen*

Mahler was able to convert his neurosis, or rather the genuine fears of the downtrodden Jew into a vigor of expression whose seriousness surpassed all aesthetic mimesis and all the fictions of the *stile rappresentativo*."[34] Over the sixty years since these statements were made, the Mahler cult of Jewish victimhood has become a cottage industry.

Lebrecht's ethnocentric outpouring is an egregious product of this industry. He sees the root of Mahler's contemporary appeal as residing in the fact he was "three times homeless" and claimed three identities: "his Jewish roots, his German language and his ineluctable sense of not belonging anywhere in the world." Mahler is said to have had no sense of permanence. "'I am three times without a *Heimat*,' says Mahler, 'as a Bohemian in Austria, an Austrian among Germans and as a Jew throughout the world – always an intruder, never welcomed.' *Heimat* is German for homeland, for roots and birthright. As a Jew, Mahler has no place to call home."[35] Steve Stove points out that once this became widely known "his identity politics credentials became the aesthetic equivalent of a nuclear warhead, lacking only homosexuality to complete his posthumous triumph." Lebrecht, eager to complete the posthumous triumph, earnestly informs us that: "Inclusivist and non-judgmental, he [Mahler] bears no prejudice against any racial and sexual minorities. The multiculturalism of his Fourth Symphony is not an empty gesture. Mahler, ahead of his time, welcomes the outsider into the fold."[36]

Even Mahler's birth date (July 7, 1860) is, for Lebrecht, laden with the rich symbolism of Jewish victimhood. "The Hebrew date is the seventeenth day of the month of *Tammuz*, the Fast of the Fourth Month when Jews begin three weeks of mourning for the destruction of Jerusalem in the years 586 BC and 70 AD. The fast is a warning from history, an omen of homelessness. Gustav Mahler enters the world on a day of dispossession."[37]

This dispossession and alienation, which Lebrecht asserts is "so prevalent in a culturally diverse twenty first century, gives a vital clue to Mahler's contemporary relevance. In an age when a half-African, part-Muslim orphan from Hawaii could rise to become President of the

United States of America, Gustav Mahler is finally able to find a home in our lives."[38] If this is indeed true, it surely indicates the extent to which Jewish sensibilities have become ours – the culmination of a triumphant group evolutionary strategy where the "otherness" of a Jewish culture, once at the periphery of European life, has now established itself at the heart of Western high culture.

Lebrecht cites several Jewish intellectual and artistic figures of his acquaintance who strongly identify with Mahler and draw inspiration from his status as the quintessential Jewish victim. A telling example is the late artist R.B. Kitaj who completed a portrait of Mahler based on a late photograph. Lebrecht recounts:

> I got to know him while he was working on the portrait, his Chelsea studio stacked with packing cases, ready for his return to America. "The School of London is now closed," said Kitaj, winding up a group he formed with Francis Bacon, David Hockney, Lucian Freud, Frank Auerbach, Leon Kossoff and Howard Hodgkin. His reason for leaving was a mauling by British critics of his 1993 Tate exhibition, an onslaught on which he blamed the death soon after of his wife, Sandra Fisher, from a brain aneurysm. What the critics hated was Kitaj's lines of comment and explanation on his paintings. Kitaj accused them of anti-Semitism. "Was it a coincidence that I was the only Jew who put the Jewish drama at the heart of my paintings?" he demanded. "Was it a coincidence that I was the only exegete among painters?"
>
> "You've caught me at a terrible moment," he said when I turned up to talk about Mahler. "I really didn't welcome intrusions this past year. But Mahler I couldn't refuse." He had felt a kinship with Mahler since he studied in 1950s Vienna, seeing hatred in the eyes of his landlady, his tutors, the shopkeepers. "The streets I walked on I could have been hauled off just a few years before," he said. Kitaj equated anti-Semitism with anti-modernism. "Jewish

brilliance", he said, "made the modern world." Jews like Mahler and Kitaj were agents of change, architects of human unease.[39]

The exact nature of R.B. Kitaj's "Jewish brilliance" was manifested in a series of paintings of a voluptuous young woman, usually nude (his much younger wife), often in the company of an older bearded man (Kitaj himself). A failure to fully appreciate the aesthetic excellence and intellectual depth of such works could only, their creator reasoned, be the result of vile anti-Semitism.

## *Jewish Influences in Mahler's Music*

It has long been suggested that Mahler's music "speaks" Yiddish. Rudolf Louis, a leading critic of Mahler, famously wrote in 1909: "What I find so utterly repellent about Mahler's music is the pro-nounced Jewishness of its underlying character. ... It is abhorrent to me because it speaks Yiddish. In other words it speaks the language of German music but with an accent, with the intonation and above all the gestures of the Easterner, the all-to-Eastern Jew." Lebrecht, not-withstanding Louis's anti-Jewish intent, concurs with this assessment – linking, as he does, Mahler's characteristic musical cadences with the Hasidic klezmer bands he was exposed to as a child:

> The Judaism in which Gustav Mahler is raised is lukewarm, main-stream Orthodox with infusions of other trends. He encounters Hasidic melody from itinerant klezmer bands, their music shift-ing, with a nod of the head, from morbid to manic and back. Klezmer is a music that obeys no code of conduct, unlike the mil-itary bands that parade daily in Iglau's town square. A collision of army discipline and smiley Jewish individualism is imprinted on the boy's mind. The first language he hears at home is Yiddish, a dialect made up of German, Hebrew, Aramaic and Slavonic terms with a syntax all its own. Known as mamelsohn, mother's tongue, Yiddish allows Jews to communicate in code. Double

negatives are designed to confuse alien ears, along with a courtesy so elaborate that only by listening to tone and observing hand motions can anyone be sure whether a word is flattery or insult.

Yiddish rings loud in Mahler's adult response "Am I a wild animal?" he shouts at celebrity gawkers, using a Yiddish term, *vilde khaye*, that conveys both feral danger and boyish mischief, terror and endearment in one useful obfuscation. ... Crucially, Yiddish gives his music the possibility of sustaining two contrary meanings. Every innovation that Mahler makes derives from his tribal origins.[40]

For Lebrecht, in the funeral march in Mahler's First Symphony he "is writing as a Jew and the irony he uses is not classical Greek but everyday Yiddish, a dialect that changes meaning by gesture and inflection. Any statement in Yiddish can be made to mean the opposite... the conjunction of gravity and gaiety is a facet of Jewish psychology and a driving motive of Mahler's First Symphony. Played without irony, the music sounds shallow. Played with too Jewish an accent, it attains self-parody. Mahler leaves it to interpreters to strike the correct balance."[41] It says something of the extent of what Richard Wagner called the "Jewification" (*Verjudung*) of contemporary Western musical taste that audiences actually have come to prefer the Yiddish-inflected musical irony of Mahler over the sincerity of a Beethoven or a Bruckner. Of course a professed love of Mahler's music cannot be taken at face value these days – often involving extra-musical motivations like a desire to make (through such a statement) tacit declaration of one's political rectitude and moral purity.

As mentioned, Lebrecht is centrally preoccupied in his book with "seeking the meaning of Mahler in the context of his ancestry" and how his artistic achievement was fully and happily determined by it.[42] In this endeavor, he finds a parallelism between Mahler with Freud. According to Lebrecht:

Mahler's closest affinity with a maker of the modern world was with Sigmund Freud, four years his senior and from a similar Czech-Jewish provincial background. Both built works out of incidents in their early lives. Freud predicated the Oedipus Theory on memories of urinating in his parents' bedroom, being his mother's favourite and seeing his father racially humiliated. Mahler, a boy who saw five of his brothers carried in coffins from the family tavern where the singing never stopped, composed a child's funeral in his First Symphony with a drunken jig. ... Both men, intellectually Jewish, could sustain discrete lines of thought within a single argument. Freud's free association is modelled on Talmudic discourse where rabbinic opinions from various places and centuries preclude a straight logical line. Mahler's interpolation of stray horns and folk-songs reveals the same methodology. ... Both used their Jewishness as a shield and a sword. "Because I was a Jew I found myself free from many prejudices which limited others in the employment of their intellects," said Freud, "and as a Jew I was prepared to go into opposition and to do without the agreement of the 'compact majority.'" Being Jewish, said Mahler, was like being born with a short arm, having to swim twice as hard. Being "three times homeless," he could ignore fixed rules. Both men felt a sense of mission to improve the world, undertaking a *tikkun olam* to assist and complete God's work of creation.[43]

This sense of a "mission to improve the world," supposedly shared by Freud and Mahler, inevitably manifested itself in vehement rejection of the cultural mores and consensus views of the Vienna of their time. For Lebrecht, *fin de siècle* Vienna was a place where the demonization of Jews is "culturally acceptable," and where "the appalling prospect of genocide germinates around the Ring of Mahler's Vienna."[44] It is a city "ruled by a militant anti-Semite [Karl Lueger] whose racialism, selective and at times quiescent, can be whipped up at will against the 'money and stock exchange Jews,' the 'beggar Jews,' the 'ink Jews' (intellectuals)

and perpetually, the 'press Jews.' Under Lueger, Vienna becomes the first modern city to make hating Jews municipal policy."[45] For Mahler, it is a place where "the forces of darkness are rallying to plot his downfall" and where "everything Mahler does with the Vienna Philharmonic is tinged with an undercurrent of anti-Semitism."[46] Vienna is a city "whose ideology is introspective, racist, regressive and smug" and where "Mahler and [the Austrian symbolist painter Gustav] Klimt represent a progressive, liberal alternative from the all-pervading unreality." In such a threatening environment, Mahler does "what Jews have done down the ages. He huddles in a ghetto of close friends, almost all of them Jewish, and keeps his head down."[47]

### Constructing Mahler's Jewish Identity

An awkward issue that Jewish Mahler-worshippers have had to deal with is the composer's conversion to Christianity. Kennicott critiques the deceptive way that Lebrecht represents Mahler's conversion to Christianity to secure his appointment in 1897 as Director of the State Opera in Vienna. Lebrecht is eager to present the conversion as a purely cynical maneuver on the part of Mahler, and one which left his strong Jewish self-identification unaltered. Lebrecht tells the story this way (citing the conductor Bruno Walter and the Austrian music critic Ludwig Karpath):

> He is the most reluctant, the most resentful, of converts. "I had to go through it," he tells Walter. "This action," he informs Karpath, "which I took out of self-preservation, and which I was fully prepared to take, cost me a great deal." He tells a Hamburg writer: "I've changed my coat." There is no false piety here, no pretence. Mahler is letting it be known for the record that he is a forced convert, one whose Jewish pride is undiminished, his essence unchanged. [48]

Kennicott quotes the full transcript of the letter to Karpath, cited in Henry Louis de la Grange's epic four-volume biography (with references to Mahler's pre-Vienna post in Hamburg where Bernhard Pollini was manager of the opera):

> Do you know what particularly offends and annoys me? The fact that it was impossible to occupy an official post without being baptized. This is something I have never been prepared to accept. Of course it is untrue to say that I was baptized only when the opportunity arose for my engagement in Vienna – I was baptized years before. In fact it was my longing to escape from the hell of Hamburg under Pollini that prompted me to contemplate the idea of leaving the Jewish community. That is the humiliating part of it. I do not deny that it cost me a great effort, indeed one could say it was an instinct for self-survival that prompted me to such an action. Inwardly I was not averse to the idea at all.[49]

As Kennicott correctly points out: "Lebrecht is too selective in his interpretation, and does not adequately confront the ambiguity of that last line: 'Inwardly I was not averse to the idea at all.'" This impediment does not, however, stop Lebrecht from "indulging in a line of Mahler bathos that, once again, was most fully embodied in Bernstein, but which has little scholarly support."[50] Lebrecht, like Bernstein, sees Mahler as forever troubled by his conversion, leading him to a wild conjecture about another event in Mahler's life – a mishap during Mahler's marriage to Alma Schindler. During the wedding, Mahler stumbled, or fell, while kneeling at the altar:

> Picture the scene: Anxious little Jew about to marry blond bombshell, trips over his prayer stool and falls flat on his face, ha-ha, no one laughing louder than the priest, Josef Pfob. Is this what really happens? My scrutiny of the spot suggests an ulterior scenario. Above the altar is a Baroque sunburst with four Hebrew letters at its centre – *yod, heh, waw, heh* – the tetragrammaton that is the

unpronounced Jewish name for God. Gustav Mahler looks up as
he sinks to his knees, misses his footing and falls. Alma thinks he
trips because he is so short. But Mahler has just seen the God of
the Jews. Guilt and betrayal clog his gullet. He needs a moment
to collect himself before he takes Christian vows. He falls over to
gain time. Alma and the priest giggle at his discomfiture. He does
not belong in church.[51]

This passage is pure fantasy which Lebrecht invents based on a few
Hebrew characters in the church. Kennicott notes that there is no evi-
dence whatever for the account, and "the idea that Mahler intentionally
throws himself to the ground 'to gain time' is completely unsupported.
... As for Mahler's feelings of guilt and betrayal, here is de la Grange
again: 'Nothing, either in Mahler's reported words or in his letters,
betrays the slightest guilt feeling for having left the religion of his
ancestors, a remorse which nevertheless has been attributed to him.'"[52]
Undaunted, the ethnocentric Lebrecht goes to great lengths to create
this very impression:

> After the act of conversion he never attends mass, never goes to
> confession, never crosses himself. The only time he ever enters
> a church for a religious purpose is to get married. His wife calls
> him a "Christ-believing Jew" but the prayers he offers in mortal
> anguish, scrawled in his final score, are only to God the Father.
> Mahler, officially a Catholic, remains a monotheist and a Jew.
> He is a relic of an unending persecution, a kind of Marrano, like
> one of thousands who went underground for centuries in Spain
> after Ferdinand and Isabella started burning the Jews in 1492. To
> Viennese anti-Semites, he is the archetypal Jew.[53]

Lebrecht is at his most blindly ethnocentric (to the point of complete
self-deception) in analyzing the last lines of *Das Lied von der Erde*,
or *The Song of the Earth* – a suite of extended orchestral songs from
1908. He seizes on the last words of the final poem: *ewig, ewig* (forever,

forever). In context, they are typical Romantic exclamations of the numinous. But Lebrecht detects a deeper hidden meaning in this song-symphony:

> How does Mahler pack so much emotion into so trite a word? The "Ewig" enigma resisted me for years until a chance sighting at a 1988 exhibition in Vienna cracked a subconscious code. It was the fiftieth anniversary of Hitler's Anschluss, and among the artefacts was a photograph of a railway station festooned with a banner: "Der Ewige Jude," the eternal Jew. Of course, "Ewig," pronounced *eh-vish*, has a specific connotation in the German mind. It is the Eternal Jew, the one that killed Christ and is condemned to wander the beloved earth, a touchstone of Christian theology. In 1940 Joseph Goebbels makes it the title of a film whose purpose is to justify genocide. "Ewig" and Jew are linked in the German mind.[54]

This leads Lebrecht to the following conclusion: "'Ewig' in 'The Song of the Earth' is the Jew in Gustav Mahler, the *alter* ego, the old, real Mahler he manages to rediscover as his life enters its closing phase."[55]

Once again, there is no evidence for this conjecture, which is based on connecting a single word from a song text, paraphrased at fourth-hand from a Tang Dynasty Chinese poem, to events three decades later. Moreover, "Ewigkeit is one of the oldest clichés of German Romanticism. Confronted with such a wild hermeneutical leap, the reader has a revelation too: the book should not be called *Why Mahler?*, a question which answers itself, but rather, *My Mahler*."[56]

The construction of Mahler as Jewish genius is a fascinating case study of the social identity processes at work among a subset of the Jewish intellectuals. It is the psychological counterpoint to exaggerating the threat of anti-Semitism as a way of promoting Jewish group cohesion. It consists of three related approaches, all of which are starkly evident in Lebrecht's book, and which are entirely predictable on the basis of social identity theory. Firstly, inflate the significance of a Jewish

figure's intellectual or artistic achievement to the point where it is held to be of "world-changing" magnitude. Secondly, accentuate the Jewish origins and affiliations of the figure so that his "world-changing" achievement is held to be the natural expression of his Jewish origins and identity. Lastly, portray this brilliant Jewish world-changing figure as subject to the unjust persecution of a hostile, and deeply immoral, gentile outgroup (in this case the society of *fin de siècle* Vienna). While crude, this is a highly effective strategy, and a type of intellectual activity which, in essence, constitutes a form of ethnic warfare.

# CHAPTER 3

# Thomas Huxley on Group Competition and Ethics

The nineteenth-century English biologist and writer Thomas Huxley is best known as a leading early supporter of Darwin's theory of evolution. His eloquent defense of Darwin during his famous 1860 debate with Samuel Wilberforce led to the wider acceptance of evolution as a biological reality. Huxley's polemical support for Darwin's theory (which earned him the title of "Darwin's Bulldog") has, however, overshadowed his status as an acute thinker in his own right. Particularly worthy of attention is his essay "Evolution and Ethics" (1894) where he proposes that human ethics are a by-product of natural selection, and particularly of the struggle for existence between groups.

Huxley starts his essay by distinguishing between what he calls the "cosmic process" and the "ethical process." The cosmic process is, for Huxley, the process that governs the universe (or more specifically, and to the purpose of Huxley's essay, all of the "forms of life which tenant the world").[57] He notes that "one of the most salient features of this cosmic process is the struggle for existence, the competition of each with all, the result of which is selection, that is to say, the survival of those forms which, on the whole, are best adapted to the conditions which at any period obtain; and which are, therefore, in that respect, and only in that respect, the fittest."[58] Like Thomas Malthus and Charles Darwin

before him, Huxley saw all living things as locked in a life and death struggle for existence – and human beings, like other living things, are fully implicated in this struggle which "tends to eliminate those less fitted to adapt themselves to the circumstances of their existence."[59] In "Evolution and Ethics" Huxley observes that:

> [W]ith all their enormous differences in natural endowment, men agree in one thing, and that is their desire... to do nothing but that which pleases them to do, without the least reference to the welfare of the society in which they are born. That is their inheritance (the reality at the bottom of the doctrine of original sin) from the long series of ancestors, human and semi-human and brutal, *in whom the strength of this innate tendency to self-assertion was the condition of victory in the struggle for existence.* [Emphasis added][60]

Here Huxley, the man who gave us the term "agnostic," offers us a thoroughly scientific and Darwinian interpretation of St. Augustine's doctrine of "original sin." Our original sin, according to Huxley, is not that we are born as humans, but rather that we are born (at least psychologically) as primates. Unlike the traditional Christian doctrine of original sin which requires us to believe in a fable about talking serpents and forbidden fruit, Huxley's version of the doctrine rests on a simple acceptance of the law of natural selection – the characteristic feature of which "is the intense and unceasing competition of the struggle for existence."[61]

If our original sin is to be born as mental primates, then, for Huxley, the only cure is for us to be made to feel ashamed of our primate nature. In identifying the biological reality at the bottom of the theological doctrine of original sin, Huxley recognized that any human group, if it hoped to cooperate and thereby survive as a group, had, of necessity, to develop internal defense mechanisms that could check the human animal's "innate tendency to self-assertion." Thus, in the interests of group survival, within any group "the cosmic struggle for existence, as

between man and man, would be rigorously suppressed."[62] It is clear that, for Huxley, the only viable societal mechanism that could perform this task of suppressing human self-assertion was the socialization of children based on shame – emotionally wrenching and physiologically manifested shame.

Huxley observes that "every child, born into the world will still bring with him the instinct of unlimited self-assertion. He will have to learn the lesson of self-restraint and renunciation."[63] Children, from a very young age, had to be taught to be ashamed of their inborn animal desire "to do nothing but that which pleases them to do." Reason, for Huxley, could not perform this service, because the instilling of shame had to occur long before the age of reason was reached; indeed, unless you first taught children to be ashamed of unreasonable behavior, you would have a hard time ever being able to reason with them at all. In short, without inculcating a shaming code in all members of a group, the group would merely be an agglomeration of different individuals, each of whom sought only "to do nothing but that which pleases them to do, without the least reference to the welfare of the society in which they were born." For Huxley, shame was such a vital element in the ethical progress of mankind for reasons that relate directly to natural selection. In essence, it was shame that led to cooperation, and cooperation to group survival.

Social organization for the purposes of group survival is certainly not peculiar to man and Huxley notes that: "Other societies, such as those constituted by bees and ants, have also arisen out of the advantage of cooperation in the struggle for existence."[64] He points out that: "Wolves could not hunt in packs except for the real, though unexpressed, understanding that they should not attack one another during the chase."[65] For Huxley, it was axiomatic that, all things being equal, an individual who was part of a larger group increased his chances of survival due to the protection offered him by the size of the group. In the struggle for survival, loners are losers. Huxley posits that the most basic form of human social organization – the family – came about for precisely this reason, noting that

> it is easy to see that every increase in the duration of the family ties, with the resulting cooperation of a larger and larger number of descendants for protection and defense, would give the families in which such modification took place a distinct advantage over the others. And, as in the [bee] hive, the progressive limitation of the struggle for existence between members of the family would involve increased efficiency as regards outside competition.[66]

But if the survival of the individual depends on the group, then the group that can be relied on the most will give its members an evolutionary advantage over those weaker groups that lack the same cohesiveness. If you are a member of a weak group, all the members of which scatter upon encountering a band of enemies, what advantage does your membership in it give you? It is always more adaptive to be a member of a strong group, and a strong group can be defined as one in which all members are united by a strong collective shaming code felt at a visceral level. Aside from ethnocentrism stemming from phenotypic similarity, it is this which will make the members of the group feel as one. They are disgusted, angered, delighted, and shamed by the same things. Huxley notes that human socialization, involving the inculcation of a group-centered shaming code (the embryo of all human ethical systems), is greatly facilitated by the mutual affection of parent and offspring during the long human infancy and, most importantly, by

> the tendency, so strongly developed in man, to reproduce in himself actions and feelings similar to, or correlated with, those of other men. ... It is needful to look around us, to see that the greatest restrainer of the anti-social tendencies of men is fear not of the law, but of the opinion of their fellows. The conventions of honor bind men who break legal, moral and religious bonds; and, while people endure the extremity of physical pain rather than part with life, shame drives the weakest to suicide. ... We judge the acts of others by our own sympathies, and we judge

our own acts by the sympathies of others, every day and all day long, from childhood upwards, until associations, as indissoluble as those of language, are formed between certain acts and the feelings of approbation or disapprobation. It becomes impossible to imagine some acts without disapprobation, or others without approbation of the actor, whether he be one's self, or anyone else. We come to think in the acquired dialect of morals.[67]

This acquired dialect of morals is what provides a group with a powerful sense of collective identity: it makes members of a group think and feel as a tribal community. This shared visceral code, when pushed to the extreme, makes it almost impossible for the individual to feel himself as an individual. This negation of the individual – so characteristic of almost all cultures besides Western culture – served an important collective purpose: it kept all the members of the tribe feeling viscerally in sync with one another, and prevented the emergence of groups within the tribe who might break down its solidarity. According to Huxley, this solidarity gave an enormous evolutionary advantage to those who had obtained it, which would explain why the tribe would react ferociously to any threat to it. It would act, in a sense, like the human immune system: the moment it detected a foreign agent that threatened the entire organism, it would not ask questions, but would promptly attack to eliminate the intruder as quickly as possible before it had a chance to reproduce and spread.

The whole point of an effective tribal shaming code is to make the person who has internalized it feel that it is entirely natural and obvious. It is instilled in us from infancy, and certainly before we have sufficient rational judgment of the world, or knowledge of ourselves, to voluntarily accept it. We could not have chosen it for ourselves – rather it was chosen for us. That is why so many people find it virtually impossible to stop being ashamed of those things that they were taught were shameful from infancy. Even when we later become aware of it, and are able to offer rational criticism of it, we are nevertheless still subject to it at a visceral level – shameful conduct will automatically

trigger physiological symptoms of panic and anxiety – we will blush, break out into a sweat, have trouble breathing, feel nausea, and so forth. The preemptive physiological judgment passed by the shaming code is not a product of moral reflection – it is like a reflex reaction, but one that has been instilled by the society, rather than endowed by nature.

In his essay, Huxley emphasizes the survival value of the tribal mind in a world ruled by the cosmic process, (i.e., the law of the jungle). A tribe that shares a powerful visceral code that inhibits the natural tendency of the individual to self-assertion will present a united front against its enemies. It will stick together and not fragment and dissolve under stress in the face of conflict. In a strong group, when an individual is given a chance to desert his fellows in order to save his own skin, he will be inhibited from this act of selfish betrayal by an unbearable visceral shame. What will keep him loyal to the group are not his higher faculties of reflection and cogitation – all of which may be screaming to him, "Run for your life, you fool!" Rather, it is the physiological reactions that have been programmed into him from an early age through the process of shaming. It is his nervous system, his sweat glands, his bowels that force him to stand and fight with his group rather than to flee at the first opportunity. One is reminded of the fanatical, indeed suicidal, resistance of the Japanese and German armed forces in the closing months of World War II.

While this can also be dubbed a code of honor, Huxley would say that a code of honor is just the intellectual assent to the rightness of the physiological responses his culture has implanted in him. A warrior, for example, is first made to feel deep shame at betraying his comrades in battle; it is only after having been programmed to feel this shame under all circumstances, no matter how adverse, that the warrior can come to take pride in the training and discipline that made him incapable of acting in his own perceived self-interest. The socialization of German children under National Socialism offers a compelling illustration of the use of a shaming code to engender intense group cohesion and promote selfless behavior. A constant refrain of the literature of the Hitler Youth

was the idea of the individual sacrificing himself for his leader, where the basic idea was

> of a group of heroes inseparably tied to one another by an oath of faithfulness who, surrounded by physically and numerically superior foes, stand their ground. ... Either the band of heroes is reduced to the last man, who is the leader himself defending the corpses of his followers – the grand finale of the *Nibelungenlied* – or through its unparalleled heroism brings about some favorable change in fortune.[68]

Huxley identified the flaw in any political ethic, like that of Thomas Hobbes (1588-1679), which is based on enlightened self-interest alone: the most enlightened self-interest cannot counsel a person to die for his group. If human beings had to wait until they were reasonable enough to see the advantage of entering into Hobbes's celebrated social contract, they would long since have become slaves or the defenseless prey of those groups whose social unity was based on a primordial and visceral sense of loyalty – a cohesion so intensely felt that it did not need rational arguments to create it. In other words, those groups animated by a high degree of ethnocentrism and group cohesion would eliminate those whose fragile solidarity was merely based on reason and the social contract. Cohesive groups invariably out-compete individualist strategies. As the late Roger Scruton pointed out: "The error of individualism lies in the attempt to found a vision of society on the idea of rational choice alone – on an 'abstract' notion, as Hegel put it, of practical reason, which makes no reference to history, community, and the flesh."[69]

### Huxley's Ethics and Judaism as a Group Evolutionary Strategy

Huxley's explanation for the emergence of human ethical structures ties in neatly with Kevin MacDonald's theory of group evolutionary

strategies that operate through the construction of culture. A key feature of any effective group evolutionary strategy will be the construction of an effective societal shaming code designed to reinforce group cohesion and solidarity. Jews are the prime example of a biological community with a powerful shaming code imposed by a set of practices aimed at socializing individuals into identifying strongly and exclusively with the ingroup. Kevin MacDonald notes that the defining feature of Jewish history has been that group interests, rather than individual interests, have been of primary importance.

> Of the hundreds of human groups in the ancient world, only Judaism avoided the powerful tendencies toward cultural and genetic assimilation. Judaism as a group strategy depends on the development of social controls reinforcing group identity and preventing high levels of genetic admixture from surrounding groups. ... As with all collectivist cultures Judaism depends on inculcating a very powerful sense of group identification. Socialization in collectivist cultures stresses group harmony, obedient submission to hierarchical authority, the honoring of parents and elders, ingroup loyalty, and trust and cooperation within the ingroup. ... There has been a very conscious attempt on the part of the Jewish community to inculcate a sense of group belongingness among all Jews. One aspect of these socialization influences is to continually place group members in situations where group activities involve very positive experiences, but there is also socialization for developing feelings of separateness from gentile culture.[70]

Charles Murray notes that "traditional Jewish culture is not all that different from Confucianism or Islamic culture in the way that it embeds individual moral agency in family and community." Orthodox Jewish culture is effective in fostering human capital through its emphasis on education and indirectly through its effects on mating patterns, but "duty takes precedence over vocation, and the interests of the family

and community takes precedence over self-fulfillment."[71] Given the potential for post-Enlightenment Western social structure (based on individualism and moral universalism) to break down Jewish cohesiveness, the socialization of Jewish children took on, post-emancipation, even greater importance as a way of maintaining the group identification and commitment of Diaspora Jews.

The strength of group identification engendered by the traditional Jewish shaming code is revealed by the fact that, in the post-emancipation Germany of the nineteenth century, assimilation did not occur at any level of the Jewish community. MacDonald notes that: "In addition to a very visible group of Orthodox immigrants from Eastern Europe, Reform Jews generally opposed intermarriage, and secular Jews developed a wide range of institutions that effectively cut them off from socializing with gentiles."[72] In accounting for the tendency of Jews to resist assimilation into German society, Jacob Katz asserts that: "What secular Jews remained attached to was not easy to define, but neither, for the Jews involved, was it easy to let go of: there were family ties, economic interests, and perhaps above all sentiments and habits of mind which could not be measured and could not be eradicated."[73] These "sentiments and habits of mind" were the product of centuries of eugenic practices which reinforced Jewish ethnocentrism, in conjunction with a virulently strong tribal shaming code which inculcated a fanatical devotion and commitment to the tribe – and an equally fanatical intolerance and enmity of the outgroup. Like Jews, Muslim immigrants to the West have, by and large, not shown an inclination to assimilate themselves. Instead, like Jews, when they move to the West, they quickly begin to demand that the local culture start to transform itself to accommodate them.

State-sponsored multiculturalism, as a Jewish intellectual and political movement, is just the latest attempt by Jews to erect a rigid barrier against the individualistic Western social structure that threatens to undermine Jewish cohesiveness through undermining and weakening the psychological grip of the traditional Jewish shaming code. Kevin MacDonald observes that multiculturalism, like neo-Orthodoxy and

Zionism, is simply another Jewish response "to the Enlightenment's corrosive effects on Judaism" which involves the creation of a "defensive structure erected against the destructive influence of European civilization."[74] It is an attempt to resolve the "fundamental and irresolvable friction between Judaism and prototypical Western political and social structure."[75]

To the extent that the rate of Jewish "intermarriage" has increased in recent times, one can assume that many Western Jews have been caught up in intellectual currents (like "multiculturalism" with its "diversity" fetish) that were only intended by their Jewish activist originators for non-Jewish (particularly European) consumption. If the figures from a recent Pew survey are to be believed, these intellectual currents *have* undermined the traditional social infrastructure of Jewish tribalism in the West – such as the enrolment of Jewish children in Jewish schools. Jewish commentary on this issue (which is generally anguished) invariably dwells on the need for the reestablishment in the West of the traditional social infrastructure of Jewish tribal fanaticism – for the partial restoration of the ghetto – a tacit acknowledgement of the power of Western societies, even in their postmodern "multicultural" incarnation (where they have been radically reengineered to specifically serve Jewish interests) to breakdown Jewish cohesiveness.

Jewish history clearly indicates that the tribal mind and ingroup fanaticism are rational adaptations to a world ruled by Huxley's cosmic process (i.e., the law of the jungle) – rational in the sense that they increase the odds of survival. In his *History of the Hebrew People*, the nineteenth-century French historian and philosopher Ernst Renan postulated, like Huxley, that tribal fanaticism has played a dialectically necessary role in the development of human ethical systems. The Jews were undoubtedly tribal fanatics, Renan observed; yet without their fanaticism they would not have preserved the cultural practices necessary for group survival. The essence of fanaticism is to follow blindly the collective mind without question or criticism. It is the negation of individual thinking that pays off in terms of the capacity of a group to survive in competition with other groups. The fanatic is the person who

is willing to follow blindly, and to trust implicitly, and never to doubt or to question the authority of the group customs and traditions.

By sharp contrast, Western history has been punctuated by numerous instances where White people have appealed to their own conscience to condemn the behavior of members of their own biological community. During the Boer War, for instance, there were many in England who thought the English were acting unjustly toward the Afrikaners, and who were particularly outraged by Lord Kitchener's policy of interning Boer women and children in disease-ridden concentration camps. The tribal actor, on the other hand, cannot take a moral stance outside the perspective of his tribe. For the tribal actor, the highest ethical idea is: "My tribe, right or wrong." The idea that his tribe could be wrong is unthinkable for the tribal actor, since he defines as right whatever the tribe deems right, and wrong whatever the tribe deems wrong.

### Huxley's Ethics and Western Individualism

Our sense of individuality is acquired by the recognition that there are differences between us and other people, but in a cohesive group ruled by a monolithic shaming code everyone is mentally in sync with each other. The question then presents itself: if a tribe can increase its chance of survival by suppressing the individual through the imposition of a group-oriented shaming code, then how did Western societies in which individualism has been encouraged and, indeed, has become the basis of law and custom, emerge in the first place? Or, to put it in Huxley's terms: how could human beings be free as individuals, and still co-operate enough to survive?

The late English political philosopher Michael Oakeshott stated the obvious when he observed that, at least by the eighteenth century, "The disposition to regard a higher degree of individuality in conduct and in belief as the condition proper to mankind and as the main ingredient of human 'happiness,' had become one the significant dispositions of the modern European character."[76] Clearly, to emerge in the first place, Western individualism had to be evolutionarily adaptive at some level. In

accounting for the historical emergence of the individualism and moral universalism of White people, some, like Kevin MacDonald, emphasize genetic factors (our unique evolutionary history as northern hunter-gatherers) while others, like Ricardo Duchesne, emphasize cultural factors. These genetic and cultural explanations are certainly not mutually exclusive. Regardless of origin, Western individualism has undoubtedly been conducive to economic development, and the resultant boost in material living standards has dramatically reduced child mortality and increased the human carrying capacity of Western nations by augmenting supplies of resources like clean water, food, clothing and housing.

In addition, Western individualism, acting in combination with the relatively high intelligence of White populations (the legacy of selection pressures imposed by the harsh European climate over millennia), facilitated an incredible explosion of creativity and invention in the arts and sciences. In his book *Human Accomplishment*, Charles Murray makes the point that: "A major stream of human accomplishment is fostered by a culture that encourages the belief that individuals can act efficaciously as individuals, and enables them to do so."[77] This explosion of European creativity and invention from the Renaissance onwards provided the basis for the development of technologies that fueled further economic development and dramatic improvements in material living standards. When the exclusive beneficiaries of this economic development were White populations in what were homogeneous White nations, Western individualism was highly adaptive and supportive of the group evolutionary interests of Europeans.

Indeed, Western individualism has, throughout most of history, offered Whites an enormous advantage in facilitating the acquisition of resources and in aiding reproductive success. However, with the advent of mass third-world immigration and multiculturalism in the West over the last few decades, this is no longer the case.

While Western civilization as a whole has been strongly characterized by moral universalism and individualism, National Socialist Germany, during its brief existence, offered a prominent example of a European society that, like Judaism, employed a strong shaming code and

which imposed a set of practices aimed at socializing individuals into identifying strongly with the group. Noting the "eerie" parallels between National Socialist ideology and traditional Jewish ideology, Kevin MacDonald notes in *Separation and its Discontents* that:

> The National Socialist movement in Germany from 1933-1945 is a departure from Western tendencies toward universalism and muted individualism in the direction of racial nationalism and cohesive collectivism... characterized by several key features that mirrored Judaism as a group evolutionary strategy. Most basically, National Socialism aimed at developing a cohesive group. There was an emphasis on the inculcation of selfless behavior and within-group altruism combined with outgroup hostility. ... These anti-individualist tendencies can be seen in the Hitler Youth movement. ... After 1936, membership was compulsory for children after their tenth birthday. A primary emphasis was to mold children to accept a group strategy of within-group altruism combined with hostility and aggression toward outgroups, particularly Jews. Children were taught an ideology of nationalism, the organic unity of the state, blind faith in Hitler, and anti-Semitism. Physical courage, fighting skills, and a warlike mentality were encouraged, but the most important aspect of education was group loyalty: "Faithfulness and loyalty irrespective of the consequences were an article of faith shared among wide sections of Germany's youth" (Koch, 1976, 119). Socialization for group competition was strongly stressed, "all the emphasis centering on obedience, duty to the group, and helping within the group" (Koch 1976, 128). The ideology of National Socialism viewed the entire society (excluding the Jews) as a large kinship group – a "*Volksgemeinschaft* transcending class and creed" (Rempel 1989, 5).[78]

As with Judaism, the National Socialists were obsessed with socializing group members into accepting group goals and the importance

of within-group altruism and cooperation in attaining these goals. In *Mein Kampf*, Hitler states that the greatest strength of the Aryan race is their willingness to sacrifice self-interest to group goals, and that in the Aryan "the instinct of self-preservation has reached its noblest form, since he willingly subordinates his own ego to the life of the community and, if the hour demands, even sacrifices it."[79] The success of the National Socialist inculcation of a group-oriented shaming code is indicated by the fact that, by some estimates, 95 per cent of young Germans remained committed to the war effort after the defeat at Stalingrad. The high level of selfless behavior among Germans during the war (both as soldiers and support personnel) clearly indicates that the indoctrination of young people with National Socialist ideology was very successful, and was causally responsible for self-sacrificing behavior.

While it is common for White people to smugly assume that the ethnocentric tribal mindset is inferior to the individualism and moral universalism that has so characterized Western societies – this is a seriously mistaken assumption. The first law of the jungle states, that in the struggle for survival and supremacy, *there are no rules*. From a biological standpoint, anything that achieves victory is automatically self-justifying, and the reality is that the morally autonomous individualist stands little chance of surviving in the jungle. He who has neither tribe nor pack to defend him will perish. The idea that Western individualism is sophisticated and modern and represents a higher stage of social or psychological evolution is based on the naive assumption that the White individualist lives, and will continue to live, in an environment where Huxley's cosmic process (i.e., the law of the jungle) has been revoked. He does not have to struggle against bands of tribal fanatics. But what if mass non-White immigration and multiculturalism radically transform his society, and he suddenly finds himself in the jungle once more?

### Huxley's Ethics and the Culture of Critique

Implicit in Huxley's theory of ethics is that an effective form of group warfare consists in subverting the shaming code of rival groups to

fracture their cohesion and reduce their solidarity, and thereby render them less effective competitors in the struggle for survival. The Jewish intellectual movements discussed in *The Culture of Critique* were centrally preoccupied with undermining the traditional ethical precepts (and shaming codes) of Western societies, thereby rendering them less effective competitors to Jews for access to resources and reproductive success. Each of these movements sought to the overturn the established expectation whereby, as Huxley notes, each man "should be mindful of his debt to those who have laboriously constructed it [their society]; and shall take heed that no act of his weakens the fabric in which he has been permitted to live."[80]

Kevin MacDonald makes the point that no evolutionist should be surprised that "intellectual activities of all types may at bottom involve ethnic warfare, any more than one should be surprised at the fact that political and religious ideologies typically reflect the interests of those holding them."[81] Based on his evolutionary theory of ethics, Huxley would have undoubtedly accepted this proposition as self-evidently true. According to the philosopher and writer, Bryan Magee, almost all the intelligent Jews of his acquaintance accepted that Judaism, while literally untrue, amounted to a highly effective group evolutionary strategy:

> Of the religions I studied, the one I found least worthy of intellectual respect was Judaism. I have no desire to offend any of my readers, but the truth is that while reading foundational Jewish texts I often found myself thinking: "How can anyone possibly believe this?" When I put that question to Jewish friends they often said that no intelligent Jew did. To quote the precise words of one: "There's not a single intelligent Jew in the country who believes the religion." What they do believe, they tell me, is that it is desirable that traditional observances be kept by at least some Jews because it is these observances more than anything else that give the Jewish people its identity, and therefore its cohesion; but that the doctrinal content or implications of the observances

are not expected to be taken with full intellectual seriousness by intelligent people.[82]

All of the Jewish intellectual movements discussed in *The Culture of Critique* encouraged the subversion of the traditional Western socialization of children (i.e., its tribal shaming code). Boasian anthropology sought, for example, to overturn established notions regarding the importance of racial differences, and therefore the perceived need to maintain immigration restrictions and instill a strong racial identity in White children and a strong aversion to miscegenation as part of their socialization. The subversive doctrines of Freudian psychoanalysis and the Frankfurt School likewise promoted the replacement of the traditional Western shaming code (based on racial pride and Christian values) with a new politically correct shaming code that amounts to a recipe for White suicide. Scruton pointed out how this new ethical paradigm:

> While exhorting us to be as "inclusive" as we can, to discriminate neither in thought, word, nor deed against ethnic, sexual or behavioural minorities... encourages the denigration of what is felt to be especially ours. ... The gentle advocacy of inclusion masks the far-from-gentle desire to exclude the old excluder: in other words to repudiate the cultural inheritance that defines us as something distinct from the rest. The "down with us" mentality is devoted to rooting out old and unsustainable loyalties. And when the old loyalties die, so does the old form of membership. ... We who live in the amorphous and multicultural environment of the postmodern city must open our hearts and minds to all cultures, and be wedded to none.[83]

This was the undoubtedly the intended consequence of the promotion of radical individualism as the epitome of psychological health by the Frankfurt School. The psychologically-healthy White person was held to be an individual who had broken free from the traditional Western shaming code, and realized their human potential without relying on membership in collectivist groups. Jewish Frankfurt School theorist

Erich Fromm argued, for instance, in his book *The Sane Society* (1956) that: "Mental health is characterized by the ability to love and create, by the emergence from incestuous ties to clan and soil, by a sense of identity based on one's experience of self as the subject and agent of one's powers, by the grasp of reality inside and outside of ourselves, that is, by the development of objectivity and reason."[84] Accordingly to Fromm's criteria, virtually no Jew would be considered to be mentally healthy. The embrace of radical individualism among non-Jews, promoted by the likes of Fromm, was, not surprisingly, very conducive to the continuation of Judaism as a cohesive group.

Most importantly, to effectively undermine the shaming code that sustained the traditional White family, and Western civilization more broadly, movements like Freudian psychoanalysis and the Frankfurt School needed to promote a revolution in the traditional Western family structure and in child-rearing practices. This revolution has had dire consequences for White group interests. Kevin MacDonald notes that: "Applied to gentile culture, the subversive program of psychoanalysis would have the expected effect of resulting in less-competitive children; in the long term, gentile culture would be increasingly characterized by low-investment parenting, and... there is evidence that the sexual revolution inaugurated, or at least greatly facilitated, by psychoanalysis has indeed had this effect."[85]

The assault on the family from the 1960s onwards was part of a great cultural shift from the affirmation to the repudiation of inherited values. "Wilhelm Reich, R.D. Laing, Aaron Esterson, and radical psychotherapists of their persuasion see the family as a burden imposed by the past: a way in which parents encumber their offspring with an inheritance of defunct authority. Schizophrenia, in Laing's view, arises because the Self is made Other by the parental imposition of dysfunctional norms."[86] Inevitably, these dysfunctional norms were the traditional family structure and regulative ideas of Western societies. Following the path laid out by these intellectuals, "radical feminism has set out to deconstruct the family entirely, exposing at as an instrument of male domination, and advocating new kinds of 'negotiated' union in

its place." This radical deconstruction of the traditional Western family structure was never accompanied by an analogous deconstruction of the traditional Jewish family structure and *its* regulative ideas. Scruton observes how under the new politically correct shaming code:

> Permission turns to prohibition, as the advocacy of alternatives gives way to a war against the former orthodox. The family, far from enjoying the status of a legitimate alternative to the various "transgressive" postures lauded by the elite, is dismissed out of hand as a form of oppression. ... Like Marxism, feminism purports to show us the world without ideological masks or camouflage. Its repudiating zeal is not, as a rule, directed against Islam or the cultures of the East. It is directed against the West, and its message is "down with us."[87]

Given the existence of significant differences between Jews and gentiles in mean IQ (and associated differential propensities toward high-investment parenting), there is, as Kevin MacDonald notes, every reason to suppose that Jews and gentiles have very different interests in the construction of culture. This is because Jews are relatively less dependent on the preservation of cultural supports for high-investment parenting compared to gentiles.

Accordingly, the consequences of the erosion of the traditional Western shaming code which enforced constraints on sexuality (the result of the triumph of the psychoanalytic and radical critiques of Western culture since the 1960s) have been far more deleterious to those lower IQ gentile groups that are genetically predisposed to precocious sexuality than to Diaspora Jews (greater intelligence being correlated with later age of marriage, lower levels of illegitimacy, and lower levels of divorce). The result has been the establishment of a society controlled by a Jewish "cognitive elite" who politically, economically and socially dominate "a growing mass of individuals who are intellectually incompetent, irresponsible as parents, prone to requiring public assistance, and prone to criminal behavior, psychiatric disorders, and substance abuse."[88]

Meanwhile, at the other end of the social spectrum, Jewish ethnic activists have recruited the most intellectually capable elements from within White populations and used them as foot soldiers in a relentless campaign against their own kind. The practice of using Europeans in this fratricidal way is not without historical precedent. Through their control of the dissemination of information in the West, Jews have reinstituted a version of the *Devçirme* practiced for centuries by the Ottoman Empire. *Devçirme* is the Turkish word for the process of stealing the best, brightest, fittest, and handsomest boys from their non-Muslim subject populations. The Turks had no compunction in stealing European children, mostly from the Balkans, forcibly converting them, training them to be fanatical and ruthless warriors (the famous Janissaries), and employing them to suppress the communities of their biological origin.

From the point of view of Huxley's cosmic process, the system of *Devçirme* was a machine of ruthless efficiency in the struggle for survival and supremacy, and it was an important part of the enormous power the Ottoman Empire wielded over centuries. In the modern Jewish version of *Devçirme*, the best and brightest White youth are brainwashed by the media and educational establishments, and trained to be fanatical intellectual warriors used to suppress communities of their own biological origin. The ongoing loyalty of these elite intellectual warriors is then sustained through a perverted system of incentives that rewards Whites who harm the interests of their own people.

For tribal groups with small populations like the Jews, there are big evolutionary advantages to creating artificial tribes based on ideology – providing these artificial tribes do not compromise the cohesiveness of the original ethnic group. The artificial tribe can be employed to work for the interests of the biological tribe, and, as in the Ottoman example, the creation of artificial tribes allows the original tribe to tap into the biological reservoir of the peoples and tribes they have under their control. By stealing European boys and instilling in them the shaming code of the Janissary, the Ottomans could create an army that far surpassed the manpower that even the largest blood tribe could produce. Similarly,

by intellectually capturing and mobilizing the cognitive elite of White societies, Jews – only a tiny fraction of Western populations – have created an army of Whites fighting aggressively for Jewish interests.

## *Conclusion*

The demographic transformation of the West taking place through mass non-White immigration will bring Huxley's cosmic process increasingly to the fore, and as the law of the jungle based on group competition becomes an ever more prominent feature of Western life, White people – despite the incessant multicultural propaganda, the legal strictures, and the perverted system of rewards and punishments in place – will inevitably start to behave more like tribal actors once again. The real danger is that White people do not make this transition quite quickly enough. Until Western societies cross a demographic threshold (perhaps the point where Whites are consigned to minority status) the majority of Whites will likely continue to try to minimize the threat posed by the steady return to the law of the jungle. They will try to explain it away, or simply deny it. They will continue to make concessions (economic, legal and cultural) to non-White groups in the hope of placating these ever-growing and increasingly emboldened and hostile communities. They will continue to resist all efforts of White partisans to enlist them to their cause.

As the demographic crisis deepens, those White people who refuse to stop playing the role of the morally autonomous individualist will find themselves increasingly friendless in a world full of enemies, until the day comes when they too must choose sides and embrace the tribal ethos of Us versus Them. The inevitable consequence of the return to the law of the jungle – even for those Whites who have been brain-washed to regard their own demise as a moral imperative – is the re-awakening of the tribal mind. If there are other tribes in my vicinity that hate me because they see me a member of an enemy tribe, then my only hope of security lies in standing firmly with my own tribe. As the old adage goes, there is safety in numbers. What good would it do for me to

assure those who hate my tribal identity that I am not really a member of my tribe, but an individual, capable of moral autonomy? The White person who insists on remaining a "rational" individualist when his world has reverted to the ways of the jungle is not, in fact, acting rationally. Rationality, at this point requires group solidarity. To survive in a dog-eat-dog world you must run in packs – and the tribe is your pack. Rationality therefore dictates the surrender of moral autonomy and the embrace of the tribal ingroup.

## CHAPTER 4

# Revolutionary Yiddishland

Alain Brossat and Sylvie Klingberg's *Revolutionary Yiddishland: A History of Jewish Radicalism* was first published in France in 1983. A revised edition appeared in 2009 and an English translation in 2016. Intended for a mainly Jewish readership, the book is essentially an apologia for Jewish communist militants in Eastern Europe in the early to mid-twentieth century. Brossat, a Jewish lecturer in philosophy at the University of Paris, and Klingberg, an Israeli sociologist, interviewed dozens of former revolutionaries living in Israel in the early 1980s. In their testimony they recalled "the great scenes" of their lives such as "the Russian Civil War, the building of the USSR, resistance in the camps, the war in Spain, the armed struggle against Nazism, and the formation of socialist states in Eastern Europe."[89] While each followed different paths, "the constancy of these militants' commitment was remarkable, as was the firmness of the ideas and aspirations that underlay it." Between the two world wars, communist militancy was "the center of gravity of their lives."[90]

While communism in Europe in the early to mid-twentieth century was characterized by economic dysfunction, systematic oppression, summary executions, and the elimination of entire ethnic groups, Brossat and Klingberg wistfully recall it as a time when European Jewry "failed to achieve its hopes, its utopias, its political programs and

strategies." Instead the messianic dreams of radical Jews were "broken on the rocks of twentieth-century European history." A product of their ethnocentric infatuation with the "romance" of Jewish involvement in radical political movements, *Revolutionary Yiddishland* is Brossat and Klingberg's hagiographic attempt to resurrect a history that is today "more than lost, being actually denied, even unpronounceable."

The unstated reason for this omission lies in the determination of Jews to absolve their co-ethnics of any responsibility for the crimes of communism, and to ensure the advent of German National Socialism is always framed in a way that conduces to a simplified narrative of saintly Jewish victimhood and German (and by extension White European) malevolence. Maintaining this narrative is supremely important for the legions of Jewish "diversity" activists and propagandists throughout the West, given the status of "the Holocaust" as the moral and rhetorical foundation of today's White displacement agenda. Invocation of this narrative is reflexively used to stifle opposition to the Jewish Diaspora strategies of mass non-White immigration and multiculturalism. By contrast, free discussion of the Jewish role in communist crimes undermines Jewish pretensions to moral authority grounded in their self-designated status as history's preeminent victims. This polarity accounts for the fact that, since 1945, over 440 feature films have been made about "the Holocaust" while the number of films that have been made about the genocide of millions of Eastern Europeans can be counted on one hand – and none have been produced by Hollywood.

The critical importance of suppressing discussion of this unsavory aspect of Jewish history was underscored by Daniel Goldhagen in his 2013 screed *The Devil That Never Dies: The Rise of Global Antisemitism*. For Goldhagen, any claim Jews were responsible for the Bolshevik Revolution and its predations is a "calumny," and morally reprehensible because "If you associate Jews with communism, or worse, hold communism to be a Jewish invention and weapon, every time the theme, let alone the threat, of communism, Marxism, revolution, or the Soviet Union comes up, it also conjures, reinforces, even deepens thinking prejudicially about Jews and the animus against Jews in one's

country."[91] It is therefore imperative the topic remain taboo and discussion of it suppressed – regardless of how many historians (Jewish and non-Jewish) confirm the decisive role Jews played in providing the ideological basis for, and the establishment, governance and administration of, the former communist dictatorships of Central and Eastern Europe.

In an article for the *Jewish Telegraphic Agency*, journalist Cnaan Liphshiz, while noting that the Goldhagen approach of absolute denial constitutes "a logical strategy" for Jews, admits the facts do "reaffirm in essence" the assessment of those like "promoter of Holocaust denial" Mark Weber who observed that: "Although officially Jews have never made up more than five percent of the country's total population, they played a highly disproportionate and probably decisive role in the infant Bolshevik regime." Liphshiz notes how Russia's main Jewish museum has, since 2012, "tackled head on the subject of revolutionary Jews" in an exhibition that "underlines unapologetically how and why Jews became central to the revolution."[92] Knowing that outright denial of the pivotal Jewish role in the Bolshevik Revolution and the murderous regimes it spawned is intellectually untenable, a growing number of Jewish historians concede the point, but insist this leading role was morally justified because it was essentially "defensive" in nature.

Thus, while freely admitting Jews had "an outsized role in the revolution," Boruch Gorin, chairman of Moscow's Jewish Museum and Tolerance Center, insists that "there were very good reasons for this," with anti-Semitism being foremost among them. For Gorin, the revolution, while offering "Russia's Jews many opportunities, equal rights and education and a chance to fill the vacuum left by the elite that was forced into exile," most importantly offered a haven from a "wave of pogroms" in the Ukraine and elsewhere that "some historians call a dress rehearsal for the Holocaust." According to this conception, a Jew in 1917 "had two choices: revolution or exile."[93]

Jewish historians and activists have distorted and weaponized the history of "pogroms" in the former Russian Empire. The mythos forged around these events, crystallized in the Russo-Jewish Committee's propaganda pamphlet *The Persecution of the Jews in Russia* (1881) and

allied reporting in Jewish-controlled newspapers throughout the West, was pivotal in accelerating the development of modern, international Jewish politics. This narrative revolves around certain claims: that Jews were oppressed for centuries in Russia; that the Pale of Settlement was a virtual prison; that tsarist authorities actively organized and directed pogroms; that pogroms were genocidal and extremely violent in nature; and that Russians, Ukrainians and other Eastern Europeans were uncivilized and barbaric savages. Contemporary Jewish historians like Simon Sebag Montefiore continue to credit lurid tales of pogroms where Jews were "massacred in such gleefully ingenious atrocities – disemboweled, dismembered, decapitated; children were cutleted, roasted and eaten in front of raped mothers..."[94] Andrew Joyce notes how the dissemination of such pornographic accounts were key to ensuring "that mass Jewish chain migration to the West went on untroubled and unhindered by nativists. After all, wasn't the bigoted nativist just a step removed from the rampaging Cossack?"[95]

Uncritically drawing on this bogus narrative, establishment historians typically ascribe the pogroms to irrational manifestations of hate against Jews, tsarist malevolence, the pathological jealousy and primitive barbarity of the Russian mob, and the "blood libel." The real underlying causes of peasant uprisings against Jews, such as the Jewish monopolization of entire industries (including the sale of liquor to peasants on credit), predatory moneylending, and radical political agitation, are completely ignored, despite tsarist authorities having repeatedly expressed alarm over how "Jews were exploiting the unsophisticated and ignorant rural inhabitants, reducing them to a Jewish serfdom."[96] Initiatives to move Jews into less socially damaging economic niches, through extending educational opportunities and drafting Jews into the army, were ineffective in altering this basic pattern. With this in mind, even the revolutionary anarchist Mikhail Bakunin concluded that Jews were "an exploiting sect, a blood-sucking people, a unique, devouring parasite tightly and intimately organized... cutting across all the differences in political opinion."[97]

In *Revolutionary Yiddishland*, Brossat and Klingberg posit the "Jewish Bolshevism as morally justified ethnic self-defense" thesis, insisting that anti-Semitism was "an insidious poison hovering in the air of the time" that comprised "the sinister background music to the action of the Yiddishland revolutionaries."[98] The real causes of anti-Jewish sentiment among the native peasantry are, once again, comprehensively ignored. Rather than seeing Jewish communist militants as willing agents of ethnically-motivated oppression and mass murder, the authors depict them as noble victims who tragically "linked their fate to the grand narrative of working-class emancipation, fraternity between peoples, socialist egalitarianism" rather than to "a Jewish state solidly established on its ethnic foundations, territorial conquests and real-politik alliances."[99] In other words, they mistakenly held communism rather than Zionism to be best for the Jews.

Determined to absolve their co-ethnics of any culpability for communist crimes, Brossat and Klingberg assure us that the militancy of their informants "was always messianic, optimistic, oriented to the Good – a fundamental and irreducible difference from that of the fascists with which some people have been tempted to compare it, on the pretext that one 'militant ideal' is equivalent to any other."[100] In other words, tens of millions may have died because of the actions of Jewish communist militants, but their hearts were pure. Regarding such arguments, Kevin MacDonald observes how Jewish involvement with Bolshevism "is perhaps the most egregious example of Jewish moral particularism in all of history. The horrific consequences of Bolshevism for millions of non-Jewish Soviet citizens do not seem to have been an issue for Jewish leftists – a pattern that continues into the present."[101]

## Jewish Participation in Bolshevism as Ethnic Revenge

That their motivations were far from pure, and that ethnic animosity and desire for revenge were key factors driving the large-scale Jewish support of, and participation in, communist movements was obvious to the Jewish historian Norman Cantor who observed that:

The Bolshevik Revolution and some of its aftermath represented, from one perspective, Jewish revenge. During the heyday of the Cold War, American Jewish publicists spent a lot of time denying that – as 1930s anti-Semites claimed – Jews played a disproportionately important role in Soviet and world Communism. The truth is that until the early 1950s Jews did play such a role, and there is nothing to be ashamed of. In time Jews will learn to take pride in the record of the Jewish Communists in the Soviet Union and elsewhere. It was a species of striking back.[102]

This corresponds with Kevin MacDonald's assessment in *Culture of Critique* that the disproportionate participation of Jews in Bolshevik crimes was, in large part, "motivated by revenge against peoples that had historically been anti-Jewish." One of the (non-Jewish) pioneers of the Dada movement, Hugo Ball, immediately recognized the agenda behind the lopsided Jewish role in the Bolshevik Revolution and resulting Soviet administration. Observing the make-up of the first Bolshevik Executive Committee (four out of six of whom were Jewish), he noted that "it would be strange if these men, who make decisions about expropriation and terror, did not feel old racial resentments against the Orthodox and pogrommatic Russia."[103]

Leading Jewish communists, like founder of the Mensheviks Yuli Martov, who became a close associate of Lenin and Trotsky, made a point of recalling his childhood experiences of Russian and Ukrainian anti-Semitism. The 1881 Odessa pogrom was his "first taste of primitive Russian anti-Semitism," and Martov was "shaken to the depths of his being by the pogromist barbarity of Tsarist Russia." The event left a "permanent mark on his impressionable mind," and he later underlined the connection between this experience and his subsequent revolutionary career, posing the question: "Would I have become what I became if the Russian reality had not imprinted her coarse fingers on my plastic, youthful soul in that memorable night and carefully planted under the

cover of that burning pity which she aroused in my childlike heart, the seeds of a redeeming hatred?"[104]

While Trotsky, the architect of the Bolshevik insurrection and creator of the Red Army, claimed his Jewish origins and Jewish interests did not guide his attraction to Bolshevism, his biographer Joshua Rubenstein disagrees, noting he "was a Jew in spite of himself," who "gravitated to Jews wherever he lived," and "never abided physical attacks on Jews, and often intervened to denounce such violence and organize a defense."[105] As leader of the Red Army during the Civil War, Trotsky "had to deal with the anti-Semitic attitudes among the population," and "successfully recruited Jews for the Red Army because they were eager to avenge pogrom attacks."[106] At the same time, he "voiced his concern over the high number of Jews in the Cheka, knowing that their presence could only provoke hatred towards Jews as a group." Trotsky was feted by Jews worldwide as "an avenger of Jewish humiliations under Tsarism, bringing fire and slaughter to their worst enemies."[107]

Ethnic revenge was also a motivation for Lazar Kaganovich, the Jewish member of the Politburo who presided over the forced famine that took the lives of millions of Ukrainian peasants, and led the mass deportation of "anti-Semitic" Cossacks to Siberia in the 1930s. Kaganovich "battled the chauvinistic and anti-Semitic Black Hundreds, especially strong in Kyiv, both before and after the 1911 Beilis affair, the Russian version of the Dreyfus affair."[108] The assassination of the Russian Prime Minister Stolypin in the same year resulted in the Black Hundreds attempting "to whip up a pogrom." In response, the "Bolsheviks took measures to protect themselves and to rebuff this threat," and "Kaganovich only joined the party after these momentous events." He studied Lenin's works at this time, and the Bolshevik leader's article "Stolypin and Revolution" which depicted Stolypin as "an organizer of Black Hundred gangs and anti-Semitic pogroms" made a "big impression" on him.[109]

Kaganovich later became known as the "butcher of the Ukrainians." As Soviet leader in the Ukraine he received reports documenting "widespread dissatisfaction among workers fuelled by high unemployment,

with widespread anti-Semitism, with workers and peasants denouncing the 'dominance of red nobility of Yids.'" Kaganovich played a "highly visible" role in suppressing this "nationalist deviation" in 1925-28, and later oversaw the forced collectivization of 1932-33, conceived as part of an "assault on the Ukrainian nationalist intelligentsia." The country was sealed off and all food supplies and livestock were confiscated with Kaganovich leading "expeditions into the countryside with brigades of OGPU troopers" who used "the gun, the lynch mob and the Gulag system to break the villages."[110] The secret police, led by Genrikh Yagoda (also Jewish) exterminated all "anti-party elements." Furious that insufficient Ukrainians were being shot, Kaganovich set a quota of 10,000 executions a week. Eighty percent of Ukrainian intellectuals were shot. During the winter of 1932-33, 25,000 Ukrainians per day were being shot or left to die of starvation.[111]

The Bolsheviks mounted murderous campaigns against entire ethnic groups. The Soviet government killed at least twenty million people, mostly in the first 25 years of the regime's existence during the height of Jewish power. With this in mind, Alexander Solzhenitsyn observed in *200 Years Together* that

> the leading Bolsheviks who took over Russia were not Russians. They hated Russians. They hated Christians. Driven by ethnic hatred they tortured and slaughtered millions of Russians without a shred of human remorse. It cannot be overstated. Bolshevism committed the greatest human slaughter of all time. The fact that the world is ignorant and uncaring about this enormous crime is proof that the global media is in the hands of the perpetrators.[112]

The Jewish intellectual, G.A. Landau, writing in 1923, was stunned by the "cruelty, sadism, and violence" of Jewish functionaries in the Red Army and secret police "who yesterday did not know how to use a gun" but who "are now found among the executioners and cutthroats."[113] I.M. Bikerman was similarly shocked at the "disproportionate and

immeasurably fervent Jewish participation in the torment of half-dead Russia by the Bolsheviks."[114] In response to attempts by Jews to disassociate their ethnicity from such figures, the Jewish intellectual I.A. Bromberg noted the cognitive dissonance in the Jewish "passion for seeking out and extolling the Jews famous in various fields of cultural life," and especially "the shameless circus around the name of Einstein," while simultaneously distancing themselves from Jewish communist criminals. D.S. Pasmanik agreed, noting how "Ethnic Jews not only do not denounce an Einstein or an Ehrlich; they do not even reject the baptized Heine and Boerne. And this means they have no right to disavow Trotsky and Zinoviev."[115]

## The Pale of Settlement

The *Revolutionary Yiddishland* of the book's title refers to the former Pale of Settlement which was comprised of twenty-six governorships in Eastern Europe where Jews were allowed to live, but only in cities and towns. Out of the eleven million Jews in the world in the early twentieth century, Russia held more than five million, and of these, four and a half million resided in the cities and towns of the Pale. For the authors, this "Yiddishland" was not just a geographical territory, but a "social and cultural space, a linguistic and religious world."[116] The much-maligned Pale of Settlement was the only response tsarist authorities could come up with when faced with the problem of how to deal with the "fanaticism of ultra-Orthodox Jewry" which was "unassimilable to official purposes."[117]

The social hierarchy of Jews in the Pale was, according to Brossat and Klingberg, made up of a wealthy financial bourgeoisie, a middling bourgeoisie which was "intellectual and commercial," and "an immense Jewish proletariat."[118] The use of the term "proletariat" to describe poorer Jews in the Pale is questionable given that they typically operated as petty traders rather than industrial employees. Jewish peddlers were notorious throughout the Pale as smugglers of contraband (as referenced in Gogol's *Dead Souls*). This large number of poorer Jews was

the result of the Jewish population explosion in Eastern Europe in the nineteenth century when their numbers grew from about 1.5 million at the beginning of the century to eight million by 1913.

This Jewish "proletariat," a hotbed of radicalism characterized by "powerful organization," played a "decisive part" in the "strikes and insurrections that broke out right across the Pale in the course of the 1905 Revolution." Regarding revolutionary agitators at this time, Tsar Nicholas II claimed that "nine-tenths of the troublemakers are Jews" who also dominated the newspapers where "some Jew or another sits ... making it his business to stir up passions of people against each other."[119]

The late nineteenth and early twentieth centuries saw millions of these poorer Jews migrate to destinations as diverse as North and South America, France, South Africa, Australia and Palestine. The ideological zealotry of these Jewish migrants directly influenced American immigration policy around this time, with Muller noting how:

> The image of the Jew as Communist played an often overlooked role in the history not only of Jews in America, but of the millions of Jews in Eastern Europe who would have liked to emigrate to the United States after World War I, but who were prevented from doing so by the immigration restrictions enacted in the early 1920s, culminating in the Reed-Johnson Act of 1924. For those restrictions were motivated in part by the identification of Jews with political radicalism.[120]

The prominent Jewish intellectual and writer Chaim Bermant observed that "To many minds, at the beginning of this [twentieth] century, the very words radical and Jew were almost one, and many a left-wing thinker or politician was taken to be Jewish through the very fact of his radicalism."[121]

From the 1860s, the effects of the Enlightenment and the rise of capitalism throughout the Pale overturned the traditional structures of Jewish life. The Jewish population became increasingly concentrated

in urban centers as Jews migrated from the *shtetl* to the cities. This geographical shift was accompanied by an intellectual shift involving "a break with the rigidity of the traditional Jewish life that invaded every sphere of existence." This break caused tensions and conflicts in Jewish families across and beyond the Pale – mainly between traditionalist parents and their children who abandoned traditional Judaism to embrace Marxism. Brossat and Klingberg note how "the theme of generational conflict, the clash between the old and the new within the family structure, returns like a leitmotiv in the statements of many of our witnesses."[122]

The progression of young Jews from religious fanaticism to political fanaticism was often a psychologically seamless process, with the Messianic creed of Marxism being grafted, without much difficulty, onto traditional Jewish paradigms. All the various branches of Jewish radicalism, the Bund (a Jewish socialist party), Poale Zion (a socialist Zionist party), and communism "sprang from the same root: the great utopia of a new world, the New Covenant that was prefigured by the writings of the socialist thinkers of the second half of the nineteenth century."[123] The European left was in large measure a Jewish creation. In Germany in the mid-nineteenth century Marx, Hess, and Lassalle, all three of Jewish origin, founded and shaped the socialist movement.

Interviewee Max Technitchek recalled how his traditionalist father, through exposure to radical literature, became convinced "that socialism was a good thing, that a day would come when everybody would be happy. Of course the good Lord still had a hand in it – the Messiah, socialism, the vision of future happiness for the Jews and all humanity – all this tended to melt together in his convictions."[124] Here we see the conception of Judaism as a universalist, morally superior movement – the "light unto the nations" theme that has recurrently emerged as an important aspect of Jewish self-identity since antiquity, and especially since the Enlightenment. This despite the fact that Jews have frequently served oppressive ruling elites in traditional societies throughout history.

The religious father of communist militant David Szarfharc expressed sympathy for communism because, for him, "the prophets were precursors of Marx."[125] It was not uncommon for the Marxist sympathies of traditionalist parents to "beat the path to radicalism and revolutionary commitment for their children."[126] Another attraction of Marxism was "its replication of Judaic traditions of book-learning, exegesis and prediction."[127] Sachar notes how "its intellectual sophistication appealed to Jews," though its chief allure lay in the fact it "rejected all forms of chauvinism and nationalist xenophobia. In short, it rejected anti-Semitism."[128]

For many in the younger generation, communism was seen not a rejection of Judaism but its logical extension. For the vast majority of Jewish communists, "their commitment to the movement was not a sign of forgetting or denying their identity; they participated in it as Jews, drawing Jewish workers into the great movement of universal emancipation." Brossat and Klingberg's informants' accounts of their transition from the closed world of religion to the open world of modernity was "not expressed in terms of violent rupture, rather of evolution, reconciliation" between Judaism and Marxism. For the authors, the testimony of their informants revealed "the plasticity, capacity for evolution and basic internal dynamism of the Jewish world of Eastern Europe."[129]

### Jewish Support for the Bolshevik Revolution in 1917

Jews naturally welcomed the February Revolution of 1917 which led to the abolition of all legal restrictions on Jews starting with the Pale of Settlement. At this time, most Jews did not support the Bolsheviks, but other more overtly pro-Jewish groups like the Bund, Poale Zion, and the Mensheviks. This changed after the Bolsheviks seized power in October 1917 and launched a campaign to wipe out all traces of anti-Semitism in the former Russian Empire. Brossat and Klingberg note how "the Bolsheviks equated anti-Semitism with counterrevolution" and applied the rigors of martial law to "pogromists." This attracted huge numbers

of Jews into the ranks of the new Bolshevik regime, who "provided very many cadres to both the provincial administrations of the new regime and the army." The prevalence of Jews in the new administration was such that the "Soviet government [effectively] made anti-Semitism a proxy for anti-Bolshevism."[130]

Once the Civil War began, Jewish support for the new regime became even more pronounced. By March 1919, a large majority of the members of the Jewish Bund "pronounced in favor of the Soviet dictatorship." Key to this support was the fact the Bolsheviks had:

> proclaimed the definitive abolition of all forms of national discrimination; the Soviet government waged an effective struggle against anti-Semitism. The abolition of the Pale of Settlement enabled Jews to move freely across the whole Russian territory; the proclamation of the equality of all citizens opened the doors of the new administration to them; the proclaimed desire of the new power to contribute to the rehabilitation of all cultures and nationalities oppressed by Great Russian chauvinism under the tsarist regime gave them hope for the *yiddische gass*, the "Jewish street," of Russia. Was not the presence of so many Jews in leading positions in the new state apparatus a tangible guarantee, a deposit in the future?[131]

Solomon Fishkowski, a Poale Zion militant in Kolno, Poland, enthusiastically welcomed the revolution. After being briefly imprisoned for distributing propaganda leaflets in 1918, he enlisted in the Polish army. When the Polish-Soviet war broke out he deserted and joined the Red Army "to rally to this revolution that had proclaimed the end to all discrimination against Jews."[132] Haim Babic, a faithful activist of the Bund in Poland, claimed that Polish Jews like him "demanded immediate and radical solutions, which pressed us to turn towards the east, the USSR."[133] Babic became convinced that "Polish Jews would never escape from their misery without a worldwide overthrow."[134]

When, after the chaos of World War I, revolutions erupted all over Europe, Jews were everywhere at the helm. The old order in Hungary was overthrown by the Hungarian Soviet Republic of Bela Kun (Cohen) who seized power in March 1919 and lasted for only 133 days before succumbing to invading Romanian troops. Of the government's forty-nine commissars, thirty-one were Jewish.[135] After seizing power, they acted in enthusiastic accord with their radical political principles:

> Statues of Hungarian kings and national heroes were torn down, the national anthem was banned, and the display of the national colors was made a punishable offense... Radical agitators were dispatched to the countryside, where they ridiculed the institution of the family and threatened to turn churches into movie theatres... Antipathy soon enough focused on the Jews. Young revolutionaries of Jewish origin had been sent to the countryside to administer the newly collectivized agricultural estates; their radicalism was exceeded only by their incompetence, reinforcing peasant anti-Semitism. The Jesuits, for their part, interpreted the revolution as Jewish and anti-Christian in essence. ... Rumors abounded that the revolutionaries were everywhere desecrating the Host. In Budapest as in the countryside, opposition to the regime, defense of the church, and anti-Semitism went hand in hand.[136]

An eyewitness account of the Hungarian Soviet Republic was published in 1921 by the French brothers Jean and Jérôme Tharaud entitled *When Israel is King*. Interspersed with accounts of the confiscation of wealth by the revolutionaries, and the replacement of Hungarian professors with young Jewish intellectuals, were reflections like: "A New Jerusalem was growing up on the banks of the Danube. It emanated from Karl Marx's Jewish brain, and was built by Jews upon a foundation of very ancient ideas."[137]

Reflecting on this history, Zsolt Bayer, co-founder of Hungary's Fidesz Party, asked: "Why are we surprised that the simple peasant whose

determinant experience was that the Jews broke into his village, beat his priest to death, threatened to convert his church into a movie theater – why do we find it shocking that twenty years later he watched without pity as the gendarmes dragged the Jews away from his village?"[138]

## A Jewish Cultural Renaissance in the USSR

After the Bolshevik Revolution the national rights of the Jewish population were fully recognized. This was manifested in the opening of Yiddish-language schools, the publication of books and periodicals in that language, and the creation, in January 1918, of a sub-commissariat of Jewish affairs.[139] Brossat and Klingberg claim a "Jewish cultural renaissance" occurred in the USSR in the 1920s, which was associated with a "remarkable flourishing of Jewish theater in this period, by an intense and varied production of Yiddish literature, the establishment of Jewish schools etc." The sudden changes introduced by the revolution "precipitated the eruption of these communities into modernity, bringing to birth the features of a new Jewish identity in the USSR." Synagogues were rebranded "cultural circles" where meetings were held on the dates of religious festivals which "denounced outdated beliefs and celebrated the cult of the revolution."[140]

It is a testament to Judaism's tenacity as a group evolutionary strategy that Jewish ethnic continuity was unaffected by the official assimilationist ideology of the new regime. The rejection of religious traditionalism was instead "accompanied by a 'self-affirmation,' a 'rejection of assimilation' by the new public that recognized itself in this original cultural production."[141] Accordingly, the "massive revolutionary commitment" of Jewish youth in the early twentieth century "cannot be equated with a flight from the Jewish world, an unqualified rejection of this world." Their commitment was "not a sign of forgetting or denying their identity; they participated in it as Jews," and Marxism-Leninism only "consolidated them in their Jewish identity."[142]

Pre-revolutionary Jewish schools were almost entirely traditional *heder* that taught the Bible and Talmud: the post-revolutionary schools

were secular institutions impregnated with communist ideology. Despite this, instruction was in Yiddish and the new schools continued to segregate Jewish children from the surrounding *goyische* society. Here was clear evidence the Jewish advocacy of radical, universalist ideologies like communism was compatible with Judaism as a group evolutionary strategy. Kevin MacDonald notes in *Culture of Critique* how the Bolsheviks "aggressively attempted to destroy all vestiges of Christianity as a socially unifying force within the Soviet Union while at the same time it established a secular Jewish subculture so that Judaism would not lose its group continuity or its unifying mechanisms such as the Yiddish language."[143]

It took opponents of the Bolsheviks little time to notice the overwhelmingly Jewish nature of the new regime. Jews were a primary target of tsarist loyalists who "mobilized under the banner 'For Holy Russia, against the Jews!'"[144] Jews were attracted to communism in the 1920s to an extraordinary extent, and their prominence, not only in the Bolshevik political leadership in the period from 1917 to 1922, but especially in the secret police, only "nourished anti-Semitism."[145] Soviet propaganda demonized Ukrainian nationalist leaders like Symon Petliura as an "anti-Semite" and "linked Ukrainian nationalism to looting, killing and above all pogroms." Petliura was murdered in Paris in 1926 by a Russian Jew, Sholom Schwatzbard, who, "inspired by Soviet propaganda" claimed to be "taking revenge for the pogroms."[146] Schwatzbard was hailed as a hero by Jews around the world.

The sudden appearance of large numbers of Jews in leadership positions throughout the ranks of the new Soviet regime, a "revolution in the revolution," had an electrifying effect on Jewish youth throughout Eastern Europe. Esther Rosenthal-Schneidermann, a Jewish communist from Poland who arrived in Moscow in 1926 to take part in the first congress of activists specializing in the field of education, recalled her emotional reaction to discovering this new reality:

> Up till then, I had never seen a Jew in the role of high official, not to say an official speaking our everyday *mamelosh* [mother

tongue], Yiddish. And here on the podium in the congress hall of the People's Commissariat for Education there were top officials speaking Yiddish, in the name of the colossal Soviet power, of Jewish education that the party placed on a footing of equality with the cultural assets of other peoples.[147]

Rubenstein notes how "In a country where Jews had been persecuted and marginalized for so long, it must have been unnerving for millions of people to see Jews among those in charge of the country."[148] After the revolution, Jews quickly moved into "important and especially sensitive positions in the bureaucracy and administration of the new regime," and, as a result, the first encounter with the new regime for many Russians "was likely to be with a commissar, tax officer, or secret police official of Jewish origin." Muller notes that:

> with so many Bolsheviks of Jewish origin in positions of leadership, it was easy to consider Bolshevism a "Jewish" phenomenon. And if Winston Churchill, who was personally remote from anti-Semitism, could regard Bolshevism as a disease of the Jewish body politic, those who had long conceived of Jews as the enemies of Christian civilization quickly concluded that Bolshevism was little more than a transmutation of the essence of the Jewish soul.[149]

Or, as Kevin MacDonald has conceptualized it, a post-Enlightenment manifestation of Judaism as a group evolutionary strategy. Following the dramatic reversal of fortune for Russian Jewry under the Bolsheviks, many Jews who had left tsarist Russia to migrate to North America or Western Europe returned to witness the "unbelievable." It was "a topsy-turvy world" said one such onlooker, A.S. Sachs, where "the despised had come to sit on the throne and those who had been the least were now the mightiest." He noted with jubilation that "The Jewish Bolsheviks demonstrate before the entire world that the Jewish people are not yet degenerate, and that this ancient people is still alive and full of vigor.

If a people can produce men who can undermine the foundations of the world and strike terror into the hearts of countries and governments, then it is a good omen for itself, a clear sign of its youthfulness, its vitality and stamina."[150]

## *Jewish Power in Stalin's Soviet Union*

Brossat and Klingberg note how the situation of Jews in the early decades of the Soviet Union is often framed in terms of their victimhood at the hands of Stalinist "totalitarianism" – emphasizing the social and political repression that struck individual Jewish intellectuals, artists and activists. With the purges of the mid-1930s, and Stalin's rejection of "cosmopolitan internationalism" in favor of socialism in one country, the political landscape did change significantly for Jews. Their confidence "in the dialectic of history" was shaken by Stalin's "restoration of the Great Russian chauvinism." Stalin was, the authors claim, "a dyed-in-the-wool anti-Semite" who

> had never completely settled accounts with the national obscur-
> antism that had poisoned the social atmosphere under the old
> regime [i.e., tsarist anti-Semitism] – in contrast to Lenin, who had
> a horror of racism and denounced national prejudices through-
> out his life. In 1907, Stalin was highly amused by the joke of a
> certain comrade Alexinski who, noting that Jews were particu-
> larly numerous among the Mensheviks, suggested that it would
> perhaps be time to "conduct a pogrom in the party." When the
> factional struggle broke out in the mid-1920s, opposing Stalin
> and Bukharin to the left led by Trotsky and Radek, soon joined
> by Zinoviev and Kamenev, the latter were amazed to discover that
> Stalin and his clique had no hesitation, in the heat of the battle,
> in coming out with sly allusions to their enemies' "exotic" origins
> and drawing on chauvinist prejudices that remained anchored in
> the consciousness of Soviet workers...[151]

Despite pointing out and condemning Stalin's hostility to Jews, the authors erect a moral firewall between Stalin's Soviet Union and Hitler's Third Reich. Doubtless with Hannah Arendt's *The Origins of Totalitarianism* in mind, they lament that the "prevailing discourse on 'totalitarianism' generally assimilates Nazi and Stalinist anti-Semitism, viewing them as equivalent and basically sharing the same features." Such a stance, they insist, fails to appreciate how "anti-Semitism fulfilled different functions in the Nazi and Stalinist systems," and only leads to "error" because "even in the worst days of Stalinist repression, under Yezhov in the late 1930s or under Beria in the early 1950s, Stalin did not practice the kind of racial discrimination and repression that the Nazis had made a precept, the very pivot of their system." They note how attempts to frame Jews as wholesale victims of Stalin's anti-Semitism also ignores the fact that most Jews in the 1930s remained loyal to the Soviet Union and "the idealism and messianism of their actions [was] still just as great."[152] Furthermore, Jews remained an elite group in the USSR during this period, and most of the women around Stalin and many of his closest collaborators, from Yagoda to Mekhlis, were Jewish.

For the authors of *Revolutionary Yiddishland*, it is "impossible to understand the scope of subsequent disappointments without stressing how strongly the majority of the Jewish population rallied to the Soviet regime in the course of the Civil War, and the attraction that the 'utopia' of the new state power continued to exert on several generations of Jewish socialist militants of Eastern Europe."[153] Jews like Bronia Zelmanovicz continued to avidly propagandize for communism in Poland in 1937 (the highpoint of Stalin's purges in the USSR). Talking to fellow Jews she "explained to them that there was no more anti-Semitism in the Soviet Union." She rapidly came to the attention of the Polish police and was ultimately imprisoned. She noted how "I found myself together with thirteen other young women – militants or communist sympathizers – twelve of whom were Jewish."[154]

Brossat and Klingberg use the term "revolutionary heroism," to describe the "militant courage" of these Jewish communists in Poland.

The Polish Communist Party was perceived by most Poles as the party of the foreigner, of Poland's hereditary enemy, "the 'fifth column' that had supported the Red Army's advance on Warsaw in 1920."[155] This was when the concept of "Judaeo-Bolshevism" (*zydeokommuna*) was coined by the nationalist right. Jewish membership of the Polish Communist Party fluctuated between 22 and 35 percent of the total. Jews were even more heavily represented in the party leadership: in 1935 they constituted 54 percent of the field leadership and 75 percent of the *technika* (responsible for propaganda).[156] According to militant Yaakov Greenstein, "The worse misery, anti-Semitism and political repression grew in the 1930s, the more convinced I was that socialism was the only possible solution for us. The communist movement was a fountain at that time for the Jewish youth in Poland."[157]

The unswerving commitment of Galician Jew, Shlomo Szlein, to Stalin was grounded in his identification of Soviet communism with philo-Semitism:

> We were on the border of the USSR, and the way in which the national question had been solved in Soviet Russia or Byelorussia, especially the Jewish question, struck us as extraordinarily positive. Younger Jews, in the late 1920s, had joined the communist movement in eastern Galicia on a massive scale. The movement's power of attraction was that it seemed to promise to resolve both the social question and national question in a short space of time. There was such a high proportion of Jewish youth in the communist movement here that you could almost say it was a Jewish national movement. In any case, the question of stifling or denial of Jewish national identity absolutely didn't arise. The majority of Jewish young people joined it with a Jewish national consciousness.[158]

Accusations of anti-Semitism directed at Stalin by Trotskyists were indignantly dismissed by leading American Jews in the 1930s. The journalist B.Z. Goldberg responded with anger, claiming "In order to beat

Stalin, Trotsky considers it right to make Soviet Russia anti-Semitic. ...
For us this is a very serious matter. ... We are accustomed to look
to the Soviet Union as our sole consolation as far as anti-Semitism is
concerned." Even Rabbi Stephen Wise, the most famous rabbi of his
generation, regarded Trotsky's claim of anti-Semitism against Stalin as
a "cowardly device."[159] During the 1920s and throughout the 1930s,
the Soviet Union accepted aid for Soviet Jews from foreign Jewish
organizations, especially the American Jewish Joint Distribution Com-
mittee which was funded by wealthy American Jews like Warburg,
Schiff, Kuhn, Loeb, Lehman, and Marshall.[160] During the 1930s, when
millions of Soviet citizens were being murdered by the Soviet govern-
ment, the Communist Party USA took great pains to appeal to specific
Jewish interests, and glorified the development of Jewish life in the
Soviet Union which was seen as "living proof that under socialism the
Jewish question could be solved. Communism was perceived as good
for Jews."[161]

### The Psychological Impact of the Hitler-Stalin Pact

Radical Jewish militants were deeply traumatized by the non-aggression
pact arranged between Hitler and Stalin just before the start of World
War II. The dilemma facing Jewish communists, the contradiction be-
tween their "visceral anti-fascism" and what was now presented to them
as an imperative of *realpolitik* for the USSR, repeatedly cropped up in
the testimony of those interviewed for *Revolutionary Yiddishland*. One
of these, Louis Gronowski, recalled how:

> I remember my disarray, the inner conflict. This pact was repug-
> nant to me, it went against my sentiments, against everything I
> had maintained until then in my statements and writings. For all
> those years, we had presented Hitlerite Germany as the enemy of
> humanity and progress, and above all, the enemy of the Jewish
> people and the Soviet Union. And now the Soviet Union signed a
> pact with its sworn enemy, permitting the invasion of Poland and

even taking part in its partition. It was the collapse of the whole argument forged over these long years. But I was a responsible Communist cadre, and my duty was to overcome my disgust.[162]

For many radical Jews, Hitler's invasion of the Soviet Union in 1941 provided a sense of "relief that was paradoxical but none the less immense. They had finally found their political compass again, recovered their footing; in short, they would be able to launch all their forces into the struggle against the Nazis without fear of sinning against the 'line.'"[163]

In late 1941, with the outcome of the battle for Moscow uncertain, Stalin, contemplating the possibility of defeat, acted decisively to ensure the field was not left open for the former Trotskyist faction. He ordered the execution of two historical leaders of the Bund, Victor Adler and Henryk Ehrlich, just after they were offered the presidency of the World Jewish Congress. For Stalin, "all the militants of the Bund and other Polish Jewish socialist parties who were refugees in the USSR were considered *a priori* political adversaries – particularly when then refused to adopt Soviet nationality – and treated accordingly."[164]

These executions caused international uproar, with Jews around the world protesting, and the furor not dying down until the establishment of a Jewish organization, the Jewish Anti-Fascist Committee (JAC), dedicated to winning the favor of American Jews. In *Culture of Critique*, Kevin MacDonald notes how American Jewish leaders, such as Nahum Goldmann of the World Jewish Congress and Rabbi Stephen Wise of the American Jewish Congress "helped quell the uproar over the incident and shore up positive views of the Soviet Union among American Jews."[165]

Stalin controlled at a distance the Jewish Anti-Fascist Committee which was headed by leaders of the Soviet Jewish intelligentsia Solomon Mikhoels and Ilya Ehrenburg. Their principle task was to "develop support for the USSR at war among Jewish communities abroad, and especially in America."[166] Interviewee Isaac Safrin recalled hearing "on the radio that a Jewish Anti-Fascist Committee had just been set up. Ilya

Ehrenburg made a great speech, very emotional, and we began to cry. The woman [he was staying with] didn't understand what had affected us, and we had to explain to her that it was because he was Jewish."[167] For the six years of its existence (1942-8), the Jewish Anti-Fascist Committee "stood at the center of an intense reactivation of Jewish life" and many of the interviewees for *Revolutionary Yiddishland* were "struck by the revival of cultural activities, even of national assertion, on the part of the Jewish community, which was encouraged by the regime in the course of the war."[168]

The wartime revival of Jewish identity in the USSR culminated in a revival of Zionist hopes for a reversal of Stalin's opposition to the establishment of a Jewish state in Palestine. Alarmed by the triumphant welcome Moscow's Jews extended to the first Israeli ambassador to the Soviet Union, Golda Meir, Stalin dissolved the Jewish Anti-Fascist Committee in 1948 and a few months later, prominent Jewish writers, artists and scientists were arrested, and Jewish newspapers, libraries and theaters were closed.

Meir's rapturous reception in Moscow underscored the reality that every Jew in the USSR was potentially an Israeli citizen, and that the Soviet authorities were right to distrust a people that, apart from its official nationality, bore another homeland in its heart. The authors note how:

> Even in the Soviet dictionary, the word "cosmopolitan" was given a new meaning; instead of "an individual who considers the whole world as his homeland" (the 1931 definition), this was now "an individual who is deprived of patriotic sentiment, detached from the interests of his homeland, a stranger to his own people with a disdainful attitude towards its culture" (the 1949 definition). The official press poured scorn on "vagabonds without passports," people "without family or roots," always in anti-Semitic tones.[169]

Stalin's campaign against "Jewish cosmopolitans" famously culminated with the "Jewish doctors' plot" of 1953 where leading Soviet doctors, for the most part Jews, were accused of plotting to kill Stalin. Arrested and threatened with trial, they owed their salvation to Stalin's death (under highly suspicious circumstances) the same year. Having surveyed these events, Brossat and Klingberg view the "failure of Soviet policy towards the Jews" under Stalin as stemming from "the application of a reactionary policy that broke fundamentally with the program of the October Revolution."[170]

### Jewish Radicals Who Remained in Europe After WWII

For the Jewish radicals who remained in Europe after 1945, the predominant feeling was, with the defeat of fascism, history was now "on the march" and the triumph of the Red Army meant that "the great socialist dream seemed finally within reach." The order of the day was "the building of a new society in those countries of Eastern and Central Europe liberated from fascism by the Red Army." Brossat and Klingberg note how "these militants rapidly found themselves drawn into the apparatus of the new states being constructed."[171]

Jewish communist cadres were "systematically entrusted with even the most senior positions in the army, the police, the diplomatic corps, economic management etc." Jews were deliberately placed in key positions because Soviet authorities feared a resurgence of nationalism in the countries they now occupied. Jews could trusted to carry out their plans and were seen as least likely to form an alliance with the local populace against the hegemony of the Soviets, as Tito had done in Yugoslavia. In the newly conquered nations of Eastern and Central Europe, the Soviets had few reliable supporters, and "because they were familiar with local conditions and fanatically antifascist, Jews were often chosen for the security police."[172] According to Adam Paszt, the Soviet authorities "knew that the population was anti-Semitic, so they tried to conceal the fact that there were Jews in leading positions." Jews were thus "encouraged to change their names."[173] The authors note how:

Few of our informants could resist the siren call. Though well established in France, where he lived with his family, Isaac Kotlarz agreed nonetheless to return to Poland; he was a disciplined militant, and the party appealed to his devotion. Adam Paszt, for his part, had already lived for some years in the USSR, and although the scales had fallen from his eyes, he still had hopes. "I told myself that the USSR was a backward country, that in Poland, a more developed country, the way to socialism would be different." Those who had been shattered by the defeat in Spain and the discovery of Soviet reality were freshly mobilized by the new situation; this upsurge of utopia, this summons from history...[174]

Bronia Zelmanowicz recalled that "When I returned to Poland I joined the party. Almost all the Jews did so. Some profited from the opportunity to rise higher than their abilities or their education should have let them. This was called 'rising with the party card.' It did a great deal to tarnish the image of Jews among the Polish population. The same phenomenon was seen in the USSR."[175] The new regimes in Poland, Romania, Bulgaria, Yugoslavia, Czechoslovakia and Hungary "needed these experienced Jewish militants, who thus turned from revolutionaries into officials, privileged people in countries that had a hard time rising from their ruins." The loyalty of these Jewish militants to the new regime was "based not only on conviction, but also on the material advantages that it gave."[176]

After World War II, Hungary offered an extreme example of the Jewish domination of the new regime brought to power by the Red Army. The key post of general secretary was occupied by a Jew, Mátyás Rákosi, who billed himself as "Stalin's best pupil."[177] The next five major positions were filled by Jews and a third of higher police officials were Jewish, and many departments of the security apparatus were headed by Jews. Many had spent years, even decades, in the Soviet Union, while others "had returned from concentration camps or who

survived the war in Budapest," and who, as well as regarding the Soviets as their liberators, nursed "a burning desire for vengeance" against Hungarians who had collaborated with the Germans. By moving into the army, the police, and the security apparatus, "these young Jewish survivors put themselves in a position to settle accounts with the men of the Arrow Cross."[178]

Jews played central roles in building societies that "obeyed the strictest canons of Stalinism, and it was with an iron broom that the new administration consolidated its power against the 'forces of the past.'" This involved "'getting their hands dirty' in this new phase of history, to bend to the Stalinist precept that you do not make an omelet without breaking a few eggs."[179] The conspicuous role played by Jews in the brutal Sovietization of Hungary led to anti-Jewish riots in 1946. The oppressive nature of the new regime can be gauged by the fact that between 1952 and 1955 "the police opened files on over a million Hungarians, 45 percent of whom were penalized," and "Jews were very salient in the apparatus of repression."[180]

Ultimately, it was the very Stalinism these Jews so zealously implemented throughout the countries of the Warsaw Pact that served to "crush them, or at least some of them, a few years later, so that today they have the sense of a great swindle."[181] Stalin's abandonment of revolutionary internationalism alienated many Jewish operatives throughout Eastern Europe. The authors note how, in the context of this new stance, where internationalism tended to be "reduced to the obligatory reverence towards the guardian power, Stalin's USSR, Jewish militants very often felt out of place."[182]

Another reason for the Jewish abandonment of the communist utopia was "the direct discovery at their own expense, not only that socialism did not put an end forever to anti-Semitism" but at times willingly used it, as in Poland in 1968, as a political tool. There, an "unbridled campaign against 'Zionists' on Polish radio and television poisoned public life, with Jewish cadres being silently dismissed..." In 1968, restrictions on emigration were abolished and thousands of Jews left Poland. In Czechoslovakia, Hungary, and Romania, the trials and

liquidations of the 1950s "also had an anti-Jewish connotation, sharper or less so as the case might be."[183] Pierre Sherf related his experience in Romania:

> I returned to Romania with my wife in December 1945. We were at the same time naive and fanatical. We had a deep sense of coming home, finally leaving behind our condition of wandering Jew. I was appointed to a high position in the foreign ministry, but after the foundation of the state of Israel one of my brothers became a minister in the Israeli government, and I was suddenly removed and transferred to another ministry. When Ana Pauker was dismissed in 1952, I felt the net tighten around me. My superior in the hierarchy was arrested and a case against me was opened. As in Czechoslovakia, Hungary and the USSR, veterans of Spain were fingered as "spies." ...

> I never hid the fact I was Jewish, and the Party needed us, as it needed cadres belonging to other national minorities living in Romania. But it was afraid the population would resent the large number of Jews in the party leadership. Like many others, I had therefore to "Romanize" my name. I now called myself Petre Sutchu instead of Pierre Sherf. During the trials of the 1950s, the specter of "Jewish nationalism" was brandished, as in other countries. The suspicion was scarcely belied by future events. Later a member of the political bureau was eliminated because his daughter had asked to immigrate to Israel. In Spain, in the Brigades, there was an artillery unit named after Ana Pauker, but when she was dismissed, it was given a different name in the official history museums.[184]

Sherf later applied for an emigration visa and left for Israel. For Jewish communist functionaries like him, "the European workers' movement and socialism had failed to resolve the Jewish question in its national dimension – not just in Europe but in the whole world." After this failure,

Jewish history seemed to "present itself as an eternal recurrence founded on the permanence of anti-Semitism."[185] According to this conception, the differences between Jews and non-Jews "swells to the dimensions of an essential and irreducible alterity. As in the preachings of the rabbis, the non-Jewish world, the universe of the goyim, tends once more to become a perpetually threatening other and elsewhere."[186] This sense of betrayal was the key to their subsequent disenchantment which would ultimately "lead the great majority of them far from communism."[187]

After 1948, many of the Yiddishland Diaspora migrated to Israel, some reluctantly, some enthusiastically. Brossat and Klingberg note that their decision to interview only former Yiddishland revolutionaries living in Israel was arbitrary, and how the same task could have been undertaken in Paris or New York. The particular situation of their informants did, however, highlight one essential factor: "the gaping, radical break between the world that they lost and the arrogant new Sparta within whose walls they have chosen to live."[188] These onetime militants for socialist internationalism, who had "waged a bitter struggle against every kind of nationalism" now pledged their allegiance to "the state of Israel, expression of triumphant Zionism" which "has carved on the pillars of the rebuilt Temple the principles of a Manichean view of the world, a system of thought founded on simple oppositions, a binary metaphysics: just as the world is divided in two, Jews and *goyim*."[189]

## Conclusion

*Revolutionary Yiddishland* is another example of that incredibly prolific literary genre: Jewish apologetic historiography. Despite this, the book merits attention because, intended for a Jewish readership, its discussion of the roots and motivations of Jewish radicalism and militancy is unusually candid. It illuminates aspects of Jewish radicalism that are usually concealed from non-Jews, like how the pursuit of Jewish ethnic interests was the primary motivating factor for Jewish participation in and support of communism in the first half of the twentieth century. When addressing non-Jewish audiences, Jews typically ascribe their

disproportionate involvement in leftist politics to the impulse of *tikkun olam* – a desire to heal the world which naturally flows from the inherent benevolence of the Jewish people. Appeals to non-Jews to serve Jewish interests by fighting for universal "human rights" have been a consistent and incredibly successful feature of Judaism as a group evolutionary strategy in the modern era. Millions of White people (who are likely genetically predisposed to moral universalism) have been enlisted to fight for Jewish interests (and against their own ethnic interests) on the assumption they are upholding the "universal brotherhood of man."

In the post-Cold War era, the Jewish revolutionary spirit chronicled and lionized in *Revolutionary Yiddishland* has been transmuted into the Cultural Marxist assault on White people and their culture. As with the older generation of Jewish revolutionaries, the pursuit of Jewish ethnic interests remains the central motivation for this new revolution which revolves around the demographic and cultural transformation of European and European-derived societies. This motivation is manifest in a review of the book by leftist Jewish activist Ben Lorber, who, placing the White heterosexual male enemy firmly in his sights, raved that "the Left faces a terrifying fascist threat unseen since the era of Yiddishland, with the rapid embrace of far-right politics engulfing Europe and culminating... with the startling seizure by Donald Trump of the most powerful political position in the world. As we combat mounting attacks on Muslim and Arab communities, black folks, immigrants, Jews, women, LGBTQ folks and more."

Reflecting on the older generation of radical Jewish activists, Lorber insists "we have much to learn from the boundless optimism, the fearless advances and the terrifying retreats of those who struggled before." Rather than decrying his radical Jewish forerunners as handmaidens and direct practitioners of oppression and genocide, Lorber fondly looks to them for inspiration, contending that "We need to draw hope from this previous generation of radicals who believed, against all odds, that a new sun was dawning in the sky of history. *Revolutionary Yiddishland* lets this generation speak, and helps us to listen." Prey to the same ethnocentric infatuation with the "romance" of Jewish radical

revolutionaries as the authors, Lorber "cannot help but look upon the passionate, almost messianic optimism of early-twentieth century radicals with a strange sense of dislocation and longing."[190]

Another Jewish reviewer extolled *Revolutionary Yiddishland* as "a marvelous bitter-sweet book" with the sweetness coming from "understanding the depth and vibrancy of the revolutionary socialist movement, from listening to the voice of the interviewees, and from the matter of factness of their everyday heroism and commitment." *Mondoweiss* described the book as "a memorial to a missing world," and claimed that "as an aesthetic composition, it is beautiful." *The Jewish Chronicle* also praised the book but thought it insufficiently apologetic and resented its "occasional anti-Zionist animus" (it contains a few tepid criticisms of Israel) which "mars an otherwise absorbing account."

The most telling (though entirely predictable) feature of the Jewish responses to *Revolutionary Yiddishland* was the absence of any reservations expressed over Brossat and Klingberg's glorification of Jewish communist militants who enthusiastically founded and served regimes that destroyed millions of lives. This provides another reminder, if any were needed, that Jewish involvement with communism remains the worst example of Jewish moral particularism in all of history. It also underscores the fact that Jewish intellectuals and activists have no problem setting aside moral consistency in pursuit of their ethnic interests.

# Jenji Kohan and the Jewish Hypersexualization of Western Culture

As detailed in Kevin MacDonald's *The Culture of Critique*, Sigmund Freud and his followers regarded anti-Semitism as a universal pathology that had its roots in sexual repression. The theoretical basis for this can be found in Freud's *Three Essays on the Theory of Sexuality* where he linked aggression to the frustration of human drives – especially the sex drive. MacDonald notes that: "Although Freud himself later developed the idea of a death instinct to explain aggression, a consistent theme of the Freudian critique of Western culture, as exemplified for example by Norman O. Brown, Herbert Marcuse, and Wilhelm Reich, has been that the liberation of sexual repressions would lead to lowered aggression and usher in an era of universal love."[191]

According to this view, anti-Semitism, regarded as a form of aggression, results from the denial of sexuality, and the role of the Jewish mission of psychoanalysis was to end anti-Semitism by freeing humanity of its sexual repressions. Individuals preoccupied with sex were considered unlikely to concern themselves with the activities of Jews, much less to organize politically against them. People who spend most of their time in search of sexual stimulation are unlikely to organize pogroms or

threaten the rich and powerful Jewish establishment. In his widely cited 2004 essay from the *Jewish Quarterly*, Nathan Abrams observed that:

> Jews in America have been sexual revolutionaries. A large amount of the material on sexual liberation was written by Jews. Those at the forefront of the movement which forced America to adopt a more liberal view of sex were Jewish. Jews were also at the vanguard of the sexual revolution of the 1960s. Wilhelm Reich, Herbert Marcuse and Paul Goodman replaced Marx, Trotsky and Lenin as required revolutionary reading. Reich's central preoccupations were work, love and sex, while Marcuse prophesied that a socialist utopia would free individuals to achieve sexual satisfaction. Goodman wrote of the "beautiful cultural consequences" that would follow from legalizing pornography: it would "ennoble all our art" and "humanize sexuality."[192]

The hypersexualization of Western culture (the most conspicuous result of the Jewish takeover and virtual monopolization of the Western media and entertainment industries) can, therefore, be viewed as the practical ethno-political application of psychoanalytic theory to a traditional Western culture regarded as inherently authoritarian, fascistic and anti-Semitic due to its "repressive" sexual morality. MacDonald points out that "psychoanalysis has been a veritable treasure trove of ideas for those intent on developing radical critiques of Western culture" with these ideas influencing thought in a wide range of areas, including sociology, child rearing, criminology, anthropology, literary criticism, art, literature, and the popular media.[193]

Daniel Goldhagen claimed to be bewildered by Billy Graham's "nutty" comment in his secretly recorded conversation with President Nixon in 1972 that Jews were "the ones putting out the pornographic stuff," and that so severe was the danger that Jews pose that their "stranglehold has got to be broken or this country's going down the drain."[194] Of course Goldhagen is uninterested in whether Graham's assertion has any grounding in empirical reality – whether Jews actually *are* the ones

"putting out the pornographic stuff," and are thereby undermining the cultural foundations and supports for high investment parenting and sending the country "down the drain." A quick look at the output of Hollywood, and the individuals responsible for it, is, however, enough to confirm that Graham's assertion is absolutely correct. Not only have Jews long dominated the pornography industry, they have also been pivotal in "mainstreaming" pornographic themes and images through the movies and TV programs they produce.

### Jenji Kohan – From Weeds to Orange is the New Black

To take just one of countless possible examples, consider the enormously popular program *Orange is the New Black* (hereafter *OitNB*). This show is the brainchild of screenwriter and executive producer Jenji Kohan who comes from a prominent Jewish show business family. Her father, Buz Kohan, a frequent writer for the Academy Awards, is the recipient of 11 Emmy Awards in a career that spans five decades. Her mother, Rhea Kohan, is a novelist, while her eldest brother, David, is the co-creator and producer of the NBC sitcom *Will & Grace*. According to Danielle Berrin, writing for the "Hollywood Jew" section of *The Jewish Journal*:

> Kohan could be the Jewish girl next door. But there is edginess to her – her hair perpetually tousled, and she always wears those signature eyeglasses with the art-deco glamour. ... Her earliest fantasy was to be a famous actress-singer named Rainbow Star. But she couldn't act. Or sing. Years later, after some time working in television, Kohan considered rabbinical school. But none of those whims proved as powerful as her (very Jewish) birthright, which has catapulted Kohan to many a writer's highest aspiration, helming her own TV show.[195]

Kohan worked for her brother David on *Will & Grace* during her early years, but decided his brand of humor was too tame. "David took the

big, commercial, funny route; I was always a little darker personally,"
she explains, "and not terrific within the system. I had to make my
own way." It was with specific reference to her brother David and the
plethora of activist Hollywood Jews like him, that Vice President Joe
Biden noted in 2013 how Jewish influence on American culture had
been "immense." Speaking of the prominent roles Jews had played
in transforming American attitudes toward civil rights, feminism, and
homosexual rights, he noted that:

> What affects the movements in America, what affects our atti-
> tudes in America are as much the culture and the arts as anything
> else... It wasn't anything we legislatively did. It was *Will and
> Grace*, it was the social media. Literally. That's what changed
> peoples' attitudes. That's why I was so certain that the vast major-
> ity of people would embrace and rapidly embrace [gay marriage].
> Think behind of all that, I bet you 85 percent of those changes,
> whether it's in Hollywood or social media are a consequence
> of Jewish leaders in the industry. The influence is immense, the
> influence is immense.[196]

In a similar vein, the Jewish writer and intellectual Chaim Bermant
observed that "the Jews that came to dominate Hollywood" between
them "did more to determine American attitudes and tastes than the
churches or even the schools."[197] This is hardly surprising given that,
as Cultivation Theory and Social Learning Theory postulate, exposure
to media content leads to increased sympathy for the values embedded
in the content, as well as an increased propensity to regard the fictional
portrayals as representations of reality.

Noting how right from Hollywood's founding Jewish ethnic net-
working and nepotism quickly led to an industry completely dominated
by Jews, Bermant wryly observed that "Hollywood, the place, as it was
said, where 'the son-in-law also rises' was the last redoubt of nepotism,
but nepotism was perhaps one of its saving virtues, for it indicated, if
only at a crude level, that it was not wholly devoid of charity."[198] Jewish

family and ethnic networking played an inevitable role in Kohen's ascent to eventually "helming" her own show. She recounts how:

> I started writing. ... I quit all of my crappy odd jobs, and I moved in with [a friend who] was living in Santa Cruz. And every day we would go to these little cafes in Santa Cruz, and I would work on spec scripts and study these videotapes I had recorded off television of *Roseanne* and *Seinfeld* and *The Simpsons*. ... What ended up happening was, my sister-in-law's father worked in a building with an agent and gave him my scripts in an elevator. And he read them, and I was on a show by spring. And it took off from there, and I never stopped working.[199]

Kohan became a screenwriter for numerous dramas and comedies, including *Sex and the City* (created by Jewish writer, director and producer Darren Star), *Gilmore Girls* (created by Jewish writer, director and producer Amy Sherman), *Mad About You* (created by Jewish writer and actor Paul Reiser and Jewish writer and producer Danny Jacobson), and *The Fresh Prince of Bel-Air* (created by Jewish writer and actor Andy Borowitz and wife Susan Borowitz).

In 2005 she was given the opportunity to write and produce her own show, which led to the dark comic satire *Weeds* – a show about the "peculiar nature of American domesticity." Originally set in the fictional suburb of Agrestic (later Majestic), the show follows the widowed, single mother Nancy Botwin (Mary-Louise Parker), who becomes a drug dealer in order to maintain her middle class lifestyle. With the help of various disreputable characters and her useless and immature brother-in-law Andy (who is representative of Hollywood's routinely unflattering depictions of White men), she raises her two sons, Silas and Shane.

The *Jewish Weekly* notes how *Weeds* "routinely deals with many of the most provocative, controversial themes on television. Any given season has its share of lawlessness, illicit relationships and an astonishing Freudian subtext (in one episode, Nancy catches her youngest son

masturbating to a nude photograph of her)."[200] Freudian themes continue to exert an enduring influence on the Jewish shapers of Western minds, like Kohan, despite that fact these ideas have long ceased to play any role whatever in mainstream developmental psychology.

Kohan's "refusal to limit herself in her show's creative content has made moral ambiguity a *Weeds* trademark. No topic is too grim, no character too depraved." In giving her the scope to explore these depraved characters, and to mine them for humor and ask questions, Kohan claimed *Weeds* allowed her to get in touch with her Jewish identity, noting that, "For me, the essence of my Judaism is to ask questions – ask why, ask more. And in a way, the show allows me to follow that path of Judaism."[201]

After the critically-acclaimed *Weeds*, which ended in 2012, Kohan adapted the (half-Jewish) author Piper Kerman's memoir *Orange is the New Black* about her experiences in a minimum-security women's prison. This series revolves around the "clueless bisexual blonde" Piper Chapman (played by Taylor Schilling) who is sentenced to 15 months in prison for transporting drug money for her drug trafficking former girlfriend Alex Vause (Laura Prepon). This offense occurred ten years before the start of the series, and Piper has since moved on to enjoying a quiet, law-abiding life among New York's upper middle class. Her sudden and unexpected arrest completely disrupts her relationships with her fiancé and family. In prison, Piper is reunited with Alex (who named Piper in her trial, resulting in her ex-girlfriend's arrest and imprisonment), and they re-examine their relationship and deal with their fellow prisoners. *OitNB* often uses flashbacks of significant events from the various inmates' backgrounds to explain how they came to be in prison and to fill in their backstories.

*OitNB* is an incredibly degenerate show that inverts traditional Western morality and glamorizes homosexuality. The main themes of the show are that committed heterosexual relationships are abnormal and that Christianity is an evil creed, which, owing to its stifling sexual morality, leads its practitioners to become hypocritical bigots with twisted, neurotic personalities. The Christian "villain" in the show was sent to

prison for killing a group of abortionists after receiving an abortion herself. Every woman in the prison, with the exception of the Christian villain, is in a lesbian relationship with one of their fellow inmates – even a nun.

Hollywood's Jewish movers and shakers love to debase Christianity and Catholicism by depicting nuns in sexual roles. Notoriously, the opening scene of the pilot of *Californication*, a program starring and produced by the Jewish actor David Duchovny (whose father was a publicist for the American Jewish Committee), depicts a nun performing oral sex on Duchovny's character Hank Moody in a church. This pornographic debasement of Christian symbols by Jews is a blatant way of defiling Christian culture. Kohan certainly has no qualms about such depictions, noting that: "When people have these sacred cows, my urge is to tip them."[202] Of course anyone attempting to "tip" a Jewish sacred cow will quickly find himself on an ADL and SPLC hit list, will likely lose his job, and if a public figure, will be relentlessly attacked by the Jewish-controlled media.

Labelling Kohan a "force of nature," *Time Magazine* notes how her "characters are a breathtaking riot of color and sexual orientation onscreen. Jenji shows a passion for diversity by creating characters of all backgrounds who are three-dimensional, flawed and sometimes unpleasant, but always human."[203] The perennial Hollywood themes of the nobility of sexual liberation and race mixing are particularly salient in *OitNB*. Asked in an interview why she included so much gratuitous sex in her show, Kohan responded by declaring that:

> I want more fucking, everywhere. That's one of my things. It expresses everything. It's comfort, it's release, it's brutality, it's companionship. It's so many things. We're all doing it. We're all thinking about it. We don't see it enough. Part of it is a dance with the [mostly non-Jewish] actors because it's very vulnerable for them to do it. But if I had my way, there would be so much more, in everything. It's so vital and integral in life, and it should

be reflected in what we're watching, if we're reflecting our experiences. And it's hot. I love the sex stuff, and I want more.[204]

Kohan likewise told *The Hollywood Reporter*: "I love graphic sex, the more sex the better. Very often it's convincing the actors to get naked... You hope everyone will just be cool about it, and then they're not. There's a lot of convincing and making people feel comfortable."[205] Hollywood's Jewish bigwigs (like Harvey Weinstein) have long used their power to make or break careers as a golden opportunity to gain access to, and sexually exploit, non-Jewish actresses and actors (and children). Bermant acknowledges that "the Jewish business man has never turned a blind eye (a furtive eye sometimes, but never a blind one) to such attractions. The Rabbis have always been aware of a lascivious streak in the Jewish character."[206]

Netflix, which airs *OitNB*, has been fully supportive of the sexually explicit content of the show, only intervening once according to Kohan. "We have some male frontal nudity this season, but I don't think it's going to be erect." For comparison, Kohan noted the comparatively strict guidelines that Showtime (a wholly owned subsidiary of the Jewish Sumner Redstone's CBS) set for a scene in *Weeds*, in which "a dildo and lube were allowed to be shown on screen, but the character was not allowed to be seen applying the lube to the dildo."[207]

Elsewhere Kohan has opined that: "I think people need to accept their sexuality no matter what environment they're in," and observed how she is "a great subscriber to the Kinsey scale, where 10% is absolutely straight and 10% is absolutely gay and everyone sort of floats in the middle, everyone else."[208] Here Kohan echoes the Freudian "argument" that "a disposition to perversions is an original and universal disposition of the human sexual instinct."

An article in *Rolling Stone* notes that *OitNB* has been at the forefront of TV shows challenging viewers' perceptions of sexuality and gender identity, specifically thanks to the performance of "trans actress" Laverne Cox, who plays Sophia Burset, and openly gay actress Lea De-Laria, who plays Carrie "Big Boo" Black. Kohan points out that in her

show "transgenderism" is "not confronted," but is "seamlessly woven" into the tale of protagonist Piper Chapman's time in a minimum security federal prison. "It's not 'The Very Special Episode about the trans character,'" she notes, "It's normalized in this conversation."[209] One source, noting how *OitNB* has succeeded in normalizing sexual perversion and the idea of the "fluid" nature of gender identity, observed that:

> This is the show, after all, that made Laverne Cox a household name as much for her sophisticated intersectional politics as for her laugh-out-loud beauty. A trans woman of color and the first trans actor to be nominated for an Emmy, Cox has consistently questioned the popular notion that visibility in itself is enough to bring about social change, instead using her position to publicize LGBTQ activism and to call attention to issues of inequality and injustice. *Orange is the New Black* makes its feminist points in a slyly subversive way: its radical themes combine with compelling storytelling as we are plunged, cellmate-like, into intimacy with the characters.[210]

In response to news that one of the female staff writers on *OitNB* had divorced her husband and was dating a star of the show after she said writing the show made her realize she was a lesbian, Kohan quipped: "I turned her gay. I made her gay. I felt like there wasn't enough balance in the room, so I have a magic wand and I make people gay."[211]

Despite these sarcastic remarks, there is evidence that sexual orientation is, to a significant extent, environmentally determined. A 2006 Danish study found, based on an analysis of two million men and women, that social and family factors played a significant role in determining sexual orientation.[212] In an interview, one of the study's authors stressed that: "Prenatal factors cannot account for the variation in human sexual orientations," and that "whatever ingredients determine a person's sexual preferences and marital choices, our population-based study shows that environmental factors are important."[213] Culture obviously mediates human sexuality through exerting an inhibitory or

disinhibitory influence on certain sexual behaviors. Through its positive portrayal of homosexuality and "transgenderism," *OitNB* clearly encourages marginal or confused individuals, such as the staff writer on the show, to identity as homosexual.

*OitNB* was showered with 12 Primetime Emmy Award nominations for its first season. Predictably, the show has been universally lauded in the Jewish-controlled media. A *Washington Post* reviewer extolled the show's "characters and ambitious writing and acting," and noted how: "In one of the new episodes, there is protracted debate about the location of the urethra in relation to the vagina – a matter definitively settled by Burset, a transgender inmate (played by Laverne Cox) – and a competition between two lesbian inmates, Big Boo and Nichols (Lea DeLaria and Natasha Lyonne) to see who can seduce the largest number of inmates, with a special emphasis on orgasm."[214] Observations like these pass for serious cultural commentary in one of America's most prominent and influential media organs.

## *Sexual Liberation – Great for Goyim, But Not for Jews*

As this critic's remarks indicate, anything goes on *OitNB* – except anything deemed racist, pro-Christian, or anti-LGBT+. Kohan's own life, however, conforms to more traditional Jewish standards. She is married to freelance journalist Christopher Noxon, with whom she has three children. Kohan claims her conventional domestic life propels her into the darker corners of storytelling. She's attracted to seedier material because, as she puts it, "This is my rebellion, this is my fun."[215] In an interview with Israeli newspaper *Haaretz*, she noted her desire to include a character named Yael in *Weeds* was borne of the Jewish milieu within which she raised her children. "My children attend a Jewish school," she said at the time. "I met a lot of Israeli mothers there, and the character of Yael is a tribute to those mothers. They're so terrific. All the Israeli mothers I've met are terrific, and so is Meital. Yael is a character I constructed from all the mothers in our school. I always check where people are in relation to their Judaism."[216]

The tendency of Jewish subverters of Western culture (like Kohan) to not personally practice what they promote for their intended audience is striking. Another noteworthy exemplar of this tendency is the Jewish entrepreneur and "King of Infidelity" Noel Biderman, the founder and CEO of the company that operates a dating website named "Ashley Madison" which is designed to make it easy for married people to arrange adulterous affairs. The slogan of the company (which Biderman himself came up with) is: "Life is short. Have an affair." While promoting infidelity (and profiting handsomely from it), Biderman himself says he is a happily married father of two, does not cheat, and admitted that if he found out his own wife was accessing his cheater's site, "I would be devastated."[217]

Former Chief British Rabbi Jonathan Sacks, writing in the *Encyclopaedia of Modern Jewish Culture*, observes that while "The sexual revolution of the 1960s found some Jewish protagonists," within Jewish communities "the primary response was a strong defence of tradition." Within Diaspora Jewish communities, sexual liberation was regarded as a direct threat to Judaism as a group evolutionary strategy, where "not only ethical values were at stake." Noting that "Images of marriage and family pervade Jewish theological language about the covenantal relationship between God and Israel," Sacks observes that "The stability and fertility of families is crucial to the demographics of Jewish survival."[218] As these comments indicate, healthy, functional societies coalesce around the propagation and protection of children. While Jews have endeavored to sustain this coalescence within Jewish communities, they have actively sought to sabotage it within non-Jewish communities.

An egregious manifestation of this cultural sabotage concerns the one time child star Miley Cyrus, who declared in 2015: "I am literally [sexually] open to every single thing that is consenting and doesn't involve an animal and everyone is of age. Everything that's legal, I'm down with... I don't relate to being boy or girl, and I don't have to have my partner relate to boy or girl."[219] Cyrus's transition from innocent child star to leading sluttish propagandist for complete sexual liberation and

"gender fluidity" can be directly ascribed to the malign influence of her Jewish manager Larry Rudolph. As Britain's *Daily Mirror* reported:

> Take a pretty young girl with a clean image, turn her into a showbiz sex goddess and watch the money roll in. That is what has happened to Miley Cyrus. And her steamy interviews plus semi-naked "twerking" routine are looking like a deliberate career switch under the guidance of a calculating manager, reports the *Sunday People*.
>
> Step forward Larry Rudolph. For Miley, the former Hannah Montana child actress turned queen of sleaze, is just the latest in a string of raunchy products from his stable. Britney Spears, Christina Aguilera and Jessica Simpson are all his creations as well. The multi-millionaire businessman and former lawyer specializes in helping performers make the transition from child star to adult entertainer.
>
> Middle America was outraged by the sight of former Disney princess Miley, 21, wearing a flesh-coloured latex bikini and gyrating suggestively against singer Robin Thicke at the MTV Video Music Awards in August. How could the sweet little thing who played children's TV favorite Hannah for eight years sink so low, asked disgusted parents' groups. But her televised performance was seen by 50 million people. And cheering her on were Rudolph and her mum and co-manager, Tish Finley.
>
> Rudolph, 50, a talent manager for 15 years, has been working with the singer since last spring. And he told the *Hollywood Reporter* magazine he thought that Miley's performance at the VMAs was an absolute corker. He declared: "We were all cheering from the side of the stage. It could not have gone better. The fans got it. The rest eventually will." Rudolph's skills have made him worth an estimated £13 million but he came from humble beginnings in the Bronx area of New York.[220]

Catholic intellectual E. Michael Jones argues the Jewish promotion of sexual license (and the increasingly full gamut of sexual perversions and gender-identity dysfunctions) is a way of exercising political control over non-Jewish populations: a way of making them politically tractable by rendering them slaves to their passions. An example that Jones frequently cites of Jews using the deliberate sexualization of culture to destabilize an enemy is when, after taking over Palestinian TV stations in 2002, Israeli soldiers immediately started broadcasting an endless stream of pornography over the airwaves. Jones notes that:

> The Israelis have recently shown themselves well-versed in what one could call the military use of pornography. At 4:30 PM on March 30, 2002, Israeli military forces took over Palestinian TV stations when they occupied Ramallah in the West Bank, immediately shutting them down. What followed was a little more unusual. Shortly after occupying the Al-Watan TV station, the Israeli forces began broadcasting pornography over its transmitter. Eventually, according to a report from *The Advertiser*, an Australian newspaper, the Israelis expanded their cultural offensive against the Palestinian people by broadcasting pornography over two other Palestinian stations, the Ammwaj and Al-Sharaq channels. One 52-year-old Palestinian mother of three children, according to the report in *The Advertiser*, complained about "the deliberate psychological damage caused by these broadcasts."[221]

Whether one accepts Jones' thesis or not, the Jewish hypersexualization of Western culture and assault on White heterosexual normativity is too ubiquitous and longstanding a phenomenon to lack a firm ethno-political basis. Regarding the overwhelming political support of Jews for sexual minorities, the late Jewish author Charles Silberman pointed out that, "American Jews are committed to cultural tolerance because of their belief – one firmly rooted in history – that Jews are safe only in a society acceptant of a wide range of attitudes and behaviors, as well as a diversity of religious and ethnic groups. It is this belief, for example,

not approval of homosexuality, that leads an overwhelming majority of U.S. Jews to endorse 'gay rights' and to take a liberal stance on most other so-called 'social' issues."[222] The Jewish professor of English at the University of Massachusetts, Josh Lambert, likewise noted that Jewish lawyers "believe that minority discourse deserves protection" on the basis that "the Holocaust was the ultimate suppression of minorities" and, consequently, for Jews, "the right for free speech became a fight for minority rights."

## The Consequences of the Jewish Hypersexualization of Western Culture

The consequences of the erosion of traditional Western constraints on sexuality (the result of the triumph of the psychoanalytic and radical critiques of Western culture since the 1960s) have been far more harmful to those lower IQ groups that are genetically predisposed to precocious sexuality than to Diaspora Jews (higher intelligence being correlated with later age of marriage, lower levels of illegitimacy, and lower levels of divorce). A 2006 study in the *Journal of Adolescent Health* found that: "The strong relationship between media and adolescents' sexual expression" is due to "the media's role as an important source of sexual socialization for teenagers."[223] According to the psychologists Richard Jackson Harris and Fred W. Sandborn in their book *A Cognitive Psychology of Mass Communication*: "Teenagers who watch a heavy diet of television with sexual content were twice as likely to engage in sexual intercourse over the following year as teens who were light viewers of sexual content, even after controlling for other possible factors."[224]

The hypersexualization of Western culture has led to soaring rates of sexually transmitted diseases among adolescents. There has been an alarming rise in gonorrhea, chlamydia, and syphilis across the United States.[225] There has also been a surge in child-on-child sexual abuse throughout the Western world. Joe Tucci, chief executive of the Australian Childhood Foundation attributes this dramatic upsurge to the fact that nowadays children "have this diet of easily accessible porn,

sexual imagery and distorted values around relationships and they put those things together and they start engaging in sexual behavior." Social commentator Melinda Tankard Reist plaintively asks, "How much worse does it have to get? How many more five-year-olds do we want to have in treatment programs until we say that maybe it shouldn't be a free-for-all where kids can access torture porn and rape porn and incest porn? Children are being groomed to think this stuff is normal."[226] It hardly needs saying that, as a result of programs like Jenji Kohan's *OitNB*, the division between pornography and popular entertainment is rapidly dissolving.

Kevin MacDonald notes that "the most basic mistake Freud made was the systematic conflation of sex and love. This was also his most subversive mistake, and one cannot emphasize the absolutely disastrous consequences of accepting the Freudian view that sexual liberation would have salutary effects on society." The psychoanalytic emphasis on the benefits of sexual liberation is "fundamentally a program that promotes low investment parenting styles."[227] By contrast, traditional Western religious and secular institutions resulted in a "highly egalitarian mating system that is associated with high-investment parenting. These institutions provided a central role for pair bonding, conjugality, and companionship as the basis for marriage. However, when these institutions were subjected to the radical critique presented by psychoanalysis, they came to be seen as engendering neurosis, and Western society itself was viewed as pathogenic."[228]

The net result of the Jewish-engineered sexual revolution has been the establishment and entrenchment of a Jewish "cognitive elite" who politically, economically and socially dominate "a growing mass of individuals who are intellectually incompetent, irresponsible as parents, prone to requiring public assistance, and prone to criminal behavior, psychiatric disorders, and substance abuse."[229] Meanwhile, at the other end of the social spectrum, Jewish activists have recruited the most intellectually capable elements from within White populations and used them (through a perverted system of financial incentives) to masochistically harm communities of their own biological origin.

The Jewish hypersexualization of Western culture seems to only intensify with each passing year as the line between pornography and popular entertainment blurs. Changing this deplorable situation will require exposing the ethnic agenda that underpins Hollywood's squalid output and, ultimately, breaking the Jewish stranglehold on the media and entertainment industries.

# Evil Genius: Constructing Wagner as Moral Pariah

A long line of books and documentaries have explored Richard Wagner's anti-Semitism and his putative role as the spiritual and intellectual godfather to Adolf Hitler. In the Jewish-dominated cultural milieu of the contemporary West, this meme has taken on such a life that Wagner's name is seldom mentioned today without the obligatory disclaimer that, while admittedly (and unfortunately) a musical genius, his reputation is forever sullied by his standing as a morally-loathsome anti-Semite. A consequence of this is that, for many people, Wagner "has become symbolic of everything evil in the world."[230]

Richard Wagner was a one man artistic and intellectual movement whose shadow fell across all of his contemporaries and most of his successors. Other composers had influence; Wagner had a way of thinking named after him. It has been claimed that "never since Orpheus has there been a musician whose music affected so vitally the life and art of generations."[231] A significant biographical feature of the composers that followed Wagner was how they grappled with his legacy. Some, like Bruckner and Strauss, imitated him; some, like Debussy and Bartok, rejected him; and some, like Hugo Wolf were almost paralyzed by the immensity of his achievement. Wagner's influence extended to writers and intellectuals like Proust, Joyce, Lawrence, Mann, Baudelaire, Eliot,

Nietzsche and Shaw. Given his huge impact on Western culture, Bryan Magee has strong grounds for his contention that "Wagner has had a greater influence than any other single artist on the culture of our age."[232]

Wagner was a deeply polarizing figure in his lifetime, and no other composer has provoked such extreme antipathy or adulation. It has been said that his music has been loved and hated more immoderately than that of any other composer. Wagner was notoriously unscrupulous in his personal life – but his sexual and financial misdemeanors pale into insignificance beside the vastness and originality of his compositions. Even anti-Wagnerites have had to acknowledge the enormity of his achievement, and his most fanatical detractors (a great many of them Jewish) have reluctantly agreed with Tchaikovsky, who wrote of the *Ring*: "Whatever one might think of Wagner's titanic work, no one can deny the monumental nature of the task he set himself, and which he has fulfilled; nor the heroic inner strength needed to complete the task. It was truly one of the greatest artistic endeavors which the human mind has ever conceived."[233]

One hundred and forty years after his death, Wagner retains a cultural prominence that surpasses any of his contemporaries. The excellence of his music has ensured its popularity has never waned, and Wagner is still well represented on recordings, on radio, and in the theater. Wealthy Wagner devotees travel the world in pursuit of live performances of his fifteen-hour, four-night opera cycle, *Der Ring des Nibelungen*. Every year thousands still make a pilgrimage to the small Bavarian town of Bayreuth where in 1876 he inaugurated a festival devoted to his own music. The appeal of Wagner's music, libretti and stagecraft have ensured his music dramas remain useful to opera companies around the world as a reliable income source, even in straitened economic times.

It is, however, Wagner's standing as "a notorious anti-Semite," and the intellectual establishment's obsession with him on this basis, that has increasingly molded his image in the popular consciousness. Wagner's reputation is now so thoroughly tainted that one almost never encounters a serious examination of his ideas. As the cultural

commentator Adrian Mourby noted: "The notion that artists don't have to be as beautiful as the works they create is a commonplace now – except in the case of Wagner. 'Judaism in Music' is what has made him the unforgivable exception."[234]

## Judaism in Music

Kevin MacDonald observes in *Separation and its Discontents* that Richard Wagner is perhaps the best known intellectual who focused on the Jewish domination of culture.[235] Wagner first expounded on what he saw as the pernicious Jewish influence on German art and culture in his 1850 tract *Das Judenthum in der Musik* (usually translated as *Judaism in Music* or *Jewishness in Music*), which was published under pseudonym in 1850.[236] Wagner's essay took up the theme of a previous article by Theodor Uhlig in the *Neue Zeitschrift für Musik* that was critical of the "Hebraic art taste" that Uhlig thought was manifest in Jewish composer Giacomo Meyerbeer's grand opera *Le Prophète*.

Wagner attempted in his essay to account for the "popular dislike of the Jewish nature," and "the *involuntary repellence* possessed for us by the nature and personality of the Jews." He concludes that Germans instinctively disliked Jews due to their alien appearance, speech and behavior, noting that "with all our speaking and writing in favor of the Jews' emancipation, we always felt instinctively repelled by any actual, operative contact with them."[237] Wagner here simply stated an obvious fact: that Germans, like all other racial and ethnic groups, were ethnocentric, and this colored their interactions with a fiercely competitive resident outgroup like the Jews. According to Wagner, "We are deliberately distorting our own nature if we feel ashamed to proclaim the natural revulsion aroused in us by Jewishness... Despite our pretended liberalism we still feel this aversion."[238]

Wagner argued in *Judaism in Music* that Jewish musicians were only capable of producing music that was shallow and artificial because they had no connection to the genuine spirit of the German people. He observes that: "So long as the separate art of music had a real organic

life-need in it down to the epochs of Mozart and Beethoven, there was nowhere to be found a Jewish composer. ... Only when a body's inner death is manifest, do outside elements win the power of lodgment in it – yet merely to destroy it."[239] Jews had not fully assimilated into German culture, so did not identify with and merge themselves into the deepest layers of that culture, including its religious and ethnic influences – the *Volksgeist*. According to Wagner, "our whole European art and civilization... remained to the Jew a foreign tongue." The Jews "through an intercourse of two millennia with European nations" had never fully abandoned the posture of "a cold, nay more, a hostile looker-on." The entry of the Jews into nineteenth-century European society was, for Wagner, the infiltration of a wholly alien and antagonistic group whose success symbolized the spiritual and creative crisis of German and European culture.

The same thesis was advanced by Zionist intellectuals like Ahad Ha'Am (the pseudonym of Asher Ginsburg). Kevin MacDonald notes that both Wagner and Ginsburg "developed the idea that Jews could not have their own artistic spirit because they failed to identify completely with the surrounding culture."[240] In Wagner's view, higher culture springs ultimately from folk culture. In the absence of Jewish influence, German music would once again reflect the deeper layers of German folk culture. For Wagner, "Judaic works of music often produce on us the impression as though a poem of Goethe's, for instance, were being rendered in the Jewish jargon. ... Just as words and constructions are hurled together in this jargon with wondrous inexpressiveness, so does the Jewish musician hurl together the diverse forms and styles of every age and every master. Packed side by side, we find the formal idiosyncrasies of all the schools, in motleyest chaos."[241]

For Wagner, Jewish art was characterized by imitativeness, and therefore, by shallowness and superficiality. This was exemplified by the compositions that dominated the music scene of his time. From the depth and intensity of Bach, Mozart and Beethoven, the music of the concert hall had descended to the superficiality of Mendelssohn – who had diverted the "tempests of revolution" into soothing salon music. Similarly,

opera had fallen from the musical-dramatic peaks of Gluck and Mozart to the barren flatlands of Meyerbeer and Halevy. For Wagner, all that was meretricious in Grand Opera could be ascribed to the Jewishness of its composers – whose work amounted to a series of glib surface effects. He writes: "Of necessity what comes out of attempts by Jews to make art must have the property of coldness, of non-involvement, to the point of being trivial and absurd. We are forced to categorize the Jewish period in modern music as the period of consummate uncreativeness – stagnation run to seed."

Bryan Magee observes that "to write works of this kind was to make use of art as a mere means – a means of entertainment, a means of giving pleasure and getting to be liked, a means of achieving status, money, fame. For Jews it was a means of making their way in an alien society."[242] It certainly worked for Meyerbeer, with the first hundred performances of *Le Prophète* in Berlin alone netting him 750,000 marks – almost 200,000 marks more than the entire sum Wagner received over nearly two decades from his patron King Ludwig II of Bavaria.[243]

Wagner's thesis has been roundly condemned by Jewish commentators, and yet the Jewish academic David Rodwin, while labelling Wagner's essay "a vile anti-Semitic screed," admits there is substantial truth in the "aesthetic eclecticism" that Wagner identified as a unifying feature of Jewish composers.[244] Regarding Wagner's attribution of "imitativeness" as a particularly Jewish trait, Jacob Katz likewise acknowledges that: "Jewish qualities may quite naturally appear – for better or for worse – in artistic creations of Jews, even of those who have joined non-Jewish culture. It would therefore be preposterous to dismiss categorically all observations from the mouths of anti-Semites as prejudicial misconceptions."[245] Magee calls Wagner's thesis "unbelievably original" and notes that:

> One does not need to share Wagner's view of Mendelssohn, who came from a Christianized and highly assimilated family, to see that his argument is substantially correct. ... A really great creative artist is one who, in freely expressing his own needs, aspirations,

and conflicts, articulates those of an entire society. This is made possible by the fact that, through his earliest relationships, mother tongue, upbringing, and all his first experience of life, the cultural heritage on which he has entered at birth is woven into the whole fabric of his personality. He has a thousand roots in it of which he is unaware, nourishing him below the level of consciousness, so that when he speaks for himself he quite unconsciously speaks for others. Now in Wagner's time it was impossible for a Jewish artist to be in this position. The ghettos of Western Europe had only begun to be opened in the wake of the French Revolution, and their abolition was going on throughout the nineteenth century. The Jewish composers of Wagner's day were among the very first emancipated Jews, pastless in the society in which they were living and working. They spoke its language with, literally, a foreign accent.[246]

According to Magee, Wagner failed to notice that he was describing a transitional phenomenon – that the creations of Jewish composers would inevitably become "deeper" and more culturally authentic as the descendants of emancipated Jews assimilated into their host societies. Magee cites the emergence of Mahler and Schoenberg in the late nineteenth century to illustrate his point.

Drawing on the thesis of Heinrich Laube's book *Struensee*, Wagner argued in *Judaism in Music* that Jews had also degraded German art by introducing their commercializing spirit into it. In February of 1848, at the funeral of Wagner's mother, Laube had commiserated with his friend Wagner, equating the sadness of the hour with their mutual despair at the state of German art and culture, noting that "On the way to the station, we discussed the unbearable burden that seemed to us to lie like a dead weight on every noble effort made to resist the tendency of the time to sink into utter worthlessness." As the preface to *Struensee* makes clear, this "worthlessness" consisted in the flowering of Jewish commercial values. Wagner's only remedy was to "plunge dully and coldly into the only thing that could cheer me and warm me, the

working out of my *Lohengrin* and my studies of German antiquity."[247] Regarding the Jewish tendency to convert art into a branch of commerce, Wagner writes:

> [All] is turned to money by the Jew. Who thinks of noticing that the guileless looking scrap of paper is slimy with the blood of countless generations? What the heroes of the arts... have invented... from two millennia of misery, today the Jew converts into an art-bazaar. ... We have no need first to substantiate the Jewification [*Verjudung*] of modern art. It springs to the eye and thrusts upon the senses. ... But if emancipation from the yoke of Judaism appears to us the greatest of necessities, we must hold it crucial above all to assemble our forces for this war of liberation. But we shall never gain these forces by merely defining the phenomenon [of Judaism] in an abstract way. This will be done only by accurately knowing the nature of that involuntary feeling of ours which utters itself as an instinctive repugnance against the Jew's prime essence. ... Then we can rout the demon from the field... where he has sheltered under a twilit darkness... which we good-natured humanists ourselves have conferred on him.[248]

For Wagner, Judaism was the embodiment of the bourgeois money-egoist spirit, and he observes that: "When our social evolution reached that turning-point at which the power of money to bestow rank began to be openly admitted, it was no longer possible to keep the Jews at bay. They had enough money to be admitted to society." Wagner believed that Jews "will continue to rule as long as money remains the power to which all our activities are subjugated." He later confessed to his friend (and future father-in-law) Liszt that: "I felt a long-repressed hatred for this Jewish money-world, and this hatred is as necessary to my nature as gall is to blood. An opportunity arose when their damnable scribbling annoyed me most, and so I broke forth at last."[249] In *Judaism in Music* Wagner finds the plea for Jewish emancipation to be "more than commonly naive, since we see ourselves rather in the position of fighting

for emancipation from the Jews. The Jew is in fact, in the current state of the world, already more than emancipated. *He rules.*"

While stressing the harmful effects of the Jewish financial domination of German society, Wagner believed that the Jewish manipulation of language and art was infinitely more pernicious than their control over money. In his essay "What is German?" (1878, but based on a draft written in the 1860s) he states that culture, not economy, lies at the heart of German identity, and that Jews had bought the German soul and turned German *Kultur* into a sham, a mere image; and in doing this had destroyed "one of the finest natural dispositions in all the human race."[250]

Wagner believed that the German people had been endowed with a uniquely rich inner life which had been forged during the crucible of the Thirty Years War. The body of the nation had almost been annihilated, "but the German spirit had passed through," and amidst the physical ruins the Germans once again realized they were a nation of the spirit. This spirit had been preserved in the music of Johann Sebastian Bach, and the German spiritual mission in the world was to proclaim *"that the Beautiful and the Noble came not into the world for sake of profit, nay, not for the sake of even fame and recognition."*[251] Wagner thus viewed the new festival theater he built in the Bavarian town of Bayreuth in 1876 as the Grail Castle of a reborn, spiritual Germany. Far from the cosmopolitan theaters operated by city-dwelling Jews, Bayreuth would allow the German nation to regain a sense of its true self by experiencing the mythic force of its own ancient epic – the *Nibelungen*. Through Bayreuth, Wagner wanted to reclaim German art and culture from that "race of mediators and negotiators whose influence was… to spread its truly 'international' power more and more widely over Germany."[252]

Wagner repeatedly observed (and lamented) the fact Jews had stormed the fortress of German high culture, especially its music, and had successfully "brought the public art-taste of our time between the busy fingers of the Jew."[253] A host of Jewish middlemen had gained a hold over the critical press, publishing, theaters, operas, orchestras, art galleries and agencies. This Jewish cultural ascendancy in Germany was,

of course, to reach its zenith in the Weimar Republic. Despite his stated
views, Wagner twice refused to sign the "Anti-Semites Petition" of 1880
(presented to Bismarck) which complained about the very economic
domination that so troubled him. The Petition, which quickly won
225,000 signatures, stated:

> Wherever Christian and Jew enter into social relations, we see
> the Jew as master, the indigenous Christian population in a sub-
> servient position. The Jew takes part only to a negligible extent
> in the heavy labor of the great mass of the nation. But the fruits
> of his [the German's] labor are reaped mainly by the Jew. By far
> the largest part of the capital which national labor produces is in
> Jewish hands. ... Not only do the proudest palaces of our large
> cities belong to Jewish masters whose fathers and grandfathers,
> huckstering and peddling, crossed the frontiers into our father-
> land, but rural holdings too, that most significant preservative
> basis of our political structure fall more and more into the hands
> of the Jews. ... What we strive for is solely the emancipation of the
> German Volk from a form of alien domination which it cannot
> endure for any length of time.[254]

Cosima Wagner gave several explanations for her husband's refusal to
sign the petition, among them that he had already done as much as
he could for the cause, that a petition he had signed against vivisection
had failed, and that the new appeal was addressed in servile language
to Bismarck, who by this time Wagner loathed.[255] Wagner deplored the
"Jewishness" of the new German empire, which he thought, thanks to
Bismarck, had turned out to be a *real-politischer* state, rather than a
truly German one. In 1878, Wagner wrote that "Bismarck is creating
German unity, but he has no conception of its nature... His conduct is a
disgrace for Germany... his decisions have brought forth from the Jews a
petition of thanks." When Bismarck spoke out against the Anti-Semites
Petition it only confirmed Wagner in his conviction that Bismarck had
"a pact with the Jews."[256]

For Roger Scruton, it was Wagner's determination to use his art to escape from the increasingly commercialized world of art he detested, a world "where value is price and price is value," and where entertainment is considered more important than art, that is central to his genius. Wagner escaped "to a garret, high above the market place" in conscious reaction against the sentimentality and disingenuousness of the art and music at his time.

> The operas of Wagner attempt to dignify the human being in something like the way he might be dignified by an uncorrupted common culture. Acutely conscious of the death of God, Wagner proposed man as his own redeemer and art as a transfiguring rite of passage to a higher world. The suggestion is visionary, and its impact on modern culture so great that the shockwaves are still overtaking us. ... In the mature operas of Wagner our civilization gave voice for the last time to its idea of the heroic, though music that strives to endorse that idea to the full extent of its power. And because Wagner was a composer of supreme genius, perhaps the only one to have taken forward the intense inner language forged by Beethoven and to have used it to conquer the psychic spaces that Beethoven shunned, everything he wrote in his mature idiom has the ring of truth, and every note is both absolutely right and profoundly surprising.[257]

Wagner fled from the commercialized world of art into the inner realm of the imagination. He believed the idealism and heroism of a bygone age could be rekindled to dwell among us again. He strove to create a new music public that would not just identify with the Germanic heroic ideal, but embrace it as part of an idealistic nationalism that eschewed the bourgeois values of the mid-nineteenth century. In this endeavor, he strived to connect at an emotional rather than a rational level with his audience. As Wagner once wrote of his *Ring* cycle: "I shall within these four evenings succeed in *artistically conveying my purpose to the emotional – not the critical – understanding of the spectators*."[258] This

was in keeping with his dictum that art should be "the presentation of religion in a lively form."

It was precisely this quality in Wagner's works that most repelled the Frankfurt School music theorist and critic T.W. Adorno, who likened Wagner's famous system of leitmotifs to advertising jingles in the way they imprinted themselves on the memory. For Adorno, Wagner's musical innovations led to feelings of disorientation and intoxication that seduced audiences and rendered them docile and dangerously susceptible to political persuasion. In every crowd applauding a Wagnerian work, Adorno insisted, lurked "the old virulent evil" of "demagogy." Elizabeth Whitcombe notes that:

> Adorno believed that Wagner's work is "proselytizing" and "collective-narcissistic." Adorno's complaint about the "collective-narcissistic" quality of Wagner's music is really a complaint that Wagner's music appeals to deep emotions of group cohesion. Like the Germanic myths that his music was often based on, Wagner's music evokes the deepest passions of ethnic collectivism and ethnic pride. In Adorno's view, such emotions are nothing more than collective narcissism, at least partly because a strong sense of German ethnic pride tends to view Jews as outsiders – as "the other." It is also not surprising that Adorno, as a self-consciously Jewish intellectual, would find such music abhorrent.[259]

Adorno's jaundiced assessment of Wagner was encapsulated in Woody Allen's quip that: "When I hear Wagner I have the irresistible urge to invade Poland." Scruton points out that Wagner's attempt to engage his audiences at the emotional level of religion (which so perturbed Adorno) was already doomed when Wagner first conceived it. The main problem being that:

> [Wagner's] sacerdotal presumptions have never ceased to alienate those who feel threatened by his message. Hence modern producers, embarrassed by dramas that make a mockery of their

way of life, decide in their turn to make a mockery of the dramas [in so-called Regietheater/Eurotrash productions]. Of course, even today, musicians and singers, responding as they must to the urgency and sincerity of the music, do their best to produce the sounds that Wagner intended. But the action is invariably caricatured, wrapped in inverted commas, and reduced to the dimensions of the television sitcom. Sarcasm and satire run riot on the stage, not because they have anything to prove or say in the shadow of this unsurpassably noble music, but because nobility has become intolerable. The producer strives to distract the audience from Wagner's message, and to mock every heroic gesture, lest the point of the drama should finally come home.

As Michael Tanner has argued, in his succinct and penetrating defense of the composer, modern productions attempt to "domesticate" Wagner, to bring his dramas down from the exalted sphere in which the music places them, to the world of human trivia, usually in order to make a "political statement" which, being both blatant and banal, succeeds only in cancelling the rich ambiguities of the drama. In contemporary Wagner productions we see exactly what the transition from modernism to the "post-modern" world involves, namely, the final rejection of high culture as a redemptive force and the ruination of the sacred in its last imagined form.[260]

In the conclusion to *Judaism and Music*, Wagner asserts of the Jews that "only one thing can redeem you from the burden of your curse: the redemption of Ahasverus – going under!"[261] Although this has been taken by some commentators to denote actual physical annihilation, in the context of the essay it refers to the eradication of Jewish separateness and traditions. Wagner advises Jews to follow the example of the German-Jewish political writer and satirist Ludwig Börne by abandoning Judaism. In this way Jews will take part in "this regenerative work of deliverance through self-annulment; then we are one

and un-dissevered!" Wagner was calling for the assimilation of Jews into mainstream German culture and society. He thus offered to take Hermann Levi, the first conductor of his last opera *Parsifal*, to be baptized. Under the influence of Darwinian thinking (promoted in Germany by Ernst Häckel), Wagner later came to favor expulsion over conversion, and thus paralleled the trajectory of German anti-Semitism over the course of the nineteenth century, which "shifted from demands for Jewish assimilation by intellectuals such as Kant and the young Hegelians in the early part of the century, to an increasing emphasis on the ethnic divide separating Germans and Jews."[262]

Wagner republished *Judaism in Music* under his own name in 1869 with an extended introduction, leading to several protests by Jews at the first performances of *Die Meistersinger von Nürnberg*. In the introduction he writes that: "Whether the downfall of our culture can be arrested by a violent ejection of the destructive foreign element I am unable to decide, since that would require forces with whose existence I am unacquainted."[263] This second edition of *Judaism in Music* was published in the same year as Wilhelm Marr's influential *Der Sieg des Judenthums über das Germanenthum* (The Victory of Jewishness over Germanism). Historian Richard Evans claims that by the end of the 1870s Wagner had read Wilhelm Marr's essay and had "broadly agreed with it."[264] In 1878, Wagner confessed that "It is distressing to me always to come back to the theme of the Jews. But one cannot escape it if one looks to the future."[265] In his late essay "Religion and Art" (1881), he described the Jews as "the plastic demon of the decline of mankind," and declared: "I regard the Jewish race as the born enemies of humanity and everything that is noble in it; it is certain we Germans will go under before them, and perhaps I am the last German who knows how to stand up as an art-loving man against the Judaism that is already getting control of everything."[266]

## Wagner's Racial Thinking

In addition to his concern about the baleful Jewish influence on German culture, Wagner, under the influence of Darwinism and the French racial theorist Arthur de Gobineau, became increasingly concerned about the fate of the White race generally. Wagner met Gobineau in Rome in 1876, and then again in Venice in 1880 when he read the French author's bestselling *An Essay on the Inequality of the Human Races* which had been published 25 years earlier. Wagner thought that Gobineau had demonstrated in this famous essay that "we should have no History of Man at all, had there been no movements, creations, and achievements of the White man," and was taken with his pessimistic notion that Western society was doomed because miscegenation would inevitably lead to the degeneration of the White race. He nevertheless disagreed with Gobineau's claim that this degeneration was unstoppable. In his essay "Hero-dom and Christianity," Wagner writes that: "We cannot withhold our acknowledgment that the human family consists of irremediably disparate races, whereof the noblest well might rule the more ignoble, yet never raise them to their level by commixture, but simply sink to theirs." The Jews, however, offered a unique exception to this general rule:

> The Jew, on the contrary, is the most astounding instance of racial congruence ever offered by world history. Without a fatherland, a mother tongue midst every people's land and tongue he finds himself again, in virtue of the unfailing instinct of his absolute and indelible idiosyncrasy: even commixture of blood does not hurt him; let Jew or Jewess intermarry with the most distinct of races, a Jew will always come to birth.[267]

While accepting many of Gobineau's basic premises, Wagner, in his 1881 essay about the German people entitled "Know Thyself," rejects the idea of Aryan superiority and writes about the "enormous disadvantage at which the German race... appears to stand against the Jewish." Furthermore, when Gobineau stayed with the Wagners for five weeks

in 1881, their conversations were punctuated with frequent arguments. Cosima Wagner's diary recounts one exchange in which Wagner "positively exploded in favor of Christianity as compared to racial theory." Wagner proposed that a "true Christianity" could provide for the moral harmonization of all races, which could, in turn, help prevent the physical unification of the races, and thereby the degeneration of the White race through miscegenation:

> Incomparably fewer in individual numbers than the lower races, the ruin of the white races may be referred to their having been obliged to mix with them; whereby, as remarked already, they suffered more from the loss of their purity than the others could gain by the ennobling of their blood. ... To us Equality is only thinkable as based upon a universal moral concord, such as we can but deem true Christianity elect to bring about.[268]

Wagner had first developed the idea of a revolutionary new Christianity in the opera text *Jesus of Nazareth* (1849), which depicted Jesus as redeeming man from the materialism of the "Roman world... and still more, of that [Jewish] world subject to the Romans. ... I saw the modern world of the present day as a prey to the *worthlessness* akin to that which surrounded Jesus."[269] Wagner here drew heavily on Kant's critique of Judaism. Enslaved to the Law, the Jews had rejected Jesus' message of love; Jewish egoism and lovelessness had led Judas to betray him. The Jews had preferred "power, domination... [and] the loveless forces of property and law, symbolized by Judaism."[270] Wagner's hope for the emergence of a "new Christianity" to act as a bulwark against miscegenation and the degeneration of the White race has not transpired, although some Jewish commentators see it as having being realized in the ideology and practice of National Socialism.

For the Jewish music critic Larry Solomon, in Richard Wagner "all the racist historical models from Luther to Fichte, Feuerbach, Gobineau, Hegel, Schopenhauer, and Chamberlain, come to full maturity."[271] Yet, despite the irate epithets routinely directed at Wagner,

most of his assertions are objectively true – not least his many warnings about the dangers of the Jewish economic and cultural domination of Western nations. The evidence shows that the races are unequal intellectually and physically, and race mixing does lead (on average) to the cognitive decline of the more intelligent racial party to the admixture. It should also be noted that Wagner's racial views were mainstream opinions at the time he expressed them – not least among the leading Jewish intellectuals I cited in my review of *Jews & Race – Writings on Identity and Difference 1880-1940* (see Chapter 16).

Wagner's views on the Jewish Question strongly paralleled those of the Zionist leader Theodor Herzl. Both Wagner and Herzl saw the Jews as a distinct and foreign group in Europe. Herzl saw anti-Semitism as "an understandable reaction to Jewish defects" brought about by the Jewish persecution of gentiles. Jews had, he claimed, been educated by Judaism to be "leeches" and possessed "frightful financial power."[272] For Herzl, the Jews were a money worshipping people incapable of understanding any other motives than money. Kevin MacDonald notes in *Separation and its Discontents* that Herzl argued that "a prime source of modern anti-Semitism was that emancipation had brought Jews into direct economic competition with the gentile middle classes. Anti-Semitism based on resource competition was rational." Herzl "insisted that one could not expect a majority to 'let itself be subjugated' by formally scorned outsiders that they had just released from the ghetto."[273] Pianist and conductor Daniel Barenboim notes that "Wagner's conclusion about the Jewish problem was not only verbally similar to Herzl's" but that "both Wagner and Herzl favored the emigration of the German Jews."[274] Despite their convergence of opinion on the Jewish Question, Herzl avoided the opprobrium that was posthumously heaped on Wagner; intellectual consistency being the first casualty of Jewish ethnic warfare through the construction of culture.

## Jewish Responses to Wagner's Ideas

Basically ignoring whether Wagner's views on Jewish influence on German art and culture had any validity, a long line of Jewish music writers and intellectuals have furiously attacked the composer for just having expressed them. In his essay "Know Thyself," Wagner writes of the fierce backlash that followed his drawing "notice to the Jews' inaptitude for taking a productive share in our Art," which was "met by the utmost indignation of Jews alike and Germans; it became quite dangerous to breathe the word 'Jew' with a doubtful accent."[275] Wagner was surprised by the hornet's nest he had stirred up, and in a letter to Liszt noted that "I seem to have struck home with terrible force, which suits me purpose admirably, since that is precisely the sort of shock that I wanted to give them. For they will always remain our masters – that much is as certain as the fact that it is not our princes who are now our masters, but bankers and philistines."[276]

Wagner's critique of Jewish influence on German art and culture could not be dismissed as the ravings of an unintelligent and ignorant fool. Richard Wagner was, by common consent, one of the most brilliant human beings to have ever lived, and his views on the Jewish Question were cogent and rational. Accordingly, Jewish critics soon settled on the response of ascribing psychiatric disorders to the composer, and this has been the typical approach ever since. As early as 1872, the German-Jewish psychiatrist Theodor Puschmann offered a psychological assessment of Wagner that was widely reported in the German press. He claimed Wagner was suffering from "chronic megalomania, paranoia... and moral derangement."[277] Cesare Lombroso, the famous nineteenth-century Italian-Jewish criminologist, branded Wagner "a sexual psychopath."[278]

In 1968, the Jewish writer Robert Gutman published a biography of Wagner (*Richard Wagner: the Man, his Mind and his Music)* in which he portrayed his subject as a racist, psychopathic, proto-Nazi monster. Gutman's scholarship was questioned at the time, but this did not prevent his book from becoming a best-seller, and as one source notes: "An entire generation of students has been encouraged to accept

Gutman's caricature of Richard Wagner. Even intelligent people, who have either never read Wagner's writings or tried to penetrate them and failed... have read Gutman's book and accepted his opinions as facts."[279] The long-time music critic for *The New York Times*, the Jewish Harold Schonberg, was one of them, describing Wagner in his *Lives of the Great Composers* as: "Amoral, hedonistic, selfish, virulently racist, arrogant, filled with gospels of the superman... and the superiority of the German race, he stands for all that is unpleasant in human character."[280]

Another prominent refrain from Jewish commentators like Jacob Katz, the author of *The Darker Side of Genius: Richard Wagner's Anti-Semitism*, is that Wagner's concern about the Jewish influence on German culture stemmed from his morbid jealousy of all the brilliant Jews around him like Mendelssohn, Meyerbeer and Heine. Taking up this theme, the music writer David Goldman insists that: "Wagner ripped off the scenario for his opera 'The Flying Dutchman' from Heine and knocked off Mendelssohn's 'Fingal's Cave' overture in the 'Dutchman's' evocation of the sea. Wagner tried to cover his guilty tracks by denouncing Jewish composers he emulated, including Giacomo Meyerbeer. Wagner was not just a Jew-hater, then, but a backstabbing self-promoter who defamed the Jewish artists he emulated and who (in Meyerbeer's case) had advanced his career."[281] Boroson, writing in the *Jewish Standard*, likewise claims Wagner's envy of Meyerbeer's success "played a pivotal role in Wagner's suddenly becoming a Jew-hater."[282]

Numerous sources trace Wagner's anti-Semitism to his perception that a clique of powerful Jews (led by Meyerbeer and Halevy) had thwarted the staging of his *Rienzi* in Paris, and "at his dependence on money lenders, mostly presumably Jewish, at this time."[283] Carr notes that from early in his career Wagner's profligacy "put him in hock with moneylenders who were usually Jews." Already in Magdeburg where he courted his first wife Minna, "he railed at having to deal with the 'Jewish scum' because 'our people' offered no credit. In Paris he pawned his goods to Jews and did work he felt was menial for, amongst others, Maurice Schlesinger, a Jewish music publisher. Schlesinger's cash helped ward off starvation but that made the struggling composer

feel no better."[284] Magee notes that the two and half years Wagner spent in Paris trying and failing to establish himself was "the worst period of deprivation and humiliation he ever had to suffer."[285]

Invoking Freud and the Frankfurt School, the Jewish music writer Marc A. Weiner in his *Richard Wagner and the Anti-Semitic Imagination*, claims that: "Wagner's vehement hatred of Jews was based on a model of projection involving a deep-seated fear of precisely those features within the Self (diminutive stature, nervous demeanor and avarice, as well as lascivious nature) that are projected upon and then recognized and stigmatized in the hated Other."[286] Weiner's view echoes that of the Jewish psychiatrist Theodore Rubin who views anti-Semitism as a "symbol sickness" that involves envy, low self-esteem and projection of one's inner conflicts onto a stereotyped other.[287]

All these various theories, where Wagner's criticism of Jewish influence is made a scapegoat for his own psychological frustrations, vastly overemphasize the irrational sources of prejudice, and effectively serve to clothe Jews in defensive innocence. According to these theories, anti-Jewish statements are *never* rational but invariably the product of a warped mind, while Jewish critiques of Europeans *always* have a thoroughly rational basis.

Another well-worn theory has it that Wagner may have been part-Jewish, and that his anti-Semitism was his way of dealing this unedifying prospect (a variation of the "self-hating Jew" hypothesis). It is claimed that Wagner's biological father was not his presumed father, the police registrar Friedrich Wagner who died of typhus shortly after Wagner's birth, but his stepfather, the successful actor and painter Ludwig Geyer. However, there is no evidence that Geyer had any Jewish roots. In his biography of Wagner, John Chancellor states plainly that he had none, and that: "He [Geyer] claimed the same sturdy descent as the Wagners. His pedigree also went back to the middle of the seventeenth century and his forefathers were also, for the most part, organists in small Thuringian towns and villages."[288] Magee is even more categorical, stating that: "Geyer was not Jewish, and it had never occurred to anyone who knew him to think that he might be. He came from a long line of church

musicians; for generations his forebears had been Lutheran cantors and organists in the town of Eisleben. There was nothing Jewish about his appearance that might have misled people who were ignorant of his background."[289]

Chancellor blames Friedrich Nietzsche for first raising the question of Geyer's possible Jewishness to add extra sting to his charge of illegitimacy, after the philosopher famously fell out with Wagner after years of close friendship. In his 1888 book *Der Fall Wagner* (The Case of Wagner) Nietzsche claimed that Wagner's father was Geyer, and made the pun that *"Ein Geyer ist beinahe schon ein Adler"* (A vulture is almost an eagle) – Geyer also being the German word for a vulture and Adler being a common (but not exclusively) Jewish surname. Magee, while agreeing that Nietzsche undoubtedly intended to rile Wagner with the suggestion of his possible Jewish ancestry, believes Nietzsche's words also represented a jibe of a quite different kind.

> Wagner, a provincial with a regional accent, a lower-middle class family background, and a long personal history of penury, had risen late in life to walk with kings and emperors; and somewhere along the way (strikingly reminiscent of Shakespeare, this, as so often) he allotted himself a coat of arms. This was revealingly (it shows what he thought his descent was), the "Geyer" coat of arms, prominently featuring a vulture against the shield while the kings and emperors would have been displaying their royal or imperial eagles. I think it is more than likely that Nietzsche was being sarcastic about Wagner's self-promotion to the arms-bearing ranks of society with his "a vulture is almost an eagle."[290]

If, as has been often claimed, Wagner was concerned with denying the possibility that Geyer may have been his father (because of Geyer's possible Jewish ancestry), why would he have adopted the Geyer coat of arms and insist it be prominently displayed on the cover of his autobiography? This obvious fact did not deter Gutman who contended that Richard Wagner and his wife Cosima tried to outdo each other

in their anti-Semitism because they both had Jewish roots to conceal. While offering no proof Geyer was Jewish, Gutman insists that Wagner in his later years discovered letters from Geyer to his mother which led him to suspect that Geyer was his biological father, and that Geyer might have been Jewish. Wagner's anti-Semitism was, according to Gutman, his way of dealing with the fear that people would think he was Jewish. Derek Strahan recycles this discredited theme in a recent article, noting that:

> Geyer's affair with Wagner's mother pre-dated the death of Wagner's presumed father, Friedrich Wagner, a Police Registrar who was ill at the time young Richard was conceived, and who died six months after his birth. Soon after this, Wagner's mother Johanna married Ludwig Geyer. Richard Wagner himself was known as Richard Geyer until, at the age of 14, he had his name legally changed to Wagner. Apparently he had taken some abuse at school because of his Jewish-sounding name. Could his later anti-Semitism have been motivated, at least in part, by sensitivity to this abuse, and by a kind of pre-emptive denial to prevent difficulties and suffering arising from prejudice?[291]

According to the only evidence we have on this point (Cosima's diaries, 26 December 1868) Wagner "did not believe" that Ludwig Geyer was his real father. Cosima did, however, once note a resemblance between Wagner's son Siegfried and a picture of Geyer.[292] Pursuing the theme that anyone who expresses antipathy toward Jews must be psychologically unhealthy, Solomon draws a parallel between Wagner and Adolf Hitler in that: "Both feared they had Jewish paternity, which led to fierce denial and destructive hatred."[293] For Magee, these theories, which are now widely entrenched in the Wagner literature, are the "crassest falsehood," and: "The idea that Geyer might have been Jewish, or even that Wagner thought that he might have been, is pure fabrication, distilled nonsense."[294]

## Wagner's Music Dramas as Coded Anti-Semitism

T.W. Adorno and Wagner biographer Robert Gutman began a modern Jewish intellectual tradition when they proposed that Wagner's antipathy to Jews was not limited to articles like *Judaism in Music*, but included hidden anti-Semitic and racist messages embedded in his operas. Numerous Jewish writers have taken up this theme and encouraged audiences to retrospectively read into Wagner's operas latent signs of anti-Semitism. The gold-loving Nibelung lord Alberich in *Siegfried* is, for instance, supposedly a symbol of Jewish materialism. Solomon writes that Alberich is clearly "the greedy merchant Jew, who becomes the power-crazed goblin-demon lusting after Aryan maidens, attempting to contaminate their blood, and who sacrifices his lust in order to acquire the gold..."[295]

Beckmesser in *The Mastersingers of Nuremburg*, who is incapable of original work and resorts to stealing the work of others, is said to symbolize the lack of Jewish originality that Wagner highlighted in *Judaism in Music*. According to Gutman, Beckmesser was modeled after Eduard Hanslick, the powerful half-Jewish music critic who constantly disparaged Wagner. The characters of Mime in the *Ring* and Klingsor in *Parsifal* are also identified as Jewish stereotypes, although none of these were actually identified as Jews by Wagner in the libretto. Mime is, for Solomon, depicted by Wagner "as a stinking ghetto Jew" while "Siegfried represents the conscience-free, fearless Teuton, he feels no remorse. ... He is glorified as the warrior hero of the *Ring*, the archetypal proto-Nazi."[296]

Unconcerned at the lack of any real evidence for his thesis, Solomon maintains that virulent racism "permeates all aspects of his music dramas through metaphorical suggestion. Wagner is always just a step away from actually calling his evil characters 'Jews,' even though it was obvious to his contemporaries." He claims that Wagner was too clever to identify Jews in his music dramas, especially after the critical reactions he received to his essay *Judaism in Music*. "His intent was far more artful and covert, but nevertheless still political: to reach his audience on an emotional, subliminal level, bypassing their critical faculties." In the

final analysis, Wagner's operas are, for Solomon, "tools of racist, proto-Nazi hate propaganda, written for the purpose of redeeming the German race from Jewish contamination, and for expelling the Jews from Germany." Moreover, the malign influence of Wagner continues insofar as "the subtext of racist metaphors has not diminished in Wagner's operas, so they will continue to exert a subliminal influence."[297]

In his book *Richard Wagner and the Anti-Semitic Imagination* (1997), Marc A. Weiner likewise argued that Wagner deliberately used the characters in his operas to promote his sociological theories of a pure Germany purged of Jewish influence. According to Weiner:

> Wagner's anti-Semitism is integral to an understanding of his mature music dramas. ... I have analyzed the corporeal images in his dramatic works against the background of 19th-century racist imagery. By examining such bodily images as the elevated, nasal voice, the "foetor judaicus" (Jewish stench), the hobbling gait, the ashen skin color, and deviant sexuality associated with Jews in the 19th century, it's become clear to me that the images of Alberich, Mime, and Hagen [in the *Ring* cycle], Beckmesser [in *Die Meistersinger*], and Klingsor [in *Parsifal*], were drawn from stock anti-Semitic clichés of Wagner's time.[298]

For Weiner, Wagner's anti-Semitic caricatures can be readily identified from their manner of speech, their singing, their roles, and their body language. "All of the stereotypical cardboard, cookie-cutter features of a Jew... show up all over the place in his musical dramas." Under Weiner's deconstruction of Wagner's characters it emerges that his Teutonic heroes are "invariably clear-eyed, deep-voiced, straight-featured and sure-footed. The Jewish anti-heroes have dripping eyes, high voices, bent, crooked bodies and a hobbling, awkward step, with these embodied metaphors all serving to reinforce the ideology of racism."[299] In response to Weiner's critique, one is reminded of the aptness of Goldwin Smith's remark that the "critics of Judaism are accused of bigotry of race, as well as bigotry of religion. This accusation comes strangely from those who

style themselves the Chosen People, make race a religion, and treat all races except their own as Gentile and unclean."[300]

Numerous Jewish commentators cite Wagner's *Parsifal*, the last of his music dramas, as his most racist opera. Gutman, for example, labels it "a brooding nightmare of Aryan anxiety." According to Jewish academic Paul Lawrence Rose in his book *Wagner, Race and Revolution*, Wagner intended *Parsifal* to be:

> [A] profound religious parable about how the whole essence of European humanity had been poisoned by alien, inhuman, Jewish values. It is an allegory of the Judaization of Christianity and of Germany – and of purifying redemption. In place of theological purity, the secularized religion of *Parsifal* preached the new doctrine of racial purity, which was reflected in the moral, and indeed religious, purity of Parsifal himself. In Wagner's mind, this redeeming purity was infringed by Jews, just as devils and witches infringed the purity of traditional Christianity. In this scheme, it is axiomatic that compassion and redemption have no application to the inexorably damned Judaized Klingsor and hence the Jews.[301]

This theory sits rather incongruously alongside the fact that when the National Socialists came to power in 1933, *Parsifal* was condemned as "ideologically unacceptable" and, for reasons never openly stated, banned throughout Germany after 1939.[302] In his diaries Goebbels dismissed the opera as "too pious."[303] If *Parsifal* truly is the racist opera that Rose alleges, one might have expected it to have been given a place of special prominence in the Third Reich.

In *Wagner, Race and Revolution*, Rose claims the philosophical revolution brought about by Kant in the late eighteenth century was a response to the Jewish Question, with Kant's transcendental idealism intended as liberation from the shackles of Jewish ways of looking at the world. The corollary of this, for Rose, is that Schopenhauer's philosophy (with its heavy debt to Kant) is thoroughly infused with

anti-Semitism, and, consequently, Wagner's Schopenhauerian opera *Tristan and Isolde* is deeply anti-Semitic. Rose proposes that: "Such is the most fundamental anti-Jewish message that underlies the apparently 'non-social' and 'non-realistic' opera composed in Wagner's Schopenhauerian phase, *Tristan*."[304] Magee trenchantly observes that:

> We are no longer surprised when he goes on to tell us that "Hatred of Jewishness is the hidden agenda of virtually all the operas." It is no good Wagner trying to slip this past Professor Rose by making no mention of it: Rose is not to be so easily fooled. ... Rose often sees the omission of any mention of Jews or Jewishness as being due to anti-Semitism, and this enables him throughout his book to expose anti-Semitism in undreamt-of places, in fact in all forms of art and ideas that are not either Jewish or about Jews. ... Writers like Professor Rose can be endlessly resourceful in arguing that the apparent absence of something is proof of its presence... Such a procedure is intellectually fraudulent from beginning to end.[305]

Jewish music critics and intellectuals, like those cited above, have enthusiastically seized upon Wagner's great-grandson Gottfried for having backed their various theories about the inherently anti-Semitic nature of Wagner's operas, and Wagner's firm standing as a moral pariah. Gottfried Wagner has made a virtual career out of attacking his ancestors – constantly denouncing his great-grandfather and other family members as evil anti-Semites. In his book *The Wagner Legacy*, he declares: "Richard Wagner, through his inflammatory and anti-Semitic writings, was co-responsible for the transition from Bayreuth to Auschwitz."[306] In writing his *Twilight of the Wagners: The Unveiling of a Family's Legacy*, Gottfried Wagner had, according to Solomon, "in an act of self-imposed moral obligation and great personal sacrifice, restored to his roots the conscience that Wagner and Hitler took away."[307] To the approval of Carol Jean Delmar (the Jewish leader of a campaign to have the LA Opera's 2009 production of the *Ring* cancelled), the philo-Semitic

Gottfried Wagner appeared at a symposium at the American Jewish University in 2010 where he continued "to set the record straight today. Always on the side of the Jews, he stopped off on Shabbos to mingle with congregants at a local temple."[308]

Despite all the claims made about the allegedly anti-Semitic nature of Wagner's operas, Strahan points out that it is equally possible to point to cultural references in Wagner's work that are sympathetic to the Jewish place in European culture. For Strahan, "the hero of the early opera The Flying Dutchman is synonymous with the 'Wandering Jew,' the Dutchman's endless journeying analogous to that symbol of the Jewish Diaspora."[309] Wagner himself referred to his eminently non-Jewish personification of redemption through love, the Flying Dutchman, as an "Ahasverus of the Ocean." Despite this, Rose argues that Wagner's making the Wandering Jew a Dutchman was itself an anti-Semitic act, claiming that: "Wagner's use of this universalized figure of a wanderer has a profoundly anti-Semitic implication; for Wagner's heroes – and especially the Dutchman – are able to achieve redemption precisely because they are not Jewish."[310]

Wagner explicitly states in *Judaism in Music* that what makes Jews such unsatisfactory characters in real life also makes them unsuitable for representation in art, including dramatic art. He writes:

> In ordinary life the Jew, who as we know possesses a God of his own, strikes us first by his outward appearance which, whatever European nationality we belong to, has something unpleasantly foreign to that nationality. We instinctively feel we have nothing in common with a man who looks like that... Ignoring the moral aspect of this unpleasant freak of nature, and considering only the aesthetic, we will merely point out that to us this exterior could never be acceptable as a subject for a painting; if a portrait painter has to portray a Jew, he usually takes his model from his imagination, and wisely transforms or else completely omits everything that in real life characterizes the Jew's appearance. One never sees a Jew on the stage: the exceptions are so rare that

they serve to confirm this rule. We can conceive of no character, historical or modern, hero or lover, being played by a Jew, without instinctively feeling the absurdity of such an idea. This is very important: a race whose general appearance we cannot consider suitable for aesthetic purposes is by the same token incapable of any artistic presentation of its nature.[311]

In this passage (first published in 1850 and then again unchanged in 1869), Wagner totally rejects the idea of Jews playing characters *and* characters playing Jews on stage, stating categorically that the Jewish race is "incapable of any artistic presentation of his nature," and leading into the statement with the words: "This is very important." Magee notes that here Wagner "positively and actively repudiates the idea of trying to present Jews on the stage; and if we seek an explanation of why he never did so, here we have it..." Wagner would not, contrary to the wishes of many of his friends, have gone out of his way to publish this again in 1869 if, as alleged, he had just done the opposite and made Beckmesser a Jewish character in *Die Meistersinger* which had premiered the previous year.[312]

Wagner produced thousands of pages of written material analyzing every aspect of himself, his operas, and his views on Jews (as well as many other topics); and yet the purportedly "Jewish" characterizations identified by Adorno, Gutman and countless others are never mentioned – nor are there any references to them in Cosima Wagner's copious diaries. It can hardly be argued that Wagner was hiding his true feelings for he took great pride in speaking out fearlessly and vociferously on the subject of Jews, and did not care who he offended. None of Wagner's supposedly obvious characterizations were ever used in the propaganda of the Third Reich. To identify such characters as Beckmesser, Alberich, Mime, Klingsor and Kundry as Jews is, therefore, entirely speculative. The Jewish pianist and conductor Daniel Barenboim makes the point that: "Whoever wants to see a repulsive attack on Jews in Wagner's operas can of course do so. But is it really justified? Beckmesser, for

example, who might be suspected of being a Jewish parody, was a state scribe in the year 1500, a position that was unavailable to Jews."[313]

Even Nietzsche, who attacked Wagner on numerous occasions for his personal anti-Semitism, never alleged there was anti-Semitism in the operas. Moreover, the audiences that flocked to Wagner's works all over the world did not seem to perceive their supposedly obvious anti-Semitic subtexts for, as Magee points out, "in the huge literature we have on the subject, unpublished as well as published, the question arises rarely until the middle of the twentieth century."[314] For Magee, a great many writers (especially Jewish writers) are simply "swept forward by the momentum of their own anger" into alleging the omnipresence of anti-Semitism in Wagner's operas. "To a number of them it comes easily anyway, for they are adept at finding anti-Semitism in places where no one had detected it before. ... At the root of it all is an unforgiving rage at the mega-outrage of anti-Semitism – and at the root of that in the modern world is the Holocaust."[315]

## Wagner and National Socialist Germany

Richard Wagner has long been reviled by Jews as the intellectual and spiritual precursor to Adolf Hitler who, according to William Shirer, once declared: "Whoever wants to understand National Socialist Germany must know Wagner."[316] This line is spoken by the Hitler character in the 2008 Hollywood film *Valkyrie* (the Wagnerian title of the film being taken from the codename for the failed Wehrmacht plot to assassinate Hitler in 1944). For music critic Larry Solomon, no other composer in history had a greater impact on world events than Richard Wagner; and "his devastating political legacy is second only to Adolf Hitler."[317] In his book *Anti-Semitism: A Disease of the Mind: A Psychiatrist Explores the Psychodynamics of a Symbol Sickness*, Theodore Rubin states that a psychologically sick Adolf Hitler "borrowed from the almost equally sick anti-Semitic Wagner."[318] Jewish activist and prolific writer on anti-Semitism, the late Robert Wistrich, likewise proposed that: "Wagner's essentially racist vision of Jewry would have a profound influence on

German and Austrian anti-Semites, including the English born Houston S. Chamberlain, Lanz von Liebenfels, and above all on Adolf Hitler himself."[319]

This widely accepted notion of a direct intellectual line of descent from Wagner to Hitler has, however, been challenged by historians like Richard Evans who points out that "the composer's influence on Hitler has often been exaggerated," and that while Hitler "admired the composer's gritty courage in adversity," he "did not acknowledge any indebtedness to his ideas."[320] Magee likewise maintains that "if one studies the intellectual development of the young Hitler one finds no evidence that he got any of his anti-Semitism from Wagner..."[321] While Evans and Magee slightly overstate their case, they are right to attempt to put the issue of Wagner's influence on Hitler into a more rational perspective.

Wagner's intellectual influence on Hitler was mainly secondhand through his son-in-law Houston Stewart Chamberlain, who developed some of Wagner's ideas in his bestselling 1899 book *The Foundations of the Nineteenth Century*, which did influence Hitler's ideas on race and the Jewish Question. The man who founded the library at the National Socialist Institute in Munich, Friedrich Krohn, compiled an inventory of the titles borrowed by Hitler between 1919 and 1921. The four page list contains over a hundred entries. Listed alongside Chamberlain's *Foundations of the Nineteenth Century* is the German translation of Henry Ford's *The International Jew: The World's Foremost Problem*, and condensations of titles such as *Luther and the Jews, Goethe and the Jews, Schopenhauer and the Jews,* and *Wagner and the Jew.* Clearly Hitler had some exposure to Wagner's anti-Jewish writing.[322] It is also clear that Hitler read and greatly admired Wagner's autobiography, and the title of his book *Mein Kampf* (My Struggle) was conceivably modeled on Wagner's *Mein Leben* (My Life).[323] According to German historian Guido Knopp, "It was not just the title, but also one of the key sentences, that Hitler copied from Richard Wagner. Just as the composer has written in *Mein Leben*: 'I decided to become a composer,' so did the prisoner [Hitler] now write: 'I decided to become a politician.'"[324]

In his book *Hitler's Private Library: The Books That Shaped His Life*, Timothy Ryback notes that among the books that found their way into Hitler's vast private collection was a biography of Wagner by Chamberlain entitled *Richard Wagner: The German as Artist, Thinker, Politician*.[325] This book contains only a few minor references to Jews. In 1933, Hitler received a volume entitled *Wagner's Resounding Universe* which was inscribed by its author, Walter Engelsmann, to "the steward and shaper of the descendants of Siegfried upon the earth."[326] Among the books found in the bunker complex after the fall of Berlin in 1945 was a 1913 treatise on Wagner's *Parsifal*.[327] Wagner's ideas clearly exerted some influence on Hitler's intellectual development. However, just three known volumes on Wagner (with none by Wagner himself) out of an estimated 16,000 books in Hitler's collection at the time of his death, hardly suggests Wagner's intellectual influence was "profound."

There is certainly no evidence to support the extravagant claim of Joachim Fest in his biography of Hitler that: "Wagner's political writing was Hitler's favorite reading, and the sprawling pomposity of his style was an unmistakable influence on Hitler's own grammar and syntax." Fest even ventured to claim that Wagner's "political writings together with the operas form the entire framework of Hitler's ideology," and that in these he "found the granite foundation for his view of the world."[328] This assessment of Wagner's influence on Hitler is utterly rejected by Jonathan Carr in his 2007 book *The Wagner Clan*. Carr makes the point that:

> If Wagner's works really were "the exact spiritual forerunner" of Nazism, surely the Fuhrer of all people would have drummed that point home ad infinitum. But one looks to him in vain not only for fascist interpretations of the music dramas but, stranger still, for direct references to the theoretical writings. There is, indeed, surprisingly little evidence that Hitler read Wagner's prose works, though he evidently did borrow some from a library before he rose to power and the wording of some of his speeches indicates that he imbibed at least *Das Judentum in der Musik*.

Why then did he not use the Master more clearly as an ally, especially in his anti-Semitic cause? In *Mein Kampf*, for instance, he notes that his early hostility to Jews owed much to the example set by Karl Lueger, the anti-Semitic mayor of Vienna. He also praises Goethe for acting according to the spirit of "blood and reason" in treating "the Jew" as a foreign element. He pays no similar tribute to the Master, indeed he only mentions Wagner by name once in the whole book (although he refers elsewhere to the "Master" of Bayreuth).[329]

In one of three brief references to Wagner in *Mein Kampf*, Hitler reflects on his early experiences attending Wagner's operas: "I was captivated. My youthful enthusiasm for the Bayreuth master knew no limits. Again and again I was drawn to hear his operas, and today it still seems to me a great piece of luck that these modest productions in a little provincial city prepared the way and made it possible for me to appreciate the better productions later on."[330] Among the "great men" in history that Hitler singled out in *Mein Kampf* were Luther, Frederick the Great, and Wagner. He praised Wagner as a "combination of theoretician, organizer, and leader in one person" which he regarded as "the rarest phenomenon of this earth. And it is that union which produces the great man."[331]

Despite the paucity of evidence for Wagner having exercised the high level of intellectual influence on Hitler that is widely alleged, for the Jewish music writer David Goldman, Wagner's name is eminently worthy of execration on the basis that he "mixed the compost heap in which the flowers of the twentieth century's greatest evil took root." According to Goldman:

The Nazis embraced Wagner not by accident or opportunism but because they recognized in him the cultural trailblazer of the world they set out to rule. ... Wagner may not have been the only anti-Semite among the composers of the 19th century, nor even the worst, but he did more than anyone else to mold the

culture in which Nazism flourished. The Jewish people have had no enemy more dedicated and more dangerous, precisely because of his enormous talent. In a Jewish state, the public has a right to ask Jewish musicians to be Jews first and musicians second. With reluctance, and in cognizance of all the ambiguities, I think the Israelis are right to silence him. [Goldman here refers to the unofficial ban on performances of Wagner's music in Israel][332]

For Goldman, Hitler's intellectual debt to Wagner and the "proto-Nazi" nature of Wagner's music dramas are unambiguous. Magee questions the idea that Wagner's works inherently support National Socialist notions of heroism, and notes that Wagner's last opera *Parsifal* (frequently cited as Wagner's most "racist" opera) was denounced by the regime in 1933 for being "ideologically unacceptable" and was not performed at Bayreuth during the war.[333] Moreover, while Wagner's music and operas were frequently performed during the Third Reich, his popularity in Germany actually declined in favor of Italian composers like Verdi and Puccini. In the theatrical year in which Hitler came to power, 1932-33, there were 1,837 separate performances of operas by Wagner in Germany. The number of performances then went steadily down until, by 1939-40, they were less than two-thirds of that figure, 1,154.[334] Evans notes that by the 1938-39 opera season, Wagner had only one opera in the top fifteen most popular operas of the season, with the list being headed by Leoncavallo's *Pagliacci*.[335]

It is well known that the Berlin Philharmonic's last performance prior to their evacuation from Berlin in April 1945 was of a scene from the conclusion to Wagner's *Götterdämmerung* to an audience that included Speer, Dönitz and Goebbels. Likewise, when the Reich Radio announced Hitler's death, the funeral march from *Götterdämmerung* was played. With these events in mind, Wagner's music has been used in countless Third Reich documentaries – in the process consolidating the misleading impression that Wagner's music was uniquely bound up with the cultural politics of the National Socialist state.

It is clear that the supposed National Socialist fascination with Wagner, to the extent it genuinely existed, was mostly Hitler's inspiration. Hitler's boyhood friend, August Kubizek, noted in his book *The Young Hitler I Knew* that what made the young Hitler so receptive to Wagner's operas was not the composer's political outlook, but rather Hitler's own "constant, intensive preoccupation with the heroes of German mythology," and Wagner's ability to translate "his boyish dreams into poetry and music" which satisfied "his longing for the sublime world of the German past."[336] Kubizek writes that: "Listening to Wagner meant to him not a simple visit to the theater, but the opportunity of being transported into that extraordinary state which Wagner's music produced in him, that trance, that escape into a mystical dreamworld which he needed in order to sustain the enormous tension of his turbulent nature."[337]

Kubizek describes the time they first went to a Wagner opera together. "We were shattered by the death of Rienzi," he writes of that fateful evening in 1906, "and although Hitler would usually begin to talk immediately after being moved by an artistic experience, and to voice sharp criticism of the performance, on this occasion Adolf remained silent for a long time." Rienzi was a Roman who rose to be tribune of the people but was then betrayed and died within the ruins of the Capitol. Kubizek described how his friend suddenly announced with "grand and thrilling images," how he would lead the German people "out of servitude to the heights of freedom."[338] According to Kubizek, Hitler's decision to become a politician "was seized in that hour on the heights above the city of Linz," when "in a state of complete ecstasy and rapture," he transferred the character of Rienzi "to the plane of his own ambitions."[339] Describing that fateful night to Winifred Wagner in 1939, Kubizek claims that Hitler solemnly declared "In that hour it began!"[340]

Hitler heard *Tristan and Isolde* at least thirty or forty times during the Vienna phase of his life. At one stage, he even wrote a brief sketch for a Wagner-style opera entitled *Wieland the Smith*. Gretl Mitlstrasser, the woman who managed the daily running of the Berghof "recounted

numerous stories of Hitler's private 'communing' on the property...
when he held late-night vigils on the Berghof balcony, watching the
Untersberg bathed in moonlight; when he let the ethereal strains of
Wagner's *Lohengrin* fill his study as he watched the jagged cliffs peek
through the enfolding mists."[341] Hitler had a bust of Wagner by Arno
Breker in his private quarters, and in his table talk once claimed that
"when I listen to Wagner I hear the rhythms of a bygone world."[342]

In the 1920s, Hitler became a friend of Wagner's children and
grandchildren, and particularly of his English-born daughter-in-law
Winifred, who joined the NSDAP in 1926, and who proposed marriage
to him. She later wrote that: "The bond between us was purely human
and personal, an intimate bond founded on our reverence and love for
Richard Wagner."[343] In the summer of 1933 she found that hundreds
of foreign ticket reservations for that year's Bayreuth Festival had been
cancelled, threatening its financial viability. Lieselotte Schmidt, a close
friend of Winifred, noted at the time that: "We have been frozen into
isolation. The hate campaign against Bayreuth, which is at root of
purely Jewish origin, stops at nothing in its lies and unpleasantness."
When the matter came to Hitler's attention, he summoned Winifred to
Berlin, and Schmidt noted that: "She flew there, and within a quarter
of an hour we had the necessary help – and how!" The festival was
made exempt from all taxes during the Third Reich, and Hitler donated
50,000 Reichsmarks of his own money for each new production.[344]

Evans points out that Hitler's personal patronage meant that "nei-
ther Goebbels nor Rosenberg nor any of the other cultural politicians
of the Third Reich could bring Bayreuth under their aegis."[345] Winifred
Wagner and the managers of the Festival were "granted an unusual
degree of cultural autonomy" by Hitler, and Knopp states that "It is a
fact that even the Bayreuth productions during the Nazi era hardly dis-
play any evidence of distortion for propaganda reasons."[346] Hitler was a
regular guest at the Bayreuth festivals between 1933 and 1939, and on
his fiftieth birthday Winifred arranged for him to be presented with the
manuscript draft to Wagner's *Rienzi* and original scores of *Das Rhein-
gold* and *Die Walküre*, as well as a sketch for *Götterdämmerung*.[347]

When considering Wagner's posthumous relationship with the National Socialists, we need to draw a clear distinction between Hitler as an individual and the Third Reich as a regime. Magee is careful to do so, and notes that:

> It was not the case that the Nazi regime in general was devoted to Wagner, or did anything to promote his works. Many people nowadays write and talk as if Wagner provided a sort of soundtrack to the Third Reich, and that on organized party occasions there was always, or usually, Wagner. This conception has become a cliché on film and television, where it is usual for any depiction of the Nazis to be literally accompanied by Wagner's music, for preference at its most brassy and bombastic, as in the Ride of the Valkyries or the Prelude to Act III of *Lohengrin*, and played very loud. The whole picture that this conjures up, and is meant to conjure up, is false.

Supporting this thesis, Evans maintains that there was a "lack of interest" in Wagner "on the part of almost everyone in the Party leadership except Hitler himself..."[348] In 1933, Hitler ordered that each Nuremberg Rally would open with a performance of *Die Meistersinger*, though these performances were very unpopular with other Party functionaries who had be ordered to attend. Evans notes that when Hitler "entered his box he found the theater almost empty; the party men had all chosen to go off to drink the evening away at the town's numerous beer halls and cafes rather than spend five hours listening to classical music. Furious, Hitler sent out patrols to order them out of their drinking-dens, but even this could not fill the theater. The next year was no better. ... After this Hitler gave up and the seats were sold to the public instead."[349]

While Joseph Goebbels seems to have shared some of Hitler's affinity with Wagner, and often visited Bayreuth, his diaries reveal no special insights into Wagner's works or ideas, and nor do his public speeches. He praised *Die Meistersinger* as "the incarnation of all that is German." It contained everything "that defines and fulfills the cultural soul of

Germany."[350] The 1933 Bayreuth Festival was opened by Goebbels with the words: "There is probably no work so close in spirit to our age and its intellectual and psychological tensions as Richard Wagner's *Die Meistersinger*. How often in recent years has its rousing chorus, '*Wacht auf, es nahet gen dem Tag*' (Awake for morn approaches), echoed the faith and longing of Germans, as a tangible symbol of the reawakening of the German people from the deep political and spiritual slumber coma of 1918."[351]

Albert Speer, Hitler's personal architect, and later also his armaments minister, was another Bayreuth regular ostensibly motivated more by duty than genuine interest. He notes in his memoirs that Hitler often discussed Wagner with Winifred and seemed to know what he was talking about. Evidently Speer did not know enough to be sure.[352] For the leading ideologist of the party, Alfred Rosenberg, the real National Socialist musical model was Beethoven who "took fate by the throat and acknowledged force as the highest morality of man... Whoever understands the essence of our movement knows that there is a drive in us all like that which Beethoven embodied to the highest degree." While he also believed Wagner embodied the strength of the "Nordic soul," Rosenberg criticized the composer's *Gesamtkunstwerk* approach, noting that "the inner harmony between word content and physical content is often hindered by the music... An attempt to wed these forces destroys spiritual rhythm and prevents emotive expression."[353]

Rosenberg was certainly not alone in his view. The general manager at Bayreuth during the Third Reich, Hans Tietjen, made the point after the war that "In reality, the leading party officials throughout the Reich were *hostile* to Wagner... The party tolerated Hitler's Wagner enthusiasm, but fought, openly or covertly, those who, like me, were devoted to his works – the people around Rosenberg openly, those around Goebbels covertly."[354] Aside from the hostility to Wagner grounded in aesthetics and ideology, Carr makes the more general point that:

> The truth is that many Nazis, in high and low places, were bored to tears by Wagner. There is nothing very odd about that. Lots

of people past and present who may well have a certain interest in other music will run a mile to escape a seemingly interminable evening with the Master. Too few tunes, too many scenes in which people stand about for ages apparently doing nothing much. The point is only worth stressing here because the Nazis are reputed to have had a special affinity to Wagner's music. The evidence suggests this was simply not so.[355]

It has been sometimes alleged that Wagner's music provided a "soundtrack to the Holocaust" and was played at concentration camps during wartime. The German historian Guido Fackler claims that Wagner's music was sometimes used at the Dachau concentration camp in 1933 and 1934 to "reeducate" political prisoners through the beneficial exposure to nationalistic music.[356] There is, however, no documentary evidence supporting claims that Wagner's music was used in this way during the war. Larry David mocked this urban legend (and the unhealthy Jewish obsession with Wagner) in an episode of *Curb Your Enthusiasm* where he is rebuked by a Jewish stranger for whistling a Wagner tune in the street.[357]

## Conclusion

The ethno-political motivation that underpins the construction of Richard Wagner as moral pariah is exemplified by the contrasting way that Jewish commentators have reflected on the life and legacy of the Jewish composer Hanns Eisler who once declared Wagner to be "a great composer, unfortunately." A committed Marxist, Eisler began in 1930 a long-standing collaboration with the poet and playwright Bertolt Brecht. With Hitler's ascent to power, Eisler left Germany and eventually settled in Hollywood, where he was nominated for Oscars for writing the music for the films *Hangmen Also Die* (1942) and *None but the Lonely Heart* (1944). In 1947, Eisler appeared before the Un-American Activities Committee, and despite the intercession of Albert Einstein, Aaron Copland and Leonard Bernstein, was deported to East Germany

in 1948 where he remained for the rest of his life, writing music for the totalitarian state (including its national anthem, and the Comintern anthem). Eisler collaborated with T.W. Adorno in 1947 to produce the book *Composing for the Films*. Instead of reproaching Eisler for his ardent commitment to a regime and ideology that destroyed millions of lives, Jewish commentators invariably portray him as the innocent victim of the anti-Semitism of the Third Reich, and then of the HUAC hearings and the Hollywood blacklist.

The Jewish-dominated intellectual and media elite eagerly invoke Wagner's life and legacy as a salutary lesson in the evils of anti-Semitism and European nationalism. Constructing Wagner as moral pariah allows the composer and his works to be constantly used as a springboard for intensive reflections on "the Holocaust," the evils of white racial feeling, and the moral necessity of state-sponsored multiculturalism and non-White immigration to the West. Only these policies, after all, will ensure that Wagner's "morally loathsome" intellectual legacy (which amounts to a proposal for a European group strategy in opposition to Judaism) can never again find a receptive White audience – by progressively doing away with White people altogether.

In the meantime, the construction of Wagner as an anti-Semitic exemplar and moral pariah ensures the composer, whose achievement far surpasses that of any Jewish composer, can never become a locus of White racial pride and group cohesion. Richard Wagner has been a particular target for Jewish denigration because of his strong and un-ashamed ethnic and racial identification and his willingness to publicly oppose Jewish influence. This, together with his status as one of the most stupendous musical geniuses that the world has ever seen, endows him with rich potential to re-emerge as a rallying point for White Nationalists. The rebirth of a strong sense of racial feeling among White people will be greatly aided by reclaiming cultural heroes like Richard Wagner from the manufactured taint of moral censure that distorts their popular remembrance.

# CHAPTER 7

# Jewcentricity

Adam Garfinkle is the founding editor of *The American Interest*, a bimonthly magazine focused on politics, culture, and international affairs. He served as speechwriter for Secretaries of State Colin Powell and Condoleezza Rice, and has taught at John Hopkins University, the University of Pennsylvania, Haverford College, and Tel Aviv University. Garfinkle's 2009 book *Jewcentricity: Why the Jews Are Praised, Blamed, and Used to Explain Just About Everything* is touted as an examination of "the various roles Jews are imagined to play on the world stage that they do not, in fact, actually play."[358] Garfinkle's basic thesis is that the ideas people have about Jews – both pro-Jewish and anti-Jewish – tend to be wildly exaggerated and often stray outside the bounds of rational thought. *Jewcentricity* is supposedly the author's attempt to offer a reasoned corrective to this phenomenon and to set the record straight.

*Jewcentricity* has a four part structure. Garfinkle identifies and analyses the positive and negative "Jewcentricity" he sees manifested among Jews and non-Jews, highlighting, along the way, the various exaggerations that supposedly distort the truth about Jews and their interactions with others. These various exaggerations are said to bounce off and reinforce each other, with the author claiming that the "four forms of Jewcentricity across our two-by-two matrix need and feed one another."[359] While *Jewcentricity* is offered as a dispassionate survey of

the interactions between Jews and non-Jews, it is, unsurprisingly (given that Garfinkle is Jewish), centrally preoccupied with the evils of anti-Semitism.

For Garfinkle, anti-Semitism (or "negative gentile Jewcentricity" as he conceptualizes it in his book) is not an easy term to define. "Not only is the subject fraught with emotion, but it is one that has been dissected and argued over by historians, psychiatrists, sociologists, philosophers, and armchair moralists for centuries... The consensus among scholars is that anti-Semitism can be defined as 'the irrational hatred of Jews.'" Garfinkle admits such a definition presupposes the possibility of a "rational" hatred of Jews, noting that:

> Jews can be pushy, clannish, arrogant, ostentatious and boastful to the point of producing irritation in others. That makes it possible to dislike Jews as individuals or as a group, even if disliking whole groups is not politically correct these days (or indicative of refined character in any days). It may be ignorant, mean-spirited, and small-minded, or it may just be a matter of taste. It may be all that and still not be irrational in the sense that psychiatrists use the term.[360]

Nowhere in his book does Garfinkle make the obvious and foundational point that anti-Semitism stems from conflicts of interests between Jews and non-Jews in a Darwinian world. The assertion by Jews of their ethnic interests (Semitism) inevitably leads to resentment and hostility from those whose interests are thereby compromised (so-called anti-Semitism). To admit this basic truth is to admit that non-Jews (including White people) have interests that are legitimate, and the desire to resist those opposed to our interests is eminently rational. Yet, while admitting that disliking Jews may "not be irrational," Garfinkle quickly sets this aside and proceeds to argue that "anti-Semitism is something different. It goes beyond mere dislike. It is a kind of disease of the mind."[361]

This attribution of psychopathology to critics of Jews has a venerable intellectual pedigree among Jewish intellectuals and activists. One is, for example, reminded of the collective Jewish response to Richard Wagner's critique of Jewish influence on German art and culture in the mid-nineteenth century, where he was branded a "sexual psychopath" who had "chronic megalomania, paranoia, and moral derangement." Garfinkle is happy to offer up the kind of spurious Freudian diagnoses of "anti-Semites" that were a Jewish stock in trade throughout the twentieth century. For example, he proposes that critics of Jews frequently "postulate Jewish conspiracies that are, in fact, mirror images of their own conspiratorial delusions."[362]

Of particular concern to Jewish activists are individuals who, like Richard Wagner, are of high intellectual or social standing, yet also critical of Jews:

> The anti-Jewish prejudices of creative individuals – T.S. Eliot and Ezra Pound, for example – are hurtful to Jews because intelligent people are supposed to know better. ... The power of educated and well-regarded anti-Semites resides in their ability to elevate latent tendencies toward bigotry to the point of being socially acceptable. Anti-Semitic leaders norm hatred; they are catalysts that join cultural bias to the impulse for scapegoating in troubled times.[363]

Garfinkle suffers from his own form of "Jewcentricity" (Jewish hyperethnocentrism) in failing to note how the anti-White prejudices of leading Jewish intellectuals and producers of culture (e.g., the Frankfurt School intellectuals, Hollywood writers and directors) are hurtful to White people because intelligent people are supposed to know better. Jews (and their non-White and sexual minority proxies) ostensibly have a monopoly on hurt feelings. He likewise fails to note that the power of educated and well-regarded Jewish intellectuals resides in their ability to norm hatred against Whites (negative Eurocentricity) and make latent tendencies toward anti-White hatred socially acceptable.

The "negative Jewcentricity" of non-Jews is especially galling, according to Garfinkle, because for eighteen hundred years Jews have been the helpless victims of non-Jewish (and particularly European and Christian) injustice, and never oppressors of others. Indeed the author approvingly quotes the "redoubtable Israel Zangwill" who claimed the Jew is "the great misunderstood of history," and argues that:

> Jews have been talented flotsam on the waves of history, usually managing not to sink and learning how to swim, but never controlling the currents or the weather. This is why the gentile purveyors of Jewcentricity are so annoying: they invert, utterly and completely, what has been most true about Jewish social and political life for the past eighteen hundred years – its helplessness. To construe a more or less successful response to a condition of helplessness as a plot to control the world is, well, crazy.[364]

Nowhere in his book does Garfinkle mention the many historical instances where Jews have dominated and ruthlessly exploited Europeans for their own benefit – and were expelled 109 times as a consequence. From Biblical times onwards, Jews have endeavored to enslave and dominate other peoples. In Europe in the Middle Ages, Jews were seen as "pitiless creditors" and the philosopher Immanuel Kant famously observed that Jews were "a nation of usurers... outwitting people amongst whom they find shelter. ... They make the slogan 'let the buyer beware' their highest principle in dealing with us."[365] The author of *Jewcentricity* is likewise silent on the enthusiastic Jewish participation in the Bolshevik mass-murder of millions of Eastern Europeans. To Garfinkle, "negative Jewcentricity" has nothing to do with Jewish behavior, but is the product of the irrationality of non-Jews who conjure wild anti-Semitic exaggerations and conspiracy theories out of their lurid imaginations.

Garfinkle characterizes any suggestion that hostility toward Jews stems from very real conflicts of interest as a manifestation of "postmodern anti-Semitism." Surveying the supposedly long and lachrymose

history of Europe's persecution of Jews, he claims that, following on from the religious anti-Semitism of pre-Enlightenment Europe, and the racially-based anti-Semitism of the nineteenth and early twentieth centuries, we have reached the "postmodern" stage of anti-Semitism.

> The third stage is the postmodern, explicitly political stage in which we live today. The irrational hatred of Jews as a group does not identify religion or race alone as the source of Jewish "crimes" but focuses instead on material and political power; the Jews are evil not because they rejected and killed Christ, or because they have inferior "blood," but because they conspire to steal power from others and live parasitically on established, "normal" communities for purposes of their own aggrandizement. They pose as people like any other, but they are not, and Zionism is the singularly deceptive and evil garb by means of which Jews plot to execute their avaricious deeds.[366]

So when criticism of Jewish behavior focuses on Jewish "material and political power" it necessarily strays outside the boundaries of rational discourse and becomes "anti-Semitic." It is, therefore "anti-Semitic" to point out that Jews have enormous financial and political power relative to their numbers – an obviously factual statement. This presupposes that Jews in the United States, and throughout the West, have *not* obtained formidable financial and political power, and have *not* used this to further Jewish interests. It also presupposes that Jews have never, and do not today, "pose as people like any other" in order to conceal their Jewish origins and loyalties. These assertions are patently false, and are openly contradicted by Garfinkle himself in other parts of *Jewcentricity*. For example, in discussing the financial resources and political power of America's Jewish activist organizations, he points out that:

> Over the last forty or so years, the clout of organized American Jewry has risen meteorically. Professional Jews have been able to tap into large sums of money, talented executives, and growing

and dedicated staffs to influence a vast array of public policy issues. They have grown fast, AIPAC being an excellent example. In the early 1950s it was a three-person office operating on a shoestring budget; twenty-five years later it had a staff of around 150 and a multimillion-dollar budget. Not only have Jewish American organizations amassed clout on matters relating to Israel, but Jewish organizational muscle has been flexed in the face of the Soviet Union and Communist Romania, on immigration and asylum policy, on trade policy, and on human-rights issues involving Haiti, Rwanda, and, more recently Darfur. Jewish "professional" political clout, augmented by a larger-than-proportional number of Jewish senators and representatives, has also influenced many domestic issues.[367]

By his own definition, this factual statement by Garfinkle would be regarded as "anti-Semitic" in describing how "the clout of organized American Jewry" has "risen meteorically" through tapping "into large sums of money" to influence "a vast array of public policy issues." Garfinkle casually mentions that Jewish activist organizations have flexed their political muscle "on immigration and asylum policy" without mentioning the transformative demographic consequences of this influence – in particular from the passing of the 1965 immigration laws in the United States, and successfully lobbying for immigration reform in other Western nations (e.g., ending the White Australia policy). Jews have been, and continue to be, the intellectual and financial backbone of the left (and neoconservative right) throughout the West. They have effectively hijacked the demographic destiny of nations in their own ethnic interests, and Europeans and European-descended people are in real danger of losing demographic control of their historical homelands as a result.

Garfinkle also fails to mention the role of Jewish activist organizations in pushing for desegregation in the United States, and the horrific Black on White violent crime epidemic that has followed in its wake. Instead he notes how Jews take "genuine pride in the roles Jews played

in the civil rights movement," including figures like Rabbi Abraham Joshua Herschel who "marched many times with Martin Luther King Jr., and they know many freedom riders were Jews, including a few who gave their lives for the cause in Mississippi." With these events in mind, Garfinkle observes that: "Many Jews therefore feel a special bitterness at post-Black Power anti-Semitism, which need not be exaggerated to be noted."[368]

Paradoxically, given that he repeatedly denies that Judaism has any firm racial or ethnic basis, Garfinkle freely admits that these Jewish activist organizations are wholly concerned with advocating for policies that serve Jewish ethnic interests.

> The main mass-membership advocacy organizations of American Jewry – B'nai B'rith and its Anti-Defamation League (ADL), the American Jewish Congress, the American Jewish Committee, the Council of Jewish Federations and Welfare Funds, the National Conference of Jewish Federations, and the Conference of Presidents of Major Jewish Organizations (a kind of steering group for the major organizations), to mention only a few – are not religious organizations but ethnic ones. It is not necessary to have any Jewish religious affiliation to be a member in good standing in these organizations, and their leaderships are composed mainly of people who are not religious or Jewishly learned Jews.

> We need not go into foundational texts and statements of purpose on the question of origins, for the answer is simple enough: organizations like B'nai B'rith and the American Jewish Committee were created to lobby for particular Jewish interests – in the latter case, for example, against a trade agreement with Russia in 1905 because of Russian anti-Semitism. The American-Jewish Joint Distribution Committee came into being to aid Jewish war refugees after World War I. The United Jewish Appeal came into existence in 1938 to help Jews trapped in Europe.

In time, these and most other Jewish organizations became explicitly or implicitly Zionist, and thereafter existed to one degree or another to support, first, a Jewish home in Palestine, and then, after 1948, the security and prosperity of the State of Israel. In other words, all these organizations have depended, and still depend, on the validity of their *serving parochial Jewish ethnic interests that are simultaneously distinct from the broader American interest but not related directly to religion.* [Emphasis added][369]

Garfinkle should have added that these organizations serve parochial Jewish ethnic interests that are simultaneously distinct from and, particularly with regard to mass non-White immigration, multiculturalism, and American foreign policy in the Middle East, *entirely contrary to* the interests of the White American majority. This statement by Garfinkle is a tacit admission that Jewish activist organizations are contemporary manifestations of Judaism as a group evolutionary strategy – they serve the interests of ethnic Jews regardless of religious affiliation or observance. Given the political power that has been exercised by these organizations in lobbying for policies contrary to the interests of White Americans, is it any wonder that increasing numbers of politically-aware Whites are critical of organized Jewry?

Garfinkle makes the observation that anti-Semitism has been far less of a problem for Jews who have resided in nations and societies characterized by heightened individualism – with the United States being the conspicuous example:

Another factor affecting the nature of anti-Semitic manifestations is cultural in a deeper sense. Some societies value individualism more than communalism, some the other way around. In most Western societies, and in American society in particular, the ethos at large sees each individual as a free and autonomous agent, so conformist behavior is less frequent and extreme than in societies in which hierarchy and communal norms prevail. On the other hand, communally-oriented societies tend to have

stronger control mechanisms against antisocial behavior. The result is that individualistic societies tend to produce outlaws and one-off weirdos, while hierarchical or communal-oriented societies are better at producing mobs. Mobs are better suited for enabling anti-Semitic policies and attitudes. It is no accident that fascism set deeper roots in more communally-oriented European societies – Germany, Italy, and Spain – than in the more individualistic ones like Britain, Holland and the Scandinavian countries.[370]

The defining feature of Jewish history has been that group interests, rather than individual interests, have been of primary importance. Judaism is the preeminent historical example of how the rejection of individualism (especially in the sociobiological niche of the Diaspora) leads to group evolutionary success (i.e., genetic continuity across millennia). Garfinkle's observation is quite correct, and in it resides the origins of the Frankfurt School's promotion of radical individualism as the epitome of psychological health for Europeans. The sane and well-adjusted White person was characterized by these Jewish intellectual activists as someone who had broken free from the traditional Western moral code, and who realized their human potential without relying on membership in collectivist groups (or "mobs" as Garfinkle describes them). This promotion of radical individualism among non-Jews was, of course, intended to undermine the group cohesion of Europeans and thereby weaken their capacity to compete effectively with Jews.

That heightened individualism within a society is advantageous for a small outgroup like the Jews explains the extensive Jewish intellectual and political involvement in libertarian movements. Jews have, of course, played an equally prominent role as intellectuals and activists in socialist movements, which, while not promoting individualism, have sought to substitute European racial and ethnic collectivisms with a transracial class collectivism (and humanitarianism) which also serves Jewish interests. Garfinkle notes that Jewish prominence in socialist and communist movements was a response to "rising romantic nationalism"

throughout Europe, which was "often associated with racial-purity dogmas and heavily tinged with anti-Semitism."[371]

Garfinkle claims that much "negative Jewcentricity" is based on the incorrect assumption that Jews comprise a distinct race or ethnic group. Despite the existence of an extensive body of population genetic evidence to the contrary, he claims to reject the idea that Jews comprise "a bloodline phenomenon." He writes:

> Jews are not a race, however, and not "just" a religion. As we have seen, Jews are a people formed around the core ideas of a religious civilization. But in light of the unusual transterritorial history of the Jews, it is not hard to see how others might be confused by a modern identity that has come to conflate religion and national identity, as in a kind of identity double helix, like few if any others. … "Religion" and "race" are modern categories: Judaism's identity formula does not accord with taken-for-granted divisions between citizenship and ethnicity. … Jews are not a race, even though there is some genetic continuity among contemporary Jews, and Jews are not a religious group if by that phrase one means an entirely elective self-selected group of believers. Jews are a hybrid of the two, a people based on a religious civilization.[372]

This doublespeak is utterly refuted by population genetic studies that have clearly established that Jewish groups do comprise a distinct genetic cluster. The idea that Judaism is not a group evolutionary strategy (implicit in claims Judaism is solely or even primarily a religion), cannot be credibly sustained in the light of studies, such that by Atzmon et al. from 2010, which confirmed that Jews *are* a distinct genetic community. This study examined genetic markers spread across the entire genome, and showed that Jewish groups (Ashkenazi and non-Ashkenazi) share large swaths of DNA, indicating close relationships, and that while each Jewish group in the study (Iranian, Iraqi, Syrian, Italian, Turkish, Greek and Ashkenazi) had its own genetic signature, each was more closely related to the other Jewish groups than to their

non-Jewish countrymen. They found that the SNP markers in genetic segments of 3 million DNA letters or longer were 10 times more likely to be identical among Jews than non-Jews, and that any two Ashkenazi Jewish participants in the study shared about as much DNA as fourth or fifth cousins.[373]

It's certainly not hard to find Jews willing to concede the racial nature of traditional Judaism, such as the late historian Norman Cantor who noted that: "Racism is itself a central doctrine in traditional Judaism and Jewish cultural history. The Hebrew Bible is blatantly racist, with all the talk about the seed of Abraham, the chosen people, and Israel as a light to the other nations. Orthodox Jews in their morning prayers still thank God daily that he did not make Jews 'like the other peoples of the earth.' If this isn't racism, what is?"[374] Garfinkle rejects this assessment, and contends, contrary to a welter of population genetic studies (although, to be fair, several of these came out after the publication of *Jewcentricity*), that Jews are not a race. Indeed he is outraged at any attempt to "construe modern Jewish nationalism to be a form of racism," indignantly labelling it an anti-Semitic "canard."

> Obviously, not all anti-Israel criticism qualifies as anti-Semitism, any more than all dislike of Jews qualifies as anti-Semitism. But the Zionism-is-racism canard, as well as the delegitimation rhetoric based on the "religion" canard [i.e., noting the lack of archeological evidence to support the Biblical account of Jewish history], are examples of anti-Semitism because they are never raised against any other country or people. If Zionism as a national movement of the Jewish people is inherently racist, then German nationalism, Japanese nationalism, and a dozen other ethnic-based nationalisms are racist, too. Indeed, bloodlines have played a far more obvious role in defining citizenship in these and other cases than it has in Israel.

> Until fairly recently, German citizenship laws were such that Turks living in Germany for generations could not become

citizens, while Volga Germans could acquire instant German citizenship upon request by proving that at least one German grandparent was of German blood. In Japan, Koreans who have been resident in the country for even five, six, or seven generations are not allowed to become citizens. Yet no one who focuses energy on delegitimizing Israel on racist grounds ever talks about Germany or Japan.[375]

Few on the Dissident Right quibble with Israel's desire to establish a Jewish ethnostate and to safeguard this through a restrictive immigration policy. This is only natural. What they desperately resent is that the same people who affirm Israel's right to exist as a "Jewish state" deny the moral legitimacy of Western nations to follow the same path through defining their national identities in racial or ethnic terms. Furthermore, it is an undeniable fact that Jews have been at the forefront of political efforts throughout the West to promote the de-Europeanization of Western nations through lobbying for mass non-White immigration and multiculturalism. Garfinkle also fails to mention that Jewish intellectual activism, in the form of scientifically fraudulent Boasian notions of racial equality (doubtless in conjunction with actual Jewish lobbying), were among the key reasons Germany abandoned its traditional blood-based citizenship laws.

The overarching proof that Judaism is not a blood phenomenon, according to Garfinkle, is right before the eyes of anyone who cares to look. "If Zionism and Israeli citizenship are based on a bloodline concept of nationalism, then it would follow that the Jewish citizens of the State of Israel today would form a fairly homogeneous population from a strict genetic perspective. The reverse is true, however; Israeli Jews make up one of the most genetically diverse populations on earth."[376] Geneticists who have conducted population genetic studies of Jews beg to differ. Garfinkle, while acknowledging some genetic commonality among Jews, argues that because Judaism technically accepts converts, it has nothing to do with blood:

In their *London Review of Books* essay, Mearsheimer and Walt claim that Israeli citizenship rests "on the principal of blood kinship." As we have seen, this misrepresentation is a staple of modern racialist anti-Semitism and all of the anti-Zionist covers for it, including the "Zionism is racism" canard of the United States General Assembly. And it is flatly false. To repeat: one cannot convert to become a German or a Japanese or a Kurd. Those nationalisms and many others are based on a principle of blood kinship. But anyone who has converted to Judaism according to Jewish law can claim citizenship under Israel's "right of return," and many have done so. It has *nothing to do with blood*.[377]

While Garfinkle's argument has a surface validity, in practical terms it is false. He fails to mention that atheists of Jewish ancestry are fully entitled to Israeli citizenship. Moreover, while the apparent Jewish acceptance of converts confers a veneer of seeming group permeability, conversion is such a marginal phenomenon as to be irrelevant. Judaism has long made "conversion" to Judaism an onerous process involving very high barriers to entry (to borrow from the lexicon of economics). To show just how marginal, and therefore irrelevant, the phenomenon of conversion to Judaism actually is, take the case of the United States. According to a 2014 survey by the Pew Research Center, Jews comprise 2.2 percent of the American population. Of this 2.2 percent only two percent are converts. In other words, non-Jewish converts to Judaism comprise just 0.0004 percent of the U.S. population. The percentage of this tiny population that is female and of child-bearing age is smaller still. The percentage of females of child-bearing age that actually have "Jewish" children is even smaller, and the percentage of these converts whose offspring are accepted as authentic Jews in the broader Jewish community is smaller still. These figures for the United States would be replicated throughout the Western world.

The reality is that the theoretical possibility of conversion to Judaism (while being of longstanding propaganda value to Jews) is such a marginal phenomenon as to be irrelevant. This truth of this assertion

is reflected in the findings of the numerous population genetic studies which confirm that Judaism *is* indeed a bloodline phenomenon, and *does* constitute a group evolutionary strategy. Of course, Judaism could still be a group evolutionary strategy even if Jews were not a genetically distinct group, providing Jews believed that they were, and behaved accordingly – which is exactly what they did believe and behave like for centuries, before modern population genetic studies confirmed what they had always assumed.

## Hollywood

In his book, Garfinkle laments the fact that "negative Jewcentricity" has often resulted from "exaggerated" claims that "Jews run Hollywood" and have subverted the traditional morality and social practices of the United States (and the broader West). He notes that:

> The best way to get at the subject is perhaps to briefly review some irrefutable facts about the entertainment-business culture in the United States. The first of those facts is, as already suggested, that this culture has been and remains disproportionately, overwhelmingly, even astonishingly Jewish. This does not mean that Jews "run" Hollywood. No one runs Hollywood, and besides, "the Jews" are not a monolithic group that gathers secretly somewhere just off Santa Monica Boulevard to plot the moral downfall of America. "The Jews run Hollywood," whether spoken by a Jew or a gentile, either in pride or anger, is a Jewcentric statement. It is a bald exaggeration.

> But Jewish prominence in Hollywood is a fact that impresses even when it is not exaggerated. The heads of nearly every major Hollywood production studio from the beginning were Jewish, as were many of the directors and not a small number of the cinematographers and actors. Jews have been only slightly less

prominent in the New York theater business for nearly a century, and in many aspects of popular music, as well.[378]

So, according to Garfinkle, it is wrong to say that "Jews run Hollywood" despite the fact that Hollywood is "disproportionately, overwhelmingly, even astonishingly Jewish." This argument hinges on a semantic distinction of no persuasive power whatever. Jews totally run Hollywood. If Jews did not control Hollywood, and, as some assert, it was run by corporations solely fixated on profits, we would see occasional unsympathetic portrayals of Jews and Judaism alongside the relentlessly unsympathetic portrayals of Whites (especially White men) and Christianity. The absence of such portrayals is definitive proof that Jews exercise editorial and creative control over Hollywood productions, and this control has been incredibly damaging to the interests of the White people.

If Hollywood was not controlled by Jews who use it to advance Jewish interests, while also generating vast revenues, then Hollywood studios would have enthusiastically lined up to finance and promote Mel Gibson's *The Passion of the Christ* – a film that generated over half a billion dollars in profits. Instead, Gibson was forced to finance and promote the film himself, and came under fire from Hollywood's Jewish establishment who feared the film would stoke anti-Semitism. Only one thing is more important than profits for a Jewish-dominated Hollywood, and that is serving Jewish ethnic interests through the construction of culture. Garfinkle is well aware of this, and admits that: "Everyone, even [Mel] Gibson, knows that many, even most, of the influential directors, producers, and agents in Hollywood, and in the bicoastal world of commercial television, are Jews," and that "It has been this way for a long time, too, although it was not so obvious several decades ago."[379]

In the first half of the twentieth century WASPs still controlled the commanding heights of American culture, and the American people were more ethnocentric and aware of (and antagonistic to) the subversive Jewish influence on American society. The Jewish challenge to the

cultural supremacy of the WASP elite (and America's once powerful Catholic lobby) had, therefore, to conceal itself for fear of prompting an anti-Jewish backlash. Garfinkle notes "many Jews used to change their names to fit in better with the American mainstream,"[380] and that:

> Show-business Jews and Judaism were discussed mostly in undertones in the years before and just after World War II, and very few were portrayed as Jews in Hollywood fare or on the radio – an informal taboo broken in 1947 by the film *Gentleman's Agreement*. Well into the 1950s efforts to portray Jews in films and in the new world of television as being "not too different" from other Americans abounded, to the point where iconic Jewish TV personalities such as Gertrude Berg and Jack Benny were depicted embracing Christmas. From around the middle 1960s, Jews in the entertainment business have been openly acknowledged and freely discussed; hence Jerry Seinfeld never had to hide his Jewishness and could even flaunt its stereotypes, at least to a limited extent, on the air.[381]

By the mid-1960s the Jews had usurped the WASP cultural elite and could, therefore, become more explicit in their Jewish identification and sympathies – together with their antipathy for the traditional people and culture of the United States. Explicitly Jewish themes began to appear in films – invariably portrayed in a positive light. This has continued through to the present day, and Garfinkle is happy to admit that: "Hollywood's infatuation with Jews makes Jews look good to non-Jews, and Jewish Americans love it."[382] He should have added that Hollywood's tendentious portrayal of Europeans and Christians makes Whites and their traditional culture look bad to everyone and Jewish Americans Jews love it.

The extent to which Jewish domination of the entertainment industry has shaped the culture and thinking of hundreds of millions of people in the United States is astounding even to Garfinkle. He notes that "it *is* striking, one has to admit, that the cultural influence of Jews

and Jewishness is what it is, considering that fewer than 5 million American Jews are influencing more than 296 million other Americans." One reason for this vast influence, he contends, is that "Jews live within a civilization that has become entertainment – and celebrity – crazy. If Americans were less obsessed with amusing themselves, this would not be the case; but Americans are thus obsessed."[383] He notes that "America's celebrity culture has become so Jewish that it has managed to become Jewcentric without involving Jews or Judaism."[384] As an example of this phenomenon, Garfinkle cites Madonna's public embrace of the Jewish mystical tradition of the Kabbalah in the 1990s.

Huge numbers of White people in the United States (and throughout the West) are mesmerized by the output of Hollywood and its vapid celebrity culture, and have difficulty directing their attention to issues of pressing concern to themselves, their families, and their race. According to the Department of Labor's Bureau of Labor Statistics, Americans spent about $725 billion in 2009 on entertainment – a staggering amount of money. Garfinkle is willing to admit that:

> There are negative as well as positive implications of Jewish pre-eminence in American entertainment culture, and one of the former has to do with the image of frivolity and even dissipation increasingly associated with America's closely related celebrity culture. ... Harvard political scientist Robert Putnam is hard to refute when he asserts that we are increasingly "bowling alone" in this country, that the robust civic participation that has usually characterized American society and democracy is in decline – even despite the eclectic energies that went into the 2008 Obama presidential campaign. And television and the aura of celebrity culture that it and the internet deliver are certainly among the main reasons for it.[385]

Garfinkle fails to add that Putnam also concluded that increased racial and cultural diversity is directly correlated with growing distrust in American society, and a decreased willingness to contribute to public

goods. He should have also mentioned that organized Jewry has been the key driving force for this increased racial and religious diversity throughout the West through their decades-long promotion of mass non-White immigration and multiculturalism as an insurance policy against another "Holocaust."

For Garfinkle, the identification of Jews with Hollywood and the entertainment industry "bears on Jewcentricity in an obvious way," in that:

> To the extent that left-wing and right-wing critiques of American society flow into one another in attacking what American popular culture has become – and increasingly they do – there are Jews at every turn, in marketing, in media, and, of course, in the entertainment business itself. Critiques launched from the left, including by Jews writing in that adversarial culture's Marxist influenced tradition, often focuses on business media concentration, alleging that big business, through the enormous power of advertising dollars, has deliberately turned what used to be actual news into pasty, hollow entertainment. Most of the same people do not appreciate, either, the increasingly salacious content of mass media or the apparent elevation of anti-patriotic sentiment and homosexual lifestyles above more traditional values. Hollywood has become very much a target of such critiques, and an increasing number of Americans are ignoring Hollywood fare. Some are homeschooling their children for similar reasons.

As detailed in Kevin MacDonald's *The Culture of Critique*, Freud and his followers (such as Wilhelm Reich) regarded anti-Semitism was a universal pathology which had its roots in sexual repression. The social cure for this affliction lay in "sexual liberation." Individuals preoccupied with sex were considered unlikely to concern themselves with Jews, much less organize politically against them. People who spend most of their time focused on sexual stimulation are unlikely to organize pogroms or threaten the rich and powerful Jewish establishment. The

hypersexualization of Western culture (the most conspicuous result of the Jewish takeover of the Western media and entertainment industries) is, therefore, a deliberate Jewish cultural strategy to undermine a Western culture regarded as inherently authoritarian, fascistic and anti-Semitic due to its "repressive" sexual morality.

Garfinkle notes that many commentators have "singled out Jews as the source of Hollywood's supposed undermining of American morals," and is particularly troubled by the fact people "have made a big deal about Hollywood Jews hollowing out the moral fiber of America" and spread this all over the internet.[386] He admits this is not altogether surprising given it "does not take a rocket scientist to connect the dots: liberals are responsible for the dangerous debauching of our society, not least through vapid entertainment-culture garbage, and a disproportionate number of liberals who are doing precisely that are Jews." Garfinkle is, however, reassured that there is little evidence that "this marginal thinking and material" has "made its way into the mainstream."[387]

There have been several prominent Jews who have offered honest critiques of the Jewish role in using Hollywood to subvert the traditional morality and culture of the West. One of these is the director David Mamet whom Garfinkle calls a "splenetic critic." Mamet contends that "Hollywood movies are profoundly, genetically Judaic; the product, via the minds of their creators, of certain distinctive racial traits that arose in the ghettos of Eastern Europe and transported themselves to Beverly Hills." Mamet believes two of these traits, indifference to wider social norms and high intelligence, combined with a form of autism known as Asperger's Syndrome, which "has its highest prevalence among Ashkenazi Jews and their descendants... sounds to me like a job description for a movie director."[388]

Garfinkle notes that Ashkenazi Jews and Northern Europeans have very dissimilar psychological makeups, and the Jewish temperament (shaped over millennia by their social marginality in the Diaspora) rendered them particularly well equipped to take on the WASP establishment and eventually dominate the American entertainment industry.

The overriding point here is that social marginality often enough generates energy, encourages unconventional perspectives, and focuses ambition. It also produces anxiety and angst, widely and probably correctly said to produce art, which is a Jewish speciality. Pierre Paul Leroy-Beaulieu (1843-1916), the French Catholic economist and philosopher, put it best over a century ago: "The Jew is the most nervous and, in so far, the most modern of men."

Indeed, Jews in the Diaspora have become connoisseurs of angst. Religious Jews tend to pour their nervous energy into prayer, study, and career; nonreligious Jews pour it into their intellectual and artistic passions. In America, historically a prosperous, secure, and self-confidant nation, the Anglo-Saxon and Northern European peoples of the land have been, again by historical standards, stolid and calm. The contrast between them and the Jews could hardly be more vivid. As wealth and technology have created the potential for a mass-based and varied entertainment culture, Jewish creative energies have helped turn that potential into reality.[389]

So how does Garfinkle, having acknowledged that Hollywood "has been and remains disproportionately, overwhelmingly, even astonishingly Jewish," defend his tribe from the accusations of those who see this ethnic monopolization of the entertainment industry as a profound societal problem? He feebly claims the Jews who run the entertainment industry are not real Jews because Judaism is a religion and not a blood phenomenon.

Hollywood's Jewish movers and shakers are with few exceptions not religious people, either in practice or in education. They certainly do not invoke religious rationalizations to justify what they do – rather the contrary. Still, many practicing Jews would be more comfortable if Howard Stern, Andrew Dice Clay, Sarah Silverman, Steven Hirsch, Al Goldstein of Screw magazine

"fame," or Sasha "Borat" Baron Cohen had been born, say, Presbyterians.[390]

This is despite that fact all these individuals are entitled to Israeli citizenship, and regard themselves, and are regarded by others, as Jews. The net result of the Jewish stranglehold over the American media and entertainment industries is that:

> There is virtually no anti-Semitism in mainstream American culture. The freedom of Jews to work and prosper, as Jews and as members of wider society, has often led to envy, resentment, and anti-Semitism. In America, so far at least, this unnerving pattern has almost been nonexistent, a conclusion that seems to be borne out by the fact that not even a systemic economic crisis with Bernie Madoff as its poster child, combined with the most broadly unpopular military action the Israel Defense Force has ever undertaken (in Gaza in January 2009), managed to evoke much evidence of mass-appeal anti-Semitism in the United States.[391]

Garfinkle notes there was a slight upsurge in "negative Jewcentricity" in the aftermath of the Global Financial Crisis, as increasing numbers of people came to the conclusion that "contemporary global capitalism resembles old-fashioned carpetbagging on a global scale." He also acknowledges that: "If global capitalism is essentially 'fixed' or crooked, manipulated so that a relative few gain huge wealth at the expense of the majority – and if Jews become prominent successes in it, as they were, for example, in the free-for-all grabfest that accompanied the fall of the Soviet Union – then global 'virtual' anti-Semitism looks to be a growth industry."[392]

The origins of the 2008 Global Financial Crisis lay in the actions of a Jewish-dominated financial elite whose speculative activities were allowed to expand for decades at the expense of the productive sectors of the economy. They behaved more like an organized criminal gang than citizens with a sense of civic responsibility and commitment to the

welfare of the nation. This is not surprising, given that Diasporic Jews have traditionally conceived of themselves as outsiders, alienated from the societies around them; a hostile elite with a potent sense of historical grievance. For American Jewry, forever fixated on the aggressive pursuit of their individual and ethnic interests, the viability of their host society has always been a lesser concern.

The problem of the Jewish domination of financial markets is not simply that Jews often exploit non-Jews and generate wealth at their expense, but also *what Jews do with the wealth they generate*. Jewish economic domination of Western societies has gone hand in hand with the Jewish capture of the commanding heights of Western political and cultural life, with profoundly negative consequences for White people. There is a fundamental nexus between disproportionate wealth and disproportionate political, legislative, and media influence, and Jewish elites have wielded this influence to reengineer Western societies in their own interests.

Given the Jewish domination of the important sectors of American society, it is only logical that, as Garfinkle puts it, "The global image of the Jews is bound up with the image of America as well as that of Israel."[393] This is because:

> America is also the world's foremost secular evangelist, urging other societies to embrace freedom, experimentation and change. And America happens to be, not coincidentally as many see it, host to the wealthiest and most influential Jewish community in the world. There are almost as many Jews in the United States (about 5.4 million) as in Israel, more in New York City than in Tel Aviv and Jerusalem combined. The prominence of American Jews, particularly over the past half century or so, is manifest as well, whether in politics, science, business, or entertainment and the arts.[394]

Garfinkle notes how most Jews regard the Jewish domination of America's financial, entertainment, media and educational sectors (and many

other fields) as the merited product of their exceptional qualities as a people. He fails to mention the role of Jewish ethnic networking and nepotism in allowing Jews to gain a hold over these sectors. He observes that many American Jews "believe that Jews possess superior intelligence, and that because of their superior intelligence they have proved to be superior achievers in so many fields." Consequently, it is very easy for many of them "to conclude that Jews are superior by blood."

> Psychometric data suggest that, yes, Jews are of high general intelligence, and data of other sorts show disproportionately large Jewish professional and intellectual achievement, not just in the United States, but wherever Jews have been allowed to compete on a reasonably level playing field... [T]here isn't much doubt that Jews, and among Jews particularly Ashkenazi Jews are significantly more intelligent by conventional measures compared to almost all other groups. Longitudinal studies of intelligence testing show consistently that two groups end up in the highest percentiles: Jews and Japanese, with other Asian groups close behind. The tests consistently show certain other groups near the bottom. The mean IQ for Ashkenazi Jews is somewhere between 110 and 115, depending on which test one cites.

> As noted, overall scores are highest for Ashkenazi Jews and Japanese, but not in the same way. Japanese do better on spatial intelligence, Jews in language ability. Those experts in psychometrics are sure that group differences are real, and that finer differences among groups are real too. There is nothing fatally wrong or culturally skewed about the tests, at least not any more. No one who understands the science doubts that these differences – and not just in intelligence but in, for example, natural aptitude for some kinds of sports – of which more in a moment – are rooted ultimately in differential genetic endowments. Obviously, it makes a lot of people uncomfortable to credit a definite link between genetic endowments and both intelligence and achievement. But

it should make these same people more uncomfortable to deny plain scientific facts.[395]

Garfinkle fails to offer further discussion of the "other groups near the bottom" of the racial IQ distribution, and the social problems these people inevitably create when imported en masse into Western nations. Garfinkle's statement above is basically an admission that the vast post-WWII literature spawned by the Boasians denying the reality of racial differences – which has *profoundly* influenced Western societies, and is now the default assumption across almost all academic disciplines – is intellectually bankrupt. The Boasian ideology of racial egalitarianism was a critical weapon in opening up the West to non-White immigration, with all its associated dysfunctions and drawbacks for Whites. For instance, Jon Stratton notes how the dismantling of the White Australia policy, and the ultimate adoption of multiculturalism, was a direct result of "internal and external pressures related to a general turning away from biological racialism."[396] The Australian Jewish academic Andrew Markus articulates the standard critique of "white racism" that became prominent in the 1960s when he asserts that it was based on the notion that:

> as a result of some (undefined) "natural" process, national groups (or "races" or "cultures") have inborn ("essential") qualities which will never alter; and there are inherent characteristics in such groups which interpose barriers against harmonious co-existence, not least against interbreeding of populations. Such ideas give rise to closed forms of nationalism which restrict membership to those qualified by birth or descent, in contrast to open forms which grant citizenship to individuals on the basis of residence and adherence to the governing principles of the nation. They justified European colonial rule; the denial of basic human rights and citizenship; segregation in the workplace, housing and education; and policies of genocide culminating in the "factories of death" established in the period of Nazi domination of

continental Europe. Rarely challenged in Western societies prior to 1940, the idea of biological racial difference lost much of its legitimacy in the aftermath of the Holocaust.[397]

It is obvious from this statement just how closely acceptance of the myth of racial equality from the 1960s onwards was bound up with Jewish post-Holocaust ethno-political activism. Note also the outright lies and hypocrisy in the above paragraph. The "(undefined) 'natural' process" Markus claims is the wholly irrational basis for "racism" is the very well-defined process of human evolution itself. The differential evolution of human groups, in response to selection pressures imposed by diverse environments, resulted, after thousands of years, in differences in external morphology and psychological traits – including intelligence as measured by IQ tests. The average intelligence of a group will profoundly influence the kind of society that will be created by that group. There is nothing undefined, irrational, or pseudo-scientific about this whatsoever.

Garfinkle notes that Jews are eager to claim significant figures from history as having had Jewish ancestry, including important figures from American history like Christopher Columbus, Alexander Hamilton, Thomas Jefferson and Abraham Lincoln. These claims are generally nonsense, though Garfinkle sees a danger in this tendency of Jews to claim important historical figures as fellow tribesmen, insisting "this is not a harmless error, because it is a form of Jewcentric philo-Semitism that feeds its opposite, Jewcentric anti-Semitism."[398] This hubristic tendency among Jews, as well as antagonizing non-Jews, provides the latter, Garfinkle argues, with dangerous confirmation that Judaism is indeed a bloodline phenomenon.

### The Israel Lobby

It angers Garfinkle (doubtless due, in part, to his role as speechwriter for Secretaries of State Colin Powell and Condoleezza Rice) that the influence exerted by the Israel Lobby over the foreign policy of the United

States, and other Western nations, provides yet another focal point for
"negative Jewcentricity." Garfinkle's discussion of this issue centers on
the publication and reception of Mearsheimer and Walt's *The Israel
Lobby and U.S. Foreign Policy* in 2007.

> In recent years, this debate has revolved around the writings of
> John Mearsheimer and Stephen Walt, notably a paper and then
> a book they wrote called *The Israel Lobby*. The authors argue in
> essence that U.S. foreign policy has been distorted, particularly
> in the Middle East but really on a global scale, by the exertions of
> Jews in the United States who have managed to bend the Amer-
> ican national interest to that of Israel. The authors believe that
> the Israel Lobby – they always use a capital L for that word – has
> made U.S. foreign policy too interventionist, notably in causing
> the Iraq war, and that U.S. support for Israel is a main source of
> Islamic terrorism directed against the United States.[399]

Garfinkle freely engages in ad hominem attacks on Mearsheimer and
Walt, implying that they wrote their book mainly out of desire for finan-
cial gain, rather than from a sincere conviction about the misdirection
of American foreign policy under the influence of the Lobby. He claims
"the authors parlayed the ruckus [over the influence of AIPAC] into
the book, published by Farrar, Straus and Giroux in 2007, for which
the two reportedly received an advance of $750,000 to split between
them."[400] He likewise notes the furor over the book soon died down
"despite the authors' efforts to keep the buzz buzzing, the better to sell
more books and promote their views."[401]

As well as writing their book for mercenary reasons, Mearsheimer
and Walt were also, Garfinkle contends, unqualified to offer their
thoughts on American foreign policy because they are not "Middle East
experts" and do not speak any Middle Eastern language. He writes:

> Like many other Israel lobby critics before them, Mearsheimer
> and Walt are not themselves Middle East experts. Before their

Israel Lobby essay and book, neither had written much on the region and anything at all for scholarly, expert audiences. They have never claimed to be regional experts, and rightly so, for neither seems to have studied, let alone mastered, any Middle Eastern language. The many factual errors they make illustrate their lack of familiarity with the basic literature on the subject. ... [S]erious scholars are supposed to respect certain standards of logic and rules of evidence, and tenured faculty at prestigious institutions are presumed to be among those professionals."[402]

Having engaged in some initial character assassination, Garfinkle finally addresses Mearsheimer and Walt's thesis that American foreign policy has been unduly influenced by an Israel Lobby which has pushed the American government into wars not in the American national interest. Garfinkle claims this assumption is based on a "vast exaggeration," and claims *The Israel Lobby* is marred by a "fundamental illogic," despite having acknowledged in other parts of *Jewcentricity* the existence of a plethora of powerful and well-funded activist organizations "serving parochial Jewish ethnic interests that are simultaneously distinct from broader American interest but not related directly to religion."[403]

The power of the Israel Lobby in shaping foreign policy is not just an American, but a broader Western, phenomenon. The sway held by organized Jewry over Australia's political leaders was highlighted by the former Australian Foreign Minister Bob Carr who hit out at the "pro-Israel lobby in Melbourne," saying it wielded "extraordinary influence" on Australia's foreign policy during his tenure in that position. Asked how the lobby achieved this influence, he said: "I think party donations and a program of giving trips to MPs and journalists to Israel. But that's not to condemn them. I mean, other interest groups do the same thing. But it needs to be highlighted because I think it reached a very unhealthy level."

Garfinkle's main counter-argument to Mearsheimer and Walt is that while Jewish activist organizations are indeed highly effective in lobbying Congress (which is surely egregious enough), its influence does

not extend to the executive branch of government. He maintains that "when a president knows what he wants, whether it pleases Israel or not, he does it. He does it because, as the steward of American national security and the commander-in-chief of the armed forces, he thinks it best for the country. He may be right or wrong in his judgments, but lobbies have never decisively influenced any major U.S. strategic judgment concerning the Middle East."[404] This argument might have some validity with regard to the Obama presidency, but is patently false with regard to the Bush administration. Regarding the disastrous invasion of Iraq, Garfinkle claims that "trying to pin the blame for it on Israel and its American supporters is a stretch well beyond credulity."[405]

So the Bush administration's decision to invade Iraq was, Garfinkle proposes, made independently of the urgings from the Israel Lobby and the neoconservative establishment. Garfinkle makes no mention of the fact that Israeli plans for a war against Iraq had been in place for several years prior to the 2003 invasion. No mention is made of the 1996 policy paper prepared for the Israeli Prime Minister Netanyahu entitled *A Clean Break: A New Strategy for Securing the Realm* which was authored by, amongst others, Richard Perle, Douglas Feith and David Wurmser – three influential Jews who later held high-level positions in the Bush Administration – and which called for an "effort [that] can focus on removing Saddam Hussein from power in Iraq, an important Israeli strategic objective in its own right..."

Garfinkle also ignores the fact Netanyahu lied brazenly about Iraqi weapons of mass destruction to goad the United States into an invasion. He likewise ignores the many media reports from around the time of the invasion that show that AIPAC was actively lobbying for the invasion of Iraq. Matt Yglesias, writing in in 2007, noted in an article entitled "AIPAC and Iraq," for example, that:

> One of the odder notions to take hold in recent years is that AIPAC specifically, and the so-called "Israel lobby" more generally had absolutely nothing to do with the Iraq War, and that

anyone who says otherwise is an anti-Semite. As John Judis writes for *The New Republic*, however, this is just false:

"At the time, a Senate staff person with a responsibility for foreign policy told me of AIPAC's lobbying. But I don't have to rely on my memory. AIPAC's lobbying wasn't widely reported because AIPAC didn't want Arab states, whose support the Bush administration was soliciting, to be able to tie Bush's plans to Israel, but it lobbied nonetheless. In September 2002, before Congress had begun considering the administration's proposal authorizing force with Iraq, Rebecca Needler, a spokeswoman for AIPAC, told the *Jewish Telegraphic Agency*, 'If the president asks Congress to support action in Iraq, AIPAC would lobby members of Congress to support him.' Then at an AIPAC meeting in New York in January 2003, before the war began, but after Congress had voted to authorize Bush to go to war, Howard Kohr, AIPAC's executive director, boasted of AIPAC's success in lobbying for the war. Reported the *New York Sun*, 'According to Mr. Kohr, AIPAC's successes over the past year also include guaranteeing Israel's annual aid package and "quietly" lobbying Congress to approve the use of force in Iraq.'"

And, obviously, other institutions of the hawkish "pro-Israel" establishment – the Washington Institute for Near East Policy, the Saban Center, JINSA, *The New York Sun*, *The New Republic*, etc. – all advocated strongly in favor of invasion.

Ignoring all of this, Garfinkle maintains that:

If, as Mearsheimer and Walt argue, even against their own realist convictions, a domestic lobby is responsible for U.S. policy decisions at the highest level and with the greatest consequence – not least the U.S. war in Iraq – and if their own argument is as new and revelatory as they claim it is, then it follows that their book should have had a major impact on how U.S. foreign

policy is made and what its basic tenets are. Yet no such thing has happened. The Bush administration did not throw up its hands in surrender after the Mearsheimer-Walt book was published, and shift its policy on cue. None of the Democratic or Republican primary contenders in the run-up to the 2008 presidential election mentioned the Mearsheimer-Walt book or said anything remotely endorsing their case against the Israel lobby.[406]

Garfinkle's bizarre reasoning seems to be that if the Israel Lobby did have undue influence over the direction of U.S. foreign policy, then exposure of this influence alone should have been sufficient for it to cease. In truth, the fact that Mearsheimer and Walt's book had no discernable impact on the direction of U.S. foreign policy can be taken as confirmation of their thesis. Political survival in the contemporary United States is contingent on garnering and maintaining the broad support of the organized Jewish lobby. Defy this lobby and you are destined for the political scrapheap. This is the reason Mearsheimer and Walt's book had no discernable effect on U.S. foreign policy. Elsewhere in his book Garfinkle acknowledges that:

> Without questioning the right of Jews, or any other ethnic group of U.S. citizens, to organize and lobby for their interests, Jewish lobbying has become so proficient, so well financed, so unvarnished, and so persistent as to have generated a certain amount of ambient resentment. Not even political animals who get elected to Congress like to be pushed around, and to put it generously, Jewish lobbying tactics are not always subtle. There is something almost the equivalent to nouveau riche behavior in the way some Jewish organizations lobby for what they want. Instead of "Look I can afford to pay five thousand dollars for a lamp I don't even like," it's "Look, I can contribute five thousand dollars to this guy's congressional race and in effect exercise a veto over what he says about Syria."[407]

It is common knowledge that Jewish organizations throughout the West respond immediately and aggressively to any individual who makes statements in the public sphere critical of Jews or Israel. These actions range from having the individual prosecuted under "hate speech" laws, to getting them fired from their job and/or forcing them to engage in some humiliating act of public contrition and obeisance to Jews. Garfinkle admits that Jewish activists are quite willing to use underhand tactics to defend their interests. He cites the March 2009 decision by then Director of National Intelligence Dennis Blair to make Charles Freeman the new director of the National Intelligence Council. As soon as Freeman's appointment was leaked, Freeman was assailed by Jewish activists and journalists. Their criticism centered on the fact Freeman, a former U.S. ambassador to Saudi Arabia, had criticized Israeli settlement and occupation policies. Garfinkle notes that:

> [W]hile AIPAC took no formal position on Freeman's nomination, a smear campaign against him mounted by American Jewish partisans of Israel sprinted into high gear from a standing start. Some of this criticism linked into insinuations that Freeman had acted as an unregistered agent for foreign governments – Saudi Arabia and China were mentioned – which is illegal. But no evidence was produced that this was so. Some criticisms of Freeman sought, in a manner of extreme political polemic, to collapse any difference between Freeman's criticisms of Israel and those of a more extreme sort. Much of this was tactical, in the sense that the polemicists knew that was what they were doing and did it anyway."[408]

Having had his appointment rejected thanks to Jewish activism, Freeman, as he headed for the door, wrote a scathing post on Salon.com worth quoting at length:

> The libels on me and their easily traceable email trails show conclusively that there is a powerful lobby determined to prevent any view other than its own from being aired, still less to factor in

American understanding of trends and events in the Middle East. The tactics of the Israel Lobby plumb the depths of dishonor and indecency and include character assassination, selective mis-quotation, and willful distortion of the record, the fabrication of falsehoods, and an utter disregard for the truth. The aim of this Lobby is control of the policy process through the exercise of a veto over the appointment of people who dispute the wisdom of its views, the substitution of political correctness for analysis, and the exclusion of any and all options for decision by Americans and our government other than those that it favors.

There is a special irony in having been accused of improper regard for the opinions of foreign governments and societies by a group so clearly intent on enforcing adherence to the policies of a foreign government – in this case, the government of Israel. I believe that the inability of the American public to discuss, or the government to consider, any option for U.S. policies in the Middle East opposed by the ruling faction in Israeli politics has allowed that faction to adopt and sustain policies that ultimately threaten the existence of the State of Israel. It is not permitted for anyone in the United States to say so. This is not just a tragedy for Israelis and neighbors in the Middle East; it is doing widening damage to the national security of the United States.[409]

## Christian Zionism

If President Bush was willing to commit U.S. troops to an incredibly expensive and destructive war benefitting Israel, then, argues Garfinkle, this should be attributed not to the Israel Lobby but the "posi-tive Jewcentricity" that exists among millions of American evangelical Christians. While drastically and disingenuously understating the role of Jewish activists in provoking the Iraq War, and vastly overestimating the political influence of evangelical Christians (who, incidentally, have lost every single cultural battle they have fought for decades, such

as opposing abortion and gay marriage), it is reasonable to mention how "evangelical Jewcentricity" influences American attitudes toward the Middle East.[410] A Pew research survey found that 30 percent of American Christians define themselves as evangelicals, and of these, 67 percent believe the Bible is the word of God; and at least 36 percent believe the foundation of the State of Israel is a harbinger of the Second Coming of Christ.[411] Garfinkle notes that:

> There can be no doubt many of the truest true believers among American Protestants today – and not only American Protestants – believe that Jews are still the Chosen People. They believe that the birth of Israel is part of divine cosmic history being revealed before our eyes. They believe they must defend Israel lest the Jews have nowhere to go to fulfill their cosmic destiny. They believe that the end of days is near, and they interpret contemporary political and strategic events in this context. All who behave this way believe, by way of foundational premise, that what Jews are and do, especially in Israel but all over the world, constitutes the core of the divine drama itself. God writes the script; the Jews and their enemies are the star actors; everyone else just sits in the audience, as it were, and watches it all pour forth. These people are Jewcentric – *very* Jewcentric.[412]

Christian Zionism is largely a British invention. Garfinkle argues this may have something to do with an indigenous tradition of British "chosenness" that emerged among early British Christians who fashioned a way to read their own historical narrative in parallel with the Hebrew Bible. *The Epistle of Gildas*, for instance, which seems to be a late sixth-century work, pronounced Britain a new Israel with its battles against heathen invaders from Scandinavia comparable to Israel's struggles against the Babylonians and Philistines. This theme was repeated in the Venerable Bede's *Ecclesiastic History* from around the year 735.[413]

Garfinkle traces the historical emergence of modern Christian Zionism in the nineteenth century to John Nelson Darby, an Irish Anglican

priest, who systematized it "into a full-fledged theology" and spread it to America.

> It was Darby who, basing himself on an interpretation of 1 Thes-salonians 4:16-17, formalized the doctrine of "the Rapture," the idea that born again Christians would rise up into the sky when the Second Coming was imminent and be transferred directly to heaven, spared the sufferings of Armageddon. It was also Darby who first specified how a reborn Israel would play pivotal roles in the series of events leading to Jesus's return. The Jews would be gathered again in their ancestral land, gain political indepen-dence, and be the pivot of end-of-history convulsions. And it was Darby who developed the idea that the history of humanity from the creation of the world onward was divided into a small number of eras – just seven – each with its own characteristics and symbols, which he called "dispensations."

> Above all, Darby challenged the classical Christian replacement, or supersession, theology. He argued that the Church – any church – has never superseded the Jews as God's Chosen People. Rather, he argued, the Church as a "parenthesis" in earthly his-tory, for it was not of this earth, but of heaven. The Jews remain and always will be God's Chosen People on earth, while the Church is God's chosen vehicle for cosmic redemption. This du-alism, which resembles ancient views that human time is unreal and only Eternity matters ultimately, seems to have been Darby's invention. As far as standard Catholic and Protestant theologians are concerned, it has no basis in Christian theology.[414]

Through inventing dispensationalism Darby consolidated the various strands of a Christian movement in Britain known as "premillennial fundamentalism." This movement is now an integral part of evangelical and Pentecostal as well as fundamentalist Protestantism in the United States. As well as essentially inventing a new theology, Darby also

founded the Plymouth Brethren and exported it, via seven missionary trips, to North America. By his death in 1881, dozens of Plymouth Brethren congregations had been founded in the United States.

One of Darby's followers, Anthony Ashley Cooper – later the seventh Earl of Shaftsbury – molded Britain's imperial ambitions to accord with Darby's Christian Zionism. Acting on his own religious convictions but arguing political rationales, Shaftsbury persuaded the British Foreign Minister, Lord Palmerston, to send a British consul to Jerusalem following a rebellion against the Ottoman Empire which allowed unobstructed British travel to Palestine. Garfinkle notes that "This Palmerston did in 1838, sending out William Young with instructions to 'promote the welfare of the Jews.' Darby was thrilled." The following year Shaftsbury wrote an article in the prestigious *Quarterly Review* entitled "The State and Prospects for the Jews." Palmerston was so receptive to this and other lobbying by Shaftsbury that the latter concluded that: "Palmerston has been chosen by God to be an instrument of good to His chosen people."[415] Garfinkle observes that:

> Taking his cue from Darby and his growing cohort of supporters, Shaftsbury kept pressing for British engagement in Palestine on behalf of the Jews. Ottoman authorities, naturally enough, took a dim view of the idea, but Shaftsbury did not. When, on the cusp of the Crimean War in 1853, it looked as though the Ottoman Empire might collapse, or at least be made more pliable as a result of another battlefield defeat, Shaftsbury, by now an earl in his own right, again picked up his pen on behalf of the idea of a Jewish return to Palestine. Writing to Lord Aberdeen, then British Prime Minister, and speaking not just of Palestine but more broadly of geographical Syria, he argued that it was "a country without a nation," needing to be matched to a "nation without a country." Shaftsbury asked rhetorically, "Is there such a nation? To be sure there is, the ancient and rightful lords of the soil, the Jews!" ... So I think it is fair to say that dispensationalist

Christians became political Zionists before many, perhaps *any*, European Jews did.[416]

Darby's dispensationalism found fertile soil in North America. Just as the Napoleonic Wars seemed a harbinger of Armageddon to many Englishmen, the American Civil War was similarly regarded by many Americans. Thanks to advocates like John Inglis, James H. Brookes, Dwight L. Moody, William Eugene Blackstone and others, dispensationalism gained millions of American adherents throughout the nineteenth and early twentieth centuries. Another major figure in the early advance of American dispensationalism is Cyrus I. Scofield who created *The Scofield Reference Bible*, first published in 1909 by Oxford University Press. Garfinkle notes that:

> It is hard to overstate the influence of this book. Depending on John Nelson Darby's own notes, Scofield annotated the whole Bible. His commentaries systematized dispensationalist theology in a way that no one before had done. The fact that Scofield had put it all in writing was the key – that and the rapid spread of rural literacy in the United States through the nineteenth and into the early twentieth centuries. Before long the Scofield Bible's commentaries took on an aura of authority equal to, if not greater than, that of the text itself. The reason is disarmingly simple: the Bible, particularly some significant stretches of the New Testament, can be rather cryptic; the text doesn't always say clearly exactly what it means. Scofield told readers what it meant, in plain, clear American English. He insisted, further that the scripture was to be taken literally. Invoking Darby, Scofield wrote: "Not one instance exists of a 'spiritual' or figurative fulfilment of prophecy. ... Jerusalem is always Jerusalem, Israel is always Israel, Zion is always Zion. ... Prophecies may never be spiritualized, but are always literal."

Among the literal meanings he made plain to his legion of readers was that the Jews, and only the Jews, were Gods Chosen

People. ... [B]y the time Scofield died in 1921, his work had
become the leading Bible used by evangelicals and fundamental-
ists in the United States, and so it remained for the next half
century. It brought greater respectability to dispensationalism,
which, before Scofield, lived in an ill-defined world suspended
between an oral and written tradition. Scofield changed that,
and in so doing helped to accelerate the institutionalization of
dispensationalism.[417]

The success of the dispensationalist movement in North America is
reflected in the fact that, as Garfinkle puts it, "The United States of
America is probably the most Jewcentric society in world history, in a
largely philo-Semitic way."[418] Perhaps the most philo-Semitic President
the United States has ever had was Lyndon Johnson who "had several
Jewish friends and associates" and whose mother admonished him as a
young man to "Take care of the Jews, God's chosen people." Johnson
recalled an aunt once telling him that "If Israel is destroyed, the world
will end." That aunt, who was a Baptist from Texas, even joined the
Zionist Organization of America.[419] Despite claiming that the United
States is the most philo-Semitic nation in history, Garfinkle nevertheless
warns that anti-Semitism lies just beneath the surface, and "American
society has been for most its history about as reflexively anti-Semitic as
most majority-Christian civilizations."[420]

## Islamic Jewcentricity

In *Jewcentricity*, Garfinkle claims that "Muslim societies today are the
site of the most virulent and widespread anti-Semitism on the planet."
He traces this to the origins of the religion itself, noting how it "inheres
in the sacred narrative of Islam." The reasons for this sentiment in Islam
are akin to the reasons for it in Christianity – the desire to separate the
religion from its foundational rootstock of Judaism. Just as Christianity
had to find some way to distance itself from its Jewish origins to justify
its claims of superiority, so did Islam.[421]

Muslims accept a differing account of the story from the Bible that describes the binding of Isaac on Mount Moriah, the future Temple Mount in Jerusalem, and of Isaac inheriting Abraham's covenant with God. According to the Quran, and as Muslims have always understood it, it is not Isaac but Ismail who is bound (and of course saved), and the place is the Valley of Arafat, in Arabia, not Mount Moriah in the Land of Israel. While agreeing with much related in the Hebrew Bible, in-the-tradition Muslims argue, with regard to the events just described, that Jews have distorted the record and "the Hebrew Bible's account of this critical event, the 'binding' of Abraham's son, is a post-Mohammedan fabrication."[422]

The fact the Torah predates the birth of Mohammed by about a thousand years apparently offers not logical barrier to Muslims in making this assertion. The reality is the other way around – large sections of the Quran were lifted from the Torah and then altered. Garfinkle notes that:

> Parts of the Quranic sura called *Yusuf* (Joseph), the twelfth sura for those keeping score, are taken largely verbatim from the Mishnah. ... It is for this reason – that the Jews had the audacity to distort the revealed word of God Himself – if not for others, in-the-tradition Muslims have, it is fair to say, a disparaging attitude toward Jews and Judaism, despite the dependence of the Quran on so much of the Jewish narrative.[423]

Mohammed also lifted material from the New Testament and this is reflected in the eschatology of Sunni Islam which looks forward to the end-of-days when Islam will be universally triumphant. Similar to the Christian account of Armageddon, the Muslim end-of-days narrative includes a series of convulsive wars before Jesus finally returns and fights the anti-Christ or anti-Allah (called *dajjal* in Arabic). After this, as with the Christian account, all the good Jews will convert to Islam and all the bad ones will die. Garfinkle notes how:

[T]here is a statement near the end of the Hadith [sayings of the Prophet Mohammed] that goes like this: "The Jews will hide behind the rock and tree, and the rock and tree will say: Oh servant of Allah, Oh Muslim, this is a Jew behind me, come and kill him!" There is both more and less than meets the eye here. There is less in the sense that this statement bears a context, that of the end of history, or of normal historical time. This is when the rocks and trees will miraculously take on voices, telling the good guys how to find and kill the Jews to hasten the destiny of History. ...

So killing Jews is not a religious obligation in the Islamic tradition, and the statement about talking rocks and trees does not come from the Quran. It is a prophecy about the "end of days," and it carries what is for most Muslims the lesser authority of Hadith. Moreover, there are many offsetting verses in the Quran (and in Hadith) that forbid violence against non-Muslims, that set conditions as to when violence and war are permitted, and that bear special protection for other members of the Abrahamic tradition – Jews and Christians in particular.[424]

Muslims generally view Jews as having strayed from the true path of God, of having distorted God's word, and of showing "traits of cunning, betrayal, and deception." Yet while anti-Jewish sentiment has been normative within Islam since its inception, Garfinkle contends that until around a century ago "Muslim anti-Semitism as such did not exist." The extent that Muslim anti-Jewish sentiment has morphed into genuine anti-Semitism, can, he argues, be ascribed to the malign influence of Europeans, in that "contemporary Muslim anti-Semitism is not Islamic in its idiom or essence – it has been imported from Europe."[425] According to the author, "Muslim anti-Semitism is mainly a European import, but its under-layer of anti-Jewish folklore gives it a vocabulary and a tone of its own."[426]

Because of European anti-Semitism having supposedly infected millions of Muslims, we now have a situation where "Negative Jewcentricity is virtually everywhere in the Muslim world these days; it has become the default view of Jews, not the exceptional view."[427] The fact that Islam has no native tradition of anti-Semitism supposedly explains the very different experience of Jews in the Islamic world and in Europe.

> Taken together, these factors explain at least in a brief, simple way why the serial expulsions and mass murder Jews suffered in Europe over the centuries did not occur, virtually without exception and certainly with no major exception, in Islamic lands. This does not mean, of course, that Jews enjoyed a kind of extended golden age while living in the various climes and eras of Muslim history. Nonetheless, again, the religious and social prejudice Jews suffered within Dar-al-Islam was nothing special: these were epochs in which toleration was at best relative, so whatever Jews may have suffered, others who were not part of the ruling group of the time suffered. This means that there was no Muslim anti-Semitism, strictly speaking, before about a century ago.

> Contemporary Muslim anti-Semitism has been bolstered by the relics of European anti-Semitism, and not only of the ubiquitous text of the *Protocols of the Elders of Zion* in translation – available in any bookstore of significant size in the region, along with an Arabic translation of Henry Ford's *The International Jew: The World's Foremost Problem*. Also widely available in Arabic is the book that Ford influenced to the point of inciting plagiarism – Adolf Hitler's *Mein Kampf*. These are books, please remember, whose origins all lie in the West.[428]

Garfinkle claims Muslim anti-Semitism today is exacerbated by the fact "Arabs and Muslims get what we may charitably call news about other places, including Palestine" from a "new group of Arab satellite TV networks. Most of these outlets are government-owned, and all,

to one degree or another, heavily propagandize certain views."[429] It is obvious to Garfinkle that control of the media in the Middle East is an important causal factor in the growth of Muslim hostility to Jews; yet when White Nationalists make essentially the same point – that Jewish control of the Western media leads to the proliferation of anti-White sentiment – they are dismissed as paranoid conspiracy theorists by the likes of Garfinkle.

With his relatively sanguine view of historical Islam, Garfinkle offers us an insight into the thinking of Jewish leaders and activists throughout the West who, to the great surprise of many, remain unperturbed by large-scale Muslim immigration into Western nations with significant Jewish populations. This favorable regard for Muslims compared with Europeans, can, as mentioned, be traced to the Jewish interpretation of history as summarized by Garfinkle:

> As to the reality of Islamic tolerance for Jews over the centuries, this is unarguable. Given a hypothetical choice, no educated Jew would trade the Jewish experience within Islam for the one within Christendom. But it is easy to tolerate a protected Abrahamic minority, or any other kind for that matter, when the minority is both weak and often useful in one way or another. When a minority plays its part in bolstering the pride of the dominant group, it confirms the social cosmology of that dominant group; it works, it fits. It is another thing to show toleration when that minority has its own politically sovereign state in one's midst, is stronger, more modern, and wealthier than one's own states – as the State of Israel is in relation to all the Arab States. That has made all the difference.[430]

Garfinkle's attitude (that the historical record shows White people are the main enemies of Jews in the West) is normative within large sections of organized Jewry, and is grounded in a simple logic: the take home lesson of the Third Reich and "the Holocaust" is that all White people are incipient Nazis, and mass non-White immigration is a form of

preemptive denazification that makes formerly White nations safe for Jews. Jewish activists pose as moral paragons and humanitarians, when their logic is nothing more than ethnic self-interest: demographically swamp White nations so the political power of Whites declines, making the rise of an anti-Jewish movement among Whites less likely. The result of these Jewish anxieties and hatreds is to swamp the West with non-White immigrants to eventually make Whites a powerless minority in countries they founded and built.

The drawbacks of Western multiculturalism for Jews (most prominently the rise of Islamic anti-Semitism alongside historically high rates of intermarriage) are ostensibly regarded by Jewish leaders and activists as prices worth paying in their quest to demographically, politically and culturally neuter potentially dangerous White populations. In the minds of Western Jewish leaders nurtured on the cult of "the Holocaust," White Nationalism is still the most ominous threat to Jews.

## Conclusion

*Jewcentricity* is a book marred by weak argumentation and a conspicuous failure to consider all the relevant aspects of the "exaggerations" it discusses. To fail to mention, for instance, the role of organized Jewry in leading the demographic transformation of the West, and how this might account for a great deal of (quite justified) "negative Jewcentricity" is an egregious omission. Garfinkle's claim that Judaism is not a "bloodline phenomenon" (and thus not a group evolutionary strategy) is simply untenable in light of population genetic evidence. A glaring example of his outright sophistry is his falling back on the age-old deceit of claiming that Judaism is just a religion to defend his ludicrous claim that Jews do not control Hollywood.

In his attempt to appear to offer a fair-minded and rounded picture of Jews and their interactions with non-Jews, Garfinkle effectively accepts many of the claims made by White Nationalists: that Jews run Hollywood and large parts of the American media, that they exercise effective control over the U.S. Congress, and that their activist

organizations wield enormous financial and political power which they use to aggressively reengineer American society in their own ethnic interests. Garfinkle concludes *Jewcentricity* by proposing that:

> Everyone, Jews and non-Jews alike, could benefit from a little inattention to the wrong things. Non-Jews should pay less attention to Jews, and the Jews should pay more attention to themselves – meaning the state of their spiritual and communal life. ... If Jews would become a little less Jewcentric themselves, especially in public, there is just a chance, if only a small one, that non-Jews will become less Jewcentric, too.[431]

White people would certainly benefit from paying more attention to the right things, and nothing is more important than the ongoing survival of their race. One cannot seriously address this issue without coming face to face with the role of Jews in leading the social, economic and cultural transformation of the West. Unfortunately, White people do not have the luxury of becoming less "Jewcentric" in a world where Jewish power remains our foremost problem.

**CHAPTER 8**

# The Pathetic Apologetics
# of Caroline Glick

Caroline Glick is an American-born Israeli journalist and deputy managing editor of *The Jerusalem Post*. The Senior Fellow for Middle East Affairs at the Washington DC-based Center for Security Policy, Glick, a radical Zionist, migrated to Israel in 1991. She served in the Israeli Defense Force before being appointed assistant foreign policy advisor to Prime Minister Netanyahu.

Glick has been showered with awards from Zionist and Jewish organizations. In 2003 the Israeli newspaper *Maariv* named her the most prominent woman in Israel. She was the 2005 recipient of the Zionist Organization of America's Ben Hecht award for Outstanding Journalism (previous recipients included A. M. Rosenthal, Sidney Zion and Daniel Pipes). She was awarded the Abramowitz Prize for Media Criticism by Israel Media Watch, and in 2009 received the Guardian of Zion Award from Bar Ilan University in Tel Aviv. In 2012, The David Horowitz Freedom Center announced the hiring of Glick as the Director of its "Israel Security Project."

Inevitably, given the Jewish stranglehold over the American media, Glick is given a regular platform to espouse her views in *The Wall Street Journal*, the *National Review*, the *Boston Globe*, the *Chicago Sun-Times*, *The Washington Times* and many other newspapers and journals around

the world. She is also a regular pundit on MSNBC and the Fox News channel. Given her wide exposure in the Jewish-controlled media, and the senior positions she holds within the neoconservative establishment (where she is touted as "a brilliant and outspoken Jewish academic"), one might expect Glick to possess a formidable intellect and have a knack for formulating intellectually-sophisticated Jewish apologetics.

Instead we find another Jewish mediocrity whose undeserved public prominence can only be ascribed to Jewish ethnic networking. Take, for example, a speech Glick gave to a neoconservative audience entitled "Why the Jews?"[432] In this speech the "brilliant and outspoken" Glick explains to us the "roots of genocidal Jew hatred." She begins by telling her audience that:

> I don't want to talk specifically about the ideology of Islamic anti-Semites or genocidal Jew-haters or European or leftist people who want to destroy Jewish power and make us all needy and begging for our very lives. I want to talk about what all of the enemies of the Jewish people throughout the ages share. Because one thing about the genocidal axis is that it's not new, it's been here throughout time and the members of the genocidal axis, they may change their accents, they may change the books that they read, they may change a million different things, the continents they live in, but one thing that they share across time is that over and over and over again the target of their genocidal blood-lust is the Jews.

So the "brilliant and outspoken" Glick begins her speech with a tautology: that the enemies of the Jewish people throughout the ages all shared one thing in common – they regarded the Jews as their enemies. Glick melodramatically claims that anyone who has ever opposed Jewish influence necessarily harbored a "genocidal blood-lust" against the Jews. Of course, unmentioned by Glick is the fierce and implacable Jewish hostility to non-Jews that has echoed down through the ages. Glick is similarly silent on the "genocidal blood-lust" against non-Jews

that motivated the enthusiastic and vastly disproportionate Jewish participation in the Bolshevik genocide of tens of millions of Eastern Europeans in the early twentieth century, which motivates the Israelis' ongoing ethnic-cleansing of the Palestinians, and which motivates the overwhelming Jewish support for the slow genocide of all White people through mass non-White immigration into Western nations.

In her speech, Glick recounts the close friendship she shared with Benjamin Netanyahu's father (who died aged 102) and notes how the old man would "repeatedly and with the same impassioned anger" declare that "he could not stand the fixation on the Holocaust as some sort of singular moment in global history because there has been a holocaust of Jewry in every generation throughout the ages." According to Glick, Netanyahu the elder believed:

> That the same passions that inflamed the Germans and then spread out throughout Europe with this bloodlust of wanting to kill children like mine was due to a passion that moves through the ages, that there was nothing unique about that desire to shoot lead into Jewish babies. There is nothing unique about it. It's been going on since the time of the Ancient Greeks and the Ancient Egyptians. Just read the Bible, what is he [the Pharaoh] talking about? He wants to annihilate a people. It's not he wants to enslave them; he wants them gone – out! What's the difference between Pharaoh and Hitler? Technology? That's it.

Conveniently, Glick has nothing to say about the genocidal Jewish hatred of non-Jews that pervades the very same Jewish Bible she cites. For instance, in Joshua 6:20-21, God helps the Israelites destroy Jericho, killing "men and women, young and old, cattle, sheep and donkeys." In Deuteronomy 2:32-35, God has the Israelites kill everyone in Heshbon, including children. In Deuteronomy 3:3-7, God has the Israelites do the same to the people of Bashan. In Numbers 31:7-18, the Israelites kill all the Midianites except for the virgins, whom they take as spoils of war. In 1 Samuel 15:1-9, God tells the Israelites to kill all the Amalekites – men,

women, children, infants, and their cattle – for something the Ama-
lekites' ancestors had done 400 years earlier. Ignoring all of this, Glick
proposes that a "genocidal Jew hatred" is the "unifying force between
Pharaoh and Ahmadinejad and Khomeini and yes the international left
which is the handmaiden of these monsters of the Islamic world, with-
out which they could never, ever, march even one step forward."

The inconvenient reality for Glick is that Jews have, for well over a
century, been the intellectual, organizational and financial backbone of
the left. Furthermore, the only reason Jews are increasingly subject to
Islamic anti-Semitism in countries like France and the United Kingdom
is because of refugee floods created by Zionist wars, and mass non-
White immigration and multiculturalism – all malignant outgrowths
of Jewish ethnic activism. So what is this mysterious "force" that Glick
believes unifies those who have opposed the Jews at any time and place
throughout history?

> It is the rejection of reason... What is it about reason and about
> choice and about the notion of moral choice and moral empow-
> erment of individuals that stands at the root of the genocidal
> bloodlust against the Jews? The answer is that, from time im-
> memorial, Judaism has been based, from the time that God first
> spoke to Abraham in Iraq and told him to leave his father's home
> after Abraham took down the idols from his father's store and
> broke them. "Get thee to the land that I have promised you and
> your children." What was it about Abraham that God embraced
> at that time, and about the Jews at every single generation since
> then, that drives people bananas? It is the idea of good and evil,
> it is the idea that we as human beings have the responsibility to
> make a discernment between good and evil and to choose good
> in our lifetimes.

The notion that all non-Jews were mired in irrational amorality before
the advent of the Jews is laughable. It is typical of hyper-ethnocentric
Jewish activists like Glick to divide humanity into two groups – the

inherently moral and righteous Jews on the on the one hand, and the inherently immoral and wicked non-Jews on the other. The origin of anti-Jewish sentiment, according to this conception, resides in the fundamental incapacity of non-Jews to exercise reason and moral discernment. As with Jewish apologetics stretching back to the ancient world, Glick once again presents us with the conception of the Jews as reasoning, intelligent moral paragons and non-Jews as brutish and irrational embodiments of evil. For Glick, what all "anti-Semites" throughout history cannot stand is:

> A belief that defines us as a holy people, as a chosen people, [that] we accept, not divine salvation, but the notion of a life of hard choices, of constantly making a decision, and loyalty to a notion that it is our responsibility to do so, and that drives people to genocidal bloodlust, because at the root of this bloodlust is a rejection of reason. It's a rejection of individualism, it's a rejection of responsibility, it's a rejection of the notion that we have to be good. Because that makes our lives a struggle, that makes our lives difficult.

It takes incredible chutzpah from an ultra-Zionist like Glick to criticize those hostile to Jews for their "rejection of individualism," when the defining feature of Jewish history has been that group rather than individual interests have been of primary importance. Judaism is the prime historical example of how the rejection of individualism leads to group evolutionary success. In Glick's condemnation of non-Jews who reject individualism we hear echoes of the Frankfurt School's promotion of radical individualism as the epitome of psychological health for Europeans. The sane and well-adjusted White person was characterized by these Jewish intellectual activists as someone who realized their potential without relying on membership in collectivist groups. This promotion of radical individualism among non-Jews was, of course, intended to undermine the group cohesion of Europeans and weaken their capacity to compete effectively with Jews.

The reality is that hostility between Jews and non-Jews stems from conflicts of interests. However, for Glick, the existence of anti-Jewish sentiment is attributable to the fact that these hostile non-Jews are unreasoning, irrational brutes who only oppose Jewish power because "reasoning" is simply too hard them. Moreover, those who have the capacity to reason still hate Jews because they are irresponsible and simply do not want to be good. According to Glick:

> It's all about what does it mean to be a human being, and if you come down on that question, understanding that to be a human being means to be a moral agent, not an object, then you're with the Jews, and you're opposing totalitarianism, and you're opposing hatred, and you're opposing genocide. And if you come down on that question: "I want somebody else to tell me what to do, I don't know, I'm too weak, I'm too lazy, I'm too uneducated, I'm too ignorant to recognize the meaning of freedom," then you're a slave, then you can run around saying "Liberate Palestine."

It takes a real talent for casuistry, married with a profound dishonesty, to offer up the kind of moral inversion Glick gives us here. If you're a reasoning moral agent you're with the Jews and against totalitarianism, hatred and genocide – because the Jews, by definition, are incapable of engaging in totalitarianism, hatred and genocide, despite their egregious historical track record with regard to all three. If you oppose the Israelis' ethnic cleansing of the Palestinians you are a brain dead slave – despite the fact this descriptor more aptly applies to the millions of people who uncritically accept the lies and cultural subversion offered them by the Jewish-controlled media and entertainment industries. So what does Glick make of those more individualistic nations, like the United States, that have been far less effective in resisting Jewish domination?

> Now what was it that made the United States the only country (to date) that didn't have the same genocidal Jew-hatred at the root of its identity that we saw in country after country in

Europe, [and] that we see in Arab world? It was that the United States, its forefathers, had this idea that was based on the Torah, of rule of law, of limited government, of the responsibility of the individual to make that decision between good and evil, and to choose good, and to have the liberty from that government to make that choice. The whole concept of the modern state is based on the philosophical works of men like John Selden and John Locke and Thomas Hobbes who were Hebrew scholars, who based their whole concept of the modern state, that these men put together, on the rule of law, on divine law, that man could not be a totalitarian because we are not God.

Here Glick engages in a longstanding but bogus Jewish intellectual tradition: that of Jews seeking to take credit for Western civilization (or at least the features of it considered amenable to Jews). Thus, the only reason the United States is any good, according to Glick, is that it's intellectual and political founders were steeped in the lore and traditions of the Jews – all roads lead to Jerusalem. Non-Jews are mostly irrational and wicked Jew-haters, and their few redeeming qualities can ultimately be traced the positive influence exerted by the Jews. Forget Plato and Aristotle and 2,500 years of Western philosophy; the best features of Western civilization find their wellspring in the mythology of the Hebrews. Indeed Glick even goes so far as to claim that: "The whole concept of the modern state was based on the Hebrew Bible and it was transported from the British Enlightenment to the new world through the American forefathers."

Glick is deeply troubled by rising anti-Jewish sentiment among sections of the academic left in the United States. Of course, this as an entirely predictable response to the radical actions of an increasingly ruthless and rabidly ethno-nationalist Israeli government and its Zionist cheerleaders in the United States – actions which include the aggressive ethnic cleansing of the Palestinians, a state-sponsored policy of ethnic apartheid, and the deportation of non-Jewish "enemy infiltrators." Glick totally ignores this and argues hostility to Israel and its supporters

stems from a rejection of American values and (because America was, in her view, created by Hebrew scholars) a rejection of Jewish values.

> What do we see today? Why is it that we see more and more and more Jew hatred and attacks on Jews in U.S. universities, in political circles, on the left? Because the left is introducing an ideology that is fundamentally un-American, that is based on the totalitarian idea of a governing power that is absolute, that knows better than an individual what's good for him or her. And if you know better than I do what's good for me, what's good for my children, then you're an absolute power, and if you're an absolute power you have to reject Jews. Because absolute powers must reject Jews who understand that there's no authority except God and you're not Him.

Anti-Zionist sentiment is growing, according to Glick, not because of the increasingly indefensible actions of the Israeli government (cheered on by their hypocritical Zionist cheerleaders in the West), but because the Zionist establishment in America is declining in influence.

> We are faced with this wave, because the strength of people in this room, and unfortunately outside this room, seems to be waning. And the wave that is rising throughout the world is a wave of hatred, of bloodlust, of totalitarianism, and again this is familiar, this is known, we understand what we're dealing with.

The ongoing Zionist outrages (despite the never-ending compensatory stream of "Holocaust" propaganda pumped out by Hollywood), has led to the erosion of Jewish moral legitimacy over recent years, and has resulted in an unprecedented situation that Glick finds extremely disturbing:

> The new thing in this generation is that we see Americans confused for the first time about what side they're supposed to be on. We see that there is a question about "Is Israel evil for

standing up for existing, for being different from all of its unaes-
thetic, misogynistic, totalitarian neighbors? Are we bad for being
loyal to everything that we've stood for for four thousand years?"
How can you question that? Because Americans are beginning
to question what it means to be an American.

For Glick, what it means to be American is to obsequiously accept the
total Jewish domination of their nation and to support Israel to the last
dollar and the last drop of American blood. For Glick, as for all of the
"Israel-firsters" of the neoconservative establishment, Israel's interests
and America's interests are indistinguishable. She thus concludes her
speech with such shameless lies as: "You want a foreign policy that
is coherent, that advances American interests? Then stand with Israel.
You want to figure out how to ensure that America is safe? Stand
with Israel."

Zionist propagandists like Glick are increasingly disturbed that the
old lies and hypocrisy don't wash with growing numbers of people.
Glick's utterly dishonest speech, aside from revealing her status as one
of the most overrated figures in the Jewish activist ranks, also makes it
abundantly clear that Israel is the Achilles heel of Jewish power and is
steadily eroding Jewish moral legitimacy.

## CHAPTER 9

# Mark Rothko, Abstract Expressionism and the Decline of Western Art

The life and career of Abstract Expressionist painter Mark Rothko is a prototypical Jewish story that encapsulates a range of themes discussed at *The Occidental Observer* and *The Occidental Quarterly*. Central to Rothko's story is the political radicalism of Eastern European Jewish migrants arriving in the United States between 1880 and 1920; the reflexive hostility of these migrants to the traditional people and culture of their new homeland; and how this hostility was reflected in the artistic and intellectual currents that dominated Western societies in the twentieth century. Rothko's story also exemplifies other familiar themes including: the power of Jewish ethnic networking and nepotism in promoting Jewish interests (both individual and collective), and the tendency for Jewish "genius" to be constructed by Jewish intellectuals as self-appointed gatekeepers of Western culture.

With Jackson Pollock, Mark Rothko has been accorded a leading place in the ranks of the Abstract Expressionists. If there is such a thing as a cult artist among the liberal Jewish intelligentsia, then Rothko is probably it. Important people stand in grave silence before his empty

expanses with looks on their faces that bespeak lofty thoughts. As a critic for *The Times* noted:

> Rothko evokes all that could be criticized as most pretentious, most clannish, most pseudish about his spectators. They stand there gravely perusing something that to the outsider probably looks more like a patch of half-stripped wallpaper than a picture and then declare themselves profoundly moved. And many outsiders will start to wonder if they are being duped, if this Modernist emperor actually has no clothes on and his fans are just the blind followers of some aesthetic faith.

For critics like Ottmann, Rothko's genius is indisputable and he possessed an "extraordinary talent" that enabled him to transfer his metaphysical "impulses to the canvas with a power and magnetism that stuns viewers of his work... In fact Rothko's skill in achieving this result – whether intentional or not – perhaps explains why he was once called 'the melancholic rabbi.'"[433] For prominent Jewish art historian Simon Schama, Rothko's "big vertical canvasses of contrasting bars of colour, panels of colour stacked up on top of each other" qualify him as "a maker of paintings as powerful and complicated as anything by his two gods – Rembrandt and Turner." For the ethnocentric Schama, "these [Rothko's] paintings are equivalent of these old masters... Can art ever be more complete, more powerful? I don't think so."[434]

After experimenting with Expressionism and Surrealism, Rothko finally arrived in 1949 at the style that would typify his work until his death by suicide in 1970 at the age of 66. This consisted of two or three floating rectangles of color painted against a monochrome background. A pioneer of what the Jewish art critic Clement Greenberg dubbed "color field" painting, Rothko claimed that only abstract painting could express the "full gravity of religious yearnings and the angst of the human condition." He intended their effect to be transcendental with his stated goal being "only in expressing basic human emotions – tragedy, ecstasy, doom, and so on." Rothko claimed that "a lot of people

break down and cry when confronted with my pictures" which showed they were "having the same religious experience I had when I painted them." His final works became so minimalistic (large black canvasses) as to be almost void of any substance.

In the twenty first century, the sale prices of Rothko's paintings at auction have risen consistently, surpassing those of his Abstract Expressionist colleagues, to reach staggering sums in the vicinity of $200 million. In 2011, Mark Rothko became the main character in *Red,* a successful Broadway play that treated him as a unique genius and won six Tony Awards.[435] Rothko would have approved of the portrayal: Elaine de Kooning once noted how he was "hypnotized by his own role, and there was just one. The role was that of the Messiah."[436]

## The Making of Mark Rothko

Born in 1903, Marcus Rothkowitz was the youngest child of pharmacist, Jacob Rothkowitz, and his wife, Anna Goldin Rothkowitz, in the Russian city of Dvinsk (today Daugavpils, Latvia). Dvinsk, at the time in the Jewish Pale of Settlement, was a hotbed of Jewish radicalism. The Pale was then inhabited by five million Jews confined there by the Tsar at a time when thousands of Polish Jews were crossing the border into Russia seeking work. Rothko's father was the stereotype of the left-wing Jewish intellectual, who presided over a family with an "intense commitment to politics and education."[437] He initially preferred secular education for his children, and political over religious involvement. According to Rothko, his father's relation to formal religion was openly oppositional: "My father was a militant social democrat of the Jewish party, the Bund, which was the social democracy of that time. He was profoundly Marxist and violently anti-religious."[438]

That this was chiefly an anti-Christian, rather than anti-religious, impulse is revealed by the fact he returned to the Orthodox Jewish fold after Marcus's birth in response to anti-Jewish violence which followed the failed Revolution of 1905. While no "pogroms" were ever visited on the Jews of Dvinsk, the town witnessed occasional incidents where

Jews were targeted as sympathizers of the Social Democratic and other revolutionary parties. In 1905, according to Baal-Teshuva, the young Rothko's "hometown was under the blanket surveillance of the Tsarist secret police. Jews were the usual victims of reprisals whenever the Cossacks, the loyal followers of the Tsarist state, came into the town to break up revolutionary uprisings." Jews living in the environs of Dvinsk "lived in constant terror of pogroms and massacres. The air was filled with slogans like 'Kill the Jews to Save Russia.' This was the atmosphere in which Rothko grew up."[439]

Despite the fact no pogroms occurred in Dvinsk, Rothko claimed to "remember the local Cossacks indulging in their favourite activity – beating up Jews." He repeatedly told "likely embellished stories that he would wear a backpack to avoid getting hit by the stones the children of Dvinsk threw at him in the streets," and that a Cossack who had come to repress demonstrations in the city had "struck him in the face with a whip."[440]

Rothko later even claimed to recall "dug-up pits in the forests around Dvinsk, where the Cossacks buried Jewish victims they had kidnapped and murdered. These images always plagued him mentally, and he says they exercised a certain influence on his painting."[441] Baal-Teshuva forgives Rothko these obvious untruths, contending it's likely "that the child heard adults talking about the pogroms and massacres elsewhere, and in his memory ended up mixing up these stories with his own memories of the nearby woods."[442] Acknowledging that some critics have happily run with these falsehoods, he observes how they have "gone so far as to say this explains his preference for rectangular forms in his late works, as a formal echo of the grave."[443]

In response to the economic and political insecurities of life in the Pale, Marcus's father migrated to the United States in 1910. Only in 1913, when Marcus was ten years old, did the rest of the family move to America. Despite the supposed hazards of life in the Pale, Rothko "referred often to the 'terrible experience' of having been torn away from his homeland against his will."[444] It was certainly not the gentile culture of America that attracted the waves of Jewish migrants from

Eastern Europe, but only the relatively advantageous conditions created by American economic growth. "They came to America's shores," notes Muller, "motivated not by religion but in spite of it, their more orthodox leaders being inclined to warn them against the dangers of godless and goyish America."[445] A massive influx of 2.3 million Jews arrived at Ellis Island between 1881 and 1920.

The Rothkowitz family spoke Hebrew, Russian and Yiddish, and South Portland in Oregon, where they settled (dubbed "Little Odessa"), provided an environment "very much as we think of a shtetl" where one could go for years speaking Yiddish, Russian, or Polish without having to learn a word of English.[446] Beginning in Dvinsk and then in Portland, his father decided Marcus would have a strict religious education. He was sent to a *cheder*, the religious school run by a synagogue, starting at the age of five, and was subject to a strict and tiring routine: praying, reading and translation of Hebrew texts, and rote memorization of Talmudic law.[447]

Rothko's parents saw no contradiction in bringing up their son as an Orthodox Jew, a Zionist, and a Communist. This is quite in keeping with Kevin MacDonald's observation that "within Russian Jewish communities, the acceptance of radical political ideology often coexisted with messianic forms of Zionism as well as intense commitment to Jewish nationalism and religious and cultural separatism, and many individuals held various and often rapidly changing combinations of these ideas."[448]

After the family had achieved a degree of economic security in Portland, they joined local chapters of radical movements. Marcus avidly participated in discussions on current affairs and argued "skillfully for the right of workers to strike, or for general access to contraception. His entire family was in favour of the Russian Revolution, as Rothko later said."[449] This was, of course, very typical, with Jewish historian Norman Cantor noting how "In the first half of the twentieth century, Marxist-Leninist communism ran like an electromagnetic lightning flash through Jewish societies from Moscow to Western Europe, the

United States and Canada, gaining the lifelong adherence of brilliant, passionately dedicated Jewish men and women."[450]

## *Another "Jewish Genius" Gets Stung by the WASPS*

Rothko was, according to Schama, very much one of these brilliant Jewish men, who, despite his Orthodox Jewish education, was "no Jewish Trappist, but a much more recognizable type (at least to me): loquacious, exuberant, hot-tempered, deeply immersed in literature and history." While the Orthodox Judaism in which Rothko was schooled was not directly expressed in his later art, Schama insists that "once you've done *cheder* – Hebrew school – it never really goes away, however much you try to banish it; nor did it for Marcus. He was what everyone would call, with smiles, both admiring and pitying, a *chocom* – a know-it-all. And what do *chochoms* do if they weren't going to be rabbis?"[451] He was, Schama insists, "just your super-educated, ungainly, sentimental Jew. In the grip of mighty ideas, he was desperate to tell you all about them, fidgeting on the sofa and waving his arms all around. A big heart and a big mouth to match – you know the type."[452]

After his Orthodox Jewish education, Rothko, at the age of fourteen, attended Lincoln High School in Portland where "he finally experienced his first true encounter with the non-Jewish world, as only 10 percent of the nine hundred students were Jewish." There he excelled academically and was a passionate debater for the radical cause. Cohen-Solal admires the way "the diligent student from Lincoln High grew into a passionate young intellectual," who "bluntly decided to confront tradition."[453] Around this time he went to hear "'Red' Emma Goldman lay into capitalism and sing the praises of the Russian Revolution."[454]

Rothko was passionately drawn to the IWW (Industrial Workers of the World) and Emma Goldman at a time of rising ethnocentrism and growing hostility to Jewish immigration among White Americans. In 1915, the Ku Klux Klan, inactive since the Reconstruction era, revived in the South, and in 1916, Madison Grant defended his racial history theory in *The Passing of the Great Race*. Rothko saw disturbing parallels

between the respective *goyim* of his old and new countries, especially at the time of Leo Frank's lynching in 1915, when he observed in a poem that:

> Those primitive barbarous people,
> They live again in my blood,
> And I feel myself bound to the past
> By invisible chains.[455]

American entry into World War One in 1917 inspired nationalist demonstrations among Americans who believed their country had no interest in the conflict. The majority of them also, as mentioned, opposed mass immigration, and Congress passed three successive, highly restrictive, immigration laws: the Immigration Act of 1917, which introduced a literacy test; the Emergency Quota Act of 1921; and the National Origins Act of 1924. Such laws were deeply distressing to Jews like Rothko who wanted the country kept open to Jewish immigration.

Schama tells us that Rothko was "scholarship material, and won a place at Yale [in 1921] before the Ivy League decided they were about to be inundated by clever Jews and imposed admission quotas." Despite his admission to Yale, "Rothko felt the sting of the WASPS all the same. If they couldn't actually evict the talky-smart kikes, 'those people,' they could at least make it hard for them to stick around."[456] Baal-Teshuva claims Rothko and his fellow Jewish students soon discovered the difficulties of gaining social acceptance in a setting where "the majority of generally affluent White Anglo-Saxon Protestants were contemptuous of the Jewish minority."[457] Exactly how these WASP students were supposed (or even remotely likely) to embrace a group who feted Emma Goldman, were deeply hostile to their people and culture, and longed for the day when a violent revolution would consign them and their kind to the dustbin of history, is unclear. The more desperately the Jews wanted to "climb the social ladder, the more panic-stricken the others became at the idea of being invaded."[458]

At the end of a year spent studying the history of philosophy and psychology, Rothko had achieved only mediocre results, and his scholarship was rescinded and replaced with a student loan. Rothko biographer Annie Cohen-Solal indignantly asks:

> How could a young man of eighteen years – the image of a 1920s intellectual, with a high forehead, an intense gaze behind round glasses, and a combed-back mass of wavy black hair – who entered with such enthusiasm into Yale, this temple of knowledge, so severely flounder there? Why would this voracious student, craving intellectual debates, so confident in his abilities after a string of successes in Portland, completely fail to find his place at this elite university?[459]

Her predictable answer: the ubiquitous anti-Semitism Rothko supposedly confronted at a Yale dominated by an "inaccessible club of young WASPs."[460] Cohen-Solal claims that Rothko quickly became a pariah after his arrival in New Haven, and was "stigmatized precisely because he was bright." He quickly learned that "the Yale social system was based more on breeding than on merit," while also discovering "the cynicism and hypocrisy of the caste-based micro-society that sought to protect and reproduce itself, in particular by excluding new, upwardly mobile immigrants who, in those years of rampant nationalism, were deemed threatening to the system."[461] By thwarting his entry into its exclusive society, Cohen-Solal accuses Yale of having unforgivably "hampered the development of the identity of the young prodigy from Dvinsk."[462]

Rothko lived off-campus with relatives in New Haven, and launched a radical underground newspaper called *The Yale Saturday Evening Post* "which took aim at the college's teaching methods and fetish for prestige."[463] He discovered his artistic calling by chance. One day, in 1923, he visited a friend studying drawing at the Art Students League and decided "It is the life for me." He dropped out of Yale after his second year, and moved to New York where he took some art courses. According

to Cohen-Solal, it was little wonder he elected to become a painter: "Socially, he was a rebel who, after enduring a series of setbacks, had developed a precocious political awareness as well as a desire for revenge. To pursue a career in art meant, for him, joining a professional group of outcasts with which he could identify."[464] Rothko would return to Yale 46 years later – when the WASPs had been overthrown and his own ethnic group was firmly in charge – to receive an honorary degree.

Rothko relocated to New York in 1925 and remained there for the rest of his life, becoming involved with Jewish institutions and close to various Jewish artists. He enrolled in the New School of Design where Arshile Gorky (not Jewish) became one of his instructors, and cubist artist Max Weber, a fellow Russian Jew, one of his mentors. In 1928, he was invited to participate in a group show at New York's Opportunity Gallery, with Lou Harris and Milton Avery – a self-taught painter connected to Brooklyn's Jewish community through his wife – who mentored various Jewish artists including Adolph Gottlieb, Barnett Newman, Joseph Solman, and Louis Schanker.[465] Rothko also gained experience by drawing maps and illustrations for *The Graphic Bible* by Lewis Browne, a retired rabbi from Portland who was a best-selling author. When he saw he wasn't credited for these works, he sued Browne for $20,000 in damages. In the end, he lost the trial.[466]

Despite all this activity, when the Wall Street crash came in 1929, followed by the Great Depression, Rothko had little to show for his decade in New York. He was exhibited but rarely sold, and when it did, it was not a living. Between 1928 and 1939, one exhibition followed the next, but his works – oils, watercolors, and paintings on paper – sold poorly. In the meantime he had married Edith Sachar, "bright and Jewish, whom he had met at a progressive summer camp at Lake George in the Adirondacks: downing dialectical materialism, Freud and Cubism along with the weak coffee."[467]

## *Creating a New "American" Art*

Before the rise of Abstract Expressionism in the 1940s, the American art scene was defined by two main currents. The first were the Regionalists (e.g., Grant Wood, Thomas Hart Benton and John Steuart Curry) who used their own signature styles to portray the virtues of the hard-working rural American population. The second group were the artists of Social Realism (e.g., Ben Shahn and Diego Rivera), whose work reflected urban life during the Great Depression and their devotion to international socialism. Neither was interested in abstract art, and despite their political radicalism the Social Realists held rather conservative attitudes to figurative representation. While these two styles dominated, the artists of the nascent New York School "met frequently at the legendary Cedar Bar, where they discussed their radical theses. They argued endlessly about the problems of art, about how to effect a total break with the art of the past, about the mission of creating an abstract art that no longer had anything to do with conventional techniques and motifs."[468]

The Museum of Modern Art did not yet exist; the Metropolitan Museum tended to "look down its WASP patrician nose at modernism;" and the Whitney favoured exactly the kind of American painting young Rothko most despised: scenic, provincial, anecdotal, and conservative.[469] For a Jewish outsider like Rothko, who in 1970 declared that he would never feel entirely at home in a land to which he had been transplanted against his will, urban America was his America.

> But what was on the mid-town gallery walls was, for the most part, another America altogether: big Skies, fruited plain, purple mountain majesty, the light of providence shining on the prairie. About that America Rothko knew little and cared less. Early on, he had the sense that America ought to offer an art that was as new and vital as its history; but he also wanted that art to play for high stakes, to be hooked up somehow to the universal ideas he was chain-smoking his way through. Just what such an art might look like, however, he had as yet not the slightest idea.[470]

The New York Intellectuals (who were overwhelmingly Jewish) associated rural America with nativism, anti-Semitism, nationalism, and fascism as well as with anti-intellectualism and provincialism. By contrast, urban America was associated with ethnic and cultural tolerance, with internationalism, and with advanced ideas. Their basic assumption was that rural America, with which they associated much of American tradition and most of the territory beyond New York, had little to contribute to a cosmopolitan culture and could therefore be dismissed.

## *Artistic Expression as "Unrelated to Manual Ability or Painterly Technique"*

Rothko's skill in rendering the human form was poor, which is evident in early works like *Bathers or Beach Scene (Untitled)* (1933/4). Schama admits as much, noting that: "When he [Rothko] stood in the Brooklyn [Jewish Center] classroom [where he taught art classes from 1929-46] it all seemed so easy. He would tell the children not to mind the rules – painting, he said, was as natural as singing. It should be like music but when he tried it came out as a croak. It's the work of a painfully knotted imagination. No not very good."[471] According to the general consensus, Rothko "never stood out as a great draughtsman and could even at times appear clumsy in the execution of his oil paintings."[472]

Rothko, in a speech in the mid-thirties, offered a quasi-philosophical rationale for the unimportance of technical skill, stressing "the difference between sheer skill, and skill that is linked to spirit, expressiveness and personality." He insisted that artistic expression was "unrelated to manual ability or painterly technique, that it is drawn from an inborn feeling for form; the ideal lies in the spontaneity, simplicity and directness of children."[473] Such grandiloquent pronouncements from Rothko were not unusual, with Collings noting that "Rothko was outrageously over-fruity and grandiose in his statements about art and religion and the solemn importance of his own art."[474]

This tendency on his part prompted one writer to declare: "What I find amazing... is how a painting which is two rectangles of different

colors can somehow prompt thousands upon thousands of words on the human condition, Marxist dialectics, and social construction." He suggests a good rule of thumb is "the more abstruse terms an artist and his supporters use to describe a work, the less worth the painting has. By this definition Rothko may be the most worthless artist in the history of humanity." Another critic humorously observed that:

> Rothko needed to be fluent in rationalizing his existence and validating himself as a relevant artist to the average idiot who spent tens of thousands of dollars on paintings which could be easily reproduced by anyone with a pulse and a paint brush. Rothko... learned to garner attention to his paintings by getting into a frenzied drama-queen state and hysterically claiming that his works were deep, profound statements and not just indiscriminate blobs of color. They were expressions that rejected society's expectation of technical expertise, actual talent and an artist's evolution over time.

As well as self-interestedly seeking to redefine the nature of great art, Rothko often spoke out for the importance of "artistic freedom," which in practice meant artistic freedom for those on the left. He became involved in the famed 1934 incident between John D. Rockefeller and the Social Realist painter, Diego Rivera. This began when Rivera was commissioned to paint a huge mural in the lobby of the main building of Rockefeller Center, the newly completed showcase of the oil baron's ideals. Shortly before Rivera completed his work, Rockefeller dropped in and saw that the mural had a defiantly socialist message based on a heroic depiction of Lenin. He ordered the removal of the mural, resulting in its destruction. After this incident, a group of 200 New York artists gathered to protest against Rockefeller, and Rothko marched with them.[475]

## Jewish Ethnic Networking and "The Ten"

In 1934 Rothko was one of the original 200 founding members of the Art Union and Gallery Secession which was devoted to the newest artistic tendencies. A year later he became a member of a group who called themselves "The Ten" (the minimum number of Jews that can pray together). This unashamed exercise in Jewish ethnic networking was an opportunity for Rothko and his colleagues to engage in mutual admiration and promotion, and agitate in favor of "experimentation" and against "conservatism" in museums, schools and galleries.[476] Among "The Ten" were Ben Zion, Adolph Gottlieb, Louis Harris, Yankel Kufeld, Louis Schanker, Joseph Solman, Nahum Chazbazov, Ilya Bolotovsky and Rothko. Gottlieb, in describing the group, later recalled: "We were outcasts, roughly expressionist painters. We were not acceptable to most dealers and collectors. We banded together for the purpose of mutual support." "The Ten" acted as an alliance against the promotion of Regionalist art by the Whitney Museum of American Art, which to them was too "provincial" for words.[477]

> Rejecting the local artists' Regionalist perspectives, they were unable to define themselves as mere U.S. citizens. Instead, they presented themselves as cosmopolitan internationalists, freer and more open to incorporate the intercultural lessons of the European Modernist avant-gardes. When the fascist regimes began to decapitate these new art movements (with the closing of the Bauhaus in 1933 and the mounting of the exhibition *Entartete Kunst* [Degenerate Art] in Munich in 1937), great masters like Josef Albers and Piet Mondrian made their way to the United States, and American Jewish artists welcomed them with open arms.[478]

The pronounced ingroup-outgroup mentality of "The Ten" mirrored that within the Jewish intellectual movements reviewed by Kevin MacDonald in *Culture of Critique*, where he notes how Norman Podhoretz described the group of Jewish intellectuals centered around

*Partisan Review* as a "family" – a sentiment derived from their feeling of "beleaguered isolation shared with masters of the modernist movement themselves, elitism – the conviction that others are not worth taking into consideration except to attack, and need not be addressed in one's writing; out of the feeling as well as a sense of hopelessness as to the fate of American culture at large and the correlative conviction that integrity and standards were only possible among 'us.'"[479]

Within these alienated and marginalized Jewish groups was an atmosphere of social support that fostered an intense "Jewish ingroup solidarity arrayed against a morally and intellectually inferior outside world."[480] Despite the ethnic superglue, there were tensions within the Jewish milieu of "The Ten," with Schama pointing out that, "Amidst the usual Talmudic bickering of leftist factions, the denunciations and walk-outs, Rothkowitz and his comrades were all burning to make an art that would say something about the alienation, as they saw it, of modern American life."[481] For Rothko, "the whole problem of art was to establish human values in this specific civilization."[482]

## Isolationism as "Hitlerism"

Jewish gallery owners like Sam Kootz decried the "nationalist" art of the Regionalists and promoted the internationalist art of a rising generation of (often Jewish) expressionist, surrealist and abstract artists. "America's more important artists are consistently shying away from Regionalism and exploring the virtues of internationalism," he commented at the time. "This is the painting equivalent of our newly found political and social internationalism."[483] For Rothko, like for most American Jews, the Second World War was a moment of universal moral crisis. He had only become an American citizen in 1938 and like many American Jews, "he was worried about the rise of the Nazis in Germany and the possibility of a revival of anti-Semitism in America, and U.S. Citizenship came to signify security." Following the Molotov-Ribbentrop pact of 1939, Rothko along with others left the American Artists' Congress to protest its continuing support for the Soviet Union.

When, on the first anniversary of Pearl Harbor, the Metropolitan Museum organized an exhibition entitled *Artists for Victory*, consisting of 1,418 works by contemporary artists – John Steuart Curry took first prize – the Federation of Modern painters vehemently criticized the works, denouncing them as "realist and isolationist."[484] Jewish abstract artist Barnett Newman took a clear stand against local American artists, declaring: "Isolationist painting, which they named the American Renaissance, is founded on politics and on an even worse aesthetic. Using the traditional chauvinism, isolationist brand of patriotism, and playing on the natural desire of American artists to have their own art, they succeeded in pushing across a false aesthetic that is inhibiting the production of any true art in this country. ... Isolationism, we have learned by now, is Hitlerism."[485]

Rothko enthusiastically welcomed American entry into the war, insisting it represented "an escape from narrow-minded isolation," and "a reconnection with the destinies of modern history." Schama observes that:

> Now Rothko and his painter friends – so many of them originally European Jews – wanted American art to go the same way. With European civilization annihilated by fascism, it was up to the United States to take the torch and save human culture from a new Dark Ages. It was not just a matter of offering safe haven to the likes of Piet Mondrian or *Guernica*, but rather the authentic American way – doing something bold and fresh, taking the fight to the enemy which had classified modernism as "degenerate" and had done its best to destroy its partisans... The Nazis had art (as well as everything else) entirely the wrong way round. The modernism they demonized as "degenerate" was in fact the seed of new growth, and what they glorified as "regenerate" was the stale leavings of neo-classicism. Their mistake was America's – and particularly New York's – good fortune.

This was a time when many American Jews were changing or modifying their names to sound less Jewish. In January 1940 Marcus Rothkowitz officially became Mark Rothko. During the war years Rothko's art changed too: he produced a series of surrealistic pictures inspired by Freud's interpretations of dreams, C.G. Jung's theories of the collective unconscious, and ancient Greek mythology. Nietzsche's *The Birth of Tragedy* was an important influence at this time.[486] One source claims that "Amid an era of rising anti-Semitism, such themes enabled Rothko to address the unfolding catastrophe in Europe without publically proclaiming his status as a Jew."[487]

## *The Jewish Ethnic Networking Finally Pays Off*

By the 1940s, Rothko's intensive Jewish ethnic networking started to bear tangible fruit. He befriended Peggy Guggenheim, "the most voracious patroness of American avant-garde art," who had migrated to New York in 1941. Guggenheim's artistic consultant, Howard Putzel, "convinced her to show Rothko in her Art of This Century gallery, where she had opened in 1942, during the low point of the war."[488] In 1945, Guggenheim decided to put on Rothko's first one-man exhibition at her gallery.[489] In 1948, Rothko invited a coterie of mainly Jewish friends and acquaintances to view his new "multiforms." The prominent Jewish art critic Harold Rosenberg found these works "fantastic," and called the experience "the most impressive visit to an artist" in his life.[490] Rothko returned the favor, lauding Rosenberg as "one of the best brains that you are likely to encounter, full of wit, humaneness and a genius for getting things impeccably expressed."[491]

When, in late 1949, Sam Kootz inaugurated his new gallery, he asked Rosenberg to select the artists for the opening show, and Rothko was inevitably among them. That year Rothko produced his first "color field" paintings, describing his new method as "unknown adventures in unknown space," free from "direct association with any particular, and the passion of organism." 1949 was also the year Jewish art critic Clement Greenberg expressed the hope that "national pride will overcome

ingrained philistinism and induce our journalists to boast of what they neither understand nor enjoy." Greenberg's article appeared in *The Nation* on June 11, and two months later, journalist Dorothy Seiberling took up Greenberg's challenge in an article in *Life Magazine* entitled: "Jackson Pollock: is he the greatest living painter in the United States?" This article, published in a magazine with a circulation of five million, made Pollock and the Abstract Expressionists famous.[492] Subsequent articles by Seiberling sought to "make Abstract Expressionists like Mark Rothko, Willem de Kooning and Franz Kline accessible to a somewhat perplexed public."[493]

When, in 1950, the Metropolitan Museum announced an exhibition entitled *American Painting Today*, Rothko's Jewish colleagues Adolph Gottlieb, Barnett Newman and Ad Reinhardt, in a letter published in *The New York Times*, lashed out at the curator for being hostile to "advanced art," accusing the director of "contempt for modern painting," and lamenting that "a just proportion of advanced art" had not been included in the upcoming exhibition.[494] Rothko was moved at the time to flatly reject the "whole tradition of European painting beginning with the Renaissance." "We have wiped the slate clean," he declared. "We start new. A new land. We've got to forget what the Old Masters did."[495]

By the 1950s, Rothko had arrived at his mature style, and with Katherine Kuh and Sidney Janis as his professional agents, "enjoyed both fame and material success at last."[496] Rothko's professional ascent was fostered by these two eminent personalities of the art world: Kuh was the curator of the Art Institute in Chicago; and Janis an art dealer with the power to make or break reputations. In her biography of Rothko, Annie Cohen-Solal emphasizes the role of Jewish ethnic networking in Rothko's rise from obscurity to celebrity in the American art scene. "Of all the 'dynamic players' instrumental to anchoring Rothko's position as artist in American society," she notes, "how not to mention that these two, in particular, were 'assimilated' Jews?"[497]

As soon as she became curator of the Art Institute's painting department in 1954, Kuh proposed a solo show of Mark Rothko, and

following the exhibition, the Institute "proudly announced that the museum had purchased No. 10, 1952, for its permanent collection. 'It is needless to tell you how greatly this transaction contributes to the peace of mind with which my present work is being done,' Rothko admitted to Kuh."[498] Meanwhile, taking on Sidney Janis as his dealer in 1954 "marked a shift into higher gear" that resulted in a "spectacular windfall for Rothko."[499] Janis signing up and actively promoting Rothko settled his status "as a protagonist of international importance in the post-war art scene." After this, Rothko's art was declared a good investment by *Fortune* magazine, which led to his relationship with colleagues Clifford Still and Barnet Newman deteriorating to the point where "They accused Rothko of harbouring an unhealthy yearning for a bourgeois existence, and finally stamped him as a traitor."[500] Sales of Rothko's work would only improve when, a few years later, Congress passed a new tax law particularly advantageous to art collectors.

## The Seagram Murals

In 1958, Rothko signed a contract to paint murals for the Four Seasons restaurant in the Seagram's Building in New York. The man who approved the commission was Seagram's American subsidiary head Edgar Bronfman Snr – later President of the World Jewish Congress. The fee offered was $35,000 (a huge sum at the time). Rothko was, however, uncomfortable with the commission and the damage it might do to his bohemian reputation, and subsequently refunded the money and asked for the completed murals to be returned. The idea that his "Seagram murals," conceived as deep metaphysical statements, would become mere background decorations, was intolerable. Nine of them were permanently installed in a room at the Tate Gallery in London in 1970.

Rothko's color field paintings of the 1950s and beyond, according to one source, "can be seen as profound mediations on the Holocaust," with their rectangular forms inviting "associations with the haunting images of mass graves seen in American newspapers and magazines during and after the war." The dark tones of Rothko's Seagram murals

are described as "doorways to Hell" and "likened to the rims of flames: responses with obvious Holocaust resonance." These paintings are widely held to be Rothko's greatest achievement. Rothko certainly thought so, immodestly equating them with Michelangelo's frescoes in the Sistine Chapel.[501]

1961 marked the climax of Rothko's public recognition as an artist with a comprehensive exhibition of his work at MoMA. The man responsible, MoMA's Jewish curator Peter Selz, raved about "these silent paintings with their enormous, beautiful, opaque surfaces [that] are mirrors, reflecting what the viewer brings with him. In this sense, they can be said to deal directly with human emotions, desires, relationships, for they are mirrors of our fantasies and serve as echoes of our experience."[502] Selz, who with Alan Henry Geldzahler at the Metropolitan Museum, was one of "New York's reigning curators," was, like Rothko, "born into a European-Jewish family, but he came from Munich and had immigrated to the United States in 1936, driven out of Germany by the rise of Nazism."[503] For Rothko, "who had already encountered various secular Jews in his professional trajectory – from Peggy Guggenheim to Sidney Janis, Katherine Kuh, and Phyllis Lambert – Peter Selz would be the one to stage Rothko's most prestigious exhibition in the United States."[504]

Despite the cheerleading of New York's Jewish-dominated art establishment, a few critics resisted the enthusiasm for Rothko, most notably the gentile Howard Devree who, regarding Rothko's paintings, noted that "the impact is merely optical rather than aesthetic, the validity as a work of art negligible. Seemingly it has become necessary for the color group to increase the size of their paintings, with corresponding emptiness; to make impact and size equivalent; and, as a corollary, they escape making any valid statement." Devree compared Rothko's paintings with "a set of swatches prepared by a house painter for a housewife who cannot make up her mind."[505]

Critic Emily Genauer described Rothko's paintings as "primarily decorations," which for Rothko was the ultimate insult. Rothko's works were, she opined, "less paintings, as a painting is generally

conceived, than theatrical curtains or handsome wall decorations."
Leading art critic and historian, John Canaday, noted "Mr. Rothko's
progressive rejection of all the elements that are the conventional ones
in painting, such as line, color, movement and defined spatial relation-
ships," before dismissing his work as "high-flown nonsense."[506] Doubt-
less with Devree, Genauer and Canaday in mind, Rothko, who was
intensely protective of his memory and paintings, once declared: "I hate
and distrust all art historians, experts and critics."[507]

## *The Rothko Chapel*

In 1965 Rothko was commissioned by the oil tycoon John de Menil
and his wife Dominique to paint a series of panels for a chapel in
Houston, the city where they lived. Rothko adorned this chapel – a
small, windowless, geometric, postmodern structure – with a collection
of dark (almost black) murals essentially devoid of any content. The
Jewish head of MoMA, Peter Selz, inevitably declared these paintings
masterpieces, insisting that "like much of Rothko's work, these murals
seem to ask for a special place apart, a kind of sanctuary, where they may
perform what is essentially a sacramental function..."[508] Dominique de
Menil claimed to be similarly impressed, asserting that Rothko's colors
"became darker, as if he were bringing us to the threshold of transcen-
dence, the mystery of the cosmos, the tragic mystery of our perishable
condition."[509]

Rothko's place at the summit of the New York art world was threat-
ened three years after his MoMA exhibition when the Golden Lion was
awarded to Robert Rauschenberg at the Venice Biennale of 1964. This
gave prominence to the emerging artists of the Neo-Dada and Pop Art
movements, and made Abstract Expressionists like Rothko seem passé.

In 1968, Rothko was diagnosed with a mild aortic aneurysm. Ignor-
ing his doctor's orders, he continued to drink and smoke heavily, avoid
exercise, and ignore dietary prescriptions – which also exacerbated his
depression and seclusion. He died in his studio on February 25, 1970
after overdosing on anti-depressants and cutting his right arm with

a razor blade. He was 66 years old and left no suicide note. After Rothko's death, 798 of his works were "procured" by his then dealer, Frank Lloyd, the Jewish director of the Marlborough Gallery, in dubious circumstances. The lengthy legal proceedings this initiated became emblematic of mounting financial corruption in the art world, and led to a growing distrust of art dealers among Americans.

## *Rothko's Legacy*

Opinions vary widely about Rothko's work and legacy. Many within the Jewish-dominated art establishment hail him as a genius, a creator of transcendental, spiritual works for secular times. Others cannot believe that any sane person would pay hundreds of millions of dollars for what amounts to nothing more than a large, empty canvas occupied by two colors divided into separate rectangles by a third color. What is clear, however, is that Rothko's career and burgeoning posthumous reputation have been overwhelmingly the result of shameless barracking and hyping on the part of the Jewish intellectual and cultural establishment. Rothko's son had the chutzpah to draw a parallel between his father's work and that of Mozart, insisting that his father's paintings are "the visual embodiment of a Mozart composition."[510]

Jews have long used their cultural dominance to construct "Jewish geniuses" to foster ethnic pride and group cohesion. It has been (and remains) a standard feature of Jewish intellectual life in the West to wildly exaggerate the significance of Jewish scientists, writers, composers, artists and intellectuals (often while downplaying the achievements of their non-Jewish peers). The absurdly exalted status accorded Mark Rothko and his oeuvre is emblematic of this practice. Rothko is surely an artist for whom the expression "the emperor has no clothes" is particularly apposite.

## Abstract Expressionism and the Culture of Critique

Abstract Expressionism was disproportionately a Jewish cultural phenomenon. It was a movement populated by legions of Jewish artists, intellectuals and critics. Prominent gentile artists within the movement, like Jackson Pollock and Robert Motherwell, married Jewish women (Lee Krasner and Helen Frankenthaler). Willem de Kooning defied the trend – though had to ingratiate himself with the Jewish intellectual and cultural elite focused around the journal *Partisan Review* which was "dominated by editors and contributors with a Jewish ethnic identity and a deep alienation from American cultural and political institutions."[511]

For Jewish writer Alain Rogier, it seems "hardly a coincidence that Jews made up a large percentage of the leading Abstract Expressionists."[512] It was an art movement where the culture of critique of Jewish artists, frustrated that the post-war American prosperity had prevented the coming of international socialism, turned inward and instead "proposed individualistic modes of liberation." This mirrored the ideological shift that occurred among the New York Intellectuals generally who "gradually evolved away from advocacy of socialist revolution toward a shared commitment to anti-nationalism and cosmopolitanism [i.e., the multicultural project], 'a broad and inclusive culture' in which cultural differences were esteemed."[513] Doss notes how this ideological shift manifested itself among the artists who became the Abstract Expressionists:

> As full employment returned, New Deal programs were terminated – including federal support for the arts – the reformist spirit that had flourished in the 1930s dissipated. Corporate liberalism triumphed: together, big government and big business forged a planned economy and engineered a new social contract based on free-market expansion... With New Deal dreams of reform in ruins, and the better "tomorrow" prophesied at the 1939-1940 New York World's Fair having seemingly led only to the carnage of World War II, it is not surprising that post-war

artists largely abandoned the art styles and political cultures associated with the Great Depression.[514]

The avant-garde artists of the New York School instead embraced an "inherently ambiguous and unresolved, an open-ended modern art... which encouraged liberation through personal, autonomous acts of expression." The works of the Abstract Expressionists were "revolutionary attempts" to liberate the larger American culture "from the alienating conformity and pathological fears [especially of communism] that permeated the post-war era."[515] Rothko claimed that "after the Holocaust and the Atom Bomb you couldn't paint figures without mutilating them." His friend and fellow artist Adolph Gottlieb, declared that: "Today when our aspirations have been reduced to a desperate attempt to escape from evil, and times are out of joint, our obsessive, subterranean and pictographic images are the expression of the neurosis which is our reality. To my mind... abstraction is not abstraction at all... it is the realism of our time."[516]

At the heart of Abstract Expressionism lay a vision of the artist as alienated from mainstream society, a figure morally compelled to create a new type of art which would confront an irrational, absurd world – a mentality completely in accord with that of the alienated Jewish artists and intellectuals at the heart of the movement who viewed the White Christian society around them with hostility. MacDonald notes that the New York Intellectuals "conceived themselves as alienated, marginalized figures – a modern version of traditional Jewish separateness and alienation from gentile culture..." Norman Podhoretz was asked in the 1950s "whether there was a special typewriter at *Partisan Review* with the word 'alienation' on a single key."[517]

During the 1950s, Jewish artists and intellectuals chafed against the social controls enforced by political conservatives and religious and cultural traditionalists who limited Jewish influence on the culture, "much to the chagrin of the Frankfurt School and the New York Intellectuals who prided themselves on their alienation from that very culture." This all ended, together with Abstract Expressionism as an art movement

embodying the alienation of the New York Intellectuals, with the triumph of the culture of critique in the 1960s, when Jews and their gentile allies usurped the old WASP establishment, and thus had far less reason to engage in the types of cultural criticism so apparent in the writings of the Frankfurt School and the New York Intellectuals. Hollywood and the rest of the Jewish-controlled media were unleashed.

## *Jews and Modernism*

In his exposition of the political significance of the widespread Jewish involvement in cultural modernism, the Jewish historian Norman Cantor noted that: "Something more profound and structural was involved in the Jewish role in the modernist revolution than this sociological phenomenon of the supersession of marginality. There was an ideological drive at work."[518] This ideological drive was the urge to subject Western civilization (deemed a "soft authoritarianism" fundamentally hostile to Jews) to intensive and unrelenting criticism – in the process of which they spawned a massive literature of cultural subversion throughout the post-war period.

Kevin MacDonald notes how there was a great deal of influence and cross-fertilization between the New York Intellectuals and the Frankfurt School. Both promoted modernism in art at least partly because of its apparent compatibility with expressive individualism, but also because it was seen as being capable of alienating people from Western capitalistic societies. For Frankfurt School intellectual Walter Benjamin, the purpose of modern art was to spread the kind of cultural pessimism that would bring on the revolution, insisting that "To organize pessimism means nothing other than to expel the moral metaphor from politics." His colleague, Willi Munzenberg, saw the central role of the Frankfurt School as being "to organize the intellectuals and use them to make Western Civilization stink. Only then, after they have corrupted all its values and made life impossible, can we impose the dictatorship of the proletariat."

## Clement Greenberg and the New "American" Art

Clement Greenberg was the most influential theorizer and promoter of modernism in America during the middle years of the twentieth century. His advocacy helped to bring about the institutionalization of Abstract Expressionism and to secure the dominance of American modernist art in the immediate post-war period. MacDonald notes that Greenberg "made his reputation entirely within what one might term a Jewish intellectual milieu" including as "a writer for *PR*, managing editor of *Contemporary Jewish Record* (the forerunner of *Commentary*), long-time editor of *Commentary* under Elliot Cohen, as well as art critic for *The Nation*."[519] Greenberg's Jewish identity was strong, and he once avowed that "that the quality of Jewishness is present in every word I write, as it is in almost every word of every other contemporary Jewish writer."[520] He also insisted "that by world historical standards the European Jew represents a higher type than any yet achieved in history."[521]

Greenberg's later rejection of Pop and Conceptual Art led to a period when his writings and preferences were dismissed by those who aligned themselves with the views of rival Jewish art guru Harold Rosenberg. This arose from Greenberg's dogmatic advocacy of abstraction, and his distaste for commercial popular culture – what he called "kitsch" in his most famous essay "Avant-Garde and Kitsch" (1939) which was his response to the repression of modernist art in National Socialist Germany and the Soviet Union. "Avant-Garde and Kitsch," one of the most influential essays of the twentieth century, made Greenberg's name as a critic and led to his participation in the world of cultural journalism as an editor of *Partisan Review*.

It is not hard to detect an underlying concern with anti-Semitism in Greenberg's famous essay. There was a general understanding among both the Frankfurt School and the New York Intellectuals that mass culture – whether in the Soviet Union (both groups were anti-Stalinist), National Socialist Germany, or bourgeois United States – promoted conformism and escape from harsh political realities. It "offered false pleasure, reaffirmed the status quo, and promoted a pervasive conformity that stripped the masses of their individuality and subjectivity."[522]

By contrast, avant-garde art had the potential to foster the kind of subjective individualism that could disconnect the masses from their traditional familial, religious and ethnic bonds – thereby reducing the salience of Jews as an outgroup and weakening the anti-Semitic status quo within these societies.

In his essay, Greenberg seeks to account for the ubiquity of "kitsch" in totalitarian societies by stressing its usefulness in ingratiating a regime with the masses – a practice that, he informs us, will only cease when these regimes "surrender to international socialism." He writes:

> Where today a political regime establishes an official cultural pol-icy, it is for the sake of demagogy. If kitsch is the official tendency of culture in Germany, Italy and Russia, it is not because their respective governments are controlled by philistines, but because kitsch is the culture of the masses in these countries, as it is every-where else. The encouragement of kitsch is merely another of the inexpensive ways in which totalitarian regimes seek to ingratiate themselves with their subjects. Since these regimes cannot raise the cultural level of the masses – even if they wanted to – by anything short of a surrender to international socialism, they will flatter the masses by bringing all culture down to their level. It is for this reason that the avant-garde is outlawed... Kitsch keeps a dictator in closer contact with the "soul" of the people. Should the official culture be one superior to the general mass-level, there would be a danger of isolation.[523]

Greenberg's thesis is not without validity. Indeed, one of the striking features of contemporary Western life under a Jewish cultural hegemony is an all-pervasive popular culture of Hollywood supersaturated with Cultural Marxist kitsch. Despite the real world failure of the utopian vision being relentlessly endorsed, this form of easily assimilated kitsch (seasoned with ever-increasing doses of sex, violence and schmaltz) works very well to brainwash the great bulk of White people and quell even the mildest forms of rebellion.

"Kitsch" works for the Jews of Hollywood for the same reason it worked for Hitler and Stalin. This is because kitsch is defined by efficiency of communication, while the avant-garde alienates some viewers "simply because this was an inescapable by-product of their formal experiments and of their rejection of kitsch."[524] Barlow notes that, for Greenberg:

> Kitsch worked to maximize *effect*, while the avant-garde sought to address *cause*. Both commerce and totalitarian regimes sought maximum penetration of controllable information. They required the culture of kitsch. Mass culture will almost inevitably be kitsch, as passive consumers will comprehend accessible effects more readily than the self-conscious explorations of cause. Only in a truly socialist society will mass culture transcend the psychology of passive consumption. Despite important differences between the two men, Greenberg's attitude to popular culture is close to that of Theodor W. Adorno.[525]

Like Greenberg, Adorno initially directed his attack not against the high culture of Western civilization, but against the "mass culture" which warred with it – a "secondary emanation of authority" which was an inescapable product of capitalism. For Adorno, nothing was more abhorrent in the mass culture of America than its music. For him, popular music, riddled with cliché and kitsch, was not art but ideology that promoted a false consciousness that numbed the revolutionary senses of the working class. The owners of the means of communication (the capitalist class) are sovereign in this debased musical culture. Under socialism, Adorno implied, this false consciousness would be swept away and the emancipated proletariat would be whistling the ideology-free music of Schoenberg and Webern in the streets.[526] However, as Roger Scruton noted, this aspect of the Frankfurt School's Critical Theory was later to change fundamentally:

Since the Frankfurters came as exiles to America, there to pour scorn on their hosts, the culture of repudiation has taken another and more home grown form. Instead of focusing on the "mass culture" of the people, it now targets the elite culture of the universities. It is indifferent, or even vaguely laudatory, towards popular art and music, seeing them as a legitimate expression of frustration and a challenge to the old forms of highbrow knowledge. Its target is the culture in the sense that I have been defending it: all those artefacts that have stood the test of time, and which are treasured by those who love them for the emotional and moral knowledge that they contain.[527]

Unlike his rival Harold Rosenberg, Greenberg never embraced this new critical paradigm. In his essay "Towards a Newer Laocoon" (1940) he articulated his famous claim that resistance to kitsch requires that art "emphasize the medium and its difficulties," adding that the history of the avant-garde is one of "progressive surrender to the resistance of the medium."[528] Greenberg argued that the vision of the Abstract Expressionists was characterized by a "fresher, opener, more immediate surface," offensive to standard taste. He related this quality to a "more intimate and habitual acquaintance with isolation," which was, in his ethnically, morally and culturally particularistic view, "the condition under which the true quality of the age is experienced."[529]

Greenberg's dismissal of Harold Rosenberg's account of Abstract Expressionism as "action painting" was based on his view that Rosenberg's claim implied that the active process of painting mattered more than the result – that one chaotic combination of drips and splodges was as good as another. For Greenberg, Rosenberg's theory gave the green light to charlatans whose work was no more than "stunts." Such stunts certainly came into prominence with the rise of Pop and Conceptual art during the 1960s as many artists embraced Rosenberg's claim that the moment of "performance" could itself be art. This aspect of the art scene in the 1960s earned Greenberg's contempt, but as Barlow points out, "could all too easily be interpreted as the conservative critic

whose time had passed – the modern equivalent of Ruskin's attack on Whistler."[530]

It is somewhat ironic that Greenberg, an ethnocentric Jewish Trotskyite, in his staunch defense of Abstract Expressionism and Post-Painterly Abstraction, and rejection of the "pre-emptive kitsch" of Pop Art, Neo-Dada and Conceptual Art, was pushed into the role of cultural reactionary. The Abstract Expressionists Greenberg championed had been eager to break with the figurative art of the Regionalist painters, but their work (owing to its highly abstract nature) lacked the more overtly ideological form of much of the conceptual art that replaced it. This shouldn't, however, obscure from us the fact that the rise of Abstract Expressionism coincided with the Jewish takeover of American high culture, and the deposing of the old WASP art establishment. Nor should it obscure the profound influence Greenberg's ideas continue to have on Western culture.

Since "Avant-garde and Kitsch," artistic and cultural production in the West has been underpinned by an aggressive "kitschophobia," with figurative painting, tonal music, and classical architecture widely regarded with suspicion (if not outright hostility) by cultural elites. It was fear of kitsch that gave rise to the pre-emptive kitsch of postmodern art:

> Artists began not to shun kitsch but to actively embrace it, in the manner of Andy Warhol, Alan Jones, and Jeff Koons. The worst thing is to be unwittingly guilty of producing kitsch; far better to produce kitsch deliberately, for then it is not kitsch at all but a kind of sophisticated parody... Pre-emptive kitsch sets quotation marks around actual kitsch, and hopes thereby to save its artistic credentials... Public galleries and big collections fill with the pre-digested clutter of modern life, brash items of salesmanship which pass their sell-by date the moment they go on permanent display. Art as we knew it required knowledge, competence, discipline and study, all of which were effective reminders of the adult world. Pre-emptive kitsch, by contrast, delights in the tacky, the ready-made, and the cut-out, using forms, colours and images

which both legitimize ignorance and also laugh at it, effectively silencing the adult voice. Such art eschews subtlety, allusion and implication, and in the place of imagined ideals in gilded frames it offers real junk in quotation marks.[531]

This "kitschophobic" art belligerently shuns the traditional Western preoccupation with beauty – substituting for it a cult of sarcasm, nihilism and ugliness (yet always within a politically correct framework). To be an "authentic" creation, postmodern art must "challenge," and preferably be offensive, to standard taste. If this requires producing a dead shark in formaldehyde or a crucifix in urine, then so be it. These deliberately ugly and offensive productions, wittingly or unwittingly, provoke among their audiences a disconnection from the traditional reinforcers of ethnocentrism and group cohesion, and engender what Frankfurt School intellectual Georg Lukacs called "a culture of pessimism" reflecting a world "abandoned by God."

Israel Shamir aptly summarized the process of degeneration that has occurred within Western art over the last 70 years when he noted that: "In the beginning, these were works of some dubious value like the 'abstract paintings' of Jackson Pollock. Eventually we came to rotten swine, corrugated iron, and Armani suits. *Art was destroyed.*" An art that emerged in response to the alienation of Jewish artists and intellectuals in America at mid-twentieth century, ushered in an art of cultural alienation for everyone. This debasement of the West's glorious cultural inheritance has inevitably sapped the cultural confidence of White people, and contributed to making Western societies, in the eyes of their increasingly atomized populations, increasingly "unlovable" and not worth defending.

# CHAPTER 10

# The Devil That Never Dies

Daniel Jonah Goldhagen is best known for his 1996 book *Hitler's Willing Executioners: Ordinary Germans and the Holocaust*. Despite its flawed historiography, this polemical work attracted enormous media attention and established his reputation as a putative authority on anti-Semitism and "the Holocaust." He was soon given a regular platform to espouse his extreme brand of Jewish apologetics in *The New York Times*, the *Los Angeles Times*, *The Washington Post*, *The New Republic*, and other Jewish-controlled media organs around the world.

A former associate professor of political science and social studies at Harvard University, Goldhagen has since penned additional books that morally indict Europeans for their inveterate anti-Semitism and supposedly enthusiastic participation in "the Holocaust." These include *A Moral Reckoning: The Role of the Catholic Church in the Holocaust and its Unfulfilled Duty of Repair* (2002), and *Worse than War: Genocide, Eliminationism, and the Ongoing Assault on Humanity* (2009). His 2013 book *The Devil That Never Dies: The Rise of Global Antisemitism* is touted as "a groundbreaking – and terrifying – examination of the widespread resurgence of antisemitism in the twenty first century."

Goldhagen favors the term "antisemitism" over the hyphenated "anti-Semitism" – doubtless because the latter implies the existence of a Semitism which could (and indeed does) provide the dialectical basis for

anti-Semitism. Goldhagen, in this way, signals his rejection of the reality that hostility to Jews stems from conflicts of interest between Jews and non-Jews in a Darwinian world. The assertion by Jews of their ethnic interests (Semitism) inevitably leads to resentment from those whose interests are compromised (so-called anti-Semitism). To admit this basic truth is to admit that non-Jews (including White people) have interests that are legitimate, and that the desire to resist those opposed to our interests is eminently rational.

For Goldhagen, however, Jewish behavior is irrelevant for understanding the hostility to Jews that has existed across nations and cultures for over two millennia. He observes that: "Antisemitism has moved people, societies, indeed civilizations for two thousand years, and has done so despite the other vast changes in the world and in these civilizations and societies – economic, scientific, technological, political, social, and cultural."[532] Despite the persistent, and often intense, antagonism between Jews and non-Jews throughout much of recorded history, Goldhagen insists that "attributing antisemitism to a reasonable (if sometimes exaggerated) reaction against the Jews' own conduct" is an example of "faulty thinking."[533]

## Explaining "Antisemitism"

Rather than being an entirely predictable and rational response to the self-interested behavior of Jews, anti-Jewish sentiment is, for Goldhagen, a form of demonic possession. He labels "antisemitism" a "devil" and claims "millions upon millions" of morally-dysfunctional people around the globe are in the thrall of this fiendish embodiment of unparalleled evil.

> The devil, with us for two thousand years, is back. This devil has already insinuated itself into hundreds of millions. He has warped religions. He has inflamed minds and hearts the world over. Unleashed riots and pogroms. Led to the expulsion of millions. He has so perverted people's sensibilities that he has

convinced them to brutalize and torture masses of people in the name of goodness and God. He has gone further, inducing people to commit mass murder again and again, including one of humanity's most cataclysmic assaults, the attempted murder of an entire people, felling six million of them in one historical instant. The devil, after a period of relative quiescence, has re-appeared, flexes his muscles again, and stalks the world, with ever more confidence, power and followers. The devil is not a *he* but an *it*. The devil is antisemitism.[534]

The words "antisemitism," "antisemitic" and "antisemite" have almost supernatural powers of imprecation for Goldhagen; for him they denote the purest form of evil that exists on the planet. By contrast, Jewish hostility to non-Jews has no equivalent label – leading us to falsely assume it does not exist. In case we have any doubt as to what "antisemitism" is, and who is deserving of the dreaded epithet of "antisemite," Goldhagen solemnly informs us that:

> Antisemitism is thought. It is emotion. It is speech. It is action. It is inaction. Antisemitism exists and can be identified if *any of these* in an anti-Jewish form are present, and a person is antisemitic if he or she engages in *any of them*. A person speaking antisemitic thoughts, prejudicial thoughts against Jews, is an antisemite regardless of his emotions, his words, his actions, or inactions. A person with an aversion or hostility toward Jews, which he feels as instinctive, even without having more coherent prejudicial thoughts or uttering words or taking actions against Jews, is an antisemite. A person who engages in antisemitic action against Jews, regardless of his views of them, is an antisemite. When it comes to prejudice, as with many other things, when you do bad things (your inner thoughts and emotions notwithstanding), you are what you do. And if a person fails to see that obviously prejudicial words against Jews is [*sic*] prejudicial and therefore

antisemitic, this emerges from prejudicial perception bias, and it too constitutes antisemitism."[535]

Having claimed, in truly paranoid words, that even thoughts (or the lack of them) can be "antisemitic," Goldhagen discusses the results of surveys conducted by the Anti-Defamation League to assess the extent of anti-Jewish sentiment internationally. These supposedly "show that tens of millions, indeed hundreds of millions of people on different continents are antisemitic."[536] However, these findings, he argues, significantly understate the extent of anti-Semitism because "people are reluctant to express their prejudicial views when such views are not sanctioned in the public sphere, and such views might get them dubbed racists or antisemites, especially as the latter might be seen to link them to Hitler and the gas chambers."[537] For Goldhagen, the alleged homicidal gas chambers are absolutely central to the "Holocaust" narrative and the new social and political order that has been founded upon it, because without them "the Holocaust" would "not have become synonymous with evil and so delegitimized everything, including antisemitism, that seemed related to it."[538]

Goldhagen informs us that "according to surveys that tap only a few of many possible antisemitic themes," some 150 million in the European Union and 45 million in the United States "hold multiple interlocking antisemitic views of Jews – and thus the reservoir for the expansion of antisemitic discourse and other antisemitic manifestations is considerable, disturbingly so."[539] Nevertheless, while claiming that anti-Semitism in the United States remains "alarming" and a "substantial problem," Goldhagen finds it "extremely heartening" that "the number of people who held multiple and interlocking antisemitic notions in 1964 was about one in three (30 percent)," while "today it is one in seven (15 percent)."

He ascribes this decline to the fact "Education, which in the United States decidedly teaches people anti-prejudicial views and integrates them more into society's public discourse, profoundly lessens antisemitism."[540] Similarly, in Europe, "Younger generations, reared in new

public discourses with new plausibility structures and taught in schools a non-antisemitic paradigm of the world, inevitably grew up less anti-semitic, so antisemitism became less prevalent across Europe, especially in its antisemitic heart, Germany."[541]

The "education" and "new public discourses" to which Goldhagen refers, are euphemisms for the Jewish domination of the West's educational, media and entertainment sectors, and their assiduous policing of all public discourse – especially as it relates to Jews. The reality is that Jews are the only identifiable people that, except for sections the internet, control the flow of information throughout the West, and have a profound *need* to do so. When Jewish motivations and behavior are widely known and discussed, anti-Jewish sentiment inevitably rises. With the consolidation of Jewish power in the West from the 1960s, Western governments and the media closed off critics of Jews' access "to the public sphere and to shaping its discourse." The result was that potential critics of Jews were "publically muzzled and had to exercise enormous self-censorship."[542]

Goldhagen notes that people in Europe and North America must still be careful how they talk about Jews because "the taboos on the manner of many aspects of antisemitic expression... still hold."[543] Nevertheless, the unmediated peer-to-peer communication offered by the internet undermines these taboos with a "power of fueling and sustaining prejudice that is vast, new, in this respect revolutionary, and continuing only to increase in scope and intensity."[544]

Jewish activists and lawyers have worked tirelessly for decades to fundamentally change the West's conception of free speech from freedom of political speech (the original intention of the First Amendment of the U.S. Constitution) to freedom to engage in obscenity and pornography – which they are keen to promote because, in line with the conclusions of *The Authoritarian Personality*, they associate sexual and moral looseness with philo-Semitism, and sexual continence with fascism and anti-Semitism. Thus, while keeping the external appearance of free speech, they have changed its essence through Hollywood propaganda films like *The People v Larry Flint*. Free speech traditionally

meant the right to criticize those in power, not the right to broadcast pornography, as Jewish activists would have us believe.

Through their control of the mainstream media and entertainment industries, the anti-White agenda of a tiny hostile two-percent minority has become the mass culture of the contemporary West. In this culture, there are no taboos about attacking and insulting White people. It is never "hate" when Hollywood is attacking "rednecks," or "White trash," or "Euro-trash," or "dumb blonds" or preachers or Germans or Southerners or Catholic priests. It is only hate when people make pointed criticisms of Jews. Hollywood subjects White people to an endless barrage of insults where White women are routinely depicted as stupid, brainless sluts, and White men as weak, wimpy, foolish and useless. The blonde male as arch villain is a longstanding Jewish Hollywood trope. Meanwhile, ruthless, avaricious bankers are always depicted as sociopathic WASPs rather than as the Jews who actually dominate the upper echelons of the banking and finance industries. Unappealing Jews or Blacks are cast as leading men and the love interests of attractive White women, regardless of how improbable this is in the real world.

Because Blacks and Whites do not naturally mix it has to be propagandized. So the message from Hollywood to White women is: "Go mate with Blacks, Blacks are really cool and noble, and athletic, and powerful, and they are sexually superior." All these memes are continuously pumped out by Hollywood in order to persuade Whites to do what they would not do naturally. This propaganda continuously chips away at the margins of White society and over time it has an erosive effect – it erodes the stable homogenous, White bulk of the population. This is exactly what Hollywood and the media are doing: systematically eroding White heterosexual normativity.

Unsurprisingly, Goldhagen offers us no corresponding analysis of Jewish attitudes towards non-Jews. Besides the fact that such information is not even collected, for Goldhagen, Jewish attitudes are not even relevant for understanding the historical and contemporary phenomenon of anti-Semitism. Indeed, he (apparently with a straight face) assures us that: "We do not need to know much about Jews in order

to study antisemitism. Prejudice is an attribute of the prejudiced people and not of their victims. This is especially true for antisemitism and Jews."[545]

He thus attempts to quarantine Jewish behavior (and the Jewish mindset) from any form of critical analysis, and contends that: "The diversity of Jews over time and today – similar to Europeans and Christians – and their many, depending on time and place, communal and individual differences of concerns and practices, render finding the common denominator, especially with regard to how Jews relate or would relate to non-Jews, an exercise in absurdity."[546] This coming from someone who made his name advancing a generalizing tendentious hypothesis about Germans in his book *Hitler's Willing Executioners*.

Even Hannah Arendt, that doyen of Jewish intellectuals and activists, was willing to concede that Jewish attitudes and behavior were integral to understanding the historical and contemporary phenomenon of anti-Semitism. In *The Origins of Totalitarianism* she notes that:

> It was Jewish historiography, with its strong polemical and apologetical bias, that undertook to trace the record of Jew-hatred in Christian history. ... When this Jewish tradition of an often violent antagonism to Christians and Gentiles came to light "the general Jewish public was not only outraged but genuinely astonished," so well had its spokesmen succeeded in convincing themselves and everybody else of the non-fact that Jewish separateness was due exclusively to Gentile hostility and lack of enlightenment. Judaism, it was now maintained, chiefly by Jewish historians, had always been superior to other religions in that it believed in human equality and tolerance. ...

> This self-deceiving theory, accompanied by the belief that the Jewish people had always been the passive, suffering object of Christian persecutions, actually amounted to a prolongation and modernization of the old myth of chosenness. ... Historiography "has until now dealt more with the Christian disassociation from

the Jews than with the reverse," thus obliterating the otherwise more important fact that Jewish dissociation from the Gentile world, and more specifically from the Christian environment, has been of greater relevance for Jewish history than the reverse, for the obvious reason that the very survival of the people as an identifiable entity depended on such voluntary separation and not, as was currently assumed, upon the hostility of Christians and non-Jews.[547]

In his masterful work *The Ordeal of Civility*, sociologist John Murray Cuddihy noted that: "Attention must be paid to the deeply apologetic structure of Diaspora intellectuality" whereby the Jewish "intelligentsia 'explains,' 'excuses,' and 'accounts' for the otherwise offensive behavior of its people. All the 'moves' made in the long public discussion of the Jewish Emancipation problematic [i.e., Jews leaving the ghetto and confronting a more refined European culture] constitute, in the case of the detraditionalized intellectuals, an apologetic strategy."[548] *The Devil That Never Dies* stands squarely within this Jewish tradition of apologetic ethnic strategizing.

In a work of some 486 pages which purports to be a rigorous and exhaustive analysis of historical and contemporary anti-Semitism, Goldhagen fails to mention (let alone discuss) the role of Jewish activist organizations in spearheading the demographic transformation of the West through lobbying for open borders and state-sanctioned multiculturalism, and the hostility this inevitably provokes from dispossessed Whites. Indeed, the words "immigration," "multiculturalism," "Frankfurt School," and "Hollywood" are not even included in the book's (13-page) index. So it is not surprising that no mention is made of Kevin MacDonald and his theory of Judaism as a group evolutionary strategy. And this despite the fact that Goldhagen, with his obsession with every conceivable manifestation of anti-Semitism, is undoubtedly aware of both the man and the theory. We can only conclude the reason for this omission is his inability to provide any refutation of MacDonald's thesis.

Goldhagen acknowledges the far-reaching significance of the intellectual revolution initiated by Darwin which fundamentally transformed our understanding of ourselves and our place in the world. Nonetheless, for him, Darwinian conceptions of Jewish relations with non-Jews remain illegitimate lines of inquiry – doubtless because they inevitably fail to exonerate Jewish behavior as a likely cause of anti-Semitism. He even, breathtakingly, proposes that Jews have never really competed with non-Jews for access to resources, claiming that "there was no acute, objective conflict over territory, resources, or political control or domination."[549]

On this farcical basis he dismisses the applicability of the most compelling intellectual framework we have for understanding intergroup dynamics, claiming that "science has often been perverted to justify such [anti-Semitic] thinking and practice... by merging it with a new body of derivative social Darwinian thought that rendered Jews a biologically-based race of evildoers."[550] So, according to Goldhagen's circular reasoning, any attempt to understand anti-Semitism along Darwinian lines is necessarily a perversion of science and is itself an example of anti-Semitism.

### Judaism as a Group Evolutionary Strategy

Paradoxically, given that he rejects the validity of Darwinian interpretations of relations between Jews and non-Jews, Goldhagen readily (if unintentionally) concedes that Judaism is a group evolutionary strategy geared to ensuring the survival of Jews as genetically distinct population. He acknowledges, for instance, that Judaism comprises "a mutually reinforcing religion and ethnicity – Judaism and Jewishness – that provided Jewish communities around the world the solid foundation to resist the natural tendencies to assimilate."[551] Furthermore, he notes that:

> From the beginning, the notion existed that Jews formed a *people*, an identifiable ethnic group, like a large family – after all they

were the twelve tribes – and not merely a freely come together collection of believers. More than just a religious group, and still more than merely an ethnic group, the Bible refers to Jews as *Am Yisrael*, the People of Israel, or better translated as the Nation of Israel, an ethnic group with an overriding corporate sense of community that also possesses a territorial home. Even when in a Diaspora with no foreseeable prospect of establishing their country, Jews thought of themselves as a nation, with a fixed idea of a national home's existence – the land of ancient Israel and Jerusalem as its capital. Only in the post-Enlightenment period, and then ever more so in the twentieth century, when the prospect of citizenship and genuine acceptance in other countries seemed possible did this notion of nationhood begin to break down – though Jews' sense of peoplehood and their commonality as an ethnic group still endured.[552]

According to Goldhagen, the capacity of Israeli Jews to "survive and prosper under a state of siege, and ongoing existential threat, for more than sixty years, is but the latest installment of this profound determination to adapt and survive."[553] Meanwhile, any profound determination on the part of non-Jewish groups to adapt and survive has, at least since World War Two, been regarded by Jewish intellectuals and activists like Goldhagen as symptomatic of a collective psychopathology.

Judaism's status as a group evolutionary strategy, rather than a proselytizing religion – reflected in how it has erected "considerable impediments deterring potential converts," has, according to Goldhagen, "been significant for Jews' relations with the worlds of non-Jews, and for antisemitism's especial strangeness, because Jews have not competed for non-Jews' bodies and souls."[554] Whilst it is true that Jews have not competed with Christianity and Islam for converts (rather the opposite), they *have* aggressively competed with non-Jews for access to resources and the enhanced reproductive opportunities that accompanies such access. In their quest to outcompete other groups, diasporic Jews have also, since the Enlightenment, reshaped other societies in their own

interests by subjecting them to radical critique, direct ethnic activism, and through the domination and construction of culture.

While promoting pluralism and diversity and encouraging the dissolution of the racial and ethnic identification of Europeans, Jews have endeavored to maintain precisely the kind of intense group solidarity they decry as immoral in others. They have also initiated and led movements that have attempted to discredit the traditional foundations of Western society: patriotism, the Christian basis for morality, social homogeneity, and sexual restraint. At the same time, within their own communities, they have supported the very institutions they have attacked in Western societies. This is Darwinian group competition played out in the human cultural arena.

Nature knows no pluralistic harmony. Nature knows only struggle for position. Even plants fight with each other for physical space and access to sunlight and to water. So it is with human demographic change. The races, just like ants and every other lower form of animal, fight and struggle for room, for sunlight, and for all the things they need to thrive. "White flight" reflects the fact that when living conditions have become unsuitable for Whites to reproduce and to live happily, they exit those conditions and seek better conditions elsewhere; that's why 85 percent of the time, Whites move to a Whiter area. While some claim that "Whites are suicidal" or "don't care" about being displaced, their behavior shows the great majority do care. What they are missing is leadership that is willing to stand up to the forces that seek their demographic destruction.

One of the ways races battle for position is through controlling the ideas that go into the minds of their rivals. That explains the ubiquitous push by Jews for ownership and/or control of the media and entertainment industries. Media influence is simply another aspect of ethnic competition: filling the heads of your competitors with maladaptive ideas that harm them but which help your group to thrive. Non-Jews who are aware of this phenomenon naturally resent this waging of ethnic warfare through the selective dissemination of information.

Seen from this broader sociobiological perspective, anti-Semitism becomes easily comprehensible and loses its "especial strangeness." Goldhagen is, however, willfully blind to this reality and for him anti-Semitism remains a tormenting mystery:

> Antisemitism has perplexed people for centuries. Why is there so much hatred against Jews? Ordinarily we would expect such a numerically small, historically mainly impotent people to have been ignored or, at most, been the object of some local prejudices. But instead Jews have been the targets of an enduring, widespread, and volcanic animosity, the world's all-time leading prejudice. Why are people around the world – this is especially relevant to Europeans – so susceptible to antisemitism?[555]

We would indeed expect a "numerically small, historically impotent people" to have been ignored. However, this description does not apply to Jews. The amount of hostility directed at, say, Gypsies, much less Mennonites or Mormons, trifles in comparison to that directed against Jews. Anti-Jewish sentiment has been a defining component of major historical upheavals, such as the Spanish Inquisition, and the rise of National Socialism – due in no small part to Jews being an elite with radically different interests than their host populations. Numerically small they may have been (though not always), but Goldhagen's characterization of Jews as "historically impotent" is patently false and any history of the Jews invariably stresses the profound influence they have exerted on others, an influence vastly disproportionate to their numbers. One outstanding area of this influence has, of course, been in the realm of religion, particularly with regard to Christianity.

## "The Real Devil that Christianity Spawned"

Rather than hostility to Jews having its primary origins in Darwinian group competition, Goldhagen contends that anti-Semitism is "the real devil that Christianity spawned."[556] He conveniently ignores the

fact that deep antipathy to Jews was widespread throughout the pre-Christian civilizations of Egypt, Greece and Rome, and falsely claims that anti-Semitism

> began in ancient Israel during the time of Jesus and migrated shortly thereafter to Greece. There it was codified in the context of early Christians' desires to appropriate the early Jewish religious and messianic tradition, really Judaism revamped, for themselves. In Greece the Gospels were written, at best based on a long chain of hearsay, not until fifty to one hundred years after Jesus' death by people who never knew or saw Jesus or the events surrounding his life. Antisemitism then moved to and became entrenched in Rome, the center of the Western world, where Christianity and simultaneously antisemitism had its greatest conquest when Emperor Constantine adopted Christianity for himself and the Roman Empire in the early fourth century. As his empire spread to more European lands in particular, the secular and religious authorities brought the antisemitic gospel with them, which, after Rome's fall (which did not see the Church fall), spread to all of Europe, so that during the Middle Ages antisemitism, together with Christianity, had solidified itself as the one pan-European belief system, about which different peoples, peoples of different classes and stations, different professions, and eventually even different and warring forms of Christianity could agree upon and coalesce. Then, with European and Christian colonization of much of the world, antisemitism spread farther.[557]

In addition to ignoring the extensive (and often violent) pre-Christian antipathy to Jews, Goldhagen also makes no mention of the fact that Christianity, unlike Judaism, is a universalist creed which eventually led to Europeans being the first people in history to ban slavery for moral reasons. Instead, he maintains that the New Testament is an "anti-semitic" and "eliminationist" tract:

The Christian bible is, whatever its subsidiary pronouncements to the contrary, at its heart an eliminationist document. A codification of eliminationist antisemitism against Jews. Their evangelical calls for Jews to follow Jesus aside, the Gospels so deprecate the Jews' existing cultural core (namely the Jewish bible's laws and codes), implicitly and explicitly calling for an end to this people as Jews, and so demonize Jews in the process for putatively being Jesus' enemies and murderers, and so threaten them with violence and destruction, that it is hard to see this as anything but an eliminationist mindset, a blueprint for eliminationist politics, and, if only tacitly, a call to eliminationist action – and this is how it has been taken by Christians and others beholden to the foundational paradigm it grounded.[558]

Goldhagen claims the New Testament contains four hundred and fifty anti-Semitic verses in the four Gospels and the Acts of the Apostles.[559] He has, however, nothing to say about the "eliminationist" mindset, politics and actions far more clearly evident in the Jewish Bible, and how this has shaped Jewish attitudes to non-Jews. Blithely ignoring the hostility to non-Jews and notions of the Jewish supremacy that pervade the Torah and the Talmud, Goldhagen proposes that

> for two millennia antisemitism has been at the core of Christian civilization, first in its European heartland and then, missionized, around the world. It is inscribed in its bible. The deprecation of Jews and the replacement theology, meaning that Jews ought to disappear, has historically been central to Christianity's and Christians' self-definition. Christianity's churches have until recently incessantly preached against Jews. Closely identifying Jews with evil, including the devil, organizing Christianity's thinking and politics for centuries and had as a focal point the disposing of Jews.[560]

On the basis of a survey carried out in 2012 in the European Union, Goldhagen claims that some 100 million Europeans believe "the most

damaging antisemitic canard ever," namely that Jews are responsible for the crucifixion of Jesus Christ. Thus, for Goldhagen, anyone believing the actual New Testament account of the life and death of Jesus is a loathsome anti-Semite. He claims that if we extrapolate the findings to include Russia and Ukraine "that would add another forty million, bringing the European total to 140 million dyed-in-the-wool antisemites."[561] Goldhagen claims survey results show "almost one in three Americans (31 percent), ninety million people, believe the most damaging antisemitic canard or all time: that 'Jews were responsible for the death of Christ.'" In other words, a third of Americans believe the standard biblical account of the life and death of Jesus.

Goldhagen claims that "despite its publicly stated and championed position," the post-Vatican II Catholic Church (including in Europe and North America) has "failed to excise antisemitism from its teaching and liturgy." He bemoans the fact the Catholic Church "has done little, and in many places nothing, to stop spreading antisemitism during the Christian calendar's most sacred time and in the Jesus story as it is portrayed," and insists that Catholicism in parts of the world is still in "a medieval" or "pre-Vatican II state" in its presentation of Jews.[562] He has no corresponding concern about how the Talmud (which remains in a *pre-medieval* state) depicts Jesus and teaches Jews to regard and treat Christians.[563]

As one would expect, Goldhagen regards Mel Gibson's film *The Passion of the Christ* as "a blatantly antisemitic film even according to the Catholic Church's own guidelines for depicting the last days and death of Jesus." He condemns Mel Gibson as "a dyed-in-the-wool, old style, Catholic antisemite" who, in *The Passion of the Christ*, "spins out his New Testament hatred publicly in cinematic calumny and incitement, and in private and uncontrollable outbursts."[564] He likewise denounces Bishop Giacomo Babini, who in 2010 had the temerity to claim a "Zionist attack" was behind criticism of the Pope over the sex abuse scandal. The bishop explained that "Jews do not want the Church, they are its natural enemies."[565] Goldhagen's palpable hatred of the Catholic Church only corroborates Babini's thesis.

### *Christianity as More "Antisemitic" than Islam*

Goldhagen claims that while the treatment of Jews in Islam's sacred texts, such as the Quran and the Hadith, "is horrifying, grounded in the foundational antisemitic paradigm, and provides the foundation for the Arab and Islamic world's profound antisemitism," it is still "not in any reasonable sense equivalent to the Christian bible's casting of Jews as the central villains in the story of Jesus' life, mission, attempt to save humanity and death."[566] He asserts that "it is only by the horrific Christian standard that Islamic antisemitism and Muslims' antisemitism have been (wrongly) judged to be not all that bad historically."[567] So while Islamic anti-Semitism is bad, for Goldhagen the Christian variety is infinitely worse.

Jewish support for large-scale Muslim immigration into what were formerly homogeneously White Christian lands – despite the real physical dangers this presents to Diaspora Jews – becomes explicable in light of such views. If, as Goldhagen claims, "antisemitism is the real devil that Christianity spawned," then it logically follows that, for this devil to be exorcised from the global body politic, overwhelmingly White Christian nations simply cannot be allowed to exist – no matter the cost.

What Jews most decidedly do not want is a population that is ninety-nine percent White and Christian where they are a tiny one percent minority. They will *always* work to undermine that, not just in America, but in Europe, Canada, Australia and New Zealand too. They feel much safer in places like New York City which is a grab bag of races and peoples. The parochial group loyalty characteristic of Jews attracts far less attention in a society devoid of a cohesive racial and cultural core. It is in the interests of Jews to dilute and weaken the identity of the nations in which they live. History shows that Jewish communities in the Diaspora only thrive when their non-Jewish hosts' have a weak collective identity.

Despite the Jewish ethno-political origins of the liberalization of Western immigration policies, Goldhagen writes as though White

people had voluntarily opened their borders to the Third World to embrace mass Islamic immigration:

> The simple fact, not sufficiently paid attention to, is that an enormous reservoir of antisemites – among the peoples of Arab and Islamic countries, and now Arabs and Islamic immigrants and their descendants living abroad – is itself streaming around the world to populate it with deeply devout antisemites. This does not mean that all Arabs or all Muslims, either living in the countries of their ancestry or now non-predominantly Arabic or Islamic countries are antisemitic, but an enormous number of them are, and they are a substantial population on the move. Tens of millions of people of Arabic descent live abroad. Nineteen million Muslims live in the European Union alone, seventeen times the 1.1 million Jews. ... Muslims and Arabs are aware of their numerical strength and conscious of their ability to spread their antisemitic beliefs and press for the adoption of their antisemitic politics, and they do so. No corner of the world is worry free for Jews, and much of the world where there are Jews (and probably where there are few of them) is dangerous for them owing to the actual or threatened violence perpetrated by Muslims and Arabs.[568]

Jews only start complaining, as Goldhagen does here, about the multiracial and multicultural fruits of their collective labors when some of the people let in to these countries (promoted intensively by Jewish activist organizations like HIAS) begin to disrupt Jewish lives – typically because they are Muslims with an intimate familiarity with the Jewish mindset, and, because they have a stronger collective sense, are not as easily undermined and, indeed, are not afraid to lose their lives in fighting Jews. By contrast, empathic, fair, and excessively-tolerant White people are far easier targets for Jewish manipulation.

## *Jewish Power as "A Figment of the Antisemitic Imagination"*

In *The Devil That Never Dies*, Goldhagen claims that notions of Jews' "alleged clannishness" and "earth-shattering power, and malevolence, continue to be a figment of the antisemitic imagination."[569] This is despite the fact that even back in the early 1970s, President Nixon, then supposedly the most powerful man in the world, and Billy Graham, the preeminent Christian leader in the United States, felt unable to publically express their grave concerns about Jewish power and influence in the United States for fear of the consequences. Labelling their conversation a "horrifying exchange," Goldhagen states that:

> In 1972, in the White House's Oval Office, Nixon let forth a brief antisemitic rant about Jews' "total domination of the media," and what he regarded as their left-wing bias. The President of the United States, with unlimited access to the best sources of information about every aspect of his country, adopted the jargon of an ignorant antisemitic bigot when speaking about Jews in private. Such is the powerful, stupefying quality of this prejudice. Graham immediately agreed with Nixon regarding Jews' power and nefariousness. Taking the president's words as a green light for him to speak to a kindred spirit, and elaborating his real views about Jews, he went still further. "They're the ones putting out the pornographic stuff," he informed Nixon. And so severe is the danger the Jews pose that, Graham declared, their "stranglehold has got to be broken or this country's going down the drain."[570]

Nixon, in response to Graham citing how the Jews had, through their own actions, provoked violent backlashes against themselves in Spain in 1492 and in Germany during the National Socialist period, observed that: "It's happening [again] – and now it's going to happen in America if these people don't start behaving... It may be they have a death wish."[571]

According to Goldhagen, this exchange "conveys the fantastical nature of antisemites' views about Jews: 'total domination,' nutty notions about pornography, 'stranglehold,' and the acute threat Jews willfully pose to the United States of 'sending it down the drain.'" Goldhagen's reaction to Nixon and Graham's conversation – so characteristic of hyper-ethnocentric Jews who instinctively and hysterically defend their interests – regardless of the facts – calls to mind Israeli journalist Manny Friedman's observation that whenever anyone claims Jews control the media or Washington:

> Suddenly we're up in arms. We create huge campaigns to take these people down. We do what we can to put them out of work. We publish articles. We've created entire organizations that exist just to tell everyone that the Jews don't control nothing. No, we don't control the media, we don't have any more sway in DC than anyone else. No, no, no, we swear: We're just like everyone else! ...

> Let's be honest with ourselves, here, fellow Jews. We do control the media. We've got so many dudes up in the executive offices in all the big movie production companies it's almost obscene. Just about every movie or TV show, whether it be "Tropic Thunder" or "Curb Your Enthusiasm" is rife with actors, directors, and writers who are Jewish. Did you know that all of the eight major production studios are run by Jews? But that's not all.

> We also control the ads that go on those TV shows.

> And let's not forget AIPAC, every anti-Semite's favorite punching bag. We're talking an organization that's practically the equivalent of the Elders of Zion. I'll never forget when I was involved in Israeli advocacy in college and being at one of the many AIPAC conventions. A man literally stood in front of us and told us their whole goal was to only work with top-50 school graduates because they would eventually be the people making

changes in the government. Here I am, an idealistic little kid that goes to a bottom-50 school (ASU) who wants to do some grassroots advocacy, and these guys are literally talking about infiltrating the government. Intense.[572]

Goldhagen – like a caricature of the type of Jew that Friedman describes – brands Johan Galtung, the Norwegian founder of the discipline of peace studies, a pernicious "antisemite" for pointing out in 2011 that "The Jews control U.S. media" and use it to warp American politics to support Israel.[573] He likewise denounces the former dean of the White House press corps, Helen Thomas, for pointing out that "Congress, the White House, and Hollywood, Wall Street, are owned by the Zionists. No question in my opinion. They put their money where their mouth is. ... We're being pushed in the wrong direction in every way." For Goldhagen, the obviously true claims of Galtung and Thomas (who was ensconced within the heart of American political journalism for decades), "are all old antisemitic tropes – about Jews and money and the media and warping the will and politics of the people – dressed up for a new global age."[574] No need to examine the data.

Again ignoring the obvious truths spelled out by Friedman (albeit for a Jewish audience), Goldhagen claims to be outraged that Karel de Gucht, formerly Belgium's minister of foreign affairs and deputy prime minister, and in 2013 the European Union's commissioner for trade, had the nerve to openly talk about Jewish power when he warned:

> Do not underestimate the Jewish lobby on Capitol Hill. That is the best organized lobby, you shouldn't underestimate the grip it has on American politics – no matter whether it's Republicans or Democrats. ... Don't underestimate the opinion... of the average Jew outside Israel... There is indeed a belief – it's difficult to describe it otherwise – among most Jews that they are right. And a belief is something that's difficult to counter with rational arguments. And it's not so much whether they are religious Jews or not. Lay Jews also share the same belief that they are right. So it is

not easy to have, even with moderate Jews, a rational discussion about what is happening in the Middle East.[575]

In making this statement de Gucht had, according to Goldhagen, exposed himself as "a rank antisemite." An examination of campaign finance contributions to both major parties in the U.S. in presidential elections is enough to confirm that Jews have absolutely captured both sides of American politics. While the Democrats push the Jewish domestic agenda harder (i.e., open borders and multiculturalism) and the Republicans push the Jewish foreign policy agenda harder (i.e., economically and militarily destroying Israel's enemies), neither party fundamentally disagrees with either of these policies. So while the Republicans are more likely to get your son killed fighting abroad for Israel, the Democrats will do all they can to ensure your children get passed over for jobs in favor of non-Whites. But Democrats are hardly immune to the machinations of the Israel Lobby, and the Republican Party actively facilitates the dispossession of White America.

### "There is No Such Thing as the Israel Lobby"

Goldhagen regards claims that Jews exert a dominating interest over the elite institutions of the United States (including Congress) as just another in the long list of calumnies that have been made against the Jews. Rather than being glaringly self-evident to anyone of average intelligence who pays cursory attention to American politics, the perception that Jewish interests are determining American foreign policy is, for Goldhagen, a testament to the success of anti-Semites who have "worked hard" to create this misleading impression.

> The notion of Jews controlling the United States was a standard Nazi one and has been a staple of antisemites ever since. The view today that if not for Jews' insidious control of the United States, the United States itself would be a better country, the Middle East would be far better off, and the world would also be a better place

comes also from those whose antisemitism is principally focused on the United States itself. In their widely discussed book *The Israel Lobby*, John Mearsheimer and Stephen Walt peddle such antisemitism dressed up in the garb of academic seriousness and respectability, with the invention of the bogeyman known as the Israel Lobby into which they subsume and thereby delegitimize people who vocally or in various ways materially support Israel. Indeed, their book is the best cloaked major antisemitic tract in English of the last several decades. ...[576]

In short, according to Mearsheimer and Walt, Jews, and the non-Jews they have co-opted or allied themselves with (Mearsheimer and Walt are careful to formally insist some non-Jews are also part of the Israel Lobby), insidiously control American foreign policy-making, betray American interests, duped the United States into launching an unnecessary war against Iraq, thereby impoverish the United States, produce enmity for it across many countries, wreak destruction halfway around the world, and cause the death of a large number of innocent Americans. Indeed in an earlier article – before they sanitized their presentation for the book – Mearsheimer and Walt wrote even more openly in the vein of antisemites past and present. They warned in ominous tones about the power of "Israel and its American supporters": "If their efforts to shape U.S. policy succeed, Israel's enemies will be weakened or overthrown, Israel will get a free hand with the Palestinians, and the U.S. will do most of the fighting, dying, rebuilding and paying."[577]

Goldhagen, himself an ultra-Zionist, insists "There is no such thing as the Israel Lobby." This despite the fact that elsewhere in *The Devil That Never Dies* he admits that "Israel's supporters, given their preponderance in a democracy and their passion for a beleaguered, existentially threatened democracy with which many sympathize and identify, have no doubt been influential in Washington." Having said this, he

reassures us that "most do not formally or informally belong to a lobby, which in American politics is an organization or group of organizations that seek to directly influence governmental officials and which has the clear connotation of something not in the public interest, or worse." Goldhagen's casuistic reasoning is seemingly that, as America's interests are indistinguishable from Israel's interests, AIPAC and the other neo-conservative organizations that aggressively lobby Congress on behalf of Israel are only really advocating for American interests, and, therefore, cannot be categorized as an actual "lobby."

Israel is, according to Goldhagen, worth expending any amount of blood and treasure to defend because "Israel has been for decades the lone genuine democracy in the Middle East and a staunch American ally, including during the Cold War."[578] Naturally he makes no mention Israel's attack on the USS Liberty, the Lavon affair, or the extensive Israeli spying operations the United States, or the fact that the alliance with Israel provides Americans with no benefit whatsoever. Nor does he exhibit any familiarly with Mearsheimer and Walt's actual arguments on whether the United States benefits from its lavish support for Israel.

Goldhagen argues that many "antisemites" see the source of "Israel's perniciousness" to reside "in its character as a Jewish state, namely a country of Jews, because even though many if not most of the countries in the world are conceived of as belonging to or expressing the political nationhood of a people, antisemites do not allow that Jews may do the same, routinely maintaining that to call Israel a 'Jewish' state, even though the overwhelming majority of the population is Jewish, is 'racist.'"[579] This is absurd. Jews maintaining an avowedly Jewish state with a racially-restrictive immigration policy is only natural. What is so galling is the hypocrisy of Jewish activists like Goldhagen supporting such a state for Jews while regarding the European and European-derived equivalents of Israel (like Australia under the White Australia policy) as morally repulsive and worthy of deconstruction through mass non-White immigration and multiculturalism.

All European and European-derived countries were originally conceived of as belonging to and expressing the political nationhood of a

people. This is no longer the case due, in large part, to Jewish intellectual and political activism. To rub salt into the wound, Zionist Jews take pride in their having destroyed the racial and ethnic basis of Western nations. Take, for example, Australian Jewish activist and former editor of the *Australian Jewish News*, Dan Goldberg, who proudly acknowledged that: "In addition to their activism on Aboriginal issues, Jews were instrumental in leading the crusade against the White Australia policy, a series of laws from 1901 to 1973 that restricted non-White immigration to Australia."[580]

## *Jewish Financial Power as a "Fantastical" Notion*

A 2007 survey found that around 40 percent of Europeans have what Goldhagen describes as the "fantastical" belief that "Jews have too much power in international financial markets," while a 2009 survey supposedly found that around 30 percent of Europeans believe Jews were, to at least some extent, responsible for the Global Financial Crisis of 2008. Goldhagen claims to be utterly bewildered why anyone would think "Jews having such power in business is a problem, is threatening, is seen as a resource that they misuse or potentially misuse." He claims to be perplexed why "international bankers and currency traders who happen to be Jews would be defined as Jews," and "why such Jews having such power (whatever that means) let alone too much power would be bad," and "for what evil are the Jews supposedly using such power?"[581]

Goldhagen obfuscates the obvious nexus between disproportionate wealth and disproportionate political, legislative, and media influence, and how Jewish elites have wielded this influence to reshape Western societies in their own interests. The current influence of Sheldon Adelson within the Republican Party is just one example of the capacity of Jewish financial power to shape American politics and with it, American foreign policy. The entire anti-White political and cultural superstructure of the contemporary West has been built on a foundation of Jewish wealth. Jewish Americans make up 2.2 per cent of the U.S. population

yet comprise around 35 percent of U.S. billionaires and around 50 percent of Wall Street bankers.[582] Goldhagen is impervious to any evidence put forward that would confirm the validity of the statements used in the Anti-Defamation League's surveys, claiming that "a person trying to justify them, in other words, to say that they are either true or believable enough, succeeds only in revealing that he or she is antisemitic."[583]

The author of *The Devil That Never Dies* is encouraged by the fact that, despite a survey that found that 80 percent of the Americans agreed that "Wall Street and major banking institutions in our country operate in their own selfish interest and not in the interest of the American economy," this has not flowed through to increased generalized hostility to Jews in the United States. He notes that: "As Jews are commonly associated with Wall Street and banking, and one of the standard questions in surveys about antisemitism focusses specifically on Wall Street, it is extraordinarily significant that there has been no upsurge in this accusation about Jews."[584] He is likewise encouraged by the fact that though around "three in five Americans (57 percent) believe that a cabal in Washington was working for its members' own narrow interests – this is an extraordinarily high number – such a conspiratorial view of American politics and economy has not implicated Jews or affected people's conception of Jews to any sizable degree."[585]

This can, to a great extent, be attributed to how bankers, financiers, politicians and political advisors are portrayed by Hollywood, where they are invariably depicted as WASPs rather than as the Jews that, in very many instances, they actually are. The bulk of Hollywood dramas portray finance professionals as unscrupulous and money hungry, but these traits are seldom associated with Jews. Even when a character is based on an actual Jew (like Jordan Belfort), they are transmuted by Hollywood into a WASP, and thus real ethnic identity of the financial and political elite is hidden from the average American.

242  –  BRENTON SANDERSON

## Jews and Communism

Goldhagen angrily declares any claim Jews "were responsible for the Russian Revolution and its predations" is a "calumny" and that: "If you associate Jews with communism, or worse, hold communism to be a Jewish invention and weapon, every time the theme, let alone the threat, of communism, Marxism, revolution, or the Soviet Union comes up, it also conjures, reinforces, even deepens thinking prejudicially about Jews and the animus against Jews in one's country."[586]

This despite the fact mainstream Jewish historians readily confirm that Jews were vastly disproportionate participants in providing the ideological basis for, and the governance and administration of, the murderous communist regimes of Central and Eastern Europe. Bernhard Wasserman, professor of Modern Jewish History at the University of Chicago, notes, for example, that "the European left was in large measure a Jewish creation. In Germany in the mid-nineteenth century Marx, Hess, and Lassalle, all three of Jewish origin, had founded and shaped the socialist movement."[587] Furthermore, the Jewish historian Norman Cantor pointed out that "In the first half of the twentieth century, Marxist-Leninist communism ran like an electromagnetic lightning flash through Jewish societies from Moscow to Western Europe, the United States and Canada, gaining the lifelong adherence of brilliant, passionately dedicated Jewish men and women.'[588]

Of the seven members of the original Politburo, the inner cabinet of the new Bolshevik regime, four – Trotsky, Zinoviev, Kamenev and Sverdlov – were Jews. After the Bolsheviks seized power in October 1917 they fought hard in the early years of Lenin's rule to wipe out anti-Semitism in Russia by legal means. After the revolution, Jews quickly moved, Jewish historian Jerry Muller notes, into "important and especially sensitive positions in the bureaucracy and administration of the new regime," and, as a result, the first encounter with the new regime for many Russians "was likely to be with a commissar, tax officer, or secret police official of Jewish origin." He concedes that:

with so many Bolsheviks of Jewish origin in positions of leadership, it was easy to consider Bolshevism a 'Jewish' phenomenon. And if Winston Churchill, who was personally remote from anti-Semitism, could regard Bolshevism as a disease of the Jewish body politic, those who had long conceived of Jews as the enemies of Christian civilization quickly concluded that Bolshevism was little more than a transmutation of the essence of the Jewish soul.[589]

The rapid movement of Jews into the economic, cultural, and political leadership ranks throughout the 1920s reached its peak in the mid-1930s. "The last Jewish member appointed to the Politburo," Muller notes, "was Lazar Kaganovich, who later presided over the politically motivated famine that took the lives of millions of Ukrainian peasants." In Poland, Jewish membership of the Communist Party fluctuated between 22 and 35 percent of the total. Jews were even more heavily represented in the party leadership: in 1935 they constituted 54 percent of the "field leadership" and 75 percent of the *technika* (responsible for propaganda).

Muller observes that "nowhere were Jews more prominent in the Sovietization of the nation" than in post-World War II Hungary, where "the key post of general secretary was once again occupied by a Jew, Mátyás Rákosi" who billed himself as 'Stalin's best pupil.'"[590] The next five major positions were filled by Jews, while 30 percent or more of higher police officials were Jewish, and "many departments of the security apparatus were headed by Jews." It was hardly surprising in such an environment that anti-Jewish riots broke out in 1946. The oppressive nature of the new regime can be gauged by the fact that between 1952 and 1955 "the police opened files on over a million Hungarians, 45 percent of whom were penalized," and "Jews were very salient in the apparatus of repression."[591]

Goldhagen refuses to even acknowledge any of this, and while vehemently condemning "Holocaust denial," freely engages in his own form of historical denial. He sanctimoniously claims that "for European

elites, and obviously for American elites, saying that the Holocaust did not happen, or some lesser but obvious stripe of Holocaust denial, places a person outside the foundational moral consensus that the Holocaust was an unsurpassed evil. A person denying this gravely violates morality, and furthermore casts doubt on the person's sanity, judgment or public fitness."[592] On the other hand, denying the reality of the extensive Jewish role in the mass murder and brutal treatment of millions of Eastern Europeans under communist regimes, as Goldhagen does, has no negative moral or psychological connotations. This is ultimately due to the vigilant Jewish policing of all historical discourse relating to Jews. Since 1945, some 440 feature films have been made about the "Holocaust" while the number of films that have been made about the Bolshevik genocide of millions of Eastern Europeans can be counted on one hand – and none have been produced by Hollywood.

Israeli journalist Sever Plocker, writing in 2006, had the honesty to admit that "some of the greatest murderers of modern times were Jewish." After noting that "at least 20 million" died as a result of the forced collectivization, the hunger, purges, expulsions, banishments, executions, and mass death at Gulags, he pointed out that

> Lenin, Stalin, and their successors could not have carried out their deeds without wide-scale cooperation of disciplined "terror officials," cruel interrogators, snitches, executioners, guards, judges, perverts, and many bleeding hearts who were members of the progressive Western Left and were deceived by the Soviet regime of horror and even provided it with a kosher certificate. ...

> And us, the Jews? An Israeli student finishes high school without ever hearing the name "Genrikh Yagoda," the greatest Jewish murderer of the 20th Century, the GPU's deputy commander and the founder and commander of the NKVD. Yagoda diligently implemented Stalin's collectivization orders and is responsible for the deaths of at least 10 million people. His Jewish deputies established and managed the Gulag system. After Stalin

no longer viewed him favorably, Yagoda was demoted and executed, and was replaced as chief hangman in 1936 by Yezhov, the "bloodthirsty dwarf." ...

Stalin's close associates and loyalists included member of the Central Committee and Politburo Lazar Kaganovich. Montefiore characterizes him as the "first Stalinist" and adds that those starving to death in Ukraine, an unparalleled tragedy in the history of humankind aside from the Nazi horrors and Mao's terror in China, did not move Kaganovich.

Many Jews sold their soul to the devil of the Communist revolution and have blood on their hands for eternity. We'll mention just one more: Leonid Reichman, head of the NKVD's special department and the organization's chief interrogator, who was a particularly cruel sadist.

In 1934, according to published statistics, 38.5 percent of those holding the most senior posts in the Soviet security apparatuses were of Jewish origin. They too, of course, were gradually eliminated in the next purges. In a fascinating lecture at a Tel Aviv University convention this week, Dr. Halfin described the waves of Soviet terror as a "carnival of mass murder," "fantasy of purges," and "messianism of evil." Turns out that Jews too, when they become captivated by messianic ideology, can become great murderers, among the greatest known by modern history.

The Jews active in official communist terror apparatuses (in the Soviet Union and abroad) and who at times led them, did not do this, obviously as Jews, but rather, as Stalinists, Communists, and "Soviet people." Therefore, we find it easy to ignore their origin and "play dumb": What do we have to do with them? But let's not forget them. My own view is different. I find it unacceptable that a person will be considered a member of the Jewish people when he does great things, but not be considered part of

our people when he does amazingly despicable things. Even if we deny it, we cannot escape the Jewishness of "our hangmen" who served the Red Terror with loyalty and dedication from its establishment.[593]

Unlike Plocker, Goldhagen "plays dumb" and refuses to accept any Jewish role *whatsoever* in communist mass murder. He is, however, very eager to apportion guilt to all Europeans (including those born after World War II) for their ancestors' alleged participation in, or failure to prevent, "the Holocaust." The Holocaust-related guilt of contemporary Europeans, and their refusal to come to terms with it, is, for Goldhagen, a significant wellspring of anti-Semitism:

> The sense of culpability for what is often characterized as the greatest horror in human history is burdensome or unbearable for most people for whom a salient (often the principal) locus of group identity is the nation, the image and standing of which they typically, especially in the eyes of people outside their countries want to bolster. If we consider how much people bristle at unflattering stereotypes about their national or ethnic group, and how afflicted it makes them feel personally, we should magnify such reactions a figurative hundred or thousand times to understand how disturbing it is to be implicated in the Holocaust.

> Germans, the French, the Dutch, Norwegians, the Swiss, Poles, Ukrainians, Lithuanians, Latvians, Slovaks, Greeks, Hungarians, Christians in general, and Catholics in particular, even Danes face this problem albeit to different degrees. Yet there is no easy way around it other than burying it or, even more effective, shifting blame to the Jews themselves.[594]

As well as engaging in Freudian theorizing about contemporary Europeans, Goldhagen also blames them for not doing nearly enough to prevent Muslim attacks on Jews in Europe, despite the fact that the large-scale Muslim presence in Europe is itself a malignant outgrowth

of Zionist wars and Jewish ethno-political activism – of a Europe that, in the infamous words of Barbara Lerner-Specter, "has now moved into multicultural mode."

Goldhagen quotes Moshe Kantor, president of the European Jewish Congress, who, surveying the European landscape following Muslim attacks on Jews in Toulouse, France and then in Malmo, Sweden in 2012, declared that "the explosion of Malmo follows an unprecedented wave of attacks against Jews and Jewish targets in recent months, since the murders in Toulouse. The Jewish community in Europe is under attack, there is a real threat to Jewish communal life in parts of Europe and not enough is being done to protect it. A threat to Jewish life in Europe is a threat to the foundations of Europe." Neither Kantor nor Goldhagen will admit the obvious: that violent, low-IQ, welfare-dependent Sunni Muslims would not even be in Malmo or Toulouse (let alone attacking anyone there) but for the concerted Jewish push to reshape Western societies in their own perceived interests.

### Conclusion

*The Devil That Never Dies* is a badly written, poorly organized, and fundamentally dishonest book. Goldhagen presents his "arguments" in a rambling and annoyingly repetitive manner. The book is full of circular arguments and convoluted, tautological nonsense such as: "Global antisemitism is built upon the foundational antisemitic paradigm, with various kinds, or worlds, of antisemitism embedded in and shaped by its global contours, and with these various worlds of antisemitism in substantial part continuing their previous antisemitic lives while also being continually altered as they intermesh and include new antisemitic features, which have emerged as a response to our global world's changed nature."[595]

Despite its many conceptual and stylistic flaws, *The Devil That Never Dies* was widely praised in the Jewish and Jewish-controlled media. Neal Gendler from the *American Jewish World*, for example, called the book a "frightening exposition on how anti-Semitism has become a

global phenomenon" which is "bursting with information and insight." Benjamin Weinthal from *The Jerusalem Post* called it a "brilliant work" that "should sound a clarion call for governmental and societal intervention." The Jewish Book Council, while extolling Goldhagen's book as "rich and provocative," admitted that Goldhagen's "writing is often dense and repetitive and the tone is occasionally shrill and hectoring, with some of his points bordering on hyperbole."

The *Devil That Never Dies* is so inept that even a leading representative of the Zionist thought police, Anthony Julius, trashed the book in a review in the *Wall Street Journal* that he wrote "with reluctance." Julius wanted to sing the book's praises, but was forced by how truly awful Goldhagen's work is to admit that it "is a bad book" that "lacks balance and originality" and which "misrepresents or misreads several readily available texts." Julius concedes that the book "is characterized throughout by overstatement and contains some truly ludicrous judgments." Julius laments the fact that, in being "so easily and justly dismissible," *The Devil That Never Dies* "weakens the very cause its author seeks to promote."[596]

Anthony Julius' own variety of Jewish apologetics has many of the same weaknesses that he attributes to Goldhagen. Ultimately, Jewish intellectual apologists like Anthony Julius, Alvin Rosenfeld, David Nirenberg and Daniel Jonah Goldhagen are hamstrung by the fact the truth happens to be "anti-Semitic." To present cogent and convincing arguments contrary to the facts is a tough assignment for any writer, even a former associate professor at Harvard.

# The Indoctrination Game: Alan Turing as Jewish Proxy

*The Imitation Game* is a 2014 historical thriller film based on the biography *Alan Turing: The Enigma* by mathematician and gay rights activist Andrew Hodges. It stars Benedict Cumberbatch as the British cryptanalyst Alan Turing, who, working with a team of experts at the country estate Bletchley Park, devises a machine that, after much trial and error (and official interference) cracks the Germans' notoriously difficult Enigma communications code. This breakthrough turns the tide of WWII and hastens Germany's defeat. Turing is later prosecuted by a British court for his homosexuality and commits suicide as a result of the hormone treatment he is forced to endure.

The film was a huge commercial success (grossing $219 million against a $14 million production budget), received many award nominations, and won an Oscar for Best Adapted Screenplay. While *The Imitation Game* was critically acclaimed, it was also slated for its many historical inaccuracies. Largely neglected in all the commentary about the Weinstein Company's historical drama is the Jewish ethno-political agenda that underpins the film.

One Jewish source notes that, despite Benedict Cumberbatch being "so gentile it's almost shocking," the film has "significant Jewish angles" while being about "a non-Jewish mathematical genius from Cambridge University, Alan Turing, and his efforts to crack Nazi codes in the bucolic British countryside." It admits that, given the Jewish domination of Hollywood, "perhaps it's not shocking that the film's producers are Jews (the clues are there in 'film' and 'producers')."[597] These producers being Ido Ostrowsky, Nora Grossman, and Teddy Schwarzman – the son of billionaire Jewish financier Stephen Schwarzman, who "were drawn to Turing's story as a tale of a brilliant outsider forced to work with others to win the war against German evil."

Naomi Pfefferman, writing for *The Jewish Journal*, claims that Turing's efforts shortened the war and "saved up to 14 million lives, including those of millions of potential Holocaust victims," and observes that:

> For the Israeli-born Ostrowsky – who moved to Los Angeles with his family when he was a baby – there was another point of connection to Turing's work: Ostrowsky's Russian-Jewish grandparents lost relatives in Nazi concentration camps, and Ostrowsky is keenly aware that he, too, as a gay Jewish man, would have worn both the pink triangle and the yellow Jewish star during the Third Reich. Of the millions of lives Turing saved, he said, "I thought about how many of those people might have been my family members; it really hit close to home that Turing was a hero for all people, but also my people. And then he was treated in such a horrific way; it just felt like a shocking injustice. Even though he was officially pardoned after we shot our movie, it felt like he had never properly been celebrated or brought back to his rightful place in history.[598]

Turing's story also resonated with fellow producer, Nora Grossman, whose "great-grandfather, Benjamin Grossman, migrated to Ventnor [New Jersey] from Poland just before World War II" while most of his

family who remained "perished in ghettos." Grossman's cousin, Gail Rosenthal, is the director of a Holocaust Resource Center at Stockton College in New Jersey. Having watched the film, a representative from the center opined that "The movie was very powerful on multiple levels," and claimed that, "On one level, the film deals with stopping the biggest bully of all time, Hitler. But it also shows how Turing himself was bullied as a kid in school and later in life. It's ironic that the man who helped defeat the biggest bully of all time met his demise as a result of bullying."[599]

Former British Prime Minister Gordon Brown summed up the line of thinking that motivated the many Jews involved in the production of *The Imitation Game* when, writing in praise of Turing in 2009, he contended that:

> Alan deserves recognition for his contribution to humankind. For those of us born after 1945, into a Europe which is united, democratic and at peace, it is hard to imagine that our continent was once the theatre of mankind's darkest hour. It is difficult to believe that in living memory, people could become so consumed by hate – by anti-Semitism, by homophobia, by xenophobia and other murderous prejudices – that the gas chambers and crematoria became a piece of the European landscape as surely as the galleries and universities and concert halls which had marked out European civilization for hundreds of years. It is thanks to men and women who were totally committed to fighting fascism, people like Alan Turing, that the horrors of the Holocaust and of total war are part of Europe's history and not Europe's present. So on behalf of the British government, and all those who live freely thanks to Alan's work, I am very proud to say: we're sorry. You deserved so much better.[600]

In 2010, Ostrowsky and Grossman pooled their money and bought the rights to Andrew Hodges' biography. At the time, Grossman was working at the Jewish-owned and controlled DreamWorks studio in the

TV department, and Ostrowsky was working at the Jewish-controlled NBC. The next step in bringing Turing's story to cinematic life was to find someone to adapt the book into a screenplay. Inevitably, their choice of screenwriter involved Jewish ethnic networking. Grossman "chanced" to invite young Jewish writer Graham Moore to her home for a party in 2010. She was discussing her "Alan Turing project" with a friend and recalls how "Graham, whom I had known from my television days, was actually involved in another conversation, but he overheard me, interrupted me and said, 'I love Alan Turing!'" As soon as he discovered Grossman and Ostrowsky had optioned the rights to Andrew Hodges' book, he lobbied for the chance to tell the story of "his underappreciated, lesser-known childhood hero."[601]

Moore, who at that time was writing a sitcom for ABC Family (a subsidiary of the Jewish-owned and managed Disney), recounts how:

> I was at a party at Nora's house, and at the time I didn't know her particularly well, but I asked her what she had been up to and she said, "Well, I just used a chunk of my own money to option a book," and I said, "Oh, that's really cool, cheers! Have a drink, that's great, doing your own thing! What's the book about?" and she said, "This mathematician, you've never heard of him." And I said, "Well, I do know a little bit about mathematics," and when she said "Alan Turing," I instantly freak out and launch into this totally insufferable 15-minute monologue about how I've dreamed about writing about Alan Turing since I was a little kid, I went to computer camp, where all we ever talked about was Alan Turing. This is what the movie is, this is how it starts, and I could see her start to inch back step by step, trying to get away from me. But somehow I convinced her to let me do it.[602]

As with Grossman and Ostrowsky, Moore's fascination with Turing is a product of his Jewish identity and sympathies. The son of two lawyers, Moore grew up on the north side of Chicago in a family with a deep commitment to left-wing politics. The *Tablet* notes that Moore's

mother is "not just any *Yiddishe Mameh*" but Susan Sher, who, during the first term of the Obama administration served as special assistant to President Obama and then as chief-of-staff to Michelle Obama (whom she first met in 1991). These jobs were in addition to her role as the official White House liaison to the Jewish community, "a realm that has become increasingly important to her son."[603]

Moore has always felt strongly connected to the Jewish community. "My Judaism has felt more and more important to me, and more and more of a social identifier," he told *The Jewish Journal*. "My grandparents passed away a few years ago, and I was very close to them, and for their generation, their Jewish identity was extremely important. And after they passed away, this notion that me and my mother [*sic*] would become the keepers of this tradition became very apparent and very important."[604] Moore's mother was involved in "advocacy" to build the Obama Presidential Library in South Side Chicago, as part of her role as senior advisor to University of Chicago President Robert Zimmer (who, inevitably, is also Jewish).

Despite being the privileged representative of the wealthiest, most well-connected and powerful ethnic group in the United States – and someone who attended Colombia University (where he became editor of the student newspaper) – Moore sees himself as an "outsider" who is alienated from the American mainstream. "I think I always felt like an outsider, like a weirdo," he claimed – a condition which, according to Danielle Berrin, writing for the 'Hollywood Jew' section of *The Jewish Journal*, has "afflicted almost every artist that ever lived, not to mention, almost every Jew."

In addition to his putative "outsider" status, Moore is stereotypically Jewish in other ways, reportedly being "hyper-articulate, to the point where he needs only a simple prompting to riff energetically on a number of subjects, and his ability to speak on a range of topics suggests the diversity of his interests – technology, journalism, rock music and politics." Moore is also, inevitably, a "genius." Berrin claims, for instance, that taken together, Moore's "back-to-back successes," suggest that he "is either experiencing an unheard of bout of beginner's luck,

or he is, perhaps, like the subjects on which he writes, something of an anomalous genius himself."[605]

The screenwriter of *The Imitation Game* grew up with a small group of friends who were "a very motley bunch of outsiders." He claims that "Some of us were gay, some were straight, but most of us wore nail polish. (I certainly did). Occasionally, lipstick and eyeliner." His best friend was the "NYU film grad Ben Epstein," who suggested they become writing partners.[606] Upon graduation, Epstein quickly secured work in Hollywood as a writer, producer and director for numerous shows including the 2014 series *Happyland* for Sumner Redstone's pestilential MTV. Moore, like Epstein was irresistibly drawn to Hollywood, where one of his earliest jobs was as a staff writer for the short-lived series *10 Things I Hate About You*. Moore's real breakthrough, however, was his novel *The Sherlockian* which was on *The New York Times* bestseller list for three weeks.

Alan Turing was a figure that meant a lot to Moore from a young age, and he claims to have become "obsessed with this idea that his cryptographic work and his computer work is him dealing with the issues of being a closeted gay man... One of the things I found so fascinating about him is that he was someone who didn't fit into the society around him for many different reasons." Moore could also identity with Turing being "the smartest person in every room that he entered," and, while apparently not homosexual himself, sympathized with the plight of a man, who, "when the government found out he was gay, he was arrested, persecuted by the country he'd just saved from Nazi rule, until he finally committed suicide..."[607] Moore told the *Los Angeles Times* that:

> Once I heard the story, I wanted to learn more. I needed to learn everything I could about him. Alan Turing was an outsider's outsider – perhaps the most brilliant scientist of his generation, a social outcast who produced theories decades ahead of their time. A gay man who was able to keep secrets for the government so well precisely because he'd been forced to spend his entire life

keeping his sexuality secret from a world in which a kiss between two men was literally punishable by two years in prison. For a weird kid like myself, who never felt like he belonged or fit in, Alan Turing wasn't just an inspiration – he was a patron saint. (As a Jew, my mother would be aghast to hear me describe anyone as a saint, but you get the idea).[608]

Moore's screenplay has been criticized for its numerous historical inaccuracies and clichéd characterizations. Writing in the *New York Review of Books*, Christian Caryl accused the film in general, and Moore specifically, of "monstrous hogwash," "caricature" and a "bizarre departure from the historical record."[609] L.V. Anderson, reviewing *The Imitation Game* for *Slate*, similarly observed that Moore "takes major liberties with its source material, injecting conflict where none existed, inventing entirely fictional characters, rearranging the chronology of events, and misrepresenting the very nature of Turing's work at Bletchley Park."

Moore's characterization of Turing is deeply flawed. His claim that Turing was someone who was forced to spend his entire life keeping his sexuality secret from the world is simply wrong. Hodges' biography is filled with instances where he boldly propositioned other men – mostly without success. Turing also told his friends and colleagues about his homosexuality.[610] Caryl points out that Moore's false characterization "is indicative of the bad faith underlying the whole enterprise, which is desperate to put Turing in the role of a gay liberation totem." He notes that the film's factual errors "are not random; there is a method to the muddle. The filmmakers see their hero above all as a martyr of a homophobic Establishment, and they are determined to lay emphasis on his victimhood."[611]

Moore strongly implies (again contrary to Hodges' biography) that Turing is somewhere on the autism spectrum: he never gets jokes, takes common expressions literally, and is totally indifferent to the annoyance and offence his behavior causes others. While Hodges describes Turing as a man who was eccentric and impatient with irrationality, he notes that he had a keen sense of humor and was charming with friends and

trusted colleagues. One of Turing's coworkers at Bletchley Park later recalled him as "a very easily approachable man" and said "we were very fond of him."[612] None of this is reflected in Moore's screenplay (or the film) which reduces Turing to a caricature of the tortured genius. Caryl observes that:

> Turing (played by Benedict Cumberbatch) conforms to the familiar stereotype of the otherworldly nerd: he's the kind of guy who doesn't even understand an invitation to lunch. This places him at odds not only with the other codebreakers in his unit, but also, equally predictably, positions him as a natural rebel. ... The film spares no opportunity to drive home his robotic oddness. He uses the word "logical" a lot and can't grasp even the most modest of jokes. ... On various occasions throughout the film, [the chief codebreaker at Bletchley Park] Denniston tries to fire Turing or have him arrested for espionage, which is resisted by those who have belatedly recognized his redemptive brilliance. "If you fire Alan, you'll have to fire me, too," says one of his (formerly hostile) coworkers.[613]

All of this is pure invention by Moore. In reality, Turing was a willing participant in the collective enterprise at Bletchley Park that featured a host of other outstanding intellects (including Denniston) with whom he happily coexisted. Ignoring this, Moore is determined to suggest maximum dramatic tension between Turing the tragic outsider and a blinkered establishment. "You will never understand the importance of what I am creating here," he has Turing wail when Denniston's minions try to destroy his machine (which is again Moore's invention). L.V. Anderson notes that:

> the central conceit of *The Imitation Game* – that Turing single-handedly invented and physically built the machine that broke the Germans' Enigma code – is simply untrue. A predecessor of the "Bombe" – the name given to the large, ticking machine that

used rotors to test different letter combinations – was invented by Polish cryptanalysts before Turing even began working as a cryptologist for the British government. Turing's great innovation was to design a new machine that broke the Enigma code faster by looking for likely letter combinations and ruling out combinations that were unlikely to yield results. Turing didn't develop the new, improved machine by dint of his own singular genius – the mathematician Gordon Welchman, who is not even mentioned in the film, collaborated with Turing on the design.[614]

Turing's "bombes" – electromechanical calculating devices designed to reconstruct the settings of the Enigma – were already being used to decipher German army and air force codes from early in the war.

Moore's account of Turing's arrest for obscenity and death also distorts the facts. In his screenplay, Turing is investigated by police on suspicion of spying for the Soviet Union, and this leads to his arrest for obscenity by police who thereby discovered his homosexual behavior. Contrary to the film's depiction, it was Turing himself who reported a petty theft to the police, and he changed the details of his story to cover up his relationship with the suspected culprit, the 19-year-old Arnold Murray. This brought his homosexual lifestyle to the attention to the police, setting off the legal proceedings against him. Turing was convicted on indecency charges in 1952, and chose a therapy involving female hormones – aimed at suppressing his unnatural desires – as an alternative to jail time.

Turing's other biographer, B. Jack Copeland, disputes the assertion in the film that the hormone treatment sent Turing into a downward spiral of depression. By the accounts of those who knew him, he endured it with fortitude, and spent the next year enthusiastically pursuing projects. Copeland cites a number of close friends (and Turing's mother) who saw no evidence that he was depressed in the days before his death, and points out that the coroner who concluded Turing had died by biting a cyanide-laced apple never actually examined the fruit. Copeland offers sound evidence that his death was accidental, the result

of accidental inhalation of cyanide fumes from a device used for electroplating spoons with gold. In statements to the coroner, friends attested to his good humor in the days before his death, and Turing left no suicide note.[615]

Even if one accepts that Turing was driven by the "homophobic establishment" to his death, *The Imitation Game*'s depiction of his fate is ridiculous. In one of the film's most egregious scenes, his wartime friend Joan pays him a visit in 1952 or so, while he is still taking his hormones. She finds him dementedly shuffling around the house in his bathrobe. He tells her that he's terrified that the authorities will take away "Christopher" – his latest computer, which he's named after the dead friend of his childhood (just as he did with his machine at Bletchley Park). Caryl notes that this scene is "monstrous hogwash, a conceit entirely cooked up by Moore," while Anderson observes that "Turing did not call any of the early computers he worked on 'Christopher' – that is a dramatic flourish invented by screenwriter Graham Moore."[616]

Clearly it is only Turing's homosexuality, and his devotion of his talents to the cause of defeating the Germans that makes his story palatable to the many Jews involved in the production of *The Imitation Game*. Lest an audience be led to assume that a White man (albeit a homosexual White man) should take all the credit for breaking the Enigma Code, one Jewish source is eager to assure its readership that the Jewish historian Martin Sugarman "has painstakingly pointed out, [that] among the 7,000-8,000 staff working at Bletchley during the war were perhaps 200-300 Jews."[617]

Moore goes even further than Sugarman and embroiders an episode from Hodges' biography to create the impression that Turing was Jewish (or at least was a victim of the "anti-Semitic" mentality of Britain in the 1920s). The scene, where a young Turing is trapped under the floorboards of a partially-built classroom by other schoolboys, is written by Moore as follows:

CUT TO:

**INT. COFFIN - A FEW MINUTES LATER**

... Alan is now inside a coffin.

He's KICKING AT THE WOODEN BOARDS ABOVE and SCREAMING TO BE RELEASED.

It's not helping.

From above, we hear the familiar LAUGHTER OF THE SCHOOL-BOYS.

REVEAL: The "coffin" is make-shift; the Boys have constructed it out of the broken floorboards of a half-finished class room. Alan is buried underground, and they're nailing him in.

ALAN TURING (Voice Over) Do you know why people like violence? Because it feels good.

The THUMP of nails entering the boards.

ALAN TURING (Voice Over) Humans find violence deeply satisfying. But remove the satisfaction, and the act becomes... Hollow.

FROM INSIDE THE COFFIN: Alan goes silent. The Boys pound away, but the silence unnerves them.

BOY #1 Alan? Alan?

BOY #2 C'mon don't be such a kike about it...

BOY #3 Leave him to bloody rot.

The Boys LEAVE.

There's still only SILENCE from inside Alan's coffin. Alan breathes slowly. Quietly. Controls his shivering to barely a tremor. He waits.

ALAN TURING (Voice Over) I didn't learn this on my own though. I had help.

Suddenly, the boards above him CREAK. Then BEND. Then SNAP.

Then an ARM REACHES DOWN and PULLS Alan out of the coffin.

REVEAL: CHRISTOPHER MORCOM, 16, tall, pretty, and charming in ways that Alan will never, ever be.

CHRISTOPHER Christ, I thought they were going to kill you.

Turing is called a "kike" by another boy – despite the fact that he was not Jewish, was never assumed to be Jewish, and that the epithet "kike"

(probably an American coinage) was not in common usage in England in the 1920s. Arguing that his screenplay is a work of art rather than a historically accurate record of events, Moore shrugged off all criticism, and claiming artistic license, insisted that:

> To criticize a film for "historical accuracy" is to fundamentally misunderstand what art is and how art works... No one looks at one of Monet's paintings of water lilies and says to themselves "Oh my God, that's not what a water lily looks like." The intention of a piece of art like that is to create in the viewer the sensation of what looking at water lilies feels like; and I think the same is true of a piece of narrative cinema. The point is to create the sensation of Alan Turing, to put the audience inside of Alan Turing's head, and for two hours let them see the world the way he did.[618]

The many historical inaccuracies of his screenplay did not prevent the 33-year-old Moore from winning an Academy Award in the Best Adapted Screenplay category. In his acceptance speech he made a plea for homosexual rights which led many to assume he was gay. He later clarified that he was not, observing that it was "the broad strokes of Turing's story [i.e., the putative victimhood] that resonated with him more than just his sexual orientation." Hollywood is so dominated by an intensively networked coterie of Jews that Moore competed for an Oscar with his Jewish ex-girlfriend Helen Estabrook – a producer for the Oscar-nominated *Whiplash* which was up against *The Imitation Game* for Best Picture.

### Jewish Involvement in Transforming Public Perceptions of Homosexuality

The recent Jewish sanctification of Alan Turing as noble gay victim and Nazi nemesis is the photographic negative of pre- and post-World War II Jewish efforts to smear Hitler and his National Socialist comrades as

"sexual perverts." For decades the supposedly sordid sex lives of Hitler and the Nazi leadership filled tomes. Allegations of homosexuality were often repeated in the Jewish-owned Munich newspapers in the years leading up to his attainment of power in 1933.

Attempts to brand Hitler and other National Socialist leaders sexual perverts have been largely abandoned since the ascendant Jewish Cultural Marxist assault on White heterosexual normativity. Two Harvard-educated (non-Jewish) homosexuals, Marshall Kirk and Hunter Madsen, authored what can only be described as an incredibly successful blueprint for marketing the radical homosexual agenda in the United States. In their book entitled *After the Ball: How America Will Conquer Its Fear & Hatred of Gays in the 90's*, they advocated the demonization of those opposed to homosexuality, painting them as evil as possible until the general public comes to view such people as moral pariahs and avoids them. The authors suggested that Christians and others opposed to homosexuality should be labelled Klansmen, Nazis, racists or unbalanced freaks.

This militant approach is now standard practice and extends to trampling on freedom of speech and religion by today's homosexual activists. With "gay marriage" legalized in most Western countries, Catholic Schools are having a difficult time teaching Catholic precepts on marriage and sexuality. In the United States, many individuals and groups are punished for what amount to thought crimes. Even non-religious dissenters to the homosexual agenda are being punished for expressing a conscientious objection to having a certain interpretation of sexuality forced on them. The Boston urologist Paul Church, who, after a distinguished career on the faculty of Harvard Medical School, was expelled from his job at the Beth Israel Deaconess Hospital in Boston for voicing his opinion that the hospital pressuring its staff to participate in Gay Pride Week activities was contrary to its mission to promote healthy behaviors and lifestyles. Using the well-established Kirk/Madsen strategy, email and blogs immediately denounced his views, although based on his medical experience, as "ignorant," "hateful," "offensive," and "bigoted."

To their credit, The American Association of Physicians and Surgeons defended Church, noting that "The penalty for making a truthful but politically incorrect statement that 'may offend' someone could be the ruin of one's medical career." The U.S. Supreme Court Justice Alito warned, in his dissenting judgement to the "gay marriage" decision, that soon those who supported natural marriage will only be able to "whisper their thoughts within the recesses of their homes."

The radical homosexual agenda could not have made such incredibly rapid strides without Jewish backing. Without this support, the agenda of a small minority whose behavior has long been frowned upon, would have gained little traction in the public sphere. Professor of Political Science at Florida University, Kenneth Wald, notes that: "The political power of the gay community does not come close to matching the impressive resource base assembled by American Jews."[619] An integral part of the "impressive resource base" of American Jewry is, of course, their domination of the media and entertainment industries. Hollywood has been integral to changing Western attitudes towards homosexuality. Then Vice President Joe Biden observed in 2013 that:

> It wasn't anything we legislatively did. It was "Will and Grace," it was the social media. Literally. That's what changed peoples' attitudes. That's why I was so certain that the vast majority of people would embrace and rapidly embrace [gay marriage]. Think behind of all that, I bet you 85 percent of those changes, whether it's in Hollywood or social media are a consequence of Jewish leaders in the industry. The influence is immense, the influence is immense.[620]

Jewish author and founding editor of *The American Interest*, Adam Garfinkle, admits that "it *is* striking, one has to admit, that the cultural influence of Jews and Jewishness is what it is, considering that fewer than 5 million American Jews are influencing more than 296 million other Americans." He notes that critiques of what American popular culture has become, including of "the increasingly salacious content of

BATTLE LINES - 263

mass media or the apparent elevation of anti-patriotic sentiment and homosexual lifestyles above more traditional values" inevitably find that "there are Jews at every turn, in marketing, in media, and, of course, in the entertainment business itself." Garfinkle observes that it "does not take a rocket scientist to connect the dots: liberals are responsible for the dangerous debauching of our society, not least through vapid entertainment-culture garbage, and a disproportionate number of liberals who are doing precisely that are Jews."[621]

With the legality of "gay marriage" secured, the next frontier in the campaign to liberate Western societies of their sexual inhibitions is "about deconstructing societal views about what it means to be a man or a woman." Among the 58 "gender identities" listed on the majority Jewish-owned and controlled Facebook are bi-gender, gender questioning, gender variant, pangender, intersex and 26 versions of trans, transgender and transsexual. Plain old male and female do not make the list. Sarah Middleton, an academic from the University of Melbourne, correctly points out that "We've seen, over the past forty or fifty years, an absolute transformation in how we think about gender and sexuality." Toby Miller, Professor of Cultural Policy Studies at Murdoch University, echoing Joe Biden, notes that Hollywood, the media and social media are driving the trend, and notes that "Reality TV has been intrinsic to normalizing some of these ideas."

Now that homosexuality is invariably portrayed by Hollywood as a behavior to an individual's credit rather than discredit, speculation about Hitler's sexuality is becoming increasingly unacceptable. One source epitomizes current thinking when it argues that: "When I read these notes about Hitler, I kept thinking over and over again, 'Why does any of this matter?' Honestly, does Hitler being gay [he wasn't] really even matter at this point? If we found out that he really enjoyed eating raspberries would that matter as well?" For this individual, the only reason the sexuality of anyone would be brought into question is "because being gay, lesbian, transsexual, transgendered, queer, or any other form of sexual 'deviance,' is controversial and often stigmatized in today's world." The new politically correct line is that:

anyone can commit horrible acts. Were Hitler's Schutzstaffel and Nazi soldiers all gay too? Were the 1500s-1800s white male slave owners, who raped and assaulted their black female slaves, gay? Were the fighters for The Crusades, who slaughtered countless people, gay? People of all backgrounds, genders, ages, and sexual orientation commit crimes against humanity. Therefore, we shouldn't assume that Hitler's sexuality played any role in his actions.[622]

Note the anti-White nature of all of the historical examples cited above. So while *anyone*, regardless of their sexuality may engage in heinous behavior, White males, it is implied, are particularly prone to committing evil acts – especially against the "oppressed" black, brown and yellow races of the earth.

The trend in recent years is to ascribe the aggressively anti-Jewish nature of German National Socialism to Hitler's neurotic denial of sexuality. As early as 1943, half-Jewish Walter C. Langer's psychoanalytical report for the American Office of Strategic Services (OSS) described Hitler as having "repressed homosexual tendencies." This line of thought can, of course, be traced back to Freud and acolytes like Wilhelm Reich. The following account from the writer Wylark Day is typical of the Freudian interpretation of German National Socialism, in claiming that:

Hitler put young Germans in sex-segregated, no nudity Youth Labor Camps; where their young sexuality was now savagely repressed. Coming from such sensual freedom [of the Weimar Republic years] to such savage repression of all sensuality, these young people quickly became *warped*. As Freud disciple Wilhelm Reich, who witnessed this before he fled Germany, said about it: "sadism originates from ungratified orgiastic yearnings." Now sexual repression has been a powerful force for redirecting people into the *violence* needed to conquer and build empires

throughout Western history (in fact it does a lot to explain how little England conquered much of the world during the ultra-repressed Victorian Age). Yet never before in history had so much repressed and redirected sexual energy been seen, as was present in Hitler's young army... So, with a truly diabolical genius, Hitler successfully repressed and channeled the normal sexual feelings of Germany's young adults, into a blinding zeal for the "father-land!"[623]

Regarding Hitler, the prolific Jewish writer on anti-Semitism, the late Robert Wistrich, similarly claimed that "A particularly striking feature of Hitler's Judeophobia was his intensely puritanical reaction against the prevailing [Weimar era] hedonism in sexual mores."[624] Psycho-therapist and writer Raymond J. Lawrence has similarly claimed that "It should strike us as no historical coincidence that Hitler personally promoted a public image of sexual abstinence. He countenanced no display of sexuality in his presence. Keeping his mistress, Eva Braun, in virtual hiding, he maintained an asexual public image, he and Eva didn't marry until just prior to their mutual suicide." Lawrence also claims that "Hitler's presumed sexual purity played well with anti-Semites... But Hitler was not the creator of such anti-Semitism; it had a long history in Christendom. The Jews have payed dearly in Christendom for their affirmation of sexual pleasure."[625]

This kind of theorizing underlies *The Imitation Game*, which is yet another manifestation of the Jewish culture of critique. In addition to providing another reminder of the "evils of Nazism," the film is a repudiation of traditional Western sexual mores and an implicit en-dorsement of "sexual liberation." There is, of course, another way of looking at Alan Turing's contribution to history. Subtract the fixation on Turing's homosexuality, and we are left with a White man whose genius changed the course of history and helped lay the foundations for the computer revolution. Turing's extraordinary intellectual gifts were, after all, the result of his European biological origins and not his sexual orientation.

# Why the Germans? Why the Jews?

The culture of the Holocaust is destroying Germany. Endlessly reinforced over decades by the intellectual and media elite, the notion that Germans and their descendants are responsible for "the single most evil event in human history" has had such a demoralizing effect that millions of Germans fully supported Angela Merkel's policy in 2015 to flood Germany with migrants and destroy the ethnic basis of their nation. The culture of the Holocaust has been used to devastating effect right throughout the West to stifle opposition to the Jewish Diaspora strategies of mass non-White immigration and multiculturalism. "The Holocaust" is the absolute lynchpin of the White displacement agenda, with any hint of European racial or ethnic identification or solidarity being instantly linked with Auschwitz and its alleged horrors in the minds of millions (probably billions) of people.

The entire social and political order of the contemporary West – based as it is on spurious notions of racial equality and the alleged virtues of racial diversity and multiculturalism – has been erected on the moral foundations of the Holocaust. White people cannot be recognized as a group with interests because "never again." Western nations have a moral obligation to accept unlimited non-White immigration from the Third World because "never again." Europe must open its borders to

hostile Islamic invaders because "never again." Whites should meekly accept their deliberate displacement (and ultimate extinction) because "never again."

Jewish historian Peter Novick notes how today's culture of "the Holocaust" emerged as part of the Jewish response to the Eichmann trial in 1961-62, the Six-Day War in the Middle East in 1967, and, in particular, the Yom Kippur War in 1973. While the foundation was laid at Nuremberg in 1946, it was with these later events, and the anxieties they engendered among Jews throughout the world, that "there emerged in American culture a distinct *thing* called 'the Holocaust' – an event in its own right," and with it a term that entered the English language as a description of all manner of horrors. From that time on, he notes, "the Holocaust" has become "ever more central in American public discourse – particularly, of course, among Jews, but also in the culture at large" and has since "attained transcendent status as the bearer of eternal truths or lessons that could be derived from contemplating it."[626]

Novick acknowledges the primary reason for this state of affairs: that Jews, with their domination of academia and the media and entertainment industries, virtually dictate this "American" (and by extension "Western" culture) which has become so Holocaust-obsessed. He argues that the importance of the Holocaust is not a spontaneous phenomenon but stems from highly focused, well-funded efforts of Jewish organizations and individual Jews with access to the major media:

> We are not just "the people of the book," but the people of the Hollywood film and the television miniseries, of the magazine article and the newspaper column, of the comic book and the academic symposium. When a high level of concern with the Holocaust became widespread in American Jewry, it was, given the important role that Jews play in American media and opinion-making elites, not only natural, but virtually inevitable that it would spread throughout the culture at large.[627]

The Jewish Hollywood director Jill Soloway observed that Jews in Hollywood are "recreating culture to defend ourselves post-Holocaust."[628] This ethnic "defense" has entailed the intensive promotion of racial diversity and mixing, the denigration of White people and their traditional culture, the hypersexualization of what now passes for Western culture, the glamorizing of sexual non-conformity and the breakdown of traditional gender roles – all alongside constant reminders of "the Holocaust" with its concomitant themes of Jewish victimhood and unsurpassed German (White, European) evil.

Since 1945, some 150 feature films have been made about "the Holocaust" – the majority after 1970. The Jewish intellectual Chaim Bermant observed that "the Jews that came to dominate Hollywood" between them "did more to determine American attitudes and tastes than the churches or even the schools."[629] The psychological effects of Hollywood's Holocaust obsession were clear by the 1990s when one survey found that 97 percent of Americans knew what "the Holocaust" was – substantially more than knew what "Pearl Harbor" related to, or that the United States has dropped two atomic bombs on Japan, and far more than the 49 percent that knew that the Soviet Union had fought on the American side in World War Two.[630]

Throughout the West, proliferating "Holocaust" memorials and museums are lavishly funded by taxpayers, and study of "the Holocaust" in schools is mandated by law in many jurisdictions. As well as serving to morally disarm Whites concerned about their own immigrant-led displacement, the culture of "the Holocaust" is a key part of Jewish efforts to prevent intermarriage in the Diaspora. Eric Goldstein, for instance, notes how "Jews discuss, read about, and memorialize the Holocaust with zeal as a means of keeping their sense of difference from non-Jews alive."[631]

"The Holocaust" has become, in the words of Nicholas Kollerstrom, "an ersatz substitute for genuine metaphysical knowledge," with Auschwitz now serving as the spiritual center of a new religion and a place of awed pilgrimage for millions of penitent Europeans. The narrative has also unleashed an endless flow of money from Germany to

Israel and to compensate more "survivors" than there were ever Jews in countries under German control.[632]

Without the "Holocaust" narrative, and the veneer of moral rectitude it confers upon Jewish activism, it is doubtful the 1965 immigration laws in the United States would have passed. Likewise, the toppling of the White Australia policy just eight years later – a direct result of Jewish ethno-politics – would probably not have occurred without the moral leverage "the Holocaust" afforded Jewish activists and their non-Jewish collaborators. The left-wing Australian historian Henry Reynolds has acknowledged the Jewish ethno-political (and Holocaust-centered) origins of the regnant belief in biological racial equality when he noted that: "My students often ask me how it was that people in the past held such objectionable views [about race]. They have no understanding of just how pervasive racial thought was a generation or two ago, how the Second World War and the Holocaust marked an intellectual watershed after which nothing would be the same again."[633]

### Boasian Anthropology and "the Holocaust"

While the Jewish critique of racialist thought, spearheaded by Franz Boas, preceded World War II by several decades, it gained urgency following Hitler's assumption of power in 1933. In his book *Racism*, posthumously published in 1938, the Jewish "sexologist" Magnus Hirschfeld set out to provide a refutation of the racial doctrines of the National Socialists. "If it were practicable," he wrote, "we should certainly do well to eradicate the term 'race' as far as subdivisions of the human species are concerned."[634] During the war the writings of Boas, his students Ruth Benedict, Melville Herskovits and others critical of the link between race, culture and ability began to reach a mass audience. Benedict's *Races and Racism*, published in 1942, dismissed racial thought as "a travesty of scientific knowledge."[635] In the same year, the Jewish intellectual Ashley Montagu (born Israel Ehrenberg) published *Man's Most Dangerous Myth: The Fallacy of Race* which became a best seller.

These Jewish ethnic activists and their allies, with their pseudo-scientific theories, were only able to reach a mass audience through Jewish influence in the press and publishing houses – not because of the intrinsic merits of their arguments. As a result of these efforts, the British historian David Cannadine has noted that: "By the end of the Second World War, the notion that race was the most significant form of collective human identity, consciousness, and ranking had been stripped of any serious claim to intellectual respectability."[636]

In 1949 the United Nations Educational, Scientific and Cultural Organization (UNESCO) convened a panel of "scientists," chaired by Montagu, to "produce a definitive verdict on race." This panel was comprised of "a team of ten scientists all of whom were recruited from the marginal group of anthropologists, sociologists and ethnographers who perceived the race concept primarily as a social construct." Most of these had, at some point, been "affiliated with the scientifically margin-alized groups of cultural anthropologists that were mostly students of Franz Boas at Colombia University in New York."[637]

After the panel's first meeting at the UNESCO headquarters in Paris, Montagu wrote a proposal for a final statement on race during one night at a nearby hotel, and over the following days the participants discussed "the race concept" in light of Montagu's draft.[638] Montagu claimed that "only if our deliberations had taken place at Auschwitz or Dachau could there have been a more fitting environment to im-press upon the committee members the immense significance of their work."[639] At that time UNESCO House was the former headquar-ters of the German military during its occupation of France during World War II. Underpinning the words of the UNESCO declaration "was widespread revulsion at the Jewish Holocaust."[640] The academic Anthony Hazard notes that "a clear rejection of anti-Semitism seemed to underline the entire effort."[641]

The Montagu-led UNESCO panel's statement (replete with false-hoods and specious arguments) was issued in 1950. "Scientists," it claimed, "have reached general agreement in recognizing that mankind is one: that all men belong to the same species, *Homo sapiens*." Genes

responsible for the "hereditary differences between men" were "always few when compared to the whole genetic constitution of man and the vast number of genes common to all human beings regardless of the populations to which they belong." It therefore followed that "the likenesses among men are far greater than their differences."[642] The error here is assuming that small differences in the input to a system must yield small differences in the system's output. On the contrary, it is often the case that small differences in the input result in large differences in the final outcome. For instance, it has often been pointed out that human beings and chimpanzees differ in less than two percent of their DNA; nevertheless, the difference in intelligence between the species is enormous. Many genetic diseases are caused by a single gene, and some of these are deadly.

The UNESCO panel's statement proposed that it would be best "to drop the term 'race' altogether," since "for all practical purposes, 'race' is not so much a biological phenomenon as a social myth." Montagu and his colleagues ended their "definitive statement on race" with a ringing endorsement of the idea of a common humanity: "Biological studies lend support to the ethic of universal brotherhood; for man is born with drives towards co-operation. ... In this sense, every man is his brother's keeper."[643] Here we find the invariable Jewish tendency to couch the pursuit of specific Jewish interests in a pretended universal benevolence.

UNESCO's Montagu-drafted "definitive verdict on race," was published with a press release with the headline: "No biological justification for race discrimination, say world scientists: Most authoritative statement on the subject."[644] *The New York Times* reported on the statement with a story under a headline proclaiming: "No Scientific Basis for Race Bias Found by World Panel of Experts."[645] The UNESCO Statement on Race amounted to the foisting of a Jewish ethno-political agenda onto the global polity – with devastating consequences for the interests of White people.

With this new agenda now in place at the highest level, and with the demonization and marginalization of dissenters, it was almost inevitable

in the decades following the defeat of Germany that the remaining policies constructed on the basis of racialist thought and identity would be dismantled. The 1950 statement on race (which contributed to the 1954 U.S. Supreme Court desegregation decision in *Brown v. Board of Education in Topeka*) was described by one sympathetic commentator as "the triumph of Boasian anthropology on a world-historical scale."[646]

Cannadine notes that, during the decades that followed, the United States, Canada, Australia, and New Zealand "abandoned their policies of racial discrimination, ended their restrictions on immigration... and embraced multiculturalism." This misleadingly implies that these changes occurred as a result of a shift in popular sentiment, of people suddenly coming to their senses and "embracing" racial diversity. The reality in the U.S., and, as I explicated in my series of essays on Australia, was that the shift toward the liberalization of immigration policies was a top-down, totally undemocratic movement pursued for Jewish ends.[647]

### Götz Aly: Reinforcing the Culture of "the Holocaust" in Germany

F. Roger Devlin has observed that "all of us in the West are supposed to be responsible for the ills of the rest of the world, but only Germans have had their identity entirely constructed on guilt for 70 years." One of those who has worked hard to reinforce the culture of "the Holocaust" in Germany and to entrench the climate of opinion that is leading the German people to destruction, is the University of Frankfurt historian Götz Aly who has written a series of books on German anti-Semitism, the Third Reich and "the Holocaust." Professor Aly, who was involved with militant far-left organizations in the sixties and seventies, is the descendent of a Turkish soldier who converted to Christianity in the seventeenth century. Despite his partial Turkish ancestry, Aly identifies as an ethnic German. He is, nevertheless, acutely critical of the German people and their history. Aly's book *Why the Germans? Why the Jews? Envy, Race Hatred, and the Prehistory of the Holocaust* is his attempt to explain "why German history culminated in genocide."[648]

Unlike the bulk of establishment historians, Aly is at least willing to accept that the origins of post-Enlightenment German anti-Semitism can be traced to conflicts of interest between Jews and non-Jews – or rather, in his view, to the envy of average Germans at the rapid social and economic advancement of Jews in the nineteenth and early twentieth centuries. He regards attempts to account for the rise of National Socialism solely on the basis of political ideology as unsatisfactory, observing that "conservatives weren't the only ones guided by hostility toward and even hatred of Jews. Reformers and pioneers of political liberty often were as well. We must look for explanations elsewhere."[649]

Despite these small concessions to reality, Aly remains firmly within the camp of intellectual apologists for Jews in proposing that anti-Semitism is a phenomenon that *always* has its wellspring in the psychopathology or delusions of non-Jews – in this case in the pathological jealousy of Germans. His exoneration of Jews from any role whatever in contributing to manifestations of anti-Semitism is hardly surprising given that Aly's book has the imprimatur of the leading Jewish representatives of the Holocaust industry. The author, who is a past winner of a Jewish Book Award, notes, for example, how his research was "made a lot easier and a lot more pleasant by my helpful and welcoming colleagues at Yad Vashem," and that his work was underwritten by the Baron Friedrich Carl von Oppenheim Stipend for Research on Racism, Anti-Semitism, and the Holocaust.

From the standpoint of an unquestioning acceptance of the canonical Hollywood version of "the Holocaust," Aly asserts that: "What remains contentious are questions of its ultimate meaning and deeper causes," and argues that "the answers will, no doubt, continue to be fragmentary. Nonetheless, historians have a duty to seek them."[650] So historians have a moral and intellectual duty to search for the ultimate meaning of "the Holocaust" (provided of course this fully exonerates Jews) but *not* a duty to determine the facts regarding the alleged event itself. So much for the once revered academic tradition of fearlessly seeking out the truth.

## Götz Aly's Envy Theory of German Anti-Semitism

As mentioned, the central thesis of *Why the Germans? Why the Jews?* is that German hostility toward Jews in the nineteenth and early twentieth centuries was overwhelmingly motivated by German envy at the rapid social and economic advancement of Jews. Aly builds upon the thesis of his previous book, *Hitler's Beneficiaries*, where he insisted that the popularity of the National Socialists can be ascribed to the fact that Germans benefited materially from the expropriation of the Jews.

Aly points out that the same argument was originally put forward by the Jewish intellectual Siegfried Lichtenstaedter, who, in attempting to account for the rise of National Socialism and its anti-Jewish policies in Germany, proposed in 1937 that the NSDAP "was a party of social climbers." Jews were hated because they were competition for "survival, honor, and prestige." Anti-Semitism in Germany owed its aggressive force, he claimed, to envy and the desire for social betterment. If Jews as a group were perceived as being "disproportionately happier" than other groups, Lichtenstaedter wrote, "why shouldn't this give rise to jealousy and resentment, worries and concerns about one's future, just as is all too often the case between individuals."[651]

This same essential argument was also advanced by the pioneering Zionist leader Theodore Herzl. Kevin MacDonald notes in *Separation and its Discontents* that Herzl argued that "a prime source of modern anti-Semitism was that emancipation had brought Jews into direct economic competition with the gentile middle classes. Anti-Semitism based on resource competition was rational." Herzl "insisted that one could not expect a majority to 'let itself be subjugated' by formerly scorned outsiders that they had just released from the ghetto."[652]

What made Germany's Jews so enviable, Aly argues, was how they took advantage of the new economic opportunities that arose in the course of the nineteenth century as the old feudal order gave way to the modern world. Nevertheless, in order to avoid the unpalatable conclusion that the German anti-Semitism at this time was rational, Aly argues that the underlying cause of this "envy-fueled" hostility toward Jews resided exclusively in the psychological inadequacies and malformations

of the Germans themselves. Thus, for him, it was German mental deficiencies, rather than any Jewish behavior, that propelled the German nation down a path that would supposedly culminate in "the Holocaust."

German feelings of inferiority, political immaturity and national anxiety, combined with the resentment over the Treaty of Versailles, made them, in Aly's view, receptive to the siren song of Hitler's National Socialist Party, which emphasized entitlements for ethnic Germans at the expense of the Jewish interlopers. Aly asserts that even if many Germans did not initially agree with the National Socialists' anti-Jewish views, they were reassured by Hitler's visions of economic progress, self-sufficiency, and upward social mobility and signed up for a "criminal collaboration" between the people and their political leadership.

Aly's envy theory of German anti-Semitism is ultimately grounded in a belief in Jewish intellectual superiority and German inferiority, which, ironically enough, was a view held by many nineteenth-century German "anti-Semites." For instance Wilhelm Marr (the man who coined the term "anti-Semitism") conceptualized Jews as "not a small, weak group, they are a world power! They are much stronger than the Germans."[653] Foreign observers like the British historian John Foster Fraser similarly proposed in 1915 that German academics were falling over themselves to keep the Jews out because the competition "between the sons of the North with their blonde hair and sluggish intellect and the sons of the Orient with their black eyes and alert minds" was so unequal.[654]

A constant refrain throughout Aly's book is that dim-witted Germans simply lacked the intellectual firepower to compete effectively with Jews in the nineteenth and early twentieth centuries. He claims, for instance, that: "Untalented Christian students, non-innovative entrepreneurs, and businessmen who got their numbers mixed up" simply couldn't compete with "intellectually superior" Jews.[655] Elsewhere in his book he asserts that

> relative to their Christian peers, they [Jews] overcame the initial
> obstacles to social betterment with ease, even though legally they

became fully equal everywhere in Germany only in 1918. Conversely, Christian social climbers were in an inferior position vis-à-vis Jews, who were objectively disadvantaged but subjectively better equipped to deal with new social demands. As Gentile Germans began to call for state protection from economically and intellectually superior Jews, laws were passed and administrative procedures were found to secure the privileges of the Christians. But such protectionism only highlighted how slow and incompetent many Gentiles were. Public failure was embarrassing, and people who were fearful, who had emerged as the losers of social change, and who were plagued by feelings of inferiority became modern anti-Semites.[656]

An analogous view to this was advanced by the early twentieth-century Jewish neurologist Abraham Meyerson who posited that it was this supposed Jewish intellectual superiority, rather than their ingroup-oriented morality and behavior, which was the main cause of European anti-Semitism, insisting that "with the downfall of the Roman Empire the Jews and Arabs alone kept the torch of culture and science lit. In other words, the Jew was easily superior in these matters [science and culture] to his uncouth warrior-like hosts. This superiority brought about a jealousy, fear of the ability of the Jew; a fear that has never been stilled, though the culture of the Western races has reached a very high plane; a fear that yet actuates most of the hostile feelings of neighboring races."[657]

Paradoxically, elsewhere in his book, Aly admits that these "untalented," "non-innovative" and "incompetent" Germans "achieved remarkable intellectual and (somewhat later) economic and technological breakthroughs in the nineteenth century."[658] Peter Watson, the British intellectual historian and author of the monumental book *The German Genius*, has pointed out that Germany in the nineteenth century was "the first modern educated country," and the one that invented the institutionalization of scientific and technological research – something which was pivotal in shaping modern industrial civilization. Observing

how the oft-repeated claims of Jewish intellectual superiority in Germany in the nineteenth century are "overdone," he maintains that, with regard to developments in music, philosophy, poetry, and science in Germany in the first two-thirds of the nineteenth century, "Jews played a very small part" (and, one might add despite Aly's statement above, a non-existent role in the Middle Ages when Jewish communities were completely isolated from surrounding cultures and absorbed in religious writings).[659]

In addition to their alleged intellectual deficiencies, the sources of the pathological envy of Germans in the nineteenth and early twentieth centuries allegedly resided in their "weakness, timidity, lack of self-confidence, self-perceived inferiority, and excessive ambition." Aly offers no real evidence that these were typical German traits during this time, but ascribes them to the "innate insecurity of German national identity" which resulted from the comparatively late development of the German nation compared with other European states.

It is true that, for various historical reasons, the Germans had a difficult time coalescing into a nation. Most histories of Germany begin by recounting the exploits of the Germanic peoples in Italy, France and Spain rather than just telling the story of the Germans in Germany. The geographically fragmented origins of the German people are reflected in the various names others have given them – they were "Saxons" to the Finns, "Niemcy" or "Swabians" to the Russians and Poles, "Germans" to the British, "Allemands" to the French, "Tedeschi" to the Italians, with the Germans themselves adopting the last root for their "Deutsche."[660] Aly accurately notes that:

> In 1806, Germans were less a people than a collection of peoples, cleft by the existence of numerous small states, each with its own history. Germans lived between the Curonian Lagoon, on the eastern Baltic Sea, and the Vosges Mountains in Alsace, between the Belt and Scheldt Rivers in Southern Tyrol, and a long way up the Danube River into Eastern Europe. They formed the largest cultural, linguistic, and ethnic group in Europe. Located exactly

in the middle of the continent, German territory was the scene of various migrations, wars and religious conflicts.[661]

The political unification of the German lands was delayed for many decades by the Thirty Years' War which devastated the infrastructure and decimated the population of the states that would eventually comprise the German Empire. In addition to the harrowing experience of the Thirty Years' War, Germany also suffered greatly a century and a half later due to the wars between revolutionary France and other European powers. Napoleon played off regional and dynastic interests against each other and demanded massive war contributions from them – both in men and material. The new social order Napoleon instituted in many German states contributed to new divisions. Aly notes that: "For the vast majority of Germans, the French occupation was a time of executions and murders, inflation, and lasting economic deprivation. More than a few communities were still paying off debt accumulated during that period in the late nineteenth century; some wouldn't succeed in clearing the books until the rampant inflation of 1923."[662]

An additional barrier to German unity was the sectarian divide between the Catholic south and the Protestant north. If that weren't enough, there were also linguistic barriers: as late as the early nineteenth century it was still unclear whether the Upper Saxon dialect of today's eastern Germany or the lower Saxon one of the central regions would serve as a basis for High German. And it wasn't until 1934 that the interior minister Wilhelm Frick succeeded in establishing "German" as a designation of nationality on passports, and not until 1938 – when Hitler presided over the unification of Germany and Austria into the greater German Empire – that the dream of a unified German state was finally (and briefly) realized.

In contrast to the painfully slow evolution of German national unity and identity, Aly claims that "Jews in fact possessed the sort of deep, meaningful roots that patriotic Germans were forever frantically digging for."[663] He approvingly quotes the Zionist writer Heinrich York-Steiner who, in accounting for the rising popularity of the National Socialists

in 1932, claimed that "From the era of the Hohenstaufens on down to today, Germany's political and social position has been uncertain, unstable and erratic... This position in world history accounts for Germans' ambivalence towards foreigners. What they lack is the strength that comes from constant development, from a nationally evolving self-confidence. The German today is a helot, tomorrow a conqueror, and he acts out his feelings in displays of ethnic hyperbole."[664] Endorsing this view, Aly claims that Germany's unique history engendered weakness and self-doubt as well as pent-up aggression and xenophobia.

While "Prussian militarism" was a real phenomenon, Aly's characterization of the Germans of the nineteenth and early twentieth centuries as "immature, aggressive bullies" only became the stereotypical view in the Anglosphere during World War I. Prior to that, Germans were more noted for their *Innerlichkeit* or inwardness. The influential French writer and salon leader, Madame de Stael, portrayed the Germans during the period of the Napoleonic Wars as a nation of "poets and thinkers, a race of kindly, impractical, other-worldly dreamers without national prejudices and disinclined to war." The English historian, Frederic William Maitland, regarding the Germans of the nineteenth century, similarly noted that "It was usual and plausible to paint the German as an unpractical, dreamy, sentimental being, looking out with mild blue eyes into a cloud of music and metaphysics and tobacco smoke."[665] Americans likewise held a benign view of Germans prior to the twentieth century, with one American historian noting that "whether seen in their newly minted nation [after 1871] or in this country [i.e., German immigrants to the United States], the Germans were generally regarded as methodical and energetic people who were models of progress, while in their devotion to music, education, science, and technology they aroused the admiration of Americans."[666]

Aly ignores all of the laudatory descriptions of the German character prior to World War I which directly contradict his preferred unflattering characterizations. He claims that, compared to the Germans, the English and the French "followed a very different trajectory" and that this explains why anti-Semitism was less prevalent and intense in these

nations. He conveniently omits any mention of how Jews were expelled from England and France (in the latter case on numerous occasions) during the Middle Ages, despite the English and French supposedly having enjoyed more secure national identities. Furthermore, a strong case can be made that, prior to World War I, the French evinced far greater hostility toward Jews than did the Germans. In France the Dreyfus affair sparked anti-Jewish riots in more than thirty towns. Nor does Aly mention that Jewish historians typically have little positive to say about English or French attitudes toward Jews.

The reason hostility to Jews eventually reached greater intensity in Germany compared to England and France was likely due to the relative size of the Jewish populations in these nations. Kevin MacDonald notes in *Separation and its Discontents* that Jews only represented a tiny percentage of the population of England in the nineteenth century – only 0.01 percent. They also played a remarkably small role in the economic development of that nation – the notable exceptions being their domination of the diamond and coral trades. He notes that: "Throughout this period England remained an ethnically homogeneous society, without ethnically-based resource conflict. However, there was anti-Semitism, directed both at the "cousinhood" of wealthy Jewish families and, later in the century, Orthodox immigrants from Eastern Europe."[667]

Pre-World War II England is held in the historical memory of Jews as a society convulsed with anti-Semitism. The Jewish historian Norman Cantor, for instance, proposed that "the thick anti-Semitism of the time, spreading slowly upwards from the Gentile lower classes, who competed with immigrant Jews, to the ruling classes, was pervasive and bitter. There were severe limitations on the entry of Jews to the better private schools, to Oxford and Cambridge colleges, and to the learned professions. The Jews were made to feel alien and unwanted."[668] He also claims that the British government "was deeply concerned that Christian young men conscripted to fight in the war were not perceived as being sacrificed for the Jews. In addition to this general caution,

high officials in the foreign and defense ministries were personally and openly anti-Semitic."[669]

While Winston Churchill "was a highly intelligent man and something of a personal philo-Semite," in the end he did "not raise a finger for the Holocaust-threatened Jews" because "he was hypersensitive to the depth of anti-Semitism in his society and haunted by a fear that special efforts to save the Jews would raise cries of 'it is a Jew's war' and 'British Christian boys are dying to save the rotten Jews.' He backed off completely." Jews in Britain "that could have intervened to help Eastern European Jewry were inhibited and distracted by the wall of hate in their own ambience."[670] England is a land of painful historical memories for Jews like *Guardian* columnist Jonathan Freedland who claims that the map of England is "pockmarked with the sites of medieval Jewish torment: Lincoln, Norwich, York."[671]

Ignoring all this, Aly claims that Germans were, among European nationalities, uniquely hostile toward Jews and that their particular brand of anti-Semitism was a byproduct of their "innate insecurity of national identity."[672] They allegedly compensated for this insecurity through immoderate displays of national and ethnic pride. He asserts that at public celebrations on Hitler's birthday in 1933, "Germans were delighted to hear themselves described as the 'premier people on earth,'" and opines that: "A nation that feels the need to boast like this lacks inner equilibrium."[673] The author apparently feels no need to judge Jews by the same standard, or to point out that the Jewish scriptures amount to one long hyperbolic (and often genocidal) assertion of Jewish superiority.

Paradoxically, Aly elsewhere notes that these "innately insecure" Germans were regarded by Jews in the early nineteenth century as far more benign than the natives of various Eastern European countries with supposedly more established and secure national identities. He makes the point that

in the nineteenth century, Jews who migrated to Germany from neighboring countries in Eastern Europe felt great relief when

they crossed the border. They appreciated the legal protections, economic freedom, and educational opportunities offered first by Prussia and later by the German Empire. Anti-Jewish pogroms, which continued well into the twentieth century in Eastern and Southeastern Europe, had died out in Germany, while the absence of governmental restrictions helped make the country a magnet for Jewish migration. By 1910, Germany had twice as many Jews as England and five times as many as France.[674]

So what changed to prompt an upsurge in German hostility toward Jews throughout the nineteenth and into the early twentieth century? After Napoleon emancipated Jews from most legal restrictions in the western German territories in 1806 and they entered mainstream German society, Germans were confronted for the first time with the full social and economic effects of unfettered *Semitism*. In 1806, the Jews in Prussia had owned almost nothing. By 1834, 13 percent of them were part of the nascent upper middle class, while more than 50 percent were firmly middle class.[675] This, not surprisingly, triggered a reaction among large sections of the native population. Aly argues that:

> This reversal was motivated by the fact that Gentile Germans were compelled to face what we might call, somewhat polemically, Jewish challenges. Bit by bit over the course of the 1800s, artisans, court-appointed merchants, owners of medium-sized farms, pastors, civil servants, and other respected figures had lost influence. The remaining trade guilds devolved into selfish monopolies that put the brakes on economic development; Berlin artisans, for instance, sought to use legal trickery to preserve their traditional privileges. Despite their efforts, the old social center was gradually replaced by a new middle class of lawyers, doctors, managers, publishers, brewers, stock brokers, theater directors, and department store owners. Their ranks contained a disproportionate number of Jews.[676]

Prior to 1806, Germans and Jews had limited contact in society. This situation gradually changed throughout the nineteenth century as the urban Jewish population surged. Between 1811 and 1875, Berlin's Jewish population increased by a factor of fourteen. It wasn't, however, simply a question of the burgeoning numbers and rapid Jewish economic advancement, it was also the "social strife" that accompanied the Jewish penetration and eventual domination of mainstream German society, and which prompted "constant discussion of the *Judenfrage.*" Aly notes that, post emancipation, "Jews were regarded less as adherents of an alien, barbaric faith and more as members of a secular socioeconomic group that disproportionately profited from modern life."[677] The realization quickly dawned on average Germans that Jews were not just a religious community but an endogamous ethnic group which had adopted a highly successful group survival strategy.

This realization intensified over decades, especially following the advent and diffusion of evolutionary thought in Germany after the publication of Darwin's *Origin of Species* in 1859 (the German translation of which appeared in 1860). Alfred Kelly has documented how Darwinism was a huge sensation in Germany, noting how "Darwinism became a kind of popular philosophy in Germany more than any other country, even England. Darwinism caught on rapidly in the German scientific community; indeed, Germany, rather than England, was the main center for biological research in the nineteenth century. ... It also offered the richest environment for Darwinism to expand beyond the confines of science." Darwin himself commented that "The support I receive from Germany is my chief ground for hoping that our views will ultimately prevail."[678]

Kevin MacDonald has noted that in Germany in the nineteenth century there were several "detailed proposals for gentile group strategies in opposition to Judaism."[679] One nineteenth-century German publication characterized Judaism as "a political, social and business alliance for the purpose of exploiting and subjugating the non-Jewish peoples."[680] After citing statistics on the percentages of Jews among employers, and among students in institutions of higher education, the

German nationalist Adolf Stoecker claimed "should Israel grow further in this direction, it will completely overcome us. One should not doubt it; on this ground, race stands against race and carries on – not in the sense of hatred but in the sense of competition – a racial struggle."[681]

This line of thinking eventually attained its clearest and strongest expression in the ideology of National Socialism. In his unpublished sequel to *Mein Kampf*, Hitler outlined his conception of Judaism as a group evolutionary strategy, noting that:

> The Jews, although they are a people whose core is not entirely uniform in terms of race, are nevertheless a people with certain essential particularities that distinguish it from other peoples living on the earth. Judaism is not a religious community; rather, the religious ties between the Jews are in reality the current national constitution of the Jewish people. The Jew has never had his own territorially defined state like the Aryan states. Nonetheless, his religious community is a real state because it ensures the preservation, propagation, and future of the Jewish people. ...
>
> Just as every people possesses, as the basic tendency of all its earthly actions the obsession with preserving itself as its driving force, the same is true of the Jews. But here the struggle for survival takes various forms, corresponding to the entirely different natures of the Aryan peoples and the Jews. ... The existence of the Jew himself thus becomes a parasitic existence within the life of other peoples. The ultimate goal of the Jewish struggle for survival is the enslavement of productively active peoples. To reach this goal – which, in reality, the Jews' struggle for survival has represented throughout the ages – the Jew uses every weapon that is in accordance with the entirety of his character.[682]

MacDonald notes in *Separation and its Discontents* that National Socialism was a German group evolutionary strategy that, in several key features, mirrored Judaism. Germany after 1933 saw the conflict of

these two opposing group strategies.[683] Aly repudiates the arguments of the German geneticist Fritz Lenz which directly mirror the moral precepts of Judaism directed at preserving the race. Lenz had observed that "in the long run, the only forms of life that can survive are those whose race can also be preserved," and the ethical imperative was therefore to ask of every action or non-action: "Is it good for our race?"[684] The Romanian revolutionary Nicolae Balcescu had similarly argued in the mid-nineteenth century that: "For me, the question of ethnic solidarity is more important than the question of freedom. A people can use freedom only when it's able to survive as a nation. Freedom can be easily regained, if it is lost, but not ethnic identity."[685] According to Aly, such thinking by non-Jews is "based on massive feelings of inferiority and envy."[686]

### Selectively Applying his Pathological Envy Thesis

While asserting that German hostility toward Jews has its origins in pathological "envy," Aly, as a fervent leftist, would never extrapolate this line of reasoning to account for the hostility of non-White groups toward Whites. Aly can safely posit that "intellectually inferior" Germans who "lacked confidence in their identity" had an envy-driven hatred for "intellectually superior" and upwardly mobile Jews, yet would never assert that intellectually inferior Blacks have an envy-driven hatred for intellectually superior and upwardly mobile Whites. Instead he would doubtless affirm the bogus narrative that Black hostility to Whites is a legitimate response to an insidious and all-pervasive White "racism" that has impeded their social and economic advancement. This, of course, is despite the fact this supposedly ubiquitous, systemic and malign force has completely failed to hinder the social and economic advancement of East Asians and Indians in Western societies.

Nor would Aly extrapolate his pathological envy thesis of intergroup hostility to explain the vastly disproportionate Jewish participation in the Bolshevik Revolution and the other oppressive communist regimes of Eastern Europe. This despite that fact that, in response to legal

restrictions in tsarist Russia that limited their economic and educational opportunities, millions of Jews gravitated to Zionism and Communism. Indeed a big weakness of *Why the Germans? Why the Jews?* is Aly's total neglect of the Jewish-Communist symbiosis and how this contributed (independently of envy at Jewish social advancement) to rising support for the NSDAP and other anti-Semitic political parties in Germany. It is common knowledge that when, after the chaos of World War I, revolutions erupted all over Europe, Jews were everywhere at the helm. One of Hitler's oft-repeated themes in the 1920s was the deadly threat that a "bloody Bolshevization" posed to Germany. In 1928, Hitler wrote:

> The goal is the destruction of the inherently anti-Semitic Russia as well as the destruction of the German Reich, whose administration and army still provide resistance to the Jews. A further goal is the overthrow of those dynasties that have not yet been made subordinate to a Jewish-dependent and led democracy. This goal in the Jewish struggle has at least to some degree been completely achieved. Tsarism and Kaiserism in Germany have been eliminated.

> With the help of the Bolshevik Revolution, the Russian upper class and also the national intelligentsia were – with inhuman torture and barbarity – murdered and completely eradicated. The victims of this Jewish fight for dominance in Russia totaled twenty-eight to thirty million dead among the Russian people. Fifteen times as many as the Great War cost Germany. After the successful Revolution he tore away all the ties of orderliness, morality, custom, and so on, abolished marriage as a higher institution, and proclaimed in its place universal licentiousness with the goal that through this disorderly bastardy, to breed a generally inferior human mush which itself is incapable of leadership and ultimately will no longer be able to do without the Jews as its only intellectual element.[687]

288 - BRENTON SANDERSON

Another National Socialist source noted that: "Only those who have experienced that period of Jewish terror and slaughter, the murder of hostages, plundering and acts of arson [in the Munich communist uprisings of 1918-1919], are able to realize why Munich became the birthplace of National Socialism, whence the movement spread to other parts of Germany, and finally put an end to Jewish domination."[688] Despite the centrality of the threat of "Jewish-Bolshevism" as part of the National Socialist platform, Aly completely ignores the whole topic because it doesn't fit into his "pathological envy" theory of German anti-Semitism. In a work of some 304 pages purporting to analyze the origins Hitler's popularity, the word "communism" rates a mere three mentions.

### No Mention of Jewish Ethnic Networking

In addition to his lack of consideration of how the very real fear of communism contributed to support for the National Socialists, another weakness of *Why the Germans? Why the Jews?* is the lack of any discussion of the role of Jewish ethnic networking in the rapid social and economic advancement of Jews at the time. Jewish historian Jerry Muller acknowledged in his book *Capitalism and the Jews* how Jewish ethnic networking has contributed to Jewish upward social mobility, observing that "the obligation to look after fellow Jews was deeply embedded in Jewish law and culture, and it existed not just in theory but in practice."[689] A recurrent theme in Germany throughout the nineteenth century was how, if unchecked by the state, Jewish ethnic networking invariably led to their monopolization of entire industries and professions, and how this harmed German interests.

In 1819, for instance, the German writer Hartwig von Hundt-Radowsky noted that the anti-Jewish "Hep" riots that year in southern Germany were precipitated by "the rights granted to Israelites in many states" which led "to the poverty and malnourishment that prevails in many regions since the Jews choke off all the trade and industry of the Christian populace." He noted that the success that Jews recorded "in

all profitable businesses ever since several states, guided by a misunderstood humanism, accorded them the freedom to choose their own trades, which is also a license to plunge Christians into misery."[690]

Around the same time the German academic Jakob Friedrich Fries likewise warned of the dangers that Jewish ethnic networking and nepotism presented for the native population, pointing out that "the Christian merchant, who stands alone, has no hope of competing." Citing the example of Jews in the city of Frankfurt, who had been released from the ghetto in 1796 and had risen rapidly up in society, he warned: "Allow them to continue for a mere forty years or more, and the sons of the best Christian houses will have to hire on as their manservants."[691]

The economist Friedrich List argued in 1820 that the state had the right and duty to protect the native German majority from Jewish economic domination and exploitation.[692] Legal restrictions on Jews were lifted in the Grand Duchy of Posen in 1833, a region with a significant Jewish population. Soon thereafter a citizens' committee on Jewish affairs noted that following the easing of restrictions it had not taken long for Jews "to take over high roads and market squares and dominate commerce and industry." If they were given full citizenship rights, the committee argued, "almost all the towns and villages in the Grand Duchy would come under the exclusive administration of Jews."[693]

In the Kingdom of Saxony, the populace pressured the royal family to maintain anti-Jewish restrictions on certain types of economic activity. Dresden allowed "at most" four Jewish merchants, lest commercial streets "swarm with Jewish salesmen and trade fall into Jewish hands." Local civic leaders warned that any easing of restrictions would result in "Jews inundating the entire country so that soon farmers wouldn't be able to sell a single calf without Jewish involvement."[694]

Kevin MacDonald observes in *A People That Shall Dwell Alone* that from "the standpoint of the group, it was always more important to maximize the resource flow from the gentile community to the Jewish community, rather than to allow individual Jews to maximize their interests at the expense of the Jewish community."[695] He notes the propensity of Jews to engage in "tribal economics" involving high

levels of within-group economic cooperation and patronage, which conferred on Jews "an extraordinarily powerful competitive advantage against individual strategies."[696] The power of this collectivist strategy was evident by 1914 when Jews earned on average five times the income of Germans.[697]

In 1924, the German economist Gustav Schmoller argued in favor of only admitting small numbers of Jews to the higher ranks of the military or civil service. Otherwise, he feared, "they would swiftly develop into an intolerant dictator of the state and its administration. ... How many cases have proved the truth of the prophecy that once you admit the first Jewish full professor, you'll have five of them or more in ten years' time?"[698] In the same year, a delegate to the Bavarian parliament, Ottmar Rutz, noting this tendency and how it had resulted in the Jewish domination of the faculties of Bavarian universities, pointed out that "every Jewish professor and every Jewish civil servant keeps down a descendant of the German people. This sort of exclusion is what's really at stake. It's not a matter of insulting or attacking one or another descendant of the Jewish people. This has nothing to do with all of that, and nor do my petitions. This is solely about productively promoting the descendants of the German people and protecting them from exclusion."[699]

Jewish overrepresentation among the learned professions was then, and is now, of such a magnitude that it cannot be accounted for solely on the basis of higher IQ and cultural differences alone – but was and is massively a product of Jewish nepotism. The role of Jewish ethnic networking in the vast overrepresentation of Jews at elite universities in the United States has been revealed by studies showing Jews are represented at the Ivy League far beyond what would be predicted by IQ, whereas Whites of European descent are correspondingly underrepresented.[700] For any given level of high IQ, non-Jews far outnumber Jews in America.[701] For example, there are around seven times as many non-Jews as Jews with an IQ greater than 130 (an IQ typical of successful professionals), and four and a half times as many with an IQ greater than 145. Obviously, there are not seven times as many non-Jews as Jews among

elites in the elite sectors of the U.S. (quite the opposite). Would the situation, given the strength of Jewish ethnocentrism, have been any different in Germany in the nineteenth and early twentieth centuries?

## *Virtually No Mention of Jewish Cultural Subversion as a Cause of German Anti-Semitism*

As well as completely ignoring the crucially important phenomenon of Jewish ethnic networking, Aly fails to acknowledge the link between disproportionate wealth and disproportionate political, legislative, media and cultural influence, and how this influence was wielded by Jewish elites to reengineer German society in their own perceived interests. Ethnic competition doesn't only exist in the economic realm but in the cultural and political realms. Resentment fueled by wealth disparities is only a part (albeit a highly significant part) of a multifaceted picture.

Kevin MacDonald has often noted that it wouldn't matter if Jews were an economic elite if they were not hostile to the traditional people and culture of the West. The unfortunate reality is that they are extremely hostile, and this hostility has existed for millennia. In *Separation and its Discontents* he notes that the heightened level of resource competition between Germans and Jews, especially after 1870, "resulted in very large Jewish overrepresentation in all the markers of economic and professional success as well as the production of culture, the latter viewed as a highly deleterious influence."[702] In his *German Genius*, Peter Watson observes that after 1880, and especially after the Dreyfus trial in France in 1893, "the Jews were increasingly identified as Europe's leading 'degenerates.'"[703]

A National Socialist publication from 1938 points out how "the disintegration and decay of German intellectual life under Jewish supremacy was most apparent and assumed their crudest aspects in the sphere of light entertainment art." When, in the unstable political aftermath of Germany's defeat in 1918, a time when all barriers of law and order had broken down, "a veritable storm of Jewish immoral literature, obscene films and plays then broke over Germany." The Berlin Revue

proprietors who "were Jews without a single exception" offered the public "veritable orgies of sexuality and licentiousness. All realities of life were regarded from the one and only aspect of erotic desire and its satisfaction." Berlin quickly assumed the mantle of "the most immoral town in the world." The increasing spread of indecency and immorality forced the government in 1926 to "take constitutional steps for the suppression of filthy or otherwise low-grade literature."[704]

The themes of Jewish moral, cultural and political subversion permeate the speeches and writings of Hitler and other leading National Socialist figures. In *Mein Kampf* Hitler argued that the Jewish influence on German cultural life mostly consisted in "dragging the people to the level of his own low mentality." He recalls how he once asked himself whether "there was any shady undertaking, any form of foulness, especially in cultural life, in which at least one Jew did not participate?" and later discovered that "On putting the probing knife carefully to that kind of abscess, one immediately discovered, like a maggot in a putrescent body, a little Jew who was often blinded by the sudden light."[705]

In a brief departure from his "envy" theory, Aly himself acknowledges the prevalence of the belief that Jews, through the insidious political and cultural influence they exerted, were destroying mainstream German culture, and that this belief, which spread through all social strata, "became a mass phenomenon and paved the way for the racial anti-Semitism at the core of the National Socialist worldview."[706] According to this worldview, "At the close of the emancipation era in Germany, the Jews enjoyed a practical monopoly of all the professions exerting intellectual and political influence. This enabled them to stamp their entirely alien features on the whole public life of the country."[707]

One of the ways that racial and ethnic groups do battle for position is through controlling what goes into the minds of their competitors. This explains the invariable push by Jews to exercise domination and control over the media and entertainment industries. They realize that media influence is an incredibly important aspect of ethnic competition in the modern world: filling the heads of your ethnic competitors with notions which are inimical to family life or other evolutionarily-adaptive

behavior, but which help your group to thrive. Those aware of what is going on naturally resent this waging of ethnic warfare through exercising control over the flow of information – and the Germans were no exception.

The German media in the decades prior to 1933 was almost entirely in Jewish hands. The largest circulation newspapers, like the *Berliner Morgenpost*, the *Vossische Zeitung*, and the *Berliner Tageblatt*, were owned by the Jewish Ullmann and Mosse companies, and were overwhelmingly staffed by Jewish editors and journalists. The Marxist press, most prominently including newspapers like *Vorwärts*, *Rote Fahne*, and *Freiheit* was likewise under Jewish control. The Jewish essayist Moritz Goldstein observed in 1912 that: "Nobody actually questions the powers the Jews exercise in the press. Criticism, in particular, at least as far as the larger towns and their influential newspapers are concerned, seems to be becoming a Jewish monopoly."[708]

Even Germans initially opposed to Hitler, like the Hamburg philosopher and women's rights activist Margarethe Adam, acknowledged the reality of Jewish media control. In a 1929 discussion on the Jewish Question she noted that the hostility of many Europeans towards Jews was an almost reflexive response to the "teeth gnashing disdain that Jews felt for Christians." As evidence for her claim, she cited the Jewish-controlled press, which, she observed, was "rife with insults and scorn hurled at the great personages of the German past." It was this press that caused "people to speak repeatedly of 'Jewish solidarity' in the worse sense."[709]

## Misrepresenting Heinrich von Treitschke

To buttress his "envy" theory of German anti-Semitism, Aly cites the 1879 publication of renowned German historian Heinrich von Treitschke's article "Our Prospects" in the prestigious journal *Preussische Jahrbücher*. This article was, Aly claims, addressed by the famous historian "to the sons of the rapidly declining artisan and merchant class," a group that were "fearful for their future." In his article,

Treitschke raised the idea that "in recent times a dangerous spirit of arrogance has been awakened in Jewish circles," and he demanded that Jews show more "tolerance and humility," noting that: "The instincts of the masses have recognized in Jews a pressing danger, a deeply troubling source of damage to our new German life." The most knowledgeable Germans, he proclaimed, were calling out with one voice: "The Jews are our misfortune."[710] According to Aly,

> Treitschke's "Our Prospects" polemic characterized Jewish immigrants to Germany from Eastern Europe as "an invasion of young ambitious trouser salesmen" who aimed to see their "children and grandchildren dominate Germany's financial markets and newspapers." The nationalist historian pilloried the "scornfulness of the busy hordes of third-rate Semitic talents" and their "obdurate contempt" for Christian Germans, noting how "tightly this swarm kept to itself." The holder of four professorships in his lifetime, Treitschke worked himself into a veritable frenzy over "the new Jewish nature," whose tendencies and attributes included "vulgar contempt," "addiction to scorn," "facile cleverness and agility," "insistent presumption," and "offensive self-overestimation." All of these qualities, Treitschke claimed, worked to the detriment of the Christian majority, with its "humble piety" and "old-fashioned, good-humored love of work." If Jews continued to insist on their separate identity and refused to be integrated into the German (which to Treitschke, meant Protestant) culture of the nation, the historian threatened that "the only answer would be for them to emigrate and found a Jewish state somewhere abroad."[711]

Aly takes Treitschke's article out of its historical and intellectual context, and claims the hostility toward Jews Treitschke expressed in his article, which Aly views as completely baseless, was "symptomatic of Germany as a whole," and ultimately grounded in pathological envy. The actual context of Treitschke's famous article was explicated by

Albert Lindemann in his book *Esau's Tears: Modern Anti-Semitism and the Rise of the Jews*. Lindemann, who notes how this context is "often neglected or ignored in accounts of the period," observes that the real catalyst for Treitschke adding his voice to complaints about Jews in Germany was the nature of the work of the leading Jewish historian Heinrich Graetz and its enthusiastic reception among German Jews. Lindemann points out that:

> Although his *History of the Jews* is still lauded by twentieth-century Jewish historians as one of the great nineteenth-century histories of the Jews, there is little question that the sense of Jewish superiority expressed in it, especially in the eleventh volume, which had first appeared in 1868, was at times narrow and excessive. Indeed compared with it, Treitschke's history of the Germans may be described as generous in spirit, especially in its treatment of the relationships of Jews and non-Jews, their relative merits and defects.[712]

Lindemann points outs that Graetz harbored a "deep contempt for the ancient Greeks and a special derision for Christians in the Middle Ages." Presaging Freud and the Frankfurt School, Graetz considered contemporary European civilization to be "morally and physically sick." Lindemann observes that "Graetz had written much that was stunningly offensive to German sensibilities of the time," and that it was hardly surprising that Treitschke responded with "such fury." Celebrating deceit and guile as highly effective forms of Jewish ethnic warfare, Graetz had written that the Jewish writers Boerne and Heine had "renounced Judaism, but only like combatants who, putting on the uniform of the enemy, can all the more easily strike and annihilate him." Moreover, in his private correspondence, Lindemann observes, Graetz "expressed his destructive contempt for German values and Christianity more forthrightly." In a letter to Moses Hess, written in 1868, for instance, he wrote that "we must above all work to shatter Christianity."

On becoming aware of such views, Treitschke angrily observed that "the man shakes with glee every time he can say something downright nasty against the Germans."[713] It was reading Graetz, and noting how his particular brand of history was so highly esteemed by Jews, that prompted Treitschke to echo the reactions of many Germans to having their people, culture and religion derided by members of an alien tribe living in their midst.

> What deadly hatred of the purist and most powerful exponents of German character, from Luther to Goethe and Fichte! And what hollow, offensive self-glorification! Here it is proved with continuous satirical invective that the nation of Kant was really educated to humanity by Jews only, that the language of Lessing and Goethe became sensitive to beauty, spirit and wit only through [the Jews] Boerne and Heine! ... And this stubborn contempt for the German goyim is not at all the attitude of a single fanatic.[714]

Graetz found his counterpart in the Weimar Republic in the figure of the Jewish intellectual and journalist Kurt Tucholsky who, using a variety of pseudonyms, "scoffed at the ideals of the German nation: he flung his biting sarcasm and venomous mockery at every religious and national sentiment."[715] By deliberately excluding the historical and intellectual context of Treitschke's famous article, Aly perpetuates the false narrative that German hostility towards Jews had absolutely nothing whatever to do with Jewish behavior. This distortion enables Aly to blithely dismiss Treitschke as an "intellectual agitator" and producer of "anti-Jewish polemics."

The author also gives the German composer Richard Wagner this kind of shabby treatment, dismissing him as "a paradigmatic example of the way that resentment provoked hatred for Jews among German intellectuals and artists." As I note in Chapter 6, the opinions Wagner expressed on the Jewish Question have a great deal of validity. Aly is unwilling, however to subject Wagner's writings on Jews to any detailed

and fair-minded analysis, simply insisting that "none of Wagner's assorted justifications could disguise the personal economic interest that clearly lay behind his animosity."[716] According to Aly, anti-Jewish statements are *never* rational, but are invariably the product of the pathological envy of the "anti-Semite," while Jewish critiques of Europeans always have a thoroughly rational basis.

### Conclusion

Aly concludes his book by claiming that "Today's generations of Germans owe a lot to their ancestors' desires to get ahead in the world. Precisely for that reason, there is no way for them to divorce anti-Semitism from their family histories." Reinforcing the toxic culture of the Holocaust that is leading Germany to destruction, he insists that today's Germans have a moral obligation to come to terms with and atone for "the murderous anti-Semitism of their forefathers."[717]

Despite its many shortcomings (in truth because of them) *Why the Germans? Why the Jews?* was lauded by establishment critics. Christopher Browning, writing for the *New York Review of Books*, described Aly's book as: "A remarkably fresh look at an old problem. ... Aly is one of the most innovative and resourceful scholars working in the field of Holocaust studies. Time and again he has demonstrated an uncanny ability to find hitherto untapped sources, frame insightful questions, and articulate clear if often challenging and controversial arguments."[718]

Most Jewish critics have been similarly admiring. Dagmar Herzog, writing for *The New York Times*, maintained that "the lavish evidence Aly heaps on – from both self-revealing anti-Semites and acutely prescient Jewish writers – is incredible in its own right and makes for gripping reading."[719] *The Forward* called the book "Consistently absorbing. ... A penetrating and provocative study [that] offers shrewd insight into the German mindset over the last two centuries."[720] Misha Brumlik, writing for the German publication *Die Zeit*, labelled Aly's work "Brilliant, passionate, provocative," and according to Michael

Blumenthal, once U.S. Treasury Secretary and now director of Berlin's Jewish Museum, Aly's "analysis of a profound social malady has made the incomprehensible comprehensible."[721]

For others, however, Aly's pathological envy thesis – despite his assiduous efforts to locate the sources of this envy exclusively in the pathologies and malformations of the German mind – is unsatisfactory because it fails to capture the truly "evil" nature of the anti-Semitism that once pervaded German society. Writing for *Commentary*, the Jewish writer Daniel Johnson dismissed Aly's underlying message as "a more scholarly version of Hannah Arendt's 'banality of evil' thesis." According to Johnson, "What made the evil of the Shoah 'radical' is that it had no social or economic rationale. Because it had no motive or purpose beyond its own insane internal logic, its cruelty also had no limits, no proportionality, no humanity. It was literally inhuman." He claims that "envy is too mild a motivation" to account for the "truly evil" depths of German Jew-hatred. In his view, "There is something darker, more pathological, more 'incomprehensible' going on here."[722]

While *Why the Germans? Why the Jews?* flirts with the truth, it is marred by the distortions and omissions identified in this essay. Competition for access to resources (broadly construed to include competition over the construction of culture) is undoubtedly a prime cause of intergroup hostility – and it was an important contributing factor in German hostility toward Jews in the nineteenth and early twentieth centuries. Nevertheless, to be charitable, making the emotion of "envy" the sole causal factor for post-Enlightenment German anti-Semitism, is overly simplistic. The sources of German hostility to Jews during the nineteenth and early twentieth centuries were manifold: Jewish economic competition (exacerbated by Jewish ethnic networking and nepotism), disproportionate Jewish involvement in revolutionary political movements, and Jewish moral and cultural subversion and domination. Ethnic competition takes many forms, and the assertion by Jews of their ethnic interests (economically, politically and culturally) inevitably leads to hostility from those whose interests are compromised as a result. The Germans of the nineteenth and early twentieth centuries

were no exception. Given the ubiquity of anti-Semitism throughout history, it should be obvious to everyone that Jews themselves are its primary carriers and transmitters.

# Balzac and the Jews

Honoré de Balzac (1799-1850) was an incredibly prolific French novelist of the first half of the nineteenth century. A pioneer of realism, he wrote 85 novels in twenty years, many comprising parts of his multifaceted examination of French society, which, invoking Dante, he dubbed *La Comédie Humaine* – or The Human Comedy. Through carefully observing every social actor, profession, institution, and condition of French life, Balzac aimed to analyze the forces underlying the economic and social changes wrought by an emerging capitalist society – a society he believed was excessively motivated by money at the expense of traditional values.

His most famous works include *Eugénie Grandet* (1833), *Père Goriot* (1934), *Lost Illusions* (1837), and *Cousin Bette* (1846). In developing the novels that would comprise *La Comédie Humaine*, Balzac hit upon the (then revolutionary) idea of using recurring characters. He wrote with great attention to detail to depict and explain their lives, and strived to present them as *real* people with real triumphs and frequent failures. Never fully good nor fully evil – his characters are entirely human in their desires and their behaviors. Balzac's attention to detail and unfiltered depiction of people in society had never been seen before in literary writing. In addition to his remarkable powers of observation and prodigious memory, he had an intuitive understanding of people

and their motivations which, borrowing a term from Sir Walter Scott, he called "second sight." The French poet Baudelaire, an ardent admirer of Balzac, noted how "All his characters are endowed with the same vital flame which was burning within himself."[723]

After working for three years as a lawyer's apprentice, the young Balzac turned his back on the profession, finding it inhumane and tedious in its working schedule. His experiences in the law did, however, provide the basis for many plotlines in his novels which often center on legal disputes, wills and contested legacies. Turning his attention to writing, his early attempts to forge a literary career proved unsuccessful, as did later attempts to achieve success as a publisher, printer, businessman, critic, and politician. Despite experiencing dire poverty and constant rejection, Balzac continued to write, and his breakthrough came with *The Chouans* (1829), a novel set in the aftermath of the French Revolution. Its success encouraged him to devote himself wholeheartedly to a literary career. From this point, his life's purpose was to achieve glory as the historian of his time, as the "secretary" of French society. In this endeavor he developed what many would regard as insane work habits.

Balzac's energy was unbounded and his productivity astounding. His phenomenal work ethic was necessitated by a penchant for luxurious living – a tendency that constantly plunged him into debt, and led to his being hounded by creditors for most of his adult life. To evade them, he registered under pseudonyms and frequently changed his lodgings. While Balzac eventually earned decent money from his literature, his reckless spending always ensnared him in further debts: bills exist for his order of fifty-eight pairs of gloves at one time, and for similarly extravagant purchases from his fashionable tailor and jeweler in Paris. Balzac was famous for his bejeweled walking sticks, red leather upholstered library, busts of Napoleon (whom he loved), and other things of a luxurious and superfluous nature. In a letter from 1828, his publisher and friend Latouche wrote:

You haven't changed at all. You pick out the [expensive] rue Cassini to live in and you are never there. Your heart clings to carpets, mahogany chests, sumptuously bound books, superfluous clothes and copper engravings. You chase through the whole of Paris in search of candelabra that will never shed their light on you, and yet you haven't even got a few sous in your pockets that would enable you to visit a sick friend. Selling yourself to a carpet-maker for two years! You deserve to be put in Charenton lunatic asylum.[724]

It's more than a little remarkable, then, to discover that, amid this obsessive pursuit of luxury goods, and a long-term romance with (and ultimate marriage to) a Polish countess, Balzac found time to write for *sixteen hours* per day. He wrote slowly and toiled with incredible focus and dedication. He described in 1833 his relentless writing routine:

I go to bed at six or seven in the evening, like the chickens; I'm awaken at one o'clock in the morning, and I work until eight; at eight I sleep again for an hour and a half; then I take a little something, a cup of black coffee, and go back into my harness until four. I receive guests, I take a bath, and I go out, and after dinner I go to bed. I'll have to lead this life for some months, not to let myself be snowed under by my debts. The days melt in my hands like ice in the sun... I'm not living, I'm wearing myself out in a horrible fashion – but whether I die of work or something else, it's all the same... I am driven by the terrible demon of work, seeking words out of the silence, ideas out of the night.[725]

While Balzac's feverish method of composition didn't always allow for meticulous attention to the niceties of style and finish, he often made innumerable corrections and revisions to the proof sheets of each novel. He dressed for the task in a monkish white robe encircled by a golden belt from which hung a pair of scissors and a penknife. Usually occupied with writing several novels at the same time, he always felt

compelled to press on, not only due to the urgency of ever-mounting debts, but to give birth to the unique conception of the world seething in his brain. In this endeavor, he kept an incredible level of focus and commitment to his craft: at one point he wrote for a stretch of 48 hours with only three hours of sleep for the entire duration.

His nocturnal working schedule necessitated a reliance on black coffee that has become the stuff of legend. Balzac, who called coffee "the great power of my life," reputedly drank between 50 to 300 cups a day to stay fueled and focused on his work, describing its effects thus: "Coffee falls into the stomach... ideas begin to move, things remembered arrive at full gallop... the shafts of wit start up like sharp-shooters, similes arise, the paper is covered with ink."[726] His extreme work habits and coffee consumption likely contributed to his death from congestive heart failure in 1851 at the age of 52.

## Balzac and the Jews

Balzac's novels offer entertaining and sharply-observed chronicles of all facets of French society from 1789 to 1848: from the Revolution through the First French Empire of Napoleon I, the Bourbon Restoration, the July Monarchy under Louis Phillippe, to the Second Republic. This era coincided with the entrance of Jews into mainstream society in Western Europe. Indeed, Balzac can be credited with being the first novelist to make Jews and non-Jews live together in the same world.

Jews overwhelmingly supported the French Revolution of 1789 which promised them civic and economic equality. They were officially "emancipated" by a proclamation of the National Constituent Assembly in 1791 – the legal culmination of the moral universalism of the Enlightenment of the eighteenth century. Notwithstanding the proclamation, many leading Enlightenment thinkers, including Voltaire, Kant, d'Holbach and Diderot, regarded Jews as exploitative and enmeshed in medieval superstition and chauvinistic, immoral behavior. While Voltaire opposed the Inquisition's targeting of Jews, he noted in his *Philosophical Dictionary* that: "You will find in the Jews an ignorant,

lazy, barbarous people who for a long time have combined the most undignified stinginess with the most profound hatred for all the people who tolerate them and enrich them."[727] Kant observed that Jews were "a nation of usurers... outwitting people amongst whom they find shelter... They let the slogan 'let the buyer beware' their highest principle in dealing with us."[728] Until the proclamation of 1791, most French Jews lived in ghettos segregated from surrounding societies. The rights granted to Jews in France were later extended to Jews throughout much of Western Europe – Germany, Italy and the Netherlands – by conquering Napoleonic armies, and then by the revolutions that swept through Europe between 1830 and 1848. After 1830, all careers were opened to Jews in France, and they entered fully into mainstream society. France's Jewish population was, however, comparatively small: only one-tenth that of Germany and one-fiftieth that of Austria-Hungary. In the Pale of Settlement, Jews were about one hundred times more numerous in relation to the native population than they were in France where the Jewish population had only reached 75,000 by the end of the nineteenth century.[729] Despite this, as Jewish migration to Paris increased, people were increasingly confronted with the social and economic effects of unfettered *Semitism*, and Jews came to constitute an important new element of the society Balzac set out to describe.

In his sociological outlook, Balzac, a political reactionary, saw parallels between human society and the animal kingdom (*Old Man Goriot* is dedicated to a zoologist, Geoffrey Saint-Hilaire). Like all species, the various types of human animal have a common origin, but they evolve and diversify according to their environment. The leafy calm of the French provinces is the natural habitat of Balzac's virtuous Rastignac family. The city of Paris, where most Jews resided, was, on the other hand, "like a forest in the New World," infested with "savage tribes, where rapacious individuals, unchecked by religion or monarchy, thrive at the expense of the weak." Humans, of course, are more sophisticated than beasts: "In the animal kingdom, there are few dramas and little confusion; animals simply attack one another. Humans attack one another too, but the intelligence that they possess to varying degrees

makes the struggle more complex."[730] Balzac both loved and hated Paris as the hub of the French world, and his novels set there offer a terrible picture of human ruthlessness.

About thirty Jewish characters inhabit the pages of *La Comédie Humaine*, with a few reappearing in several novels. Despite comprising an important new part of French society in the domains of the arts and sciences, the theater, and especially the world of finance, Balzac's Jewish characters remain ethnically distinct. Rashkin claims that Balzac's unsparing portrayal of Jews (none of whom are given French names), and his implicit emphasis on "openly converted Jews" and "unseen, infiltrating Jews," is evidence of his being "haunted by France's trauma of Jewish assimilation."[731] Balzac always stresses the uniqueness of Jews, portraying Jewishness as a strong and troubling trait. Conversion and assimilation in no way erase Jewish identity which, for Balzac, was fundamentally ethnic.

## *Jewish Physical and Psychological Characteristics*

Balzac's Jewish characters don't always identify themselves as Jewish, though their origins are immediately apparent to non-Jews through physiognomy or scent or aura. One non-Jewish character in *Cousin Pons* (1847), Rémonencq, is said to possess close-set eyes that revealed "a Jew's slyness and concentrated greed," though in his case, "the false humility that masks the Hebrew's unfathomed contempt for the Gentile was lacking." Another Jewish character, Moses Halpersohn, a refugee Polish Jewish physician possesses a nose that is "Hebraic, long and curved like a Damascus blade." Halpersohn's stereotypically Jewish physiognomy reflects his stereotypically Jewish character: specializing in the treatment of nervous disorders, he becomes rich through charging exorbitant prices for his services – a practice reflecting "his scorn for his patients and society in general... Medicine becomes a game of high finance, a means to acquire gold and power."[732]

Balzac's depiction of Jewish women reflects, by contrast, "an orientalist fantasy" characteristic of the romantic literature of the time.

Balzac's Jewesses, who are mostly confined to the (often overlapping) roles of actress and prostitute, exude mystery, charm and exoticism, possessing a beauty beyond the conventional that evokes the biblical atmosphere of *The Song of Songs*. In *Scenes from a Courtesan's Life* (1838-47), Balzac contends that Jewish women, "though so often deteriorated by their contact with other nations," often exhibit a "sublime type of Asiatic beauty," and "When they are not repulsively hideous, they present the splendid characteristics of Armenian beauty." Such a description applies to Jewish art dealer Elie Magus' daughter Noemi, "a Jewess as beautiful as a Jewess can be when the Semitic type reappears in its purity and nobility in a daughter of Israel." The actress Coralie is likewise portrayed as "a Jewess of the sublime type" who, notwithstanding her physical appeal, retains "all the native Hebrew instinct for gold and jewels – for the golden calf."

Balzac's (often attractive) Jewesses differ not only physically from their male co-ethnics, but also morally in their capacity for loyalty and generosity. At the same time, their exotic sexuality exerts over their non-Jewish lovers a "paralyzing fascination that constitutes an obvious analogue to the dominance enjoyed by Jewish men in the world of finance."[733] For Balzac, an inability to detect Jewish physical features and exercise requisite caution condemns "a poor fellow of twenty-seven" who "had the innocence of a lad of sixteen" to be ripped off by the art dealer Magus. A more vigilant and experienced man would, Balzac contends, "have noticed the diabolical look on Elie's face and seen the twitching of the hairs of his beard, the irony of his moustache, and the movement of his shoulders which betrayed the satisfaction of Walter Scott's Jew in swindling a Christian."

Magus is Balzac's exemplification of a type he grew to know exceedingly well due to his passion for collecting art and antiquities – the Jewish trader who, through sharp business practices and ethnic networking, becomes immensely wealthy:

> The name of Elias Magus is too well-known in the Human
> Comedy to need introducing. He had retired from trading in

pictures and *objets d'art* and, as dealer, had adopted the proce-
dure that Pons had followed as a collector. The celebrated valuers
– the late Henry, Messieurs Pigeot and Moret, Thoret, Georges
and Roehn, in fact, the experts of the Louvre Museum – were as
babes compared with Elias Magus, who could pick out a master-
piece from under the grime of centuries, who knew every school
and the signature of every painter. This Jew, who had come to
Paris from Bordeaux, had given up business in 1835 without giv-
ing up his squalid appearance: that he maintained, in accordance
with the habits of most Jews, so faithful to its traditions does this
race remain. In the Middle Ages, persecution forced the Jews to
disarm suspicion by going about in rags, perpetually complain-
ing, whining and pleading poverty. What was once a necessity
has become, as is always the case, an ingrained racial instinct, an
endemic vice. By dint of buying and selling diamonds, dealing
in pictures and lace, rare curios and enamels, delicate carvings
and antique jewelry, Elias Magus had come to enjoy an immense
untold fortune, which he had acquired through this kind of
commerce, nowadays so important.[734]

Jews who, like Magus, feign poverty while being secretly rich make
repeated appearances in Balzac's novels. In *The Initiate* (1848), one
character is surprised at the luxury of a room in a poor section of Paris,
"but his surprise only lasted for an instant, for he had seen among
German and Russian Jews many instances of the same contrast be-
tween apparent misery and hoarded wealth." Balzac's wealthy Jews live
frugally, and the moneylender Gobseck even denies ownership of a gold
coin he drops to maintain the illusion of poverty. Jewish women, on the
other hand, enjoy opulent luxury in Balzac's world. As courtesans and
actresses, they live in houses furnished by the men who keep them. The
more beautiful the Jewess, the richer the dwelling she demands.

## *Jewish Ethnic Networking, Swindling and Avarice*

Magus uses Jewish ethnic networks to assiduously track every master-work in Europe, with Balzac explaining how: "Magus had his own map of Europe with every masterpiece marked on it, and at every relevant spot he had co-religionists who kept their eyes open on his behalf in return for a commission – but the reward was meagre for the amount of vigilance entailed!" Balzac likens the monomania of Magus to the desires of kings: Magus is proud of his power to buy the finest canvases which he hoards in his mansion, thus depriving the gentile community of its great works of art.

In *Cousin Pons* (1847), Magus is given the opportunity to plunder the art collection of Sylvain Pons, an elderly professor of music, who has carefully accumulated precious artworks over his lifetime. Tricking Pons' landlord into selling him four of the professor's masterpieces while their owner lays stricken on his deathbed, Balzac informs us that, when confronted by such a magnificent collection, "Admiration, or, to be more accurate, delirious joy, had wrought such havoc in the Jew's brain, that it had actually unsettled his habitual greed, and he fell head-long into enthusiasm, as you see." The Jewish dealer, however, quickly regains his composure: "'On an average,' said the grimy old Jew, 'every-thing here is worth a thousand francs.' 'Seventeen hundred thousand francs!' exclaimed Fraisier in bewilderment. 'Not to me,' Magus an-swered promptly, and his eyes grew dull. 'I would not give more than a hundred thousand francs myself for the collection. You cannot tell how long you may keep a thing on hand... There are masterpieces that wait ten years for a buyer, and meanwhile the purchase money is doubled by compound interest. Still, I should pay cash.'"

The ability of Jewish merchants to swindle their naive non-Jewish interlocutors is a recurrent theme in Balzac's novels. In *Eugenie Grandet*, for example, Eugenie's skinflint father is taught a valuable lesson by a cunning Jewish dealer:

> Some years earlier, in spite of his shrewdness, he had been taken
> in by an Israelite, who in the course of the discussion held his

hand behind his ear to catch sounds, and mangled his meaning so thoroughly in trying to utter his words that Grandet fell victim to his humanity and was compelled to prompt the wily Jew with the words and ideas he seemed to seek, to complete the arguments of the said Jew, to say what the cursed Jew ought to have said for himself; in short to be the Jew instead of being Grandet. When the cooper came out of this curious encounter he had concluded the only bargain of which in the course of a long commercial life he ever had occasion to complain. But if he lost at the time pecuniarily, he gained morally a valuable lesson; later he gathered its fruits. Indeed, the good man ended by blessing that Jew for having taught him the art of irritating his commercial antagonist and leading him to forget his own thoughts in his impatience to suggest those over which his tormentor was stuttering.[735]

Avarice, lust for power and contempt for gentiles are psychological traits Balzac frequently ascribes to his Jewish characters, and they often serve as paradigms for the analysis of non-Jewish characters who manifest similar traits. One non-Jewish character is said to be as "eager for gain as a Polish Jew," while in *Lost Illusions* the luckless and penniless poet, Lucian Chardon, is advised that, in order to succeed in Paris, he needs to become as "grasping and mean as a Jew; all that the Jew does for money, you must do for power." This characterization of the Jewish mindset persisted in French literature through to the late nineteenth century. In Guy de Maupassant's *Bel Ami* (1885), for example, two young journalists discuss their boss, a Jewish newspaper proprietor, in the following terms:

> They went into a café and ordered iced drinks. Saint-Potin started to talk. He talked about everybody and about the paper with a profusion of surprising detail. "The boss? A real Jew. And you know, you'll never change the Jews. What a race!" And he quoted amazing examples of their avarice, the peculiar avarice of the sons of Israel, the efforts they would make to save ten centimes, their

haggling, their barefaced way of asking for discounts and getting them, their whole moneylending, pawnbroking attitude. "And yet with all that, a good sort, who doesn't believe in anything and diddles everybody. His paper, which is semi-official, Catholic, liberal, republican, 'Orleanist,' custard pie and sixpenny ha'penny, was only founded to help him play the stock market and back up his other ventures. He's very good at that and he earns millions by means of companies that haven't got tuppence worth of capital... And the old skinflint talks like someone out of Balzac."[736]

In the 2012 film version of *Bel Ami*, the Jewish identity of this newspaper owner was totally erased from the story.

While the Jew is placed by Balzac at the margins of French society, he remains at the center of the forces generating destructive social change. This particularly applies to his Jewish characters connected to the world of finance. Such characters include the Keller brothers, the moneylender Gobseck, and the financier Nucingen. In *Gobseck* (1830-35), Balzac depicts "a usurer sitting like a spider at the center of his web and asserting his power over the 'socialites' and ne'er-do-wells who come to him for loans."[737] Gobseck is a man who uses gold to exert influence and to control the destinies of others, and is "Balzac's model of the successful Jew whose extraordinary self-discipline enables him to pursue his quest for gold, despite obstacles."[738]

As the self-appointed historian of French social life in the first half of the nineteenth century, Balzac was acutely conscious of the immense and steadily growing significance of money. "God of the Jews, thou art supreme!" he quotes Racine. Through usury, he notes, "Jews have monopolized the gold of the world, that all powerful invention due to the Jewish intellect of the Middle Ages, which after six centuries still controls monarchs and peoples." In a letter to his sister in 1849 from the Ukraine, an exasperated Balzac declared "You have no idea of the avidity of the Jews here. Shylock is a mere rogue, an innocent. Remember, this is merely in the matter of exchange; loans are sometimes fifty per cent even between Jew and Jew!"[739] In the world of Balzac's novels, a "good

Jew" is one "who only charged us fifteen per cent for the money we borrowed."[740] The Jewish propensity for usury is regarded by Balzac as a hardwired ethnic trait stretching back to the ancient world, where even "In the days of Moses there was stock-jobbing in the desert!" In the Balzacian novel, gold is invariably the emblem of the Jew, symbolizing the tribe's rapacity and wealth.

In *The Rise and Fall of Cesar Birotteau* (1837) Balzac presents the life story of a manufacturer of cosmetics who "becomes a prey to a group of blood-sucking bankers and speculators," while in his 1843 novella *The Imaginary Mistress*, he tells the story of Polish Count Adam Laginski, "one of the great Polish lords who let themselves be preyed on by the Jews."[741] Symbolizing the close historical relationship forged between Jews and European aristocratic elites against the interests of the native peasantry, the Count of Roche-Corbon in *The Venial Sin* (1832) pressures his Jews "only now and then, and when they were glutted with usury and wealth. He let them gather their spoil as the bees do honey, saying that they were the best of tax-gatherers. And never did he despoil them save for the profit and use of the churchmen, the king, the province, or himself."

Balzac modelled his Jewish financier, Nucingen, who appears in more of his novels than any other character, on Baron James Meyer de Rothschild, whom he knew personally. Balzac told his future wife in 1844 that James, "the high baron of financial feudalism," was "Nucingen to the last detail and worse."[742] Nucingen is Balzac's personification of Jewish money power and the social and political corruption attendant on the misuse of that power. In *Splendors and Sorrows of Courtesans* (1838-47), Balzac, with Nucingen (and thus Baron James) in mind, declared that "All rapidly accumulated wealth is either the result of luck or discovery, or the result of legalized theft."[743] Nucingen is "the wiliest of all the rogues in The Human Comedy: a banker who can engineer a liquidation of his own assets, or plan an investment portfolio on a client's behalf, simply and solely to further his own ends – enriching himself but bankrupting others by what is tantamount to legalized crime."[744]

## The Rothschilds: Balzacian Exemplars of Jewish Money Power

Balzac is the likely originator of the claim that the Rothschilds made their fortune through obtaining advance news of Napoleon's defeat at Waterloo – using this information to make a huge profit on the stock exchange. The story is incorporated into the plot of *The House of Nucingen* (1838), where he describes the Jewish financier's second greatest business coup as resulting from a massive speculation on the Battle of Waterloo. The twentieth-century Jewish-American banker, Bernard Baruch, claimed it was this story that "inspired him to make his first million."[745] While the scale of the Rothschilds' return on this speculation has been exaggerated over the years, the Third Baron Victor Rothschild confirmed the basic accuracy of the story, and economic historian Niall Ferguson contends that Napoleon's return from Elba on March 1, 1815, can be regarded as "an immense stroke of luck for the Rothschilds" with Bonaparte plunging Europe back into war and thus "restoring the financial conditions in which the Rothschilds had hitherto thrived."[746]

The idea of a large speculative profit made from advanced news of a military outcome shocked many of Balzac's contemporaries: "indeed, it epitomized the kind of 'immoral' and 'unhealthy' economic activity that both conservatives and radicals disliked when they contemplated the stock exchange." To patriotic Frenchmen, the Waterloo speculation symbolized the greed, cynicism and rootless cosmopolitanism of the Rothschilds. In his book *Jews: Kings of our Time* (1846), the socialist writer Georges Dairnvaell maintained that: "The Rothschilds have only ever gained from our disasters; when France has won, the Rothschilds have lost," and noted that Baron James is "the Jew Rothschild, king of the world, because today the whole world is Jewish." The very name Rothschild, he declared, "stands for a whole race – it is the symbol of a power which extends its arms over the entirety of Europe."[747] For Dairnvaell's political mentor, Pierre Proudhon, Jewish financiers like the Rothschilds were "always fraudulent and parasitical."[748]

The Rothschilds extended huge loans to Austria, Prussia and Bourbon France after 1815. Kings and ministers throughout Europe could obtain all the cash they needed on demand, letting the Rothschilds handle the details as to where it came from, and how it would be repaid. This enabled the Rothschilds to exercise extraordinary leverage over governments. In Paris, James de Rothschild successfully lobbied King Louis-Philippe, to whom he had constant access, to dismiss the government of Jacques Laffitte, because he disliked the latter's foreign policy. When, in 1830, Charles X was toppled from the French throne, the fact that Baron James, his Court Jew, survived unscathed only confirmed for many the existence of an unassailable Jewish oligarchy.

James Meyer de Rothschild's ability to secure from the French government the rail concession to link Paris and Belgium also incensed observers on both sides of French politics. In his 1846 book *The Jews, Kings of the Epoch: A History of Financial Feudalism*, Alphonse Toussenel criticized the terms under which the concession was granted. Believing the French rail network should be owned and managed by the state, Toussenel argued that France had been "sold to the Jews" and particularly to "Baron Rothschild, the King of Finance, a Jew ennobled by a very Christian King... Thus does high finance dominate everything; Jewish interests are visible all about us."[749]

Niall Ferguson contends that, in addition to pecuniary self-interest, "the Rothschilds saw their financial power as a means to advance the interests of their fellow Jews." To poorer Jews throughout Europe, Nathan Rothschild's extraordinary rise to riches had "an almost mythical significance" and his wealth "was intended for a higher purpose: 'to avenge the wrongs of Israel' by securing 'the reestablishment of Judah's kingdom – the rebuilding of thy towers, Oh Jerusalem!' and 'the restoration of Judea to our ancient race.'"[750] The Rothschilds were to play a critical role in the Zionist project. Indeed, Walter Rothschild, the 2nd Baron Rothschild, was the personal addressee of the 1917 Balfour Declaration which committed the British government to establishing a Jewish state in Palestine. Baron Edmond James de Rothschild funded the first Jewish settlement in Palestine at Rishon-LeZion, buying from

the Turks large parts of the land that now comprises Israel. In 1924, he established the Palestine Jewish Colonization Association which acquired an additional 125,000 acres of land.

## Conclusion

Grodzinsky contends that, while his Jewish characters "display common stereotypes of evil and avarice, Balzac was not a facile anti-Semite." His portrayal of Jews in his novels is accurate to the extent that, in the French society of his day, disproportionate numbers of Jewish men *were* usurers and Jewish women *were* courtesans or actresses. Therefore, for Balzac "to create a community where Jews abounded in every profession would have been to create a world alien to the French reader. Balzac's portrayal of the Jews reflects both his reality and literary tradition."[751]

While Balzac, following his customary practice, paints each of his Jewish characters as a unique personality, they remain representative of Jews in general and fundamentally separate from mainstream French society. Thus, while Balzac, with characters like Gobseck and Nucingen, "takes the Jewish money monster and creates a real human being, this person is still an outcast."[752] Moreover, Balzac's male Jewish characters are invariably "unpleasant people, characterized by avarice, shrewdness and lack of conscience."[753] The Balzacian Jew also exhibits fierce will-power, and is a protean figure who rapidly adapts and changes to advance his interests. In this endeavor, he, unlike many of Balzac's French characters, effectively uses his intellect to override his emotions.

Balzac, in his quest for realism, lets some of his Jewish characters succeed despite their misanthropic personalities and practices. Lehrmann notes that Balzac "does not like the Jews but he admires them; he notes without pity their vices and idiosyncrasies, but he acknowledges a certain genius thanks to which they rise above the vulgarity of their profession and social condition."[754] Balzac acknowledged the power of gold to cut across social barriers and to buy power and status, and despite his "frank hostility towards the Jews," remained fascinated by a group whose "despised greed and cunning resulted in admired wealth."[755]

Balzac didn't scorn the social and monetary rewards of success, and his years of struggling to establish a literary career only sharpened his understanding of the power of money – and of the ethnic group inseparably linked with that power.

# CHAPTER 14

# Jews and Race: A Pre-Boasian Perspective

Whether Jews comprise a religion, a nation, an ethnic group, or a race (or a combination of these) has always been central to the Jewish Question. The 2011 book *Jews & Race – Writings on Identity and Difference 1880-1940* (Edited by Mitchell B. Hart) is an anthology of Jewish writing which offers a fascinating insight into Jewish racial thinking during a period when hierarchic social Darwinian race theory was generally accepted throughout the West. Before the rise of Boasian anthropology in the 1920s and 1930s, Western anthropologists posited a direct correlation between external racial traits and internal psychological traits. Skin color, for example, was regarded as not just a physical attribute, but an external racial marker tied to a correlative set of intellectual, political, and cultural capabilities.

The Jewish socialist writer Chaim Zhitlowsky expressed the orthodox view in 1939 when he noted that: "It is understood that each Volk is endowed with certain characteristic traits, some bodily, some mental. Such traits are transmitted hereditarily from generation to generation, and determine how in fact a people receive the phenomena of the external world and how it reacts to these phenomena. On such traits depend the particular and specific national customs or manners, insofar as the blessed children of a people, the most gifted by nature, bring

forth human cultural treasures."[756] The study of racial differences was
held by Zhitlowsky to be necessary "in order to clarify the fundamental
role of biology in human progress. Here the history of culture must be
considered with racial descent in thinking about the creator of culture,
and it is not a superfluous or meaningless thing to take [the biological]
into account"[757]

As Kevin MacDonald points out in *The Culture of Critique*, this
approach was largely abandoned after World War Two with the rise to
dominance of Boasian anthropology which was instrumental in totally
suppressing evolutionary theory in the humanities and social sciences.
The Jewish historian Norman Cantor noted how: "Since 1945 and more
intensively since the 1960s all forms of racialist thinking are excluded
from rational and enlightened discourse, especially in the United States,
where the liberal civil libertarians have made racial doctrine intrinsically
wrong, evil, and undiscussable." The reason for this exclusion being
that: "Modern anthropology, as defined by the German-Jewish expatri-
ate Franz Boas, for three decades head of the anthropology department
at Columbia University, declared nineteenth-century race theory with-
out foundation." Cantor admitted that "this behavioral egalitarianism
and universality was itself an ideology," and that the Boasians never
actually disproved social Darwinian race theory, but rather insisted it be
"excluded from civil discourse as a result of what the Nazis and other
such hate-mongering groups did with it." This new ideology repre-
sented a radical shift in Jewish thinking given that "race" and "racism"
lies at the heart of Judaism as a group evolutionary strategy. Cantor
acknowledged this, and noted how:

> [R]acism is itself a central doctrine in traditional Judaism and
> Jewish cultural history. The Hebrew Bible is blatantly racist,
> with all the talk about the seed of Abraham, the chosen people,
> and Israel as a light to the other nations. Orthodox Jews in their
> morning prayers still thank God daily that he did not make Jews
> "like the other peoples of the earth." If this isn't racism, what is?
> That highly regarded medieval book, Judah Halevi's *Kuzari*, is

blatantly racist. Halevi will not even allow that a convert to Juda-ism is the equal of a natural-born Jew. Martin Buber, the much-praised theologian and mystic, was still talking in the early 1920s about the distinctiveness of Jewish "blood." Early Zionism was greatly affected by a positive view of racism. Herzl was inclined that way, and his close associate Max Nordau, for two decades a prominent Zionist leader in Europe, was the author of a classic of racist theory, *Degeneration*.

From about 1830 to 1900 Jews in Western Europe, especially in Britain, benefited rather than suffered from racist attitudes. Jews of Sephardi origin, if they were affluent, were regarded in aristo-cratic circles as esoteric creatures possessing superior bloodlines, and intermarriage with a converted Jew was entirely permissible in the best social and political circles. The behaviour of the British Prime Minister Benjamin Disraeli is an example of this attitude. Far from trying to play down his Jewish ethnicity, Dis-raeli, the shrewdest of politicians, emphasized it by turning up in Parliament in a hairdo and clothes that fit the racial stereotype of a Mediterranean Jew.[758]

Darwinian race theory only lost widespread Jewish support when they felt threatened by the emergence of a variant "of hierarchic Social Dar-winism, which had wide acceptance as a legitimate sociology between 1880 and 1920. Darwin's population biology was regarded in the late nineteenth century as scientifically verifiable... It was popular in Britain as sustaining [what Cantor regards as] the myth of the white man's burdensome privilege of ruling over the coloured races."[759] The key rationale for the emergence of Boasian anthropology as a Jewish intel-lectual movement, according to Cantor, was the fact that: "In the 1890s Social Darwinists, including some in universities, began to turn out hierarchic tables in which Jews were placed near the bottom of the list of races, just above blacks." He notes that: "If universalist multiculturalist

equality rather than Social Darwinism had been fashionable," then this "polemic against the Jews would not have been possible, of course."[760]

It is hardly surprising in this intellectual milieu that Jews would resort to embracing "a cultural pluralism that removed the claim for the superiority of one culture over another" and which protected Jews from claims they were an inferior race. Jewish support for Boasian anthropology – an explicitly antiracist "science" – grew as the expanding and prosperous Jewish communities in the West "suffered a severe check in the 1920s and 1930s from anti-Semitic discrimination and the closing of opportunity, particularly with regard to open access to the learned professions."[761] This, and the rise of the National Socialists in Germany, convinced many Jews that social Darwinian race theory was antithetical to their ethnic interests. The overthrow of this theory (and the resultant diminution of White ethnocentrism and group cohesion) was, as Kevin MacDonald points out, an ethno-political campaign that had nothing to do with real science, with the "shift away from Darwinism as the fundamental paradigm of the social sciences" resulting from "an ideological shift rather than the emergence of any new empirical data."[762]

The Boasian revolution in anthropology represented such a dramatic departure from preceding Jewish thinking about race that an examination of Jewish racial writing from 1880 to 1940 forces us, notes Hart, "to reorient the way we think about the normative narrative of the Jewish past" according to which historians have "told the story of the relationship between Jews and race largely within the framework of victimhood."[763] The abandonment of Darwinian race theory by Jewish anthropologists from the 1920s and 1930s necessitated obscuring the inherently racial nature of Judaism in order to forestall charges of hypocrisy. Yet Hart admits that race remains "one of the building blocks of contemporary Jewish identity construction" and that "biological and genetic arguments possess a power for many Jews as they seek to explain to themselves and others just what it is that constitutes Jewishness."[764] Even though such thinking may have been submerged or made invisible for fifty years, many Jews still "think with blood" about Jewish

belonging. University of Washington Professor Susan Glenn agrees, noting how: "Throughout all the de-racializing stages of twentieth-century social thought, Jews have continued to invoke blood logic as a way of defining and maintaining group identity."[765]

With the steady accumulation of population genetic studies demonstrating just how threadbare the Boasian assumptions really are (Boas was known for his antipathy to genetics), Hart is forced, despite his leftist politics, to concede that "race" is actually a meaningful concept after all:

> [T]he assertion that the Jews are not a race would appear at present to be fairly unproblematic, at least if we look at science as our guide to such matters. Since many biologists have told us that races in general do not exist in any "real" or natural way – that they are, rather, a cultural or social construct – then it seems patently absurd to consider the Jews a race. As Steven Kaplan has asked, if there are no races how can Jews be a race? Yet, it turns out that things are not that simple. Science, it seems, has not made up its mind on the issue of race. Some researchers in genetics now insist, as the philosopher Ian Hacking has written, "that stereotypical features of race are associated with ancestral geographic origin and, to some extent, with genetic markers." In other words, "race" might not be just a social construct after all, though it certainly is that. Race no longer exists in the older version of the nineteenth and early twentieth centuries, but modern genetic research may be in the process of redefining notions of identity that reanimate the "racial."[766]

Implicit here is an admission that the vast post-WWII literature spawned by the Boasians denying the reality of race – which has *profoundly* influenced Western politics and culture – is based on assumptions that are increasingly hard to sustain in the face of population genetic data confirming the reality of race and racial differences. Likewise, the idea that Judaism is not a group evolutionary strategy (implicit in claims

Judaism is just a religion), cannot be credibly sustained in the light of studies like that of Atzmon et al. from 2010 which confirmed that Jews *are* a distinct genetic community. This study examined genetic markers spread across the entire genome, and showed the Jewish groups (Ashkenazi and non-Ashkenazi) share large swaths of DNA, indicating close relationships, and that while each Jewish group in the study (Iranian, Iraqi, Syrian, Italian, Turkish, Greek and Ashkenazi) had its own genetic signature, each was more closely related to the other Jewish groups than to their non-Jewish countrymen. Atzmon and his colleagues found that the SNP markers in genetic segments of three million DNA letters or longer were ten times more likely to be identical among Jews than non-Jews, and that any two Ashkenazi Jewish participants in the study shared about as much DNA as fourth or fifth cousins.[767]

Of course, Judaism could still be a group evolutionary strategy even if Jews were not a genetically separate group, providing that Jews believed that they were and behaved accordingly – which is exactly what they did believe and behave like for millennia before recent population genetic studies confirmed what they had always assumed. The Zionist writer Robert Weltsch neatly summed up this longstanding hyperethnocentric Jewish mentality when he noted in 1913 that: "When it comes to the unity of the Jews, there is one irrefutable proof: the consciousness of this unity, which is an inner experience that every individual Jew possesses."[768]

### Ethnic Strategizing in Pre-Boasian Jewish Writings

Hart, Professor of Jewish History at the University of Florida, concedes that Jewish texts dealing with race have always been "unavoidably political," and notes that: "Racial narratives written and disseminated by Jews about Jews [during the 1880-1940 period] were intended in part as a direct polemical response to anti-Semites. Jewish racial thinkers believed that they could use racial science as an intellectual weapon against their enemies."[769] This tendency is clearly evident in writer and Zionist activist Moritz Goldstein's review of Ignaz Zollschan's book *The Racial*

*Problem, with Particular Attention Paid to the Theoretical Foundations of the Jewish Racial Question* (1909), where Goldstein was less concerned with the validity of Zollschan's arguments than with their potential for providing a "scientific justification of all that we, as modern Jews, believe and must believe if we wish to retain our self-esteem in the face of those who despise us, and if we are supposed to have trust in the future of our Volk." Goldstein admired how "This author [Zollschan] permits himself no emotional expressions, no mysticism, and no hypotheticals" and yet he could "sense a passionate temperament and an enthusiastic partiality pulsating beneath that cool façade." Goldstein aptly defined the Jewish culture of critique in his review, pointing out that: "What would be essential here [in utilizing Zollschan's ideas] would be to reply to those value judgments that are so hostile to us with our own counter judgments."[770]

Indeed, in reading the essays and articles that make up this volume, one is struck by the continuity between the pre- and post-Boasian Jewish discourses on race in the way that Jewish ethnic politics is embedded into purportedly "academic" writing. We find early versions of arguments that have become ubiquitous in the post-WWII anti-White cultural and political context. For example, we find the proposition that the Western nation state is, of moral necessity, based solely on a set of abstract ideas (democracy, legal equality etc.) and not on racial or ethnic kinship. For instance, in his article entitled "Reflections on the Jews" (1891) the French-Jewish rabbi and scholar Isidore Loeb declared that "it is certain that race does not enter into the idea of a nation as an indispensable factor."[771] Instead, he insisted that "all scholars agree that the unity of a nation is not founded on the unity of race," but rather on "a group of people united by the same allegiances, the same historical memories, the same aspirations for the future, attaching all these feelings to a common homeland, real if not ideal, and having a defined political existence."[772] Anticipating the neoconservatives with their cynical invocation of the kind of morally universalistic arguments they know strongly appeal to White people, Loeb maintained that:

It is absolutely impossible to find any reason to justify excep-
tional laws for a group of people, in particular, for the Jews. The
principle of human brotherhood, of equal rights for all men,
is the foundation of every modern state. Outside this principle,
there can only be arbitrariness and injustice, and a state that is
not founded on justice cannot even be conceived of.[773]

Presumably, the modern ethno-nationalist state of Israel would have
been inconceivable to Loeb – though I strongly doubt it. Also promi-
nent in pre-Boasian Jewish writing on race, are attempts to depict the
different European ethnic groups as already so intermixed as to render
the distinctive European ethnic identifications meaningless. This argu-
ment was ostensibly deployed to suggest that efforts to exclude Jews as
racial/ethnic outsiders, with incompatible group interests, are irrational
given that the various European nations have no cohesive racial/ethnic
basis to begin with. Why, then, should the various European ethnic
groups care if an alien people, like the Jews, live within their borders
and add another ethnic element to the existing heterogeneous mix? In
an early call for multiculturalism, Loeb in his "Reflections on the Jews"
(1893) argued that European nation states, which "are formed of an
amalgam of diverse races," are morally-obliged to accept Jews and other
non-assimilating groups:

> Between a French or German Jew and a French or German
> Christian there is assuredly less of a difference, if there is one at
> all, than between a Frenchman and a German, a German and a
> Slav. But even if this difference were more obvious, there would
> be no reason to drive Jews out of a country and to refuse them
> civil and political rights. Every nation is composed of different
> races, and therein the Jewish race can find a legitimate place.[774]

A classic example of the widespread pattern of Jews espousing patently
insincere views for the greater benefit of their ethnic kindred was the
testimony of the American Jewish Committee and Union of Amer-
ican Hebrew Congregations before the United States Immigration

Committee in 1910. Here the judge and cofounder of the American Jewish Committee, Julian Mack, together with the lawyer and Jewish community leader, Simon Wolf, asserted under oath that there is no such thing as a "Jewish race," and that the practice of classifying Jews as a race on U.S. immigration forms should therefore cease. The mendacity of this testimony embarrassed some Jews at the time, which was reflected in the American Zionist newspaper *The Maccabaean*, which condemned Mack and Wolf in an editorial for having

> attempted to have their interpretation of the facts of Jewish history fastened upon the entire Jewish citizenship of this country not for personal reasons, but in order to retard the growing anti-Jewish feeling which, they declare, will result in immigration restriction should the American people become aware of the number of Jews who come to this country. Though their motives are prompted by interest in the welfare of the Jewish people, we cannot permit them to utilize arguments, and to misinterpret facts, in a manner to bring the Jewish people of this country into contempt with the legislators who are now considering the immigration situation. Without entering into the merits of [the] argument, which was advanced by them not as matters of conviction, but primarily as matters of policy, we desire to dissociate ourselves from their point of view, from their logic, and from their policy... [W]e believe that if anything could stimulate prejudice against the Jews it would be the shifting, unmanly, and undignified pretense of representatives of a people who, against fact and history, and against their own private convictions, disown their racial and national birthright...

> By asserting boldly a theory that there is no Jewish race, but only a conglomeration of people professing the Jewish religion, Judge Mack and Mr. Wolf, and the organizations they represented, uttered a statement, which, if true, would exclude from among our ranks many who are devoted to the ranks of the Jewish

people but who are not religionists in the accepted meaning of the term. We believe we speak in the name of the entire Jewish people when we say the Jewish people, native born and naturalized in this country, are not ashamed to have themselves or their brethren classified as racial Jews.[775]

Such shameless ethno-political expediency exercised by Jews like Mack and Wolf prompted Madison Grant to characterize Jewish immigrants to the United States as "ruthlessly self-interested whereas American Nordics were committing racial suicide and allowing themselves to be 'elbowed out' of their own land."[776]

### Pre-Boasian Jewish Writing on the "Jewish Race"

The results of population genetic studies, like that by Atzmon et al. from 2010, essentially confirm the views of the majority of Jewish writers represented in *Jews and Race*. Hart notes how "questions about Jewish racial purity and mixing constitute a crucial component of many – perhaps most – of the texts in this volume."[777] For instance, in a 1907 article entitled "The Jewish Racial Question" the physician, writer and Zionist Elias Auerbach observed:

> The Jewish race is very homogeneous around the world. It is not uniform, as no civilized race (*Kulturrasse*) is, but its variations do not differ fundamentally from one country to another. A different fate, a distinct environment, did not result in the blurring of a common and wholly durable type, and indeed the Jews can demonstrate more clearly than any other race how overwhelming an influence heredity has, when compared to assimilation, in the matter of a race's fate.[778]

The Austrian-Jewish anthropologist and physician Ignaz Zollschan was equally convinced that the Jews had mostly retained their racial homogeneity in the Diaspora:

The Jewish nation has propagated itself in an essentially pure manner from the time of Ezra until today, and for more than two thousand years represents an ethnically peculiar race, which was not diluted by foreign blood. It is self-evident that a few drops of foreign blood must have found their way among the Jews during the long time in the Diaspora. But these admixtures were too insignificant to have any essential influence upon the ethnic character of the nation. Thus the Cohanim, who were absolutely excluded from mixed marriages, are typically the same as the other Jews. The state of affairs can best be described in one sentence: a great deal of blood was exported from Jewry, but little indeed was imported from outside. And, consequently, we can assume with certainty, that the blood that flows today in the veins of the Jews is the same as that of two thousand years ago.[779]

The onetime Director of the Bureau of Jewish Statistics in Berlin, Arthur Ruppin, agreed with this assessment, noting that: "An English, French, German, Italian, Spanish, or Portuguese Jew is still a Jew based on features, regardless of the nuances he presents: that is to say that they have all the same characteristics of shape and proportion – in a word, that which essentially constitutes a type."[780] Highlighting the fundamental nature of Judaism as a group evolutionary strategy, he also made the obvious point that: "Among all other *Völker*, religion and race have very little to do with one another; whereas, among the Jews, religion is a certain indicator of racial affiliation."[781]

Ruppin traced the Jews' racial homogeneity back to Judaism's historical roots when: "In Palestine itself, Ezra placed particular importance on keeping the pure families clear from intermixture with foreign elements, and made sure that foreign Volk elements would be purged. Therefore at the time of the Second Temple's destruction the Jews in Palestine were racially constituted more or less as they had been at the time of the destruction of the First Temple."[782] Elias Auerbach likewise made the point that: "Throughout all the historical books of the Bible and the numerous speeches of the prophets, there occurs a constant

repetition of the warning against mixing with neighboring peoples."[783]
Given this constant repetition, Auerbach is compelled to make

> the point vigorously that in general, over the course of the entire
> racial history of the Jews, the most rigorous opposition to racial
> mixing does not stem from other peoples but from the Jews
> themselves. ... It is only by knowing and taking into consideration
> this tendency that we are able to make anthropological use of
> the historical facts, for it is this tendency alone that allowed the
> Jews to remain unscathed [unaffected] by their long wanderings
> in exile, the enormity and length of which would have long since
> brought other races to the point of dissolution. The active re-
> serve displayed by the Jews is, notably, taken to such lengths that
> it is forbidden for them to proselytize, because religious equality
> [between Jews as a race and other races] would do away with the
> most powerful barrier against physical intermixing... With the
> sort of racial pride that the Jewish nation, on the basis of all our
> sources, evinces to a high degree, we should hardly wonder that
> measures against the influx of foreign types into the race were
> put in place.[784]

Alfred Nossig, a Polish-Jewish writer and social scientist active in Zion-
ist politics, argued in *The Chosenness of the Jewish in the Light of Biology*
(1905) that the idea of divine "chosenness" was the single greatest intel-
lectual innovation of the early Hebrews because, through this, they hit
on the key to the long-term survival of the Jewish people as a distinct
entity. The natural corollary of "chosenness" was "endogamy" which
became the lynchpin of Judaism as a highly effective group evolutionary
strategy. For Nossig, that the ancient Hebrews could devise such a
brilliant idea is testament to the genius of his ancient forebears, noting:
"Just like the idea of God as the highest abstraction of being, this idea
[of chosenness], too, is obviously nothing more than the product of
Jewish intellectual and moral ability, a result of the mental efforts of the

Jewish Volk – and this despite the fact that the Bible presents it as divine revelation."[785]

The result of this intellectual achievement was that Jewry became "intoxicated by the idea of its own chosenness" and the most striking result of this idea was "the fact of the continuing survival of the Jews, and their exceptional vitality and reproductive power. The Mosaic concept of an 'eternal people' appears to have been realized. This alone already demonstrates that the chosenness of the Jews is something other and deeper than the ordinary racial pride that could not prevent the decline of other, far more powerful peoples. It brought about the eternal existence of the Jewish Volk through the biological effects of its intellectual ideals and its moral law."[786] The German anthropologist and ethnologist Curt Michaelis dismissed Nossig's claims, arguing that the idea of "chosenness" stemmed exclusively "from the racial pride of the Jews," and, assessing the problems this presented for non-Jews, observed that: "Emboldened by this concept, the racial pride of the Jews becomes biogenetically fatal. It brought about isolationism, strict laws of endogamy, and contempt, cruelty, and hate for all other peoples."[787]

## Pre-Boasian Jewish Discourse on Intermarriage

The Zionist Elias Auerbach viewed Jewish intermarriage as not necessarily a problem providing the endogamous Jewish racial core population remained unpolluted by the taint of gentile blood. The offspring of mixed marriages (*Mischlinges*) are, he noted, overwhelmingly lost to the Jewish community – leaving the "sacred chain" of Jewish heredity within that community intact. As Kevin MacDonald pointed out in *A People that Shall Dwell Alone*, this had the eugenic effect of selecting for high levels of ethnocentricity among the remnant Jewish community. Those with low levels of ethnocentricity (manifested in a propensity for intermarriage) were lost to the Jewish community – leaving a hyper-ethnocentric endogamous core behind. Auerbach observes that:

In Germany at present (1903), the rate of Jewish intermarriage is approximately one sixth of pure (*rein*) Jewish marriages. This number is so large that one would be forced to derive from it a total and imminent dissolution of German Jewry. *A genuine intermixture, however, has only really taken place when the off-spring of this intermarriage then introduce this foreign blood into the Jewish Volk.* Now the fact of the matter is that the overwhelming majority of these offspring of mixed marriages (*Mischlinge*) withdraw from Jewry both religiously and nationally, shutting themselves off thereby from any union through marriage with the Jewish nation (*Stamme der Juden*); thus, they remove themselves from the equation, for the most part, when it comes to [our analysis of] racial mixture. The Jewish human material (*Menschenmaterial*) that we are analyzing from an anthropological viewpoint and that is the foundation of the Jewish race in the progressive movement of history will consequently have altered very little and remains a homogeneous mass; they [the Jews] seldom lose elements to another people through dissolution. A careful and scrupulous authority on this issue, the statistician Arthur Ruppin, estimates the number of offspring of mixed marriages who remain within Jewry to be only 10 percent of all offspring produced by the mixture of Jews and non-Jews in Germany. As to actual mixing of blood, we would thus have to figure that at only 1/60 of the racial stock of German Jews. However, even this small, though nevertheless not infinitesimal, number is valid only for Germany and for a few other countries, in which altogether a very small percentage of the Jewish people (*Stamm*) live.

If one goes back just a few decades, the number of Jewish inter-marriages declines precipitously in relation to the Jewish popu-lation overall. In Prussia the number of mixed marriage declines by half, if one goes back twenty years; for the Jewish population in general this occurs only when one goes back sixty years. Before

this period, around the turn of the nineteenth century, the inter-
mixing of the Jews [with other peoples] in Europe dwindles al-
most to the vanishing point. For the entirety of the Middle Ages
– and for Jewish racial history, the term "Middle Ages" is valid
up until the French Revolution – the number of intermarriages
was so minute as to be negligible, the more so as barely any off-
spring of such marriages mingled their blood with that of Jews.
The law of racial isolation of the Jews from the peoples around
them in Europe held true for the entire Middle Ages. [Italics in
the original][788]

Maurice Fishberg, a Russian-Jewish professor of medicine and anthro-
pologist who migrated to the United States in 1889, was far less
sanguine than Auerbach about intermarriage, declaring it to be "the
final result of the abjuration of nearly everything that has kept the Jews
alive among the nations for centuries." He argued that "Without the
separative tenets of its religious practices, Judaism is inconceivable and
in danger of extinction through absorption by the surrounding major-
ity of other faiths."[789] Fishberg echoed the view of the leading Zionist
newspaper in Germany, *Die Welt*, which in 1897 lamented that: "The
greater their [the Jews] distance from the ghetto, the more they will
lose their social, anthropological, and racial-hygienic particularities."[790]
Describing in 1911 how the rate of Jewish intermarriage had signifi-
cantly increased in Europe, Fishberg was careful to make it clear to his
readers that: "It should also be understood that while pointing at the
process of the assimilation of the Jews, we by no means advocate their
absorption by the surrounding people of different faiths. We do not
find it important for the remnants of Israel, or of those around them,
that Jewry should commit race suicide."[791]

Fishberg was sympathetic to the view of the Zionists who believed
that only in their own home, in Palestine, would Jews "be in a position
to save the remnants of Israel."[792] He notes that:

To the Zionists, the Jews are a distinct non-European race which has preserved itself in its original purity in spite of the Jews wanderings all over the globe. They [the Zionists] hold that the Jews can never merge with the European races and are bound to remain distinct from their Christian and Mohammedan neighbors. The Jewish problem can therefore not be solved by emancipation, as is evident in Western Europe, where they still have troubles after one hundred years of freedom and political equality. Nor will emigration solve the problem of the Jews in countries where they suffer from political oppression. "Like the previous migration of Jews, it has produced fresh trouble," says the Zionists in an "Official Statement to the Christian World [1907]." "These large numbers of poor Jews, are, at best, not welcome in the places to which they migrate. Their immigration is not that merely of an alien people who, whatever temporary inconvenience may be caused by their arrival, will soon merge in the general population of their new home. The immigration of Jews is different. They form or augment a body differentiated from the general population." They object to assimilation. With whom is the Jew of Eastern Europe to assimilate if he is to assimilate at all? Clearly not with the Russian muzhik or the Galician or Polish peasant. This is a proposal that a superior race shall be absorbed by a greatly inferior, a stronger by a weaker, a sober by a particularly unsober one, and is altogether contrary to the course of race absorption. The Jew has no mean opinion of the status of his race in the world. Purer than most, it is one of the oldest; its preservation is part, a great part, of his religious belief. He does not readily yield to it even to advance civilization.[793]

Nevertheless, Fishberg realized the existence of Zionism effectively confirmed the view of those who saw the Jews as an alien race in Europe, whose presence created a "Jewish problem" that directly gave rise to the "Jewish Question" of how the Jewish problem should be solved. He writes:

On the one hand we have those Jews who take great pride in the purity of their breed, and, on the other, the people among whom they live who see a peculiar peril in the prospect of indefinitely harboring an alien race which is not likely to mix with the general population. This apprehension is confirmed by the Jewish nationalists, who look for repatriation to Palestine, or some other territory, thus corroborating the opinion that they are aliens in Europe, encamped for the time being, and waiting for an opportunity to retreat to their natural home in Asia.[794]

Moses Hess, the Jewish philosopher and pioneering Zionist was one of those who conceived of the Jewish Question as a racial problem, rather than one about equal rights for a religious sect. The true historical essence of Jewishness was its biological racial roots. Like Theodor Herzl, Hess concluded that a national homeland in Palestine – rather than assimilation – was the proper resolution of the Jewish Question.[795] In 1862 he published *Rom und Jerusalem: die letze Nationalitätsfrage* (Rome and Jerusalem: A Study in Jewish Nationalism), in which he claimed that:

The Jewish race is one of the primary races of mankind that has retained its integrity, in spite of the continual change of its climatic environment, and the Jewish type has conserved its purity through the centuries. The Jewish race, which was so pressed and almost destroyed by the many nations of antiquity, would have disappeared long ago in the sea of Indo-Germanic nations, had it not been endowed with the gift of retaining its peculiar type under all circumstances and reproducing it.[796]

Perhaps the best-known instance of a *volkisch* manifesto in the history of Zionism was Martin Buber's 1911 essay "Zionism, Race, and Eugenics," a celebration of blood as the paramount essence of Jewish identity. Buber argued the Western Jew was rootless, that the languages and customs of his European hosts were alien to his essential being – having not stemmed from his "community of blood" (*Gemeinschaft seines Blutes*).

Nevertheless, Jews retained an "autonomous reality" beyond mere geo-political continuity with the past which "does not leave us at any hour in our life... blood, the deepest, most potent stratum of our being." When he envisions the line of ancestors that led to him, the Jew, Buber declared, perceives "what confluence of blood has produced him... He senses in this the immortality of the generations of a community of blood."[797]

The radical Zionist Vladimir Jabotinsky likewise insisted the source of Jewish national feeling should be sought "in the blood... The feeling of national identity is ingrained in the man's 'blood,' in the physical-racial type, and in it only."[798] In 1931, Arthur Ruppin joined the Zionist movement and lobbied for the "right of the Jews to come to Palestine not on some 'political' agreement and concession, but on their historical and racial connection to Palestine."[799] This remains an argument used by Zionist activists today: Australian Jewish leader Peter Wertheim, for example, slams as a "disgraceful falsehood" any claim Jews displaced Palestinians from their land on the basis that Jews "are indigenous to the Holy Land." With such claims in mind, Falk notes that "Zionism and race are as intertwined today as they were a century ago."[800]

### Pre-Boasian Jewish Discourse on Race Mixing and Eugenics

Agreeing with most European anthropologists of the time, the Austrian-Jewish anthropologist and physician Ignaz Zollschan believed that race mixing was a bad idea which would lead to the degeneration of the superior racial party to the admixture. He cited historical examples to bolster his position, noting how:

> The observations made in countries which have a population of half-breeds have pointed to the unfavorable effect of crossing... We also know very well the wretched conditions of Central and South America, which are inhabited by half-breeds whose cultural stagnation stands in striking contrast to the rapid and ambitious development of the United States and Canada. It is

certain that the conditions in Central and South America must, to some extent, be considered as a result of race crossing. It is true also in North America the population arose from a blending of various nationalities. But here it was chiefly Englishmen, French-men, Spaniards, Dutchmen, and Germans; that is to say, nations that were closely related to one another, who were amalgamated; whereas in South America it was Spaniards, Indians, Negroes, and Mongolians who formed affinities. Colonization in newly discovered countries has always succeeded in those places where, like in North America, the conquering nations have avoided crossing [with the indigenous peoples]. In Brazil, on the other hand, there rules an indescribable mixed type whose bodily, intel-lectual, and moral energy is exceedingly enfeebled. The natives of South Africa have a proverb: "God created the white man, God created the black man, but the devil created the mulatto."[801]

Based on these and many other examples, Zollschan concludes that: "All investigations thus point to the ennobling influences of racial purity, and the destructive effects of racial chaos."[802] He was also eager to point out that "We have proved by our investigations that the Jews have racial purity, and that an extraordinarily high racial value falls to their share."[803] Accordingly, Jewish intermarriage, as well as being the negation of the very essence of Judaism, was seen as likely to diminish the high racial value that he ascribed to Jews. Alfred Nossig shared this view, and noted that:

Numerous generations of thinkers and communal leaders have bred [*gezüchtet*] a [Jewish] Volk characterized by pure blood, not poisoned by venereal disease or alcohol; a Volk that has a marked sense of family, a deeply rooted habituation to the virtuous life, an unusual intellectual dexterity, and an ideal spirituality. Therefore, it was self-evidently necessary to establish strict guide-lines to protect these foremost ethical treasures from annihi-lation through intermixture with less carefully bred races. The

prohibition on intermarriage ensured that the primary component in racial formation, heredity, could operate at the height of its potential and power; not only did the positive qualities referred to above get passed on undiminished from generation to generation, but – thanks to endogamy, or inbreeding – they were constantly increased. That is what it took for the Volk that Ibsen called "the nobility of mankind" to emerge.[804]

On the other hand, Jewish race-mixing reverses, and ultimately extinguishes, the genetic fruits of centuries of eugenic practices that forged the supposedly superior qualities of the Jewish people. In his "Successes of the Jews in Capitalistic Enterprise" (1913), Arthur Ruppin maintained that the anti-Semitic environment of medieval Europe created selection pressures that honed the "formidable" intellectual resources of the Jews. He insisted that "the continual persecutions and restrictions acted as a sort of natural selection by which the less cunning and resourceful Jews were removed, and only the very cleverest – those who could extricate themselves from the greatest difficulties – were able to survive."[805] Ruppin compares the Diaspora Jew favorably with the typical German:

> In the struggle for life, besides intellectual gifts, the industry, versatility, and powers of adaptation of the Jew stand him in good stead. The Jew does not despair if one of his enterprises fails; he begins straight away with another. If he should be altogether unsuccessful in one calling, he is ready at once to take up another. In this he is totally unlike the German Christian, for example, who is slow to change his vocation, but similar to the North American, who also changes his profession without the slightest hesitation. The adaptability of the Jew is shown also in another direction; he changes his manner of living according to circumstances, without in the least being upset by the change. Thus he can exist on less than the European Christian, and yet not be satisfied with the best that money can buy. This is due

to the fact that the Jew, unlike, let us say, the German peasant, has no fixed standard of life; he is always in a state of uncertain equilibrium, always pushing forward, never satisfied, whereas the Christian is usually content when he has arrived at the standard of his class.[806]

Alfred Nossig was another Jewish intellectual who underscored the positive eugenic effects he believed Jewish survival in the European Diaspora inevitably yielded, whereby:

[T]he struggle for perpetual existence, which was a command-ment for chosenness as well, engendered a selective breeding that is almost unequalled in human history. In the struggle for existence of the [Jewish] nation – convulsed as it has been to its core by fire and sword, by the severest economic and moral pres-sures, and by the constant allurement of desertion – only those individuals who were intellectually and spiritually the strongest and physically fittest survived and reproduced; those who, to the greatest degree, did not place the existence of the Jewish people in danger, but who possessed the art or skill of adaptation. And thus, up until today, the Jewish Volk is taken to be the most skilled at adaptation.[807]

An editorial in the Zionist newspaper *Die Welt* in 1912 entitled *On the Jewish Racial Question* likewise insisted that advantageous Jewish racial traits were the fruits of the Jewish struggle for survival in the Diaspora, pointing out that "such [Jewish racial] traits are to be explained by the centuries-long difficult struggle for existence, together with the intimate cohesion of their original or primary living space. The Diaspora, in con-trast, stimulated their mental agility and the other acknowledged Jewish traits."[808] Counterbalancing the alleged superior intellect of the Jews, the neurologist Abraham Myerson noted their relatively higher suscep-tibility for neurosis and various other psychopathological conditions. For Myerson this tendency was likely the unfortunate, but unavoidable, flipside of "Jewish genius." He writes:

It is idle, or course, to deny that the Jew has an innate character, different from that of other races, which perhaps predisposes him to psychoneuroses and other mental diseases. Unquestionably deeply emotional, clinging to belief and opinion with a capacity unparalleled in the history of the world, extremely active mentally, and in point of intellectual achievement to be compared only with the great races of the world, he is curiously passive in his resistance and curiously indomitable in his hold on life and success. Accused of materialism and yet furnishing proportionately more social reformers than any other race; accused of materialism and yet responsible for the two most ethical religions in the world; said to be dominated by love of gain, but the birthplace of the ethics that govern his accusers, the Western peoples; a race of contradictions, inconsistencies, strongly individualistic and extraordinary social, it may well be that such a soil would produce great failure as well as great success, psychoneurosis as well as genius.[809]

For Myerson it was this Jewish intellectual superiority, rather than their ingroup-oriented morality and behavior, which was the primary cause of European anti-Semitism, insisting that: "with the downfall of the Roman Empire the Jews and Arabs alone kept the torch of culture and science lit. In other words, the Jew was easily superior in these matters [science and culture] to his uncouth warrior-like hosts. This superiority brought about a jealousy, fear of the ability of the Jew; a fear that has never been stilled, though the culture of the Western races has reached a very high plane; a fear that yet actuates most of the hostile feelings of neighboring races."[810] Ignaz Zollschan argued that Jewish endogamy benefited the whole world by preserving the superior Jewish racial traits he held to be an asset for all mankind:

> Now let us... accept provisionally the hypothesis of Jewish racial superiority. From this fact, and from the additional consideration that, generally, it would have to be the common pursuit of all

to reach the highest possible level of culture for the sake of the
totality of human civilization, it would follow that it would be
deemed valuable to retain the integrity of the [Jewish] race.[811]

Notions of racial purity and racial competition pervaded Zionist think-
ing in the early to mid-twentieth century, a time when "*volkisch* concep-
tions were firmly established among Zionist intellectuals."[812] Raphael
Falk notes how "Zionist writers appealed to biological conceptions of
race and nation and displayed an awareness of their responsibility not
only to serve this biologically circumscribed ethnic group but also
to propagate and improve it."[813] Many Zionists viewed evolutionary
theory "as a conceptual framework for understanding the detrimental
effects of Diaspora life and argued for the positive benefits that would
accrue to Jews in Palestine." Weikart observes that many "Jewish phy-
sicians, feminists and sexual reformers embraced eugenics" in the early
twentieth century.[814]

Several leading Jewish physicians and educators became flag bearers
of a campaign to promote the eugenic aspects of Zionism. In 1922, the
Zionist physician Mordechai Bruchov emphasized that: "In the struggle
of nations, in the clandestine 'cultural' struggle of one nation with
another, the one wins who provides for the improvement of the race, to
the benefit of the biological value of the progeny."[815] Parental guidance
articles and books published in Palestine from the 1920s emphasized
"the purity of the race and the quality of children required to improve
the nation," which "subsequently shifted to the need to increase the
birthrate in order to catch up with the high birthrate of the neighbor-
ing nations."[816] Jewish biologist Fritz S. Bodenheimer (1897-1959), the
son of one of Theodor Herzl's closest allies, stressed "the external threat
posed by the faster reproductive rate of the Arab population."[817]

Ignaz Zollschan, also active in Zionist politics, readily acknowledged
the existence of the "racial question" which consisted of the way "the
racial factor is significant for historical and cultural development."[818]
He regarded "the Jewish racial problem, as that in which the Jewish
Question culminates," and as being inseparable from the "vast problem

of race in general."[819] The Jewish Question was, for Zollschan, ultimately "a question of the principle of 'inheritance,' of 'immutability' of 'specific racial traits.'"[820] He writes that:

> When it comes to the racial politics within Europe, we are dealing in essence with a struggle of Germans versus *Romanen* [that is French, Italians and Spanish] as well as the struggle of Germans against Slavs, and the struggle of all the above against Jews. This latter opposition, between Aryans and non-Aryans, manifests itself in the sphere of European foreign affairs as a political opposition against the "black" and "yellow" dangers outside [of the continent]. For Europe the classic representatives of the Aryan and non-Aryan indeed are the Teutons and the Jews.[821]

Zollschan posited that: "Insofar as one cannot escape from the general interest taken in the Jewish Question, the issue ought to be considered by posing the following questions:

1. Are the Jews economically and culturally harmful, insignificant, or useful to the countries in which they reside?
2. Is there a homogeneous Jewish race, and, if so, does it possess distinct traits that determine its historical trajectory for all eternity?"[822]

A century on, these questions remain as pertinent as ever. One Jewish trait which the essays and articles in *Jews and Race* consistently evince is hyper-ethnocentrism, as reflected in the tendency for Jewish intellectual activity to become enmeshed with Jewish ethno-political activism. This trait continues to distort Jewish contributions to the humanities and social sciences. Another conspicuous trait is hypocrisy. With population genetic studies confirming that Jews are a distinct genetic community, Jewish intellectuals and activists have engaged in a double game where racialist thinking is tacitly permitted as a means of enhancing Jewish group cohesion, while White people who invoke the

same racialist arguments continue to be pathologized. Jews continue to attempt to have their cake and eat it too on the issue of concern for genetic continuity: supporting mass non-White immigration and opposing White identity and interests in the West, while supporting an ethnostate in Israel and taking steps to ensure Jewish genetic continuity in the Diaspora.

# Jill Soloway and the Jewish Transgender Agenda

A prominent feature of popular culture in the West over the last decade has been the increased promotion of transgenderism and "gender fluidity." In 2014, *Time Magazine* announced that the transgender moment had arrived, presenting transgender rights as the next great civil rights struggle. Hollywood's output over the decade reflected this new ideological fixation. The intellectual basis for this cultural crusade is ultimately to be found in the subversive doctrines of the Frankfurt School – in particular the conclusions of *The Authoritarian Personality* which found those who ranked highly on the ethnocentrism scale (i.e., those more likely to harbor anti-Semitic views) tended to live in worlds with rigid gender boundaries, where attractiveness was based on traditional ideas of masculinity and femininity.

Kevin MacDonald notes that "Jews, as a highly cohesive group, have an interest in advocating a completely atomistic, individualistic society in which ingroup-outgroup distinctions are not salient to gentiles."[823] It is, therefore, in Jewish interests to subvert all non-Jewish social categories – whether based on race, religion or gender boundaries and roles. Hence their enthusiastic championing of "fluidity" as the very antithesis of anything separate, homogeneous, or with clear boundaries. All of the evolutionarily-adaptive social categories that have characterized

Western culture have, in the past few decades, been subverted by Jewish activists motivated by fear of, and animus toward, White people. White masculinity have been a particular target. In his book *Theorizing Masculinities* the Jewish academic Michael Kaufman notes that:

> If the hypotheses so patiently investigated by the Frankfurt School were right, this was a masculinity particularly involved in the maintenance of patriarchal ideology – marked by hatred for homosexuals and insistence on the subordination of women. But it was not the only show in town. *The Authoritarian Personality* analyzed this character type in contrast to a "democratic character" that could resist the appeals of fascism. Inadvertently, therefore, the research documented different *types of masculinity*, distinguished along lines other than the normal versus pathological categories of clinical psychoanalysis.[824]

This association between traditional masculinity with rigid gender boundaries and "authoritarian personality traits" has been taken up and elaborated by others. A 2010 paper entitled "Gender, Sexuality, and the Authoritarian Personality" published in the *Journal of Personality*, claimed to "present new data and review old data from our laboratories that show the myriad ways in which authoritarianism is implicated in the important domain of gender roles." The authors claim to "show that women and men high in authoritarianism live in rigidly gendered worlds where male and female roles are narrowly defined, attractiveness is based on traditional conceptions of masculinity and femininity, and conventional sexual mores are prescribed."[825]

It logically follows, if one takes such views seriously, that those seeking to curb the prevalence of "authoritarianism" in Western societies – including Jews looking to suppress anti-Semitism – should attempt to break down traditional gender boundaries and sexual mores by subverting traditional conceptions of Western masculinity and femininity. This is exactly what we see: from organizations like the ADL, to the throngs of Jewish academics who dominate the humanities and social science

faculties of Western universities, and to the Jews that dominate the Western media and entertainment industries. Kevin MacDonald notes the fundamental agenda of *The Authoritarian Personality*, and those who espouse its doctrines, is "to undercut gentile family structure, but the ultimate aim is to subvert the entire social categorization scheme underlying society."[826]

## Jill Soloway: From Six Feet Under to Transparent

A prominent Jew who aggressively promotes the hypersexualization of culture, spurious notions of "gender fluidity," and fetishizes the "other" (i.e., everyone but White heterosexual males) is Jill Soloway, the creator of the transgender-themed show *Transparent*. Soloway has acknowledged that Jews in Hollywood are "recreating culture to defend ourselves post-Holocaust,"[827] and her own work can certainly be viewed in this light, with the *Jewniverse* website labelling her show *Transparent* "The New Trans TV Show That's Good for the Jews."[828]

Soloway grew up in a secular Jewish home on the north side of Chicago in a home with parents "who prayed to the gods of Woody Allen and Sigmund Freud." While eschewing the rituals of traditional Judaism, the message "that horrible shit happens for no good reason, and it happens even worse to the Jews" was constantly stressed during her upbringing. This Jewish victimology left an indelible mark on the young Soloway who noted in her memoir that: "My parents are the post-Holocaust generation... My mom came from parents who ran from pogroms."[829]

Soloway's mother, Elaine, the author of a memoir of her childhood in Chicago's Jewish ghetto in the 1940s, *The Division Street Princess*, worked in left-wing Chicago politics as a communications director. Her father is a retired psychiatrist who, bizarrely, at the age of 73, came out as "transgender." Soloway now refers to her father as her "parent" and her "mapa" and with the plural pronoun "they." This event was the genesis of her show *Transparent*.

Another "really huge influence" on Soloway as a child was the Jewish children's author Judy Blume. She claims "reading all her books as a young, kind of neurotic Jewish girl and seeing her kind of neurotic Jewish girls as protagonists allowed me to see myself as a protagonist... I love a kind of shambling outsider protagonist who always feels like they're 'other.'"[830]

Graduating from the University of Wisconsin-Madison as a Communications Arts major, Soloway traces the roots of her radical feminism to her time at the university in the 1980s when she "took a bunch of women's studies classes, and sort of got politicized." At this time she first felt the desire to take "feminism and Judaism – and try to translate them into the popular culture in a way that feels resonant with a non-feminist audience." For Soloway, Judaism and feminism have "always gone together," and notes how the radical Jewish feminist Andrea Dworkin "wrote that if you want to understand anti-Semitism, you have to understand misogyny – that the hatred of the Jew is really the hatred of the feminine."[831]

Before moving to Hollywood, Soloway and her lesbian activist sister Faith wrote plays including *The Real Brady Bunch*, *Not Without My Nipples* and *The Miss Vagina Pageant*. Arriving in Hollywood in 1992, they established a connection with the Jewish-controlled HBO where they pitched a pilot called *Jewess Jones* about a female Jewish superhero, but it failed to get picked up. Faith subsequently moved to Boston where she wrote and performed in "schlock operas" such as "Miss Folk America," "Jesus Has Two Mommies," and "Faith Soloway's Lesbian Cinema Schlock Treatment."

Jill stayed in Hollywood and kept submitting pilots while working on a string of sitcoms and reality shows. Inevitably, Jewish ethnic networking was decisive in her ascent through the Hollywood system. In 2006, she penned a story called "Courtney Cox's Asshole" which was published in a literary journal edited by the Jewish poet, novelist, and NPR commentator Andrei Codrescu. This story caught the eye of the director of HBO's *Six Feet Under* who hired her as a producer on the show. This, in turn, led to work as a producer on Showtime's *United*

*States of Tara* (five out of the seven producers of which were Jews) and *How to Make It in America* (created and produced by the Jewish writer and producer Ian Edelman). All three of these shows are about "dysfunctional families – whose work is unusually frank about gender and sexuality."

While working on these shows, Soloway kept trying to get her own television series. Being passed over by HBO in favor of fellow Hollywood Jewess Lena Dunham's series *Girls* prompted her to study Dunham's work. *Girls* is an incredibly degenerate show which glamorizes homosexuality, having multiple sex partners and abortion. There is an arc in the second season in which the main character (played by Dunham) dates a conservative White man, only to break up with him because his views are "immoral." It was seeing and admiring Dunham's work that prompted Soloway to undertake a six-week filmmaking workshop with the Jewish director and producer Joan Scheckel (who became a consulting producer on *Transparent*). Soloway has called Scheckel a "director's guru" who convinced her that she already had years of experience being at the center of a group of people and calling the shots: "Being a mom, being a Jewish woman control freak, means we're all just directing all the time anyway."[832]

After this crash course in directing and producing, Soloway wrote and directed her first movie, *Afternoon Delight*, a film which focuses on a bored therapist-frequenting Jewish housewife, Rachel, who "drops a bomb into her marriage when she takes in a stripper named McKenna, after receiving a mind-blowing lap dance from the sex worker." This 2013 film, shot in and around Soloway's own home, won her the directing prize at the Sundance Film Festival.

One Jewish source notes that: "While it would be incorrect to describe *Afternoon Delight* – which Soloway calls a 'coming-of-middle-age' film – as autobiographical, it is assuredly an amalgam of the Chicago native's passions: Judaism, feminism, sex, comedy and spirituality."[833] Soloway's Jewish hyper-ethnocentrism, radical feminism, and obsession with sexual non-conformists pervade *Afternoon Delight* and, indeed, her entire body of work. She observed that "sex workers, feminism,

queer art are all alive in the same space for me. In some ways, I feel like it's my work to be a translator between the queer world and the straight world."[834]

## Transparent

All of Soloway's ideological fixations (particularly her obsession with "otherness") are manifest in her show *Transparent* which is the story of Mort (Jeffrey Tambor) the elderly father of a Jewish family coming out to his three grown children as a transvestite – his ex-wife Shelly (Judith Light) already knows. He now wants to go full-time in women's clothing, be called "Maura," and be referred to as "she." Meanwhile, his son Joshua (Jay Duplass) is having an affair with the new woman rabbi. One daughter, Sarah (Amy Landecker), the mother of two children, leaves her husband for a lesbian lover from her earlier days. Another daughter, Ali (Gaby Hoffmann) is "pansexual, moody and masochistic," and especially enjoys "being bossed around by a transsexual man with a beard and a vagina."[835] *Transparent* is, in the words of *The Village Voice*, replete with "Adultery, abortion, threesomes, lesbians, transgenders, interracial hook-ups."

*Transparent* is Soloway's answer to the question she asked herself: "What would I do if I granted myself the same kind of artistic entitlement that [fellow Hollywood Jewess] Lena Dunham grants herself?" According to Jewish writer Anna Goldsworthy, writing for *The Monthly*:

> *Transparent* does bear some resemblance to Dunham's *Girls*: Jewish people behaving badly; indie soundtrack; assorted humiliations of the flesh (the slap of the over-lubricated dildo falling onto the public bathroom floor, as Ali experiments with a trans boyfriend). It is attention-grabbing television, with generous lashings of nudity, but it differs from *Girls* in that it believes in good sex and allows its protagonists to enjoy it. And if this sometimes looks like sex in the movies, it is salvaged by an attention to

everyday detail, such as the children's car seats hastily abandoned alongside the SUV in which Tammy and Sarah have their first tryst.[836]

The negative effect this kind of hypersexualized programming has on young people has been noted by psychologists Richard Jackson Harris and Fred W. Sandborn in their book *A Cognitive Psychology of Mass Communication*: "Teenagers who watch a heavy diet of television with sexual content were twice as likely to engage in sexual intercourse over the following year as teens who were light viewers of sexual content, even after controlling for other possible factors."[837] Record high rates of sexually transmitted diseases is just one negative consequence of the dysfunctional behavior encouraged by the hypersexualization of Western culture.

Noting how Soloway's salacious output rivals that of Lena Dunham and Jenji Kohan, creator of *Orange is the New Black*, one source makes the point that "All three shows explore the sexual 'other' and attempt to wrest depictions of female sexuality from the boys. These aren't new pursuits. *The L Word*, *Glee*, and even *Will & Grace* were pioneers for humanizing LGBTQ roles on television, while *Sex and the City* paved the way for a broader look at women's sex lives. But *Transparent* is the first to feature a fully fleshed-out trans character as the protagonist."[838] All of these shows were created and produced by Jews.

Soloway is proud to follow this path laid out by fellow Jews in "recreating culture to defend ourselves post-Holocaust," observing that: "My work privileges the Other, with a capital 'O,' meaning all kinds of other – Jewish, trans, gay, unattractive, weird, freaky, outsider, different, fucked up." She insists that "it's impossible for cis white men to understand how every, every, every other person has to synthesize the feeling of being 'otherized,' always."[839]

*Cis* being short for *cisgender*, a bogus etymological construction which supposedly describes a normal person who identifies with their actual gender. The term was first used by the (likely Jewish) "gender warrior and transactivist" Eli R. Green in a 2006 article in the *Journal*

*of Lesbian Studies*, and was then popularized by the transgender writer Julia Serano in "her" 2007 book *Whipping Girl: A Transsexual Woman on Sexism and the Scapegoating of Femininity*. A big fan of Serano, Soloway neglects to explain how Africans living in a homogeneously Black Africa, or Chinese living in a homogeneously Asian China (or billions of other non-Whites living in countries with few or no White men) are afflicted with "the feeling of being otherized always." Instead she claims to feel "less angry after having made *Transparent*, because the experience of watching *Transparent* privileges the other."

*Transparent*'s place at the vanguard of "mainstream pop culture's explorations of gender and sexuality" – alongside HBO's *Girls* and Netflix's *Orange is the New Black* – "isn't secured simply through its trans focus, but its multivalent privileging of the other."[840] Another commentator claims that: "It's very interesting that the most noted shows of two of the major streaming TV services, Netflix and Amazon Prime, are by women showcasing an astonishing diversity of female (and queer) characters."[841] While it may be interesting, this situation is hardly surprising given all of these women are Jewish, and a Jewish ethno-political agenda is the driving force behind their squalid output: the hypersexualization of culture and overthrow of traditional Western sexual mores, and, in recent years, the feminization of White men and the breaking down of traditional gender boundaries.

In addition to its highly sexual nature, *The Forward* declared *Transparent* "the Jewiest show ever," a sentiment echoed by *The New Yorker*. Soloway, referring to her show, told the Jewish journalist Daniel Fienberg:

> I want it to be super Jewy! I want it to be really, really Jewy. When I gave you that list of people who don't normally get consulted when pilots get ordered – Feminists, gay people, trans people – and Jews. There's a lot of Jewish writers, but the old adage is "Write Jewish, Cast British." You're supposed to write the Jewish anxieties, but then take out any references to Tu Bishvat and make sure that the actors look WASP-y. So I think I'm gonna

subvert that and write Jewish, cast Jewish, act Jewish, fall apart Jewish, make mistakes Jewish, cry Jewish. Even when I was working on [HBO's] *Six Feet Under* [2001-05], I was thinking, "One day I'm going to have my own show, and it's going to be about a family and it's going to be really Jewy and really sexy."

Naturally Jews and Judaism are *always* presented sympathetically in the show. According to Debra Nussbaum Cohen, writing for *The Forward*, Soloway's *Transparent* "shows a family – not a religious Jewish family, but one that is in many respects typically American – connecting with Jewishness in fits and starts, treating Judaism in an intimate and lovingly familiar ways."[842] Soloway's Jewcentric output has, not surprisingly, endeared her to the doyens of Hollywood's Jewish establishment. The Jewish television writer and producer Norman Lear, creator of the subversive 1970s comedy *All in the Family*, labelled Soloway his hero, noting that: "I'm utterly taken by *Transparent*, with lead actor Jeffery Tambor walking a line between hilarity and heartbreak."[843] The Jewish director, screenwriter and producer Darren Aronofsky has been similarly effusive, tweeting, "I gotta hang @jillsoloway #TransparentTV next to the best of Philip Roth."

In her promotion of sexual liberation and gender fluidity to help Jews "defend ourselves post-Holocaust," Soloway naturally opposes feminists who are "anti-porn," and favors "the modern feminists who are pro-sex worker, pro-porn, pro-choice." Despite trumpeting and propagandizing the alleged virtues of "diversity," she "is happily married to a Jewish man" and sent her son Isaac to a private Jewish day school. Asked in an interview why she did this, despite having written favorably of her parents' decision to send her to a public school, Soloway disingenuously claimed that: "It wasn't really the plan. Part of it was that my son is allergic to peanuts and the school is a peanut free environment. Also, I wasn't in a good public school district, otherwise I would have used the public school."[844]

It was while she was in the process of looking for a nursery school for her son that Soloway "rediscovered her Jewishness." After walking

into the Temple Israel in Hollywood she "knew immediately that this was where I want to be. After that I sort of rediscovered the tribe. I love being a community organizer and became very active with the East Side Jews and Reboot." A decade ago Soloway went on retreat with Reboot, an organization that, in its own parlance, brings together "Jewishly unconnected cultural creatives." This provided a welcome opportunity for Jewish ethnic networking, and many of the writers on *Transparent* are people Soloway met through Reboot and East Side Jews.

### Promoting the Idea of "Gender Fluidity"

The ideological glue that holds Jill Soloway's *Transparent* together is the deconstruction of the concept of gender. What does it mean to be a man? What does it mean to be a woman? As one character in the show puts it, "We're just a bunch of bodies, that's it. No penis, no vagina, what does it matter?" According to Soloway, "The show questions the binary; trans people question the binary. Trans-ness demands that people live in the gray. The word 'trans' is about traveling the space between the binary. Judaism/feminism/trans politics – they can all really be woven together. Living at that ground zero place of otherness is inspiring to me." Soloway is passionate about normalizing the concept of "gender fluidity" with *Paste Magazine* noting that: "In *Transparent* sexual identity loses its 'statehood' and becomes fluid, treated like an ongoing process with its own ebbs and flows."

The reality, as former psychiatrist in chief for John Hopkins Hospital, Dr. Paul McHugh, noted, is that rather than being a normal healthy behavior, "transgenderism" is a "mental disorder" that merits treatment. Changing sex is "biologically impossible," McHugh observes, and "People who undergo sex-reassignment surgery do not change from men to women or vice versa. Rather, they become feminized men or masculinized women. Claiming that this is civil-rights matter and encouraging surgical intervention is in reality to collaborate with and promote a mental disorder."

Those who believe that their maleness or femaleness is different to what nature assigned to them biologically suffer from "a disorder of 'assumption'" which is similar to a dangerously thin person suffering from anorexia who looks in the mirror and thinks they are overweight. McHugh notes how the sense of being transgendered constitutes a mental disorder in two respects: firstly, the idea of sex misalignment is simply mistaken – it does not correspond with physical reality; secondly, it can lead to grim psychological outcomes.

The suicide rate among transgendered people who had reassignment surgery is twenty times higher than the suicide rate among non-transgender people. Studies from Vanderbilt University and London's Portman Clinic of Children found that of those who at one time in their life expressed transgender feelings, 70 to 80 percent "spontaneously lost those feelings." Given these findings, McHugh claims that those who enable or encourage the "transgendered" to identify as such are validating and reinforcing a mental disorder.[845]

Soloway's *Transparent* plays exactly this role. Jeffrey Tambor, who won a Primetime Emmy Award for his role as Jewish trans parent Maura Pfefferman, met some parents who told him:

"We love your show... We really, really love your show." Their son called and said, "I don't want to go back to softball anymore, please don't make me go back." The parents said, "Why? What's wrong?" He [the son] said, "Daddy, mommy, I'm not a boy-boy." The parents asked, "What do you mean?" And he said, "Mommy, daddy, when I grow up, I want to be like Katy Perry."

Tambor went on to say the parents listened, and all three of them watch the show together. "My father wanted me to be a teacher, and in a way, Jill Soloway and company, we're sort of teaching about not fearing the other and not ostracizing people. I've always believed acting and laughter was instruction." So perhaps Jeffrey Tambor became a teacher after all. Teaching us a lesson that may be hard for some to hear, but as Jews we understand

what it is like to be "the other." We know the pain of exclusion, the history of separation, and the fear of living in a world that sees us as outcasts.[846]

By promoting "transgenderism" as normal behavior, McHugh notes that the "media are doing no favors either to the public or the 'trans-gendered' by treating their confusions as a right in need of defending rather than as a mental disorder that deserves understanding, treatment and prevention."[847]

The assumption, promoted by Jill Soloway, Jenji Kohan and others, that gender is only in the mind regardless of anatomical reality, has led "transgendered" people to push for social and legal acceptance and affirmation of their own subjective "personal truth." The result is that some states – California, New Jersey, and Massachusetts – have passed laws barring psychiatrists, even with parental permission, from striving to restore natural gender feelings to a transgender minor. McHugh notes the increasing prevalence of doctors who, working with very young children who seem to imitate the opposite sex, will administer "puberty-delaying hormones to render later sex-change surgeries less onerous – even though the drugs stunt the children's growth and risk causing sterility."[848] Such actions represent child abuse given that close to 80% of those children will abandon their confusion and grow naturally into adult life if untreated.

In 2012, the American Psychiatric Association announced a revision to its official guide to classifying mental illnesses – the DSM-5. The new, highly-politicized, DSM eliminated the term "gender identity disorder" in response to the pressure from LGBTQ (and Jewish) activists. The previous diagnosis meant that a man who believed he was destined to be a woman was considered mentally ill. The new DSM now only refers to "gender dysphoria" which focuses attention only on those who feel distressed by their gender identity. Gender dysphoria was only left as a diagnosis to ensure that a "transgender" person could still access "health care" if needed (e.g., hormone treatment and counseling). Many activists felt that the gender dysphoria diagnosis could be a powerful

legal tool when challenging discrimination in health insurance plans and services.[849]

These changes to the DSM were spearheaded by the Jewish psychiatrist and psychoanalyst Dr. Jack Drescher, the head of the APA group that approved the changes. One source notes that Drescher, the former editor of the *Journal of Gay and Lesbian Mental Health*, "grew up as an observant Jew in a kosher household."[850] On announcing the change, Drescher offered no scientific justification for it, but claimed the move "reduced the amount of stigma and harm that existed before."[851] Another Jewish member of the working group, the transgender rights activist, Dr. Dana Beyer, was likewise only concerned with the sociopolitical impact (rather than the actual scientific validity) of the changes. Writing in the *Huffington Post* she noted that "Our greatest accomplishment on the Working Group was reconceptualizing the state of 'being trans' from a mental illness to a normal human variant."[852]

Beyer would doubtless approve of the way Soloway's show "*Transparent* has gone a long way toward normalizing formerly foreign terrain for the American public." One of the show's stars, the Jewish actor Jay Duplass, considers *Transparent* to be "at the forefront of a civil-rights movement, but in a way that has Jill's irreverent, hilarious, deep, dark cloak over it. We're not, like, touting, 'Hey we're changing the world for transgender people!' We're just making a great family show that's weird and dark and funny but also part of this greater movement."[853] Noting the slyly subversive nature of *Transparent*, one journalist admired the show "not just for its entertainment value but for the layers of feminist questioning about sexuality behind it, which make her [Soloway's] programming plug into the brain's dopamine receptors all the more strongly."[854]

Soloway believes that the revolution in gender identity is only "at the very, very, very beginning," and looks forward to when "we're gonna look back at this moment 20 years from now and say, "Oh, remember when people had to only be male or female?" Her objective in producing shows like *Transparent* is "not to make all of the queer activists happy, because that's really quite difficult, and it's not really to change

the minds of super-right-wing Republicans. It's really to address this moveable middle. The largest group of people who are in between those two poles, who really just need information."[855] For "information" read subversive propaganda which chips away at the margins of White society and over time has an erosive effect – breaking down White heterosexual normativity to destabilize traditional society.

Given the Jewish domination of Hollywood and their ideological proclivities, *Transparent* was inevitably included in the list of winners at the 2015 Emmy Awards. Since its debut on Amazon Prime in 2014, the conversation around the place of transgenderism in Western culture has shifted dramatically. *Transparent* anticipated the most high-profile public gender transition in history, with Soloway's show promoting the "fluidity of gender and sexuality" before Bruce Jenner's asked us to call him Caitlyn on the cover of *Vanity Fair*. Soloway was delighted by Jenner's coming out as transgender and "actually had great conversations with Caitlyn and with Kim [Kardashian], awesome little moments where Kim told me that the family watched the show together. Caitlyn told me that she loved it."[856]

*Transparent* was normalizing the "transgendered" before the Jewish-controlled *New York Times* started running "Transgender Today," a series of high-profile feature stories published under the byline of the editorial board itself. And before Jewish *Time Magazine* journalist Katy Steinmetz wrote a flurry of articles promoting the normalization of transgenderism, with titles like "How transgender people choose their new names," "Exclusive: Inside Miley Cyrus' Photo Shoot With People Across the Gender Spectrum," "Miley Cyrus: You Can Just Be Whatever You Want to Be," "Meet TV's Newest Transgender Star," "The Case for Allowing Transgender Athletes in Youth Sports," "Lawmakers to Introduce Historic LGBT Non-Discrimination Bills," "Everything You Need to Know Over the Debate About Transgender People and Bathrooms," "Why Transgender People Are Being Murdered at a Historic Rate," and "San Francisco to House Inmates According to Gender Identity."

In 2014, the Anti-Defamation League launched a "Curriculum on Transgender Identity" which provides "an opportunity for high school students to learn more about transgender identity and issues, the barriers faced by people who identify as transgender or are gender non-conforming and how we can make our schools safe and welcoming for transgender and gender non-conforming students."[857] For the ADL, no child is too young to be subjected to "trans-positive" propaganda, and its website features a list of books it recommends for young children, which include: *George* ("When people look at George, they think they see a boy. But she knows she's not a boy. She knows she's a girl"); *10,000 Dresses* ("Every night, Bailey dreams about magical dresses but unfortunately, when Bailey's awake, no one wants to hear about these beautiful dreams"); *I am Jazz* ("From the time she was two years old, Jazz knew that she had a girl's brain in a boy's body"); *Jacob's New Dress* ("This heart-warming story speaks to the unique challenges faced by boys who don't identify with traditional gender roles"); *My Princess Boy* ("Dyson loves pink, sparkly things and sometimes he wears dresses"); and *When Kayla Was Kyle* ("Can Kyle find the words to share his feelings about his gender – and can his parents help him to transition into the girl he was born to be?").

Miley Cyrus, who, under the direction of her Jewish manager Larry Rudolph, transitioned from innocent child star to leading sluttish propagandist for complete sexual liberation and "gender fluidity," declared in 2015: "I am literally [sexually] open to every single thing that is consenting and doesn't involve an animal and everyone is of age. Everything that's legal, I'm down with. ... I don't relate to being boy or girl, and I don't have to have my partner relate to boy or girl."[858] That year she launched a photography series focused on "transgender and non-binary people" in order to increase "trans visibility."

Another show seeking to normalize transgenderism is *I am Jazz* which screened on TLC – a division of Discovery Communications which is headed by the Jews Robert Miron (chairman) and David Zaslav (President and CEO). A further initiative in the trans-normalization agenda was the film *About Ray* (2015) about a female teenager Ramona (Elle

Fanning) who realizes and pursues her "true identity" as a male called "Ray." "His" mother Maggie (Naomi Watts), lesbian grandmother Dolly (Susan Sarandon) and absent father Craig (Tate Donovan) must learn to accept "him" for who "he" is. This film is completely Jewish in origin, production, and distribution – being written and directed by Jewish lesbian activist Gaby Dellal (granddaughter of billionaire British Jewish property mogul Jack Dellal). Four of the film's five producers are Jewish, and the film was distributed by The Weinstein Company.

As previously mentioned, Jews push transgenderism and notions of gender fluidity because they associate rigid gender boundaries in White societies with authoritarianism (i.e., with fascism and anti-Semitism). The goal of breaking down traditional Western social categories is really just an extension of the broader Jewish "diversity" and multicultural agenda. By using their media power to normalize the abnormal, Jewish writers, producers and directors strive to create a public culture of limitless toleration for the "other" in order to ensure a limitless toleration of Jews. This was Soloway's essential point when she noted that Jews in Hollywood are "recreating culture to defend ourselves post-Holocaust."

# CHAPTER 16

# Jews and the Left

In Chapter 4 of this book I review Alain Brossat and Sylvie Klingberg's *Revolutionary Yiddishland: A History of Jewish Radicalism*, a shameless apologia for (and indeed glorification of) Jewish involvement in radical political movements in the early to mid-twentieth century. A book that covers much of the same ground, and which rehashes many of the same apologetic tropes, is *Jews and the Left: The Rise and Fall of a Political Alliance* by Philip Mendes.

An Associate Professor at Monash University in Melbourne, Mendes describes his book, published in 2014, as "the first publication to provide a systematic historical and political overview of the relationship between Jews and the Left."[859] Largely ignoring scholarly literature on the subject emanating from non-Jewish and non-philo-Semitic sources, Mendes insists that "With the exception of Arthur Liebman's outstanding 1979 text, *Jews and the Left*, there has been little systematic analysis of the Jewish-Left relationship."[860] Such an ideologically-selective survey of the literature leads him to conclude that, "the phenomenon of Jewish radicalism seems to have been seriously under-researched by both general students of sociology and history, and Jewish studies specialists."[861]

Unlike some of the more egregious Jewish propagandists and apologists who have contributed to the topic, Mendes makes no attempt to

deny disproportionate Jewish involvement in political radicalism, stating openly that:

> The disproportionate historical contribution of Jews to the political Left has been well documented. Both as individual theorists and activists of the stature of Marx, Trotsky, Rosa Luxemburg, Léon Blum and Emma Goldman, and as organized mass labor movements in, for example, revolutionary Russia and early-mid 20th century Warsaw, Amsterdam, Paris, Toronto, Buenos Aires, New York and London, Jews have been conspicuous for their socialist and communist affiliations.[862]

Indeed, Mendes points out that from about 1830 until 1970, an "informal political alliance existed between Jews and the political Left."[863] Many Jewish historians and intellectuals are, however, reluctant to offer any discussion, let alone objective assessment, of the dynamics of the Jewish-Left alliance, its scale, causes, and the extent to which radical Jews were motivated by explicitly Jewish concerns. Discussion of these issues are inhibited, he contends, "by concerns regarding the use of the alleged Jewish-Bolshevik conspiracy by the Nazis and other anti-Semitic groups," which is reflected in "the associated concern by many Jewish writers to minimize the role of Jews in radical movements."[864]

Another factor contributing to the Jewish reluctance to discuss the relationship between Jews and the left is the determination to absolve Jews of any responsibility for the horrific crimes of communist regimes. Maintaining a narrative of universal, trans-historical, and unparalleled Jewish victimhood is, or course, supremely important for the cadres of Jewish "diversity" activists and propagandists throughout the West, given the status of "the Holocaust" as the moral foundation of today's White displacement agenda. Free discussion of the Jewish role in communist crimes undermines Jewish pretensions to moral authority grounded in their self-designated status as history's preeminent victims. In contemporary academia there are, in addition, strong personal and professional disincentives for highlighting the Jewish role in communist

crimes, and it is, therefore, not surprising that non-Jewish historians and intellectuals are equally reluctant to recognize the Jewish backgrounds of many revolutionaries and to explore how their Jewish identity influenced their beliefs and actions. The Jewish-controlled media organs in the United States have conditioned most Americans to suffer a sort of mental allergic reaction to topics sensitive to Jews. The Jewish role in the Bolshevik Revolution and the administration of the Soviet Union and its satellite states is one such topic.

## Origins of the Jewish-Left Alliance

Mendes attributes disproportionate Jewish involvement with the left to four (frequently overlapping) factors: class and ethnic oppression, Jewish cultural values, leftist support for Jewish equality, and the urbanization and intellectualism of Jews. The Jewish population explosion in Eastern Europe during the nineteenth century contributed to the growth of an uncharacteristically large number of the poorer Jews who would inevitably be attracted to the economic egalitarianism of Marxist political movements. This was particularly the case in the Pale of Settlement where, while some Jewish families became very wealthy through moneylending, railway building, sugar production and exporting, most Jews were petty traders or artisans who worked long hours for relatively low wages. Throughout the second half of the nineteenth century "close to one-third of the Russian Jewish population of five million relied on charity. Chronic unemployment, limited education, overcrowding, poor hygiene, disease and high mortality rates were prominent."[865]

By contrast, most Jews in Germany and Austria were middle class, and the poorer Jews were frequently *Ostjuden*, immigrant Jews from Eastern Europe who mostly worked in petty trade or as manual laborers. Anglo-Jewry was also a comparatively affluent community consisting of bankers, stockbrokers, craftsmen and shopkeepers with only a small working class. As with Germany, the mass immigration of poor Eastern European Jews, who mostly settled in the East End of London from the 1880s, substantially increased the number of poorer Jews. The

French and Dutch Jewish communities were likewise characterized by a group of ultra-wealthy Jews, a comfortable middle class, and a poorer newly-arrived population of immigrant Jews from Eastern Europe who operated as street traders, or workers in the cigar, garment and diamond industries.

A high percentage of Jews who migrated from the Pale of Settlement to North America and South Africa were poorer Jews with radical political sympathies. Many Jewish immigrants in the U.S. worked for low wages in the clothing industry, with associated poor living conditions and ill-health. Poverty alone does not, however, explain the overwhelming draw of the left for Jews, and Mendes acknowledges that many of the most prominent Jewish radicals came from middle class and even wealthy backgrounds. The case of Hungary stands as a refutation of the thesis that Jews embraced communism most enthusiastically where their economic circumstances were poorest. Nowhere was the economic and social ascent of Jews as rapid as in Hungary in the half century before World War One. The prominence of Jews in the Hungarian Soviet Republic of 1919 is "all the more striking when one considers that the Jews of Hungary were richer than their coreligionists in Eastern Europe and remarkably successfully in attaining positions of status." Though only five percent of the population, on the eve of World War One Jews made up almost half the doctors, lawyers, and journalists in Hungary.[866] Despite this, of the forty-nine commissars who governed Bela Kun's short-lived Hungarian Soviet Republic, thirty-one were Jewish.[867]

Another part of the allure of Marxism for Jews was its intellectualism and replication of Judaic traditions of book-learning, exegesis and prediction. Many radical Jews noted similarities between their Marxist education and traditional Jewish religious classes, and "the term 'Talmudic' was often used to describe the complex interpretation and analysis of Marxist texts." One Jewish communist recalled that "we [the students] behaved like yeshiva bokhers and they [the instructors] like rabbis in relation to this training."[868] Mendes notes how the European left of the late nineteenth and early twentieth centuries included "vast numbers of left-wing Jews who rejected the Jewish religious faith, but

nevertheless identified as Jews in an ethnic and cultural sense."[869] It is only through classifying a Jew in this ethnic and cultural sense that one can "illuminate why so many Jews were drawn to left-wing movements, and equally why the association between Jews and the Left provoked such controversy during the late 19th and early to mid-20th century."[870] Such a definition encompasses key socialist and communist leaders like Karl Marx and Leon Trotsky, though Mendes excludes Lenin "whose part-Jewish background via his maternal grandfather, was only publicly revealed many years later."[871]

While poverty in the Pale of Settlement and cultural affinities between the Marxist and Jewish milieus undoubtedly added to the allure of communism for Jews, its chief attraction lay in the fact it rejected anti-Semitism. For Mendes, the extensive Jewish involvement in communism was a defensive and morally-justified response to the European persecution of Jews, and he claims that "many if not most of these Jewish activists were almost certainly influenced towards their radicalism by their Jewish origins and upbringing, and particularly by their personal experiences of anti-Semitism."[872] Such prominent Jewish revolutionaries are said to include Rosa Luxemburg, Julius Martov, and Pavel Axelrod. While this influence was "downplayed later on in response to the assimilationist atmosphere of the movement," a "surprising" number of radical Jews expressed

> concern about specifically Jewish issues, and solidarity with Jewish victims of anti-Semitism at particular points of their career. They included Anna Kulichev, Rosalie Bograd, Charles Rappoport, Julius Martov, Pavel Axelrod and Henri Polak. Even committed internationalists such as Leon Trotsky and Emma Goldman still demonstrated considerable sensitivity to, and interest in, the question of anti-Semitism. Other radicals such as the German revolutionaries Kurt Eisner, Erich Musham, Gustav Landauer and Ernst Toller also demonstrated considerable Jewish consciousness.[873]

While Trotsky claimed his Jewish origins did not influence his attraction to Bolshevism, his biographer Joshua Rubenstein notes he "was a Jew in spite of himself," who "gravitated to Jews wherever he lived," and "never abided physical attacks on Jews, and often intervened to denounce such violence and organize a defense."[874] As leader of the Red Army during the Civil War, Trotsky "had to deal with the anti-Semitic attitudes among the population," and "successfully recruited Jews for the Red Army because they were eager to avenge pogrom attacks"[875] At the same time, he "voiced his concern over the high number of Jews in the Cheka, knowing that their presence could only provoke hatred towards Jews as a group." Trotsky was feted by Jews worldwide as "an avenger of Jewish humiliations under Tsarism, bringing fire and slaughter to their worst enemies."[876]

Mendes falsely claims the butcher of the Ukrainians, Lazar Kaganovich, "rejected any link with the Jewish people," and was "actively hostile to Jewish concerns." Kaganovich began his political career battling the "anti-Semitic Black Hundreds, especially strong in Kyiv, both before and after the 1911 Beilis affair, the Russian version of the Dreyfus affair."[877] In response to attempts of the Black Hundreds "to whip up a pogrom," the "Bolsheviks took measures to protect themselves and to rebuff this threat," and "Kaganovich only joined the party after these momentous events." He was strongly influenced by Lenin's article "Stolypin and Revolution" which depicted the assassinated Russian Prime Minister Stolypin as "an organizer of Black Hundred gangs and anti-Semitic pogroms."[878]

### Evading and Excusing the Causes of Anti-Jewish Sentiment in the Pale of Settlement

The actual causes of the hostility of the native population toward Jews in the Pale, such as the Jewish monopolization of entire industries, including the sale of liquor, and centuries of predatory moneylending are evaded or excused by Mendes. Tsarist authorities repeatedly expressed alarm over how "Jews were exploiting the unsophisticated and ignorant

rural inhabitants, reducing them to a Jewish serfdom."[879] Initiatives to move Jews into less socially-damaging economic niches, through extending educational opportunities and drafting Jews into the army, were ineffective in altering this exploitative pattern. Noting this, even the revolutionary anarchist Mikhail Bakunin concluded that Jews were "an exploiting sect, a blood-sucking people, a unique, devouring parasite tightly and intimately organized... cutting across all the differences in political opinion."[880]

According to Mendes, to the extent Jews engaged in exploitative practices against non-Jews, the latter only had themselves to blame, with Jewish "cultural characteristics such as the practice of usury" having only "developed as a result of oppression."[881] Thus we are encouraged to believe Jews were compelled by "ethnic oppression" to lend money at extremely high rates of interest when they would have much preferred earning an honest living through physical labor. Moreover, Mendes (a putative Marxist) is unsure whether usury is even necessarily exploitative, with the anti-Jewish hostility of the native peasantry merely reflecting, in his view, their primitive susceptibility to "stereotypes concerning *allegedly* exploitative Jewish trade and financial practices."[882] [My emphasis]

In seeking to ignore or excuse the reasons Jews were hated in the Pale of Settlement and beyond, Mendes leads us inexorably into that last redoubt of Jewish apologetic historiography: the psychological inadequacies and moral failings of the European mind. According to this conception, Jewish behavior is irrelevant for understanding the hostility to Jews that has existed across nations and cultures for over two millennia. The ultimate source of anti-Jewish sentiment is said to reside in the fundamental incapacity of non-Jews to exercise reason and moral discernment. Andrew Joyce noted the tendency of Jewish historians to ascribe "to Christian/Western society a deep-seated psychological malfunction shot through with fantasy, repression, and sadism." Reflecting on this longstanding tendency of Jewish scholarship, sociologist John Murray Cuddihy called our attention to "the deeply apologetic structure of Diaspora intellectuality," whereby the Jewish "intelligentsia

'explains,' 'excuses,' and 'accounts' for the otherwise offensive behavior of its people."[883]

## Mendes' Critique of "the Myth of Judeo-Communism"

Mendes devotes a chapter of *Jews and the Left* to debunking of what he calls "the myth of Judeo-Communism." Having chronicled the incredible scale of Jewish involvement in radical political movements, including Soviet communism (while assiduously avoiding reference to specific examples of oppression and mass-murder committed by individual Jewish communist leaders and functionaries), he cannot, and indeed does not, attempt to deny the enormity of the Jewish contribution to socialism and communism. Nevertheless, he contends that "the statistical reality of Jewish prominence in left-wing movements is distorted and exaggerated to falsely equate all Jews everywhere and at any time with communism."[884] According to Mendes:

> These theories are based on an anti-Jewish construct that assumes the collective guilt of all Jews for the actions of some Jews who were or are communists. They stereotype all Jews as holding the same opinions even though Jewish political attitudes are highly diverse. Equally, they represent an attempt to delegitimize Jewish involvement in politics by suggesting that any political movements that include Jews are automatically contaminated by that connection. Most contentiously, they suggest that anti-Semitism can be justified as a form of self-defense against Jewish subversion.[885]

The assertion that non-Jews unfairly stereotype Jews by generalizing about their political allegiances prompts an obvious response: Jewish activists and community leaders are notorious for generalizing about groups *they* regard as potentially threatening. White people exhibiting *any* racial feeling (no matter how tepid) are *always* "white supremacists" and "Nazis." Likewise, political movements involving White

people who explicitly identify as White, and who seek to advance White interests are *always* "automatically contaminated by that connection." For Mendes, this ubiquitous Jewish stereotyping of non-Jews is uncontroversial, while *any* generalization made about Jews, regardless of how empirically grounded, is deemed illegitimate due to its epistemological inexactitude.

Mendes proposes that "anti-Semitic allegations of Jewish political power and repression constructed a reversal of cause and effect, in that Jewish leftism was almost always a response to, and consequence of, rather than objective cause of right-wing anti-Semitism."[886] Mendes here engages in what Andrew Joyce has dubbed the "cropped time-line version of Jewish history" where the historical chain of cause and effect invariably begins with non-Jewish malevolence; this despite the fact that Jews have elicited a strongly negative reaction from their hosts virtually everywhere they have dwelt over the two thousand years of the Diaspora.

For Mendes, it is natural and laudable that Jews would mobilize politically in defense of their common interests, claiming that "Jews have as much right to lobby and seek power as any other ethnic or religious groups."[887] However, in responding to Jewish economic predation and political subversion, rather than following this example by mobilizing politically in their collective interests, Europeans should, he insists, have introduced "social and political reforms which ended discrimination against Jews."[888] Mendes takes it for granted that all policies limiting Jewish economic and political activity were totally unnecessary and motivated by irrational hatred, and claims that "the anti-Semitic persecution of Jews included government-organized pogroms in late 19th and early 20th century Tsarist Russia."[889] As the late John Klier established, the history of "pogroms" in the former Russian empire has been systematically distorted for propaganda purposes.

## *The Protocols of the Elders of Zion*

Mendes traces the origins of "Judeo-Communist theory" to far-right individuals and groups in tsarist Russia who "regularly accused Jews of provoking revolution, and consequently of being responsible for provoking anti-Jewish outbreaks including pogroms."[890] The most powerful manifestation of this theory emanated from the *Protocols of the Elders of Zion*, first published in Russia in 1903, which announced a Jewish plan to establish a world government. Copies of the *Protocols* were distributed worldwide, and Mendes ascribes their huge impact to the fact that contemporary events lent support to the basic narrative of the *Protocols*, especially "the prominence of Jewish participation in the wave of revolutions (Russia, Hungary and Bavaria) that followed World War One."[891]

After the Bolshevik revolution, Jews quickly moved into important and especially sensitive positions in the bureaucracy and administration of the new regime, and, as a result, the first encounter with the new regime for many Russians was likely to be with a commissar, tax officer, or secret police official of Jewish origin. Following the dramatic reversal of fortune for Russian Jewry under the Bolsheviks, some Jews who had fled tsarist Russia returned to witness the unbelievable. It was "a topsy-turvy world" said one Jewish onlooker, "The despised had come to sit on the throne and those who had been the least were now the mightiest." That individual, A.S. Sachs, noted with exultation:

> The Jewish Bolsheviks demonstrate before the entire world that the Jewish people are not yet degenerate, and that this ancient people is still alive and full of vigor. If a people can produce men who can undermine the foundations of the world and strike terror into the hearts of countries and governments, then it is a good omen for itself, a clear sign of its youthfulness, its vitality and stamina.[892]

Even Winston Churchill and the American President Woodrow Wilson "accepted the argument that Jews were responsible for the Bolshevik

revolution."[893] The strong Jewish presence within the new Soviet regime, Mendes contends, only "reinforced popular belief in the Judeo-Communist theory, and seems to have contributed to an intensification of pogroms." The result of this was that "many non-socialist Jews were forced to turn to the lesser evil of the Bolsheviks and Red Army as their only chance for self-protection, and significant numbers of Jews joined the Soviet secret police (the Cheka). Some joined to revenge themselves upon the pogromists, but others were committed communists who regarded their Jewishness as irrelevant."[894]

Mendes catalogues the figures who, he maintains, "promoted the Judeo-Communist myth" in the United States, including the Southern Methodist University English Professor John Beaty, industrialist Henry Ford, and Father Charles Coughlin. Significantly, Mendes makes no attempt to refute a single assertion by any of these figures. Instead he declares that "We have noted in earlier chapters that the equation of Jews with socialism contains some element of truth. But as with other racist frameworks, the Judeo-Communist myth is based on an anti-Semitic construction that exists independently of any objective reality."[895] Based on this *a priori* assumption, Mendes sees no need to engage in actual argumentation. He also conveniently makes no mention in his book of the very prominent and documented role of Jews in financing the Bolshevik Revolution.

Another important source of the "Judeo-Communist myth" identified by Mendes is the Catholic Church, which from the 1871 Paris Commune onward closely associated Jews with revolution. The Polish Primate, Cardinal August Hlond and other leading Church officials defended the political exclusion of Jews, which they associated with atheism and Bolshevism. Hlond stated plainly that "Jewish Communists are running this country. Why does World Jewry allow them to take over the government and oppress the Christian people? ... As long as the Jews continue to rule, there will be trouble, and the people will retaliate."[896] Pope Pius XII himself was present in Bavaria during the 1919 Soviet Republic, and publicly declared that all the leading communists were Jews.

## Denying the Jewish Role in the Ukrainian Famine

Mendes sees a revival of "the Judeo-Communist theory" in Australian author Helen Darville's 1994 novel, *The Hand That Signed the Paper*, which posited that the collaboration of some Ukrainians with the Germans in World War Two could be attributed to the role played by Jewish Bolsheviks in imposing the genocidal Ukrainian famine of the 1930s. For Darville's central characters, anti-Jewish massacres were understandable revenge for earlier Jewish actions. For Mendes, Darville's book provides a "classic example of the way in which the Judeo-Communist theory both reverses the cause and effect of anti-Semitism and communism, and acts as a self-fulfilling prophecy... In short, it provides no explanation of the factors that drove many Jews to join the socialist movement. The historical context of anti-Semitism creating Jewish sympathy for Bolshevism is simply omitted."[897] This is a disingenuous analysis given Mendes' own gross misrepresentation of the context for Ukrainian anti-Jewish sentiment (i.e., casually dismissing centuries of economic predation).

In *Jews and the Left*, Mendes even asserts that "the argument that Jews as an ethnic group or even Jews as individual Bolsheviks played a significant role in the Ukrainian famine lacks any concrete evidence."[898] He evades discussion of the role of the Jewish Soviet leader in the Ukraine, Lazar Kaganovich, in overseeing the forced collectivization of 1932-33, conceived as part of an "assault on the Ukrainian nationalist intelligentsia." The country was sealed off and all food supplies and livestock were confiscated, with Kaganovich leading "expeditions into the countryside with brigades of OGPU troopers" who used "the gun, the lynch mob and the Gulag system to break the villages."[899]

Similarly omitted is any mention of the role of the Jewish-dominated secret police in the Ukraine led by Genrikh Yagoda (also Jewish) in exterminating all "anti-party elements." In his book *The Jewish Century*, Yuri Slezkine notes how "the Soviet Secret Police – the regime's sacred center, known after 1934 as the NKVD – was one of the most Jewish of all Soviet Institutions."[900] Furious that insufficient Ukrainians were being shot, Kaganovich set his secret police in the Ukraine a quota

of 10,000 executions a week. Eighty percent of Ukrainian intellectuals were shot. During the winter of 1932-33, 25,000 Ukrainians per day were being shot or left to die of starvation.[901]

Even non-Jewish representatives of the Communist Party in the Ukraine recognized the unmistakable Jewish role in the unfolding catastrophe:

> After some moments of hesitation, he [the Party representative] went on explaining that the Jews, generation after generation, had been brought up in the belief that the Ukrainians were anti-Semites, and responsible for the terrible and violent atrocities against them. This the Jews could not forgive nor forget. They know how to take revenge. It is a well-known fact, he continued, that the Jews, using the Communist Party as a springboard for their ambitions, have penetrated all branches of central and local governments, especially such branches as security and justice. Our local GPU, he pointed out, was entirely in their hands. They have been using these official positions for their own benefit. The Communist Party, announcing the policy of total collectivization and liquidation of kurkuls, had entrusted the local governments and special party representatives such as Thousanders almost unlimited power. The Jews took advantage of this power to take revenge against Ukrainians. They became overzealous in expropriating the grain from farmers, and causing starvation in Ukrainian villages. More than that, they pinned the labels "kurkul" and "enemy of the people" on the majority of the farmers without any justification and had them exiled to concentration camps and locked up in prisons.[902]

This Party member's initial hesitation to discuss the above was the result of laws in the Soviet Union strictly prohibiting anti-Semitism, where even "The slightest derogatory remark or even a joke that might have been construed as such could have brought severe punishment."[903] The famous dissident writer, Alexander Solzhenitsyn, devoted three

chapters of his book *Two Hundred Years Together* to the Jewish role in Bolshevism and its mass purges of Soviet citizens. Solzhenitsyn urged Jews to accept "moral responsibility" for their ethnic kinsmen who "took part in the iron Bolshevik leadership, and, even more so, in the ideological guidance of a huge country down a false path." He called on Jews to repent for their role in "the Cheka executions, the drowning of the barges with the condemned in the White and Caspian Seas, collectivization, Ukrainian famine – in all the vile acts of the Soviet regime."[904] While no authorized English translation of *Two Hundred Years Together* has ever appeared, the field of Soviet history, including of the Ukrainian famine, has lately been dominated by the work of Anne Applebaum, a Jewish-American journalist, who inevitably exculpates her own ethnic group from any prominent role in Soviet atrocities. Her work has been showered with awards and praise by our hostile elite.

## Poland

Alongside the Ukraine, Mendes claims the "Jew-equals-communist stereotype (*Zydokomuna*) was particularly virulent in Poland."[905] In the early years of the independent Polish state, including during the unsuccessful invasion by Trotsky's Red Army (1918-20), Polish anti-Jewish sentiment was activated by the large number of Jews who collaborated with the Red Army. Jewish membership of the Polish Communist Party fluctuated between 22 and 35 percent of the total. Jews were even more heavily represented in the party leadership: in 1935 they constituted 54 percent of the "field leadership" and 75 percent of the *technika* (responsible for propaganda).[906]

Matters came to a head during the Soviet invasion and occupation of Eastern Poland in 1939-41. Jews welcomed the Soviet presence, enjoyed a close relationship with the Soviet occupiers, and played a leading role in the short-lived Soviet administration and police, including among those responsible for the mass deportations of Poles to exile or death in the Gulag. According to Mendes, the enthusiastic collaboration of Jews with the Red Army "was driven by anxiety and fear and a feeling of

relief rather than pro-communist sentiments, and may have also been influenced by their negative experiences under Polish rule." He insists that Polish memories of the "alleged collaboration" of Jews with the Soviet authorities were "influenced by pre-existing stereotypes of Jewish-communism" rather than by their actual experiences. Most evidence of substantial collaboration, he argues, appears "to be impressionistic and exaggerated, rather than based on formal documentation... What cannot be doubted is that Poles deeply resented the positions of authority that some Jews (regardless of number) enjoyed under Soviet rule."[907]

## The Muscovites

Jews enjoyed unparalleled power and prestige within the Soviet establishment of the 1920s and 1930s. They were equally prominent as party leaders and functionaries, and particularly as members of the security police, in the post-war communist regimes in Eastern and Central Europe. Mendes notes how the "early prominence of Jews in these communist governments mirrored the rise of many Jews to powerful positions in the early Soviet Union."[908] These Jews were commonly known as Muscovites because they had spent the war in Moscow, were known for their loyalty to Stalin, and returned to their countries of origin in the wake of the conquering Red Army. These Jewish communist cadres were systematically entrusted with the most senior positions in the army, the diplomatic corps, economic management, and especially the security police.

In Hungary the five leading figures of the communist government – Mátyás Rákosi, Ernest Gero, Mihaly Farkas, Zoltan Vas and Jozsef Revai, were Jewish. Jews were also prominent in other Communist Party and government institutions, and constituted at least a quarter of the security police.[909] The conspicuous role played by Jews in the brutal Sovietization of Hungary led to anti-Jewish riots in 1946. The oppressive nature of the new regime can be gauged by the fact that between 1952 and 1955 "the police opened files on over a million Hungarians,

45 percent of whom were penalized," and "Jews were very salient in the apparatus of repression."[910]

In Czechoslovakia, Jews like Rudolf Slánský was Secretary-General of the Communist Party, Josef Frank deputy Secretary-General, and Stefan Rais Minister for Justice. Other Jews held powerful positions in the ministries of foreign affairs, trade, planning and propaganda.[911] Ana Pauker was the Foreign Minister of Romania, Secretary of the Communist Party, and arguably the most powerful person in the communist government there. Other Jews held prominent roles in the Romanian Communist Party and in the leadership of the secret police. Jews were equally prominent in the East German Party leadership, among them Albert Norden, Hermann Axen, Alexander Abusch and Gerhard Eisler.

In Poland, thousands of Jews "subsequently attained government positions in the new communist government, and many appear to have held leading roles in the Ministry of Public Security." Two Jews, Jakub Berman (responsible for the secret police and propaganda) and Hilary Minc (economic planning), held the second and third leading positions respectively in the government. Jews were deliberately placed in these and other key positions because the Soviet authorities feared a resurgence of nationalism in the countries they now occupied. Jews were seen as least likely to form an alliance with the local populace against the hegemony of the Soviets, as Tito had done in Yugoslavia. Mendes notes how "these Jews were loyal communists who could be relied on to introduce unpopular policies and defend Soviet interests amidst hostility from the nationalist intelligentsia. They were often highly educated and able to speak foreign languages, which made them valuable assets in areas such as propaganda, education, and foreign affairs and trade."[912]

In the newly conquered nations of Eastern and Central Europe, the Soviets had few reliable supporters, and because they were familiar with local conditions and "fanatically antifascist," Jews were often chosen for the security police.[913] Desire for ethnic revenge was an unmistakable motivation for the many Jews who flooded into the ranks of the security police, who viewed "the new political regimes as an opportunity to take revenge on those who had killed their family and friends, and/

or prevent a repeat of pre-war anti-Semitism."[914] The Soviet authorities knew that the population of these countries was strongly anti-Jewish, so they tried to conceal the fact there were Jews in leading positions, and Mendes observes that:

> concerns about the conspicuousness of Jewish communists were aired from time to time both by the Soviet Union and by the Jews themselves. For example, Ana Pauker refused to take the leadership of the Romanian Party on the grounds that the people would not accept a Jewish woman as leader. Both Rákosi and Gero actively discouraged the prevalence of Jews in Hungarian communist groups due to their fear that it would alienate other potential sources of support, such as the peasants. Władysław Gomułka, the prominent Polish communist, wrote to Stalin in 1948 complaining that too many Jews had been appointed to leading positions in the Communist Party, and that they lacked an allegiance to the Polish nation. Both the Bulgarian communist leader, Georgii Dimitrov, and the leading Russian Communist, Molotov, advised the new Hungarian communist government to limit the number of Jews in public positions.[915]

Both the Soviet leadership and local communists were aware of the risk of elevating Jews to power in countries with strong anti-Jewish traditions, and the potentially negative implications for the Party. In 1953, Mátyás Rákosi was removed from the Hungarian Party leadership in favor of the non-Jewish Imre Nagy. Later, Khrushchev vetoed the proposed appointment of Zambrowski as Polish Party leader in 1956, commenting: "You have too many Abramoviches in your leading cadres."[916] The reign of the Muscovites concluded once Stalin and Khrushchev identified sufficiently reliable indigenous communists to take their place. The purges of the early 1950s eroded significant Jewish influence in most Eastern European communist parties. By the mid-1950s, a generation of Jewish communists had fallen from power. It would not be until after the fall of the Soviet Union in 1991 that an

Eastern European country would again fall under the domination of a group of Jewish oligarchs – and a decade of misery and impoverishment followed for most of the Russian population.

## Redefining the "Left"

Since the 1960s, and particularly in the post-Cold War era, the left has progressively abandoned the tenets of orthodox Marxism for a (now corporate-capitalist-backed) Cultural Marxism based on the Critical Theory of the Frankfurt School, which Mendes describes as having "introduced a much more fluid and broad range of ideas that seek to liberate numerous groups beyond those principally disadvantaged by social class."[917] After World War Two, the Frankfurt School abandoned attempts to appeal to the White working class because they had succumbed to fascism in Germany and Italy. This prompted a rejection of the orthodox Marxist emphasis on class struggle and a new emphasis on non-White identity politics and advocacy of non-White immigration and multiculturalism, as well as recruiting Whites who had complaints against the traditional culture, particularly feminists and sexual minorities, into a new coalition of the left. Mendes notes that:

> the lesson that most Jews worldwide (even radical Jews) drew from the Holocaust was that the great working-class movements of Europe had failed to defend the Jews from genocide, and that any future defense strategy would have to be based primarily on the Jews' own resources. This disillusionment was encapsulated in the Marxist intellectual Isaac Deutscher's famous statement that his "confidence in the European labor movement, or more broadly, in European society and civilization... had not (been) justified." Both Deutscher and the former leader of pre-war Polish Trotskyism, Hersh Mendel, abandoned their earlier opposition to Zionism. Mendel even migrated to Palestine, and became a "proletarian Zionist."[918]

While the support of working class Europeans for fascism in the 1920s and 1930s was the most shocking and traumatizing of the "sharp disappointments" that afflicted Jews wedded to international communism, there were several others. Mendes catalogues the other events that prompted Jews to progressively abandon orthodox Marxism, which included: the communist support for the 1929 anti-Jewish riots in Palestine, the 1936-38 show trials which targeted many Soviet Jews, the 1939 Soviet-Nazi Pact, and Stalin's anti-Jewish campaign of 1948-53, which adversely affected Jews throughout the Eastern Bloc. Mendes notes that:

> Sadly, many Jewish identifying communists were among the leading apologists for a number of these actions by the Soviet Union, which proved to be an enemy rather than a friend of the Jews. Those left-wing Jews not already disillusioned were later confronted by the Soviet Union's support for the Arab states during the 1967 Six Day War, and the 1968 anti-Jewish campaign in communist Poland. And many younger Jews drawn to left-wing ideas by the Vietnam War were alienated by the pro-Palestinian position adopted by much of the New Left. For some progressive Jews, the final betrayal came as recently as 2000-2003 when sections of the Left celebrated the suicide bombings of the second Palestinian Intifada.[919]

In the pre-WWII period, Jewish intellectuals (not exclusively Marxist) were deeply impressed by the Soviet Union's outlawing of anti-Semitism, and its creation of a putative Jewish homeland in Birobidzhan. For many, this presented a practical and potentially more viable alternative to Zionism and Palestine. In the first two decades after the Bolshevik Revolution, Jewish communists held an overwhelming faith and trust in the Soviet Union as a protector and ally of Jews. This unqualified support for the Soviet Union was not dissimilar to the uncritical pro-Israel views held by many Jews today. Radical Jews could cite Soviet initiatives and actions which appeared to justify their loyalty,

including the fact that the Soviet Union had taken strong measures to eliminate anti-Semitism, a crime under the Soviet constitution, and Lenin's declaration that "anti-Semitism is counterrevolution."[920] They lauded the Soviet Union as "a powerful ally in the world-wide struggle against anti-Semitism." Left-wing Jews more generally believed that "the international working class could be relied on to defend the civil and political rights of Jews."[921]

A common refrain of Jewish communists in the first two decades after the Bolshevik Revolution was that a successful revolution based on the Soviet model would ensure the protection of Jews all over the world, and Mendes notes how many Jews joined left-wing groups precisely because they were convinced that a socialist victory would bring about a complete end to anti-Semitism. For example, Julius Braunthal, a prominent Jewish socialist in Austria, commented:

> I think that the structure and spirit of a Socialist society precludes the emergence of anti-Semitism. I believe that in fact Socialism is the only solution of the Jewish problem, in the sense of the emancipation of the Jewish people (as every oppressed people) from any moral or social discrimination or disability.[922]

As representatives of the group that stood to gain most from the victory of an international movement that transcended national boundaries and promoted the universal brotherhood of man, Jews were inevitably "amongst the strongest initiators and defenders of the Left's internationalism."[923] This explains, in part, why American Jewish radicals were prominent among those who eagerly swallowed the false reports of *The New York Times'* Moscow correspondent Walter Duranty disputing reports of widespread famine in the Ukraine resulting from the forced collectivization of agriculture. It was only Stalin's anti-Jewish campaign of 1948-1953 that finally and irrevocably disillusioned many Jewish communists, and prompted the realization that "they had actually supported a regime which was murderously anti-Semitic rather than philo-Semitic. The nexus between Jews and communism had come to an

end."[924] The result was a mass-migration of Jews away from orthodox Marxism and into the New Left and neoconservatism.

## Jewish Involvement in the New Left

In *Jews and the Left*, Mendes recounts the disproportionate Jewish involvement in the New Left – a political movement that began in the early 1960s when students travelled to the southern states to support the emerging "civil rights" movement. In the mid-1960s, the movement switched to northern campuses to advocate student rights, free speech and opposition to the Vietnam War. This was the time when the ideas of Frankfurt School intellectuals like Erich Fromm and Herbert Marcuse began to displace orthodox Marxism in leftist movements throughout the West. Mendes notes that:

> Jews contributed significantly to the theoretical underpinning of the New Left. From 30 to 50 per cent of the founders and editorial boards of such New Left journals as *Studies on the Left*, *New University Thought*, and *Root and Branch* (later *Ramparts*) were of Jewish origin. Radical academic bodies and think tanks such as the Caucus for a New Politics, the Union of Radical Political Economists and the Institute for Policy Studies were overwhelmingly Jewish. A number of the key intellectual gurus of the New Left such as Paul Goodman, Noam Chomsky, Howard Zinn, and Herbert Marcuse were also Jewish.[925]

The Jews who flooded the ranks of the New Left in the early-to-mid 1960s "appear to have been largely assimilated third-generation Jews from Old Left backgrounds [i.e., red diaper babies], although some had participated in Labor Zionist Groups." Studies of American Jewish New Left activists reveal many had grown up in highly politicized left-wing family environments. Jews made up two-thirds of the "Freedom Riders" who went south in 1961, and about one-third to one-half of committed New Left activists in the U.S. including key leaders such

as Abbie Hoffmann and Jerry Rubin. In 1964, one-half to two-thirds of the volunteers who flooded Mississippi to help register black voters were Jewish. Around one-third of the leaders of the Free Speech Movement (FSM) demonstrators at Berkeley in 1964 were Jewish, including over half of the steering committee (e.g., Bettina Aptheker, Suzanne Goldberg, Steve Weisman, and Jack Weinberg who coined the famous phrase "You can't trust anyone over thirty").[926] Moreover:

> In 1965 at the University of Chicago, 45 per cent of the protestors against the university's collaboration with the Selective Service System were Jews. At Columbia University in 1968 one-third of the protestors were of Jewish origin, and three of the four student demonstrators killed at Kent State in 1970 were Jewish. Jews comprised a large proportion of the leaders and activists within Students for a Democratic Society (SDS). Some of the key leaders included the founder Al Haber, Todd Gitlin and Mark Rudd. Approximately 30 to 50 per cent of the SDS membership in the early-mid 1960s were Jewish.[927] At one point in the late 1960s, SDS presidents on the campuses of Columbia University, University of California at Berkeley, University of Wisconsin (Madison), North Western University, and Michigan University were all Jews. Jewish participation in SDS was particularly high at Pennsylvania University and the State University of New York. There was also a number of Jews in the violent Weathermen group.[928]

In accounting for the Jewish domination of the leadership and prominent activist ranks of the New Left, Mendes proposes a range of contributing factors, chief among them "the impact of the Holocaust (and, sometimes, personal experiences of anti-Semitism)." Mendes quotes former SDS leader Mark Rudd who noted that: "World War II and the Holocaust were our fixed reference points. We often talked about the moral imperative not to be good Germans. We saw American racism as akin to German racism towards the Jews."[929] Many Jewish SDS activists

had a strong Jewish identity and this influenced their politics through informing the struggle against "the institutions of racist, imperialist, capitalist America."[930]

Many Jewish feminists were also strongly influenced by their Jewish identity and their tribe's supposed "history of oppression." Betty Friedan specifically linked to the development of her feminist views to "anti-Semitism":

> I think my passion against injustice came from my experience of being a Jew in Peoria. I wouldn't be the first of our people to have taken the experience of injustice, the passion against injustice, which, if it's not in our genes, is certainly a product of centuries of experience, and applied it to the largest human category of which one is a part. Jews have been very, very present in centuries of revolutions against one form of injustice or another, one form of oppression or another.[931]

Many of the prominent early leaders of the feminist movement in the United States were Jewish, such as Gloria Steinem, Betty Friedan, the author of *The Feminine Mystique* and first President of the National Organization for Women (NOW). Co-founders of NOW included Susan Brownmiller, Shulamith Firestone and Naomi Weisstein, whilst Muriel Fox and Karen Lipschutz DeCrow held executive roles. Other prominent Jewish feminists included Andrea Dworkin, Phyllis Chesler, Letty Cottin Pogrebin and Gerda Lerner. A large number of the founders of the feminist movement in the UK, such as Eva Figes, the author of the influential 1970 text *Patriarchal Attitudes*, were also Jewish.

Jews comprised between a third and a half of the leaders of the French New Left, including prominent individuals like Alain Krivine, Alain Geismar, Andre Glucksmann and Daniel Cohn-Bendit. Eleven of the twelve members of the political bureau of the Trotskyist *Ligue Communiste Revolutionnaire* were Jewish. Mendes notes that "about three-quarters of the members of Trotskyist groups in the Paris area were identifiably Jewish. Jews were also very well represented among

those students who occupied the universities and engaged in other radical activities, such as confrontation with the authorities and the police."[932] Many Jewish participants in the French New Left came from relatively affluent backgrounds, and had communist or anarchist parents who "had spent the war in Nazi or Soviet camps." Like their American counterparts, they recognized "the specific influence of the Holocaust" on their political commitments.[933]

A key difference between Jewish involvement in the Old Left and the New Left was the fact the latter barely provoked any anti-Jewish backlash. While there were isolated incidents (the best known being a reference in the French media to the prominent New Left radical Danny Cohn-Bendit as a "German Jew"), no organized campaign targeting Jews for their New Left radicalism emerged. Some Jewish leaders nevertheless feared the prominence of Jews in the New Left would provoke an anti-Jewish backlash or discredit the movement by stereotyping it as Jewish.

Despite the Jewish domination of the American left in the post-War period, Mendes notes that "most Americans do not appear to have adhered to the same anti-Semitic assumptions about Jewish links with communism that dominated public opinion in parts of Europe."[934] As evidence of this, he cites the decidedly muted public response to the conviction and execution of Julius and Ethel Rosenberg for selling atomic secrets to the Soviet Union. Despite the recognizably Jewish identity of the couple (given their name), and of all of their co-conspirators (David Greenglass, Ruth Greenglass, and Morton Sobell), and the fact the Rosenberg spy network consisted almost exclusively of Jews from the Lower East Side of Manhattan, the case "provoked remarkably little overt anti-Semitism."[935] Nor, he observes, did the "significant number of Jews – including teachers and Hollywood actors – who were victims of anti-communist purges" and the prominence of Jews amongst those subpoenaed by the House Committee on Un-American Activities, lead to a significant reaction. All public opinion polls conducted during this period showed a consistent decline in anti-Semitism, and only a

small minority of those surveyed (about 5 percent) identified Jews with communism.[936]

The lack of any real backlash to Jewish prominence in the New Left is ascribed to various factors: that many members of the public were not aware of the Jewish background of many of the radical leaders; that these Jewish radicals were ostensibly "not campaigning about any specifically Jewish issues that would have focused attention on Jews per se;" and to the "general decline in anti-Semitism since World War Two."[937] This latter shift in public opinion (unsurprisingly) coincided with the Jewish seizure of the commanding heights of American (and Western) culture in the 1960s, and the growing emergence of the culture of "the Holocaust." The combined effect was to banish overt critical discussion of Jewish power to the margins of public discourse. While Americans opposed communist activities during the Cold War, they did not widely equate communism with Jews (at least publicly), or view Jewish participation in leftist politics with particular concern.

## Neoconservatism

Neoconservative leaders were among those feared that the Jewish prominence in the New Left of the late 1960s and early 1970s would fuel a conservative backlash against Jewish radicalism. For example, Norman Podhoretz, the editor of *Commentary* magazine, attacked leading Jewish leftists as "self-hating Jews" and as completely unrepresentative of the Jewish community.[938]

Mendes ascribes the defection of many Jews from the radical left to neoconservatism in the 1970s to a growing misalignment between modern leftist politics and Jewish ethnic interests: the key factor being "the creation of the State of Israel which transformed Jewish dependence from international to national forces."[939] With the advent of the state of Israel, Jewish interests were no longer exclusively represented by the universalistic agendas of the left. According to Mendes: "Most Jews have lost their faith in universalistic causes because they do not perceive the left as supportive of Jewish interests, and have turned

382 - BRENTON SANDERSON

instead to nationalist solutions."[940] The creation of a Jewish national entity featuring (thanks to American taxpayers) a strong and powerful army meant that Jews all over the world could look to the Zionist state to safeguard their interests rather than depending on internationalist movements and ideologies (i.e., communism and the Soviet Union) which had proven to be unreliable allies. Even many left-wing Jews, who might have been anti-Zionist prior to World War Two, shifted their position after the birth of Israel. For example, the long-time Austrian Jewish leftist Jean Amery commented in 1976:

> There is a very deep tie and existential bond between every Jew and the State of Israel... Jews feel bound to the fortunes and misfortunes of Israel, whether they are religious Jews or not, whether they adhere to Zionism or reject it, whether they are newly arrived in their host countries or deeply rooted there... The Jewish State has taught all the Jews of the world to walk with their head high once more... Israel is the virtual shelter for all of the insulted and injured Jews of the earth.[941]

The perceived anti-Zionism of the New Left from 1967 onwards served to alienate many Jews and confirm their commitment to nationalist, rather than internationalist solutions. An additional factor was the 1967 Six-Day War in the Middle East, which provoked fears of "another Holocaust," and galvanized even non-Zionist Jews in support of Israel. There were rallies in support of Israel throughout the Western world accompanied by large donations. American Jews held massive fund-raising campaigns and reportedly raised 180 million dollars. Numerous volunteers travelled to Israel to support the Jewish State. In Australia, more than 20 per cent of the Jewish population attended public rallies to express their support for Israel, and 750 young Jews volunteered to go to Israel. According to Taft:

> There was a widespread, almost universal, absorption in the Middle East Crisis of June among the Jews of Melbourne. This

absorption took the form of extreme concern about the safety of Israel, emotional upsets, obsessive seeking of news, constant discussion of events and taking spontaneous actions to support Israel's cause.[942]

The rise of left-wing anti-Zionism after the Six-Day War further alienated sections of Western Jewry from the social democratic left. Another factor that pushed American Jews in a neoconservative direction was the decline in Black-Jewish relations. The emergence of the Black Power movement in the mid-1960s led to the removal of Jews from the leadership of organizations like the NAACP. Black hostility was seen by some Jews as evidence of the failure of the longstanding strategy of courting non-White groups to advance Jewish interests. This failure prompted many Jews to concentrate on a narrower ethnic self-interest.[943]

This, in turn, contributed to the creation of "pragmatic alliances" with conservative political parties such as the Republicans and evangelical groups such as Christians United for Israel which "have been consistent supporters of Israel in the USA." An associated factor was that pro-Israel perspectives within Western countries increasingly emanated from mainstream conservatives, rather than from the moderate or radical left. This occurred despite the fact "many in these groups hold socially conservative views on issues such as abortion, homosexuality, the environment, multiculturalism, state support for the poor and disadvantaged, and refugees, which are anathema to many Jews."[944] Mendes makes the point that "These alliances were based solely on the latter's position of support for Israel, irrespective of their conservative views on social issues such as abortion, homosexuality and the welfare state, which were often sharply at odds with the more liberal opinions of most Jews."[945]

Despite the defection on many Jews from the radical left to neoconservatism, most American Jews still see their ethnic interests as basically aligning with the Democratic Party. Their willingness to prioritize their ethnic interests over their personal economic interests is reflected in the fact that "high numbers of affluent Jews compared to others of the same

socioeconomic status still vote for moderate Left parties that do not seem to favor their economic interests." Today, the economic factors that historically drew many Jews to the left no longer pertain. Most Jews sit comfortably in middle or even higher-income categories. This "middle-classing" of Jews has meant the "Jewish proletariat that motivated Jewish identification with left-wing beliefs no longer exists."[946] Consequently, "the specific link between Jewish experience of class oppression and adherence to left-wing ideology has ended."[947]

## Most Western Jews Still Support Parties on the Left

Despite the widespread break with the radical left over support for Israel, Jews nevertheless remain a "massively significant presence" in the left in terms of their numbers and fundraising, their organizational capacity, and their impact on popular culture.[948] It was estimated that about a quarter of the world's leading Marxist and radical intellectuals in the 1980s were still Jews, including Ernest Mandel, Nathan Weinstock, Maxime Rodinson, Noam Chomsky, Marcel Liebman, Ralph Miliband, and the founder of deconstructionism, Jacques Derrida. Despite continuing to comprise much of the intellectual and financial backbone of the left, today's Jews, "an influential and sometimes powerful group, with substantial access to politics, academia and the media," no longer must "rely on the Left to defend their interests and wellbeing."[949]

The primary reason most Western Jews still vote overwhelmingly for parties on the left is the perceived threat posed by the "social conservatism" of parties further to the right of the political spectrum in majority European-derived, notionally Christian, nations:

> With the possible exception of ultra-orthodox groups, Jews seem to prefer social liberal positions on issues such as religious pluralism, abortion, feminism, illicit drugs, same-sex marriage, the science of climate change and euthanasia. Another significant factor is the long history of Christian anti-Semitism has led

Jews to remain suspicious of any attempts by Christian religious groups to undermine the separation of church and state. This fear of organized religion [and of the White people who practice it] seems to explain the continued strong support of American Jews for the Democratic Party in presidential elections. A further complicating factor is the growing universalization of Jewish teachings and values, including the lessons of the Holocaust, in support of social liberal perspectives. ... For example, Berman (2006) presents evidence that the younger Jewish generation in Australia have been influenced by the experience of the Holocaust into taking a strong stand against any forms of racial or religious discrimination. Many are active in campaigns for indigenous rights, and to support refugees from Afghanistan, Sudan, and Middle Eastern countries seeking asylum in Australia.[950]

This advocacy is, of course, entirely hypocritical and cynical. While promoting pluralism and diversity and encouraging the dissolution of the racial and ethnic identification of White people, Jews have endeavored to maintain precisely the kind of intense group solidarity they decry as immoral in others. They have initiated and led movements that have discredited the traditional foundations of Western society: patriotism, the Christian basis for morality, social homogeneity, and sexual restraint. At the same time, within their own communities, they have supported the very institutions they have attacked in Western societies. This is ruthless, uncompromising Darwinian group competition played out in the human cultural arena.

The ideological preoccupations of organized Jewry today are reflected in comments by *Boston Globe* writer, S.I. Rosenbaum, who insisted the main lesson of "the Holocaust" is "that white supremacy could turn on us at any moment," and the strategy of appealing to the White majority "has never worked for us. It didn't protect us in Spain, or England, or France, or Germany. There's no reason to think it will work now."[951] The central question of Jewish political engagement in Western societies, she insists, is "how we survive as a minority

population," where the one great advantage American Jewry enjoys is that "unlike other places where ethno-nationalism has flourished, the U.S. is fast approaching a plurality of minorities." Presiding over a co-alition of non-Whites groups to actively oppose White interests is the new Jewish ethno-political imperative: "If Jews are going to survive in the future, we will have to stand with people of color for our mutual benefit."

Jewish writer David Cole questioned the wisdom of this strategy of using non-Whites as "golem" to protect Jews from a recrudescence of National Socialism. He notes that many of the Jews' non-White pets (like Ilhan Omar) have a disconcerting tendency to turn on their Jewish masters:

> For decades, leftist Jews have been flooding the West with Third World immigrants, "Hey here's a plan – let's dump a hundred thousand Somalis in the whitest parts of the U.S. *That'll* save us from Fargo Hitler!" Inundating the West with non-White immigrants is seen by Jews as an insurance policy against "white supremacy." The idea is that these immigrants will act as a wedge, diluting "white power" while remaining small enough to be manageable.

> Jews have done this everywhere – playing two groups against each other as a way of assuring Jewish security. Let's play Hamas against the Palestinian authority. Let's play ISIS against Assad. ... But today we live in a world in which even the lowliest bark-eater in the Kalahari can have internet access. It's not as easy to fool entire groups anymore (individuals, sure, but not an entire race, ethnicity or faction). ...

> And now we Jews, so worried that Minnesota might become the Frozen Fourth Reich if left in the hands of evil whites, have created for ourselves a good old-fashioned golem in Ilhan Omar (and a bunch of the other Third World freshman congressthingies).

Yeah, Omar hates whites. Yeah, she thinks white supremacy lurks behind every glass of milk and "OK" finger sign. But she hates Jews a hell of a lot more...

In a perfect world, the Rabbinical Rain Men would finally get the fuck over the Holocaust and end their war of hostility against the West. They'd see that whites are no longer the enemy, but indeed the opposite. They'd see that importing foreign mud to mold golem in traditionally white regions of the U.S is bad strategy.[952]

This strategy is, nevertheless, regarded by Jewish leaders and activists steeped in the cult of "the Holocaust" as a risk worth taking in their quest to demographically, politically and culturally disempower White populations. In the minds of most Jewish leaders and activists, White Nationalism remains the most ominous threat to Jewish survival. This is reflected in their unquestioning commitment to mass non-White immigration and multiculturalism in all historically White nations.

## Conclusion

While *Jews and the Left* offers a useful catalogue of Jewish involvement in radical political movements over the last two centuries, it recycles many of the same apologetic tropes that permeate the work of other Jewish historians and intellectuals. Mendes mischaracterizes the Jewish identity and affiliations of important Jewish communist leaders (like Lazar Kaganovich), and offers no examination of their often-murderous actions. He offers feeble apologies for the Jewish practices that engendered intense hostility among the native peasantry in the Pale of Settlement. The inherent weakness of his position necessitates specious argumentation and desperate resort to that evergreen of Jewish apologetic historiography: the supposedly inveterate irrationality and malevolence of the European mind and character. This is the invariable fallback position in any attempt to exculpate Jews from responsibility for the crimes of communism. Though less inclined than Brossat and

Klingberg to glorify Jewish communist militants, Mendes is equally keen to evade, sanitize and morally excuse disproportionate Jewish involvement in some of the worst crimes of the twentieth century.

# Leonard Bernstein and the Jewish Cultural Ascendency

2018 marked the centenary of the birth of Jewish-American conductor, pianist, composer and teacher Leonard Bernstein. This milestone saw a global bonanza of some 2,500 concerts, programs, exhibitions and theatrical productions. Bernstein features prominently in the pantheon of "Jewish geniuses" as designated by the West's Jewish-dominated cultural and intellectual establishment. Bernstein's centenary year inevitably yielded hagiography: for his Jewish biographer Allen Shawn, he was not just a "genius" but "a powerful cultural and political voice and symbol, transcending all categories."[953] Mark Horowitz, curator of an exhibition at Philadelphia's Jewish museum celebrating Bernstein's "pride of tribe," fully endorses this view, while for the music writer for *The New Yorker*, Alex Ross, Bernstein remains "American music's dominant figure."

Bernstein lived during the heyday of the recording industry, at the dawn of the television era and of video recording. He left behind what is possibly the most extensive documentation in recordings, films, and on paper of any musician in history. His archive at the Library of Congress already lists some 400,000 items.[954] During the 1950s and

1960s Bernstein was not only the best known of all American classical musicians; his fame rivalled that of Elvis Presley or Marilyn Monroe. Attitudes to Bernstein varied dramatically during his lifetime, and many responded negatively to the fact he was so visible, so outspoken, so dramatic, and so politically active on the left.

Famous for his flamboyantly extroverted temperament, Bernstein was a "personality on such a big scale that he would naturally manage to offend many people along the way... His self-regard and need for attention were also, to be sure, extreme."[955] Bernstein's brash self-confidence and monstrous ego incurred the enmity of many people he encountered. He "loved to be the center of attention, even if it meant being obnoxious" observed a fellow student at the Curtis School of Music who noted that his "extroversion was extreme."[956] John Rockwell, writing for *The New York Times* in 1986, observed that "It is quite a remarkable personality, for better and for worse, that defines every aspect of his near-manic existence. There are those who still find him inherently annoying – when he shoots off what he likes to call his 'big Jewish mouth,' when he prances and gyrates on the podium, when he seems to squander his compositional gifts in flashy trivia or overwrought excess."[957] Bernstein's own children pointed out his unsurpassed ability to become emotional on his own behalf, to "move himself."[958]

Bernstein's unusual, extremely emotional, visual presentation was his trademark as a conductor. He conducted with his entire body in a style that led to much criticism and derision over the years. German composer Gunther Schuller, for example, observed that Bernstein was "one of the world's most histrionic and exhibitionistic conductors." Schuller saw Bernstein as a musician with "very little discipline and no shame," whose interpretation of Brahms' First Symphony contained "too much of an 'oy-vey' *Weltschmerz* to be bearable."[959]

Bernstein's conducting style was modelled on Dimitri Mitropoulos, the flamboyant Greek conductor he met while at Harvard in 1937. Under this influence, the art of conducting turned into what Bernstein defined as "an erotic act" involving "a love affair in which you [the conductor] and a body are breathing together, pulsing together, lifting and

sinking together. I'm making this sound too lurid or sexual? It is sort of sexual, but it's with a hundred people."[960] Perhaps not coincidentally, Bernstein, a promiscuous homosexual, was seduced by the equally wanton Mitropoulos.

Aside from Mitropoulos, Bernstein was mentored and promoted by a succession of Jewish conductors and composers. These included Fritz Reiner and Serge Koussevitzky, the conductor of the Boston Symphony Orchestra and Bernstein's teacher at the Berkshire Music Center at Tanglewood, Massachusetts. In Koussevitzky, Bernstein "found a champion and father figure," while for the older conductor "it was the discovery of a surrogate son and potential successor."[961] Koussevitzky, a Jew who converted to Russian Orthodoxy to advance his career, hoped Bernstein would eventually succeed him as conductor of the Boston Symphony, but worried his homosexual tendencies (which he called "pederastical") and his Jewish name would harm his chances.[962]

Bernstein was appointed assistant conductor at Tanglewood in 1942 where he was known to enter a classroom and "hug, touch, and embrace everyone in sight." There he worked closely with the composer Aaron Copland who (while 18 years his senior), as a Jewish homosexual communist, had much in common with Bernstein, and quickly became more than just a father-figure to the "Boston boychik" (as the young Bernstein was known). Letters between them "show that they had briefly been lovers, with Bernstein recalling the time he and Copland had spent together: 'I've never felt about anyone before as I do about you, completely at ease, and always comforted by you. This is not a love letter, but I'm quite mad about you.'"[963] Copland, as promiscuous as Bernstein, though more discrete, was involved in a "sometimes bewildering series of personal relationships with younger men."[964] Within musical circles at Tanglewood, Copland was "assumed to show too much favor to young gay and/or Jewish musician-acolytes."[965]

Another Jewish homosexual communist who bonded with, mentored and promoted the young Leonard Bernstein, was the composer Marc Blitzstein. It was Bernstein's association and collaboration with Blitzstein that first "gave rise to notes on the young musician and his

'left-wing associations' in a folder at the Federal Bureau of Investigation."[966] The FBI were notified by an informant that "80% of the faculty of the Tanglewood group are Communists."[967]

## Conductor of the New York Philharmonic

On November 14, 1943, a twenty-five-year-old Bernstein stepped in for an ill Bruno Walter at a New York Philharmonic concert at Carnegie Hall – an event that effectively launched his conducting career. The press, alerted beforehand, "went wild with praise." His debut made the front page of *The New York Times* which gave ecstatic coverage of the event. Bernstein was aggressively promoted by this and other Jewish-controlled media organs: in the two weeks after his debut with the New York Philharmonic he was interviewed and promoted by *Life, Time, Newsweek, Pic, Look, Vogue, PM, Pix, Harper's Bazaar, The New York Times, The Herald Tribune*, the *Jewish Forward*, the *Jewish Telegraphic Agency, Jewish Day, The New York News, The New York Post*, and *The New Yorker*.[968]

In 1958, Bernstein displaced Mitropoulos as the youngest ever music director of the New York Philharmonic, a position he held until his retirement in 1969. Bernstein's rise to this exulted position coincided with the Jewish seizure of the commanding heights of American culture. Allen Ellenzweig, writing for *Tablet*, notes how: "After World War II, it seemed as if American culture high and low had been taken over by the Jews: Danny Kaye in the movies, George Burns and Milton Berle on television, Norman Mailer and Saul Bellow in literature, Arthur Miller in theatre, Jerome Robbins in ballet and on Broadway, Leonard Bernstein on Broadway and in the concert hall."[969]

In the first half of the twentieth century WASPs still controlled American culture and the American people were generally more ethnocentric and aware of (and antagonistic to) the subversive Jewish influence on American society. The Jewish challenge to the cultural supremacy of the WASP elite (and America's once powerful Catholic lobby), might, in the absence of active Jewish efforts to prevent it, led

to a backlash against undue Jewish influence on American culture and mores. Efforts to forestall such a backlash included the novel *Gentleman's Agreement* by Laura Hobson (born Zametkin), and its Academy Award winning film adaptation released in 1947 which decried the "unspoken snobberies of the American suburbs that allowed for 'restricted' hotels, country clubs, and golf courses and signaled that Jewishness remained a problematic social marker."[970]

The Jewish domination of the film and television industries around this time transformed the American cultural landscape. Neal Gabler has described how the Jews that ran Hollywood "colonized the American imagination... Ultimately American values came to be defined largely by the movies the Jews made. Ultimately, by creating their idealized America on the screen, the Jews reinvented the country in the image of their fiction."[971] By the mid-1960s, the Jews of Hollywood had usurped the WASP cultural elite and became more explicit in their Jewish identification and sympathies – together with their antipathy for the traditional people and culture of the United States. Explicitly Jewish themes began to regularly appear in films and were invariably portrayed sympathetically. The Jewish film director David Mamet makes the unambiguous point that "Hollywood movies are profoundly, genetically Judaic; the product, via the minds of their creators, of certain distinctive racial traits that arose in the ghettos of Eastern Europe and transported themselves to Beverly Hills."[972]

### Bernstein's Political Radicalism

This Jewish takeover of American culture (high and low) was accompanied by a dramatic shift in the political sensibilities of the cultural elite. Bernstein had grown up in a Jewish home in Massachusetts where his father, a Jewish immigrant from an ultra-Orthodox shtetl town in the Ukraine, held forth on "subjects running from Talmudic meditations and the history of the Jewish people from biblical times to their plight under Nazi power in Europe."[973] In Jewish homes in the 1930s, talk frequently centered on "the condition of American Jewry and devotion

to President Roosevelt, whom many Jews saw as a bulwark against foreign and domestic fascists such as Father Coughlin, whose broadcasts reached across the nation, and other anti-Semites."[974]

Bernstein pursued a musical career against the wishes of his father. His paternal grandfather was the last in a long line of rabbis in the family tree. While breaking this family tradition, Bernstein's businessman father nevertheless remained "devout, intense, rule-bound, sometimes harsh" whose "principle reading matter and point of reference for all things, worldly and unworldly, was the Talmud."[975] His personality was marked by "consuming ambition and penny-pinching."[976]

Bernstein from his young adulthood joined and openly advocated for various communist front groups, beginning with the John Reed Society while an undergraduate at Harvard in the 1930s. This inevitably attracted the attention of the FBI, as did his support for organizations opposing Franco's Spain; his appearances at rallies and functions with known communists Paul Robeson, Dashiell Hammett, Billie Holliday, Rockwell Kent, and Lorna Horne; and his membership in the Council on African Affairs, the National Negro Congress, and the National Council of American-Soviet Friendship. In December 1946, Bernstein's FBI file (which would ultimately run to 800 pages) records an informant's declaration that he was "a communist."[977]

This claim is bolstered by Bernstein's open support for the Jewish communist composer Hanns Eisler when Eisler was threatened with deportation from the United States as a threat to national security. A committed Marxist, Eisler left Germany following Hitler's ascent to power, eventually settling in Hollywood where he was nominated for Oscars for writing the music for the films *Hangmen Also Die* (1942) and *None but the Lonely Heart* (1944). In 1947, Eisler appeared before the Un-American Activities Committee (HUAC) and, despite the intercession of Bernstein, Albert Einstein and Aaron Copland, was deported to East Germany in 1948 where he remained for the rest of his life, writing music for the totalitarian state (including its national anthem, and the Comintern anthem). Instead of reproaching Eisler for his ardent commitment to a regime and ideology that destroyed millions of lives,

Jewish commentators invariably portray him as the innocent victim of the anti-Semitism of the Third Reich, the HUAC hearings and the Hollywood blacklist.

As was typical for a generation of Russian Jewish immigrants and their offspring, Bernstein's political radicalism existed alongside a "staunchly pro-Zionist" outlook. In April 1947, he paid an emotional first visit to Palestine – then a British protectorate with a one-third Jewish population. He arrived in the middle of a tense conflict between rival Jewish groups over how best to achieve the independent Jewish state mandated by the Balfour Declaration. The terrorist Irgun, led by Menachem Begin, battled with those seeking a political solution. There he bonded with members of the Palestine Symphony Orchestra (all Jewish despite the name) and conducted a concert in Tel Aviv consisting of his *Jeremiah* Symphony, the Ravel Piano Concerto, and Schumann's Second Symphony. The audience responded "with an overwhelming ovation and tears. With his ability to speak Hebrew, his affinity for the place and its people, and the passionate bond he had created with the members of the orchestra, Bernstein felt himself deeply at home."[978] Bernstein would conduct the orchestra, later renamed the Israel Philharmonic, frequently without fee for the rest of his life.

Bernstein was blacklisted by CBS radio and television in 1950, the year he was listed as a dangerous subversive in the pamphlet *Red Channels: The Report of Communist Influence in Radio and Television* which listed the names of 151 writers, directors and performers who had been members of radical organizations before World War Two – over one-third of whom were Jewish. In June that year he was banned from official State Department functions overseas as a "loyalty and security risk." In 1951, his name was placed on a list of prominent individuals to be placed in detention facilities in the event of a "national emergency." Shawn observes how this "put him at risk of scrutiny by the House Un-American Activities Committee (HUAC) and to attacks by the anti-communist crusader Senator Joseph McCarthy."[979] Bernstein had good reason to suspect that, if he wasn't careful, his entire conducting career (and all that went with it) would be in jeopardy.

396 - BRENTON SANDERSON

Despite the threat, Bernstein participated in a trip to Washington by delegates from the film and Broadway communities in support of the "Hollywood Ten" screenwriters who had opposed testifying before the HUAC. The members of the Hollywood Ten were subsequently cited for contempt by Congress and fired by the studios, and the Hollywood blacklist became official. A prime source of the animus against Hollywood as identified by one member of the House Committee, Congressman John Rankin from Mississippi, was "the large number of Jews eminent in the film industry. ... In Rankin's mind, to call a Jew a Communist was a tautology."[980]

### The "Homintern"

Worried his homosexual activities would prevent his landing a major conducting appointment in the conservative world of classical music, Bernstein married actress Felicia Cohn Montealgre at the Temple Mishkan Tefila in September 1951. They married on the clear under-standing that so long as Leonard did not embarrass Felicia publicly, he was free to pursue his homosexual affairs. That the marriage yielded three children led some to assume Bernstein was bisexual. According to one of his collaborators on *West Side Story*, however, "Bernstein was simply 'a gay man who got married. He wasn't conflicted about his sexual orientation at all. He was just gay.' As was customary at that time, Bernstein appeared a devoted husband and father in the public eye, while carrying on a promiscuous homosexual life behind the scenes."[981]

Bernstein's marriage was a response to the "Lavender Scare" that coincided with the anti-communist movement of the 1940s and 1950s, when homosexuals were targeted as potential security risks. Thousands of civil servants, uniformed service members, and teachers across the country were fired from their jobs as blackmailable risks to national security who were engaged in moral turpitude. In 1950, the head of the Republican National Committee warned that "the sexual perverts who have infiltrated our government in recent years" were "as dangerous as the actual communists." *Human Events*, a newsletter read in power

circles in Washington DC, declared in 1952: "[B]y the very nature of their vice," homosexuals "belong to a sinister, mysterious, and efficient international." A 1951 article in H.L. Mencken's *American Mercury* insisted publishing was under homosexual control, producing a literary culture that was "chic, artificial, and possibly effeminate," thereby abetting a "gradual corruption of all aspects of American culture."[982]

As concern about international communism often centered on the Comintern, the Soviet-sponsored Communist International with representatives around the globe, concern about homosexuals led to an equivalent coinage: the "Homintern." The "Lavender Scare" impacted on the coterie of homosexual Jews clustered around Bernstein during the 1940s and 1950s, including David Diamond, Aaron Copland and Jerome Robbins. A friend of Bernstein noted how during this time in New York, "They all went to bed with each other but was all very casual. Like a Turkish bath. Anyone who showed up." Jewish leftist homosexuals like Aaron Copland, Leonard Bernstein, Jerome Robbins, Arthur Laurents, and Lincoln Kirstein developed "mixed communal and professional networks to reach cultural prominence," and "Within cosmopolitan circles, all were discreetly known as transgressing the heterosexual norms of the postwar period."[983]

Bernstein bonded with Jerome Robbins, a choreographer with the Ballet Theatre in New York. Born to Russian and Polish Jewish immigrants, Robbins (Rabinowitz) had become a member of the (then legal) Communist Party in 1943.[984] Bernstein and Robbins collaborated to produce *On the Town* in 1945, a show combining elements of classical, jazz, boogie-woogie and blues, and which was "the first racially-integrated musical on Broadway, starring a Japanese-American, Sono Osato, as the all-American girl Miss Turnstiles." *On the Town* contained pioneering multicultural and race-mixing propaganda which included black and white dancers clasping hands while singing "New York, New York, a helluva town" two decades before a White woman touching a Black man's arm on television triggered a scandal. The show also promoted feminism, celebrating "the modern American woman" who was "confident, employed, and sexually bold."[985]

## *Off the Blacklist*

In July 1953 the U.S. Passport Office refused to renew Bernstein's passport due to the extensive record compiled by the FBI on his radical political affiliations. Desperate to travel to Italy to make his conducting debut at La Scala opera house in Milan, he hired a lawyer known for clearing political reputations who had once been on the side of the investigators. The result was

> a humiliating exoneration that must have both relieved him and crushed his self-respect. The long affidavit he signed made light of all the times he had lent his name to a cause or appeared at a function, saying that he had endorsed letters and petitions casually, without knowing what they contained. He admitted that he was mistaken not to have immediately "made a public disavowal" of the associations implied by photos seen in *Life* magazine or portrayed in the pages of *Red Channels*. He pronounced himself a "foe of communism."[986]

Signing the affidavit made a mockery of his contempt for the investigations, which he regarded as "a farce" and "part of a strategy to undermine support for legitimate revolutions abroad."[987] The affidavit made possible his trip to Milan and, after he made additional assurances, cleared the way for his participation as composer in the film *On the Waterfront*, written by Budd Schulberg, directed by Elia Kazan, and featuring Lee J. Cobb – each a HUAC informer.

These informants to the HUAC were certainly not alone: the film director Robert Rossen (born Rosen) explained to the committee in 1953 why he had joined the Communist Party in the 1930s and remained a member "until revelations of Soviet anti-Semitism disillusioned him. He then named names. Within short order, he was off the blacklist."[988] Bernstein's friend and collaborator Jerome Robbins also named names in testimony to HUAC in 1953 – professionally dooming colleagues he had briefly known in a "theatrical transient group" called the Communist Political Association. Robbins said he joined under the

naive impression that "the Russian Communists were against fascism and anti-Semitism and in favor of artistic freedom."[989]

With his work for *On the Waterfront*, Bernstein's rehabilitation commenced. At the same time, his humiliating backdown "fueled his anger in future decades against right-wing extremism and abuses of power."[990] In 1953, Lillian Hellman, another Jewish communist, approached Bernstein about composing a musical theatre work based on Voltaire's satirical novella *Candide*. Hellman was especially taken with a scene from the book set in Lisbon during the Inquisition, which gave her "a particularly ripe opportunity for satirizing the activities of HUAC."[991]

## West Side Story

Bernstein's most popular and culturally significant work is undoubtedly *West Side Story* (1957), created in collaboration with the Jews Arthur Laurents (librettist), Stephen Sondheim (lyricist), and Jerome Robbins (director and choreographer). Robbins had introduced Bernstein to Laurents whose 1945 Broadway play *Home of the Brave* "dealt with anti-Semitism in an army unit during World War Two and had brought Bernstein to tears."[992]

Many regard *West Side Story* as the highest peak the Broadway musical has ever attained. Its popularity only really took off, however, with the film version of 1961. *West Side Story* was originally conceived by Robbins as a story of Jewish-Catholic gang rivalry focusing on conflict during Easter/Passover between an Italian Catholic Greenwich Village family and a Jewish family living on the Lower East Side of Manhattan. In Laurents' first draft – called "East Side Story" – the Maria character (originally called "Tante," the Yiddish word for aunt) was a Holocaust survivor who had emigrated from Israel to America. The conflict centered on the anti-Semitism of the (Catholic) Jets and the justified resentment of the Jewish Emeralds.

As Bernstein wrote in his diary in late 1948: "Jerry R. called today with a noble idea: a modern version of Romeo and Juliet set in slums

at the coincidence of Easter-Passover celebrations. Feelings run high between Jews and Catholics. Former: Capulets, latter: Montagues. Juliet is Jewish. Friar Lawrence is the neighborhood druggist. Street brawls, double death – it all fits."[993] Clues as to the original scheme for the show are captured in Robbins' original headings which include "Hideout (initiation: Beating up Jews)" and Bernstein's annotations, which include "Ball or Seder or Motza'e Shabbat" and "Romeo's death with Tante." Bernstein even suggested including "a song on racism called 'It's the Jews.'"[994]

Ultimately, the musical that became *West Side Story* reflected gang violence in New York and Chicago then making headlines. Despite the changed ethnicities of the protagonists, the show remained, for its creators, an unashamed vehicle for Jewish ethnic activism: promoting, most fundamentally, changed ideas what it meant to be an American. Two star-crossed lovers, Tony and Maria, find themselves caught between the rival street gangs: The Jets, a group of Whites who consider themselves the true Americans, and the Sharks, first generation immigrants from Puerto Rico. The musical's creators "projected Jewish otherness onto the Sharks, seeking recognition as full Americans by the Jets."[995] Though the Jewish gang originally contemplated for "East Side Story" ultimately became the Sharks, "the gang retained an inherent Israeli characteristic: a readiness to 'die defending their turf.'"[996] Librettist Arthur Laurents declared "We're Jews... *West Side* can be said to be informed by our political and sociological viewpoint."[997]

In 2018, Jewish director Stephen Spielberg announced plans to remake *West Side Story*. Spielberg's frequent collaborator, the Jewish playwright Tony Kushner, will write the script. Kushner has declared himself: "a big believer in identity politics and political correctness," and asked "Why shouldn't we want to be politically correct, if by correct you mean not toeing the party line but toeing the line of history, being on the right side of history, being moral and ethical?"[998] Writing for *Tablet*, Rachel Shukert wondered whether Spielberg and Kushner would merely be "content to explore these themes through the distance of the past" or would contemporize and deploy them as part of the

Jewish crusade against President Trump: "Will we see gangs of MAGA-hatted bullies" she asks, "snapping their fingers dancing in the streets as they attempt to terrorize undocumented immigrants and DACA recipients?" According to Shukert, the Jets, like the White Americans who supported Trump, "never really accept the Sharks," while at the time of *West Side Story*'s premiere in 1957, "somewhere, far from the West Side, in a leafy upper-middle class suburb of Queens, a bratty little blond boy [Donald Trump] was already planning never to rent to them."[999]

## Bernstein's Mahler Obsession

I have examined the tendency of Jewish intellectuals to use their privileged status as self-appointed gatekeepers of Western culture to advance their group interests through the way they conceptualize the artistic and intellectual achievements of Jews and Europeans. Jews have long used their cultural dominance to construct "Jewish geniuses" to enhance ethnic pride and group cohesion (Einstein being surely the most egregious case). In this endeavor, Jewish music critics and intellectuals have transformed the image of the Jewish composer Gustav Mahler from that of a relatively minor figure in the history of classical music at mid-twentieth century into the cultural icon of today. The tendency among Jewish intellectuals has been to overstate and ethnically-particularize Jewish achievement, thereby making it a locus for ethnic pride. Meanwhile, European achievement is downplayed, or where undeniable, universalized and thus neutralized as a potential basis for White pride and group cohesion.

Leonard Bernstein played a leading role in the development of the Mahler cult and the movement of the composer's music to the center of the classical repertory. The proliferation of performances of Mahler's music in the United States between 1920 and 1960 can be ascribed to the combined efforts of Bernstein and a coterie of Jewish advocates like Bruno Walter, Arnold Schoenberg, Theodor Adorno, Aaron Copland, and Serge Koussevitzky. Lionizing Mahler as the saintly Jewish victim of gentile injustice, the Jewish composer Arnold Schoenberg "canonized

Mahler as 'this martyr, this saint' and in a Prague lecture in March 1912 announced: 'Rarely has anyone been so badly treated by the world; nobody, perhaps, worse.'"[1000] Frankfurt School music theorist Theodor Adorno later took up this theme, affirming that:

> Mahler's tonal chords, plain and unadorned, are the explosive expressions of the pain felt by the individual subject imprisoned in an alienated society. ... They are also allegories of the lower depths of the insulted and the socially injured. ... Ever since the last of the *Lieder eines fahrenden Gesellen* Mahler was able to convert his neurosis, or rather the genuine fears of the downtrodden Jew into a vigor of expression whose seriousness surpassed all aesthetic mimesis and all the fictions of the *stile rappresentativo*."[1001]

Bernstein likewise conceptualized Mahler as a cruelly persecuted and alienated Jew torn apart by dualisms: "composer/conductor, Christian/Jew, sophisticate/naïf, provincial/cosmopolitan – all of which contributed to the musical schizo-dynamics of his texture, and his ambivalent tonal attitudes."[1002] Bernstein advocated for Mahler with missionary zeal, introducing the symphonies to audiences from New York to Vienna. He considered Mahler "the twentieth century's musical prophet, whose extremes spoke for the times, and thought his symphonies constituted 'as sacred a bunch of notes as Brahms's symphonies.'"[1003] While all Mahler's works were available singly on recordings, it was Bernstein who first recorded the complete set of symphonies.

Mahler was not standard repertoire in 1960, and the composer was not part of the generally acknowledged pantheon of great composers. He does not, for instance, feature in the top twenty leading composers compiled by Charles Murray in his book *Human Accomplishment*. Prior to Bernstein's advocacy, Mahler's larger symphonies, nos. 3, 6, 7, 8 and 9 were rarities in American concert halls. Mahler was considered "excessive" and "decadent" by influential critics and performers.[1004] Shawn notes that:

Early European performances of Mahler had met with similarly mixed reactions. During the Nazi era... a reviewer could simply write that Mahler's work exhibited "the inner uncertainty and deracination of the superficially civilized western Jew in all his tragedy." In the postwar years, when anti-Semitic writing was banned, the standard line that Mahler's was "a tragic case" remained, the cause now being that he was "a man of a more effeminate eastern type... [who] had succumbed to the magic of the German national character." These supposed characteristics were still noted in mid-century European criticism, which deployed a kind of code for the presumed inherent weaknesses of people of his background (and which resembled those frequently levelled against Bernstein's music). Mahler biographer Jens Malte Fischer lists them as "eclecticism and triviality... the gap between intention and ability... the hankering after empty effects... the imitation of all forms and styles... shallowness and saccharine sweetness."[1005]

Many commentators noted the depth of Bernstein's identification with the composer, and described his uncanny feeling while conducting Mahler that he was performing his own music. Bernstein's own execrable Third Symphony (*Kaddish*) is said to bear "the imprint of his identification with Mahler in its intensity, overt emotionality, extremes of contrast, and prophetic tone."[1006] As Mahler's symphonies stretched the idea of what a symphony can be, so did Bernstein's three essays in that form likewise challenge traditional notions of symphonic structure.

Before his ethnocentric infatuation with Mahler, Bernstein had, as a young man, experienced an "almost eerie sense of identification" with the Jewish composer George Gershwin.[1007] He was particularly taken with Gershwin's jazz-infused musical language, and his senior year thesis at Harvard "took as its central proposition the bold (an unHarvardian) notion that jazz was the first truly American music to have penetrated into the soul of the people to the degree that it could constitute the foundation of a national idiom."[1008] In making his case, "he dismissed

many nineteenth and early twentieth-century American [i.e., gentile] composers in such general terms that one exasperated faculty reader scrawled on the manuscript: 'What sweeping criticism! I wonder what critics in 1975 will have to say on young American composers of 1938!'"[1009] Gershwin's incorporation of jazz elements into his music directly influenced Bernstein's own compositional style in works like *Fancy Free*, the early musicals, the Masque section of the *Age of Anxiety*, and *Prelude, Fugue and Riff*.

Bernstein became increasingly politicized in the early to middle 1960s, not only in his public life and outlook but also in his musical analysis. This is manifested in his attribution to Mahler of superhuman powers of prophecy. In 1967, Bernstein hyperbolically declared it was:

> only after we have experienced all this through the smoking ovens of Auschwitz, the frantically bombed jungles of Vietnam, through Hungary, Suez, the Bay of Pigs, the farce-trial of Sinyavsky and Daniel, the refueling of the Nazi machine, the murder in Dallas, the arrogance of South Africa, the Hiss-Chambers travesty, the Trotskyite purges, Black Power, Red Guards, the Arab encircle-ment of Israel, the plague of McCarthyism, the Tweedledum armaments race – only after all this can we finally listen to Mahler's music and understand that it foretold all.[1010]

It was only after the musical world had endured such events that, Bernstein insisted, it could "finally listen to Mahler's music and under-stand that it foretold all. And in that foretelling it showered a rain of beauty on this world that has not been equaled since."[1011] For Seldes, the bulk of the Mahler-consuming public in the 1960s and 1970s were "preoccupied with existential and Freudian reflections on the individ-ual's isolation and spiritual discontent." This generation, he contends, felt a need to reconnect with "the artistic, and musical culture of pre-fascist Europe and to express empathy with the victims of the European catastrophes."[1012] Of course, a professed love of Mahler's music cannot be taken at face value – often involving extra-musical motivations like

a desire to make (through such a statement) tacit declaration of one's political rectitude and moral purity.

Following the 1967 Six-Day War, Bernstein performed Mahler's second symphony with the Israel Philharmonic at an outdoor concert on Mount Scopus in Jerusalem, an event that Yitzhak Rabin described as the single greatest experience of his life. After the Kennedy's were assassinated, Bernstein (inevitably) offered up Mahler as a memorial. Alongside Mahler, the ethnocentric Bernstein championed other Jewish composers from the podium including, most notably, Gershwin, Copland and Blitzstein. By contrast, he declared "I hate Wagner, but I hate him on my knees" – a grudging acknowledgement of the scale of German composer's achievement.[1013]

## Conductor of the Vienna Philharmonic

Bernstein regularly programmed Mahler while conductor of the Vienna Philharmonic. He was offered the chance to conduct the orchestra in 1947 as a symbol of Austria's "denazification." Bernstein was reluctant, and it took a massive financial inducement to secure the appointment. While he eventually "fell head over heels for the city itself: its orchestra, its cultural atmosphere, its certain *Gemütlichkeit*," Bernstein claimed to be "profoundly disturbed by the anti-Semitism within it."[1014] The sound of crowds shouting in German, he wrote, "makes my blood run cold." By his own reports the orchestra "was still 60 percent Nazi" at the time of his appointment. Jewish music writer Norman Lebrecht marvels at Bernstein's ability to succeed as a guest conductor of the Vienna Philharmonic, "triumphing as a Jew in what many regard as the centre of anti-Semitism."[1015]

After his appointment, conflict arose immediately over programming, with Bernstein recalling how "They wanted Bach, Mozart, and Schumann, which is silly." Bernstein was instead determined to march Mahler back into Vienna as a "second wave of liberation, a musical Marshall Plan." One of Bernstein's biographers observes that: "Bernstein's chief goal in Vienna was to restore the music of the great Jewish

composer Gustav Mahler – music that Hitler had banned."[1016] Burton notes how he:

> tackled three Mahler symphonies in quick succession with the Vienna Philharmonic, beginning with the Fifth, which, like the Third, the following week, had not been performed by the Philharmonic in Vienna since the Anschluss in 1938. As the *Wochenpresse* tartly observed, "until now the Philharmonic did Mahler only in extreme emergency cases." Despite their success with the Ninth the previous year, Bernstein felt a wave of hostility from the orchestra toward Mahler's music. "They didn't know Mahler. They were prejudiced against it. They thought it was long and needlessly complicated and over-emotional. In the rehearsals they resisted and resisted to the point where I did finally lose my temper because in God's name this was their composer as much as Mozart was, or Beethoven, who had come from much further away."[1017]

Despite his apparent success with the orchestra, Bernstein retained an ambivalent attitude to Vienna. He wrote to his parents in March 1966: "I am enjoying Vienna enormously – as much as a Jew can. There are so many sad memories here; one deals with so many ex-Nazis (and maybe still Nazis); and you never know if the public that is screaming bravo for you might contain someone who 25 years ago might have shot me dead."[1018] Bernstein was criticized by several Jewish colleagues for having conducted the former supporters of Adolf Hitler who played in the Vienna Philharmonic Orchestra, and for having fraternized with the conductors, and unapologetic NSDAP members, Herbert von Karajan and Karl Bohm. This contrasted with the violinist Isaac Stern and pianist Arthur Rubinstein, who had actively "shunned these former Nazis."[1019]

In August of 1987, the sixty-nine-year old Bernstein was still conducting the Vienna Philharmonic in Salzburg. On an evening off he sat

through a performance of Schoenberg's twelve-tone opera *Moses and Aron* with his friend Betty Comden (Cohen) who recalled that:

> Lenny told me that he had heard it only once before and was not sure how he felt about it, that it might be rough going, and we might want to wander out at some point. We sat there totally mesmerized and deeply moved. The prologue was a brief re-enactment of Kristallnacht with Jews hunted and cemeteries and synagogues defiled and destroyed. Onstage through the whole opera there was the menorah, overturned and broken, lying on its side. During the Golden Calf scene, they ingeniously used the arms of the candelabra to construct the golden horn of the idol. At the end Lenny turned to me and, visibly shaken, said that that was the opera he wished he had written.[1020]

Throughout his life Bernstein's Jewish identity remained incredibly strong: he repeatedly composed music on Jewish themes and in later years referred to himself as a "rabbi," a teacher with a penchant to pass on scholarly learning, wisdom and lore to orchestral musicians. Bernstein adopted an Old Testament prophetic voice for much of his music, including his first symphony, *Jeremiah*, and his third, *Kaddish*. Music writer David Denby noted Bernstein's fondness for using his symphonies as sanctimonious vehicles for ethnic and political propaganda:

> In his symphonies, a natural lyrical impulse got overtaken by the hectoring political stances that had surrounded him as a young man. Bernstein was influenced first by the popular-front attitudes of the thirties and later by resistance to McCarthyism and the struggles against racism and anti-Semitism, all of which imbued liberalism with a high ethical fervor. The Holocaust and the birth of Israel extended these emotions into a mood of redemptive anger. He was a liberal who took things personally, and he confused "speaking out" with politics. Unfortunately, he began to confuse it with art, too.[1021]

While *West Side Story* has retained its popularity with audiences, Bernstein's "serious" compositions for the concert hall have, except for his overture to *Candide* (and notwithstanding the recent resurgence to mark the Bernstein centenary), fallen out of the classical repertory. Bernstein's "serious" works were criticized during his lifetime for self-consciously striving for "profundity" while only achieving "grandiose gesture." One critic scathingly observed that:

> The serious music is a barrage of heartfelt emotions, the tortured, longwinded, richly orchestrated ramblings of one man's public contact with the angst of life, the power of nature, the sorrow of death and pain. All is cast in vicarious musical language on the scale of Beethoven, Mahler and Shostakovich. The sentiment is sincere but commonplace. The art is secondhand. Bernstein's serious music, at its best, is reminiscent of an exuberant adolescent who, lacking confidence in himself, uses impressive mannerisms, clichés and gestures to pour out his heart.[1022]

## Radical Chic

For all his left-wing activist pretensions, Bernstein lived in grandeur in Manhattan and Connecticut, waited on by an army of liveried servants. He was famously the subject of a scathing article by Tom Wolfe in the *New York Magazine* in June 1970 which focused on his relationship with the Black Panthers. When, in 1969, twenty-one Panthers were charged with plotting to kill policemen, bomb police stations, department stores and railroad facilities, Bernstein's wife Felicia organized a legal-defense fundraiser to be held at their Park Avenue apartment. Wolfe attended the event incognito.

Five months later his 25,000-word article "Radical Chic: That Party at Lenny's" was published, portraying the evening as a ham-fisted attempt to appear fashionably leftist. It made the event and Wolfe's catchphrase world famous, and the Bernsteins the object of mockery and derision. Bernstein was even booed by his normally adoring Jewish

subscribers at the Philharmonic who were horrified he seemed cozy with a group whose members had made statements in support of the Palestinians. When organized Jewry got wind of the Panthers' anti-Zionist position, the Jewish Defense League picketed Bernstein's apartment.

Despite his ostensible support for the Black Panthers and advocacy for Black musicians, in his tenure as chief conductor and artistic director of the New York Philharmonic from 1958 to 1969 Bernstein hired only one African-American musician, the violinist Sanford Allen.

President Richard Nixon was advised to avoid attending the premiere of Bernstein's "Mass" on September 7, 1971, a work that contained coded anti-Nixon messages in its Latin text. The White House tapes reveal Nixon later received reports of the "absolutely sickening" events that transpired at the premiere, including "Bernstein's tearful response to the ovation, his embrace of members of the cast, the kisses he bestowed on the men." Nixon notes Bernstein's support for the Black Panthers and expresses revulsion at news Bernstein "is kissing people on the mouth, including the big black guy." According to Nixon, Bernstein was a "son of a bitch" and "the personification of the complete decadence of the American upper class intellectual elite."

## French Kissing the World

In 1974, Bernstein's wife Felicia was diagnosed with breast cancer and underwent a double mastectomy. This marked the "beginning of a painful era for the entire family, marked by an erosion in Bernstein's sense of discretion about his relationships with men."[1023] Bernstein's "slow creep toward overt gayness" in middle age was abetted by his manager Harry Kraut, who "threw attractive young men in his path." On one occasion Bernstein had sex with a twenty-year-old man in the hallway of his Manhattan apartment while his wife was sitting in the living room. When he met the young Tom Cothran in 1973, he allowed his wife to catch them in bed together. Felicia "detested" Cothran and threatened to "make a public scandal," and New York Society was indeed shocked when Bernstein moved out of his marital home and into an apartment

on Central Park South with Cothran. Felicia, distraught at Bernstein's betrayal, one night "pointed her finger across the table at him and with her biggest scariest actress voice laid a curse on him: 'You're going to die a lonely, bitter old queen.'"

The following year, when Felicia was diagnosed with lung cancer, Bernstein broke up with Cothran and Mr. and Mrs. Bernstein were reconciled. After Felicia's death a year later, Bernstein "gave free reign to his addiction to alcohol and drugs, and engaged in openly crude homosexual activities." His wife's death deprived him of any calming influence and his "intense physicality and flamboyance... became a beast unleashed." He now felt free to lead an openly homosexual lifestyle, and was "frequently surrounded by groups of adoring young men." Bernstein's daughter recalls her father starting to act "exuberantly gay and calling everyone darling." He loved to shock and was notorious for greeting backstage guests wearing nothing but a jockstrap or red bikini brief. Shawn observes that:

> Without the rudder of his marriage he became more extreme and more insecure. Even an admirer such as composer Ned Rorem was taken aback by his friend's self-absorption and need to be reassured and flattered during this time. In public, Bernstein's physical demonstrativeness – which was not always entirely consensual – was sometimes too much of a good thing. As one old friend put it, "He had his tongue down everyone's throat – men and women. He wanted to French kiss the world." Copland, Blitzstein, and Laurents had cautioned him about the destructive and drug-like properties of fame. Writer and composer, Paul Bowles, a friend since the 1930s, told a biographer that fame had made Leonard "smarmy and false."[1024]

Pianist William Huckaby, after performing at a White House recital in the late seventies, was talking with President Carter when he "felt these hands clamped on my shoulders. I was whirled around and engaged in a deep kiss of the French variety and Bernstein was saying, 'I haven't heard

such virile piano playing for fifteen years. It was magnificent.' President Carter watched all this with his mouth open and then walked away." During his last decade, Bernstein was "surrounded by an entourage of beautiful boys, each one as intoxicated and obnoxious as his patron." Over-indulged by this fawning entourage, Bernstein (who used the car license plate "MAESTRO 1") behaved as he liked, even regularly patting his assistants' crotches.

In her 2018 book *Famous Father Girl: A Memoir of Growing Up Bernstein*, Bernstein's daughter Jamie revealed her father even liked to put his tongue in her mouth when he kissed her. It was designed, she says, to find out "how accommodating they were, how sexy they were, how much impact he was making. My dismay was tempered by knowing he did it to so many others." She was, nevertheless, confused by her father's mix of "tenderness and raunchiness." She felt a "vaguely unclear boundary" about their relationship when she was a teenager, recalling that "It was hard not to feel my father's sexuality... everybody felt it. Tricky stuff for a daughter."[1025]

The Bernstein family had to put up with the man they called "LB" throwing lit cigarettes at them across the dinner table, calling them "fuckface," and dumping them in awkward situations. An insomniac who worked mostly at night, Bernstein drank heavily and became addicted to prescription painkillers, "keeping a vast, multi-colored collection of them in a large black leather toiletry case." While her father wore tails to work, he was a slob at home who had a signature smell of "cigarette smoke and flatulence, which would commence at the breakfast table."

Late in life, Bernstein became ever more focused on teaching and mentoring young people, including the young Jewish homosexual conductor Michael Tilson Thomas – today the music director of the San Francisco Symphony Orchestra. His late compositions, including *A Quiet Place*, a two-hour opera built upon his earlier work *Trouble in Tahiti*, were deemed failures. One reviewer described the plot of *A Quiet Place* as a "gloomy soap opera about uninteresting characters, with an emphasis on incest and homosexuality." Critic Donal Henahan

wrote, "To call the result a pretentious failure is putting it kindly."[1026] Bernstein died aged 72 five days after announcing his retirement from conducting on October 9, 1990 of a heart attack brought on by mesothelioma – his body ravaged by alcohol, amphetamines and cigarettes. His family deny he was HIV positive at the time of his death.

## Conclusion

For the National Museum of American Jewish History, Bernstein's lasting cultural legacy, aside from his lifelong commitment to Jewish causes, resides in his "pushing boundaries, breaking down walls, bucking tradition." Bernstein's Jewish background and radical political outlook are "absolutely essential to understanding many of his key works." Examination of the subtexts of his works, including *West Side Story*, reveals "more subversive content" than many have chosen to see. In such works, and in his political activism, Bernstein "challenged norms and tried to change the world order." Alex Ross, the music critic for *The New Yorker*, argues that Bernstein's political stance "once mocked and dismissed, looks different in today's political climate."[1027]

That Bernstein was a pathbreaker for the Cultural Marxism that now dominates Western culture, and is lauded by Jews as such, is revealed by the fact two hagiographic Hollywood movies about him are in production: *The American* which is being developed by the Jewish actor Jake Gyllenhaal, and *Bernstein* which is set to be directed by and star Bradley Cooper. Gyllenhaal, in a statement, said "Like many people, Leonard Bernstein found his way into my life and heart through *West Side Story* when I was a kid. But as I got older and started to learn about the scope of his work, I began to understand the extent of his unparalleled contribution and the debt of gratitude modern American culture owes him."[1028] This contribution to modern American culture: promoting multi-racialism, black grievance politics, feminism, and sexual license were – it hardly needs saying – contrary to the collective interests of White Americans.

# The Pathetic Apologetics of Jonathan Sacks

Jonathan Sacks has been acclaimed by the *Jerusalem Post* as "one of contemporary Britain's most outstanding thinkers and spokesmen." The former Chief British Rabbi, who has been showered with awards from Jewish organizations and appointed to professorships in New York and London, has been feted as a "brilliant philosopher and an enlightening presence for the whole world." He has even been called "the outstanding moral authority of our time," and the egregious Prince Charles once described him as "a light unto this nation." Not surprisingly, given the Jewish stranglehold over the Western media, Sacks, who was made a peer of the House of Lords in 2009, is given a regular platform to peddle his brand of Jewish ethno-politics in a range of media outlets including the BBC, *The Guardian*, *The Telegraph*, *The Times*, and *The Wall Street Journal*.

Despite his high profile, and the honors and appointments lavished upon him, Sacks' intellectual output is filled with feeble apologetics, empty platitudes and facile homilies. All of these are evident in a speech this "brilliant philosopher" gave to the European Parliament entitled "The Mutating Virus – Understanding Antisemitism," to open a conference on the future of Jewish communities in Europe.

In his speech Sacks bewails the supposedly dire plight of European Jewry and offers his analysis of "what antisemitism is, why it happens, [and] why antisemites are convinced that they are not antisemitic." Like the Jewish "historian" Daniel Goldhagen, Sacks favors using the term "antisemitism" over the hyphenated "anti-Semitism" – doubtless because the latter implies the existence of a Semitism which could (and indeed does) provide the dialectical basis for anti-Semitism. In this way they signal their denial of the reality that hostility to Jews stems from conflicts of interest between Jews and non-Jews in a Darwinian world. In this essay I will use "antisemitism" for the sake of consistency.

Given his status as one of Britain's (and indeed the world's) leading Jewish intellectuals, one would expect Sacks to be a veritable fount of intellectually-sophisticated Jewish apologetics. Instead, this "brilliant philosopher," while claiming to offer "precision and understanding" about "a phenomenon full of vagueness and ambiguity," offers his audience the usual litany of threadbare Jewish apologetic tropes. He begins by defining what "antisemitism" is:

> First let me define antisemitism. Not liking Jews is not antisemitism. We all have people we don't like. That's OK; that's human; it isn't dangerous. Second, criticizing Israel is not antisemitism. I was recently talking to some schoolchildren and they asked me: is criticizing Israel antisemitism? I said No and I explained the difference. I asked them: Do you believe you have a right to criticize the British government? They all put up their hands. Then I asked: Which of you believes that Britain has no right to exist? No one put up their hands. Now you know the difference, I said, and they all did.

While initially claiming that criticizing Israel is not antisemitic, Sacks devotes much of his speech to arguing the contrary: that "anti-Zionism is the new antisemitism" and that criticizing Israel amounts to denying Jews the right to exist. Such "criticism" includes pointing out the obvious double standards of those who, like Sacks, promote "diversity"

for the West while aggressively defending the ethno-nationalist state of Israel. Inevitably, like legions of Jewish apologists before him, Sacks flatly refuses to countenance the possibility that Jews are in any way responsible for the adverse reaction they have *always* elicited from those affected by their behavior. Instead, he assures us that:

> Antisemitism is not about Jews. It is about antisemites. It is about people who cannot accept responsibility for their own failures and have instead to blame someone else. Historically, if you were a Christian at the time of the Crusades, or a German after the First World War, and saw that the world hadn't turned out the way you believed it would, you blamed the Jews. That is what is happening today. And I cannot begin to say how dangerous it is. Not just to Jews but to everyone who values freedom, compassion and humanity.

This perennial "Jew as the eternal scapegoat for the psychological inadequacies of non-Jews" narrative never loses its utility in accounting for antisemitism in a way that fully absolves Jews of all responsibility. With this theory, there is no need to delve into actual reasons why Jews have been hated in particular historical instances: the origin of anti-Jewish sentiment invariably resides in the incapacity of non-Jews to exercise reason and moral discernment. As with Jewish apologetics stretching back to the ancient world, Sacks yet again presents us with the conception of Jews as reasoning, intelligent moral paragons, and non-Jews as embodiments of irrationality and malevolence. Reflecting on the countless Jewish narratives built on these underlying assumptions, sociologist John Murray Cuddihy observed in *The Ordeal of Civility* how "Attention must be paid to the deeply apologetic structure of Diaspora intellectuality," whereby the Jewish "intelligentsia 'explains,' 'excuses,' and 'accounts' for the otherwise offensive behavior of its people."[1029]

Sacks proceeds to chastise non-Jews for doing exactly what Jews do: *never* engaging in honest self-criticism and *always* blaming others for their problems. According to Sacks:

416 - BRENTON SANDERSON

When bad things happen to a group, its members can ask one of two questions: "What did we do wrong?" or "Who did this to us?" The entire fate of the group will depend on which it chooses. If it asks, "What did we do wrong?" it has begun the self-criticism essential to a free society. If it asks, "Who did this to us?" it has defined itself as a victim. It will then seek a scapegoat to blame for all its problems. Classically this has been the Jews.

This then reduces complex problems to simplicities. It divides the world into black and white, seeing all the fault on one side and all the victimhood on the other. It singles out one group among a hundred offenders for the blame. The argument is always the same. We are innocent; they are guilty. It follows that if we are to be free, they, the Jews or the state of Israel, must be destroyed. That is how the great crimes begin.

Rabbi Sacks eschews any introspection about Jewish history and is content to focus all his attention on portraying Jews as archetypal victims. He is equally content to find a scapegoat for this eternal Jewish victimhood in the menacing specter of the ubiquitous and deranged "antisemite." Sacks has elsewhere contended that attempts to understand the origins of antisemitism must always give way to the maintenance of "Jewish pride," claiming that: "For Jews, the response to antisemitism must be to fight it but never to internalize it or accept it on its own terms."[1030] Rather than seeking a genuine understanding of the phenomenon, Sacks insists that, for Jews, "the only sane response," is to "monitor it, fight it, but never let it affect our idea of who we are. Pride is always healthier response than shame."[1031] This coming from the same man who has insisted that "intellectual honesty is a precondition for the religious life."[1032]

Pursuing his basic theme that hostility to Jews is indisputable evidence of mental impairment, Sacks informs us in his speech that:

Antisemitism is a form of cognitive failure, and it happens when groups feel that their world is spinning out of control. It began in the Middle Ages, when Christians saw that Islam had defeated them in places they regarded as their own, especially Jerusalem. That was when, in 1096, on their way to the Holy Land, the Crusaders stopped first to massacre Jewish communities in Northern Europe. It was born in the Middle East in the 1920s with the collapse of the Ottoman Empire. Antisemitism re-emerged in Europe in the 1870s during a period of economic recession and resurgent nationalism. And it is re-appearing in Europe now for the same reasons: recession, nationalism, and a backlash against immigrants and other minorities. Antisemitism happens when the politics of hope gives way to the politics of fear, which quickly becomes the politics of hate.

Unmentioned by Sacks is the fierce and implacable Jewish hatred of non-Jews that has echoed down through the ages, where Jews ruthlessly exploited Europeans and others for their own benefit – prompting some 109 expulsions from European countries alone. From Biblical times onwards Jews have invariably sought to dominate and exploit other peoples. In Europe in the Middle Ages Jews were seen as "pitiless creditors," and the philosopher Immanuel Kant famously observed that Jews were "a nation of usurers... outwitting people amongst whom they find shelter... They let the slogan 'let the buyer beware' their highest principle in dealing with us."[1033] Most Jewish religious holidays celebrate the massacre of their enemies.

Jewish hate was fully evident in the enthusiastic Jewish participation in the Bolshevik mass murder of millions of Eastern Europeans in the early twentieth century, and remains apparent in the fear and loathing of the White Christian West that results in overwhelming Jewish support for massive non-White immigration into Western nations. The result of these Jewish anxieties and hatreds is to swamp the West with tens of millions of non-White immigrants which, in the not too distant future, will make Whites powerless minorities in the countries they founded

and built. Sacks ignores all this and insists that antisemites have a monopoly on hate, and moreover:

> The hate that begins with Jews never ends with Jews. That is what I want us to understand today. It wasn't Jews alone who suffered under Hitler. It wasn't Jews alone who suffered under Stalin. It isn't Jews alone who suffer under ISIS or Al Qaeda or Islamic Jihad. We make a great mistake if we think antisemitism is a threat only to Jews. It is a threat, first and foremost, to Europe and to the freedoms it took centuries to achieve.

Sacks naturally fails to mention the vastly disproportionate number of Jews among the ranks of both the founders of Bolshevism and Stalin's willing executioners. Also unmentioned is Israel's cynical willingness to purchase oil from ISIS and to provide emergency medical treatment for radical Islamists to get these implacable "antisemites" back onto the battlefield in order to topple Assad.

According to Sacks, hostility to Jews is *never* rational and is *always* a manifestation of an anti-social mania on the part of the neurotic non-Jew which, while initially directed at Jews, is subsequently arrayed against other minority groups. This assertion is falsified by a quick survey of history where we find that hostility to Jews has, in most cases, existed independently of animus to other minorities. In any case, Sacks neglects to explain why the hostility that has been directed at other minorities like gypsies, much less Mennonites or Mormons, trifles in comparison to that directed at Jews. Anti-Jewish feeling has been a defining component of major historical upheavals, such as the Spanish Inquisition and the rise of National Socialism – due in no small part to Jews being an elite with radically different interests than the people they have lived among.

For Sacks, hatred of Jews is ultimately hatred of humanity itself and, therefore, "Antisemitism is never ultimately about Jews. It is about a profound human failure to accept the fact that we are diverse and must create space for diversity if we are to preserve our humanity."[1034] While

constantly invoking the necessity of "creating space for diversity," Sacks never explores the actual nature of that "diversity" – like differences in mean IQ and associated behavioral tendencies, or entrenched cultural assumptions about women – and the disquieting implications these have for daily life in the diverse, multi-racial societies he advocates for the West (but not for Israel). Instead of addressing such considerations, he simply assures us that, "the only response to the fear and hatred of difference is to honor the dignity of difference. That is the Jewish massage to the world."[1035]

Sacks is an exemplar of the Jewish tendency to couch the pursuit of specific Jewish interests in a pretended universal benevolence. One of his oft-repeated themes is that: "Antisemitism – the hatred of difference – is an assault not on Jews only, but on the human condition as such," and accordingly, "A world without room for Jews is one that has no room for difference, and the world that lacks space for difference lacks space for humanity itself."[1036] Appeals to non-Jews to serve Jewish interests by fighting for "humanity" have been a consistent feature of Judaism as a group evolutionary strategy in the post-war era. Millions of White people (who are likely genetically predisposed to moral universalism) have been enlisted to fight for Jewish interests (and against their own ethnic interests) on the understanding they are upholding the "universal brotherhood of man." This cynical Jewish strategy is based on the calculation of Jews that, as Sacks observes, "The only people who can successfully combat antisemitism are those active in the cultures that harbor it."[1037]

## Antisemitism is "the Beginning of the End of Europe"

Turning his attention to the welfare of European Jewry, Sacks yet again peddles the kind of spurious Freudian diagnoses of "anti-Semites" that were a Jewish stock in trade throughout the twentieth century, informing us that "the appearance of antisemitism in a culture is the first symptom of a disease, the early warning sign of collective breakdown."

Consequently, if Europe "allows antisemitism to flourish," then "that will be the beginning of the end of Europe."

Sacks doesn't conceptualize "Europe" as a biologically kindred community with a shared history and culture, but rather as a place governed by values and institutions that are either favorable or unfavorable to Jews. Sacks is unconcerned whether, for example, the native English, French or Germans become besieged minorities in their own lands, providing Jews can continue to flourish within these territories. Rather than denoting the demographic eclipse of actual Europeans, the "end of Europe" for Sacks means the end of Europe as an amenable host society for Jews. He thus bemoans the fact that "In every single country of Europe, without exception, Jews are fearful for their or their children's future. If this continues, Jews will continue to leave Europe, until, barring the frail and the elderly, Europe will finally have become *Judenrein.*"

His reflexive hostility to native Europeans is such that, despite Muslim immigration being the overwhelming factor behind any recent upsurge in hostility to Jews in Europe, Sacks refuses to single it out as a particular problem. To do so would bring the entire "diversity" project (the centerpiece of the Jewish ethno-political strategy for the West) into question. Careful to avoid this, he speaks as though the presence of very large numbers of Muslims in Europe (with their alien and belligerent culture) is uncontroversial and desirable. Indeed, in Sacks' mind, these newcomers *are* Europeans and their attitudes and behavior are the responsibility of real Europeans.

Rather than seeing Muslim hostility to Jews as a distinct problem that has been latterly (and deliberately) injected into European societies, Sacks simply conflates it with Europe's own supposedly long and lachrymose history of antisemitism. He claims that:

> We are not today back in the 1930s. But we are coming close to 1879, when Wilhelm Marr founded the League of Anti-Semites in Germany; to 1886 when Édouard Drumont published *La France Juive*; and 1897 when Karl Lueger became Mayor of

Vienna. These were key moments in the spread of antisemitism, and all we have to do today is to remember that what was said then about Jews is being said today about the Jewish state.

Muslims criticizing Israel and physically and verbally attacking Jews in Britain and France is not, according to Sacks, the inevitable result of an insane social experiment (multiculturalism) that could easily have been avoided, but is just another "mutation" of Europe's long and inveterate tradition of Jew-hatred. To underscore his point, he solemnly reminds us how "Europe's treatment of the Jews added certain words to the human vocabulary: disputation, forced conversion, inquisition, expulsion, *auto da fe*, ghetto, pogrom and Holocaust, words written in Jewish tears and Jewish blood."

Sacks insists that Jews were hated through large stretches of European history not because their ethnic interests often ran directly counter to those of large segments of the European population, but simply because "they were different" and "the most conspicuous non-Christian minority in a Christian Europe." One of the Rabbi's central philosophical "insights" is that, at its heart, "Antisemitism has always been about the inability of a group to make space for difference."

Multiculturalism is nothing if not a Jewish-originated, promoted, and now state-sponsored, program to "make space for difference" (i.e., for Jews). Mass non-White immigration and multiculturalism are the weapons Jewish activists have deployed to achieve what they regard as the preemptive denazification of the entire Western world. The practical corollary of "never again" for Jews has been to never again allow the kind of homogeneously White society that was a precondition for the rise of National Socialism. Using tens of millions of Muslims as the agents for this diversification has, however, provoked consternation among the ranks of Jewish neoconservatives.

## *European Meltdown Threatens Jews*

In an article for the *Jerusalem Post* entitled "European Meltdown Threatens Jews," the veteran Jewish leader and activist Isi Leibler lamented the negative impact of large-scale Muslim immigration on European Jewry. He noted that "With the indigenous population shrinking and the Muslim birthrate alarmingly high, unless the flow of migrants is stemmed, there is every possibility that by the end of the century the foundations of European civilization will be destroyed." Through "dramatically destabilizing the social cohesion and security of countries harboring them," Muslim migrants have led to Diaspora Jews "suffering severe trauma as they experience the erosion of the acceptance and security they have enjoyed over the past half-century." What makes this worse for Leibler is the fact this influx of Muslims is the direct result of Jewish ethnic activism. He observes how:

> Yet ironically, many liberal Jews are at the forefront of campaigns to open the door to widespread immigration of Muslim "refugees" and even make ridiculous bleeding-heart analogies to the plight of Jews during the Holocaust. In so doing, they are facilitating the entry of hordes of embittered anti-Semites who have been brought up to consider Jews as the "offspring of apes and pigs."

For Leibler, flooding Europe with these "hordes" is regrettable, not primarily because, if the trend continues, "by the end of the century the foundations of European civilization will be destroyed," but because the end result will be that Jews in Europe are increasingly forced to "live in societies where horrific terrorist attacks against their schools, synagogues, museums and supermarkets have necessitated military or armed guards to provide security."

The mass importation of Muslims into Europe also presents a danger to Jews, according to Leibler, in fueling the rise of the far-right. He notes that activist Jews, in advocating and facilitating the influx of Muslims into Europe, inevitably "enrage many of their neighbors who

loathe these 'refugees' and fear that this flood of immigration will destroy their way of life." The result has been "the meteoric rise of radical right-wing movements in all European countries – Jobbik in Hungary and the Golden Dawn in Greece [which] are outright anti-Semitic and neo-Nazi movements." Despite nationalist leaders like Marine Le Pen having "vigorously condemned and disassociated her party from its former anti-Semitism," Leibler insists the rank and file members of such parties that notionally "support Israel" remain "unreconstructed traditional anti-Semites."[1038]

Leibler is part of the distinct (though growing) minority of activist Jews who regard the Jewish strategy of transforming Europe through mass Islamic immigration as "bad for the Jews." In 2010 he voiced his strong support for non-White immigration and multiculturalism for Australia while rejecting these policies for Israel. He accepts that Jewish interests are served by the dilution and weakening of the identity of the majority European-derived nations in which many Jews live. For Leibler, however, this diversification strategy is only good for Jews providing "hordes of embittered anti-Semites" (i.e., Muslim immigrants) aren't the primary means of achieving it.

A silver lining of the rapidly-accelerating destruction of Europe, for Leibler, is that, unlike vulnerable Europeans, Jews can always flee to an ethnically-homogeneous "Jewish state" that provides "a haven for all Jews." As an ultra-Zionist, he naturally hopes that, as European societies become increasingly violence-plagued, dysfunctional and inhospitable to Jews, "many will leave and join us in Israel and participate in the historic renaissance of our people." As a result of Jewish activism, millions of White people are also increasingly fearful of their or their children's future. Unlike Jews, they have no option of fleeing to the relative safety of an ethnostate.

Less resigned than Leibler to an eventual mass evacuation of Jews from Europe to Israel, Sacks proposes that "European liberty" is entirely dependent on the ongoing presence of Jews on the continent, and warns Europe's leaders that "If you do nothing, Jews will leave, European liberty will die, and there will be a moral stain on Europe's

name that all eternity will not erase." In entreating the EU to do "something" to curb antisemitism in Europe, Sacks is not proposing that they should stop Muslim immigration, but rather implement tougher and more far-reaching restrictions on speech than already exist throughout the continent. For the rabbi, unless European governments make all criticism of Jews and Israel a criminal offence subject to harsh criminal sanctions, "European liberty will die."

## Rabbi Sacks' "Critique" of British Multiculturalism

As he approached the end of his tenure as Chief Rabbi of Britain in 2013, Sacks became increasingly critical of Britain's model of multiculturalism which, he acknowledged, had originally emerged "in response to the Holocaust." While having been "undertaken for the highest of motives" and "intended to create a more tolerant society, one in which everyone, regardless of color, creed or culture, felt at home," multiculturalism in Britain was no longer working. It was not, however, the beheading of Lee Rigby, the no go zones, or revelations of Muslim rape gangs that prompted the rabbi's unexpected critique; it was because "Jews especially in London and Manchester have found themselves attacked on their way to and from synagogue, or abused by passers-by."[1039]

Maintaining that "multiculturalism has led not to integration but to segregation," Sacks argued that the policy should be reformed to place greater emphasis on "tolerance" and "integration."[1040] While still stressing the sanctity of "diversity" and "difference," Sacks insisted the British government should do more to promote "tolerance" and called for greater consultation between ethnic communities, arguing that: "In a society of plurality and change, there may be no detailed moral consensus that can be engraved on tablets of stone. But there can and must be a continuing conversation, joined by as many voices as possible, on what makes our society a collective enterprise: a community that embraces many communities."[1041] Elsewhere the rabbi opined that "The more plural a society we become, the more we need to reflect on what holds us together."[1042]

Sacks here pretends that all interests that can be reconciled through open dialogue, when, in truth, the interests of different racial and religious groups are often fundamentally opposed and irreconcilable. In responding to the proliferating social dysfunctions that "diversity" has introduced into Western societies, Sacks advises Europeans to "answer hatred with love, violence with peace, resentment with generosity of spirit and conflict with reconciliation."[1043] The fact that the "Jewish state" he fiercely defends exhibits none of these traits causes him no disquiet. Instead, for the rabbi, this epic double standard is a normative part of contemporary Jewish identity where: "In Israel one is Jewish by living in a Jewish state, surrounded by a Jewish culture and Jewish institutions. But elsewhere, being Jewish means going against the grain, being counter-cultural."[1044]

In practical terms, this means promoting pluralism and diversity and encouraging the dissolution of the racial and ethnic identification of Europeans, while endeavoring to maintain an intense group solidarity in Jewish communities. Jews have initiated and led movements that have discredited the traditional foundations of Western society: patriotism, the Christian basis for morality, social homogeneity, and sexual restraint. At the same time, within their own communities, they have supported the very institutions they have attacked in Western societies.

Writing in the *Encyclopaedia of Modern Jewish Culture*, Sacks observed that while "The sexual revolution of the 1960s found some Jewish protagonists," within Jewish communities "the primary response was a strong defence of tradition." Within diaspora Jewish communities, sexual liberation was regarded as a direct threat to Judaism as a group evolutionary strategy, where "not only ethical values were at stake." Noting that "Images of marriage and family pervade Jewish theological language about the covenantal relationship between God and Israel," Sacks observed that, "The stability and fertility of families is crucial to the demographics of Jewish survival."[1045] As these comments indicate, healthy, functional societies coalesce around the propagation and protection of children. While Jews have endeavored to sustain this

426 – BRENTON SANDERSON

coalescence within Jewish communities, they have actively sought to sabotage it within non-Jewish (particularly White) communities.

Despite gaining considerable media attention, it soon became apparent that Sacks' "critique" of multiculturalism threatened none of the pillars of the Jewish diversification agenda for the West. As *Commentary* magazine noted:

> Sacks has contested neither the reality nor the desirability of a multi-ethnic society; instead, he has consistently argued that the communally-centered model of multiculturalism that prevails in Britain has frustrated attempts to forge an overarching [post-British] British identity. No one is talking about how to persuade Muslims to leave the historically Christian nations in which they've settled, but rather how they might *remain* on peaceable terms.[1046]

So Sacks fully supports the ongoing dispossession of the British people, but prefers a version of multiculturalism more consonant with the physical safety of Jews in Britain. While advocating for the greater "integration" of migrants into the White British community in order to pacify burgeoning populations of Jew-hating Muslims, Sacks remains profoundly committed to Jewish separatism and is vehemently opposed to intermarriage. This leading "anti-racist" regards the latter as a "tragedy" because "a family tree that had lasted a hundred generations comes to an end with them, a chain of continuity that held strong for a hundred generations has broken." Rather than betraying their genetic legacy, Sacks urges all Jews to be "united by a powerful sense – reinforced by the Holocaust and the State of Israel – of a shared history, fate, and responsibility."[1047]

Sacks is quite open about Judaism being not just a religion but a group evolutionary strategy, noting that "The first recorded words of man to God in the history of the covenant are a plea for there to be future generations," and how "the secret of Jewish continuity is that no people has ever devoted more of its energies to continuity. The focal

point of Jewish life is the transmission of a heritage across the generations."[1048] He has noted that German National Socialism, in having addressed itself "to the biological, not the theological community of Jews," actually served to reinforce "the traditional understanding of *keneset yisrael* as a community of birth, not faith alone."[1049]

### *"The Holocaust" and the "New Antisemitism"*

Sacks laments that "the Holocaust" – which he regards as a "moral stain on Europe's name that all eternity will not erase" – has lost some of the power it once exercised over the Western imagination in curbing antisemitism. Despite the unceasing efforts of Jewish activists, the invocation of "the Holocaust" no longer yields the bountiful ethno-political dividends it once did. The aggressive ethno-nationalism of the current Israeli government (despite the endless compensatory stream of "Holocaust" propaganda from Hollywood), has led to the rapid erosion of Jewish pretensions to moral authority. Sacks is appalled by this development, observing that:

> If there is one thing I and my contemporaries did not expect, it was that antisemitism would reappear in Europe within living memory of the Holocaust. The reason we did not expect it was that Europe had undertaken the greatest collective effort in all of history to ensure that the virus of antisemitism would never again infect the body politic. It was a magnificent effort of anti-racist legislation, Holocaust education and interfaith dialogue. Yet antisemitism has returned despite everything.

Here Sacks admits the entire post-World War II political and cultural order throughout the West (centered on non-White immigration, multiculturalism and legislated speech codes) was essentially a grand exercise in Jewish ethno-politics. "The Holocaust" has, or course, been the rhetorical lynchpin of this new order. Given the belligerent and ethnocentric mentality of many Muslims, it's hardly surprising

428 – BRENTON SANDERSON

the Holocaust narrative exerts minimal psychological leverage over the Muslim migrants and refugees Jews have lobbied to bring to the West.

Having the temerity to notice that the conduct of the Israeli state is starkly at odds with the "human rights" rhetoric and political prescriptions espoused by Jews for other societies is, for Sacks, a key feature of the "new antisemitism":

> The ultimate weapon of the new antisemitism is dazzling in its simplicity. It goes like this. The Holocaust must never happen again. But Israelis are the new Nazis; the Palestinians are the new Jews; all Jews are Zionists. Therefore the real antisemites of our time are none other than the Jews themselves. And these are not marginal views. They are widespread throughout the Muslim world, including communities in Europe, and they are slowly infecting the far left, the far right, academic circles, unions, and even some churches. Having cured itself of the virus of antisemitism, Europe is being reinfected by parts of the world that never went through the self-reckoning that Europe undertook once the facts of the Holocaust became known.

In condemning this "new antisemitism," Sacks makes no attempt to set the record straight and correct the supposedly fallacious notions that underpin this worldview: that the state of Israel was founded on terrorism and ethnic cleaning where Palestinians were killed or violently driven from land they occupied for millennia to make way for Jewish settlers, that Israel's immigration policy is based on ethnic discrimination, that Israel bans marriage between Jews and non-Jews, and that Israel has a two-tier political and legal system akin to the old South African apartheid. For Sacks, these notions are so self-evidently false they require no gainsaying. Despite the "new antisemitism" being supposedly "dazzling in its simplicity," Sacks thus shies away from the ostensibly simple task of deconstructing its main logical fallacies.

Aware, however, that Israel *is* exposed to attack from those noting its fundamental *lack* of multiculturalism, Sacks feebly attempts to argue

that Israel is actually a pillar of "diversity" because it has so many different kinds of Jews in it. It is only in Israel, he notes "that you become conscious, in the faces you see and the accents you hear, of the astonishing diversity of Jews from every country and culture, brought together in the great ingathering as once, in Ezekiel's vision, the dismembered fragments of a broken people joined together and come to life again."[1050]

What the "new antisemitism" shares with the old variety, according to Sacks, is that while "there is a difference between Zionism and Judaism, and between Jews and Israelis," this difference "does not exist for the new antisemites themselves. It was Jews not Israelis who were murdered in terrorist attacks in Toulouse, Paris, Brussels and Copenhagen. Anti-Zionism is the antisemitism of our time." Rather than regarding these attacks (all by Muslims) as evidence, alongside the ever-growing list of terrorist attacks in Europe and throughout the West, of the total disaster of mass Islamic immigration, they are, for Sacks, symptomatic of the anti-Zionism that is "the antisemitism of our time" and which is but a "mutation" of the inveterate Jew-hatred that has existed among Europeans for millennia. At its core:

> Antisemitism means denying the right of Jews to exist collectively as Jews with the same rights as everyone else. It takes different forms in different ages. In the Middle Ages, Jews were hated because of their religion. In the nineteenth and early twentieth century they were hated because of their race. Today they are hated because of their nation state, the state of Israel. It takes different forms but it remains the same thing: the view that Jews have no right to exist as free and equal human beings.

Are Palestinians treated as "free and equal human beings" in Israel? Despite his weasel words, it is clear that Sacks *absolutely* denies the right of Europeans to exist collectively with the same rights as Israelis: that is, to explicitly define their national identity in ethnic or racial terms, to protect their group genetic interests through a racially-restrictive

immigration policy, and to have no moral obligation to accept Muslim (or any non-kindred) refugees. Sacks takes it as axiomatic that Jews should be able reside in all non-Jewish nations with the same rights as natives, despite the fact that this arrangement is emphatically not reciprocated by Jews.

Sacks laments that those who criticize Israel have plausible deniability to the charge of "antisemitism." He notes that today the highest source of moral authority worldwide is "human rights" and that Israel "is regularly accused of the five cardinal sins against human rights: racism, apartheid, crimes against humanity, ethnic cleansing and attempted genocide." One again, Sacks doesn't attempt to refute these charges, but assumes it is morally reprehensible they even be levelled, and that criticizing Israel on such grounds is "anti-Zionism" which is the "new antisemitism."

> The new antisemitism has mutated so that any practitioner of it can deny that he or she is an antisemite. After all, they'll say, I'm not a racist. I have no problem with Jews or Judaism. I only have a problem with the State of Israel. But in a world of 56 Muslim nations and 103 Christian ones, there is only one Jewish state, Israel, which constitutes one-quarter of one per cent of the land mass of the Middle East. Israel is the only one of the 193 member nations of the United Nations that has its right to exist regularly challenged, with one state, Iran, and many, many other groups, committed to its destruction.

Have activist Jews not been committed to the destruction of European and European-derived nations in their historical incarnations? Which traditionally White Christian nation is today accepted as such by activist Jews like Sacks? Certainly not the Britain in whose parliament the celebrated rabbi now sits. Jews not only challenged the right of Australia to exist under the White Australia policy but actively fought for, and achieved, its ultimate destruction.

## Conclusion

The absurdly inflated status of Jonathan Sacks as a public intellectual, pillar of the new British establishment, and "outstanding moral authority of our time" is a testament to Britain's cultural decline. Sacks plays ethnic hardball while posing as a moral beacon and is rewarded with acclaim and sinecures from the representatives of the people he has devoted his life to destroying. His writings and public utterances are suffused with the same ethnic strategizing that preoccupied the Jewish intellectuals that Kevin MacDonald examined in *The Culture of Critique*.

The political prescriptions of Sacks and the other Jewish intellectuals and activists enjoining White people to "make space for difference" have resulted in the non-White swamping of European homelands, the Islamization, and the spiraling crime rates (including the mass rape of European women and children by Muslims). In peddling Cultural Marxism and the lies of Boasian anthropology for decades, Jewish intellectuals and activists laid the intellectual and moral foundations for the insane actions of European leaders like Angela Merkel.

Yet when the negative (and entirely predictable) consequences of "making space for difference" rebound on Europe's Jews, Sacks has the chutzpah to depict his community as blameless victims of European antisemitism and demand a crackdown on speech to "stop it now while there is still time." Instead of being feted as a moral beacon, Sacks should to be subjected to the same relentless attack that he and other activist Jews have mounted on our people and culture.

# Tristan Tzara and the Jewish Roots of Dada

The twentieth century saw a proliferation of art inspired by the Jewish culture of critique. The exposure and promotion of this art grew alongside the Jewish penetration and eventual capture of the Western art establishment. Jewish artists sought to rewrite the rules of artistic expression – to accommodate their own technical limitations and facilitate the creation (and elite acceptance) of works intended as a rebuke to Western civilizational norms.

The Jewish intellectual substructure of many of these twentieth-century art movements was manifest in their unfailing hostility toward the political, cultural and religious traditions of Europe and European-derived societies. I have examined how the rise of Abstract Expressionism exemplified this tendency in the United States and coincided with the usurping of the American art establishment by a group of radical Jewish intellectuals. In Europe, Jewish influence on Western art reached a peak during the interwar years. This era, when the work of many artists reflected their radical politics, was the heyday of the Jewish avant-garde.

A prominent example of a cultural movement from this time with important Jewish involvement was Dada. The Dadaists challenged the very foundations of Western civilization which they regarded, in the

context of the destruction of World War One, and continuing anti-Semitism throughout Europe, as pathological. The artists and intellectuals of Dada responded to this socio-political diagnosis with assorted acts of cultural subversion. Dada was a movement that was destructive and nihilistic, irrational and absurdist, and which preached the overturning of every cultural tradition of the European past, including of rationality itself. The Dadaists "aimed to wipe the philosophical slate clean" and lead "the way to a new world order."[1051] While there were many non-Jews involved in Dada, the Jewish contribution was fundamental to shaping its intellectual tenor as a movement, for Dada was as much an attitude and way of thinking as a mode of artistic output.

Writing for *The Forward*, Bill Holdsworth observed that Dada "was one of the most radical of the art movements to attack bourgeois society," and that at "the epicenter of what would become a distinctive movement... were Romanian Jews – notably Marcel and Georges Janco and Tristan Tzara – who were essential to the development of the Dada spirit."[1052] For Menachem Wecker, the works of the Jewish Dadaists represented "not only the aesthetic responses of individuals opposed to the absurdity of war and fascism" but, invoking the well-worn light unto the nations theme, insists they brought a "particularly Jewish perspective to the insistence on justice and what is now called *tikkun olam*." Accordingly, for Wecker, "it hardly seems a coincidence that so many of the Dada artists were Jewish."[1053]

It does seem hardly coincidental when we learn that Dada was a genuinely international event, not just because it operated across political frontiers, but because it consciously attacked patriotic nationalism. Dada sought to transcend national boundaries and deride European nationalist ideologies, and within this community of artists in exile (a "double Diaspora" in the case of the Jewish Dadaists) what mattered most was the collective effort to articulate an attitude of revolt against European cultural conventions and institutional frameworks.

First and foremost, Dada wanted to accomplish "a great negative work of destruction." Presaging the poststructuralists and deconstructionists of the sixties and seventies, they believed the only hope for

society "was to destroy those systems based on reason and logic and replace them with ones based on anarchy, the primitive and the irrational."[1054] Robert Short notes that Dada stood for "exacerbated individualism, universal doubt and [an] aggressive iconoclasm" that sought to debunk the traditional Western "canons of reason, taste and hierarchy, of order and discipline in society, of rationally controlled inspiration in imaginative expression."[1055]

## Tristan Tzara and Zurich Dada

The man who effectively founded Dada was the Romanian Jewish poet Tristan Tzara (born Samuel Rosenstock in 1896). "Tristan Tzara" was the pseudonym he adopted in 1915 meaning "sad in my country" in French, German and Romanian, and which, according to Gale, was "a disguised protest at the discrimination against Jews in Romania."[1056] It was Tzara who, through his writings, most notably *The First Heavenly Adventure of Mr. Antipyrine* (1916) and the *Seven Dada Manifestos* (1924), laid the intellectual foundations of Dada.[1057] Tzara's Dadaist Manifesto of 1918, was the most widely distributed of all Dada texts, and "played a key role in articulating a Dadaist ethos around which a movement could cohere."[1058]

In his book *Dada East: The Romanians of Cabaret Voltaire*, Tom Sandqvist notes that Tzara's intellectual and spiritual background was infused with the Yiddish and Hassidic subcultures of his early twentieth-century Moldavian homeland, and how these were of seminal importance in determining the artistic innovations he would institute as the leader of Dada. He links Tzara's revolt against European social constraints directly to his Jewish identity, and his perception the Jewish population of Romania (and particularly of his native Moldavia) was cruelly oppressed by anti-Semitism. Under Romanian law, the Rosenstocks, a family of prosperous timber merchants, were not fully emancipated. Many Russian Jews settled in Romanian Moldova after being driven out of other countries and lived there as guests of the local Jews who only became Romanian citizens after the First World War (as

a condition for peace set by the Western powers). For Sandqvist, the treatment of Jews in Romania fueled an attitude of revolt against the socio-political status quo in Tzara, and this was fully consistent with the anarchist impulses he exhibited at the Cabaret Voltaire in Zurich and later in Paris.

Agreeing with this thesis, the ethnocentric Jewish poet and Dada historian, Andrei Codrescu, claims the supposedly ubiquitous anti-Semitism suffered by Romanian Jews like Tzara extends into the present day, insisting: "The Rosenstocks were Jews in an anti-Semitic town that to this day does not list on its website the founder of Dada among the notables born there." This is considered all the more egregious given that, despite its marginality, Tzara's hometown Moineşti is, in Codrescu's opinion, "the center of the modern world, not only because of Tristan Tzara's invention of Dada, but because its Jews were among the first Zionists, and Moineşti itself was the starting point of a famous exodus of its people on foot from here to the land of dreams, Eretz-Israel." For Codrescu, Tzara's Jewish heritage was of profound importance in shaping his contribution to Dada.

> The daddy of dada was welcomed at his bar mitzvah in 1910 into the Hassidic community of Moineşti-Bacau by the renowned rabbi Bezalel Zeev Safran, the father of the great Chief Rabbi Alexandre Safran, who saw the Jews of Romania through their darkest hour during the fascist regime and the Second World War. Sammy Rosenstock's grandfather was the rabbi of Chernowitz, the birthplace of many brilliant Jewish writers, including Paul Celan and Elie Weisel [both of whom wrote about the Holocaust]. ... Sammy's father owned a saw-mill, and his grandfather lived on a large wooded estate, but his family roots were sunk deeply into the mud of the shtetl, a Jewish world turned deeply inward.[1059]

For Codrescu, Tzara was one of the many "shtetl escapees" who was "quick to see the possibility of revolution," and became a leader within

"the revolutionary avant-garde of the 20th century which was in large measure the work of provincial East European Jews." Crucially, for shaping the intellectual tenor of Dada, Tzara and the other Jewish exiles from Bucharest like the Janco brothers "brought along, wrapped in refugee bundles, an inheritance of centuries of 'otherness.'"[1060] This sense of "otherness" was rendered all the more politically and culturally potent given the "messianic streak [that] drove many Jews from within." Codrescu notes that: "By the time of Samuel's birth in 1896, powerful currents of unrest were felt within the traditional Jewish community of Moineşti. The questions of identity, place and belonging, which had been asked innumerable times in Jewish history, needed answers again, 20th century answers."[1061] In this need for answers lay the seeds of Dada as a post-Enlightenment (proto-postmodern) manifestation of Jewish ethno-politics.

While there is some controversy over who exactly invented the name "Dada," most sources accept that Tzara hit upon the word (which means hobbyhorse in French) by opening a French-German dictionary at random. "Da-da" also means "yes, yes" in Romanian and Russian, and the early Dadaists reveled in the primal quality of its infantile sound, and its appropriateness as a symbol for "beginning Western civilization again at zero." Crepaldi notes how the choice of the group's name was "emblematic of their disillusionment and their attitude, deliberately shorn of values and logical references."[1062] Tzara seems to have recognized its propaganda value early with the German Dadaist poet Richard Huelsenbeck recalling that Tzara "had been one of the first to grasp the suggestive power of the word Dada," and developed it as a kind of brand identity.[1063]

Tzara's own "Dadaist" poetry was marked by "extreme semantic and syntactic incoherence."[1064] When he composed a Dada poem he would cut up newspaper articles into tiny fragments, shake them up in a bag, and scatter them across the table. As they fell, they made the poem; little further work was called for. With regard to such practices, the Jewish Dadaist painter and film-maker Hans Richter commented that "Chance appeared to us as a magical procedure by which we could

transcend the barriers of causality and conscious volition, and by which the inner ear and eye became more acute... For us chance was the 'unconscious mind,' which Freud had discovered in 1900."[1065] Codrescu speculates that Tzara's aleatoric poetry had its likely intellectual and aesthetic wellspring in the mystical knowledge of his Hassidic heritage, where Tzara was inspired by:

> the commentaries of other famous Kabbalists, like Rabbi Eliahu Cohen Itamari of Smyrna, who believed that the Bible was composed of an "incoherent mix of letters" on which order was imposed gradually by divine will according to various material phenomena, without any direct influence by the scribe or the copier. Any terrestrial phenomenon was capable of rearranging the cosmic alphabet toward cosmic harmony. A disciple of the Smyrna rabbi wrote, "If the believer keeps repeating daily, even one verse, he may obtain salvation because each day the order of the letters changes according to the state and importance of each moment..."

An old midrashic commentary holds that repeating everyday even the most seemingly insignificant verse of the Torah has the effect of spreading the light of divinity (consciousness) as much as any other verse, even the ones held as "most important," because each word of the Law participates in the creation of a "sound world," superior to the material one, which it directs and organizes. This "sound world" is higher on the Sephiroth (the tree of life that connects the worlds of humans with God), closer to the unnamable, being illuminated by the divine. One doesn't need to reach far to see that the belief in an autonomous antiworld made out of words is pure Dada. In Tzara's words, "the light of a magic hard to seize and to address."[1066]

That Tzara returned to study of the Kabbalah towards the end of his life certainly lends weight to Codrescu's thesis. Finkelstein notes how Tzara's poetry "sounds eerily like a Kabbalistic ritual rewritten as a Dadaist café performance," and links Tzara's Dadaist spirit to the

influence of the seventeenth and eighteenth century Jewish heresies that were centered on the notion of "redemption through sin" which involved "the violation of Jewish law (sometimes to the point of apostasy) in the name of messianic transformation." The Jewish American poet Jerome Rothenberg calls these heresies "libertarian movements" within Judaism and connects them to Jewish receptivity to the forces of secularization and modernity, leading in turn to the "critical role of Jews and ex-Jews in revolutionary politics (Marx, Trotsky etc.) and avant-garde poetics (Tzara, Kafka, Stein etc.)." Rothenberg sees "definite historical linkages between the transgressions of messianism and the transgressions of the avant-garde."[1067] Heyd endorses this thesis, observing that: "Tzara uses terminology that is part and parcel of Judaic thinking and yet subjects these very concepts to his nihilistic attack."[1068] Perhaps not surprisingly, the Kabbalist and Surrealist author Marcel Avramescu, who wrote during the 1930s, was directly inspired by Tzara.

Nicholas Zarbrugg has written detailed studies of the ways that Dada fed into the sound and visual poetry of the first phase of postmodernism.[1069] Tzara's poetry was, for instance, to strongly influence the Absurdist drama of Samuel Beckett, and the poetry of Andrei Codrescu, Jerome Rothenberg, Isidore Isue, and William S. Burroughs. Allen Ginsberg, who encountered Tzara in Paris in 1961, was strongly influenced by Tzara. Codrescu relates that: "A young Allen Ginsberg, seated in a Parisian café in 1961, saw a sober-looking, suited Tzara hurrying by, carrying a briefcase. Ginsburg called to him "Hey Tzara!" but Tzara didn't so much as look at him, unsympathetic to the unkempt young Americans invading Paris again for cultural nourishment." For Codrescu, it was a minor tragedy that "the daddy of Dada failed to connect with the daddy of the vast youth movement that would revive, refine and renew Dada in the New World."[1070]

## The Cabaret Voltaire

The Cabaret Voltaire was created by the German anarchist poet and pianist Hugo Ball in Zurich in 1916. Rented from its Jewish owner,

Jan Ephraim, and with start-up funds provided by a Jewish patroness, Käthe Brodnitz, the Cabaret was established in a seedy part of the city and intended as a place for entertainment and avant-garde culture, where music was played, artwork was exhibited, and poetry was recited. Some of this poetry was later published in the Cabaret's periodical entitled *Dada*, which soon became Tristan Tzara's responsibility. In it he propagated the principles of Dadaist derision, declaring that: "Dada is using all its strength to establish the idiotic everywhere. Doing it deliberately. And is constantly tending towards idiocy itself. … The new artist protests; he no longer paints (this is only a symbolic and illusory reproduction)."[1071]

Evenings at the Cabaret Voltaire were eclectic affairs where "new music by Arnold Schoenberg and Alban Berg took its turn with readings from Jules Laforgue and Guillaume Apollinaire, demonstrations of 'Negro dancing' and a new play by Expressionist painter and playwright Oskar Kokoschka."[1072] The inclusion of dance and music extended Dada activities into areas that allowed a total expression approaching the pre-war (originally Wagnerian) ideal of the *Gesamtkunstwerk* (combined art work). In time the tone of the acts "became more aggressive and violent, and a polemic against bourgeois drabness began to be heard…"[1073] Performances sought to shock bourgeois attitudes and openly undermine spectator's templates for understanding culture. Thus, a June 1917 lecture "on modern art" was delivered by a lecturer who stripped off his clothes in front of the audience before being arrested and jailed for performing obscene acts in public.[1074] Godfrey notes that: "This was carnival at its most grotesque and extreme: all the taste and decorum that maintains polite society was overturned."[1075] Robert Wicks points out that:

> The Dada scenes conveyed a feeling of chaos, fragmentation, assault on the senses, absurdity, frustration of ordinary norms, pastiche, spontaneity, and posed robotic mechanism. They were scenes from a madhouse, performed by a group of sane and

reflective people who were expressing their decided anger and disgust at the world surrounding them.[1076]

The outrages committed by Dadaists attacking the traditions and preconceptions of Western art, literature and morality were deliberately extreme and designed to shock, and this tactic extended beyond the Cabaret Voltaire to everyday gestures. For instance, Tzara, "the most demonic activist" of Dada, regularly appalled the dowagers of Zurich by asking them the way to the brothel. For Godfrey, such gestures are redolent of the "propaganda of the deed" of the violent anarchists who, through their random bombings and assassinations of authority figures, sought to "show the rottenness of the system and to shock that system into crisis."[1077] Arnason likewise underscores the serious ideological intent behind such gestures, noting that: "From the very beginning, the Dadaists showed a seriousness of purpose and a search for a new vision and content that went beyond any frivolous desire to outrage the bourgeoisie. ... The Zurich Dadaists were making a critical re-examination of the traditions, premises, rules, logical bases, even the concepts of order, coherence, and beauty that had guided the creation of the arts throughout history."[1078] Jewish Frankfurt School intellectual Walter Benjamin, spoke admiringly of Dada's moral shock effects as anticipating the technical effects of film in the way they "assail the spectator."[1079]

The leadership of Zurich Dada soon passed from Ball to Tzara, who, in the process, "impressed upon it his negativity, his anti-artistic spirit and his profound nihilism." Soon Ball could no longer identify with the movement and left, remarking: "I examined my conscience scrupulously, I could never welcome chaos."[1080] He moved to a small Swiss village and, from 1920, became removed from social and political life, returning to a devout Catholicism and plunging into a study of fifth and sixth-century saints. Ball later embraced German nationalism and was to label the Jews "a secret diabolical force in German history," and when analyzing the potential influence of the Bolshevik Revolution on Germany, concluded that, "Marxism has little prospect of popularity in

Germany as it is a 'Jewish movement.'"[1081] Noting the makeup of the new Bolshevik Executive Committee, Ball observed that:

> There are at least four Jews among the six men on the Executive Committee. There is certainly no objection to that; on the contrary, the Jews were oppressed in Russia too long and too cruelly. But apart from the honestly indifferent ideology they share and their programmatically material way of thinking, it would be strange if these men, who make decisions about expropriation and terror, did not feel old racial resentments against the Orthodox and pogrommatic Russia.[1082]

Tzara, as Ball's successor, quickly converted Ball's persona as cabaret master of ceremonies into a role as a savvy media spokesman with grand ambitions. Tzara was "the romantic internationalist" of the movement according to Richard Huelsenbeck in his 1920 history of Dada, "whose propagandistic zeal we have to thank for the enormous growth of Dada."[1083]

In addition to the Jewish mysticism of his Hassidic roots, Tzara was strongly influenced by the Italian Futurists, though, not surprisingly, he rejected the proto-Fascist stance of their leader Marinetti. By 1916, Dada had replaced Futurism as the vanguard of modernism, and according to Jewish Dadaist Hans Richter, "we had swallowed Futurism – bones, feathers and all. It is true that in the process of digestion all sorts of bones and feathers had been regurgitated."[1084] Nevertheless, the Dadaists' intent was contrary to that of the Futurists, who extolled the machine world and saw in mechanization, revolution and war the logical means, however brutal, to solving human problems. Dada was never widely popular in the birthplace of Futurism, although quite a few Italian poets became Dadaists, including the poet, painter and future racial theorist Julius Evola, who became a personal friend of Tzara and initially took to Dada with unbridled enthusiasm. He eventually became disillusioned by Dada's total rejection of European tradition, however,

and began the search for an alternative, pursuing a path of philosophical speculation which later led him to esotericism and fascism.[1085]

The entry of Romania into the war on the side of Britain, France, and Russia in August 1916 immediately transformed Tzara into a potential conscript. Gale relates that: "In November Tzara was called for examination by a panel ascertaining fitness to fight. He successfully feigned mental instability and received a certificate to that effect."[1086] At this time, living across the street from the Cabaret Voltaire in Zurich were Lenin, Karl Radek and Gregory Zinoviev who were preparing for the Bolshevik Revolution.

After the November 1918 Armistice, Tzara and his colleagues began publishing a Dadaist journal called *Der Zeltweg* aimed at popularizing Dada at time when Europe was reeling from the impact of the war, the Bolshevik Revolution, the Spartacist uprising in Berlin, the communist insurrection in Bavaria, and, later, the proclaiming of the Hungarian Soviet Republic under Bela Kun. These events, observed Hans Richter, "had stirred men's minds, divided men's interests and diverted energies in the direction of political change."[1087] According to historian Robert Levy, Tzara around this time associated with a group of Romanian communist students, almost certainly including Ana Pauker, who later became the Romanian Communist Party's Foreign Minister and one of its most prominent and ruthless Jewish functionaries.[1088] Tzara's poems from the period are stridently communist in orientation and, influenced by Freud and Wilhelm Reich, depict extreme revolutionary violence as a healthy means of human expression.[1089]

Among the other Jewish artists and intellectuals who joined Tzara in neutral Switzerland to escape involvement in the war were the painter and sculptor Marcel Janco (1895-1984), his brothers Jules and George, the painter and experimental film-maker Hans Richter (1888-1976), the essayist Walter Serner (1889-1942), and the painter and writer Arthur Segal (1875-1944). After Zurich, Dada was to take root in Berlin, Cologne, Hanover, New York and Paris, and each time it was Tzara who forged the links between these groups by organizing (despite the disruption of the war and its aftermath) exchanges of pictures,

books and journals. In each of these cities, Dadaists "gathered to vent their rage and agitate for the annihilation of the old to make way for the new."[1090]

## Dada in Paris

By 1919, when Tzara left Switzerland to join the poet André Breton in Paris, he was, according to Richter, regarded as an "Anti-Messiah" and a "prophet."[1091] His *1918 Dada Manifesto* had appeared in Paris, and, according to Breton, had "lit the touch paper. Tzara's *1918 Manifesto* was violently explosive. It proclaimed a rupture between art and logic, the necessity of the great negative task to accomplish; it praised spontaneity to the skies."[1092] The editors of the avant-garde literary review *Littérature* felt that Tzara could fill the gap left by the deaths of Guillaume Apollinaire and Jacques Vaché. Gale notes that "Tzara immediately became the most extreme contributor to *Littérature*," and by the end of 1919, "the *Littérature* editors had to defend his work from nationalistic attacks in the *Nouvelle Revue Française*."[1093] A coordinated Dada insurgency was not, however, achieved until Tzara's arrival in Paris in 1920.

In addition to his messianic zeal, Tzara brought to Paris Dada a skill in managing events and audiences, which transformed literary gatherings into public performances that generated enormous publicity. In the five months from January 1920 he helped organize six group performances, two art exhibitions and more than a dozen publications. Dempsey notes how "the popularity of these events with the public soon turned these revolutionary 'anti-artists' into celebrities. The cumulative effect of this first 'Dada season' as it became known, was to mark the movement as a nihilistic collective force leveled at the noblest ideals of advanced society."[1094] The performances with which Dadaists tested their Parisian audiences were consistently aggressive in nature, and psychological aggression characterized many of their artworks and journals. As one source notes: "Like the plays and stage appearances, individual works produced within Dada emanate a violent humor,

ranging from vulgar to sacrilegious language to images of weapons and wounds, or references to taboos great and small: suicide, cannibalism, masturbation, vomiting."[1095]

It was widely observed at the time that the output of Paris Dada exhibited a "profound violence: physical hurt, damage to language, a wounding of pride or moral spirit," that to native observers seemed wholly "uncharacteristic of French sensibility."[1096] *Comoedia*, a Parisian arts daily focused on theatre and cinema, soon became the central forum for debates over Dada and its effects on French audiences. Charges of enemy subversion, lunacy and charlatanism regularly appeared – just as it did in many German newspapers – pretexts to isolate what seemed to many a traitorous insurgency against bedrock national values.[1097] Attacks on Dada in Paris soon took on an openly anti-Semitic tone when the French writer Jean Giraudoux, in explaining his rejection of Dada, pointed out: "I write in French, as I am neither Swiss nor Jewish and because I have all requisite honors and degrees."[1098]

The French cultural establishment looked askance at Dada from its arrival in Paris at the beginning of 1920. It was common knowledge that the Dadaists were avowed partisans of revolution and supported the communist uprisings in Berlin and Munich that had barely been put down. Trotsky's red legions were, at that time, cutting a swathe of death and destruction in Poland, and many perceived a conjoined ethnic agenda behind Trotsky's Bolshevism and Tzara's Dada – especially given Dada's appearance at socialist and anarchist venues throughout Paris. The connection was unambiguous in the mind of the Romanian nationalist Nicolae Rosu who noted that: "Dadaism and French Surrealism exploit the moral and spiritual exhaustion of a war-torn society: the aggressive revolutionary currents in art seem to be an explosion of primal instincts detached from reason; post-war German socialism, largely developed by Jews, uses the opportunity of defeat to dictate the Weimar constitution (written by a Jew), and then through Spartakism, to install Bolshevism. Russian Bolshevism is the work of Jewish activists."[1099]

In October 1920, the messianic Jewish Dadaist Walter Serner arrived in Paris and reconvened with Tristan Tzara, who had just returned from his first visit to Romania since 1915. Serner's campaign of shameless self-promotion, which included placing an advertisement in a Berlin newspaper describing himself as the world leader of Dada, was resented by Tzara, who was eager to establish his own priority as leader. By 1921, many of the original Dadaists had converged on Paris, and arguments between them created difficulties. By 1922, internal fighting between Tzara, Francis Picabia, and André Breton led to the dissolution of Dada.[1100] Dada was officially ended in 1924 when Breton issued the first *Surrealist Manifesto*. Hans Richter claimed that: "Surrealism devoured and digested Dada."[1101] Tzara distanced himself from Surrealism, disagreeing with its dream-centered Freudian dynamic, despite its anti-rationalism. Robert Short notes that:

> For Tzara, automatism [literary and artistic free association] was a visceral spasm, an explosion of the senses and the instinct that expressed the primitive and chaotic intensity in man and Nature. Where Surrealist automatism was introverted and sought to reveal patterns in the human unconscious, Dada art mimicked an objective chaos... Surrealism was to prospect and exploit a vast substratum of mental resources which the Western cultural and economic tradition had deliberately tried to seal off. In place of science and reason, Surrealism was to cultivate the image and the analogy. In its efforts to restimulate the associative faculties of the mind, it turned its attention with respect and enthusiasm toward the thought processes of children and primitive peoples, towards the lyrical manifestations of lunacy and the synthesizing notions of occultism.[1102]

Tzara also increasingly disagreed with the political orientation of Surrealism which evolved from the near-nihilist anarchism of the Dadaists to a strict adherence to the Communist Party line by the late 1920s, and then to Trotskyism following Breton's personal meeting with

Trotsky in Mexico in 1938.[1103] Nonetheless, Tzara willingly reunited with Breton in 1934 to organize a mock trial of the Surrealist Salvador Dalí, who, at the time, was a confessed admirer of Hitler.[1104]

Tzara's own politics were profoundly radical, and with Hitler's ascension to power in 1933 effectively marking the end of Germany's avant-garde, Tzara threw his support behind the French Communist Party (the PCF). Codrescu notes that the secular Jews of Tzara's parents' generation "were capitalists whose practical materialism horrified Samuel. The French resistance to the Nazis was, of course, the reason he later joined the Communist Party, but there was also an oedipal reason for his joining the communists: as a mystic, he was viscerally opposed to capitalism. He had to kill his father."[1105] The allegiance of the great majority of Dadaists to Marxism was paradoxical given that Marxist dialectical materialism and forecast of the historical inevitability of communist revolution was based on a kind of mathematical rationalism that ran directly counter to the Dada spirit.

Tzara's allegiance to Marxism-Leninism was reportedly questioned by the PCF and the Soviet authorities. This was because Tzara's irregular vision of utopia made use of particularly violent imagery – shocking even by Stalinist standards.[1106] Tzara backed Stalinism and rejected Trotskyism (at least publically), and unlike some of the leading Surrealists, even submitted to PCF demands for the adoption of socialist realism during the writers' congress of 1935. Tzara nevertheless interpreted Dada and Surrealism as revolutionary currents, and presented them as such to the public.[1107]

During World War Two, Tzara took refuge from the German occupation forces by moving to the southern areas controlled by the Vichy regime. Back in Romania, he was stripped of Romanian citizenship, and his writings were banned by the Antonescu regime, along with 44 other Jewish-Romanian authors. In France, the pro-German publication *Je Suis Partout* made his whereabouts known to the Gestapo. In late 1940 or early 1941, he joined a group of anti-Nazi and Jewish refugees in Marseille who were seeking to flee Europe. Unable to escape occupied France, he joined the French Resistance and contributed to

their published magazines, and managed the cultural broadcast for the Free French Forces clandestine radio station.

During 1945, he served under the Provisional Government of the French Republic as a representative to the National Assembly, and two years later received French citizenship. Tzara remained a spokesman for Dada, and in 1950 delivered a series of radio addresses discussing the topic of "the avant-garde revues in the origin of the new poetry."[1108] Towards the end of his life Tzara returned to his Jewish mystical roots, with Codrescu noting that "after the Second World War, after the Holocaust, after membership of the French Communist Party, Tzara returned to the Kabbalah."[1109]

In 1956, Tzara visited Hungary just as the hated government of Imre Nagy faced a popular revolt (with strong undercurrents of anti-Semitism), and while receptive of the Hungarians' demand for political liberalization, did not support their emancipation from Soviet control, describing the independence demanded by local writers as "an abstract notion." He returned to France just as the revolution broke out, triggering a brutal Soviet military response. Ordered by the PCF to be silent on these events, Tzara withdrew from public life, and dedicated himself to promoting the African art he had been collecting for years. He died in 1963 and was buried in the Montparnasse cemetery in Paris.

### Dada in New York and Germany

According to the account of Marcel Duchamp, in late 1916 or early 1917 he and Francis Picabia received a book sent by an unknown author, one Tristan Tzara. The book was called *The First Adventure of Mr. Antipyrine* which had just been published in Zurich. In this work, Tzara declared Dada to be "irrevocably opposed to all accepted ideas promoted by the 'zoo' of art and literature, whose hallowed walls of tradition he wanted to adorn with multicolored shit."[1110] Duchamp later recalled: "We were intrigued but I didn't know who Dada was, or even that the word existed."[1111] Tzara's scatological message was the catalyst for the establishment of the antipatriotic and anti-rationalist Dada

message in New York, and it may well have informed Duchamp's decision to submit his infamous *Fountain* to the Society of Independent Artists in New York.

In 1917, Duchamp famously sent the Independent an upside-down urinal entitled *Fountain*, signing it R. Mutt (famously photographed by Alfred Stieglitz). By doing so, Duchamp directed attention away from the work of art as a material object, and instead presented it as an idea – shifting the emphasis from making to thinking. He later did the same with a bottle rack and other items. Through subversive gestures like these, Duchamp parodied the Futurist machine aesthetic by exhibiting untreated *objets trouvés* or readymade objects. To his great surprise, these readymades became accepted by the mainstream art world.

Alongside the Frenchman Marcel Duchamp (1887-1968) and the French-born Cuban Francis Picabia (1879-1953) were the American Jews Morton Schamberg (1881-1918) and Man Ray (1890-1977). The work of the New York Dadaists was focused around the gallery of the Jewish photographer Alfred Stieglitz and his publication *291*, and the art collectors Walter and Louise Arensberg. Picabia later described this group as "a motley international band which turned night into day, conscientious objectors of all nationalities and walks of life living into an inconceivable orgy of sexuality, jazz and alcohol."[1112] They hotly debated such topics as art, literature, sex, politics and psychoanalysis. Dada in New York stayed in contact with Dada in Zurich, though it ultimately failed to take hold, and in 1921 Man Ray wrote to Tzara, complaining that "Dada cannot live in New York. All New York is Dada and will not tolerate a rival, will not notice Dada."[1113]

Most of the artists of New York Dada left for Paris. Man Ray arrived there in July 1921, shortly after Duchamp, and remained there until 1940, becoming the youngest member of the Paris Dada group, and later of the Surrealists, even though this did not reflect any real modification of his art. With the arrival of Duchamp and Man Ray in Paris, New York Dada, which had not engaged in the kind of militant cultural protest seen in the European centers of Dada, came to an end. Their experiences were not dissimilar to that of other Dadaists "who were swept

along, as they were, by the vehemence of André Breton into the coils of the new Surrealist movement which was, in many ways, an offspring of Dada."[1114]

Early in 1917, Richard Huelsenbeck, a twenty-four-year-old German medical student and poet, returned to Berlin from Zurich, where he had spent the preceding year in the company of the Zurich Dadaists under the leadership of Tristan Tzara. After the war ended, Dada activity in Germany increased as Dadaists dispersed to various sites throughout the country including, most prominently, Berlin, Cologne and Hannover. In Germany, alongside George Grosz, Walter Mehring, Johannes Baader, Hannah Höch and Kurt Schwitters were Jews like Johannes Baargeld (1876-1955), Raoul Hausmann (1886-1971), and Eli Lissitzky (1890-1941).

The political radicalism of the Berlin Dadaists was even more pronounced than that of the Zurich or Paris Dadaists, with most belonging to the League of Spartacus, a radical socialist group that became the German Communist Party in 1919. German Dada was also closer to the Eastern European avant-garde led by Jewish artists like Eli Lissitzky and László Moholy-Nagy. The new Soviet state that emerged after the Bolshevik Revolution initially adopted a policy in favor of radical experimentation. In Berlin, more than anywhere outside the Soviet Union, "a direct equation could be made between political reform and artistic radicalism. Despite the seeming absurdity of some of their activities, the Dadas' reinvention of poetic language and artistic form could be seen as a prelude to reforming the whole of the decayed social system."[1115] A Dada Manifesto by Huelsenbeck and Hausmann, published in a Cologne newspaper, declared that Dada "is German Bolshevism"[1116] and that "Dadaism demands: the international revolutionary union of all creative and intellectual men and women on the basis of radical Communism."[1117]

The Berlin Dadaists even condemned the Weimar Republic as representing a renaissance of "Teutonic barbarity," and held Communism to be the best hope for freedom.[1118] Short notes that, among the German Dadaists, were those for whom: "Dada was a political weapon and those

for whom communism was a Dadaistical weapon. There was a faction which saw anarchy and anti-art as a sufficient programme in itself, and a second faction which saw anarchy as a provisional precondition for the introduction of new values."[1119]

Falling into the latter category was Johannes Baargeld. Born Alfred Emanuel Ferdinand Gruenwald to a prosperous Romanian-Jewish insurance director, "Baargeld" was the ironic, leftist pseudonym he adopted (Baargeld being the German word for cash or ready money). Growing up in Cologne in a wealthy home, he was exposed from a young age to contemporary art and culture, beginning with his parents' collection of modernist paintings. He joined the Independent Socialist Party of Germany (USPD) – the radical left wing of the Socialist Party – and in the process "turned his back on his wealthy bourgeois upbringing and became actively involved in the leadership of the Rhineland Marxists."[1120]

Baargeld (also called "Zentrodada") and Max Ernst cofounded Dada in Cologne in the summer of 1919. Baargeld's father was anxious about his son's political leanings and sought Ernst's help. Robert Short notes that: "They succeeded in convincing him that Dada went further than Communism and that its combination of new-found inner freedom and powerful external expression could do more to set the whole world free. In return, Grunewald senior financed the publication of a new international Dada magazine *Die Schammade*."[1121]

In April 1920, Cologne Dada staged one of the most memorable of German Dada's exhibitions. Entered by way of a public lavatory, it included "exhibits" like a young girl in communion dress reciting obscene verses, and a bizarre object by Baargeld consisting of an aquarium filled with red fluid from which protruded a polished wooden arm and on whose surface floated a head of woman's hair.[1122] The First International Dada Fair was held in Berlin in June 1920, and was the most significant Dadaist event organized in the Berlin milieu. The radical political orientation of the organizers was illustrated by a mannequin of a German officer with the head of a pig hanging from the ceiling with a

notice "Hanged by the revolution," which triggered fierce debate about its subversive and anti-military character.[1123]

Given such provocative gestures and the extensive Jewish participation in Dada, it was not surprising that, between the two world wars, German nationalists linked Dada (and avant-gardism generally) to Jews, claiming these modern trends aimed to destroy the principles of classical beauty and eradicate national traditions. The Dadaists were said to express the "nihilistic Jewish spirit" (a common phrase at the time), if they were not actually mad. In response to the activities of Jewish Dadaists, "calls for 'degenerate' art to be banned were widely published in pre-Nazi and later in Nazi Germany, as well as in France."[1124]

Interestingly, *Mein Kampf* was composed by Hitler at the time of Paris Dada's existence, and his comments about Jewish influence on Western art need be understood in this context. He mentions the "artistic aberrations which are classified under the names of Cubism and Dadaism," and clearly has the Dadaists in mind when he observes that: "Culturally, his [the Jew's] activity consists in bowdlerizing art, literature and the theatre, holding the expressions of national sentiment up to scorn, overturning all concepts of the sublime and the beautiful, the worthy and the good, finally dragging the people to the level of his own low mentality."[1125] Likewise, when he recalls how he once asked himself whether "there was any shady undertaking, any form of foulness, especially in cultural life, in which at least one Jew did not participate?" and subsequently discovered: "On putting the probing knife carefully to that kind of abscess one immediately discovered, like a maggot in a putrescent body, a little Jew who was often blinded by the sudden light."[1126]

In 1933, Hitler's new government announced that: "The custodians of all public and private museums are busily removing the most atrocious creations of a degenerate humanity and of a pathological generation of 'artists.' This purge of all works marked by the same western Asiatic stamp has been set in motion in literature as well with the symbolic burning of the most evil products of Jewish scribblers."[1127] At the exhibition of degenerate art held in Munich in 1937 the Dadaist

works were considered the most degenerate of all – the epitome of *Kulturbolschewismus*. In that year the Ministry for Education and Science published a pamphlet in which Dr. Reinhold Krause, a leading educator, wrote that "Dadaism, Futurism, Cubism, and other isms are the poisonous flower of a Jewish parasitical plant."[1128]

British historian Paul Johnson points out that: "Hitler always referred to degenerate art as 'Cubism and Dadaism', maintaining that it started in 1910, and the 'Degenerate Art' exhibition bore a curious resemblance to the big Dada shows of 1920-22, with a lot of writing on the walls and paintings hung without frames."[1129] He also notes that the Nazi campaign against "degenerate art" was "the best thing that could possibly have happened, in the long term, to the Modernist Movement." This is because since the Nazis, universally reviled by all governments and cultural establishments since 1945, tried to destroy and suppress such art completely, then its merits were self-evident morally, and anything the Nazis opposed was assumed to have merit – on the illogical basis that the enemy of my enemy must be my friend. "These factors," notes Johnson, "so potent in the second half of the twentieth century, will fade during the twenty-first, but they are still determinant today."[1130]

### The Legacy of Dada

Dada's destructive influence has been seminal and long-lasting. As Dempsey points out, Dada's notion that: "The presentation of art as idea, its assertion that art could be made from anything and its questioning of societal and artistic mores, irrevocably changed the course of art."[1131] The movement represented "an assertive debunking of the ideas of technical skill, virtuoso technique, and the expression of individual subjectivity. ... Dada's cohesion around these procedures points to one of its primary revolutions – the reconceptualization of artistic practice as a form of tactics."[1132] These tactics consisting, variously, of "intervention into governability, that is, subversions of cultural forms of social authority – breaking down language, working against various

modern economies, willfully transgressing boundaries, mixing idioms, celebrating the grotesque body as that which resists discipline and control."[1133]

Dada's iconoclastic force had enormous influence on later twentieth-century conceptual art. Godfrey notes that: "Dada can be seen as the first wave of conceptual art" which exercised an enormous influence on subsequent art movements.[1134] In the late 1950s and 1960s, in opposition to the then dominant Abstract Expressionism and Post-Painterly Abstraction, Robert Rauschenberg and Jasper Johns resurrected the Dadaist tradition, describing the works they produced as "Neo-Dada" – a movement that, together with the "pre-emptive kitsch" of Pop Art, effectively relaunched the conceptual art of the original Dadaists, and which has plagued Western art ever since. The Neo-Dadaists themselves left a deeply influential Cultural Marxist legacy insofar as their

> visual vocabulary, techniques, and above all, their determination to be heard, were adopted by later artists in their protest against the Vietnam War, racism, sexism, and government policies. The emphasis they laid on participation and performance was reflected in the activism that marked the politics and performance art of the late 1960s; their concept of belonging to a world community anticipated sit-ins, anti-war protests, environmental protests, student protests and civil rights protests that followed later.[1135]

Another pernicious influence of Dada stemmed from its rejection of the identity between art and beauty. Crepaldi notes that "many artists before Dada had called into question the aesthetic canons of their contemporaries and had proposed other canons, destined to meet varying degrees of success." The Dadaists went beyond this, and called into question "the notion according to which the goal of art is the expression of a value called 'beauty.'"[1136] The Dadaists legitimized the idea that the artist has a right (nay a duty) to produce ugly works, and

instituted a cult of ugliness in the arts that has since eroded the cultural self-confidence of the West.

## Dada and Deconstruction as Jewish Attack Vectors

A final destructive legacy of Dada, and one which merits more attention, is how its anti-rationalism prefigured Jacques Derrida's deconstruction as a Jewish intellectual movement arrayed against Western civilization. The parallels between Dada and Deconstruction have been noted by numerous scholars. Robert Wicks observes how strongly Dada resonates "with the definitively poststructuralist conception of deconstruction advanced by Jacques Derrida in the 1960s."[1137] Pegrum likewise notes the "strong link between Dada and postmodern artistic theory, the most obvious point of contact being with the work of Derrida."[1138] The literary critic Frank Kermode also traces deconstruction back to Dada influences, while Richard Sheppard regards the poststructuralists "as more introverted, less politicized, and less carnivalesque descendants of their Dada daddies."[1139]

For the Dadaists, European civilization consisted of "an alienation-generating amalgam of rationalistic thinking, science, and technology that adhered to the preservation of order, systematicity, and methodicality." They believed firmly that "European cultural values were not worth preserving."[1140] Tzara once stated that "logic is always false," and a core concept in his thought was "as long as we do things the way we think we once did them, we will be unable to achieve any kind of livable society."[1141] The Dadaists famously "spat in the eye of the world," replacing logic and sense with absurdity and defiance.[1142] Even the word Dada itself, suggesting basic drives and childlike behavior, was self-consciously absurd, even self-mocking, and a subversive anthem of resistance to more fully instrumentalized speech and disciplined rationality, and ridiculed Western confidence in the "autonomy of the rational ego and the efficacy of reason." They denounced the post-Renaissance Western conception of reality which "assumed that the world was organized according to humanly intelligible laws," and

"condemned 'bourgeois cultures' deadening determination to stabilize and categorize all phenomena."[1143]

The Dadaists even criticized the "rationality and excessive formalism" of Cubism, particularly during its analytic period.[1144] In May 1922, at a mock funeral for Dada, Tzara proclaimed: "Dada is a virgin microbe which penetrates with the insistence of air into all those spaces that reason has failed to fill with words and conventions."[1145] Dickerman notes how: "Resistance to fixed meaning" remained a key feature of Dada.[1146] Godfrey likewise observes that: "At the heart of Dada was an implicit critique of language as supposedly transparent."[1147] Dada acted as a bridge between the modern and the postmodern in anticipating Derrida's deconstruction and Michel Foucault's analysis of power, which, like Dada, attacked the notion of objective truth which had been the cornerstone of Western thinking and knowledge production since the Enlightenment.

In order to deconstruct Western culture, Derrida had to identify a fundamental fault with it – which he decided was its "logocentrism." By this he meant Western culture privileged speech over the written word (a dubious assertion), and that it is founded on the false belief that the world really is as our concepts describe it (i.e., on philosophical realism). Like Barthes and Foucault, Derrida used nominalism (the view that concepts are nothing more than human artifacts that have no relation to the real world) to deconstruct and subvert Western realism. In doing so, he mimicked the approach of the Dadaists, for whom:

> It followed from their rejection of the belief in progress, in tamable nature and rational man, that the Dadas should cast doubt on the power of language, literature and art to represent reality. The information which the senses communicated to men was misleading, even the ideas of the individual "personality" and the external world were elusive and incoherent. How then could language, by definition an instrument of public communication, do other than deform and betray life's authentic character as a discontinuous sequence of immediate experiences? The Dadas

answered that words were mere fictions and that there was no correspondence between the structures of language and those of reality. Thus the belief in order which the power of a common, inherited language inculcated was illusory.[1148]

In order to attack Western realism Derrida and the Dadaists borrowed from the Swiss linguist Ferdinand de Saussure the notion of *"différence"* – which Saussure used to denote the arbitrary nature of language signs. It does not matter what signs we use to mean "night" and "day;" what matters is that we use signs to signal a certain difference, and this structural property was, for Saussure, the true carrier of meaning. The French *différer* also means to defer, in the sense of put off, and on this coincidental etymological basis Derrida decided that that Saussure had definitively proven that meaning is always deferred by the text.

The consequence is that the process of meaning is something that never gets started: or rather, if and when meaning starts is an arbitrary human decision. Texts do not have a single authoritative meaning: rather, there is a "free play of meaning" and anything goes. Consequently, we are *liberated* from meaning. Moreover, the text is "emancipated from authorship." Once written, the author disappears and a text becomes a public artifact. It is for us to decide what the text means, and we are free to decide as we please, and since "all interpretation is misinterpretation" no particular reading is privileged.[1149] Sheppard notes that: "Derrida, dynamizing Saussure's model of the sign, sees humanity caught in an endless flow of textuality where signifieds and signifiers perpetually fracture and recombine anew. Consequently, he concludes that there is nothing outside the text."[1150] Under Derrida's deconstruction "a new text thus gradually begins to emerge, but this text too is at subtle variance with itself, and the deconstruction continues in what could be an infinite regress of dialectical readings."[1151]

While Derrida posed as a leftist Parisian intellectual, a secularist and an atheist, he descended from a long line of crypto-Jews, and explicitly identified himself as such: "I am one of those marranes who no longer say they are Jews even in the secret of their own hearts."[1152] Derrida

was born into a Sephardic Jewish family that immigrated to Algeria from Spain in the nineteenth century. His family were crypto-Jews who retained their Jewish identity for 400 years in Spain during the period of the Inquisition. Derrida changed his first name to the French Christian sounding 'Jacques' in order better blend into the French scene. Furthermore, he took his crypto-Judaism to the grave:

> When Derrida was buried, his elder brother, René, wore a tallit at the suburban French cemetery and recited the Kaddish to himself inwardly, since Jacques had asked for no public prayers. This discreet, highly personal, yet emotionally and spiritually meaningful approach to recognizing Derrida's Judaism seems emblematic of this complex, imperfect, yet valuably nuanced thinker.[1153]

Derrida was a crypto-Jew until the end, even instructing his family to participate in the charade. Kevin MacDonald notes the obvious reason: "Intellectually one wonders how one could be a postmodernist and a committed Jew at the same time. Intellectual consistency would seem to require that all personal identifications be subjected to the same deconstructing logic, unless, of course, personal identity itself involves deep ambiguities, deception, and self-deception."[1154]

In his notebooks, Derrida underscores the centrality of Jewish issues in his writing: "Circumcision, that's all I've ever talked about." His experience of anti-Semitism during World War II in Algeria was traumatic and resulted in a deep consciousness of his own Jewishness. He was expelled from school at age 13 under the Vichy government because of official caps on the number of Jewish students, describing himself as a "little black and very Arab Jew who understood nothing about it, to whom no one ever gave the slightest reason, neither his parents nor his friends."[1155] Later, in France, his "suffering subsided. I naively thought that anti-Semitism had disappeared. ... But during adolescence, it was the tragedy, it was present in everything else." These experiences led Derrida to develop "an exhausting aptitude to detect signs of racism, in

its most discreet configurations or its noisiest disavowals."[1156] Caputo
notes how Jewish ethnic activism underpins Derrida's deconstruction:

> The idea behind deconstruction is to deconstruct the workings
> of strong nation-states with powerful immigration policies, to
> deconstruct the rhetoric of nationalism, the politics of place,
> the metaphysics of native land and native tongue. ... The idea
> is to disarm the bombs... of identity that nation-states build to
> defend themselves against the stranger, against Jews and Arabs
> and immigrants, ... all of whom... are wholly other. Contrary to
> the claims of Derrida's more careless critics, the passion of de-
> construction is deeply political, for deconstruction is a relentless,
> if sometimes indirect, discourse on democracy, on a democracy
> to come. Derrida's democracy is a radically pluralistic polity that
> resists the terror of an organic, ethnic, spiritual unity, of the
> natural, native bonds of the nation (natus, natio), which grind
> to dust everything that is not a kin of the ruling kind and genus
> (Geschlecht). He dreams of a nation without nationalist or nativ-
> ist closure, of a community without identity, of a non-identical
> community that cannot say I or we, for, after all, the very idea of
> a community is to fortify (munis, muneris) ourselves in common
> against the other. His work is driven by a sense of the consum-
> mate danger of an identitarian community, of the spirit of the
> "we" of "Christian Europe," or of a "Christian politics," lethal
> compounds that spell death of Arabs and Jews, for Africans
> and Asians, for anything other. The heaving and sighing of this
> Christian European spirit is a lethal air for Jews and Arabs, for
> all les juifs [i.e., Jews as prototypical others], even if they go back
> to father Abraham, a way of gassing them according to both the
> letter and the spirit.[1157]

Derrida's sociological preoccupations (and suggested solutions) repli-
cated those of Tristan Tzara. Sandqvist links Tzara's profound revolt
against European social constraints directly to his Jewish identity, and

his anger at the persistence of anti-Semitism. For Sandqvist, the treatment of Jews in Romania fueled the Dada leader's revolt against Western civilization. Bodenheimer notes that:

> As a Jew, Tzara had many reasons to call into question the so-called disastrous truths and rationalizations of European thinking, one result of which was the First World War – with the discrimination of Jews for centuries being another. ... He came from a background in which jingoistic and anti-Semitic arguments had long reproached Jews for using impure, falsified language, from early examples in the sixteenth century... all the way to the arguments of the Romanian intellectuals in Tzara's time, who attacked Jews as "foreigners" importing "diseased ideas" into Romanian literature and culture.

> [Tzara consequently] seeks to unmask language itself as a construction that draws its value, and sometimes its claim to superiority, from an equally constructed concept of identities and values. In themselves, all languages are equal, but equal in their differences. This claim to the right of equality while upholding difference is the basic Jewish claim to a secular society. But the European peoples, be it first for religious or later for nationalist reasons, have never managed to actually understand this right, let alone grant it to minority societies.[1158]

One of the catalysts for the dissolution of Dada in Paris was Surrealist leader André Breton's concern that Dada's nihilism posed a threat to the "process of intellectual sanitation" that became necessary with the rise of fascism.[1159] Boime likewise claims the Dadaists in their "assault on the Enlightenment and bourgeois liberalism in Zurich and then in Berlin eventually played into the hands of the Fascists and right-wing nationalists. Although these latter groups condemned Dadaist spectacle and modernist thinking, Dada's rejection of parliamentary politics and

democratic institutions helped pave the way for Nazism's direct assault on humanitarian ideals."[1160]

Derrida has been similarly criticized by some Jews because his writings "lead to 'nihilism,' which threatens, in their denial of the notion of objective truth, to 'efface many of the essential differences between Nazism and non-Nazism.'"[1161] However, Derrida's writings have certainly not had any effect on the power of the Holocaust Industry, and indeed, some of Derrida's biggest backers were intellectual Holocaust activists. This strange state of affairs may be explained by the fact that for some Jews, like Derrida, acknowledging the possibility of objective truth is dangerous because of the possibility that truth could be arrayed against the "other." Similarly, for the Dadaists, the principles of Western rationality "were held to be highly problematic, because of its instrumental connections to social repressions and domination."[1162] Consequently, a world where truth had been deconstructed is very much a desirable world. As Kevin MacDonald points out in *Culture of Critique*:

> Such a world is safe for Judaism, the prototypical other, and provides no warrant for the universalizing tendencies of Western civilization – what one might term deconstruction as de-Hellenization or de-Westernization. Minority group consciousness is thus validated not in the sense that it is known to be based on some sort of psychological truth, but in the sense that it can't be proved untrue. On the other hand, the cultural and ethnic interests of majorities are 'hermeneuticized' and thus rendered impotent – impotent because they cannot serve as the basis for a mass ethnic movement that would conflict with the interests of other groups.[1163]

When the Frankfurt School established itself in the United States, it made a conscious effort to give its Jewish intellectual activism a "scientific" veneer by gathering "empirical data" (such as that which formed the basis for *The Authoritarian Personality*) in order to challenge existing scientific theories seen as inimical to Jewish interests (such

as Darwinian anthropology). Derrida and the poststructuralists instead sought (like the Jews within Dada) to discredit threatening concepts by undermining the notion of objective truth underpinning *all* Western thought. Like the Dadaists, the poststructuralists decided, if you dislike the prevailing power, then strive to ruin its concepts. Dada used nonsense and absurdity to achieve this goal, while Derrida developed his methodology of deconstruction.

### Fostering subjective individualism

Despite the tactical differences, a Jewish ethno-political thread runs through Tzara's Dada, Derrida's deconstruction, and the Critical Theory of the Frankfurt School. Each attempted to foster subjective individualism to disconnect the non-Jewish masses from their familial, religious and ethnic bonds – thereby reducing the salience of the Jews as the prototypical outgroup, and thus weakening the anti-Semitic status quo within Western societies.

This attempt to foster radical individualism (at least among Europeans) through critiquing the logical basis of language was an explicitly stated goal of Dada, with the early leader of the movement Hugo Ball declaring that: "The destruction of the speech organs can be a means of self-discipline. When communications are broken, when all contact ceases, then estrangement and loneliness occur, and people sink back into themselves."[1164] Dickerman notes how the Dadaists' use of abstraction in the visual arts and language "work against structures of authority communicated through language" and that the Dadaist "assault on 'language as a social order' would counter sociality itself, producing instead a productive form of solipsism." The Jewish Dadaist Hans Richter declared the abstract language of the Dadaists "beyond all national language frontiers," and saw in Dadaist abstraction a new kind of communication "free from all kinds of nationalistic alliances."[1165]

The Jewish Dadaist painter Arthur Segal expressed a similar view, contending that "the compositional principle of equivalence is an attempt to abolish hierarchies so that dominant and subordinate forces

would no longer exist." Hockensmith points out that: "Abstraction thus provided Segal with a means of theorizing a world without authoritative force, one in which people and things would stand in free relation to one another."[1166] Tristan Tzara similarly affirmed that: "Dada proposed to liberate man from all servitude, whatever the origin, intellectual, moral, or religious."[1167] This is precisely what Derrida attempted to do with deconstruction, where "All that remains thereafter is the subject who can choose what to think, what to feel and what to do, released from external constraints, and answerable to nothing and to no one."[1168]

In his book *The Jewish Derrida*, Israeli academic Gideon Ofrat relates how in 1990 Derrida took part in a symposium in Turin, Italy, on the theme of "European Cultural Identity."

> Having imbibed into his very being the European culture in which he had been raised, the Algerian Jew now set about defining "Europeanism" by reference to the horrors of World War II and Nazism, and to a survey of the present day, with its "crimes of xenophobia, racism, anti-Semitism, religious or national fanaticism." It was probably this archive that prompted Derrida to come up with his somewhat paradoxical definition of European cultural identity: "The characteristic of a culture is not to be identical with itself;" in other words, one's cultural identity lies in separation from oneself. Moreover, a knowledge of your own cultural identity is contingent upon knowledge of the culture of the Other. ... [Derrida is] simultaneously proposing a fundamental alteration in thinking about Europe, in terms of non-European Otherness. Europe will know itself as Europe if it advances toward that which it is not. ... Here your identity lies in your own self-denial, in your death (in identity). Moreover, Derrida points out a basic contradiction between the pursuit of universality by European culture, and, by implication, the sense of exemplariness: an individual national arrogance, setting itself apart from the rest of the world. It is the contradiction between the message of values designated for the whole world, and one society's claim

to a monopoly of that gospel. Derrida puts forward a different concept: opening up Europe to Otherness, to the other, the aliens, as recognition of the Other culture and its adoption into society overall – possibly a proposal for the deconstruction of Europe, that is, a study of the Other root of the European essence, and its substitution by a pluralism of heterogeneity[1169]

Clearly, deconstruction was a Jewish intellectual movement that was a post-Enlightenment (indeed postmodern) manifestation of Judaism as a group evolutionary strategy. Inevitably, as with the other Jewish intellectual movements discussed in Kevin MacDonald's *Culture of Critique*, the solution to all social problems lies in convincing Europeans to commit racial, national and cultural suicide by embracing the *Other* through acceptance of racial and cultural diversity. All Jewish intellectual roads lead to mass third-world immigration and multiculturalism.

Also inevitably, as with the Frankfurt School, Derrida's deconstructive scalpel is never turned on the Jews themselves, or Israel, who are always outside the culturally-critical frame of reference. Thus the "pluralism of heterogeneity" is never recommended as a way of opening Israel to Otherness and thereby helping Jews to better understand their identity "by advancing to what they are not." Why? Because the whole point of this intellectual exercise is to cook up specious morally-universalistic rationales of enough persuasive force to convince White people to become complicit in their own racial and cultural self-destruction – thereby furthering the unstated goal of eliminating European anti-Semitism and making the entire Western world safe for Jews.

Derrida's exercise in Jewish ethno-politics was, of course, primarily concerned with deconstructing Western culture and the belief systems that had sustained European civilization in the past (e.g., Christianity, nationalism) and those which could be deployed to save it now and in the future, such as race realism and evolutionary theories of the ethnic basis of cultural conflict in the West. By contrast, the chauvinistic Jewish beliefs that have sustained Jewish societies and culture for millennia escaped Derrida's deconstructive attack.

Regarding poststructuralism generally, Scruton notes that, from Foucault's analysis of knowledge as ideology of power to the "deconstructive virus" released into the academic air by Derrida, "this culture of repudiation may present itself as 'theory,' in the manner of the critical theory of Horkheimer, Adorno, and Habermas, developing ponderous 'methodologies' with which to root out the secret meanings of cultural works, to expose their ideological pretensions, and to send them packing into the past." Nevertheless, the aim of the poststructuralists "is not knowledge in the post-Enlightenment sense, but the destruction of the vessel in which unwanted knowledge has been contained."[1170]

Poststructuralism and deconstruction rapidly infested Western academia during the seventies and eighties, becoming stock approaches in literary criticism, the humanities and social sciences, and this critical approach was presaged by the Dadaists who, in response to the First World War and the persistence of anti-Semitism, gradually morphed their movement into a disgust at rationalism as a defining feature of post-Enlightenment European culture. The Dadaists were keenly aware of the paradoxical nature of their revolt and against logic and reason. Robert Wick notes how "self-contradictory phrases sprinkle themselves across the Dada manifestos – phrases which proclaim that everything is false, that Dada is nothing, that there is no ultimate truth, that everything is absurd, that everything is incoherent and that there is no logic. They are phrases that present themselves in the manifestos as being true, meaningful, coherent, and logical, while they deny all truth, meaning, coherence, and logic."[1171] The Dadaists recognized that they were trapped inside a "double hermeneutic" in that they were compelled to use the forms of bourgeois society to mount a critique of that society.

In an analogous way, Foucault and Derrida attempted to develop an "ontology of the present" that would enable them to "abstract" themselves from their cultural surroundings. The paradoxical and self-invalidating nature of this endeavor did not, however, limit the immense influence that poststructuralism and deconstruction exerted. The logical flaw at the heart of the entire poststructuralist intellectual edifice is simply ignored – this being that same logical fallacy perpetrated by

Nietzsche when he expressed the view that there are no truths, only interpretations. Either Nietzsche's position is true – in which case it is not true, since there are no truths, or it is false. Derrida's and Foucault's central arguments amount to the same point made less brusquely, and while they presented their arguments in opaque pseudo-profound language to conceal the paradox, it nevertheless remains.

Foucault and Derrida owe their inflated intellectual reputations to their role in giving authority to the rejection of authority, and their absolute commitment to the impossibility of absolute commitments. Those who point out the obvious flaw in Foucault's poststructuralist analysis of power and Derrida's deconstructionist analysis of language – namely, that a rational critique assumes precisely what they put in question – are simply accused of aligning themselves with the oppressive, hegemonic forces of the Eurocentric bourgeois patriarchy through assuming the frame of reference that this group has normalized. Indeed, they are told that the very belief in neutral enquiries is not a neutral belief, but rather the expression of the hegemonic worldview most in need of deconstruction. There is, therefore, no position from which deconstruction can be critiqued. If there were such a vantage point, it would be founded on rational argument; but rationality itself has been deconstructed.

> Deconstruction is therefore self-vindicating, and provides the culture of repudiation with its spiritual credentials, the proof that it is "not of this world" and comes in judgment upon it. Of course that subversive intention in no way forbids deconstruction from becoming an orthodoxy, the pillar of the new establishment, and the badge of conformity that the literary apparatchik must now wear. But in this it is no different from other subversive doctrines: Marxism, for example, Leninism and Maoism. Just as pop is rapidly becoming the official culture of the post-modern state, so is the culture of repudiation becoming the official culture of the post-modern university.[1172]

In poststructuralism and deconstruction, the spirit of Dada extended far beyond what had been hoped for by its most messianic propagandists like Tristan Tzara and Walter Serner. For the British historian Paul Johnson: "Dada was pretentious, contemptuous, destructive, very chic, publicity-seeking and ultimately pointless."[1173] Johnson is wrong on the last score. Dada had far-reaching intellectual and cultural consequences – in revolutionizing art, undermining trust in the notion of objective truth, and in pioneering a vector of attack on Western civilization that was subsequently taken up by Jewish intellectual activists like Derrida.

# Wagner Reclaimed

The late Roger Scruton (1944-2020) was Britain's (many would say the world's) leading conservative philosopher and intellectual. His prolific output included books on philosophy, politics, art, architecture, music and aesthetics. Scruton, who was knighted in 2016, wrote with unusual clarity and fluency, and was a model for how to combine analytical rigor with lucidity and accessibility. His critiques of leftist thought were, however, ultimately hamstrung by his unwillingness to stray outside the bounds of "acceptable" thought. Scruton assiduously avoided straying into the forbidden fields of race realism or honest discussion of the Jewish Question.

Despite his rather timid brand of intellectual conservatism, Scruton has much to offer readers on the Dissident Right. He had a profound knowledge of European high culture and particularly the Western musical tradition. His analyses of the German composer Richard Wagner were always insightful, and his 2016 book *The Ring of Truth: The Wisdom of Wagner's Ring of the Nibelung* is no exception. It offers readers a rich account of Wagner's masterpiece though an examination of its drama, music, symbolism and philosophy. Scruton's goal was to interpret one of the supreme works of the European imagination to "show its relevance to the world in which we live."

Wagner's *Ring* cycle is enormous in every way. Performed over four evenings, and made up of *Das Rheingold, Die Walküre, Siegfried* and *Götterdämmerung*, it lasts some fifteen hours. Its composition began in 1848, a year when Europe was torn by nationalist and democratic revolutions, but not finished until 26 years later. The final product is widely considered the finest piece of musical theatre ever written, and even critics of Wagner grudgingly acknowledge the enormity of his achievement, agreeing with Tchaikovsky's assessment that: "Whatever one might think of Wagner's titanic work, no one can deny the monumental nature of the task he set himself, and which he has fulfilled; nor the heroic inner strength needed to complete the task. It was truly one of the greatest artistic endeavors which the human mind has ever conceived."[1174] The German critic Wilhelm Mohr, who had originally dismissed Bayreuth as "cloud-cuckoo land," left the 1876 premiere of *The Ring* comparing Wagner to the "two masters of all masters, Shakespeare and Beethoven."[1175]

*The Ring* began life as a single drama, devoted to the story of Siegfried's death as Wagner had extracted and embellished it from his reading of the old German *Nibelungenlied* and the Icelandic *Völsunga saga*. The original is a far cry from the masterpiece that Wagner eventually composed from its useable fragments. He looked for a subject that would provide a suitably large-scale vehicle for his vision of contemporary German society and destiny. The result, notes Scruton, while "far from authentic as an account of Viking theology," is nevertheless "a remarkable attempt to give coherence and meaning to the pagan narratives."[1176] The final product, which Wagner intended to "involve all life" encompasses an emotional spectrum wider than any other opera, from superhuman rage and self-annihilating heroism to the meanest of base emotions.

The opera revolves around a ring, fashioned in gold stolen from the Rhinemaidens by the dwarf Alberich that grants its possessor the power to rule the world. Alberich is tricked out of the ring by the god Wotan who uses to it pay the giants Fafner and Fasolt for building Valhalla. It is subsequently hoarded by Fafner, then won by Wotan's grandson

Siegfried who slays Fafner (who has magically transformed himself into a dragon). Siegfried and his betrothed Brunnhilde later foil Alberich's son Hagen's plan to acquire the ring, which is finally returned to the Rhinemaidens when Siegfried is killed by Hagen as the old world is destroyed by fire and water. Certain themes recur throughout the tetralogy: the abuse of power, the immutability of fate, the need for atonement and redemption, and the status of love as the final true and knowing redeemer.

Many of these themes will be familiar to readers of the *Lord of the Rings* by J.R.R. Tolkien who unconvincingly denied he had been influenced by Wagner. As the composer intermittently worked on the dramatic poem and music over a quarter of a century, it was reconceived as a quasi-religious festival, with the *Oresteia* of Aeschylus in mind. It was to unfold "a world-embracing myth, through intimate human dramas."[1177] Its characters were conceived both as believable people and symbols of universal powers. By following their fate the audience would be led by natural sympathy towards a vision of redemption in which human beings stand higher than the gods.

The essence of Wagnerian opera lies in the music which deepens and subtilizes the overt meaning of the storyline. Profound, far-reaching psychic changes are accomplished through the music with little or no help from the words, and *The Ring* includes some of the most powerful scenes in all opera: the opening which conjures up the Rhine in a single, extended and elaborated chord; the Entry of the Gods into Valhalla at the end of *Rheingold*; the *Ride of Valkyries* and *Magic Fire Music* in the third act of *Die Walküre*; or Siegfried's funeral march from *Götterdämmerung*.

*The Ring* is notable for its 150 or so leitmotifs, musical phrases associated with an idea or character. Not simply accompanying the libretto, they reveal the subconscious feelings of the characters or anticipate what will happen later in the story. There is no one-for-one correspondence between a leitmotif and the concept, idea or emotion that is first attached to it. The leitmotif has a potential to develop – but to develop musically. Scruton observes how "by implanting the principal of

musical development in the heart of the drama Wagner is able to lift the action out of the events portrayed on the stage, and to endow it with a universal, cosmic and religious significance."[1178]

## The Construction of Wagner as Anti-Semitic Moral Defective

A full appreciation of Wagner's genius and remarkable artistic and intellectual legacy has, in recent decades, been occluded by the preoccupation of our Jewish-dominated intellectual establishment with Wagner's anti-Semitism and his putative status as the intellectual and spiritual forerunner to Adolf Hitler (see Chapter 6). Even Scruton, while mostly dismissive of the aura of moral turpitude that now disfigures the composer's memory, felt compelled to mildly validate the construction of Wagner as anti-Semitic moral defective. The task the author set himself in *The Ring of Truth* – of conveying the intellectual and artistic meaning of Wagner's great masterpiece – is made all the more difficult, he observed, by the fact that:

> Enormous obstacles stand in the way of this endeavour, by no means the least of them being Richard Wagner, whose vast ambitions and titanic character have made him into a regular target of denigration in our anti-heroic age. From the point of view of his posthumous reputation, Wagner's life was riddled with mistakes. He made no secret of his anti-Semitism, and broadcast it to the world in a notorious pamphlet. He provided the story and the characters that would, in their Nazi caricature, become the icons of German racism. ... Nor did his mistakes end with his death. Not only did he become Hitler's favourite composer, but the Nazi caricature of the Jew was read back into Wagner's villains. Alberich, Mime and Klingsor were regularly presented on the German stage as though imagined by Dr Goebbels, and his theatre in Bayreuth was used to turn Wagner into the founder and high priest of a new and sinister religion.[1179]

The denigration of Wagner in the post-World War II era, spearheaded by Jewish musicologists and intellectuals like T.W. Adorno, established the pattern of treating his works as expressions of a deeply pathological personality, where the musicological task at hand was to "analyse them as exhibits in a medical case study, and to create the impression that we can best understand them not for what they say but for what they reveal about their creator."[1180] Wagner's autobiography is regularly trawled for evidence of psychopathology and "for the proof – however fleeting and arcane – that in this or that respect he was just as ordinary as the rest of us, even though the mind revealed in the book is one of the most extraordinary and comprehensive that has ever existed."[1181]

This approach can be traced back to the late nineteenth century when Nietzsche tried to break the spell Wagner had cast on him in *The Case of Wagner* (1888) and *Nietzsche Contra Wagner* (1895). In these books the philosopher rejected Wagner's moral vision which, he claimed, translated directly into aesthetic faults in music that corrupted listeners by encouraging surrender to a polluted ideal. Nietzsche insisted that Wagner's music is disingenuous, only pretending to the emotion it proclaims. The noble music only serves to disguise the fact that the "heroic" characters seeking redemption in his operas are just analogues of the morally-sick refuse of nineteenth-century society. Nietzsche also repeatedly attacked Wagner for his personal anti-Semitism.

Wagner was surprised, but not displeased, by the backlash that resulted from the publication of his *Judaism in Music*. In a letter to the composer Franz Liszt he noted that "I seem to have struck home with terrible force, which suits my purpose admirably, since that is precisely the sort of shock I wanted to give them."[1182] In panicked response to Wagner's cogent and incisive critique of Jewish influence on German art and culture, Jewish critics soon settled on the response of ascribing psychiatric disorders to the composer and this has been the standard approach ever since. As early as 1872, the Jewish psychiatrist Theodor Puschmann offered a psychological assessment of Wagner which was widely reported in the German press. He claimed Wagner was suffering from "chronic megalomania, paranoia...

472 - BRENTON SANDERSON

and moral derangement."[1183] Cesare Lombroso, the famous nineteenth-century Jewish-Italian criminologist, branded Wagner "a sexual psycho-path."[1184]

Later, with the advent of Freudian psychoanalysis and Expression-ism in art and music, the habit arose of treating works of art as journeys into the inner life of their creator. Scruton observes that:

> From the first days of psychoanalysis, Wagner's works were singled out as both confirming and demanding a psychoanalytic reading. Their super-saturated longing, their cry for redemption through sexual love, their exultation of Women as the vehicle of purity and sacrifice – all these features have naturally suggested, to the psychoanalytic mind, incestuous childhood fantasies, involving a fixation on the mother as wife. Such is the interpretation main-tained by [the Jewish psychoanalysts] Max Graf and Otto Rank, both writing in 1911. Thereafter the habit of reading the works in terms of the life became firmly established in the literature.[1185]

It was only, however, after the Second World War that the notion that Wagner's music dramas contained implicit fascism and anti-Semitism gained traction. Frankfurt School intellectual Theodor Adorno led the assault, condemning Wagner as a symbol of all that was hateful in the culture of nineteenth-century Germany. Scruton notes how Adorno's criticisms of Wagner were deeply influenced by "the Holocaust and all that it meant concerning the roots of German nationalism."[1186]

Adorno attacked Wagner as a purveyor of "phantasmagoria" whose aim and effect is to falsify reality, and likened Wagner's system of leit-motifs to advertising jingles in the way they imprinted themselves on the memory. Adorno detected a sinister agenda behind Wagner's stated purpose regarding *The Ring* that: "I shall within these four evenings succeed in artistically conveying my purpose to the emotional – not the critical – understanding of the spectators." Adorno here echoed Nietzsche in dismissing the Wagnerian magic as a kind of manipulation. Wagner's musical innovations (ironically later imitated by Hollywood)

intoxicated audiences, leaving them dangerously susceptible to political indoctrination. In every crowd applauding a Wagnerian work, Adorno insisted, "lurked the virulent old evil" of "demagogy." Elizabeth Whitcombe points out how:

> Adorno believed that Wagner's work is "proselytizing" and "collective narcissistic." Adorno's complaint about the "collective narcissistic" quality of Wagner's music is really a complaint that Wagner's music appeals to deep emotions of group cohesion. Like the Germanic myths that his music was often based on, Wagner's music evokes the deepest passions of ethnic collectivism and ethnic pride. In Adorno's view, such emotions are nothing more than collective narcissistic, at least partly because a strong sense of German ethnic pride tends to view Jews as outsiders – as the "other." It is also not surprising that Adorno, as a self-consciously Jewish intellectual, would find such music abhorrent.[1187]

Adorno set the template for a generation of Jewish intellectuals and musicologists like Robert Gutman, who, in his egregious 1968 book *Richard Wagner: The Man, The Mind and His Music,* portrayed his subject as a racist, psychopathic, proto-Nazi monster. Gutman's scholarship was questioned at the time, but this did not prevent his widely reviewed and promoted book from becoming a best-seller. One source notes how "An entire generation of students has been encouraged to accept Gutman's caricature of Richard Wagner. Even intelligent people, who have never read Wagner's writings or tried to penetrate them and failed... have read Gutman's book and accepted his opinions as facts."[1188] The long-time Jewish music critic for *The New York Times,* Harold Schonberg, was one of them, describing Wagner in his *Lives of the Great Composers* as "Amoral, hedonistic, selfish, virulently racist, arrogant, filled with the gospels of the superman... and the superiority of the German race, he stands for all that is unpleasant in human character."[1189]

Gutman's characterization was obsessively reinforced by Marc A. Wiener in his 1995 polemic *Richard Wagner and the Anti-Semitic Imagination*. Putting Wagner on the psychoanalysts' couch, Wiener insisted that: "Wagner's vehement hatred of Jews was based on a model of projection involving a deep-seated fear of precisely those features of the Self (diminutive stature, nervous demeanor and avarice, as well as lascivious nature) that are projected upon and then recognized and stigmatized in the hated Other."[1190] Modern audiences have been encouraged by the likes of Gutman and Wiener to read into Wagner's operas latent signs of anti-Semitism, where, for instance, the gold-loving Nibelung lord Alberich in *Siegfried* is a symbol of Jewish materialism.

For Jewish music writer Larry Solomon, Alberich is unquestionably "the greedy merchant Jew, who becomes the power-crazed goblin-demon lusting after Aryan maidens, attempting to contaminate their blood, and who sacrifices his lust in order to acquire the gold." Declaring that virulent racism "permeates all aspects of his music dramas through metaphorical suggestion," Solomon insists that Wagner is always "just a step away from actually calling his evil characters 'Jews,' even though it was obvious to his contemporaries." According to this analysis, Wagner's operas are indisputably "tools of racist, proto-Nazi hate propaganda, written for the purpose of redeeming the German race from Jewish contamination, and for expelling the Jews from Germany." Moreover, Wagner's malign influence continues insofar as "the subtext of racist metaphors has not diminished in Wagner's operas, so they will continue to exert a subliminal influence."[1191]

Scruton notes how such interpretations have strongly influenced the discussion of Wagner's works, where "revenge on Wagner" has for some time been "an almost obligatory part of the intellectual's apprenticeship."[1192] Books like Jean-Jacques Nattiez's *Wagner Androgyne* and Joachim Kohler's *Richard Wagner: Last of the Titans* continue a now venerable tradition in regarding "anti-Semitism as the meaning and Oedipal confusion as the cause of just about everything the master composed." Even the respected British musicologist Barry Millington

frequently writes "as though anti-Semitism is somewhere near the top of Wagner's musical and intellectual agenda."[1193]

The invidious construction of Wagner as anti-Semitic moral pariah, and the psychoanalytical interpretation of his works to confirm this tendentious preconception, continues despite the discredited status of Freudian psychoanalysis, and despite Wagner scholars Michael Tanner and Brian Magee having offered powerful rebuttals of this approach. Wagner explicitly stated in *Judaism in Music* that what makes Jews such unsatisfactory characters in real life also makes them unsuitable for representation in art, including dramatic art. He writes:

> In ordinary life the Jew, who as we know possesses a God of his own, strikes us first by his outward appearance which, whatever European nationality we belong to, has something unpleasantly foreign to that nationality. We instinctively feel we have nothing in common with a man who looks like that. ... Ignoring the moral aspect of this unpleasant freak of nature, and considering only the aesthetic, we will merely point out that to us this exterior could never be acceptable as a subject for a painting; if a portrait painter has to portray a Jew, he usually takes his model from his imagination, and wisely transforms or else completely omits everything that in real life characterizes the Jew's appearance. One never sees a Jew on the stage: the exceptions are so rare that they serve to confirm this rule. We can conceive of no character, historical or modern, hero or lover, being played by a Jew, without instinctively feeling the absurdity of such an idea. This is very important: a race whose general appearance we cannot consider suitable for aesthetic purposes is by the same token incapable of any artistic presentation of its nature.[1194]

In this passage (first published in 1850 and then again unchanged in 1869), Wagner totally rejects the idea of Jews playing characters *and* characters playing Jews on stage, stating categorically that the Jewish race is "incapable of any artistic presentation of his nature," and leading

in to this statement with the words: "This is very important." Magee observes that here "Wagner positively and actively repudiates the idea of trying to present Jews on the stage; and if we seek an explanation of why he never did so, here we have it."[1195] Wagner would not, contrary to the wishes of many of his friends (and his own professional and pecuniary interests) have gone out of his way to publish this again in 1869, if, as widely alleged, he had just done the opposite and made Beckmesser a Jewish character in *Die Meistersinger von Nürnberg* which had premiered the previous year.

Wagner produced thousands of pages of written material analyzing every aspect of himself, his operas, and his opinions on Jews (and innumerable other topics); and yet the purported Jewish characterizations identified by Gutman, Wiener and others are never mentioned; nor are there any references to them in Cosima Wagner's copious diaries. It can hardly be argued that Wagner was hiding his true feelings for he took great pride in speaking out vociferously on the Jews, and did not care who he offended – famously labelling the tribe "the plastic demon of decomposition." Moreover, none of Wagner's supposedly obvious characterizations were ever used in the propaganda of the Third Reich. Accordingly, to identify such characters as Beckmesser, Alberich, Mime, Klingsor and Kundry as Jewish caricatures is entirely speculative.

Even Nietzsche, who attacked Wagner on numerous occasions for his personal hostility to Jews, never alleged there was anti-Semitism in the operas. Furthermore, the audiences that flocked to Wagner's works all over the world did not perceive their supposedly obvious anti-Jewish subtexts for, as Magee points out, "in the huge literature we have on the subject, unpublished as well as published, the question arises rarely until the middle of the twentieth century."[1194] Magee observes that many critics (especially the Jewish ones) are "simply swept forward by the momentum of their own anger" into alleging the omnipresence of anti-Semitism in Wagner's operas. He notes that "To a number of them it comes easily anyway, for they are adept at finding anti-Semitism in places where no one had detected it before. ... At the root of it all is an

unforgiving rage at the mega-outrage of anti-Semitism – and at the root of that in the modern world is the Holocaust."[1197]

Wagner was the first artistic giant who was an avowed German (and later White) nationalist. After reading Gobineau's bestselling *An Essay on the Inequality of the Human Races,* he declared that "we should have no History of Man at all, had there been no movements, creations, and achievements of the White man."[1198] As a man genuinely committed to prioritizing the interests of his own people, it was inevitable Wagner would confront the Jewish Question. In 1878 he confessed that "it is distressing for me always to come back to theme of the Jews, but one cannot escape it as one looks to the future."[1199] For the hyperbolic Larry Solomon, no other composer had a greater impact on history than Richard Wagner, and "his devastating political legacy is second only to Hitler."[1200] Despite the paucity of evidence for Wagner having exercised the high level of intellectual influence on Hitler that is often alleged, for the Jewish music critic David Goldman, Wagner is eminently worthy of execration on the basis that he "mixed the compost heap in which the flowers of the twentieth century's greatest evil took root." For Goldman, "The Jewish people have had no enemy more dedicated and more dangerous, precisely because of his enormous talent."[1201]

The Jewish obsession with Wagner shows no signs of abating two decades into the twenty-first century. A new play by the Jewish playwright Victor Gordon entitled *You Will Not Play Wagner* revolves around the fact that "since the Holocaust, performing works by the composer Richard Wagner has been taboo in Israel." The play is set in contemporary Tel Aviv, where a young Israeli conductor "causes a storm" by performing Wagner, "whose anti-Semitism and the use of his music by the Nazis are well known," in the finals of an international conducting competition. His decision brings him "into conflict with Esther, Holocaust survivor and competition patron who has her own tragic connection with Wagner's music."

While keen to move beyond this Jewish construction of Wagner as proto-Nazi embodiment of evil, Scruton does single out the famous forging scene from *Siegfried* as one that is "uncomfortably near

the bone for those sensitive to the 'blond beast' interpretation of Wagner."[1202] Here the fearless Siegfried files, smelts, casts and hardens the steel of his father Siegmund's shattered sword while the malevolent Mime, the hateful, sycophantic dwarf who has raised Siegfried (and is ultimately killed by him), exults in the background over his prospective future as lord of the Ring. For Solomon, Mime is here depicted by Wagner "as a stinking ghetto Jew," while "Siegfried represents the conscience-free, fearless Teuton, he feels no remorse... He is glorified as the warrior hero of the *Ring*, the archetypal proto-Nazi."[1203] Scruton calls the scene "a musical and dramatic triumph" and notes that whether Wagner used stereotypically Jewish elements in his characterization of Mime is ultimately irrelevant because the composer's artistry transcends the elements of which it is made.

In offering politically incorrect assessments like these, and for being insufficiently deferential to the orthodox conception of Wagner as proto-Nazi anti-Semitic monster, Scruton incurred the disapproval of one reviewer of *The Ring of Truth* who protested that:

> Sir Roger is not always so attuned to historical and philosophical context. Take his discussion of anti-Semitism, which looms large in the popular understanding of Wagner. Scholars enjoy mining the operas for evidence of how anti-Jewish Wagner "really" was (Alberich, the money-grabbing dwarf, is a particularly controversial character). But in Sir Roger's view, these critics' single-minded focus on Wagner's anti-Semitism means that they fail to understand the many other ideas explored in the operas. While this has some truth, in his own analysis he overcompensates, choosing to ignore the anti-Semitism theme almost entirely. It is a bizarre choice, which leaves the discussion incomplete.[1204]

The Cultural Marxist establishment's success in pathologizing Wagner is reflected in how Wagner and his works are discussed in university courses, in popular culture and in the media. It is also reflected in productions of the operas. The result, notes Scruton, is that: "The

antagonism has made it almost impossible now to experience these works as their creator intended, since they are regularly produced in such a way as to satirize or deny their inner meaning." No work of Wagner's has suffered more from this type of creative censorship that *The Ring of the Nibelung*, which tells the story of civilization from beginning to end.

## *"Sarcasm and Satire Run Riot on the Stage"*

Productions of *The Ring* in the modern era have invariably sought to satirize the drama to subvert the message Wagner attempts to convey. Scruton observes that, notwithstanding the increasingly tiresome preoccupation with dissecting the tetralogy for anti-Jewish and proto-fascistic themes and images (and counteracting them), *The Ring* is also, on a more basic level, problematic for opera producers because its "world of sacred passions and heroic actions offends against the skeptical and cynical temper of our times. The fault, however, lies not in Wagner's tetralogy, but in the closed imagination of those who are so often invited to produce it."[1205]

The template for modern productions was set with the Bayreuth production of 1976, when Pierre Boulez sanitized the music, and Patrice Chereau satirized the text. Scruton notes that:

> Since that ground-breaking venture, *The Ring* has been regarded as an opportunity to deconstruct not only Wagner but the whole conception of the human condition that glows so warmly in his music. *The Ring* is deliberately stripped of its legendary atmosphere and primordial setting, and everything is brought down to the quotidian level, jettisoning the mythical aspect of the story, so as to give us only half of what it means. The symbols of cosmic agency – spear, sword, ring – when wielded by scruffy humans on abandoned city lots, appear like toys in the hands of lunatics. The opera-goer will therefore very seldom be granted the full experience of Wagner's masterpiece.[1206]

This certainly describes the *Ring* I attended in Melbourne in 2016. While the soloists and the orchestra were excellent, Neil Armfield's postmodernist, Eurotrash-inspired production detracted from the power of the music and drama. Following established precedent, Armfield set much of the action in a space akin to an industrial wasteland. He lampooned the heroic forging scene by setting it in a tawdry apartment replete with fluorescent lighting, microwave, bar fridge and bunk beds. Fafner (meant to have transformed himself into a dragon) was depicted as a transvestite-like figure smearing make-up on his face and appearing naked on the stage.

Productions like these deliberately sabotage Wagner's attempt to engage his audiences at the emotional level of religion. They let "sarcasm and satire run riot on the stage, not because they have anything to prove or say in the shadow of this unsurpassably noble music, but because nobility has become intolerable. The producer strives to distract the audience from Wagner's message, and to mock every heroic gesture, lest the point of the drama should finally come home."[1207]

### Conclusion

Scruton did an admirable job in *The Ring of Truth* of clearing a path through the accumulated intellectual detritus of the last half century which impedes a full understanding and appreciation of Wagner's great masterpiece. He analyzed the drama, music, symbolism and philosophy of *The Ring* on the basis of the actual evidence, and eschewed the usual tiresome preoccupation with speculating about what the tetralogy reveals about its creator's supposed moral failings. In doing so, he entered a plea on behalf of a work that is more travestied than any other in the operatic repertoire, but whose vision is nevertheless as important to the times in which we live as it was to those of its creator.

The post-Christian West has, in recent decades, undergone a disastrous realignment of its public morality to accord with the Jewish intellectual movements Kevin MacDonald examined in *The Culture of Critique*. Richard Wagner would be absolutely disgusted with the

state of contemporary Germany, Europe, and of the West in general. He pessimistically anticipated our current plight, and its Jewish ethno-political foundations, when, in a late essay, he pessimistically forecast that "we Germans will go under before them, and perhaps I am the last German who knows how to stand up as an art-loving man against the Judaism that is already gaining control of everything."[1208] In *Judaism in Music* Wagner declared himself "unable to decide" whether "the downfall of our culture can be arrested by a violent ejection of the destructive foreign [Jewish] element" since "that would require forces with whose existence I am unacquainted."

Wagner's injunction in *The Ring* to abjure materialism and find meaning through sacrifice is a message that should resonate with today's Dissident Right. Wagner insisted in *The Ring* that a life lived in a spirit of sacrifice is worthwhile, despite the enormous cost of it. Nothing is worthier of sacrifice than safeguarding the biological survival of one's own race. In his own life, Wagner had the fortitude (in defiance of his pecuniary self-interest) to identify and publicly oppose those forces contrary to his own ethnic interests. In his intellectual integrity and, of course, in his stupendous musical legacy, Richard Wagner remains one of the most inspiring figures our race has produced.

# NOTES

1.     Sophy Burnham, *The Art Crowd* (Philadelphia: David McKay Publications, 1973), 25.

2.     Kevin B. MacDonald, *The Culture of Critique: An Evolutionary Analysis of Jewish Involvement in Twentieth-Century Intellectual and Political Movements* (Westport, CT: Praeger, 1998; first paperback edition: Bloomington, IN: 1stbooks Library, 2002), 18.

3.     Robert Short, *Dada and Surrealism* (London: Laurence King Publishing, 1994), 7.

4.     Paul Lawrence Rose, *German Question/Jewish Question: Revolutionary Anti-Semitism from Kant to Wagner* (Princeton, New Jersey: Princeton University Press, 1992) 377-8.

5.     Kevin B. MacDonald, *The Culture of Critique: An Evolutionary Analysis of Jewish Involvement in Twentieth-Century Intellectual and Political Movements* (Westport, CT: Praeger, 1998; first paperback edition: Bloomington, IN: 1stbooks Library, 2002).

6.     Milton Friedman, "Capitalism and the Jews," speech at Chicago Law School, 1972. An audio recording of this speech is available at: http://www.law.uchicago.edu/audio/friedman101578
   A written transcript of the speech is available at:
   http://www.thefreemanonline.org/columns/capitalism-and-the-jews/

7.     Ibid.

8.     Ludwig von Mises, *Omnipotent Government: The Rise of the Total State and Total War* (New Haven, CT: Yale University Press, 1944), 169–92.
   Available at: http://mises.org/daily/1484

9.     Originally published as "Racism" in the September, 1963 issue of *The Objectivist* Newsletter and subsequently included as a chapter in: Ayn Rand, *The Virtue of Selfishness* (New York: Signet, 1964), 147–57.

10.     Kevin B. MacDonald, *A People That Shall Dwell Alone: Judaism as a Group Evolutionary Strategy with Diaspora Peoples* (Lincoln, NE: iUniverse, 2002; originally published in 1994 by Praeger [Westport, CT]), 247.

11.     Ibid., 217.

12.   Friedman, "Capitalism and the Jews," op. cit.

13.   Jerry Z. Muller, *Capitalism and the Jews* (Princeton University Press, 2010).

14.   See: Richard Lynn, *The Global Bell Curve: Race, IQ and Inequality Worldwide* (Augusta, GA: Washington Summit Publishers, 2008).

15.   See: Richard Lynn, "The intelligence of American Jews," *Personality and Individual Differences*, 36, 2004, 201–206; Richard Lynn & Tatu Vanhanen, *IQ and Global Inequality* (Augusta, GA: Washington Summit Publishers, 2006), 312.

16.   Friedman, "Capitalism and the Jews," op. cit.

17.   von Mises, *Omnipotent Government*, Ibid., 169–92

18.   See MacDonald, *The Culture of Critique*, Preface to the first paperback edition.

19.   Friedman, "Capitalism and the Jews," op. cit.

20.   Rand, *The Virtue of Selfishness*, Ibid., 147–57

21.   Ayn Rand, appearance on Donahue, 1979: http://www.youtube.com/watch?v=2uHSv1asFvU

22.   Frank Salter, "The Misguided Advocates of Open Borders," Quadrant, 54(6), 2010. http://www.quadrant.org.au/magazine/issue/2010/6/the-misguided-advocates-of-open-borders

23.   MacDonald, *The Culture of Critique*, Preface to the first paperback edition

24.   Ibid.

25.   Norman Lebrecht, *Why Mahler? How One Man and Ten Symphonies Changed the World* (London: Faber and Faber, 2010), x.

26.   Ibid., 232.

27.   Ibid., 132.

28.   Leonard Bernstein, "Mahler: His Time Has Come," *High Fidelity*, April, 1967.

29.   Lebrecht, *Why Mahler?*, 9.

30.   Ibid., 20.

31.   Ibid., 9.

32.   Phillip Kennicott, "Defacing the Score," *The New Republic*, October 4, 2010. http://www.tnr.com/book/review/defacing-the-score

33.   Lebrecht, *Why Mahler?*, 225.

34.   Adorno, T., "Centenary Address, Vienna 1960," in *Quasi una fantasia – Essays on Modern Music*, trans. by Rodney Livingstone (London & New York: Verso, 1963), 88.

35.   Lebrecht, *Why Mahler?*, 24.

36.   Ibid., 114.

37.   Ibid., 25-6.

38.   Ibid., x.

39.   Ibid., 155-6.

40. Ibid., 28-9.
41. Ibid., 59-60.
42. Ibid., xi.
43. Ibid., 8-9.
44. Ibid., 41.
45. Ibid., 100.
46. Ibid., 108.
47. Ibid., 41.
48. Ibid., 95.
49. Quoted in: Kennicott, "Defacing the Score," op. cit.
50. Ibid.
51. Lebrecht, *Why Mahler?*, 133-4.
52. Kennicott, "Defacing the Score." op. cit.
53. Lebrecht, *Why Mahler?*, 95.
54. Ibid., 181.
55. Ibid., 181-2.
56. Kennicott, "Defacing the Score," op. cit.
57. Thomas Huxley, *Evolution and Ethics*, 2. http://www.searchengine.org.uk/ebooks/33/63.pdf
58. Ibid., 2.
59. Ibid., 24.
60. Ibid., 8.
61. Ibid., 4.
62. Ibid., 6.
63. Ibid., 13.
64. Ibid., 7.
65. Ibid., 17.
66. Ibid., 8.
67. Ibid., 9.
68. Quoted in: Kevin MacDonald, *Separation and its Discontents: Toward an Evolutionary Theory of Anti-Semitism* (1st Books Library, 2004), 162.
69. Roger Scruton, *Modern Philosophy* (New York: Penguin, 1996), 436.
70. Kevin MacDonald, *A People That Shall Dwell Alone, Judaism As a Group Evolutionary Strategy with Diaspora Peoples* (Lincoln, NE: iUniverse, 2002; originally published in 1994 by Praeger [Westport, CT]), c.
71. Charles Murray, *Human Accomplishment* (New York: Perennial, 2004), 404.
72. MacDonald, *Separation and its Discontents*, 166.
73. Ibid.
74. Kevin MacDonald, *The Culture of Critique: An Evolutionary Analysis of Jewish Involvement in Twentieth-Century Intellectual and Political Movements*, (Westport, CT: Praeger, Revised Paperback edition, 2001), 316.

75. Ibid., 320.

76. Michael Oakeshott, "The masses in representative democracy," In: *Rationalism on politics and other essays* (Indianapolis: Liberty Fund, 1991), 366.

77. Murray, *Human Accomplishment*, 394.

78. MacDonald, *Separation and its Discontents*, 161-2.

79. Adolf Hitler, *Mein Kampf*, trans. by James Murphy (Bottom of the Hill, 2010), 255.

80. Huxley, "Evolution and Ethics," 24.

81. MacDonald, *The Culture of Critique*, 18.

82. Bryan Magee, *Confessions of a Philosopher: A Personal Journey Through Western Philosophy from Plato to Popper* (New York: Random House, 1999), 347.

83. Roger Scruton, *The West and the Rest* (London: Continuum, 2002), 72-3.

84. Erich Fromm, *The Sane Society* (London & New York: Routledge, 1956/ 1991), 67.

85. MacDonald, *The Culture of Critique*, 151.

86. Scruton, *The West and the Rest*, 70-1.

87. Ibid.

88. MacDonald, *The Culture of Critique*, 151.

89. Alain Brossat & Sylvie Klingberg, *Revolutionary Yiddishland: A History of Jewish Radicalism* (London; Verso, 2016), xii.

90. Ibid., 59.

91. Daniel Jonah Goldhagen, *The Devil That Never Dies; The Rise of Global Antisemitism* (New York NY; Little, Brown & Co., 2013), 291; 126.

92. Cnaan Liphshiz, "What was the Jewish role in 1917 Russian Revolution? This Moscow museum gives a full picture," *Jewish Telegraphic Agency*, November 6, 2017. https://www.jta.org/2017/11/06/global/what-was-the-jewish-role-in-1917-russian-revolution-moscow-museum-gives-a-full-picture

93. Ibid.

94. Simon Sebag Montefiore, *The Romanovs 1630-1918* (London: Weidenfeld & Nicholson, 2016), 50.

95. Andrew Joyce, "Myth and the Russian Pogroms, Part 2: Inventing Atrocities," *The Occidental Observer*, May 11, 2012. https://www.theoccidentalobserver.net/2012/05/11/myth-and-the-russian-pogroms-part-2-inventing-atrocities/

96. John Klier, *Russians, Jews, and the Pogroms of 1881-2* (New York: Cambridge University Press, 2011), 5.

97. Robert Wistrich, *From Ambivalence to Betrayal: the Left, the Jews and Israel* (Lincoln: University of Nebraska Press, 2012), 186.

98. Brossat & Klingberg, *Revolutionary Yiddishland*, 85.

99. Ibid., ix.

100. Ibid., 56.

101.  Kevin MacDonald, *The Culture of Critique: An Evolutionary Analysis of Jewish Involvement in Twentieth-Century Intellectual and Political Movements*, (Westport, CT: Praeger, Revised Paperback edition, 2001), xl.

102.  Norman Cantor, *The Jewish Experience: An Illustrated History of Jewish Culture & Society* (New York; Castle Press, 1996), 364.

103.  Albert Boime, "Dada's Dark Secret," In: Washton-Long, Baigel & Heyd (Eds.) *Jewish Dimensions in Modern Visual Culture: Anti-Semitism, Assimilation, Affirmation*, (Waltham MA: Brandeis University Press, 2010), 96.

104.  Robert Wistrich, *Revolutionary Jews from Marx to Trotsky* (London: George G. Harrap & Co Ltd, 1976), 178.

105.  Joshua Rubenstein, *Leon Trotsky: A Revolutionary's Life* (New Haven CT: Yale University Press, 2013), 67; 78; 52.

106.  Ibid., 113.

107.  Wistrich, *Revolutionary Jews*, 199.

108.  Hiroaki Kuromiya, *Russia's People of Empire: Life Stories from Eurasia, 1500 to the Present* (Bloomington: Indiana University Press, 2012), 276.

109.  E. A. Rees, *Iron Lazar: A Political Biography of Lazar Kaganovich* (Anthem Press, 2013), 6.

110.  Myroslav Shkandriij, *Jews in Ukrainian Literature: Representation and Identity* (Yale University Press, 2009), 137.

111.  Lesa Melnyczuk, *Silent Memories, Traumatic Lives* (RHYW, 2013), 25.

112.  Alexander Solzhenitzyn, *Two Hundred Years Together: Russo-Jewish History*, Unauthorized English Translation. https://archive.org/stream/Solzhenitsyn200YearsTogether/Solzhenitsyn-200%20Years%20Together_djvu.txt

113.  Yuri Slezkine, *The Jewish Century* (Princeton NJ: Princeton University Press, 2006), 183.

114.  Ibid.

115.  Ibid., 184.

116.  Alain Brossat & Sylvie Klingberg, *Revolutionary Yiddishland: A History of Jewish Radicalism* (London; Verso, 2016), 29.

117.  Robert Service, "John Klier," *The Guardian*, October 27, 2007. https://www.theguardian.com/news/2007/oct/26/guardianobituaries.obituaries

118.  Brossat & Klingberg, *Revolutionary Yiddishland*, 1.

119.  Anne Applebaum, *Red Famine: Stalin's War on Ukraine* (New York NY: Doubleday, 2017) 114.

120.  Jerry Z. Muller, J.Z. (2010) *Capitalism and the Jews* (Princeton NJ: Princeton University Press, 2010), 161-2.

121.  Chaim Bermant, *Jews* (London; Weidenfeld & Nicholson, 1977), 160.

122.  Brossat & Klingberg, *Revolutionary Yiddishland*, 37.

123.  Ibid., 56.

124.  Ibid., 47.

125.    Ibid.

126.    Ibid.

127.    Robert Service, *Comrades! A History of World Communism* (Cambridge MA: Harvard University Press, 2010) 123.

128.    Howard M. Sachar, *A History of the Jews in the Modern World* (New York NY: Knopf, 2005) 151.

129.    Brossat & Klingberg, *Revolutionary Yiddishland*, 46.

130.    Terry Martin, *The Affirmative Action Empire: Nations and Nationalism in the Soviet Union, 1923-1939* (Cornell University Press, 2001), 43.

131.    Brossat & Klingberg, *Revolutionary Yiddishland*, 183.

132.    Ibid., 192.

133.    Ibid., 66.

134.    Ibid., 67.

135.    Ibid., 153.

136.    Muller, *Capitalism and the Jews*, 156-7.

137.    Ibid. 160.

138.    Liphshiz, "What was the Jewish Role in the 1917 Revolution?," op. cit.

139.    Brossat & Klingberg, *Revolutionary Yiddishland*, 189.

140.    Ibid., 199.

141.    Ibid., 194.

142.    Ibid., 51.

143.    Kevin MacDonald, *The Culture of Critique: An Evolutionary Analysis of Jewish Involvement in Twentieth-Century Intellectual and Political Movements*, (Westport, CT: Praeger, Revised Paperback edition, 2001), 58.

144.    Brossat & Klingberg, *Revolutionary Yiddishland*, 184.

145.    Robert Wistrich, *Revolutionary Jews from Marx to Trotsky* (London: George G. Harrap & Co Ltd, 1976), 199.

146.    Applebaum, *Red Famine*, 188.

147.    Brossat & Klingberg, *Revolutionary Yiddishland*, 186.

148.    Joshua Rubenstein, *Leon Trotsky: A Revolutionary's Life* (New Haven CT: Yale University Press, 2013), 113-14.

149.    Bermant, *Jews*, 139.

150.    Ibid., 171-2.

151.    Brossat & Klingberg, *Revolutionary Yiddishland*, 211.

152.    Ibid., 61.

153.    Ibid., 191.

154.    Ibid., 72.

155.    Ibid., 71.

156.    Bernard Wasserstein, *On the Eve: The Jews of Europe Before the Second World War* (Profile Books, 2012), 64.

157.    Brossat & Klingberg, *Revolutionary Yiddishland*, 62.

158.    Ibid., 61.

159. Rubenstein, *Leon Trotsky: A Revolutionary's Life*, 176.
160. MacDonald, *The Culture of Critique*, xxxix.
161. Ibid., xl.
162. Brossat & Klingberg, *Revolutionary Yiddishland*, 139-40.
163. Ibid., 141.
164. Ibid., 225.
165. MacDonald, *The Culture of Critique*, xxxix.
166. Brossat & Klingberg, *Revolutionary Yiddishland*, 225.
167. Ibid., 230.
168. Ibid., 232.
169. Ibid., 234.
170. Ibid., 236.
171. Ibid., 264.
172. Ibid., 171.
173. Ibid., 267.
174. Ibid., 265.
175. Ibid., 267.
176. Ibid., 267-8.
177. Ibid., 173.
178. Ibid., 175.
179. Ibid., 268.
180. Ibid., 178-9.
181. Ibid., 268.
182. Ibid., 272.
183. Ibid., 275.
184. Ibid., 375-6.
185. Ibid., 277.
186. Ibid., 285.
187. Ibid., 268.
188. Ibid., 241.
189. Ibid.
190. Ben Lorber, "In the Age of Trump, Progressive Jews Can Learn From the 20th Century's Radical Yiddish Tradition," In *These Times*, November 30, 2016. http://inthesetimes.com/article/19681/donald-trump-progressive-jews-revolutionary-yiddishland-anti-semitism
191. Kevin MacDonald, *The Culture of Critique: An Evolutionary Analysis of Jewish Involvement in Twentieth-Century Intellectual and Political Movements*, (Westport, CT: Praeger, Revised Paperback edition, 2001), 113.
192. Nathan Abrams, "Triple Exthnics," *Jewish Quarterly*, May, 2013, 27-31.
193. Ibid. 138-9.
194. Daniel Jonah Goldhagen, *The Devil That Never Dies: The Rise of Global Antisemitism* (New York NY: Little, Brown & Co., 2013), 91-92.

195. J. Correspondent, "Smoking the stereotypes: Weeds creator delights in tipping over Judaism's sacred cows," *Jewish Weekly*, June 12, 2009. https://www.jweekly.com/2009/06/12/smoking-the-stereotypes-weeds-creator-delights-in-tipping-over-judaisms-sac/

196. Adam Edelman, "Vice President Biden: Jewish leaders, pop culture drove gay marriage acceptance," *New York Daily News*, May 22, 2013. https://www.nydailynews.com/news/politics/vice-president-biden-jewish-leaders-pop-culture-drove-gay-marriage-acceptance-article-1.1351817

197. Chaim Bermant, *Jews* (London; Weidenfeld & Nicholson, 1977), 91.

198. Ibid., 94.

199. Unsigned, "'Orange' Creator Jenji Kohan: 'Piper Was My Trojan Horse,'" *NPR*, August 13, 2013. https://www.npr.org/2013/08/13/211639989/orange-creator-jenji-kohan-piper-was-my-trojan-horse

200. J. Correspondent, "Smoking the stereotypes," op. cit.

201. Ibid.

202. Ibid.

203. Unsigned, "Jenji Kohan," *Time*, April, 23, 2014. https://time.com/70867/jenji-kohan-2014-time-100/

204. Christina Radish, "Creator Jenji Kohan talks ORANGE IS THE NEW BLACK, Her Research Into Prison Life, and Graphic Sex Scenes," *Collider*, July 7, 2013. https://collider.com/jenji-kohan-orange-is-the-new-black-interview/

205. Michael O'Connell, "'Orange Is the New Black's' Jenji Kohan Details Her Frustrating Negotiations to Get Actors Naked," *The Hollywood Reporter*, April 16, 2014. https://www.hollywoodreporter.com/live-feed/orange-is-new-blacks-jenji-696916

206. Bermant. *Jews*, 107.

207. O'Connell, "Orange Is the New Black's' Jenji Kohan," op. cit.

208. Ruta Kupfer, "Everything You Didn't Know About Women's Prisons, Now on TV," *Haaretz*, July 24, 2013. https://www.haaretz.com/israel-news/culture/.premium-everything-you-didnt-know-about-womens-prisons-1.5298781

209. Jon Blistein, "Jenji Kohan on the Naked Truth of 'Orange Is the New Black,'" *Rolling Stone*, April 17, 2014. https://www.rollingstone.com/tv/tv-news/jenji-kohan-on-the-naked-truth-of-orange-is-the-new-black-244767/

210. Debra Ferreday, "Orange is the New Black is fast becoming a feminist classic," *The Conversation*, June 11, 2015. https://theconversation.com/orange-is-the-new-black-is-fast-becoming-a-feminist-classic-40353

211. Julianne Escobedo Shepherd, "Creators of OITNB and Transparent Butt Heads at New Yorker Festival," *Jezebel*, October 13, 2014. https://jezebel.com/creators-of-oitnb-and-transparent-butt-heads-at-new-yor-1645663247

212. Morten Frisch & Anders Hviid, "Childhood Family Correlates of Heterosexual and Homosexual Marriages: A National Cohort Study of Two

Million Danes," *Arch Sex Behav* 35, 533–47, 2006. https://doi.org/10.1007/s10508-006-9062-2

213.     Warren Throckmorten, "Environmental factors may influence sexual orientation," *Life Site*, October 26, 2006. https://www.lifesitenews.com/news/environmental-factors-may-influence-sexual-orientation

214.     Hank Stuever, "'Orange is the New Black' returns to Netflix, wickedly unrestrained," *The Washington Post*, June 14, 2014. https://www.washingtonpost.com/entertainment/tv/orange-is-the-new-black-returns-to-netflix-wickedly-unrestrained/2014/06/04/42b0a09e-ec01-11e3-9f5c-9075d5508f0a_story.html

215.     J. Correspondent, "Smoking the stereotypes," op. cit.

216.     Kupfer, "Everything You Didn't Know About Women's Prisons," op. cit.

217.     Niv Elis, "Cheating on your spouse in Israel just got easier". *Jerusalem Post*, May 22, 2014.

218.     Jonathan Sacks, *Encyclopedia of Modern Jewish Culture*, Ed. By Glenda Abramson (Abingdon, Oxon; Routledge, 2004), 245.

219.     Unsigned, "Miley Cyrus fluid with sexuality," *The Washington Post*, June 9, 2015. https://www.washingtonpost.com/entertainment/miley-cyrus-fluid-with-sexuality/2015/06/09/a7c4563a-0edb-11e5-a0fe-dccfea4653ee_story.html

220.     Lara Gould & Pamela Owen, "Meet Larry Rudolph: The man behind Miley Cyrus' sex goddess image," *Mirror*. January 5, 2014. https://www.mirror.co.uk/3am/celebrity-news/miley-cyrus-meet-larry-rudolph-2989569

221.     E. Michael Jones, "Rabbi Dresner's Dilemma," *Culture Wars*, Vol. 22, 2002, 38.

222.     MacDonald, *The Culture of Critique*, 85.

223.     Sam Jones, "Media 'influence' adolescent sex," *The Guardian*, March 22, 2006. https://www.theguardian.com/media/2006/mar/22/pressandpublishing.broadcasting

224.     Richard Jackson & Fred W. Sanborn, *Media Affects: Advances in Theory and Research* (Abingdon, Oxon: Routledge, 2009), 313.

225.     Martha Kempner, "Sexually Transmitted Infections Are on the Rise Throughout the Country," *Rewire.News*, April 28, 2015. https://rewire.news/article/2015/04/28/sexually-transmitted-infections-rise-across-country/

226.     Jill Stark, "Porn, family violence linked to surge in child-on-child sex abuse cases." *The Age*, June 28, 2015. https://www.theage.com.au/national/victoria/porn-family-violence-linked-to-surge-in-childonchild-sex-abuse-cases-20150626-ghykne.html

227.     MacDonald, *The Culture of Critique*, 136.

228.     Ibid., 138.

229.     Ibid., 151.

230.     William Berger, *Wagner Without Fear: Learning to Love – and Even Enjoy – Opera's Most Demanding Genius* (New York, Viking, 1998), 373.

231.     Paul Lang, *Music in Western in Western Civilisation* (London: J.M. Dent, 1963), 878.

232.      Bryan Magee, *Aspects of Wagner* (Oxford: Oxford University Press, 1988), 56.

233.     Quoted in Martin Kitchen, *The Cambridge Illustrated History of Germany* (London: Cambridge University Press, 2000), 195.

234.     Adrian Mourby, "Can we forgive him?," *The Guardian*, July 21, 2000. http://www.guardian.co.uk/friday_review/story/0,3605,345459,00.html

235.     Kevin MacDonald, *Separation and its Discontents: Toward an Evolutionary Theory of Anti-Semitism* (1st Books Library, 2004), 60.

236.     Richard Wagner, "Judaism in Music," trans. by William Ashton Ellis, In: *Richard Wagner's Prose Works Vol. 3* (London: 1894; repr. 1966), 79-100. http://www.jrbooksonline.com/PDF_Books/JudaismInMusic.pdf

237.     Ibid.

238.     Bryan Magee, *Wagner and Philosophy* (London: Penguin, 2001), 349.

239.     Wagner, "Judaism in Music," op. cit.

240.     MacDonald, *Separation and its Discontents*, 184.

241.     Wagner, "Judaism in Music," op. cit.

242.     Magee, *Aspects of Wagner*, 27.

243.     Jonathan Carr, *The Wagner Clan* (London: Faber and Faber, 2007) 83-4.

244.     David Rodwin, "Wagner Was Right: Eclecticism and the Jewish Aesthetic," (Los Angeles: 2011). http://www.youtube.com/watch?v=RkfGEqo3YjQ

245.     Quoted in MacDonald, *Separation and its Discontents*, 98.

246.     Magee, *Aspects of Wagner*, 24.

247.      Paul Lawrence Rose, *German Question/Jewish Question: Revolutionary Anti-Semitism from Kant to Wagner* (Princeton, New Jersey: Princeton University Press, 1992) 360.

248.     Wagner, "Judaism in Music," op. cit.

249.     Richard Wagner, letter of April 1851 trans. by W. Ashton Ellis, In: *Correspondence of Wagner and Liszt 1841-1853*, (London: 1897; repr. 1973), 145.

250.     Richard Wagner, "What is German?" trans. by William Ashton Ellis, In: *Richard Wagner's Prose Works Vol. 4* (London: 1894; repr. 1966), 151-69. http://users.belgacom.net/wagnerlibrary/prose/wagwiger.htm

251.     Ibid. (Italics in the original)

252.     Rose, *German Question/Jewish Question*, 376.

253.     Wagner, "Judaism in Music," op. cit.

254.     Quoted in MacDonald, *Separation and its Discontents*, 52.

255.     Jonathan Carr, *The Wagner Clan*, 75.

256.     Rose, *German Question/Jewish Question*, 372.

257.     Roger Scruton, *Modern Culture* (London: Continuum, 2000), 69.

258. Richard Wagner, "A Communication to my Friends," trans. by William Ashton Ellis, In: *Richard Wagner's Prose Works Vol. 1* (London: 1895; repr. 1966), 269-392.
http://users.belgacom.net/wagnerlibrary/prose/wagcomm.htm

259. Elisabeth Whitcombe, "Adorno as Critic: Celebrating the Socially Destructive Force of Music," *The Occidental Observer*, August 28, 2009.
http://www.theoccidentalobserver.net/2009/08/adorno-as-critic/

260. Scruton, *Modern Culture*, 69.

261. Wagner, "Judaism in Music," Ibid.

262. MacDonald, *Separation and its Discontents*, 165.

263. Richard Wagner, "Some Explanations Concerning 'Judaism in Music,'" trans. by William Ashton Ellis, In: *Richard Wagner's Prose Works Vol. 3* (London: 1894; repr. 1966), 77-122. http://users.belgacom.net/wagnerlibrary/prose/wagjuda2.htm

264. Richard Evans, *The Coming of the Third Reich* (New York: Penguin, 2005), 33.

265. Rose, *German Question/Jewish Question*, 377-8.

266. Richard Wagner, "Religion and Art," trans. by William Ashton Ellis, In: *Richard Wagner's Prose Works, Vol. 6* (London: 1897; repr. 1966), 211-52.
http://users.belgacom.net/wagnerlibrary/prose/wlpr0126.htm

267. Richard Wagner, "Hero-dom and Christianity," trans. by William Ashton Ellis, In: *Richard Wagner's Prose Works Vol. 6* (London: 1897; repr. 1966), 275-84.
http://users.belgacom.net/wagnerlibrary/prose/waghero.htm

268. Richard Wagner, "Know Thyself," trans. by William Ashton Ellis, In: *Richard Wagner's Prose Works Vol. 6* (London: 1897; repr. 1966), 264-74.
http://users.belgacom.net/wagnerlibrary/prose/wagknow.htm

269. Quoted in Paul Lawrence Rose, *German Question/Jewish Question*, 361.

270. Ibid.

271. Larry Solomon, *Wagner and Hitler*, (Online article: 2002) http://solomonsmusic.net/WagHit.htm

272. MacDonald, *Separation and its Discontents*, 57.

273. Ibid., 54.

274. Daniel Barenboim, "Wagner, Israel and the Palestinians," Blog post, Undated.
http://www.danielbarenboim.com/index.php?id=72

275. Richard Wagner, "Know Thyself," op. cit.

276. Magee, *Wagner and Philosophy*, 352.

277. Quoted in Martin Kitchen, *The Cambridge Illustrated History of Germany*, op. cit.

278.     Christopher Nicholson, *Richard and Adolf: Did Richard Wagner Incite Adolf Hitler to Commit the Holocaust* (Jerusalem: Gefen Publishing House, 2007) 131.

279.     Unsigned, "Parsifal and Race: Wagner's Last Card," *Monsalvat website*, Undated.
http://www.monsalvat.no/racism.htm

280.     Harold Schonberg, *The Lives of the Great Composers* (New York: W.W. Norton, 1997), 268.

281.     David P. Goldman, "Muted: Performances of Wagner's music are effectively banned in Israel. Should they be?" *Tablet*, August 17, 2011.
http://www.tabletmag.com/jewish-arts-and-culture/music/75247/muted

282.     Warren Boroson, "Richard Wagner – The Devil Who Had Good Tunes," *Jewish Standard*, August 7, 2009, 16.

283.     Michael Steen, *The Lives and Times of the Great Composers* (London: Icon Books, 2005), 464.

284.     Carr, *The Wagner Clan*, 83.

285.     Magee, *Aspects of Wagner*, 26.

286.     Marc A. Weiner, *Richard Wagner and the Anti-Semitic Imagination* (Lincoln: University of Nebraska Press, 1997), 6.

287.     Theodore Isaac Rubin, *Anti-Semitism: A Disease of the Mind* (New York: Barricade, 2011), 12.

288.     John Chancellor, *Wagner* (New York: HarperCollins, 1980), 6.

289.     Magee, *Wagner and Philosophy*, 358.

290.     Ibid., 360.

291.     Derek Strahan, "Was Wagner Jewish: an old question newly revisited," Online article, Undated. http://www.revolve.com.au/polemic/wagner.html

292.     Quoted in John Deathridge, *Wagner: Beyond Good and Evil* (Los Angeles: University of California Press, 2008), 1.

293.     Solomon, "Wagner and Hitler," op. cit.

294.     Magee, *Wagner and Philosophy*, 358.

295.     Solomon, "Wagner and Hitler," op. cit.

296.     Ibid.

297.     Ibid.

298.     Mourby, "Can we forgive him?," op. cit.

299.     Quoted in Lisa Norris, "Jewish Dwarfs and Teutonic Gods," *H-Net Reviews*, September 1997.
http://www.h-net.org/reviews/showrev.php?id=1318

300.     Quoted in MacDonald, *Separation and its Discontents*, 56.

301.     Paul Lawrence Rose, *Wagner, Race and Revolution* (Yale University Press, 1998), 166.

302.     Magee, *Wagner and Philosophy*, 366.

303.     Quoted in Carr, *The Wagner Clan*, 182.

304.     Magee, *Wagner and Philosophy*, 373.

305.     Ibid., 373; 377 & 380.

306.     Gottfried Wagner, *The Wagner Legacy: An Autobiography* (Sanctuary, 2000), 240.

307.     Solomon, "Wagner and Hitler," op. cit.

308.     Carol Jean Delmar, "Let the Truth be Heard!," Ring Festival LA Protest Campaign, June 14, 2010. http://ringfestlaprotest.wordpress.com/2010/06/14/gottfried-wagner-at-the-american-jewish-university-june-6-2010/

309.     Strahan, "Was Wagner Jewish: an old question newly revisited," op. cit.

310.     Magee, *Wagner and Philosophy*, 373.

311.     Wagner, "Judaism in Music," trans. by Bryan Magee, In: *Wagner and Philosophy* (London: Penguin, 2000), 375.

312.     Ibid., 375-6.

313.     Daniel Barenboim, "Wagner, Israel and the Palestinians," op. cit.

314.     Magee, *Wagner and Philosophy*, 374.

315.     Ibid., 373; 380.

316.     William Shirer, *The Rise and Fall of the Third Reich* (New York: Random House, 2002), 101.

317.     Solomon, "Wagner and Hitler," op. cit.

318.     Rubin, *Anti-Semitism: A Disease of the Mind*, 127.

319.     Robert S. Wistrich, *Anti-Semitism: The Longest Hatred* (London: Thames Mandarin, 1992), 56.

320.     Richard Evans, *The Third Reich in Power* (New York, Penguin, 2005), 199.

321.     Magee, *Wagner and Philosophy*, 362.

322.     Timothy Ryback, *Hitler's Private Library: The Books That Shaped His Life* (New York: Vintage, 2010), 50.

323.     Guido Knopp, *Hitler's Women,* trans. by Angus McGeoch (Phoenix Mill: Sutton, 2003) 158.

324.     Ibid., 169.

325.     Ryback, *Hitler's Private Library*, 134.

326.     Ibid., 146.

327.     Ibid., 239.

328.     Joachim Fest, *Hitler* (London: Harcourt Brace Jovanovich, 1992), 56.

329.     Carr, *The Wagner Clan*, 187.

330.     Adolf Hitler, *Mein Kampf,* trans. by James Murphy (Bottom of the Hill, 2010), 23.

331.     Ibid., 488.

332.     David Goldman, "Muted: Performances of Wagner's music are effectively banned in Israel. Should they be?" op. cit.

333.     Magee, *Wagner and Philosophy*, 366.

334.     Ibid., 365.

335.     Evans, *The Third Reich in Power*, 201.

336.     August Kubizek, *The Young Hitler I Knew*, trans. by Geoffrey Brooks (London: Greenhill Books, 2006), 84.

337.     Ibid.

338.     Ibid., 118.

339.     Ibid., 116-8.

340.     Ibid., 118-9.

341.     Ryback, *Hitler's Private Library*, 176.

342.     Nicholson, *Richard and Adolf*, 21.

343.     Knopp, *Hitler's Women*, 152.

344.     Ibid., 181.

345.     Evans, *The Third Reich in Power*, 200.

346.     Knopp, *Hitler's Women*, 189.

347.     Ibid., 193.

348.     Evans, *The Third Reich in Power*, 201.

349.     Ibid.

350.     Knopp, *Hitler's Women*, 184.

351.     Ibid., 182.

352.     Jonathan Carr, *The Wagner Clan*, 184.

353.     Ibid.

354.     Quoted in Magee, *Wagner and Philosophy* (London: Penguin, 2000), 366.

355.     Jonathan Carr, *The Wagner Clan*, 184.

356.     Guido Fackler, "Music in Concentration Camps 1933-1945," trans. by Peter Logan, *Music & Politics*, Undated.
    http://www.music.ucsb.edu/projects/musicandpolitics/archive/2007-1/fackler.html

357.     To view this scene see: http://www.youtube.com/watch?v=_nS66IvbvcI

358.     Adam Garfinkle, *Jewcentricity: Why the Jews Are Praised, Blamed, and Used to Explain Just About Everything* (Hoboken NJ: John Wiley, 2009), 1.

359.     Ibid., 219.

360.     Ibid., 53.

361.     Ibid.

362.     Ibid., 209.

363.     Ibid., 57-8.

364.     Ibid., 112.

365.     Paul Lawrence Rose, *Wagner, Race & Revolution* (New Haven CT: Yale University Press, 1992), 7.

366.     Garfinkle, *Jewcentricity*, 6.

367.     Ibid., 179-80.

368.     Ibid., 156.

369.     Ibid., 167-8.

370.     Ibid., 56.

371.     Ibid., 62.

372.    Ibid., 64; 67.
373.    Gil Atzmon et al., "Abraham's Children in the Genome Era: Major Jewish Diaspora Populations Comprise Distinct Genetic Clusters with Shared Middle Eastern Ancestry," *American Journal of Human Genetics*, 86(6): 850–9.
374.    Norman Cantor, *The Sacred Chain: The History of the Jews* (New York, HarperCollins, 1994), 336.
375.    Garfinkle, *Jewcentricity*, 65.
376.    Ibid., 67.
377.    Ibid., 211.
378.    Ibid.,130.
379.    Ibid., 128.
380.    Ibid., 131.
381.    Ibid., 128-9.
382.    Ibid., 130.
383.    Ibid., 134.
384.    Ibid., 140.
385.    Ibid., 135-6.
386.    Ibid., 137.
387.    Ibid., 137.
388.    Ibid.
389.    Ibid., 133.
390.    Ibid., 140.
391.    Ibid., 114.
392.    Ibid., 88.
393.    Ibid., 73.
394.    Ibid.
395.    Ibid., 158-9.
396.    Jon Stratton, *Coming Out Jewish – Constructing Ambivalent Identities* (London: Routledge, 2000), 223.
397.    Andrew Markus, *Race: John Howard and the remaking of Australia* (Sydney: Allen & Unwin, 2001), 5-6.
398.    Garfinkle, *Jewcentricity*, 152.
399.    Ibid., 206.
400.    Ibid.
401.    Ibid., 207.
402.    Ibid., 212.
403.    Ibid., 168.
404.    Ibid., 217.
405.    Ibid.
406.    Ibid.
407.    Ibid., 218.
408.    Ibid., 220.

409. Ibid., 221.
410. Ibid., 4.
411. Ibid., 50.
412. Ibid., 51.
413. Ibid., 42.
414. Ibid., 43-4.
415. Ibid., 45.
416. Ibid., 46-7.
417. Ibid., 48-9.
418. Ibid., 93.
419. Ibid., 97.
420. Ibid., 96.
421. Ibid., 243.
422. Ibid., 249.
423. Ibid.
424. Ibid., 250.
425. Ibid., 244.
426. Ibid., 246.
427. Ibid., 245.
428. Ibid., 258-9.
429. Ibid., 226.
430. Ibid., 256.
431. Ibid., 178.
432. Caroline Glick, "Why the Jews? Caroline Glick explain the roots of genocidal Jew hatred," January 19, 2014. https://www.youtube.com/watch?v=_63GLG15hBo
433. Klaus Ottmann, *The Essential Mark Rothko* (New York, NY: Harry N. Abrams, 2003), 8.
434. Simon Schama, *Simon Schama's Power of Art*, BBC TV Series, Great Britain, 2006.
435. Annie Cohen-Solal, *Mark Rothko, Toward the Light in the Chapel* (New Haven CT: Yale University Press, 2015), 207.
436. Ibid., 78
437. J.E.B, Breslin, *Mark Rothko: A Biography* (Chicago: University of Chicago Press, 1998), 14.
438. Ibid., 15.
439. Ibid., 19-20.
440. Cohen-Solal, *Mark Rothko*, 15.
441. Schama, *Simon Schama's Power of Art* TV Series.
442. Jacob Baal-Teshuva, *Rothko* (Cologne, Germany: Taschen, 2009), 19-20.
443. Ibid.
444. Ottmann, *Essential Mark Rothko*, 17.

445.     Jerry Z. Muller, J.Z. (2010) *Capitalism and the Jews* (Princeton NJ: Princeton University Press, 2010), 96.

446.     Cohen-Solal, *Mark Rothko*, 26.

447.     Baal-Teshuva, Rothko, 20.

448.     Kevin MacDonald, *The Culture of Critique: An Evolutionary Analysis of Jewish Involvement in Twentieth-Century Intellectual and Political Movements*, (Westport, CT: Praeger, Revised Paperback edition, 2001), 82.

449.     Baal-Teshuva, *Rothko*, 23.

450.     Norman Cantor, *The Sacred Chain – The History of the Jews* (New York: HarperCollins, 1994), 281.

451.     Simon Schama, *Simon Schama's Power of Art*, BBC Books, London: BBC Books, 2006), 401-2.

452.     Schama, *Simon Schama's Power of Art* TV Series.

453.     Cohen-Solal, *Mark Rothko*, 35; 30.

454.     Schama, *Simon Schama's Power of Art*, 402.

455.     Cohen-Solal, *Mark Rothko*, 38.

456.     Schama, *Simon Schama's Power of Art*, 402.

457.     Baal-Teshuva, *Rothko*, 23.

458.     Cohen-Solal, *Mark Rothko*, 45.

459.     Ibid., 39.

460.     Ibid., 45.

461.     Ibid., 42-3.

462.     Ibid., 43.

463.     Baal-Teshuva, *Rothko*, 23.

464.     Cohen-Solal, *Mark Rothko*, 56

465.     Ibid., 57.

466.     Baal-Teshuva, *Rothko*, 24.

467.     Schama, *Simon Schama's Power of Art*, 405.

468.     Baal-Teshuva, *Rothko*, 10.

469.     Schama, *Simon Schama's Power of Art*, 403.

470.     Ibid.

471.     Schama, *Simon Schama's Power of Art* TV Series.

472.     Cohen-Solal, *Mark Rothko*, 64.

473.     Baal-Teshuva, *Rothko*, 24.

474.     Matthew Collings, *This is Modern Art* (London: Weidenfeld & Nicholson, 1999), 169.

475.     Baal-Teshuva, *Rothko*, 26.

476.     Schama, *Simon Schama's Power of Art*, 405.

477.     Baal-Teshuva, *Rothko*, 26.

478.     Cohen-Solal, *Mark Rothko*, 7

479.     In MacDonald, *The Culture of Critique*, 217.

480.     Ibid., 218.

481.    Schama, *Simon Schama's Power of Art*, 406.
482.    Schama, *Simon Schama's Power of Art* TV Series.
483.    Cohen-Solal, *Mark Rothko*, 90.
484.    Ibid., 79.
485.    Ibid., 88.
486.    Baal-Teshuva, *Rothko*, 33.
487.    Unsigned, "Mark Rothko," *The Art Story*, https://www.theartstory.org/jewish-artist-rothko-mark.htm
488.    Baal-Teshuva, *Rothko*, 38.
489.    Ibid., 39.
490.    Ibid., 45.
491.    Cohen-Solal, *Mark Rothko*, 97.
492.    Ibid., 116.
493.    Bonnie Wertheim, "Dorothy Seiberling, Influential Arts Editor, Dies at 97," *The New York Times*, November 24, 2019. https://www.nytimes.com/2019/11/24/business/media/dorothy-seiberling-dead.html
494.    Cohen-Solal, *Mark Rothko*, 121.
495.    Ibid., 126.
496.    Ibid., 153.
497.    Ibid., 138.
498.    Ibid., 144.
499.    Ibid., 117.
500.    Baal-Teshuva, *Rothko*, 50.
501.    Norbert Lynton, *The Story of Modern Art* (Oxford: Phaidon, 1989), 242.
502.    Cohen-Solal, *Mark Rothko*, 174.
503.    Ibid., 175.
504.    Ibid.
505.    Ibid., 147.
506.    Ibid., 176.
507.    Ibid., 161.
508.    Ibid., 185.
509.    Ibid.
510.    Christopher Rothko, "My father and music: how Mark Rothko's love of Mozart made his paintings sing," *The Art Newspaper*, January 1, 2016. https://www.theartnewspaper.com/feature/my-father-and-music-how-mark-rothko-s-love-of-mozart-made-his-paintings-sing
511.    MacDonald, *The Culture of Critique*, 211.
512.    Alain Rogier, "Jewish Artist Mark Rothko: An Outsider in Life and Death," *ReformJudaism.org*, April 26, 2016. https://reformjudaism.org/blog/2016/04/26/jewish-artist-mark-rothko-outsider-life-and-death
513.    Ibid., 212.

514. Erika Doss, *Twentieth-Century American Art* (Oxford: Oxford University Press, 2002), 124.

515. Ibid., 130-1.

516. Doss, *Twentieth-Century American Art*, 128.

517. MacDonald, *The Culture of Critique*, 212.

518. Cantor, *The Sacred Chain*, 303.

519. Ibid., 211.

520. Ibid., 213.

521. Ibid.

522. Kevin MacDonald, Review of Thomas Wheatland's "The Frankfurt School in Exile," *The Occidental Observer*, October 19, 2009. https://www.theoccidentalobserver.net/2009/10/19/macdonald-wheatland-i/

523. Clement Greenberg, "Avant-Garde and Kitsch," In: *Art and Culture: Critical Essays* (Boston: Beacon Press, 1971), 18.

524. Paul Barlow, In: *Key Writers on Art: The Twentieth Century*, Ed. By Chris Murray (London: Routledge, 2003), 152.

525. Ibid., 150.

526. Roger Scruton, *Culture Counts – Faith and Feeling in a World Besieged* (New York: Encounter Books, 2007), 70.

527. Ibid., 73.

528. Barlow, *Key Writers on Art*, 150-1.

529. A. Everitt, "Abstract Expressionism" In: *Modern Art – Impressionism to Post-Modernism*, Ed. By David Britt (London: Thames and Hudson, 1974), 256.

530. Barlow, *Key Writers on Art*, 151.

531. Roger Scruton, *Modern Culture* (London: Continuum, 2000), 93.

532. Daniel Jonah Goldhagen, *The Devil That Never Dies: The Rise of Global Antisemitism* (New York NY: Little, Brown & Co., 2013), 1.

533. Ibid., 406.

534. Ibid., Ix; 9.

535. Ibid., 22-3.

536. Ibid., 255.

537. Ibid., 256.

538. Ibid., 110.

539. Ibid., 287.

540. Ibid., 286; 282.

541. Ibid., 122.

542. Ibid., 327.

543. Ibid., 329.

544. Ibid., 253.

545. Ibid., 12.

546. Ibid., 20.

547.     Hannah Arendt, *The Origins of Totalitarianism* (Orlando FL; Harcourt, 1966), xii-xiv.
548.     John Murray Cuddihy, *The Ordeal of Civility: Freud, Marx, Levi-Strauss and the Jewish struggle with Modernity* (New York NY; Beacon, 1987), 6.
549.     Goldhagen, *The Devil That Never Dies*, 79.
550.     Ibid., 4.
551.     Ibid., 14.
552.     Ibid., 15.
553.     Ibid., 14.
554.     Ibid., 13.
555.     Ibid., 11.
556.     Ibid., 458.
557.     Ibid., 194-5.
558.     Ibid., 61.
559.     Ibid., 70.
560.     Ibid., 94.
561.     Ibid., 259-60.
562.     Ibid., 241.
563.     Ibid., 243.
564.     Ibid., 33.
565.     Ibid., 243.
566.     Ibid., 223.
567.     Ibid., 95.
568.     Ibid., 197-8.
569.     Ibid., 20-1.
570.     Ibid., 91-2.
571.     Ibid., 93.
572.     Manny Friedman, "Jews DO Control the Media," *The Times of Israel*, July 1, 2012. https://councilforthenationalinterest.org/?p=833
573.     Goldhagen, *The Devil That Never Dies*, 30.
574.     Ibid., 289.
575.     Ibid., 288-9.
576.     Ibid., 26.
577.     Ibid., 28.
578.     Ibid., 29.
579.     Ibid., 332.
580.     Dan Goldberg, "Jews key to Aboriginal reconciliation," *Jewish Telegraphic Agency*, February 2, 2008. http://anivlam.blogspot.com.au/2008/02/jews-in-australia-aboriginal.html
581.     Goldhagen, *The Devil That Never Dies*, 267.

582.    See for example http://www.theoccidentalobserver.net/2013/05/steve-sailer-jews-are-on-top-now/ and http://www.amazon.com/The-Fatal-Embrace-Jews-State/dp/0226296660

583.    Goldhagen, *The Devil That Never Dies*, 270.

584.    Ibid., 284.

585.    Ibid.

586.    Ibid., 291; 126.

587.    Bernhard Wasserman, *On The Eve: The Jews of Europe Before The Second World War* (London; Profile Books, 2012), 61.

588.    Norman Cantor, *The Sacred Chain — The History of the Jews* (New York, NY; HarperCollins, 1994), 281.

589.    Jerry Muller, *Capitalism and the Jews* (New Jersey; Princeton University Press, 2010), 139.

590.    Ibid., 173.

591.    Ibid., 178-9.

592.    Ibid., 191.

593.    Sever Plocker, "Stalin's Jews," *ynet.news.com*, December 26, 2006. http://www.ynetnews.com/articles/0,7340,L-3342999,00.html

594.    Goldhagen, *The Devil That Never Dies*, 415-6.

595.    Ibid., 218.

596.    Anthony Julius, "Book Review: 'The Devil That Never Dies' By Daniel Jonah Goldhagen," *The Wall Street Journal*, September 12, 2013. http://www.wsj.com/articles/SB10001424127887324463604579042904257147952

597.    Erica Terry, "The Jewish Oscars: How Judaism is Present at the Academy Awards," *J Space News*, February 2, 2015. http://jspacenews.com/jewish-oscars-judaism-present-academy-awards/

598.    Naomi Pfefferman, "Solving the enigma: Producing Alan Turing's story against the odds," *Jewish Journal*, January 22, 2015. https://jewishjournal.com/culture/arts/154078/solving-the-enigma-producing-alan-turings-story-against-all-odds/

599.    Unsigned, "Showing of 'The Imitation Game' to Benefit Sara & Sam Schoffer Holocaust Resource Center," Stockton College Press Release, January 8, 2015. https://intraweb.stockton.edu/eyos/extaffairs/content/docs/pressrel/StocktonImitationGame2015PressRelease.pdf

600.    Gordon Brown, "Gordon Brown: I'm proud to say sorry to a real war hero." *The Guardian*, September 10. 2009. https://www.telegraph.co.uk/news/politics/gordon-brown/6170112/Gordon-Brown-Im-proud-to-say-sorry-to-a-real-war-hero.html

601.    Pfefferman, "Solving the enigma," op. cit.

602.    E.A. Hanks, "How 'The Imitation Game' Screenwriter Graham Moore Made It In Hollywood," *Buzzfeed*, September 28, 2013. https://www.buzzfeed.com/eahanks/benedict-cumberbatch-alan-turing-graham-moore#.gcwXazkp8

603.     Gabriela Geselowitz, "The Oscar Winner's White House Connection," *Tablet*, February 26, 2015. https://www.tabletmag.com/scroll/189247/the-oscar-winners-white-house-connection

604.     Danielle Berrin, "Meet Oscar-winner Graham Moore: Hollywood's newest Jewish writing prodigy," *Jewish Journal*, February 6, 2015. https://jewishjournal.com/culture/arts/156179/meet-oscar-winner-graham-moore-hollywoods-newest-jewish-writing-prodigy/

605.     Berrin, "Meet Oscar-winner Graham Moore," op. cit.

606.     Graham Moore, "Alan Turing's story the perfect fit for 'Imitation Game' scriptwriter," *Los Angeles Times*, December 11, 2014. https://www.latimes.com/entertainment/envelope/la-et-mn-alan-turing-writer-graham-moore-imitation-game-20141211-story.html

607.     Hanks, "How 'The Imitation Game' Screenwriter Graham Moore Made It In Hollywood," op. cit.

608.     Moore, "Alan Turing's story the perfect fit," op. cit.

609.     Christian Caryl, "A Poor Imitation of Alan Turing," *The New York Review of Books*, December 19, 2014. https://www.nybooks.com/daily/2014/12/19/poor-imitation-alan-turing/

610.     L.V. Anderson, "How Accurate is The Imitation Game?," *Slate*, December 4, 2014. https://slate.com/culture/2014/12/the-imitation-game-fact-vs-fiction-how-true-the-new-movie-is-to-alan-turings-real-life-story.html

611.     Caryl, "A Poor Imitation of Alan Turing," op. cit.

612.     Anderson, "How Accurate is The Imitation Game?," op. cit.

613.     Caryl, "A Poor Imitation of Alan Turing," op. cit.

614.     Anderson, "How Accurate is The Imitation Game?," op. cit.

615.     See B. Jack Copeland, *Alan Turing: Pioneer of the Information Age* (Oxford: Oxford University Press, 2014).

616.     Caryl, "A Poor Imitation of Alan Turing," op. cit.

617.     Terry, "The Jewish Oscars: How Judaism is Present at the Academy Awards," op. cit.

618.     Berrin, "Meet Oscar-winner Graham Moore," op. cit.

619.     Kenneth Wald, *The Politics of Gay Rights* (Chicago: University of Chicago Press, 2000), 18.

620.     Adam Edelman, "Vice President Biden: Jewish leaders, pop culture drove gay marriage acceptance," *New York Daily News*, May 22, 2013. https://www.nydailynews.com/news/politics/vice-president-biden-jewish-leaders-pop-culture-drove-gay-marriage-acceptance-article-1.1351817

621.     Adam Garfinkle, *Jewcentricity: why the Jews are praised, blamed, and used to explain just about everything* (Hoboken NJ: John Wiley, 2009), 137.

622.     Caleb Peng, "Was Adolf Hitler Gay? Maybe, Says New Evidence, But Does it Even Matter?," *Mic*, May 11, 2013. https://www.mic.com/articles/41125/was-adolf-hitler-gay-maybe-says-new-evidence-but-does-it-matter

623.     Wylark Day, *The Conclusion of the Sexual Revolution* (Self-published, 2014), 97.

624.     Robert Wistrich, *Laboratory for World Destruction: Germans and Jews in Central Europe* (University of Nebraska Press, 2007), 361.

625.     Raymond J. Lawrence, *Sexual Liberation: The Scandal of Christendom* (Praeger, 2007), 26.

626.     Peter Novick, *The Holocaust and Collective Memory* (London: Bloomsbury, 2000), 144.

627.     Ibid., 12.

628.     http://estherkustanowitz.typepad.com/myurbankvetch2005/2009/04/jenji-kohan-jill-soloway-and-the-hebrew-mamita-inside-the-jewish-noggin.html

629.     Chaim Bermant, *Jews* (London; Weidenfeld & Nicholson, 1977), 91.

630.     Novick, *The Holocaust*, 232.

631.     Eric L. Goldstein, *The Price of Whiteness: Jews, Race, and American Identity* (New Jersey: Princeton University Press, 2008), 211.

632.     Nicholas Kollerstrom, *Breaking the Spell: The Holocaust, Myth & Reality* (Uckfield: Castle Hill, 2014), 133.

633.     Henry Reynolds, *Why Weren't We Told? — A personal search for the truth about our history* (Melbourne: Penguin, 2000), 248-9.

634.     David Cannadine, *The Undivided Past: Humanity Beyond Our Differences* (New York: Alfred A. Knopf, 2013), 205.

635.     Ibid., 210.

636.     Ibid., 211.

637.     Poul Duedahl, "From racial strangers to ethnic minorities, On the socio-political impact of UNESCO, 1945-60." Paper presented at 7th Annual International Conference on Politics and International Affairs in Athens, Greece, in 2009.

638.     Ibid.

639.     Anthony Q. Hazard, *Postwar Anti-Racism: The United States, UNESCO, and "Race,"1945-1968* (New York: Palgrave MacMillan, 2012), 38.

640.     Cannadine, *The Undivided Past*, 212.

641.     Hazard, *Postwar Anti-Racism*, 39.

642.     http://www.honestthinking.org/en/unesco/UNESCO.1950.Statement_on_Race.htm

643.     Ibid.

644.     Duedahl, "From racial strangers," op. cit.

645.     Elazar Barkan, *The Retreat of Scientific Racism: Changing Concepts of Race in Britain and the United States between the World Wars* (Cambridge UK: Cambridge University Press, 1993), 341.

646.     Robert Wald Sussman, *The Myth of Race: The Troubling Persistence of an Unscientific Idea* (Cambridge MA: Harvard University Press, 2014), 207.

647.     Brenton Sanderson, "The War on White Australia: A Case Study in the Culture of Critique," *The Occidental Observer*, August 13, 2012. http://www.theoccidentalobserver.net/2012/08/the-war-on-white-australia-a-case-study-in-the-culture-of-critique-part-1-of-5/
648.     Götz Aly, *Why the Germans? Why the Jews?: Envy, Race Hatred, and the Prehistory of the Holocaust* (New York: Metropolitan Books, 2014), 2.
649.     Ibid., 3.
650.     Ibid., 9.
651.     Ibid., 4.
652.     Kevin MacDonald, *Separation and its Discontents: Toward an Evolutionary Theory of Anti-Semitism* (1st Books Library, 2004), 171.
653.     Ibid.
654.     Yuri Slezkine, *The Jewish Century* (NJ: Princeton University Press, 2006), 57.
655.     Aly, *Why the Germans?*, 222.
656.     Ibid., 222-3.
657.     Abraham Meyerson, "The 'Nervousness' of the Jew," In: *Jews and Race: Writings on Identity and Difference 1880-1940*, Ed. Mitchell Hart (Waltham MA: Brandeis University Press, 2011), 177-78.
658.     Aly, *Why The Germans?*, 221.
659.     https://www.youtube.com/watch?v=btlxtf2txPk
660.     Peter Watson, *The German Genius: Europe's Third Renaissance, the Second Scientific Revolution and the Twentieth Century* (London: Simon & Schuster, 2010), 429.
661.     Aly, *Why the Germans?*, 46-7.
662.     Ibid., 43-4.
663.     Ibid., 220.
664.     Ibid., 221.
665.     Peter Birks & Arianna Pretto, *Themes in Comparative Law: In Honour of Bernard Rudden* (Oxford: Oxford University Press, 2002), 265.
666.     David G. Haglund, *Ethnic Diasporas and the Canada-United States Security Community: From the Civil War to Today* (New York: Rowman & Littlefield, 2015), 170.
667.     MacDonald, *Separation and its Discontents*, 176.
668.     Norman Cantor, *The Sacred Chain: The History of the Jews* (New York: Harper-Collins, 1994), 360.
669.     Ibid., 361.
670.     Ibid., 349.
671.     Jonathan Freedland (2005) *Journey into the Heart of Belonging* (London: Hamish Hamilton, 2005), 9.
672.     Aly, *Why the Germans?*, 6.
673.     Ibid., 7.

674.     Ibid., 1.

675.     Ibid., 29.

676.     Ibid., 65-6.

677.     Ibid., 3.

678.     Alfred Kelly, *The Descent of Darwin: The Popularization of Darwin in Germany, 1860-1914* (Chapel Hill, University of North Carolina Press, 1981), 5; 21-3.

679.     MacDonald, *Separation and its Discontents*, 165.

680.     Ibid., 171.

681.     Ibid.

682.     Adolf Hitler, *Hitler's Second Book: The Unpublished Sequel to Mein Kampf* (Enigma Books, 2003), 233-4.

683.     MacDonald, *Separation and its Discontents*, 163.

684.     Aly, *Why the Germans?*, 213.

685.     Ibid., 57.

686.     Ibid., 206.

687.     Adolf Hitler, *Hitler's Second Book*, 236-7.

688.     Friederich Karl Wiehe, *Germany and the Jewish Question*, Published for the Institute for Studies of the Jewish Question, Berlin, 1938. http://www.controversyofzion.info/germany_jewish_question.htm

689.     Jerry Muller, *Capitalism and the Jews* (NJ: Princeton University Press, 2010), 91.

690.     Götz Aly, *Why the Germans?*, 34.

691.     Ibid., 55.

692.     Ibid., 34.

693.     Ibid., 36.

694.     Ibid., 38.

695.     Kevin MacDonald, *A People That Shall Dwell Alone: Judaism as a Group Evolutionary Strategy, with Diaspora People* (Lincoln, NE: iUniverse, 2002), 247.

696.     Ibid., 217.

697.     Götz Aly, *Why the Germans?*, 31.

698.     Ibid., 132.

699.     Ibid., 137-8.

700.     Kevin MacDonald, "Ron Unz on the Illusory American Meritocracy," *The Occidental Observer*, December 13, 2012. http://www.theoccidentalobserver.net/2012/12/ron-unz-on-the-illusory-american-meritocracy/

701.     Kevin MacDonald, "Jewish Overrepresenation at Elite Universities Explained," *The Occidental Observer*, July 16, 2010. http://www.theoccidentalobserver.net/2010/07/kevin-macdonald-jewish-overrepresentation-at-elite-universities-explained/

702. Kevin MacDonald, *Separation and its Discontents: Toward an Evolutionary Theory of Anti-Semitism* (1st Books Library, 2004), 170.

703. Watson, *The German Genius*, 434.

704. Friederich Karl Wiehe, *Germany and the Jewish Question* (Ostara Pub. Kindle Edition, 2014), 1232.

705. Adolf Hitler, *Mein Kampf* (London: Imperial Collegiate Publishing, 2010), 281; 58.

706. Aly, *Why the Germans?*, 4.

707. Wiehe, *Germany and the Jewish Question*, 367.

708. Ibid.

709. Aly, *Why the Germans?*, 161-2.

710. Ibid., 74.

711. Ibid., 77.

712. Albert Lindemann, *Esau's Tears: Modern Anti-Semitism and the Rise of the Jews* (Cambridge: Cambridge University Press, 2000), 139-40.

713. Ibid., 141.

714. Ibid., 140.

715. Wiehe, *Germany and the Jewish Question*, 1439.

716. Aly, *Why the Germans?*, 39.

717. Ibid., 232.

718. Christopher Browning, "How Envy of Jews Lay Behind It," *The New York Review of Books*, January 8, 2015. http://www.nybooks.com/articles/2015/01/08/how-envy-jews-lay-behind-it/

719. Dagmar Herzog, "Nazism: Bernard Wassersteins's 'Ambiguity of Virtue' and More," *The New York Times*, June 6, 2014. http://www.nytimes.com/2014/06/08/books/review/bernard-wassersteins-ambiguity-of-virtue-and-more.html?_r=1

720. Malcolm Forbes, "Germany's Inferiority Complex and the Holocaust," *Forward*, May 23, 2014. http://forward.com/culture/198652/germanys-inferiority-complex-and-the-holocaust/

721. Aly, *Why the Germans?*, Back cover.

722. Daniel Johnson, "It Was More Than Envy," *Commentary*, October 1, 2014. https://www.commentarymagazine.com/articles/it-was-more-than-envy/

723. Honoré de Balzac, *Cousin Pons* (London: Penguin, 1978), 11.

724. Quoted: in Daniel J. Boortstin, *The Creators: A History of Heroes of the Imagination* (New York: Random House, 1992), 359.

725. Ibid., 358.

726. Frederick Lawton, *Balzac* (London: Wessels & Bissell Co, 1910), 129.

727. Voltaire quoted in: Hyam Maccoby, *Antisemitism and Modernity: Innovation and Continuity* (London: Routledge, 2006) 55.

728. Immanuel Kant quoted in: Paul Lawrence Rose, *Wagner, Race & Revolution* (New Haven CT: Yale University Press, 1992), 7.

729. Albert S. Lindemann, *Esau's tears: Modern Anti-Semitism and the Rise of the Jews* (Cambridge UK: Cambridge University Press, 2000), 208.

730. Graham Robb in Introduction to: Balzac, *Old Man Goriot* (London Penguin, 1972), vi-vii.

731. Esther Raskin, *Unspeakable Secrets and the Psychoanalysis of Culture* (New York: SUNY Press, 2009), 133.

732. Frances Schlamowitz Grodzinsky, *The Golden Scapegoat: Portrait of the Jew in the Novels of Balzac* (New York: Whitson, 1989), 48.

733. Susan Rosa, "Balzac," In: *Antisemitism: A Historical Encyclopedia of Prejudice and Persecution*, Volume 1 Ed. by Richard S. Levy (Chicago: ABC-CLIO, 2005), 54.

734. Balzac, *Cousin Pons*, 141.

735. Honoré de Balzac, *Eugenie Grandet* (London: Penguin, 2004), 115.

736. Guy de Maupassant, *Bel Ami* (London, Penguin, 1975), 64.

737. Balzac, *Cousin Pons*, 10.

738. Grodzinsky, *The Golden Scapegoat*, 18.

739. *The Correspondence of Honoré de Balzac with a Memoir by his Sister Madame de Surville*, Vol. 2 (London: Richard Bentley & Son, 1878), 345.

740. Balzac, *Cousin Pons*, 123.

741. Ibid., 10.

742. Niall Ferguson, *The House of Rothschild: Money's Prophets 1798-1848* (London: Penguin, 1999), 351.

743. Ferguson, *The House of Rothschild*, 15.

744. Balzac, *Cousin Pons*, 123.

745. Ferguson, *The House of Rothschild*, 15.

746. Ibid., 96.

747. Herbert R. Lottman, *Return of the Rothschilds: The Great Banking Dynasty Through Two Turbulent Centuries* (I.B. Tauris & Co Ltd, 1995), 269.

748. Ibid., 31.

749. Lottman, *Return of the Rothschilds*, 31.

750. Ferguson, *The House of Rothschild*, 21.

751. Grodzinsky, *The Golden Scapegoat*, 1.

752. Ibid., 32.

753. Ibid., 17.

754. Ibid., 12.

755. Ibid., 1.

756. Chaim Zhitlowsky, "Jews and Jewishness," In: *Jews and Race: Writings on Identity and Difference 1880-1940*, Ed. Mitchell Hart (Waltham MA: Brandeis University Press, 2011), 325-6.

757. Ibid., 330.

758. Norman Cantor, *The Sacred Chain – The History of the Jews* (New York: HarperCollins, 1994), 336.

759.    Ibid., 337.

760.    Ibid.

761.    Ibid., 308.

762.    Kevin MacDonald, K. B. (1998/2001) *The Culture of Critique: An Evolutionary Analysis of Jewish Involvement in Twentieth-Century Intellectual and Political Movements* (Bloomington, IN: 1st Books, 2001), 20.

763.    Mitchell Hart, *Jews and Race: Writings on Identity and Difference 1880-1940*, Ed. Mitchell Hart (Waltham MA: Brandeis University Press, 2011), 14.

764.    Ibid., 31-2.

765.    Ibid., 31.

766.    Ibid., 9-10.

767.    Atzmon, G.; Hao, L.; Pe'er, I.; Velez, C.; Pearlman, A.; Palamara, P. F.; Morrow, B.; Friedman, E. et al., "Abraham's Children in the Genome Era: Major Jewish Diaspora Populations Comprise Distinct Genetic Clusters with Shared Middle Eastern Ancestry," *American Journal of Human Genetics* 86 (6), 2010, 850–59. http://www.ncbi.nlm.nih.gov/pmc/articles/PMC3032072/?tool=pmcentrez

768.    Robert Weltsch, "Concerning Racial Theory," In: *Jews and Race: Writings on Identity and Difference 1880-1940*, Ed. Mitchell Hart (Waltham MA: Brandeis University Press, 2011), 312.

769.    Hart, *Jews and Race*, 242.

770.    Moritz Goldstein, "The Jewish Racial Problem," In: *Jews and Race: Writings on Identity and Difference 1880-1940*, Ed. Mitchell Hart (Waltham MA: Brandeis University Press, 2011), 319; 321.

771.    Isidore Loeb, "Reflections on the Jews," In: *Jews and Race: Writings on Identity and Difference 1880-1940*, Ed. Mitchell Hart (Waltham MA: Brandeis University Press, 2011), 53.

772.    Ibid., 52.

773.    Ibid., 50.

774.    Ibid., 58.

775.    Unsigned editorial from *The Maccabaean*, In: *Jews and Race: Writings on Identity and Difference 1880-1940*, Ed. Mitchell Hart (Waltham MA: Brandeis University Press, 2011), 258-7.

776.    MacDonald, *The Culture of Critique*, 24.

777.    Hart, *Jews and Race*, 205.

778.    Elias Auerbach, "The Jewish Racial Question," In: *Jews and Race: Writings on Identity and Difference 1880-1940*, Ed. Mitchell Hart (Waltham MA: Brandeis University Press, 2011), 208-9.

779.    Ignaz Zollschan, "The Significance of the Mixed Marriage," In: *Jews and Race: Writings on Identity and Difference 1880-1940*, Ed. Mitchell Hart (Waltham MA: Brandeis University Press, 2011), 228-9.

780. Arthur Ruppin, "On the Origins and Race of the Jews," In: *Jews and Race: Writings on Identity and Difference 1880-1940*, Ed. Mitchell Hart (Waltham MA: Brandeis University Press, 2011), 86.

781. Arthur Ruppin, "The Mixed Marriage," In: *Jews and Race: Writings on Identity and Difference 1880-1940*, Ed. Mitchell Hart (Waltham MA: Brandeis University Press, 2011), 220.

782. Arthur Ruppin, "On the Origins and Race of the Jews," 78.

783. Auerbach, "The Jewish Racial Question," 213.

784. Ibid., 214.

785. Alfred Nossig, "The Chosenness of the Jews in the Light of Biology," In: *Jews and Race: Writings on Identity and Difference 1880-1940*, Ed. Mitchell Hart (Waltham MA: Brandeis University Press, 2011), 261-2.

786. Ibid., 264.

787. Ibid., 260.

788. Auerbach, "The Jewish Racial Question," 209-10.

789. Maurice Fishberg, "Intermarriage between Jews and Christians," In: *Jews and Race: Writings on Identity and Difference 1880-1940*, Ed. Mitchell Hart (Waltham MA: Brandeis University Press, 2011), 237.

790. Die Welt article In: *Jews and Race: Writings on Identity and Difference 1880-1940*, Ed. Mitchell Hart (Waltham MA: Brandeis University Press, 2011), 304.

791. Maurice Fishberg, "Preface from Jews, Race and Environment," In: *Jews and Race: Writings on Identity and Difference 1880-1940*, Ed. Mitchell Hart (Waltham MA: Brandeis University Press, 2011), 63.

792. Ibid., 61.

793. Fishberg, "Intermarriage between Jews and Christians," 297-8.

794. Fishberg, "Preface from Jews, Race and Environment," 61-2.

795. Raphael Falk, "Zionism, Race, and Eugenics," In: *Jewish Tradition and the Challenge of Darwinism*, Eds. Geoffrey Cantor & Marc Swetlitz (Chicago: University of Chicago Press, 2006), 138.

796. Ibid.

797. Ibid., 142.

798. Ibid., 143.

799. Ibid., 146.

800. Ibid., 162.

801. Zollschan, "The Significance of the Mixed Marriage," 232-3.

802. Ibid., 234.

803. Ibid., 236.

804. Nossig, "The Chosenness of the Jews in the Light of Biology," 265.

805. Arthur Ruppin, "Successes of the Jews in Capitalistic Enterprise," In: *Jews and Race: Writings on Identity and Difference 1880-1940*, Ed. Mitchell Hart (Waltham MA: Brandeis University Press, 2011), 203.

806. Ibid., 204.

807. Nossig, "The Chosenness of the Jews in the Light of Biology," 265.

808. Unsigned editorial from Die Welt In: *Jews and Race: Writings on Identity and Difference 1880-1940*, Ed. Mitchell Hart (Waltham MA: Brandeis University Press, 2011), 309.

809. Abraham Meyerson, "The 'Nervousness' of the Jew," In: *Jews and Race: Writings on Identity and Difference 1880-1940*, Ed. Mitchell Hart (Waltham MA: Brandeis University Press, 2011), 177.

810. Ibid., 177-8.

811. Ignaz Zollschan, "Foreword and Introduction from The Racial Problem, with Particular Attention Paid to the Theoretical Foundations of the Jewish Racial Question," In: *Jews and Race: Writings on Identity and Difference 1880-1940*, Ed. Mitchell Hart (Waltham MA: Brandeis University Press, 2011), 283.

812. Falk, "Zionism, Race, and Eugenics," 143.

813. Ibid., 138-9.

814. Richard Weikart, "The Impact of Social Darwinism on Anti-Semitic Ideology in Germany and Austria, 1860-1945," In: *Jewish Tradition and the Challenge of Darwinism*, Eds. Geoffrey Cantor & Marc Swetlitz (Chicago: University of Chicago Press, 2006), 107.

815. Falk, "Zionism, Race & Eugenics," 151.

816. Ibid., 152.

817. Ibid., 154.

818. Zollschan, "Foreword and Introduction," 277.

819. Ibid., 278.

820. Ibid., 282.

821. Ibid., 278.

822. Ibid., 279.

823. Kevin MacDonald, *The Culture of Critique: An Evolutionary Analysis of Jewish Involvement in Twentieth-Century Intellectual and Political Movements*, (Westport, CT: Praeger, Revised Paperback edition, 2001), 170.

824. Harry Brod & Michael Kaufman, *Theorizing Masculinities* (Thousand Oaks, CA; Sage, 1994), 29.

825. Bill E. Peterson & Eileen L. Zurbriggen, "Gender, Sexuality and the Authoritarian Personality," *Journal of Personality*, December, 2010.

826. MacDonald, *The Culture of Critique*, 174; 177.

827. Esther Kustanowitz, "Jenji Kohan, Jill Soloway, and the Hebrew Mamita: 'Inside the Jewish Noggin,'" *My Urban Kvetch* blog, April 27, 2009. https://estherkustanowitz.typepad.com/myurbankvetch2005/2009/04/jenji-kohan-jill-soloway-and-the-hebrew-mamita-inside-the-jewish-noggin.html

828.      Ester Bloom, "The New Trans TV Show That's Good for the Jews," *Jewish Telegraphic Agency*, October 15, 2014. https://www.jta.org/jewniverse/2014/why-the-new-trans-tv-show-is-good-for-the-jews

829.      Debra Nussbaum Cohan, "How Jill Soloway Created 'Transparent' – the Jewiest Show Ever," *Forward*, October 21, 2014. https://forward.com/culture/207407/how-jill-soloway-created-transparent-the-jewiest/

830.      Kari Mozena, "Talking Writing, Drugs, and Comfortable Bedding With TV's Top Hitmakers," *Los Angeles Magazine*, April 9, 2015. http://www.lamag.com/theseen/talking-writing-drugs-and-bedding-with-tvs-top-hit-makers/

831.      Danielle Cantor, "Interview: Jill Soloway," *JW Magazine*, September 25, 2015. https://www.daniellecantor.com/articles/2016/9/25/interview-jill-soloway

832.      Margy Rochlin, "Not Your Father's Sitcom," *DGA Quarterly*, Winter, 2015. https://www.dga.org/Craft/DGAQ/All-Articles/1501-Winter-2015/Indie-Voice-Jill-Soloway.aspx

833.      Michael Fox, "L.A. housewife shakes up her world in sexy Afternoon Delight," *The Jewish News of Northern California*, August 30, 2013. https://www.jweekly.com/2013/08/30/l-a-housewife-shakes-up-her-world-in-sexy-afternoon-delight/

834.      Gregg Shapiro, "Simply Delightful: an interview with Afternoon Delight's Jill Soloway," *Go Pride*, September 5, 2013. http://chicago.gopride.com/news/interview.cfm/articleid/541584

835.      Lawrence Bush, "O My America, Queer Jews Go Mainstream," *Jewish Currents*, October 11, 2013. https://jewishcurrents.org/o-america-transparent/

836.      Anna Goldsworthy, "Seeing clearly," *The Monthly*, April, 2015. https://www.themonthly.com.au/issue/2015/april/1427806800/anna-goldsworthy/seeing-clearly#mtr

837.      Richard Jackson & Fred W. Sanborn, *Media Affects: Advances in Theory and Research* (Abingdon, Oxon: Routledge, 2009), 313.

838.      Jada Yuan, "How Jill Soloway is Bending Hollywood," *Elle*, January 13, 2015. https://www.elle.com/culture/movies-tv/a25432/jill-soloway-transparent/

839.      Josh Horn, "Jill Soloway on Transparent and How Lena Dunham's Success Convinced Her to Stop Pretending," *Vulture*, September 16, 2014. https://www.vulture.com/2014/09/jill-soloway-interview-transparent-amazon-lena-dunham-girls-louie.html

840.      Inkoo Kang, "Transparent's Jill Soloway Continues TV's Sexual (R)evolution," *The Village Voice*, September 30, 2014. https://www.villagevoice.com/2014/09/30/transparents-jill-soloway-continues-tvs-sexual-revolution/

841.      Paula Kamen, "Transparent's Jill Soloway on Inventing the Female Gaze," *Ms.*, October 6, 2014. https://msmagazine.com/2014/11/06/transparents-jill-soloway-on-inventing-the-female-gaze/

842.     Nussbaum Cohan, "How Jill Soloway Created 'Transparent,'" op. cit.

843.     Yuan, "How Jill Soloway is Bending Hollywood," op. cit.

844.     Helaine Olen, "An Interview with Jill Soloway," *Literary Mama*, January, 2006. http://www.literarymama.com/profiles/archives/2006/01/jill-soloway.html

845.     Paul McHugh, "Transgender Surgery Isn't the Solution," *The Wall Street Journal*, May 13, 2016. https://www.wsj.com/articles/paul-mchugh-transgender-surgery-isnt-the-solution-1402615120

846.     Tanya Schwied, "Lessons from 'Maura,'" *JLife*, Undated. http://jlifeoc.com/lessons-from-maura/

847.     McHugh, "Transgender Surgery Isn't the Solution," op. cit.

848.     Ibid.

849.     J. Bryan Lowder, "Being Transgender Is No Longer a Disorder," *Slate*, December 3, 2012. https://slate.com/technology/2012/12/dsm-revision-and-sexual-identity-gender-identity-disorder-replaced-by-gender-dysphori,"a.html

850.     Jim Burroway, "NARTH Counselor Admits Failure in Changing Sexual Orientation, Blames Patient, Sues California for the Right to Try Again," *Box Turle Bulletin*, January 25, 2013. http://www.boxturtlebulletin.com/tag/jack-drescher

851.     Unsigned, "Transgender no longer a mental 'disorder' in diagnostic manual," *Fox Denver 31 News*, December 27, 2012. https://kdvr.com/news/transgender-no-longer-a-mental-disorder-in-diagnostic-manual/

852.     Dana Beyer, "The End of Transgender as a Mental Illness," *HuffPost*, December 5, 2012. https://www.huffpost.com/entry/the-end-of-transgender-as-a-mental-illness_b_2238147?ir=Australia

853.     Yuan, "How Jill Soloway is Bending Hollywood," op. cit.

854.     Kamen, "Transparent's Jill Soloway on Inventing the Female Gaze," op. cit.

855.     John Horn, "Jill Soloway on Transparent and How Lena Dunham's Success Convinced Her to Stop Pretending," *Vulture*, September 26, 2014. https://www.vulture.com/2014/09/jill-soloway-interview-transparent-amazon-lena-dunham-girls-louie.html

856.     Allison Corneau, "Caitlyn Jenner, Kim Kardashian, Watch Transparent Together, Says Creator Jill Soloway," *Us Magazine*, June 4, 2015. https://www.usmagazine.com/entertainment/news/caitlyn-jenner-kim-kardashian-watch-transparent-together-201546/

857.     Unsigned, "ADL Launches Curriculum on Transgender Identity," ADL website, May 5, 2014. https://chicago.adl.org/curriculum-transgender-identity-issues/

858.     Unsigned, "Miley Cyrus fluid with sexuality," *The Washington Post*, June 9, 2015. https://www.washingtonpost.com/entertainment/miley-cyrus-fluid-with-sexuality/2015/06/09/a7c4563a-0edb-11e5-a0fe-dccfea4653ee_story.html

859.     Philip Mendes, *Jews and the Left: The Rise and Fall of a Political Alliance* (Melbourne, Victoria; Palgrave MacMillan, 2014), viii; 1.

860.     Ibid., 1.

861.     Ibid., 2.

862.     Ibid., viii.

863.     Ibid.

864.     Ibid.

865.     Ibid., 6-7.

866.     Jerry Z. Muller, *Capitalism and the Jews* (Princeton NJ: Princeton University Press, 2010), 154.

867.     Ibid., 153.

868.     Mendes, *Jews and the Left*, 15.

869.     Ibid., 3.

870.     Ibid., 4.

871.     Ibid.

872.     Ibid., 16.

873.     Ibid., 15.

874.     Joshua Rubenstein, *Leon Trotsky: A Revolutionary's Life* (New Haven CT: Yale University Press, 2013), 67; 78; 52.

875.     Ibid., 113.

876.     Robert Wistrich, *Revolutionary Jews from Marx to Trotsky* (London: George G. Harrap & Co Ltd, 1976), 199.

877.     Hiroaki Kuromiya, *Russia's People of Empire: Life Stories from Eurasia, 1500 to the Present* (Bloomington: Indiana University Press, 2012), 276.

878.     E. A. Rees, Iron Lazar: *A Political Biography of Lazar Kaganovich* (Anthem Press, 2013), 6.

879.     John Klier, *Russians, Jews, and the Pogroms of 1881-2* (New York: Cambridge University Press, 2011), 5.

880.     Robert Wistrich, *From Ambivalence to Betrayal: the Left, the Jews and Israel* (Lincoln: University of Nebraska Press, 2012), 186.

881.     Mendes, *Jews and the Left*, 26.

882.     Ibid., 25.

883.     John Murray Cuddihy, *The Ordeal of Civility: Freud, Marx, Levi-Strauss and the Jewish struggle with Modernity* (New York NY; Beacon, 1987), 6.

884.     Mendes, *Jews and the Left*, 219.

885.     Ibid., 219.

886.     Ibid.

887.     Ibid., 288.

888.     Ibid., 225.

889.     Ibid., 9.

890.     Ibid., 220.

891.     Ibid.

892.     Chaim Bermant, *Jews* (London; Weidenfeld & Nicholson, 1977), 171-2.
893.     Ibid., 221.
894.     Ibid., 226.
895.     Ibid., 225.
896.     Ibid., 224.
897.     Mendes, *Jews and the Left*, 227.
898.     Ibid., 227.
899.     Myroslav Shkandriij, *Jews in Ukrainian Literature: Representation and Identity* (Yale University Press, 2009), 137.
900.     Yuri Slezkine, *The Jewish Century* (Princeton NJ: Princeton University Press, 2006), 254.
901.     Lesa Melnyczuk, *Silent Memories, Traumatic Lives* (RHYW, 2013), 25.
902.     Miron Dolot, *Execution by Hunger: The Hidden Holocaust* (W.W Norton & Company, 2011), 83.
903.     Ibid.
904.     Slezkine, *The Jewish Century*, 360.
905.     Ibid., 227.
906.     Bernhard Wasserman, *On The Eve: The Jews of Europe Before The Second World War* (London; Profile Books, 2012), 63.
907.     Mendes, *Jews and the Left*, 229.
908.     Ibid., 247.
909.     Ibid., 244.
910.     Ibid. 178-9.
911.     Ibid., 244-5.
912.     Ibid., 247.
913.     Ibid. 171.
914.     Ibid., 245.
915.     Ibid., 247-8.
916.     Ibid., 248.
917.     Ibid., 5.
918.     Ibid., 235-6.
919.     Ibid., 286.
920.     Martin Amis, *Koba the Dread: Laughter and the Twenty Million* (Vintage Digital, 2013), 217.
921.     Mendes, *Jews and the Left*, 285-6.
922.     Ibid., 14.
923.     Ibid., 18.
924.     Ibid., 237-8.
925.     Ibid., 250.
926.     Ibid., 249.
927.     Ibid., 250.
928.     Ibid.

929.     Ibid., 254.

930.     Ibid., 255.

931.     Ibid. 259.

932.     Ibid., 251.

933.     Ibid., 256.

934.     Ibid., 229.

935.     Ibid., 230.

936.     Ibid.

937.     Ibid., 257.

938.     Ibid., 22.

939.     Ibid., viii.

940.     Ibid., 235.

941.     Ibid., 236-7

942.     Ibid., 238.

943.     Ibid., 243.

944.     Ibid., 287.

945.     Ibid., 239.

946.     Ibid., 239.

947.     Ibid., 241.

948.     Ibid., 287.

949.     Ibid., 286.

950.     Ibid., 288-9.

951.     S.I. Rosenberg, "A shocking number of Jews have become willing collaborators in white supremacy A shocking number of Jews have become willing collaborators in white supremacy," *Boston Globe*, March 1, 2019. https://www.bostonglobe.com/ideas/2019/03/01/the-last-temptation-michael-cohen/1d1163vl6NuUpSndJ7wOpO/story.html

952.     David Cole, "Stop With the Golems Already!," *Taki's Magazine*, April 2, 2019. https://www.takimag.com/article/stop-with-the-golems-already/

953.     Allen Shawn, *Leonard Bernstein: An American Musician* (New Haven: Yale University Press, 2014), 6.

954.     Ibid., 6-7.

955.     Ibid., 10

956.     Ibid., 35.

957.     John Rockwell, "Bernstein Triumphant," *The New York Times Magazine*, August 31, 1986.

958.     Shawn, *Leonard Bernstein: An American Musician*, 240.

959.     Quoted in: Eyal Sherf, "Remembering the Musical Genius of Leonard Bernstein," *Haaretz*, August 9, 2018.

960.     Ibid.

961.     Shawn, *Leonard Bernstein: An American Musician*, 50.

962.     Ibid., 56.

963.     Ibid., 51.

964.     Humphrey Burton, *Leonard Bernstein* (London: Faber & Faber, 2017), 77.

965.     Allen Ellenzweig, "Don't Ask, Don't Tell," *Tablet*, November 6, 2012. https://www.tabletmag.com/jewish-arts-and-culture/theater-and-dance/113152/dont-ask-dont-ask

966.     Shawn, *Leonard Bernstein: An American Musician*, 44.

967.     Barry Seldes, *Leonard Bernstein: The Political Life of an American Musician* (Los Angeles: University of California Press, 2009), 220.

968.     Shawn, *Leonard Bernstein: An American Musician*, 71.

969.     Ellenzweig, "Don't Ask, Don't Tell."

970.     Ibid.

971.     Neal Gabler, *An Empire of Their Own: How the Jews Invented Hollywood* (New York: Crown, 1988) 6-7.

972.     Adam Garfinkle, *Jewcentricity: why the Jews are praised, blamed, and used to explain just about everything* (Hoboken NJ: John Wiley, 2009), 137.

973.     Seldes, *Leonard Bernstein: The Political Life of an American Musician*, 9.

974.     Ibid.

975.     Shawn, *Leonard Bernstein: An American Musician*, 18.

976.     Ibid.

977.     Ibid., 85.

978.     Ibid., 86.

979.     Ibid., 84.

980.     Ellenzweig, "Don't Ask, Don't Tell," op. cit.

981.     Georg Predota, "Leonard Bernstein and Felicia Montealegre: A Divided Life," *Interlude*, June 28, 2015. http://www.interlude.hk/front/leonard-bernstein-felicia-montealegrea-divided-life/

982.     Ellenzweig, "Don't Ask, Don't Tell," op. cit.

983.     Ibid.

984.     Shawn, *Leonard Bernstein: An American Musician*, 67.

985.     Ibid., 74.

986.     Ibid., 120.

987.     Ibid., 121.

988.     Seldes, *Leonard Bernstein: The Political Life of an American Musician*, 220.

989.     Ellenzweig, "Don't Ask, Don't Tell," op. cit.

990.     Shawn, *Leonard Bernstein: An American Musician*, 121.

991.     Ibid.

992.     Ellenzweig, "Don't Ask, Don't Tell," op. cit.

993.     Stephen J. Whitfield, *In Search of Jewish American Culture* (Waltham MA: Brandeis, 2001), 81.

994.     Devorah Goldman, "Leonard Bernstein's Multitudes," *The American Interest*, September 14, 2018. https://www.the-american-interest.com/2018/09/14/leonard-bernsteins-multitudes/

995.    Marjorie Ingall, "Leonard Bernstein: Behind the Music," *Tablet*, April 24, 2018. https://www.tabletmag.com/jewish-life-and-religion/260093/leonard-bernstein-behind-the-music

996.    Saul Jay Singer, "Leonard Bernstein and 'East Side Story,'" *The Jewish Press*, January 21, 2016. http://www.jewishpress.com/sections/features/features-on-jewish-world/leonard-bernstein-and-east-side-story/2016/01/21/

997.    Ivy Weingram, "Leonard Bernstein: American Icon," National Museum of American Jewish History. https://artsandculture.google.com/exhibit/KgLiDNgrN817Kw

998.    Goldman, "Leonard Bernstein's Multitudes."

999.    Rachel Shukert, "Will Spielberg's New 'West Side Story' Be MAGA Vs. DACA?," *Tablet*, January 26, 2018. https://www.tabletmag.com/scroll/254175/will-spielbergs-new-west-side-story-be-maga-vs-daca

1000.   Norman Lebrecht, *Why Mahler? How One Man and Ten Symphonies Changed the World* (London: Faber and Faber, 2010), 225.

1001.   Adorno, T., "Centenary Address, Vienna 1960," in *Quasi una fantasia – Essays on Modern Music*, trans. by Rodney Livingstone (London & New York: Verso, 1963), 88.

1002.   Leonard Bernstein, *The Unanswered Question: Six Talks at Harvard* (Cambridge MA: Harvard University Press, 1990), 313.

1003.   Allen Shawn, *Leonard Bernstein: An American Musician* (New Haven: Yale University Press, 2014), 175.

1004.   Ibid., 174.

1005.   Ibid., 174-5.

1006.   Ibid., 179.

1007.   Ibid., 38.

1008.   Ibid., 42.

1009.   Ibid.

1010.   Leonard Bernstein, "Mahler: His Time Has Come," *High Fidelity*, April 1967.

1011.   Ibid.

1012.   Barry Seldes, *Leonard Bernstein: The Political Life of an American Musician* (Los Angeles: University of California Press, 2009), 195.

1013.   Rick Schultz, "The Wagner Problem," *Jewish Journal*, April 7, 2010. https://jewishjournal.com/culture/music/78198/

1014.   Quoted in Liam Hoare, "Leonard Bernstein's Tense, Torn Love Affair With Vienna," *Tablet*, October 2, 2018. https://www.tabletmag.com/scroll/273026/leonard-bernsteins-tense-torn-love-affair-with-vienna

1015.   Paul R. Laird, *Leonard Bernstein* (London: Reaktion Books, 2018), 238.

1016.   Caroline Evensen Lazo, *Leonard Bernstein: In Love With Music* (Minneapolis MN: Twenty First Century Books, 2002), 97.

1017.   Humphrey Burton, *Leonard Bernstein* (London: Faber & Faber, 2017), 442.

1018.     Museum Judenplatz, "Leonard Bernstein: A New Yorker in Vienna," Jewish Museum Vienna. http://www.jmw.at/en/exhibitions/leonard-bernstein-new-yorker-vienna

1019.     Ibid.

1020.     Shawn, *Leonard Bernstein: An American Musician*, 262.

1021.     Seldes, *Leonard Bernstein: The Political Life of an American Musician*, 170.

1022.     Ibid.

1023.     Ibid., 234.

1024.     Ibid., 243.

1025.     Tom Leonard, "His West Side Story is a work of genius but will Leonard Bernstein's reputation survive his daughter's VERY unsettling book?," *Daily Mail*, June 29, 2018. https://www.dailymail.co.uk/news/article-5899063/TOM-LEONARD-Leonard-Bernsteins-reputation-survive-daughters-unsettling-book.html

1026.     Ibid., 250.

1027.     Kendall Todd, "Fun Five: Bernstein Rocks, Boston Pops, and Mahler Groves," *The Bernstein Experience*, February 28, 2018. https://bernstein.classical.org/features/fun-five-bernstein-rocks-boston-pops-mahler-grooves/

1028.     Mia Galuppo, "Jake Gyllenhaal to Play Leonard Bernstein in Cary Fukanaga's 'The American,'" *The Hollywood Reporter*, May 1, 2018. https://www.hollywoodreporter.com/news/jake-gyllenhaal-play-leonard-bernstein-cary-fukunagas-american-1107618

1029.     John Murray Cuddihy, *The Ordeal of Civility: Freud, Marx, Levi-Strauss and the Jewish Struggle with Modernity* (New York NY; Beacon, 1987), 6.

1030.     Jonathan Sacks, *The Chief Rabbi's Haggadah* (Essays) (New York NY; HarperCollins, 2003), 41.

1031.     Jonathan Sacks, *Radical Then, Radical Now* (London; Bloomsbury Academic, 2004), 205.

1032.     Jonathan Sacks, *One People?: Tradition, Modernity, and Jewish Unity* (London; Littman Library of Jewish Civilization, 1993), vii.

1033.     Immanuel Kant quoted in: Paul Lawrence Rose, *Wagner, Race & Revolution* (New Haven CT: Yale University Press, 1992), 7.

1034.     Jonathan Sacks, *Future Tense: Jews, Judaism and Israel in the Twenty-First Century* (New York; Schlocken, 2012), 129.

1035.     Sacks, *Radical Then, Radical Now*, 88.

1036.     Sacks, *Future Tense*, 111.

1037.     Ibid., 108-9.

1038.     Isi Leibler, "European meltdown threatens Jews," *The Jerusalem Post*, December 20, 2016. https://www.jpost.com/Opinion/European-meltdown-threatens-Jews-476004

1039.    Jonathan Sacks, "Having pride in Britain protects all cultures," Jonathan Sacks blog, February 11, 2011. http://rabbisacks.org/having-pride-in-britain-protects-all-cultures-published-in-the-times/

1040.    Jonathan Sacks, *The Home We Build Together: Recreating Society* (London; Bloomsbury Academic, 2009), 3.

1041.    Jonathan Sacks, *The Persistence of Faith: Religion, Morality and Society in a Secular Age* (London; Bloomsbury Academic), 68.

1042.    Ibid., 67.

1043.    Jonathan Sacks, *The Dignity of Difference: How to Avoid the Clash of Civilizations* (London; Bloomsbury Academic, 2003), 190.

1044.    Jonathan Sacks, *Will we have Jewish Grandchildren?: Jewish Continuity and How to Achieve It* (London; Vallentine Mitchell, 1994), 38.

1045.    Jonathan Sacks, *Encyclopedia of Modern Jewish Culture*, Ed. By Glenda Abramson (Abingdon, Oxon; Routledge, 2004), 245.

1046.    Ben Cohen, "Rabbi Sacks on Multiculturalism's Dangers," *Commentary*, August 21, 2013. https://www.commentarymagazine.com/bencohenonlinemailcom/rabbi-sacks-on-multiculturalisms-dangers/

1047.    Sacks, *One People?*, 195.

1048.    Ibid., 112; 34.

1049.    Sacks, *Radical Then, Radical Now*, 184.

1050.    Sacks, *Future Tense*, 46-7.

1051.    Menachem Wecker, "Eight Dada Jewish Artists," *The Jewish Press*, August 30, 2006. http://www.jewishpress.com/printArticle.cfm?contentid=19293

1052.    Bill Holdsworth, "Forgotten Jewish Dada-ists Get Their Due," *The Jewish Daily Forward*, September 22, 2011. http://forward.com/articles/143160/#ixzz1ZRAUpOoX

1053.    Wecker, "Eight Dada Jewish Artists," *op. cit.*

1054.    Amy Dempsey, *Schools and Movements – An Encyclopaedic Guide to Modern Art* (London: Thames & Hudson, 2002), 115.

1055.    Robert Short, *Dada and Surrealism* (London: Laurence King Publishing, 1994), 7.

1056.    Matthew Gale, *Dada & Surrealism* (London: Phaidon, 2004), 46.

1057.    Wecker, "Eight Dada Jewish Artists," *op. cit.*

1058.    Leah Dickerman, "Introduction & Zurich," Leah Dickerman (Ed.) *Dada* (Washington D.C., National Gallery of Art, 2005), 10.

1059.    Andrei Codrescu, *The Posthuman Dada Guide: tzara and lenin play chess* (Princeton University Press, 2009), 209.

1060.    *Ibid.*, 173.

1061.    *Ibid.*

1062.    Gabriele Crepaldi, *Modern Art 1900-1945 – The Age of the Avant-Gardes* (London: HarperCollins, 2007), 194.

1063.    Dickerman, "Introduction & Zurich," Leah Dickerman (Ed.) *Dada*, 33.

1064.    Alice Armstrong & Roger Cardinal, "Tzara, Tristan," Justin Wintle (Ed.) *Makers of Modern Culture* (London: Routledge, 2002), 530.

1065.    John Russell, *The Meanings of Modern Art* (London: Thames & Hudson, 1981), 179.

1066.    Codrescu, *The Posthuman Dada Guide: tzara and lenin play chess*, 213.

1067.    Jerome Rothenberg in Norman Finkelstein, *Not One of Them in Place and Jewish American Identity* (New York: State University of New York Press, 2001), 100.

1068.    Milly Heyd, "Tristan Tzara/Shmuel Rosenstock: The Hidden/Overt Jewish Agenda," Washton-Long, Baigel & Heyd (Eds.) *Jewish Dimensions in Modern Visual Culture: Anti-Semitism, Assimilation, Affirmation* (Lebanon, NH: University Press of New England, 2010), 213.

1069.    See Nicholas Zurbrugg et al. *Critical Vices: The Myths of Postmodern Theory* (Amsterdam: OPA, 2000).

1070.    Codrescu, *The Posthuman Dada Guide: tzara and lenin play chess*, 212.

1071.    Sarane Alexandrian, *Surrealist* (London: Thames & Hudson, 1970), 30-1.

1072.    Russell, *The Meanings of Modern Art*, 182.

1073.    Jeffrey T. Schnapp, *Art of the Twentieth Century – 1900-1919 – The Avant-garde Movements* (Italy, Skira, 2006), 392.

1074.    *Ibid.*, 389.

1075.    Tony Godfrey, *Conceptual Art* (London: Phaidon, 1998) 41.

1076.    Robert J. Wicks, *Modern French Philosophy: From Existentialism to Postmodernism* (Oxford: Oneworld, 2003), 10.

1077.    Godfrey, *Conceptual Art*, 40.

1078.    H. Harvard Arnason, *A History of Modern Art* (London: Thames & Hudson, 1986), 224.

1079.    Dickerman, "Introduction & Zurich," Leah Dickerman (Ed.) *Dada*, 9.

1080.    Schnapp, *Art of the Twentieth Century – 1900-1919 – The Avant-garde Movements op cit.*, 396.

1081.    Boime, "Dada's Dark Secret," Washton-Long, Baigel & Heyd (Eds.) *Jewish Dimensions in Modern Visual Culture: Anti-Semitism, Assimilation, Affirmation*, 98 & 95-6.

1082.    *Ibid.*, 96.

1083.    Dickerman, "Introduction & Zurich," Leah Dickerman (Ed.) *Dada, op cit.*, 35.

1084.    Hans Richter, *Dada – Art and Anti-art*, (London & New York: Thames & Hudson, 2004), 33.

1085.    Gale, *Dada & Surrealism*, 80.

1086.    *Ibid.*, 56.

1087.    Richter, *Dada – Art and Anti-art*, 80.

1088.    Robert Levy, *Ana Pauker: The Rise and Fall of a Jewish Communist* (Berkley: University of California Press, 2001), 37.

1089.    Philip Beitchman, *I Am a Process with No Subject* (Gainesville: University of Florida Press, 1988), 37-42.

1090.    Dempsey, *Styles, Schools and Movements - An Encylopaedic Guide to Modern Art, op cit.*, 115.

1091.    Richter, *Dada. Art and Anti-art*, 168.

1092.    Fiona Bradley, *Movements in Modern Art - Surrealism* (London: Tate Gallery Publishing, 2001), 18-19.

1093.    Gale, *Dada & Surrealism*, 180.

1094.    Janine Mileaf & Matthew Witkovsky, "Paris," Leah Dickerman (Ed.) *Dada*, 349.

1095.    *Ibid.*, 358.

1096.    *Ibid.*, 350.

1097.    *Ibid.*, 352.

1098.    *Ibid.*, 366.

1099.    Codrescu, *The Posthuman Dada Guide: tzara and lenin play chess*, 174.

1100.    Dempsey, *Styles, Schools and Movements - An Encyclopaedic Guide to Modern Art*, 119.

1101.    Richter, *Dada - Art and Anti-art*, 119.

1102.    Robert Short, *Dada and Surrealism* (London: Laurence King Publishing, 1994), 69; 83.

1103.    Patrick Waldberg, *Surrealism* (London: Thames & Hudson, 1997), 18.

1104.    Carlos Rojas, *Salvador Dalí, or the Art of Spitting on Your Mother's Portrait* (University Park: Penn State University Press, 1993), 98.

1105.    Codrescu, *The Posthuman Dada Guide: tzara and lenin play chess*, 215.

1106.    Beitchman, *I Am a Process with No Subject*, 48-9.

1107.    Irina Livezeanu, "From Dada to Gaga: The Peripatetic Romanian Avant-Garde Confronts Communism," Mihai Dinu Gheorghiu & Lucia Dragomir (Eds.), *Littératures et pouvoir symbolique* (Bucharest: Paralela 45, 2005), 245-6.

1108.    Hockensmith, "Artists' Biographies," Leah Dickerman (Ed.) *Dada*, 489.

1109.    Codrescu, *The Posthuman Dada Guide: tzara and lenin play chess*, 211.

1110.    Michael Taylor, "New York," Leah Dickerman (Ed.) *Dada*, 287.

1111.    Pierre Cabanne, *Duchamp & Co.*, (Paris: Finest SA/Editions Pierre Terrail, 1997), 115.

1112.    Taylor, "New York," 278.

1113.    Hockensmith, "Artists' Biographies," 479.

1114.    Schnapp, *Art of the Twentieth Century - 1900-1919 - The Avant-garde Movements*, 412.

1115.    Gale, *Dada & Surrealism*, 120.

1116.    Bernard Blisténe, *A History of Twentieth Century Art* (Paris: Fammarion, 2001), 62.

1117.    Dawn Ades, "Dada and Surrealism," David Britt (Ed.) *Modern Art - Impressionism to Post-Modernism*, (London, Thames & Hudson, 1974), 222.

1118.    Edina Bernard, *Modern Art – 1905-1945* (Paris: Chambers, 2004), 86.

1119.    Robert Short, *Dada and Surrealism* (London: Laurence King Publishing, 1994), 42.

1120.    Doherty, "Berlin," Leah Dickerman (Ed.) *Dada*, 220.

1121.    Short, *Dada and Surrealism*, 42.

1122.    Robert Short, *Dada and Surrealism* (London: Laurence King Publishing, 1994), 50.

1123.    Schnapp, *Art of the Twentieth Century – 1900-1919 – The Avant-garde Movements*, 399.

1124.    Philippe Dagen, "From Dada to Surrealism – Review" (*The Guardian*, July 19, 2011). http://www.guardian.co.uk/artanddesign/2011/jul/19/dada-to-surrealism-dagen-review

1125.    Adolf Hitler, *Mein Kampf* (trans. By James Murphy), (London: Imperial Collegiate Publishing, 2010), 281.

1126.    *Ibid.*, 58.

1127.    Peter Adam, *Arts of the Third Reich* (New York: Harry N. Abrams, 1992), 55.

1128.    *Ibid.*, 12-15.

1129.    Paul Johnson, *Art – A New History* (New York: HarperCollins, 2003), 707.

1130.    *Ibid.*, 709.

1131.    Dempsey, *Styles, Schools and Movements – An Encylopaedic Guide to Modern Art*, 119.

1132.    Dickerman, "Introduction & Zurich," Leah Dickerman (Ed.) *Dada*, 8.

1133.    *Ibid.*, 11.

1134.    Godfrey, *Conceptual Art*, 37.

1135.    Dempsey, *Styles, Schools and Movements – An Encyclopedic Guide to Modern Art*, 204.

1136.    Gabriel Crepaldi, *Modern Art 1900-1945 – The Age of the Avant-Gardes* (London: HarperCollins, 2007) 195.

1137.    Robert J. Wicks, *Modern French Philosophy: From Existentialism to Postmodernism* (Oxford: Oneworld, 2007), 11.

1138.    Mark A. Pegrum, *Challenging Modernity: Dada between Modern and Postmodern* (New York: Berghahn Books, 2000), 269.

1139.    Richard Sheppard, *Modernism-Dada-Postmodernism* (Evanston, Northwestern University Press, 1999), 365.

1140.    Wicks, *Modern French Philosophy: From Existentialism to Postmodernism*, 9-10.

1141.    Beitchman, *I Am a Process with No Subject*, 29.

1142.    Irwin Unger & Debi Unger, *The Guggenheims – A Family History* (New York: Harper Perennial, 2006), 354.

1143.    Short, *Dada and Surrealism*, 12.

1144.     Loredana Parmesani, *Art of the Twentieth Century – Movements, Theories, Schools and Tendencies 1900-2000* (Milan: Skira, 1998), 36.

1145.     Richter, *Dada. Art and Anti-art*, 191.

1146.     Dickerman, "Introduction & Zurich," Leah Dickerman (Ed.) *Dada*, 33.

1147.     Godfrey, *Conceptual Art*, 44.

1148.     Short, *Dada and Surrealism*, 17.

1149.     Roger Scruton, *Modern Philosophy* (London: Penguin, 1994), 478-9.

1150.     Sheppard, *Modernism-Dada-Postmodernism*, 363.

1151.     Roger Poole, "Deconstruction," Alan Bullock & Peter Trombley (Eds.) *The New Fontana Dictionary of Modern Thought* (London: HarperCollins, 2000), 203.

1152.     Jacques Derrida, "Circumfession," In *Jacques Derrida*, Ed. G. Bennington & Jacques Derrida, Trans. G. Bennington (Chicago: University of Chicago Press, 1993), 170.

1153.     Benjamin Ivry, "Sovereign or Beast?" *Forward*, December 1, 2010. https://forward.com/culture/133536/sovereign-or-beast/

1154.     Kevin MacDonald, *The Culture of Critique: An Evolutionary Analysis of Jewish Involvement in Twentieth-Century Intellectual and Political Movements* (Bloomington, IN: 1stbooks Library, 2001), 198.

1155.     Derrida, "Circumfession," op. cit., 58)

1156.     Jacques Derrida, *Points... Interviews, 1974-1994*, Trans. P. Kamuf et al (Palo Alto, CA: Stanford University Press, 1995), 120–21.

1157.     J.D. Caputo, *The Prayers and Tears of Jacques Derrida: Religion without Religion* (Bloomington: University of Indiana Press, 1997), 231–2.

1158.     Alfred Bodenheimer, "Dada Judaism: The Avant-Garde in First World War Zurich," In: Gelber, Mark H. and Sjöberg, Sami. *Jewish Aspects in Avant-Garde: Between Rebellion and Revelation*, Berlin, Boston: De Gruyter, 2017. https://doi.org/10.1515/9783110454956

1159.     Malcolm Haslam, *The Real World of the Surrealists* (London: Weidenfeld & Nicholson, 1978), 93.

1160.     Boime, 'Dada's Dark Secret,' Washton-Long, Baigel & Heyd (Eds.) *Jewish Dimensions in Modern Visual Culture: Anti-Semitism, Assimilation, Affirmation*, 102.

1161.     Benjamin Ivry, "Sovereign or Beast? Jacques Derrida and his Place in Modern Philosophy" (*The Jewish Daily Forward*, December 1, 2010. http://www.forward.com/articles/133536/

1162.     Matthew Biro, *The Dada Cyborg: Visions of the New Human in Weimar Berlin*, (Minnesota: University of Minnesota Press, 2009), 154.

1163.     Kevin MacDonald, *The Culture of Critique: An Evolutionary Analysis of Jewish Involvement in Twentieth-Century Intellectual and Political Movements* (Bloomington, IN: 1stbooks Library, 2001), 205.

1164.     Dickerman, "Introduction & Zurich," Leah Dickerman (Ed.) *Dada*, 29.

1165.   Hockensmith, "Artists' Biographies," Leah Dickerman (Ed.) *Dada*, 482.

1166.   *Ibid.*, 486.

1167.   Codrescu, *The Posthuman Dada Guide: tzara and lenin play chess*, 176.

1168.   Scruton, *Modern Philosophy*, 479.

1169.   Gideon Ofrat, *The Jewish Derrida* (New York: Syracuse University Press, 2001), 30-1.

1170.   Roger Scruton, *Culture Counts – Faith and Feeling in a World Besieged* (New York: Encounter Books, 2007), 70.

1171.   Wicks, *Modern French Philosophy: From Existentialism to Postmodernism*, 10.

1172.   Scruton, *Modern Culture*, 138.

1173.   Paul Johnson, *Art – A New History* (New York: HarperCollins, 2003), 669.

1174.   Quoted in Martin Kitchen, *The Cambridge Illustrated History of Germany* (London: Cambridge University Press, 2000), 195.

1175.   Matthew Boyden, *The Rough Guide to Opera* (London: Penguin, 2002), 269.

1176.   Roger Scruton, *The Ring of Truth: The Wisdom of Wagner's Ring of the Nibelung* (London: Allen Lane, 2016), 28.

1177.   Ibid., 6.

1178.   Ibid., 9-10.

1179.   Scruton, *The Ring of Truth*, 1.

1180.   Ibid., 2.

1181.   Ibid., 3.

1182.   Bryan Magee, *Wagner and Philosophy* (London: Penguin, 2000), 352.

1183.   Quoted in Martin Kitchen, *The Cambridge Illustrated History of Germany*, Ibid.

1184.   Christopher Nicholson, *Richard and Adolf: Did Richard Wagner Incite Adolf Hitler to Commit the Holocaust* (Jerusalem: Gefen Publishing House, 2007), 131.

1185.   Scruton, *The Ring of Truth*, 2.

1186.   Ibid., 300.

1187.   Elisabeth Whitcombe, "Adorno as Critic: Celebrating the Socially Destructive Force of Music," *The Occidental Observer*, August 28, 2009. http://www.theoccidentalobserver.net/authors/Whitcombe-AdornoI.html

1188.   Monsalvat website, "Parsifal and Race: Wagner's Last Card," Undated. http://www.monsalvat.no/racism.htm ·

1189.   Harold Schonberg, *Lives of the Great Composers* (New York: W.W. Norton, 1997), 268.

1190.   Marc A. Weiner, *Richard Wagner and the Anti-Semitic Imagination* (Lincoln: University of Nebraska Press, 1997), 6.

1191.   Larry Solomon, "Wagner and Hitler," Online article, 2002. http://solomonsmusic.net/WagHit.htm

1192.    Scruton, *The Ring of Truth*, 3.

1193.    Ibid.

1194.    Richard Wagner, "Judaism in Music," trans. By Bryan Magee, In: *Wagner and Philosophy* (London: Penguin, 2000), 375.

1195.    Magee, *Wagner and Philosophy*, Ibid., 375-6.

1196.    Ibid., 374.

1197.    Ibid., 373; 380.

1198.    Richard Wagner, "Hero-dom and Christianity," trans. by William Ashton Ellis, In: *Richard Wagner's Prose Works Vol. 6* (London: 1897; repr. 1966), 275-84.

1199.    Richard Wagner, "Religion and Art," trans. by William Ashton Ellis, In: *Richard Wagner's Prose Works, Vol. 6* (London: 1897; repr. 1966), 211-52.

1200.    Solomon, "Wagner and Hitler," op. cit.

1201.    David P. Goldman, "Muted: Performances of Wagner's music are effectively banned in Israel. Should they be?" *Tablet*, August 17, 2011.

1202.    Scruton, *The Ring of Truth*, 102.

1203.    Solomon, "Wagner and Hitler," op. cit.

1204.    Unsigned, "Getting into Valhalla," *The Economist*, June 23, 2016. https://www.economist.com/news/books-and-arts/21701100-how-understand-most-daunting-opera-ever-written-getting-valhalla

1205.    Scruton, *The Ring of Truth*, 5.

1206.    Ibid., 6.

1207.    Roger Scruton, *Modern Culture* (London: Continuum, 2000), 69.

1208.    Richard Wagner, "Religion and Art," trans. By William Ashton Ellis, In: *Richard Wagner's Prose Works, Vol. 6* (London: 1897; repr. 1966), 211-52.